The Cinema Effect

The Cinema Effect

Sean Cubitt

The MIT Press Cambridge, Massachusetts London, England

This book was set in Janson and Rotis Semi Sans by Graphic Compostion, Inc., and was printed and bound in the United States of America.

Library of Congress Cataloging-in-Publication Data

Cubitt, Sean.
 The cinema effect / Sean Cubitt.
 p. cm.
 Includes bibliographical references and index.
 ISBN 0-262-03312-7 (hc. : alk paper)
 1. Motion pictures—Philosophy. 2. Cinematography—Special effects. I. Title.
PN1995.C77 2004
791.43—dc21 2003046405

10 9 8 7 6 5 4 3 2

For Terry, Orlando, Eliza, and Sue

Contents

Acknowledgments

This book was commenced during and could not have been achieved without a research fellowship in the School of Television and Imaging at Duncan of Jordanstone College of Art and Design at the University of Dundee in the first months of 2000. My thanks especially to Steve Partridge for inviting me, and to Jo Coull, Peter Estgate, Mike Stubbs, Simon Yuill, and the staff of the Visual Research Centre at Dundee Contemporary Arts. To my friends and colleagues at Liverpool John Moores University especial thanks, most of all to Warren Buckland, Trevor Long, Nickianne Moody, Tom Moylan, Yiannis Tzioumakis, Lydia Papadimitriou, and Corin Willis. Moving to Aotearoa, New Zealand, in the middle of the project was greatly eased, and the creative thinking that has gone into it subsequently has been immensely enriched, by my colleagues in screen and media at the University of Waikato: Ann Hardy, Craig Hight, Stan Jones, Anne Kennedy, Geoff Lealand, Suzette Major, Mark McGeady, Maree Mills, Alistair Swale, and Bevin Yeatman. I also owe much to conversation, that most delightfully endless of all human activities, with John Armitage, Jonathan Beller, Eddie Berg, Michael Bérubé, Sue Clayton, Tom Conley, David Connearn, Edmond Couchot, Rachel Dwyer, Stuart Evans, Mike Featherstone, Jane Graves, John Grech, Susan Hiller, Steven G. Jones, Thierry Jutel, Eduardo Kac, Douglas Kahn, Ryszard Kluszinski, Jim Lastra, Geert Lovink, Tara Macpherson, Janine Marchessault, Laura U. Marks, Margaret Morse, Tim Murray, Steve Neale, Bethany Ogden, Daniel Reeves, Katarina Sarakakis, Zia Sardar, Brian Shoesmith, Yvonne Spielmann, Kaspar Straecke, Mike Stubbs, Petr Szepanik, Tan See Kam, Patti Zimmerman, and many more. A draft of part of chapter 2 was published in *Wide Angle* 21(1), and of chapter 11 in *Aliens R Us: The Other in Science Fiction Cinema*, edited by Ziauddin

Sardar and Sean Cubitt, Pluto Press, 2001. Early versions of various parts of the text were presented the University of Illinois Urbana–Champaign; the Society for Cinema Studies conference, Chicago; the University of Dundee; the Cultural Studies Association of Australia at the University of Tasmania, Hobart; the University of Volos, Greece; the National Film Archive, Wellington; Roskilde University, Denmark; the University of Toronto; the Association of Art Historians *Body and Soul* conference, Edinburgh University; the School of the Art Institute of Chicago; the Watershed, Bristol; Sheffield Hallam University; the Institute for Popular Music at the University of Liverpool; the Screen Studies Conference, University of Glasgow; Oxford University Computing in the Humanities Centre; the Centre for Contemporary Art, Warsaw; Trinity College, Cambridge; University of Technology Sydney; Gasteig, Munich; the Royal College of Art, London; the Centro Nacional de Arte Moderna Reina Sofia, Madrid; the Centre for Contemporary Art and the Academy of Fine Art, Prague; and the Central St Martins School of Art, London. An especial debt of gratitude to the Centre for Audiovisual Studies at the Masaryk University of Brno, Czech Republic for the opportunity to review the theses contained here with them, and to the British Council for their support of that visit.

The manuscript was completed with the aid of research grants from the Faculty of Arts and Social Sciences at the University of Waikato. Special thanks for images are due to Donald Crafton, Vinu Vinod Chopra, Katherine Oakes of the BFI Stills Library, and the New Zealand Film Commission. Patrick Ciano, Chrys Fox, Judy Feldmann, Doug Sery, and my anonymous reviewers at the MIT Press made production a lively and challenging process.

ENTRÉE: THE OBJECT OF FILM
AND THE FILM OBJECT

In some sense all cinema is a special effect.

—*Christian Metz*

I want to know what cinema does. If it causes no effect, however ornery or belated, cinema doesn't do anything, and there is left only the question of what it is or, more exactly, what it fails to be. Cinema does something, and what it does matters. Cinema's first effect is to exist. Yet like everything else it has trouble existing, and the effects it produces—images and sounds, dimensions, durations, sensations, understandings, and thoughts—all share a quizzical and oblique relation to reality. Certainly you could measure physiological dilations and palpitations to ascertain the reality of a film's emotional clout. But there is something fictive, something uncanny, or something that, however marginally, fails the reality test in even the most engrossing films, and perhaps in them most of all. Studying special effects has led me to an odd little problem that has turned out, over the years we have spent together, to be fascinating and revealing companion: the problem of the object of cinema.

Like most of my generation I went to school with Western Marxism and psychoanalytic semiotics, and their overriding concern with subjectivity. The greatest film analysts outside that tradition have grappled with the phenomenology of cinema. Bazin (1967, 1971) and Deleuze (1986, 1989), revisited in recent years by Sobchack (1992), Bukatman (1994, 1998, 2000), and Marks (2000), address sensation and what we do with it. Between subject and sensation lies the puzzling and enticing question of the object. Somewhere in the action of perceiving, the endlessness of sensation is ordered into a unity that can be recognized as an object, and in that same act,

the subject comes to be as the perceiver of the object. Simple, if mysterious, this process, which lies among other things at the heart of the sociocultural process of "othering," has become utterly central to the mediated world we live in.

I take it as a premise that communication is the fundamental activity of human beings, that socialization, sexuality, trade, labor, power, and status are all modes of communication, and that in our period the dominant medium of communication is no longer face-to-face interaction but the commodity. To ask the question about the object in our day is to ask about the mysterious entity it has become, and to inquire into the changing nature of the commodity form that came into being with capitalism and whose per-mutations in and of the communicative herald, I believe, its eventual col-lapse. The historical study of the object of film is then also a study of the evolution of the commodity form. Drawing inspiration from Marx's found-ing insight into commodity fetishism, this book speaks to the materiality of mediation, the object status of the media through which, so often, we en-gage with our objects, as cinematographers, critics, and audiences.

Between sensuous inhabiting of the world and the elaborations of meaning, there is the necessary stage in which the world is "othered," "ob-jected," its flux categorized into identifiable objects thrown apart from any consciousness of them. Marx adds the vital thought that this process has a history. People have not always and everywhere made or exchanged objects in the same way. In the hundred years or so since the invention of moving pictures, that exchange has occurred more and more in the form of media whose microhistory is also a microhistory of the commodity, from industrial use value through the society of the spectacle (Debord 1977), to the virtual objects of data exchange. Of all media, the popular cinema can claim to reflect "the social characteristics of [people]'s own labour as objective char-acteristics of labour themselves" (Marx 1976: 164–165). Labor is a com-modity, a thing that can be exchanged. It is a mediation, a material form in which communication goes on between people. Labor, cinema, and com-modities are media, each of them proper to a particular epoch of history. Communication is fundamentally human, but therefore also fundamentally historical. To investigate a medium is to analyze and synthesize the histor-ical nature of the material mediations that characterize a period in time. Film is uniquely situated to reveal the inner workings of the commodity,

since it was for most of the last century the most popular, as it is now still the most strategic medium. Cinema has art's capability for analyzing its own being without, among the films addressed here, the embarrassment of having undermined it.

Guiding the inquiry into the cinematic object has been the cryptic but inspiring conception of firstness, secondness and thirdness developed by C. S. Peirce. Peirce himself noted the symmetry of his triad with Hegel's being, essence, and notion (Hegel 1975: 5–6), and with Kant's categories. These concepts are especially fascinating because they are relational (Peirce 1958: 383): they concern, for the purposes of this writing, the relations between sensation, cognition, and comprehension. Think, for example, of a football game. In the first instance there is only grass, air, milling figures. In the second there are the structures defining the action: the goals, the bleachers, and the touchline—and the apperception that identifies all this as "the game." Third is appreciating the significance of the running—the strategic pass, the lightning dart, the feint, the skill and grace of a game well played. I use the terms *pixel*, *cut*, and *vector* here, both to anchor the discussion in the material of film, and to shape the whole as a retrospective historiography of images in motion from the standpoint of the digital era, written for a digital audience.

Karl Brown gives a sense of the Wordsworthian delirium of the early period. Griffith explains what he wants for a shot in *Broken Blossoms*:

"I want a river . . . a misty . . . misty river . . ." His long, sensitive hands were molding the picture that he was seeing with his inner eye. "A river of dreams . . . the Thames as Whistler or perhaps Turner might have painted it, only it must be a real river, do you understand? A real river, flowing, endlessly flowing, carrying destiny, the never-ending destiny of life on its tide. I must see that flow, that silent flow of time and fortune, with all the mystery of unknowable future there to be seen and yet not to be seen . . ." The vision vanished, and with it the poetic spell. He asked, in his sharp, penetrating, directorial voice, "Do you know what I mean?" (Brown 1973: 216–217)

Brown describes the trough used for the river, the flash powder dropped in to give it sheen, the electric fan, the lead weights wired to the flat cutout luggers to keep them upright in the breeze. He adds artisanal pride

in inventing the techniques of miniature set photography to the already doubled demands the director makes of him, to be at once realistic and mesmerizing. Such triple consciousness informs the digital viewer, alert to the mechanisms of illusion, delighted by their effectivity, and entranced by their developments. This book contends that the same triangulation shapes the cinematic object.

States of schizophrenia are native to film's present-absence, its not-quite-existence, its fictionalization of truth and its verification of illusion. For Kant, "This fundamental principle of the necessary unity of apperception is indeed an identical, and therefore analytical proposition; but it nevertheless explains the necessity for a synthesis of the manifold given in an intuition, without which the identity of self-consciousness would be incogitable" (Kant 1890: 83). Now, self-consciousness is indeed "cogitable," but is it necessary? The axiom that communication is human may lead to individual human communicators, but it need not, since selfhood is a derivative of communication, a special effect of a particular historical mode of communication. Since self-consciousness is no longer a given but an effect, synthesizing the myriad sensations that crowd upon us into recognizable identities is also in question. I am thus never sure whether what I perceive is raw phenomenality, abstract identity, or synthetic truth. To that extent this work deals also with the sense of self as that arises in the division of object from subject in the relationships with light particles in time, the horizon of the screen, or cinema's represented worlds. These relationships are unstable, I argue. For this reason, it is important to distrust the normative thrust of statements like this:

This . . . compromise between deep space and selective focus typifies mainstream style today. The eclecticism introduced at the end of the 1960s and canonised in such films as *Jaws* and *The Godfather* seems to have become the dominant tendency of popular filmmaking around the world. Long lenses for picturesque landscapes, for traffic and urban crowds, for stunts, for chases, for point-of-view shots of distant events, for inserted close-ups of hands and other details; wide-angle lenses for interior dialogue scenes, staged in moderate depth and often with racking focus; camera movements that plunge into crowds and arc around central elements to establish depth; everything held together by rapid cutting—if there is a current professional norm of 35mm commercial film style around the world, this synthesis is probably it. (Bordwell 1997: 259–260)

Bordwell's strategy here is to establish as normative the practices of the North American film industry, and to derive all other filmic styles from that norm (in the pages that follow, for example, he describes the film style of Angelopoulos as "dedramatizing," as if the dramatic were the norm from which Angelopoulos' films are an aberration), thus leaving space neither for film styles independent of the North American industry nor for dialectical currents within the normative style itself. The historian must be alert to difference as much as to similarity, and the materialist historian has also the ethical duty to watch out for contradiction and alternatives. Aumont and his colleagues note that "film analysis must be very detailed in order to be fruitful or even accurate" (Aumont et al. 1992: 77). Normative criticism may be a necessary phase in the establishment of film studies as a university discipline, but its priority of the model over the actual is only an example of how to construct a filmic object. Our task here is to take Aumont's suggestion, and to work at a moment prior to the constitution of either the model or the represented as a given. We have to start, then, not with things but with relationships and especially with change.

The moving image moves. But where does that movement come from? For a certain approach in art history, an image is a discrete, whole entity. To move from one image to another is already an immense wrench: even the analysis of a diptych is wildly complex. What then is it to speak of "a" moving image, constructed from thousands of constituent images? In what sense is it *an* image? Cinematic movement is a fundamental challenge to the concept of wholeness and integrity, its becoming a test of the primacy of existence. In particular, it raises the question of temporality: when is the object of cinema? When, indeed, is the moving image?

For although it is the most ancient of all the arts, the moving image is also the most modern. Its relation to the commodity fetish becomes only more apparent in the mysteries of its origins. Before it was technological, before history began, there were firelight and shadows, gestures of the shaman, strides of the dancer, puppetry of hand-shadows cast on the walls at the rough dawn of consciousness. In these oldest arts, the immediate world became image, an altar, for a god or a throng of gods to inhabit. Of those millennia of tragedy, sacrifice, and dream, not a shred remains. History begins with recording, the records that start with the preparation of spaces for bodies and light. Pigment stains adapting the accidents of geology, carved modification of rockfaces, the petroglyphs of the Cave of the

Bison inscribe before the event what would remain long after it. More frag-
ile and corruptible than even rock paintings, we no longer or scarcely pos-
sess wooden artifacts of the Stone Age, but looking at the stone figurines of
the Cyclades, we can catch hints of a coeval culture of carved dolls passed
hand-to-hand among the tribe, a precursor of the more intimate and seden-
tary arts of television. Film, however, begins in the public scale of torchlight
processions through Altamira, the play of sunlight, moonlight, and dappling
cloud on the stained glass windows of medieval Europe, the fireworks and
waterworks of the Baroque (rendered cinematic in Anger's *Eaux d'artifice*)—
one more reason to be delighted that the Lumière brothers should be named
for light.

In the painted caves of Lascaux, the temporary community of ritual at-
tains continuity through repeated returns to the same marked space. Their
time is no longer only the experience of the moment but an ordering of
action. This ancient ordering is the founding principle of all those arts
that devolve on the movement of bodies through illustrated space. Disney
World mimics the passage through the sculpted cave in times set aside
from the ordinary. In a more banal vein, the same itinerary through illu-
minated places marks the traverse of airports, the guided meander through
supermarket aisles. From monumental statuary and triumphal arches (War-
ner 1985) to Benjamin's arcades (Buck-Morss 1989) and the protocinema
of railway travel (Schivelbusch 1980), the stillness of the image and the mo-
tion of the body become characteristic forms of modernity. The comple-
mentary form, movement of the image and stillness of the body, begins,
if we are to believe Boal (1974), in the Greek drama with the distinction be-
tween performer and spectator. The protocinemas of the masque, the melo-
drama, and the magic lantern add the spectacle of technique. Cinema and
its associated media merely industrialize the stasis of the audience in the
movement of the image. Perhaps one day, perhaps soon, there will be an art
of moving bodies and moving images. Perhaps, as Virilio (1994) argues, we
are moving instead toward a world of static bodies and stationary images.
The magic of cinema, cinema as special effect, arises from this intertwin-
ing of relations of movement, scale, distance, and repetition, from this an-
cient history of time. But there is also the modernity of cinema to consider,
the specificities of time in the age of capital and of globalization.

Image and transport technologies, revolutionized in the nineteenth
century, instigated new relationships with time as fundamental as those be-

gun in the transition from prehistory to recorded time (Kern 1983). Both Paul Virilio (1989) and Friedrich Kittler (1999) suggest that cinema must be located in the twinning of media and military technologies. As Siegfried Zielinski argues, however, reiterating the assertion made earlier by Lewis Mumford (1934: 12–18), nineteenth-century military and media technologies both depended for their mechanization and automation on the logically and chronologically prior development of the clock (Zielinski 1999: 72–74). The new armaments and logistics of the Maxim gun and the tank, like the new network of rail and telegraph, like the structured time of the shutter, derive both technologically and conceptually from the mechanized measurement of time. Without the mass-scale precision engineering required by the popularization of watches and clocks in the 1870s, the machine gun, the railway schedule, the production line, the cash register, and the cinematograph are not thinkable. The splitting of human action into mechanically discrete movements, the atomization of economic and bureaucratic flows into distinct and quasi-autonomous, even meaningless keystrokes on the adding machine and typewriter, the Taylorization of work at Ford's River Rouge plant all spring from the same imagining of time as a discrete series of steps. And yet, although the cinema has the discretion of a chronometer, it also struggles with other temporalities, some coming into being, some fading from their old hegemony. However important the addition of the second hand to mass-produced watches, it alone cannot account for the opening up of microscopic, infinitessimal times, or the *mise-en-abyme* of the commodity fetish as it spiraled into spectacle. The proletarianization of chronometric time and its extension from the workplace to the world of pleasures and reproduction brings it into a dialectical realm of contradictions and disputations. Reform movements in the last decades of the nineteenth century shortened the working week across Europe and North America, producing the new phenomenon of surplus time, a time that now fell to the emergent entertainment industries to commodify. Indeed, by the late 1920s it would become apparent that the time of consumption was as vital to economic growth as the time of production.

The first part of the book looks at this first period, focusing on France in the decade after 1895. I propose here three elementary aspects of the moving image corresponding to Peirce's categories and derived from the mathematical foundations of digital media. I want to supplant the metaphors of film as language pursued by Metz (especially 1974a, b) and film as

psychology pursued by Bordwell (1985, 1989), with a more digital analysis of the mathematical bases of motion. This choice of terminology comes with an admission that like all histories this is a retrospective. Because cinema so clearly traces a history from mechanical to digital time, I have tried to indicate that the shifting temporalities of the commodity film have neither ceased to change nor mutated into something utterly different in the digital era. In the work of the Lumières, Méliès, and Cohl, it is possible to descry the distinctive qualities of cinema as an autonomous medium. That autonomy would survive scarcely a handful of years, perhaps even less. Within months of its invention, film had become a commodity, and its unique ontology embarked on its long dialectical relation with the larger world.

The second part leaps over the rich innovations of the first thirty years of the twentieth century to engage with the sound cinemas of the 1930s. Once the technical difficulties associated with the innovation of synchronized sound were resolved around 1929 (Crafton 1997; Gomery 1980), the cinemas of the 1930s began to move swiftly through experiments to secure stable modes of operation. As Terry Smith puts it, "The urges to disorder and totality of the competing modernities of the 1920s, dreams/projections then, seek generalization, institutionalization in the mid-1930s. They seek to control the social gaze—in short, to govern" (Smith 1993: 161). Mack Sennett's life at Keystone (Sennett 1967) and Griffith's actresses' at Biograph (Gish 1969; Griffith 1969; Pickford 1955) seem full of joyful inventiveness. In Ben Hecht's sour account of the classical studio era (Hecht 1954), governance has triumphed in the stabilization of new cinematic norms. Control over patents, cartelization of research and development, market domination of supplies to the film industry (e.g., in film stock and lights; Winston 1996: 39–57; Bordwell 1985: 294–297), and the increasing role of the banks in film financing (Wasko 1986) all supported a growing monopolization of the photomechanical and nascent electronic media (Mitchell 1979a, b). A parallel monopolization occurred in 1934 in the tyranny of social realism, when both Hitler and Stalin embraced it as the art of the state (Hitler 1968; Zhdanov 1992).

The third part moves to the postwar period. Slow motion, freeze-frame, steadicam, bullet-time: across three decades, cinema moves toward a spatialization of time. This process is refracted through other dialectics as well: order and entropy, local and global, analog and digital. Dadoun's de-

scription of Hollywood in the 1930s is premature: it was in the postwar pe-
riod that "While being subjected more completely than anything else to the
constraints, the rules and ideas of the economic system, the cinema projects
the delusion of being an autonomous world, above reality, concerned only
with the higher pursuit of image-making" (Dadoun 1989: 46). The 1940s
are the hinge on which all arguments concerning the power to depict must
pause. The Holocaust was not the largest genocide undertaken by the Eu-
ropean empires, nor the most complete. It names more than the deaths of
the Poles, Romanies, homosexuals, Communists, and Jews: it names also, in
ways we are still learning to articulate, the massacres of slavery, the ethno-
cides in Tierra del Fuego, Tasmania, and Newfoundland, the slaughter of
the Aborigines, the destruction of the First Americans and on and on and
on. No attempt to write historically, not one written by a European, can be
taken seriously unless it confronts this vacuum into which the dream of ra-
tional Enlightenment descended.

Far from making reference impossible, the camps made it essential, the
metaphysical task of cinema, for a period that is only now coming to an end.
This is one reason the realist and total cinemas sometimes appear confused
in works like *Imitation of Life*. The demand that we weep is not negotiable,
when Mahalia Jackson sings. To some extent we are impelled to empathize
with a world that only ever knows too late how great we were (Neale 1986),
so that the film invites us to live a posthumous fantasy. *Imitation* is not itself
a fascist film, but it is a film that reveals fascism through fascism's aestheti-
cization of politics. The totalitarianism of Eisenhower-era North America
is not just depicted in the enclosed deep-staging; it is voiced as loss in the
language of Riefenstahl, applied now to living rooms and kitchens that look
like the direct heirs of Albert Speer's architecture of light. The cinema itself
became more than an alibi: it was the allegorical building where dreams and
aspirations went to die.

The postwar world began to pose in new ways another Kantian aes-
thetic, the division of the beautiful from the sublime. Beauty is, in *The Cri-
tique of Judgment*, a common thing, shared and social. Beauty is ephemeral,
a property of things that change, mature, are lost: a lover, a landscape, a work
of art. Beauty is our highest expression of what it is to be mortal. It speaks
of history, it speaks of the future, and therefore it speaks ethically. The sub-
lime, at the opposite pole, speaks of a life unbounded by the horizon of

death, perhaps without the stain of birth: the timeless time of the universal. The sublime endures outside history, and its permanence is a presence that overwhelms the everyday contingencies of history. As absolute and unquestionable presence, the sublime exceeds and stands aside from the world. The opposite of beauty, which, in its becoming, perpetually confronts the world with its ephemerality, sublimity antedates sociality. Sublimity hails us as unique: it is an elitism. Beauty hails us as common: its roots are democratic. The confrontation of beauty and sublimity is an ethical issue: media democracy or media elitism. Beauty confronts ugliness: sickness, squalor, brutality, things that can be changed. The sublime stares into the unchanging maw of evil. The sublime addresses us phatically: like a demanding child, it posits the interlocutor, the individual in the audience, as its other. The individual it hails is intensely personalized and thus abstracted from the social world, but also lifted out of language and thus without a name. Beauty calls to us across what is shared; to empathy, to sympathy, to common taste, common sense, and common knowledge. Its ephemerality addresses itself to the common fate, embracing forgetting as the necessary partner of becoming. Beauty is communicative, then, while the sublime is the voice of the incommunicable, the supernatural, the secret knowledge of the anonymous elect, even though that elect is made up of every audience member who has ever succumbed to the lure of totality in the late Eisenstein or his heirs.

At issue here is the status of the audience and of "media effects." The common editorial and legal line that blames the media is based on the premise that there is an individual prior to mediation on which the media operate. Yet neither societies nor individuals are conceivable without language, that is, without mediation. The opposite case, now general in cultural studies, privileges the subject over the object, presuming that there is a fully formed personality on whom the latest media message impinges only tangentially and late. But the problematic of the cinematic object demands that we countenance the mutuality of their construction: that audiences constitute the media that constitute them in a dialectical antagonism of mutual creation, mutual annihilation, and that this is entirely true to the shifting nature of the commodity relation in which it is no longer producers' labor but consumers' attention that is bought and sold.

The sublime in this perspective is entirely comprehensible as a function of the commodity form as it strives to colonize what little is left of the world

to commodify. The sublime and innocent effect, incongruously and unconsciously evoked in Lyotard's (1978) essay "Acinema" in the figure of the child playing with matches, belongs to an order of time from which narration, dependent on time's passing and its loss, is debarred. It is the time of the fetish. The cinematic sublime constructs an apparatus for the imitation of death, that zero degree of speech, and so becomes an object of awe, an event that contradicts its own existence. That is the source of the sacramental innocence of cinema: the pretence of a timeless and universal order of communication bordering our own structures as supernatural and universal, the commodity form of communication in our time.

The spectacle was only ever one of the possible worlds that might have emerged from the investigation of time in film. From the earliest films,

The illusion of motion, with its consequent sensations of temporal flow and spatial volume, provided enough innovation for spectators already familiar with a range of spectacular visual novelties. If cinema's blend of spatiotemporal solidity and metamorphic fluidity was largely assigned to the representation of narrative, these effect[s] of the medium nevertheless remained central to the experience. Special effects redirect the spectator to the visual (and auditory and even kinaesthetic) conditions of the cinema, and thus bring the principles of perception to the foreground of consciousness. (Bukatman 1998: 79)

Distinctions between realism and illusion make no sense in an epoch when it was neither the illusion of life nor the illusion of illusion that fascinated but rather the spectacle of their making. The fascination of these experiments on the raw material of time is not the collusion of cinema in the hegemony of commodity capitalism and emergent consumerism, but the fact that the new device took on at once an anima of its own, aspiring to "more and better freedom" (Bauman 1999: 1) than the freedom of free trade.

The evolving combinatorics of cinematic time's elementary dimensions begin to alter the dimensions themselves, providing insight not only into how the cinema has been, but into what it may become. The task of theory today is no longer negative. The job of media theory is to enable: to extract from what is and how things are done ideas concerning what remains undone and new ways of doing it. As the poet Hopkins put it in a letter to Robert Bridges, "The effect of studying masterpieces is to make me admire

and do otherwise" (Hopkins 1953: 210). Discovering the temporalities of film is as close as we get to understanding the why and wherefore of commodity fetishism as it has developed over the last hundred years. It is the argument of this book that we must look into this secret and bizarre space of the commodity to understand the terms under which mediation functions in our epoch, and therefore to understand the conditions under which we can make the future otherwise than the past or the present.

| Part I |

Pioneer Cinema

TEMPORAL FILM: THE PIXEL

Leaving the Factory: A Myth of Origin

For the Uncreated is that whose beginning does not exist; and Nothing, we say, is that whose beginning does not pre-exist. Nothing contains all things.

—*Otto von Guerricke*[1]

Picturing Leisure

The first and most special of all effects is the depiction of motion, an event as dizzying as the invention of perspective in the Quattrocento. What happens when the still photograph begins to move? On the morning after the first public projections, *La Poste*'s review of December 30, 1895, invited its readers to "Imagine a screen, placed at the end of a room as large as one can wish. This screen is visible to a crowd. On the screen appears a photographic projection. So far, nothing new. But, suddenly, the image, lifesize or reduced, is animated and springs to life" (Ministère des affaires étrangères 1996: np). From this description, it sounds as if viewers saw (whether or not the Lumières engineered) a still projection that suddenly came alive, in a moment of amazement. The novelist Maxim Gorky would note the same thing the following summer:

When the lights go out in the room in which Lumière's invention is shown, there suddenly appears a large grey picture, "A Street in Paris"—shadows of a bad engraving. As you gaze at it, you see carriages, buildings and people in various poses, all frozen into immobility. All this in grey, and the sky above is also grey—you anticipate nothing new in this all too familiar scene, for you have

seen pictures of Paris streets more than once. But suddenly a strange flicker passes through the screen and the picture springs to life. (Gorky 1950: 407)

The projection of still photographs had been a staple of the magic lantern long enough to be banal. The Lumières and their itinerant projectionists used the familiarity of slide projection to lull their audience into comfortable inattention, before zapping them with the new apparatus, to reactions of wonder and amazement that we can only imagine. This chapter analyzes the moment of movement as the miraculous first effect of cinema, the instigating moment of cinema as special effect.

According to the editors of the Lumières' letters, the first public screening at the Salon Indien "was probably like a cocktail party" (Lumière and Lumière 1995: 94). Shown in the festive period between Christmas and New Year, with twenty sessions a day between 10:00 A.M. and 1:30 P.M., the cinematograph attracted a crowd of *flâneurs* from the Boulevards. Clément Maurice recalled, "What I remember as being typical was some passer-by sticking his head round the door, wanting to know what on earth the words Cinématograph Lumière could possibly mean. Those who took the plunge and entered soon reappeared looking astonished. They'd come back quickly with a few friends they'd managed to find on the boulevard" (ibid.).

This little description tells us that the cinematograph instantly took its place as a distraction for the strolling crowds, that it participated from the start in what Tom Gunning (1989) identifies as "an aesthetic of astonishment," but also that the subjectivity it promoted was not only flexible and mobile but also significantly social. The dynamism of the cinematograph as event, rather than narrative, induces its spectators not to anchor themselves

as the narrated objects of a screen performance, but to mobilize themselves as hectic and excited participants in an event that leads them not to contemplation but to sharing. It is a brief moment of innocence before the regulation of cinema into an industrial formation, an Eden from which the stories of good and evil would soon eject it. But it is vital to an understanding of cinema's utopian capabilities that we acknowledge how, in this formative instant, it was able to activate rather than absorb its audiences.

Between 1894 when the first filmstrips were exposed and 1896 when Gorky witnessed it, the Lumière cinematograph was anchored not in literary or popular genres of the novel and theater but in the crowd. Social, public, and active, the event of cinema articulated the modernization of urban experience. On the one hand, this belongs to the expansion of commodity capitalism into the sphere of leisure, a market the cinematograph screenings on the Boulevard des Capucines during the holiday season were designed to exploit. But on the other hand, there is also a relation, technical but also thematic, to utopian innovations in concepts of perception. The Lumières' first film is exemplary in this respect. Familiarity has worn away the strange choice of subject matter: workers, in the first instance, and workers not working, or arriving for work, but leaving the brothers' factory and setting off for their own, unregulated pastimes. The theme of the first movie is the crowd at leisure. Whether or not, as seems possible, the camera was concealed during the making of both versions (accounts of the March screening refer to a horse-drawn *diligence*; both *La Poste* and *Le Radical* mention *voitures*; current prints show neither), the remarkable modesty of the shot is apparent. No one hams to camera as in other Lumière films, even though there are some gestures and movements that suggest that some of the employees are aware of being visible, not to the camera but to one another. The informality of the scene, however arrived at, is an unstaged event, a moment of liberation (from work) in a framing characterized by liberation from formal pictorial composition and formal theatrical staging, and from the unifying and artificially coherent vision of academic painting and commercial melodrama. Inured to endless closed-circuit TV, we have lost the astonishment that ought to greet this mode of picturing and this choice of material: why would the first film ever made picture workers *leaving* a factory?

Although it seems to us so ordinary as to be invisible, the picturing of factory workers at leisure was the result of almost fifty years of struggle to legitimate images of daily life. Linda Nochlin notes how the politically rev-

olutionary Pissarro was committed to the unsentimental demands of modernity, communicated in the "direct, vivid, matter of fact" way in which he depicts the railway in *Lordship Lane Station, Upper Norwood* (1871), when compared with the flamboyant romanticism of Turner's or Monet's treatments of similar subjects (Nochlin 1991: 64). Baudelaire asserted the heroism of modern life in 1846 (Blake and Frascina 1993: 81–82), but twenty years later, in 1868, the painter Boudin, a teacher of Monet's, still had to defend his decision to paint middle-class people in everyday dress:

The peasants have their painters of predilection . . . and this is good: these men carry on sincere and serious work, they partake of the work of the Creator and help Him make Himself manifest in a manner fruitful for man. This is good; but between ourselves these middle-class men and women, walking on the pier toward the setting sun, have they no right to be fixed on canvas, *to be brought to light*? (Boudin, quoted in Nochlin 1966a: 83–84)

The painting of contemporary peasant life had itself developed only slowly as a respectable subject for art. Initially only Italian peasants were permissible subjects. Between the Paris Universal Expositions of 1855 and 1867, the veil of the exotic was dropped and it became possible to exhibit scenes of rural life in France (Brettell and Brettell 1983). Boudin's complaint was that if the peasantry were suitable subjects, why not the bourgeoisie? The answer was, in part, that the peasantry could be represented as natural: naturally poor, of course, but also naturally in harmony with the seasons and with God. For artists like Boudin and the Impressionists, the introduction of industrial buildings, fashionable clothing, and the urban poor into the landscape, or the emergence of the cityscape as a motif, made way for a different kind of harmony, one that no longer had a place for the premodern pieties of agrarian Catholicism. Pissarro would make a specialty of depictions of peasant life, again focused on moments of idleness snatched from the demands of an emergent capitalist agriculture. But even the Impressionists had trouble depicting the working class: Caillebotte's sinewy, sweating floor-scrapers laboriously lifting layers of varnish is a rare example. Even in the 1890s, it is startling to see the Lumières make the choice to debut their new device with an image of the industrial proletariat.

The *Sortie des usines* (figure 2.1) is usually dated 1895, but Louis Lumière himself reported shooting it during August of 1894. Since the workers

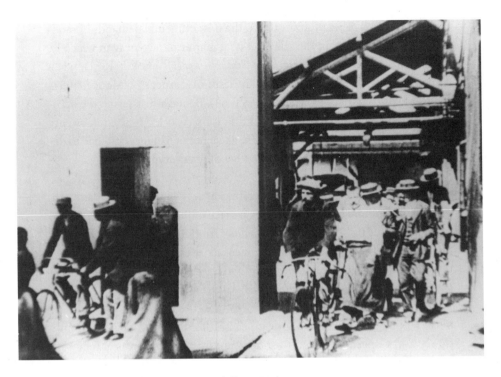

| Figure 2.1 |

Workers Leaving the Factory: lunchtime sunlight, the pursuit of leisure,.and the utopian freedom of the bicycle. Courtesy BFI Collections.

are clearly wearing summer clothes, and the strong noon sunlight of high summer beams down casting only a short shadow from the tree under which the camera has been placed, we can presume a summer shoot. The film was first shown on March 22, 1895 (though Davanne's letter of March 26 seems to suggest a prior projection in Lyon [Lumière and Lumière 1995: 16]): there seems little reason to doubt Lumière's word. Other scenes taken between then and midsummer 1896 include a family scene, street scenes, views of work in progress (*The Demolition of a Wall*), transport scenes, landscapes and seascapes associated with family holidays, and formal occasions (see Rittaud-Hutinet 1990 for a complete listing). Only the *Arroseur arrosé*, a brief tableau of a naughty child standing on a hosepipe and being spanked by the gardener for his troubles, resembles genre painting. The others are resolutely scenes of everyday life in the modern world among the bour-

geoisie, showing their work and their leisure, with a strong emphasis on technological achievements. It is intriguing to note how different these subjects are from the content of the contemporaneous Edison films of 1894 and 1895. There we find an immediate conforming of cinema with the entertainment industry, from party pieces like *Fred Ott's Sneeze* to *Annabelle Serpentine Dance* (reprised the following year by American Mutoscope, and later filmed again by the Lumières). We could argue that the Lumières foregrounded the process of film, while Edison already grasped the commercial potential of the medium (see Punt 2000: 35–68 for an extended comparison). Alternatively, in a familiar if by now largely discredited argument, we might perhaps be tempted to see the Lumières as the fathers not of film but of documentary.

But what is documented in the cinematic event? We might want to argue that it is not the event in the world, which seems to be related rather than documented, but a specific aspect of the event. The frames themselves, in Thierry Kuntzel's account, are not what we watch; rather, "In the unrolling of the film, the photograms which concern us 'pass through,' hidden from sight: what the spectator retains is only the movement within which they insert themselves" (Kuntzel 1977: 56). There is a curious foreshadowing of this perception of cinema in one of the first newspaper accounts of the cinematograph: "It is life itself, it is movement taken from life" ("*C'est la vie même, c'est le mouvement pris sur le vif,*" *La Poste*, December 30, 1895, reprinted in Ministère des affaires etrangères 1996: 16). The *Poste* journalist appears confused. Is this life? Clearly not: it is a picture of life. In fact, it is movement abstracted from life. But the contradiction makes sense if we understand the two uses of the word "life" in slightly distinct ways: life, "*le vif,*" the living aspect of life, is movement, which is brought by the cinematograph from life into the cinema. Thus what cinema "documents" is not "*la vie*" but "*le vif,*" not the world as object but movement. The *Sortie des usines* is not a documentary but a magical transformation, and one effected not on the world but on a reality inclusive of both world and film. Deleting still photography's claim to truthful knowledge of an external world in favor of a metaphotographic technology of movement, the cinematic event emphasizes that the world is not the object of a cinematic subject, but that both are part of the same process: *le vif.* The cinematograph is put into motion by the contradiction between work and leisure, at the moment at which one ends and the other begins. Cinematic time originates in the dialectic between the

discrete movements of the factory's clock and the fluidity of the *flâneur*'s aimless drifting.[2]

These were, of course, not just any workers, nor purely hands whose loyalty and diligence their bosses could show off to the *Sociéte d'Encouragement pour l'Industrie Nationale*, to whom they would first be shown. They were also workers at Europe's most important manufacturer of photographic plates: specialists in the art being used to picture them. Not just an industry, but a cutting edge, high-tech industry at the brink of its most explosive period of growth. Louis and Auguste Lumière had taken over management of the plant from their father a few years before and turned around a specialist local firm to become major European and international players. But they were enlightened employers, establishing at their own expense generous pension funds and benefits. Good Marxists will point out that the workers had paid for the brothers' wealth in the first instance, but Lyons at the time was the center of a syndicalist politics that promoted the joint participation of workers and bosses in reform and welfare, and the Lumières were honored for their pioneering of occupational pensions and workers' welfare.

Is it possible to read the choice of the noon remission from labor as a theme derived from the utopian socialism of the 1890s? These suggestions for understanding an unusual choice of theme—the promotion of the firm, respect for high technology, celebration of class solidarity—can be placed alongside others, such as the possibility that this was the easiest spot to find a lot of motion on the day the camera was ready for testing, all of which privilege the intentions of the authors of the film. As technologists first and artists second, the brothers may not have cared what they filmed. But it is significant that, unlike Marey's chronophotography, the Lumière cinematograph was not turned immediately to anthropometric time and motion studies, aimed at optimal mechanization of gesture in the factory, but to leisure, to the immediately accessible utopia of time off. These girls caught leaving the factory at the end of their shift (figure 2.2), in an innocence of movement that never after could recur in front of the camera, these careless boys on their bikes, these never to be repeated familiarities, all at the edge of a leisure that cannot be remade or recorded: these are as much visions of immanent utopia as Pissarro's sleepy peasant girl idly playing with a stick, so indistinguishable from her land in the 1881 *Jeune fille à la baguette*.

The anonymity of the workers not only underwrites the anonymous social subject formed in the cinematic event. Abstracting movement from life,

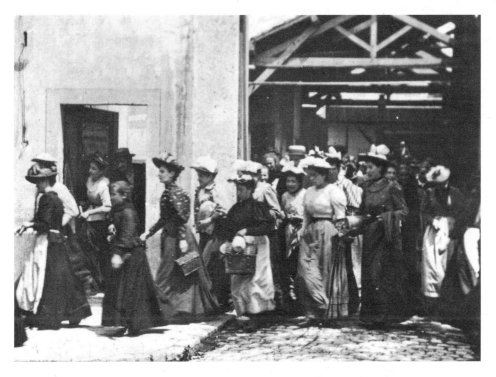

| Figure 2.2 |

Workers Leaving the Factory: Women high-technology workers in department store fashions.
Courtesy BFI Collections.

le vif from *la vie*, does away with uniqueness. There is of course the possibility of there having existed several versions of a similar film, probably shot to replace a damaged experimental roll. There is also quite separately the aesthetic of repetition. Not only is the film always already a repetition of a profilmic event; not only is it ready to be shown over and over; not only is it a series of very nearly identical frames; but the event it records takes place daily, and though every day in a unique manner, nonetheless also in some degree every day the same. What we have is a unique exemplar, something at once singular and typical.

Once again the *Sortie* amazes and delights: to have placed at the instigation of cinema's dialectic of difference and repetition not a story but an event that is at once an end—of work—and a beginning—of leisure—neither of

which is visible, and neither of which is therefore composable as an equilibrium. In place of closure, we have only commotion, a document not of truth but of the space between truths. The only truth of cinema is its movement, its ephemeral occupation of the present. It is here that we lose the distinction between fiction and documentary, the depiction of diegetic and external worlds, in the cinematograph, since both will depend on the uniquely credible aspect of the movies: that they move. The cinematic event cannot claim absolute truth, as photography had done. But neither does it deny all possibility of truth, as Przyblyski (1995) argues of Appert's propagandist photomontage.[3] Instead it insists on the revelation that truth is impermanent and exists not even in flashes but as the stuff of movement itself: time. That this is also the stuff of fictions and lies is a matter for later chapters.

Fiat lux

The *Sortie* is an account of unstable movement: it lacks the narrative characteristic of conforming actions to either desire or understanding. If anything, the viewer is subjected to the disparate desires of the crowd of workers. At the same time, it lacks a compositional center around which to organize our viewing. Despite the square-on view (also used in the *Arrivée des Congressistes à Neuville-sur-Sâone* of March 1895; much the same is true of the dramatic diagonal of the *Arrivée d'un train*), the description-baffling busyness of the scene, the ways in which the near-anonymous figures move according to their own multiple and complex motivations, asserts the independence of the image from a composing eye. The autonomy of the elements of composition, the relative freedom of the viewer who returns to the same short reels of crowd scenes with constantly new patterns of looking, this anarchy of vision imitates the Impressionist move from the beaux-arts tradition of hierarchy toward "all-over composition," seeking attention democratically for every area of the frame. Simultaneously, the image slips away from the organizational control of narrative. A small experimental proof: whereas narratives are largely memorable, in the sense that we can reconstruct a fiction after viewing it, I defy anyone to rehearse from memory the activities figured in the *Sortie des usines*.

In the early days, films could be copyrighted only as collections of individual photographs. It was only later that it became possible to copyright not the frames themselves but the idea behind them, typically a story (Gaudreault 1990b). Then the organized succession of images became not just

property but the thing itself, and even the script was sufficient to copyright the film, regardless of the visual form it might take. Until then, we can still see cinema in its utopian moment: the very halt and judder of the early "flickers" that severs the frames from one another, emphasizing the discrete quality of each moment at which the shutter opened to seize its fifteenth of a second of light. The physical processes of perception were both beneath the threshold of sight and just visible at its edges (Noël Burch [1990: 48] makes much of the bourgeoisie's dislike of this flicker-effect with its disjointing of one impression from another: their complaints of eye strain, we might say, arise from the effort they put in to trying to force the incoherent to cohere, to hierarchize the democratic). These images—in England we still use the plural form when going to the pictures—take the everyday apart and figure forth, even in their linear and chronological ordering, the anarchy of light that makes the positive construction of objects positively unthinkable. We might say of the temporal raster effect of the frameline what Krauss says of the widespread use of the grid in modern art, that it demonstrates "its hostility to literature, to narrative, to discourse. . . . it is antinatural, antimimetic, antireal" (1986: 9); save only that in cinema, as in the wider modern visual culture, the struggle between the literary and the visual remains a central contradiction. Film not only opposes the presumption of a "natural" vision that sees the "real" world as an assemblage of objects: it proposes another, synthetic vision.

Like the spots and dots of the divisionist aesthetic practiced by Seurat, Signac, and Pissarro in the 1880s and 1890s, the frames of the Lumière cinematograph fragment vision beyond the point of narrative perception. Louis Lumière attended the March 22 meeting of the *Société d'Encouragement* to project slides produced using the brothers' new autochrome color photographic process. The cinematograph made its debut at the conclusion of the lecture as an example of the progress being made in other fields of photography (Lumière and Lumière 1995: 17). The autochrome would become a major product for the Lumière business, a line they would continue to market long after they left the cinema. It would become the leading color product of the day: Flaherty (2000) mentions using autochrome during the shoot for *Nanook of the North;* Edward Steichen would use them throughout World War I and into the early 1930s.

The autochrome was the result of several years of research on the part of the brothers, at first jointly with Gabriel Lippman, later Nobel laureate

for his analyses of the solar spectrum, who presented the first results of their work in May 1892. These first plates required several hours exposure. By 1893, when they exhibited their results in Geneva the Lumières had reduced the exposure time to four minutes. However, the Lippman process proved intractable to industrial production, and the brothers embarked on a new route, "indirect photography," which would be marketed from 1903 as the autochrome and would remain dominant in the field until the invention in 1930 of colors more reliable than aniline dyes that enabled the marketing of Eastman-Kodak's Kodachrome, itself first marketed as movie film (Rosenblum 1989: 449–450). Among those with whom they discussed the progress of their works were Louis Ducos du Hauron, who wrote in a letter of June 4, 1892:

I shall never forget that, nearly a quarter of a century ago, you were good enough to sponsor my invention at the Société Française de Photographie on 7 May 1869. . . . Will [printers] not soon be able to produce immense quantities of my three-colour photographs? I am certain they will. Then shall all controversy end and the late lamented Charles Cros and I shall be fully acknowledged. (Lumière and Lumière 1995: 7–8)

Cros and du Hauron had discovered separately and simultaneously in 1869 a three-color additive process akin to that which the Lumières eventually adopted for the autochrome. Du Hauron was never a successful man, but the brothers had established him with a pension of 1800 francs a year. Cros was a poet, an inventor, and a friend and portrait subject of Manet. All three played a major part not only in the history of color photography but, with Lippman, in the development of color theory generally, and especially in the evolution of new concepts of color among the divisionist painters around Seurat (see Rewald 1978: 134–135). It would be redundant to rehearse the narrative of cinema's debt to the technologies of optical toys and visual spectacle discussed by Oettermann (1997), Ceram (1965), and Dagognet (1992), or in terms of the commodification of leisure addressed by the contributors to *Cinema and the Invention of Modern Life* (Charney and Schwartz 1995), Friedberg (1993), and many others. Without wishing to minimize the importance of these findings, and in fact in parallel with them, let me note that the attempt to understand why the Lumières chose their factory hands as their first motif has already led us into the neighboring field

of avant-garde painting. Situating the Lumières as inventors of the auto-chrome puts them in another excellently modernist context, the scientific and artistic quest for an elementary understanding of light.

The proximity of the artistic, scientific, and cinematic realms in the emergence of this atomist optic is well summed up in Fénéon's account of Seurat in "The Impressionists in 1886": "his immense canvas, *La Grande Jatte*, whatever part of it you examine, unrolls, a monotonous and patient tapestry: here in truth the accidents of the brush are futile, trickery is impossible; there is no place for bravura—let the hand be numb, but let the eye be agile, perspicacious, cunning" (Nochlin 1966b: 110). Cinematic technique comes out in the sense of unrolling, the agility of the eye rather than the hand, the lack of the flamboyant "bravura" handling of paint that still signifies emotional expression. The new, mechanical aesthetic beckons toward egress from the impasse of the lonely Romantic artist. No longer marked by artisanal cunning, the speed of perception waits to be standardized at 24 frames per second.

Rosalind Krauss notes an even closer parallel to our conception of the cinematic event when she notes that "the grid—as an emblem of the infrastructure of vision" became "an increasingly insistent and visible feature of neo-Impressionist painting, as Seurat, Signac, Cross and Luce applied themselves to the lessons of physiological optics" (Krauss 1986: 15). This granular severity could not be reconciled with an older Impressionism. Pissarro, after a decade's discipline in the scientific division of tones, found that he could no longer reconcile his own anarchistic vision of the artist with the new method, "having found," he wrote to Henri van de Velde in a letter of March 27, 1896, "that it was impossible to be true to my sensations and consequently to render life and movement, impossible to be faithful to the so random and so admirable effects of nature, impossible to give an individual character to my drawing. I had to give up" (Nochlin 1966b: 59). The clash was one not so much of two modes of painting, nor even of two politics. Rather, we witness in Pissarro the struggle of rigorous modernity with an older and still Romantic conception of the artist as the subjective center of art, whose vision counts only insofar as it is deeply and intrinsically personal.

Of the options, the Lumières embraced the scientific mode. Although many of the brothers' own autochromes are clearly designed to demonstrate the method's ability to imitate the chiaroscuro technique of molding forms, many are equally clearly destined to be inspected across the

whole frame. Such, for example, is the untitled autochrome of a young woman picking flowers.[4] Her face obscured by her bonnet, she stretches over an iron railing to pick blossoms against a pastoral hillside crowned with ploughed fields and a small village, behind her on the rough track a bright red umbrella that gives a powerful optical contrast to the greens of the landscape. The viewpoint emphasizes the diagonal of the railings in the left foreground, typical of the contingency celebrated in impressionist *études*, rapidly sketched oils painted in the field, while the mixture of modern ironwork with arcadian nature, of umbrella with dirt road, and the clarity of textures across the whole image bring it sharply into the modern aesthetic of Impressionism.

Brettell's description of the disciplined way in which Pissarro handled such motifs is illuminating: "The carefulness and technicality of the craftsman is replaced by the ceaseless experimentation of the representor. Sight itself is subject to continual scrutiny. Seeing, the most natural of faculties, has to be learned" (Brettell 1990: 4). Brettell's emphasis is confirmed in another of Fénéon's pamphlets, "The Impressionists at the Tuileries" of 1886: "These painters [Pissarro, Seurat, Signac] are accused of subordinating art to science. Instead, they only make use of scientific data to direct and perfect the education of their eye and to control the accuracy of their vision" (Broude 1978: 39). Where the oil *étude* emphasized the contingent nature of the artist's position vis-à-vis his or her environment, Impressionism makes the matter of seeing itself an issue. There is no innocent eye, and what is recorded is not necessarily reality as it might be captured in a Dutch interior two centuries earlier. The excess of the visible has become the excess of vision.

As with the autochrome of the woman picking blossoms, it is impossible to find a unique focal point to the *Barque sortant du port* of 1895. The film offers two focal zones: the rowers and the women and child watching them. Although it is feasible to read the composition as triangular, it becomes so only if the audience agrees to take up the position of the infant, who, guided by the two women, watches the boat. But early audiences seem to have had a different interest. The success of similar films, such as Birt Acres's *Rough Sea at Dover* of 1895 and Bamforth and Company's *Rough Sea* (c. 1900), suggests that the sheer play of light on water, so meticulously sought after by Renoir and Monet, was considered as precious as the human figure. The journalists of both *La Poste* and *Le Radical* single out the waves as special effects. In the *British Journal of Photography* of March 6, 1896, G. R. Baker, their regular

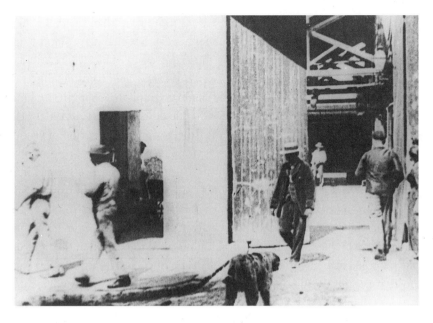

| Figure 2.3 |

Workers Leaving the Factory: the dog saunters back toward the half-closed gates. Courtesy BFI Collections.

columnist on projection and lantern shows, gives this account of the pièce de resistance of the Lumières' first London screening, at the Regent's Street Polytechnic, *Sea Bathing in the Mediterranean:* "here we have the breaking waves on a shingly shore, a diving or jumping board, and the bathers in succession going down this board, jumping into the sea, battling with the breakers, climbing the rocks, and getting once more on the diving board, all so faithfully to life that one 'longed to be there'" (cited in Coe 1981: 71).

This delight in the naturalism of the cinematograph is echoed in a comment elicited from *The New York Dramatic Mirror* by the first Lumière screenings in New York: "The first view was *A Dip in the Sea*, and showed several small boys running along a plank on stilts and diving into the waves, which dashed upon the shore in the most natural manner" (Slide 1982: 65), a comment that, like that of his London contemporary, emphasizes the illusionistic aspects of the cinematograph. But Harry Tyrell, commenting on the same show, sees a different aspect: "Sea-waves dash against a pier, or roll in and break languidly upon the sandy beach, as in a dream; and the

emotion produced upon the spectator is far more vivid than the real scene would be, because of the startling suddenness with which it is conjured up and changed, there in the theatre, by the magic wand of electricity" (ibid.: 67). Baker's comments in the *British Journal of Photography* continue this line of thought: the aspect of realism in the cinematograph that so impresses him is the way in which several of the views "baffle description" (Coe 1981: 71).

This intensity of seeing evokes the drive toward a renovation of vision in Impressionism. What the eye sees is, for Pissarro, not the world of objects, which begin to disintegrate in his already pixelated brushwork, but light. Pissarro was, however, caught in a contradiction between truth to his perception and truth to light. Seeking a clue to the translation from light to pigment, the divisionists, like the Lumières, opted for the latter. This is in particular why the first cinematograph films need to be seen in the light of the schooled eye emerging from the dialectic of subjective impression and objective optics. Pissarro's works of this period, for example, only come into focus as depictions when the viewer stands back from them, back further than the painter could have done while applying the pigment. From his point of view, at arm's length from the canvas, what is being applied is not an image *of*—of a blouse or a flower—but a specific and particular shade of blue, or a dappling of colors selected to produce an optical mixing in the eye of the beholder rather than the palette of the painter, a technique already industrialized in photomechanical printing in the 1890s.

In the same way, the autochrome analyzes the world as a manifold, not of objects but of wavelengths. The cinematograph extends this spatial fragmentation of vision into the temporal by registering not things but the movement of things, that movement which strikes its first audiences as at once reality itself and a dream of reality. Where Burch (1990: 20–21) sees in these early responses a Frankensteinian desire to suppress death, and Bazin (1967: 9) sees a "mummy complex" that realizes an age-old desire to transcend mortality, I would argue that the fragmentation of vision in first spatial and then temporal terms is in fact an homage to life as animation, *le vif*. It sacrifices possession of the world in favor of a dream condensing and displacing film's ephemeral truth of absolute movement, the underlying gridwork of the dynamic present.

Peter Galassi comments on the Impressionist oil *études* that they represent "an art devoted to the singular and contingent rather than the universal and stable" (Galassi 1981: 25). Jacques Aumont concurs on the importance

of ephemerality, but understands the address to "the fugitive and aleatory" as "a new confidence in seeing as an instrument of knowledge" in the sciences as well as the arts, specifically as "the acquisition of knowledge through appearances" (Aumont 1997b: 234). Elsewhere in the same volume James Lastra comes much closer to the point of view expressed here when he contrasts 1890s photographic discourses of composition with early responses to cinematography. Instead of attracting the criticisms directed at similarly "undisciplined" still images, "films in which clouds and random motion proliferated in unprecedented abundance represented a quantum leap in pictorial immediacy" (Lastra 1997: 273). Aumont's gaze is still firmly fixed on the photographic authority of the frame. But the open arms with which early audiences greeted effects of water, smoke, steam, and dust suggest that it was not the extension of empirical knowledge concerning objects in motion that interested them. That was the goal of Marey's chronophotography, but it does not describe the undisciplined nature of the composition in fragmented light that the mobility of the frameline brings into play. Lastra emphasizes the lack of a disciplining gaze, the absence of authority and its delegation to the pure effect of motion.

As Dai Vaughan has it in his lyrical account of the *Barque sortant d'un port:* "The unpredictable has not only emerged from the background to occupy the greater portion of the frame; it has also taken sway over the principals. Man, no longer the mountebank self-presenter, has become equal with the leaves and the brick-dust—and as miraculous" (Vaughan 1990: 65). In that process, the presence of "Man"—in the person of the figure perched on the stern of the boat who seems on the verge of being tossed from it in the final frames of the film—is rendered as ephemeral as the motion of light on the water. The effect is not, as Lastra suggests, "immediate" but temporal. It brings us into a new and properly cinematic relation with time.

The Cinematic Event

The time of the cinematic event is dispersed. Fragmentation in the composition of the *Sortie* produces a dispersal of time, both as the random scattering of light-sensitive silver salts and in the roving, saccadic gaze that cannot take it all in, alert to movements that can be attended to only one at a time but that occur simultaneously. Cinema, in this first moment, encourages both an analytic eye leaping from pinprick to pinprick of light, and peripheral awareness of movement as a blurred penumbra of the half-seen, whose

detail escapes but which subsists as pure motion. The cinematic image is nonidentical in the sense that events inside the frame are not only incomplete in time but fragmentary as percepts, so that each event of projection evokes a new assemblage of focalized and marginal imagery. *La Sortie* is both attraction and distraction, a locus of fine optical distinctions and simultaneously of a mobile, fleeting, and distracted gaze.

As attraction the cinematograph belongs to the new urbanity of the late nineteenth century. The drain of populations toward the cities is both effect and cause of their status as communication centers, financial or spectacular. The attraction of the city is its energy, especially in the last decade of the nineteenth century when the society of the spectacle is coming into being. That society requires mass populations, which it will learn to individuate as consumers, who will in turn, as fashionable *flaneurs*, not only communicate but be communicated. The *Sortie* coincides with this invention of the consumer as leisured, modish, and mobile. But its charm and power derive from its depiction of the disappearance of another moment, in which the workers might return to their small holdings, darn socks, weed a row of vegetables, feed their chickens. That self-sufficient remnant of the peasant economy disappears in the cranking of the camera. From here on everyone, in Lyon, in France, in the modern world, will be ready to be pictured. As Debord argues (1977: ¶68), to become consumers, we must also be consumed; to enter new modes of communication, we must be communicated. Once photography democratizes the portrait, everyone becomes a spectacular image.

In the cinematograph, the human vision of the audience is synchronized with a machine perception in the process of formation. Designed as camera, printer, and projector in one device, the cinematograph was at this stage an instrument for rendering visible, and thus an instrument that profoundly affected the visibility of the crowd. On the one hand, the Marey tradition leads to the scientific uses of cinema for the analysis of events too big, small, close, remote, fast, or slow for human perception; on the other, it creates the field of an omnivoyance that will enable both Merleau-Ponty's optimistic phenomenology and Foucault's pessimistic theory of surveillance. At the same time that this "objective" vision was being formed, the cinematograph presented its audience with "the disintegration of a faith in perception" (Virilio 1994: 16). One fragments the objects of perception, the other perception itself. In the Marey tradition, analysis of vision leads to the ideology of power over the object world; in the cinematograph, human and

machine perception become mutually dependent, the human reconfigured by the mechanical, the mechanical reliant on this newly decentered human sensorium for its realization.

While it creates the possibility for an integral human-machine perception, however, the cinematograph also produces the myths of immortality pinpointed by Burch and Bazin. To their reactions we might add the well-known passage in which Gorky, attending the first screenings in Russia, speaks of a silent and colorless realm of shadows, ghosts, and ashes. As he castigates the immorality of the venue and the likely pornographic futures of cinema, Gorky also adumbrates for the first time a sense of the cinema as a machine for dreaming: "You are forgetting where you are. Strange imaginings invade your mind and your consciousness begins to wane and grow dim. . ." (Gorky 1960: 408). At such a moment, the representational force of the cinematograph is in question: the objects and the subjects dissolve in the dissolving views offered by the interface between human and mechanical intrinsic to cinema. The analytical, Marey tradition is representational, in the sense asserted by Gilles Deleuze, for whom representation "signifies this conceptual form of the identical which subordinates differences," a process of "re-cognition," rather than cognition or perception. In the cinematograph, on the other hand, we are confronted with the possibility of a loss of identity in both object and subject realms, gaining a sense of the uniqueness of every instant of perception alongside the loss of self-presentation that Vaughan observed in the *Barque sortant*. In Deleuze's terms, "Every object, every thing, must see its own identity swallowed up in difference, each being no more than a difference between differences. Difference must be shown *differing*. We know that modern art tends to realise these conditions: in this sense it becomes a veritable *theatre* of metamorphoses and permutations" (Deleuze 1994: 56).

As it occurred to Gorky at Aumont's in Nizhny-Novgorod, the proliferation of difference brings about a distracted state in which consciousness fades and thoughts arise that are experienced as belonging to another. This distracted gaze, this hypnotic trance induced in a spectator mesmerized by the flickering of the nonidentical still exercises critics of television, console games, and the Internet. Its emergence is not, Jonathan Crary argues, a novel departure from an innocent and attentive consciousness. On the contrary, distraction is constructed in precisely those devices, like the cinematograph, that try to anchor consciousness in attention: "If distraction

emerges as a problem in the late nineteenth century, it is inseparable from the parallel construction of an attentive observer" (Crary 1999: 49). The fragmentation that was intended to produce attentiveness also produces the oneiric trance.

The trance is a timeless mode constructed in time. That contradiction poses one of the fundamental problems of cinema: the problem of starting and stopping. Elsaesser (1998a) sees in the teetering man in the closing frames of the *Barque sortant* a moment of suspense constructed not only by the abrupt end of the reel but by the framing. But whereas suspense in narrative creates a concern for what happens next, for the distracted viewer suspense comes from her solicitude for the wholeness of the experience that stops without ending, without a motive or a signal from the represented as to why the action stops. The effect of beginning is relatively easily controlled in both the camera and the projector. But the end of the filmstrip is not a function of the closure of an action, most clearly in the *Barque sortant* but also in the *Sortie*. What is at stake, then, in the suspense of the ending is not what happens next but what happened just now: how was that experience whole?

For Gorky the experience begins "when the lights go out": in the darkness out of which the moving image will flicker into the motion of becoming from the stillness of existence. We spend much of the duration of a film in darkness. Each frame is exposed twice, interrupted by the motion of the shutter, which also cuts off the projector's light while the frameline travels across the aperture before the lens. So the frameline is doubly invisible, its darkness hidden behind the repeated dousing of the lamp. The photographic image, and the single frame projected at the beginning of the Lumières' shows of 1895 and 1896, is a random spatter of light-sensitive molecules. The still image would not become a grid until the invention of the raster image, usually traced back to the radar monitors of World War II (Buderi 1996). The moving image, on the other hand, begins life as a grid, dependent on the accurate registration of the frame in front of the lens of the camera-printer-projector of the Lumière cinematograph. Cinema starts out as a raster display, but rather than a spatial map like the bit map of computer images, it is a map of time. The frameline separating frame from frame distinguishes between past and future, negative and positive time, so that the frame itself, the present, appears as their pure difference, the moment of cinematic motion. In those graphs where one axis represents time,

origin is marked as zero, neither positive nor negative but distinguishing between them. Because we look back from an age in which images are encoded mathematically, and because in a digital age the humanities can no longer afford to remain innumerate, the cinematic present, the frames we see on the screen rather than the separating framelines that stay invisible, can be considered as pixels, with the significant difference that these pixels are temporal, not spatial. That cinematic present, like the point of origin of graphs, can be given a number: zero.

Zero is not a quantity so much as a relation. We can attempt to identify "4" as an essential fourness. But zero is not what it is—after all, it is null. On the one hand, zero can be used adjectivally: "The number 0 is therefore identified with the extension of all concepts which fail to be exemplified" (Zalta 2000). For instance, you could say "there are no fairies at the bottom of the garden," because fairies "fail to be exemplified." On the other, as a noun, zero itself "fails to be exemplified": "Since nothing falls under the concept 'not identical with itself,' I define nought as follows: 0 is the number which belongs to the concept 'not identical with itself'" (Frege 1974: 87). The concept of nonidentity reveals zero's quality of internal difference. Zero is a relation rather than a (no)thing because it is always already a relation of nonidentity with itself. Zero acts, rather than is, because of this instability. And it acts in relation to the cardinal numbers (1, 2, 3 . .) because it is the other to their identity. Nothing comes first in the beginnings of cinema: zero is the nonidentity out of which the image arises, the difference that surrounds, supports, and activates apparent motion, the instability of the unmoving still image between what it was and what it will become.

Zero serves to denote origin in coordinate space, the point at which the axes of graphs intersect. Traditionally placed at the center to allow for negative as well as positive values, zero is the relation between plus and minus, existence and nonexistence. As origin, zero neither exists nor does not exist: it is the privileged marker of difference. In the raster grid of bit-mapped images, origin stands in the top left corner of the screen, so that every point on a computer display derives its address from that point, the pixel whose position is written "(0,0)."[5] Each pixel address is symbolized by its distance from zero, its difference from the nonidentical, the fullness of that apparently empty address (0,0). As original difference, the absent pixel (0,0) of origin is both essential and nonexistent. Its resultant instability is the perpetual source of movement.

Zero has also been the bottom line, the sum of balanced books since the invention of double-entry bookkeeping in the first half of the fourteenth century. As the relation between debt and credit, Micawber's happiness, zero is the point of equilibrium between positive and negative. Rather than a simple absence of money, it denotes an even standing of income and expenditures. This is the same zero as that which informs the first law of thermodynamics, the law of the conservation of energy. In a stable system, energy is neither created nor destroyed, and over time, whatever activities take place, the sum of all gains and losses is always the zero of conserved energy. It is vital to distinguish this zero from the "negative theologies" of absolute absence that characterize a twentieth-century secularism for which "The awesome and the gruesome no longer wear the anthropomorphic guise of the most perfect being but take on that of a Void in whose regard our aspirations are doomed to defeat" (Eco 1986: 93). The mathematical zero of cinema read from the age of the digital image is not a zero of emptiness and inactivity but its opposite: the sum of all activities. In this way a zero of completion complements the zero of origin. Combining the final conservative zero of dynamic equilibrium with the zero origin of coordinate space, zero extends throughout both equilibrium systems and Cartesian space. So zero is the ground of pure relationality on which activity takes place. Without the origin at zero, no drawing in coordinate space; without the divagations away from and toward zero, no play of cash flow to induce film production.

This unseen and invisible continuum of the filmstrip that binds disparate frames into a whole motion is, then, paradoxically, the continuum of difference, zero not as void but as the sum of all differences. As temporal dimension, zero is neither adjective nor noun but verb: the null activity without which the intermittent flashing of images would not become the illusion of movement. Virilio fears we have usurped this "zero time" from God: "For God, History is a landscape of events. For him, nothing really succeeds anything else because everything is co-present" (Virilio 1996: 9), a simultaneity that we mortals can experience only diachronically. Avant-garde films are occasionally exhibited in galleries mounted as filmstrips fixed to lightboxes. The paradox of this kind of exhibition is that the moving image has no presence, whereas the strip itself, to which we remain oblivious during projection, can be reconstructed as a presence but only at the cost of losing its movement. Virilio's God sees the filmstrip, not the film. As divine and changeless present, the frameline as we see it in those lightbox displays can-

not act but can only be. A gallery exhibition of motionless frames is like a museum case of pinned butterflies: lovely but dead. In the divine presence, their life is stilled and their zero becomes void. Yet this zero time, which from God's seat looks like the static copresence of all times, is for us the principle of a difference that the One God cannot perceive. And the reason He cannot perceive it is His self-identity. Only those for whom identity is incomplete and othered, those whose subjectivity, in other words, is nonidentical, is zero, can inhabit time rather than regard it.

The zero time of the frameline that shapes the time of cinema is in turn shaped by a constitutive quirk of human beings: what separates us from divinity is that the divine is self-sufficient, where we are incomplete. Although we are used to saying "One says," perhaps more correctly we should say "No one says" to recognize this internal differentiation, this unstable lack of totality and equilibrium that makes it impossible to be at home with oneself alone, and makes us social. Cinema in its infant moments is profoundly human in just this sense. There is no still frame. In the Lumières' earliest films, every image is an unstable nonidentity seeking equilibrium among the society of images that precede and follow it. Rather than breathing the puff of life into still photography, cinema ends the discipline of the single image that contains in itself, in Coleridge's phrase, the reason why it is so and not otherwise. The moving image is always otherwise. Its radical instability is both a quality of a technology achieving its autonomy from the human (its superhuman speed of perception) and a subjectivity attaining its autonomy from identity. Even though, in the decades following its invention, the cinema was turned toward domination and the closure of communicative networks, the relational principle—relations of technology to image, image to image, subject to subject, image to subject, subject to technology—governs all of cinema's futures.

Against Narrative

Cinematic time originates in zero's dynamic equilibrium. Cinema thus does not represent time but originates it. At this foundational stage, then, we can no longer share Bazin's (1967) and Kracauer's (1960) proposals that cinema's destiny was the depiction of the world. A rival and widespread school of thought sees narration as the essential model of cinematic duration, and cinema as a machine for telling stories. Now a major theme of film and cultural research, narratology is nonetheless at once too narrow a focus and too

broad a concept to provide us with an insight into the multiple ontological temporalities of films. It may indeed be true that, as Deutelbaum (1979) argues, the Lumières' first film of the workers leaving the factory can be read as a narrative beginning with the opening of the gates and concluding with their closing, but this seems to force attention toward what the film is, to the detriment of looking at what it does. Deutelbaum's argument is more stimulating than his conclusion. He elaborates on an intensive formal organisation in the early Lumière films, emphasizing their sophisticated structuring of space and their use of repetitions, mirroring, framing and staging in depth. *La Sortie des usines Lumière*, for example,

nearly returns the scene before the camera to the state at which it was when the film began. Both at the beginning and the close, the cinematic image offers only the exterior of the factory seen from the same point of view. So similar in appearance are these opening and closing images to one another, in fact, that if one were to loop the film into a continuous band, the action would appear to be a single periodic event. (Deutelbaum 1979: 30)

This sense of structure, apposite to the rediscovery of early cinema in the late 1970s by filmmakers of the structural-materialist avant-garde, is, however, betrayed by the conclusion that this symmetry is in fact narrative. Defining structure in duration through the Aristotelian categories of beginning, middle and end, as Deutelbaum does, gives an adequate description of a film whose duration matches the opening and (incomplete) closing of the factory gates. But as a definition of narrative, it is too general to be informative in the analysis of a particular film. To attempt to deploy the methods of any major school of narratology, from Propp to cognitivism, in the analysis of the *Sortie des usines* would be misguided, since the film's "story" is by any standards minimal and its duration too brief to allow the definition of narrative functions that such analyses require.

Moreover, despite the excellence of his observations, Deutelbaum gives the game away when he notes that the conclusion "nearly returns the scene" to the beginning. In fact, the two frames are not symmetrical. Not surprisingly, since there is only one shot and the camera is stationary, opening and closing frames are "similar in appearance," but in my copy the gates do not close: two gates open, but only one is swung partly back into the closed po-

sition, while the door on the left of the screen opens but is not closed. Meanwhile, the man who opens the gate disappears in the crowd, but he can be seen half in shot standing next to a woman in dark skirt and blouse at the extreme right-hand side of the last frames, a space unoccupied in the opening frame. There are some other gaps in symmetry, notably between the man in an apron who runs out with the dog, and the man in a dark *blouson* who runs back with it. Moreover, given the bicycle's identification at that time with mobility, freedom, and health, the four bicycles that pass through the gates suggest to this observer at least that there is an element of anarchy, of unstable dispersal, which the critical attempt to narrativize the film circumscribes and erases.

In a response to Deutelbaum, Gaudreault (1990a) offers to distinguish between the two modes of organization represented by the *Arrivée d'un train à La Ciotat* at one extreme and *L'Arroseur arrosé* at the other, with the *Sortie des usines* midway between. Gaudreault's case is that there are two modes of narration, a primary micronarration at the level of the shot and a secondary level created through the articulation of shots, something that of course does not occur in the *Sortie*. The distinction is an important one: narrative, in the generally accepted sense of the word, is an effect created through special techniques. Unfortunately, Gaudreault also argues that the articulation of time in the shot is predestined to produce this secondary level of narration: cinema is "a machine which is doomed to tell stories 'for ever.' This special feature of the cinema, that of always having been narrative right from the beginning, explains why this art, which 'has narrativity built into it' so quickly found its vocation as storyteller" (Gaudreault 1990a: 71; citing Metz 1974a: 118). Such twenty-twenty hindsight recreates the past in its own image: because we know cinema came to be dominated by narrative fictions, therefore it must have been narrative all along.

Second, Gaudreault's definition of the content of a shot as narrative calls on a definition of narrative so general as to be nearly universal. He cites a definition from Jacques Aumont and his collaborators that makes narrative indistinguishable from either representation or duration: "if a statement relates an event, a real or fictitious action (and its intensity and quality are of little importance), then it falls within the category of narrative" (Aumont et al. 1983: 77). On this definition, flicking a switch is narrative. This is a kind of theoretical imperialism, enforcing a narrative frame on events

that, in film as in reality, frequently have no definite beginning or end. Such a universalizing definition of narrative blurs Gaudreault's initial distinction between telling and showing.

We can clarify the distinction by describing what we have presented to us in the *Sortie des usines* as an event. In the first instance, we should restrict our understanding of the formal organization of this event to the simple fact that it has duration. In the Lumières' first films, that duration is isomorphic with the duration of an external time enacted for the camera, but even that shared shape depends on the rate of projection and the problem of stopping. The cinematic event is, then, not identical with an event in the real world: it *relates* real or fictitious events, as Aumont's group argued quite correctly and precisely. The verb "relates," however, should be understood to mean "establishes a relationship," not as "tells a story." To relate is to make a statement, and so far as a statement presumes someone to whom it is addressed, relating first and foremost establishes a relation. In Gaudreault's own term, early cinema's statements are monstratory: they are events of showing. Certainly one can assemble cinematic events into a narrative. But equally one can assemble them to make a pattern, or even jumble them together at random. It is important to recognize that narrative is neither primary nor necessary to cinema, and it forms no part of any putative essence of the medium.

Narrative, then, is not an essential quality of film, but only a potential and secondary quality arising from the production of time in the differentiation within and between frames. To misunderstand this leads to a more serious mistake, that of endowing the discrete machinery of cinema with the illusory attributes of continuous flow. It is exactly the lack of continuity, the fragmentation of flow into discrete and manageable packets, that not only allows cinema to work and be perceived working, but also, as internal instability, produces the possibility for narrative as a mode of address, one among the many relations that cinema produces. In the first films, I want to argue, that mode of address can be envisaged by analogy with the remaking of numbers as nouns rather than adjectives. In Brian Rotman's account, this arises specifically from the semiotics of zero:

by drawing attention to the failure of the anteriority of things to signs in the case of itself (what possible prior "thing" can it be referring to?) zero demolishes the illusion of anteriority for *all* numbers. Once zero enters the scene numbers . . .

must instead be considered . . . to be elements of a system *created* by zero; or rather created by the counting subject whose presence as a signifying agency zero witnesses. (Rotman 1987: 96–97)

Here zero is both a numerical sign within the system and the origin of that system, both in formal terms and as the "witness" of an indefinite and anonymous counting subject. Analogously, the frameline, the invisible darkness out of which motion pictures achieve their motion, addresses an indefinite, anonymous, distracted subject in the first films; the frameline is a subject of motion itself, inhabitant of a time that is genuinely isomorphic with the time of projection (in a way in which projection is not isomorphic with the world depicted in the filmstrip). Narrative cinema also depends on the prior existence of this zero subject of motion, but the zero subject does not necessarily imply the subject of narrative as its sole outcome.

Rotman argues, in the passage just cited, that the introduction of zero made it apparent that no number depends on the existence of an external world to which it must refer. By the same token, the cinematic event, as a process of perpetual change, does not depend on a prior external world. The loss of a transcendent referent for numbers and for film might at first glance appear to produce two entirely self-sufficient, indeed simulacral systems. But the loss of transcendence is an ontological rather than an epistemological event. What alters is the status of the external world (the countable or the profilmic), which is posited no longer as the transcendent source of the system, but instead as an integral element of it. Theories of film that see it as referring essentially to an external world entail that film transcends its own materiality by referring to something that transcends and predates it. Likewise, privileging narration suggests that film transforms nonnarrative reality into an essence—narrative—that enjoys an existence outside the cinema. Over these transcendent essences, I want to prioritize the material of film, the reality of film itself. The filmstrip neither has nor lacks a transcendent origin, whether external reality or narration, that lies anterior to it. Film and world are of the same matter. Demanding that the one represent the other not only creates the distinction between the two; the thesis of cinematic realism ensures that either the world or the cinema is condemned to unreality. Likewise, if all film is narrative, then it is to that extent not film but something else. Without a material theory of film we have no grounds for distinguishing what in film is narrative and what is not.

In Rotman's argument, the place of the counting subject is marked by the number zero. The equivalent place in perspective painting is marked by the vanishing point, rendering the subject as "optically specified and disembodied" (Bryson 1983: 96). In cinema, the dark transport of the filmstrip undermines the subject as timeless being, specifying in its place a constant process of coming into being. Cinematic zero inscribes the dynamic equilibrium of spectatorship as unfinished process. The subjects of nineteenth-century medical, police, and social photographic archives (see, e.g., Cartwright 1995; Gunning 1995a; Jordanova 1989; Sekula 1986; Tagg 1988) were promised whole and discrete moments of indexicality, like Virilio's "landscape of events." Scientists, police officers, and bureaucrats poring over the files believed that power over images translated into power over the world. By contrast, because every frame of a film is incomplete, it cannot produce that imperial or bureaucratic gaze. Against the tyranny of scientific certainty premised on the distance between observer and observed and the fixity of their relationship, the cinematograph constitutes the viewer as temporal and temporary subject of the procession of images.

Narration tends toward a gestalt.[6] The goal of narration's subject is its own completion in the contemplation of the completed narrative, a goal of closure and fixity. The cinematic event tends toward incompleteness. Its subject is constituted in the ephemeral movement from frame to frame, mobile and unfixed. This fleeting cinematic subjectivity already existed in modernity's drift (see Charney 1998), the *flâneur* celebrated in Benjamin's (1973b) account of Baudelaire. Baudelaire's "dandy" was always implicitly male and leisured. The workers leaving the factory are female and work for a living, but they are also of that first generation to visit the Bon Marché and wear the new affordable fashions. The high-tech industry of photographic manufacture celebrated by the cutting edge technology of the cinematograph captures the feminization and democratization of drift. The systematically differed/deferred subjectivity of the urban nomad is the newly democratic subject of the cinematic event. Unlike Edgar Allen Poe's *Man of the Crowd*, translated by Baudelaire, with his hyperindividuated sense of alienation, the democratic subject of the frameline is social, from the moment of the first projected films. Against this social, democratic, and unfixed subjectivity, narration sets itself the task of constructing a temporal system that can contain that drifting mobility. Seeking to return cinema to a transcendent origin it will reveal as gestalt, narrative conjures up identity as a

method for controlling the unfixed dynamic of the event, and by implication the democratic upwelling. The cinematic event *La Sortie des usines* is neither a self-sufficient system nor subordinate to a prior, transcendent narrative or representational truth. Instead, its dynamic equilibrium brings us face to face with a dynamic zero subjectivity.

Movement starts in nonidentity, the unstable zero pixel at origin. Ending movement begins the task of instigating identity in cinema. Ending is not only temporal but spatial, both the cutting edge of the frame, as in Elsaesser's account of the *Barque sortant*, and the cut that identifies the shot by defining its difference from other shots. The cut that inscribes identity into the cinema is itself a difference that proliferates difference. At the end of the *Barque sortant*, in stoppage time, we confront the jolt of awareness that arises from the sudden need to establish the gestalt of the film, a renewed attentiveness, but one that also promotes a further oneiric distraction from what is at hand to what has gone before. It is as if cinema were, in this brief instant, still preconscious, emerging, dazed and entranced, into a mode of communication that may still have the power to renew not innocent and primordial but artificial and social perception. With the emergence of cinematic time as special effect, we enter the universe of the synthetic.

MAGICAL FILM: THE CUT

A Slice of Life

Nothing is visible without light.
Nothing is visible without a transparent medium.
Nothing is visible without boundaries.
Nothing is visible without colour.
Nothing is visible without distance.
Nothing is visible without instrument.
What comes after this cannot be learned.

—*Nicholas Poussin, 1665*[1]

The Cinematic Object

The story of how the magician took over the laboratory is probably apocryphal. One day, Méliès's camera jammed. When it was restarted, the movie changed a bus into a hearse, and the men into women (see, e.g., Sadoul 1973: 390–391). The accuracy of the story is less important than its status as the canonical origin of stop-motion: the myth that the new art of trick shots owed its creation to purely mechanical contingency. In this chapter, I will argue that Méliès's accident at one of the great crossroads of the Paris of the Belle Epoque is, like a Freudian slip, the result of an unconscious overdetermination by new global cultural flows, by new spectacular forms of the commodity, and, not least, by the internal logic of cinematography.

As Aumont and his collaborators argue, Méliès "did not really use editing principles," rendering his films "at best mere successions of tableaux" (Aumont et al. 1992: 46). Méliès displaces rather than repositions, synthesizes, or assembles, or any of the other principles of editing. Instead, he cuts, not just between but within frames. As Michael Chanan has it, writing of the

Voyage à travers l'impossible, "if the first audiences saw Lumière's train as if it could detach itself from the screen, then in a way, Méliès's film—in which a cut out of a train flies through the skies and vaults across the ravines of a kind of painted backdrop—was simply the film of a train *which had so detached itself*" (Chanan 1980: 32). The *Voyage* analyzes. It separates the rush of the pixelated screen into objects and distinguishes objects from their movement. Méliès is the first master of the cinematic third dimension, that of space, analyzing movement into layers stacked in front of or behind each other. His tableaux identify the boundaries of the screen (and so create off-screen space). Once established, these layered and contiguous spaces create the temporality of hiding and revealing and thus also the possibility of cutting from place to place. Framing, compositing in layers (in the mise-en-scène, in-camera or in postproduction), and jumping from tableau to tableau are all acts of singling out and multiplying, of converting the unstable equilibrium of the pixel into places and objects, organizing the on- and offscreen, the behind and before into coherent worlds. The innocent but abstracted delight in sensation, in light moving in time, gives way to the analytic pleasures of recognizing objects and their movements in space. This new mode of analytic cinema I will call the cut.

Innovation is never purely accidental. Méliès had to recognize his good luck. The jammed shutter condensed and reiterated the practice of exhibiting single-shot films back to back (Bottomore 1988). But there is also an internal logic at work in the genesis of cutting as the basis of film form. Directionless and omnidirectional, the unstable equilibrium of zero already demands a pivot; the order of the nonidentical produces the order of identity. The mise-en-scène of the Lumières' *L'Arroseur arrosé* (fig. 3.1) already

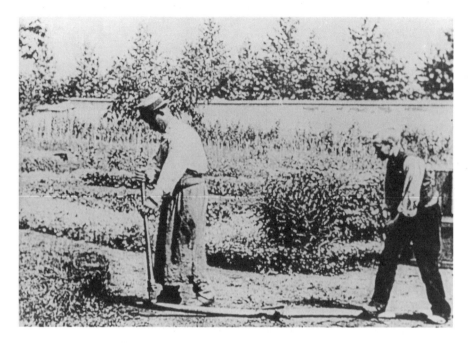

| Figure 3.1 |

L'Arroseur arrosé: figures and ground, planes cut in depth. Courtesy BFI Collections.

stages its action in discrete segments (following formulas already industrialized in the comic strip) and carefully framed for maximum visibility, as when the naughty boy is ear-tweaked front and center to receive his punishment. As Aumont (1997b: 252) points out while discussing the impact of photographic practice on Degas, "the cutting force of the frame" is a principle of unification. The first cut in film is the power of the frame to differentiate what is visible from what is not. Long before Kubrick, the Lumières recognized the power of symmetry to spatialize looking.

Using layers in a way that would reach formal purity in the work of Méliès, *L'Arroseur* composes its action in depth. When we see the boy standing in midground on the hosepipe while the bemused gardner inspects its nozzle in the foreground, their relation is established in the distinction between planes. Evoking the theatrical flats of the proscenium arch stage, the film differentiates figure and ground in order to establish hierarchies of interest that the indifferentiation of *La Sortie* so signally failed to provide.

The inertia of the garden acts as a foil to the activity of the figures, so that generalized movement is separated into discrete actions of identifiable and identified figures, distinct from the world that surrounds them. As ground, the garden becomes one kind of object, while the actors become another. So the process of objectification simultaneously unifies flux into objects and multiplies the number and kind of objects—here foreground figure, background figure, ground.

Though the first spectators immersed themselves in the mesmeric ebbing and flowing of waves, both the ideology of attentiveness and the pointlessness of reverie demanded a more substantial organization of film's primal temporal flux. Framing and compositing distinguish in time as they determine in space. Composing the image in layers not only distinguishes movement into objects: it demands a temporal relation between layers, here in the construction of causality (the boy steps on the hose; the water stops flowing). Likewise in later films the construction of offscreen space creates the temporal relation of "where next?": the principle of the edit. In *L'Arroseur* the only edit comes at the end, matching the gardener's return to his hosepipe with the end of the reel. Here is the narrative symmetry Deutelbaum mistakenly identifies in *La Sortie des usines*, the symmetry of restored equilibrium. The ending provides us with the material for a rearview (and ideological) reconstruction of the action by making the humor and morality of the scene legible: that honest toil is more rewarding than childish pranks. By providing this ideological conclusion, the final edit provides that horizon which, for Merleau-Ponty (1962), was the necessary base for any figure-ground relation. Unlike his, however, the horizon of the final cut is temporal rather than spatial. Coming at the end rather than the beginning, the horizon of the final cut controls retrospectively the endlessly unstable sameness of sensation. The internal logic of indifference, the endless and formless froth bubbling in and out of being, is too unstable to survive. The cut that establishes foreground and background, onscreen and offscreen space allies with the construction of a temporal horizon to convert the random jostling of pixels into unified and discrete cinematic objects.

This task is in part purely technical. *Le Radical*'s account of the Salon Indien screening proposed that "Their work will be a veritable marvel if they manage to reduce, if not suppress, which scarcely seems possible, the juddering produced in their first scenes" (Ministère des affaires etrangères 1996: 16). Improving registration (the fit between sprocket and sprocket hole) and

speeding up the shutter to smooth the transition from image to image does more than soothe the eyes. Nor did the technical stabilization of the shot merely serve to normalize cinema for the bourgeoisie (Burch 1990: 48, 52). The judder, still celebrated in the slang term "flicks" or "flickers," tended to induce the state of reverie typical of the unstable equilibrium of the pixel. Anchoring the frame firmly at the moment of projection minimized and managed distraction by ensuring that the image stayed in its place. Getting pin-registration right was the first step toward that Romantic aesthetic of organic unity believed essential for attentive viewing, the proper mode for moral education and edifying entertainments. Though the cut is seen as emblematic of the fragmentation of modernity, it is that only insofar as it is also a principle of unification, as witness both Eisenstein (1949a) and Pound (see Fenollosa 1986). The technical fix made the image truly bourgeois when it made it identical with itself.

Once the judder had been stilled, the frame could come into its own. *L'Arroseur* does not invite us to speculate about what lies beyond the frame— that would come later. It does allow us to pause long enough to consider its shape. The rectangular frame established by the Lumières was arbitrary only in the sense that it was dictated by the device, not its inventors. But the device itself was the product of all those who had worked on the technologies of picturing over the centuries, from seamstresses to picture framers, whose skills were expropriated, made concrete and automated in the machinery of the cinematograph.[2] The rectangular frame was both the dead tradition of the past and the instrument for bringing it back to life. The cyborg process that transforms living labor into fixed technologies allows the skills of all the dead to participate in the creativity of the present. The rectangle framing *L'Arroseur* anchors attention by exclusion. But the world beyond the frame could not be kept out forever. The stolen labor of those lost, anonymous artisans comes back to life when the frame itself begins to move.

Because the frame intimates contiguous but invisible spaces beyond itself, it urges the invention of reframing (moving the camera to keep an action in shot). Reframing in turn requires the edit as a way of structuring itself. Both techniques appear in an exemplary exploration of space as time, Porter's *Pan-American Exposition by Night* of 1901. The camera pans from right to left over the sunlit central avenue of the exposition until it reaches the central axis, a tower. Here the film fades to black, and a second take begins, on the same reel and from the same position, following the same rate

of panning, but now capturing the vista by night, enlivened by thousands of lightbulbs furnished by Porter's employer, Thomas Alva Edison. A single static shot could have captured the play of the searchlight and been quite as successful financially and historically as an early example of product placement. But the film clearly simulates the vistas of the popular, century-old panoramas, many of which required the audience to move, rather than the screen image. A static shot would have invited the viewers' eyes to rove across the frame, as happens in *La Sortie*. Porter's pan is an attempt to unify and guide that roving gaze.

Panning (the word derives from "panorama") transfers the inertia of the ground to the audience, the unity of the vista to the identity of the spectator, so restructuring the audience's aimless, flickering glances as a recognizably cinematic gaze. Far from exploding the scene into fragments, the midpoint edit transforms this public location—conventionally the most uncontrollable conditions to shoot—into the mastered object of privatized looking. Where the *Sortie* is entranced by the autonomy of its figures, Porter's *Exposition* ignores the few moving people we can see. Most of them are moving left to right, against the pan, and the moment when one male figure can be seen walking along the midway toward the camera is the moment Porter fades to black. Here the logic of the cut is mathematical: at the symmetrical point in the pan, the fade is already scheduled, no matter what happens. The two shots pitch themselves toward unity through a hierarchy of movements. The man's progress toward us is interrupted by a fade he has no part in, dictated by a pan whose rhythms are utterly alien to his own. Porter's shot is timed to absolute symmetry, mirroring day and night, sunlight and electrical illumination in a machine that depended on both. His apparatus of tripod, camera, and clock takes precedence over the unruly world in front of it. The cut, then, does not sever the first and second halves: it is a tool for joining fragments, here a mechanism for symmetry, more generally for articulating and generating higher orders.

Initially spatial, as the metaphor of pattern suggests, the crossfade is also an early example of time-lapse (Musser 1991: 186) and hence also temporal. The frame identifies, gives identity and unity to, its contents. But the individual frame cannot bear this burden. We are too aware of what it excludes and we want to see what has been excluded, a desire that propels the movement of the pan. What first appears as the unity of the frame is immediately remade as the desire to see something else, something whole. That

is the higher unity Porter achieves. The subordination of the event to the frame cannot be completed: it must lead to another framing device, another ground, another image to supplant the one that is now rendered static and exclusive. An appropriately mechanical logic leads from the spontaneous difference of every pixel from every other, the fascinating scintillation of the Lumières' crowding elements, toward a larger difference between successive frames, marked in Porter's film by the cut at the axis of symmetry in the arc of the pan. After the cut, wholeness is a matter of "re-cognition," a temporal effect.

The edges of the frame unify the image as composition, reducing the flux of movement to the rectangle of illumination. But framing excludes at the same time that it unifies, differentiating the framed by opposing it to the unframed. So it doubles cinematic space into onscreen and offscreen. There are at least two points in the fifty-four seconds of the *Pan-American Exposition* when the direction of the pan could have been reversed: once when a daylit figure gets our attention by walking left to right against the right-to-left reframing; the other as the searchlight tower passes out of sight. The moving figures give the composition depth and scale, but they also distract from the apparatus of the pan. Organizing the single shot to produce unity through exclusion of offscreen space implies the possibility of alternate views: a reverse pan, insert edits to identify the figures, or cutaways to the emblematic searchlight. Meanwhile, the foreground figures also introduce the possibility of seeing from other points inside the figured space: point-of-view shots and reverse angles to complete the description of the world of the film. The struggle toward wholeness progresses by multiplication, a system of checks and balances, levers and props, each of which implies a further accretion of fulcrums and buttresses. The unification of the shot leads mercilessly to the proliferation of cuts.

In mathematics and in cinema, unity is always subsequent: it derives from that numberless movement at zero that initiates number.[3] The nonidentity of the pixel, the formless, initiating instant of sensation, is the moment of firstness proposed by the semiotician Charles Sanders Peirce, who describes it as "Feeling, the consciousness which can be included with an instant of time, passive consciousness of quality without recognition or analysis" (Peirce 1991: 185). Jonathan Crary equates this passivity with the distracted gaze, associating it with the timelessness of the cinematic event (Crary 1999: 59–60). Umberto Eco suggests that firstness "is a quality of

feeling, like a purple color noticed without any sense of the beginning or the end of the experience; it is not an object, nor is it initially inherent to any recognizable object" (Eco 1999: 100). For cinema, it is the interpenetration of the physics of light and the physiology of seeing, the world worlding freely over the senses. Duration without beginning, end, or direction, firstness is the simplest possible awareness of sensation, and it antedates, logically, chronologically, and phenomenologically, all consciousness of unified objects.

That unity belongs to Peirce's secondness, when the formless instant becomes an object because we re-cognize it, shaping the flux of sensations, not yet even identifiably internal or external, into a specific object for the contemplating subject. In terms evoking the cinematic cut, Peirce describes secondness as "Consciousness of an interruption into the field of consciousness, sense of resistance, of an external fact, of another something" (Peirce 1991: 185). In the cinema, we are aware first of movement and only secondarily of what moves and that its movement constitutes a coherent action. In late fragmentary notes, Merleau-Ponty names *Rückgestaltung*, "'retrograde movement of the true.' . . . This means: there is a *germination* of what *will have been* understood" (Merleau-Ponty 1968: 189). Making a whole in retrospect, the literal translation of *Rückgestaltung*, is the habit of mind that associates the action of photons on the optic nerves with the presence of known objects. But, Merleau-Ponty asserts, prior to objectification is a "germination": the pixel, Peirce's firstness. The cut turns sensation into perception in a retrospective ordering of raw, undifferentiated (and mechanical) flux into identified objects. Through framing, compositing, and editing, the cut distinguishes the gestalt wholeness of bounded figures and bounded duration from the effervescence of photons. Identifying the content of the image as composition, figure, and duration at once unifies and multiplies the "germination" of the image's pure movement by pointing indexically to *what* moves.

In the transition from sensation (of the cinematic event) to apperception (of the cinematic object), the elementary practices of the cut convert the play of pixels into objects, worlds, and identities. Staging in depth, the parallax effect (objects close to the camera appear to move more quickly than objects in the distance), the use of mattes, optical printing, and other layering technologies separate figure from figure, and figures from ground. These compositing techniques describe sensation as object. Framing separates a particular fragment of the scene for our attention by use of the frame

edge but also by irising in on a detail, shortening the depth of field or using scrims and other elements of the mise-en-scène (Sternberg's favorite: Baxter 1980, 1993) or masks, filters, or vaseline on the lens to discriminate centers of focus. Because it creates both offscreen space and obscure patches within the imaged field, the frame also produces an intuition of a world extending beneath, beyond, and in front of what the frame makes visible. That always imaginary world, whether documentary or fiction, does not exist in *La Sortie:* it has to wait for reframing to be produced. Framing and compositing create diegesis, the properly Imaginary world. Another doubling occurs here: the flaring photons are reduced to the objects of a masterful gaze, the gaze of the newborn subject. But because the diegetic world so created extends to the differentiated space in front of the screen, that subject is also subjected to the diegesis.

For the first audiences of the *Sortie* there was no expectation about how long the experience would last, no sense that it would necessarily be timebound. But once knowledge that a film ends becomes common sense, audiences come to expect a concluding edit and to anticipate from the unfolding flux of motion a goal toward which it tends. Once that conclusion is reached, as in *L'Arroseur*, we turn our focus backward to reconstruct the action in the light of its conclusion. The edit instigates a doubled movement in time, one that demands both retrospect and prospect. In Porter's *Pan-American Exposition*, this happens at the edit, which tells us that the second shot will last as long, pan at the same pace, and conclude in mirror symmetry with the opening shot. Retrospect and prospect, starting and stopping, recognition and expectation, between them unify the cinematic object in time and space, but at the same time double the subject that is both master of and mastered by imaginary wholeness.

Serial production of distinct units and the hierarchy of unities, striving toward the formal unification of flux, end up atomizing the flow of light into space and time. The cut spatializes the timeless time of the pixel. Cinematic space, however, produces temporal relations like causality and point of view, behind and in front, inside and outside. The temporality involved is itself double, both future and past, expectation and memory, desire and loss. This temporal doubling mirrors the spatial doubling of on- and off-frame, presence and absence. In a process familiar from Lacan, the work of manufacturing the presence of desire's object on celluloid ends only in its lack in being. To compensate, when compositing, framing, and editing establish

objects, worlds, and identities, they hierarchize our interest in the image. Anticipation of an ending likewise constrains motion to a hierarchy of expectation and recall. But it only constrains; it cannot determine. The process of guiding the audience to a single focus is never concluded. Every exclusion is an invitation to anticipate or recall what remains unseen, what else happens before or after, within or beyond the frame. Cutting proliferates in the endless attempt to structure the boundless flow of the pixel, so much so that cinematic unity is indistinguishable from the proliferation of multiplicity.

In pursuit of an ideally attentive and stable subject, the cut produces multiple unities and hierarchies. And yet the oceanic protosubjectivity of the pixel is never entirely subsumed into the new formation. Oscillating between focus and forgetfulness, this new subject ticks and tocks between the nonidentity of the pixel, constantly generating new movements, and the cut's proliferating identities and hierarchies of attention. In that dialectic the subject of cinema inhabits a triple time. Enticed into imagining what happens beyond the frame as a movement toward the future, while also composing a retrospective account of what has already passed by, she nonetheless also inhabits the zero point traveling at exactly the same speed as the film. *Pace* Deleuze, film began in the time-image, the simplest dreamy identification with *durée*. Its reemergence in the postwar *cinéma d'auteur* is only evidence of a forlorn effort to recreate the innocence of the unfurling present. Surveillance cameras, the last bastion of the pure cinematic event, demonstrate the banality of the results.

Setting boundaries within and around movement, the cut makes us judges and manipulators of time in the cinema. If, in the transition from the *Sortie* to *L'Arroseur*, film lost the innocence of sheer perception, it gained the keys to time as a medium. At first and for many years after, filmmakers had the tools to construct new temporalities for audiences, who were not only consumed and communicated but temporalized as subjects of the cinema. These new temporalities enabled by the introduction of the cut were not, of course, pure productions of an autonomous inspiration or of a technology determining its own evolution; nor did they emerge solely from the internal logic of the cinematograph. Cinematic time is inseparable from the matrix of the commodity, because film became, already, in the 1890s, the cutting edge of the commodity's reorientation as spectacle, the first intimation of media technologies as the powerhouse of globalization.

Belle Epoque

The women who stroll out of the Lumière factory are walking into a new kind of public space. In front of the camera, they share the visibility of the men, no longer the privileged objects of a presumed male gaze. They too are represented; they too are communicated. The anonymous mobility and monopoly over the gaze of Baudelaire's "dandy" of the 1860s was exclusively male (Buck-Morss 1986; Huyssen 1986a; Pollock 1988: 50–90; Wolff 1985). But the 1890s and 1900s witnessed a democratization of *flânerie* that would embrace the women who not only worked for the high-tech photographic industry but had replaced more expensive, traditionally skilled men in the office trades with the introduction of the typewriter and adding machine, and who were the primary workforce in the new retail business.

This feminization of the cutting edges of the late nineteenth- and early twentieth-century economy reinforced and was reinforced by the reorientation of metropolitan capital toward consumerism. The preserve of the male *flâneur* was the arcade; the privileged domain of the emergent and cross-class *flâneuse* was the department store. The new security offered by electrical illumination and plate glass promoted shopping as a female occupation by assuring women of protection from weather, darkness, and unwanted approaches (Rappaport 1995). Urban space became available for women to promenade through in a way impossible a scant decade before. Anne Friedberg writes, citing Walter Benjamin (1973b: 170):

The department store that, like the arcade before it, "made use of *flânerie* itself in order to sell goods," constructed fantasy worlds for itinerant lookers. But unlike the arcade, the department store offered a protected site for the empowered gaze of the *flâneuse*. Endowed with purchase power, she was the target of consumer address. New desires were created *for her* by advertising and consumer culture, desires elaborated in a system of selling and consumption which depended on the relation between looking and buying, and the indirect desire to possess and incorporate through the eye. (Friedberg 1993: 37)

The price of the liberty to stroll is a certain indifferentiation, a generalized equivalence of men and women. The *flâneuse* not only abrogated the dominance of male desire but anulled desire as a whole by anchoring it no longer in the person but in the visually charged form of the commodity as spectacle, which not only targeted her, but in the newly democratizing fash-

ion trade, made her a commodity spectacle herself. This equation of disparate and uneven desire, shaped not even by the presence but by the presentation of goods, also shapes cinematic unification in the cut. At the same time, like the cut, the internally contradictory nature of the commodity produces the endless procession of fashionable novelties, the multiplicity on which consumerism depends. In this it shares that vertigo discernible among the filmmakers who first engaged the cinema in the articulation of fantasy.

In the emergent consumer culture of arcades and department stores, fashion, and spectacle, the erotic seeped into public space as a guiding motivation for individuated success, individuated consumption, individuated madness: no wonder that the spectacle, psychoanalysis, and cinema share a birthday. At the same time that fashion became available as a mass entertainment, industrialized, and reduced in price so that working women like those from the Lumière plant could afford it (Wilson 1985; Williams 1982), the female body was being partitioned into a montage of fetishized parts (Apter 1991). Simultaneously, the obligation to be looked at implied the liberty to look (Gleber 1997). The price of entry into the democratized world of consumer capital was visibility: not just to be seen but to see as and in terms of the commodity form. The privileged moment at which this historic shift in the formation of the psyche was achieved lay in the same "dream world of mass culture" (Buck-Morss 1989: 253) of late nineteenth-century France that first gave rise to the moving image. In the Paris of the department stores, these contradictions of the commodity were endlessly interworked with the spectacle of the new technologies. Far from unifying, the democratization of the commodity as spectacle splits and multiplies. Spectacularizing the erotic, eroticizing the spectacle, generates a curiously asexual unconscious, explored and exploded in the films of Georges Méliès.

In 1888, newly ensconced as proprietor of the popular Théâtre Robert-Houdin (after which Houdini was to name himself), Méliès began to enliven the already florid late-century stage with new tricks (Barnouw 1981). Like the North American theater described by Eisenstein (1949b), the spectacular school in which D. W. Griffith acquired his sense of cinematic form, the melodramatic theaters of Paris were majestically devoted to earthquakes, waterfalls, railway crashes, airborne apparitions, imaginary journeys, stampedes, battles, and mythical beasts. The apparatus of traps and projections, prestidigitation, wire acrobats, wrangling, massive and mobile sets, lighting and sound effects put it on a par with the 1990s music theater

of Andrew Lloyd Weber. Méliès belonged to this tradition, and as a designer of *trucages* for the stage (Arias 1984) already in the 1880s he occupied the key position of technologist-engineer-artist central to the cultures of technological media. Magic lantern shows and panoramas had, by the early years of the French republic, achieved a degree of movement and three-dimensionality unrepeated until the virtual reality experiments of Krueger and Lanier in the 1980s (see El Nouty 1978: 49–58; Levie 1990). As the technologization of spectacle accelerated, its thematics moved bizarrely in the opposite direction: to folklore (giants, *féeries*), the gothic (ghouls, ruined castles), the melodramatic grotesque (guignol, satanism), and the exotic (tales from the Arabian Nights, "exotic" dances). Only in the theatricalization of the works of Jules Verne did the fantastic imaginary of technologized consumerism express itself in motifs derived from engineering, and even then only after the massive success of Dennery's stage adaptation of *Around the World in Eighty Days*, itself a classic of orientalism.

The avant-gardes of the imperial powers orientalized the Bible, archetypically in the sensualist Salomés of Wilde, Beardsley, and Moreau—the symbolist painter with whom, putatively, Méliès studied for a year in 1888. Meanwhile, the popular culture of spectacle produced the Indian rope trick, Maskelyne's Egyptian Hall (home of conjuring on the London stage), and the pantomime traditions of Ali Baba and Aladdin, enduring legacies of a love affair with imagined empires. Imperial dreams suffuse Méliès titles (see Frazer's 1979 filmography). Many of them developed from *trucs* initially presented at the Robert-Houdin (Deslandes 1963: 33–49), titles like *Les Miracles de Brahman* and *Le fakir de Singapoure* indicate a decade-long infatuation with the image of the orient. Other orientalist extravangzas like Ferdinand Zecca's *Pathé* shorts and Wilde's transvestite performance as Salomé constitute the orient as other in the sense of the *objet petit "a,"* the impossible object of desire. For Méliès the East is a core though not unique form of what speaks in the unconscious as Other, the constitutive ventriloquism of a subjectivity that never speaks but is always spoken by a desire it perpetually disavows.

In Méliès's films, the absolute exteriority of hallucinations, like the elephant-moon of his 1911 *Les Hallucinations du Baron Munchausen*, derives from the crisis of overconsumption experienced as indigestion, the suppressed bodily life of his lunatic scientists and whacky academicians. Dressed in the formal evening wear of the professional magician, Méliès is

already ringmaster of an unforeseeable universe of transformations, master of them all yet perpetually condemned to plunge back into the ring with animals, imps, and clowns, embodiments of Bakhtin's "lower bodily functions" (Bakhtin 1968). In his favorite guise of carnivalesque Satan, "he could mobilise a recurring, yet continually shifting bricolage of otherness—particularly in terms of religion, race and gender—in order to invert the hierarchical values of modern French society and hold them up to ridicule in a riot of the carnivalesque" (Abel 1994: 65).

Méliès's sexuality is still patriarchal, fleshed out in his pneumatic star-maidens and mermaids, and unabashed. The orient as something inherently unconscious in the European order of commodities is not just erotic, because eroticism was obscenely conscious in the Belle Epoque. Zecca's orientalism is commodity fetishism proper, a denegation disguising desire for the commodity-spectacle as desire for the spectacle, pure and simple, figured as the unknown East. Méliès instead speaks to the constitutive unknowability of the spectacle, evoking as demonic the inattentive, reckless, feckless, irrepressibly pointless imps of distraction that the commodity fetishism of the cut has come to control. Méliès's unconscious is the formless chaos underlying the order of objects, spectacle, and the commodity.

In the Vernean titles (*Voyage dans la lune*, *Voyage à travers l'impossible*), which for audiences a century later most evoke Méliès, the cineast makes up for slow lenses and emulsions by widening the aperture to admit more light, diminishing the depth of field as a consequence. Compensating for this foreshortening with *trompe l'oeil* backdrops, the living actors and foreground props project toward the front of the image, like the foregrounded layering effects characteristic of Peter Greenaway's digital films (Spielmann 1997). Of the twenty-six tableaux making up the *Voyage à travers l'impossible* (fig. 3.2), only two use backdrops that are explicitly designed to give a sense of receding space. The others rely on building up planes. The prop submarine and the cutaway railway carriage occupy only extremely shallow spaces. Even outer space and the deep ocean are inert grounds that propel the human figures up to the surface of the screen. The human environment is restricted to a single shallow plane of action or, at most, a double plane divided only by the cardboard cutout of the circulating wheel in the second tableau, the interior of Crazyloff's factory. In the Swiss scenes, some action occurs across a diagonal axis—the exit of the porter in the ticket office and the scattering of the peasants when the motor car crashes into the inn. But these

| Figure 3.2 |

Voyage a travers l'impossible: layering theatrical flats and trompe-l'oeuil compensate for the flattening effect of brilliant daylight. Courtesy BFI Collections.

scenes are closed off by a high horizon line that limits movement into the scene along the z-axis, rendering the performance space discrete from the layered theatrical flats that make up its landscape. The only apparent depth comes in those scenes from which the human protagonists are absent and the machines take on their own lives: the traverse of the Alps, for example, in which the train crosses left to right in the background and right to left in the foreground.

In this positive sense Méliès's films are superficial. The shallow space of the reflective screen folds distance and desire into one another. A visual repertoire already *démodé* when the later films were released, the personifi-cations of celestial bodies and the incessant magical transformations of Méliès's imaginary come not from far way but from before. Where Zecca's other is elsewhere, Méliès's is removed in time to the postmortem universe of mummies, the afterworld, the vanishing temporal perspectives of "once

upon a time." Eroticized, commodified, desire is constantly confounded with the ridicule of death, the body, eating, sleeping, and disorganization: whatever is here. And what is here is the impossibility of existing as pure surface, pure spectacle. The shrinking dimensions of the shallow screen figure the commodity form not as yearning and desire but as anxiety, a troubled relation with the disavowed past of immersion in zero's aimless satisfaction. Beneath the foreshortened image of space lies the suddenly compressed archaism of the unconscious: beneath these pictures of the nonexistent, the commodity evokes the conflicting temporalities of the nonidentical only to deny them.

Between Worlds

Sadoul is not the only historian to see in Méliès the realization of the cinema beyond the technological spectacle achieved by the Lumières and Edison. Cavalcanti (1979), Richter (1986), and Eisenstein (1988) among many others attribute to Méliès the beginnings of the fantasy film. It is equally a truism to see in the films of Dadasaheb Phalke, the pioneer of the Indian cinema, an imitator—of genius, but an imitator—of Méliès in the years just after Méliès, bankrupted by sharp practices in the North American marketplace, gave up his cinema business. But chronology can be a liar. Phalke's nationalist reworkings of stories from the Mahabharata and the Ramayana draw from the same Asian traditions that, since Dryden and Racine, had fed the spectacular theaters of the great colonial powers with stories, imagery, and techniques. Phalke's dramas are palpably cosmic, but his cosmos possesses the dignity of ancient belief, where Méliès's makes a game of its distinction from the commonsense scientism of his age and is at its most poetic when at its most debunking. Moreover, Phalke operates at the scale of an ideal village life and the home-industry Swadeshi movement associated with Mohatma Gandhi; Méliès's is a tangibly urbane art. And whereas Méliès's work is, with some exceptions, studio-based, Phalke's is shot on location in full daylight, thereby enjoying a depth of field that Méliès eschewed.

Like Méliès, Phalke was a skilled artisan and trained artist, with a passion for magic tricks, some of which he filmed under the anagramatic pseudonym Prof. Kelpha. Unlike the boulevardier Méliès, however, he had only a brief visit to London in which to acquaint himself with the state of film technique. "Phalke's greatness," notes Firoze Rangoonwalla, "can be realised from the fact that he had to work almost single-handed, doing

the pioneering and innovating in every respect, while his contemporaries abroad had the benefits of resources, equipment and specialised services in studios" (Rangoonwalla 1983: 35). Phalke even perforated his own film-stock by hand. This became a strength: "My films are Swadeshi," he wrote, "in the sense that the capital ownership, employees and the stories are Swadeshi" (cited in Dharap 1985: 40). Despite the foreign technology, in his first experiment, a short on the growth of a pea-plant, Phalke had to reinvent the principles of stop-motion photography. *Rajah Harischandra*, probably completed late in 1912, like all of Phalke's features, was a devotional film. Its audience too was new to the cinema: "The people who came were seldom two-rupee customers. Most paid four annas, two annas, or even one anna, and most of them sat on the ground. The weight of the coins, on the homeward trip, could be enormous" (Barnouw and Krishnaswamy 1980: 15), necessitating a bullock cart on at least one occasion. His success is also credited with enabling a viable indigenous cinema, and he is praised for making it possible for Indian women to appear on Indian screens.

Phalke's effects are not only beautifully achieved but integrated with both traditional and anticolonial cultural formations. Religiously legitimated magic not only evades colonial censorship but charms the unwitting colonizer. *Lanka Dahan*, *Shri Krishna Janma*, and *Kaliya Mardan* delighted viewers with familiar stories, much as silent film historians have argued of the use of narratives from the Bible, folklore, and the popular stage in European and North American cinemas of the early period. Méliès conforms to the thesis of the cinema of attractions as proposed by Gunning (1986), narrative taking second place to spectacle. In Phalke, however, the narrative, though fragmented by the vagaries of preservation and transmission, occupies a sovereign position, but as metonymic, almost holographic shards of the Hindu epic tradition. According to Gaudreault (1987), Mitry (1968), and Jenn (1984), among others, the often overlooked complexity of the narrative structure of his editing is evidence of Méliès's ambition as *montageur*. Phalke's cinema deploys similar cuts, trimming to circumnavigate the difficulty of in-camera editing for stop-motion action scenes, cutting between shots with similar framing, following characters' actions from tableau to tableau, and establishing montage within single frames through multiple exposure in camera or optical printing. But where Méliès is spectacular in objectifying the internal dialectic of the commodity form, Phalke's cinema subordinates the film to the revealed truth of the Mahabharata. In Peirce's

terms, Phalke's cinema is indexical of the theology of apparition, the making-manifest of the Lords Krishna and Rama, whose human forms are always only aspects of their being.

Ashish Rajadhyaksha notes that Phalke's "initial influences of art derived from the great painter of kitsch, Raja Ravi Varma. Phalke's work was a logical successor to Varma, for it actually implemented what Varma merely expressed—an art of the post-industrial, mechanical reproduction age"; he adds that, though cinema was seen as an art for the urban middle classes, Phalke moved away from Bombay to distance himself from the Westernization of urban life (Rajadhyaksha 1985: 230; on Varma, see Khanna and Kurtha 1998; Mishra 2002: 10–13). At the same time, his acceptance of foreign-made technology and foreign travel for a fundamentally nationalist appeal to traditional beliefs indicates both a commitment to modernization and a belief that the new devices are assimilable within an authentically Indian tradition of conjuring and illusion. Two of his greatest successes, *Shri Krishna Janma* and *Kaliya Mardan*, are stories of the infant Krishna. That aspect of tradition which is a handing on from father to offspring, and so a kind of immortality, is here joined to a more secular faith in the possibility of a future in reach of the child—Krishna is played by Phalke's daughter Mandakini, who could be expected to live long enough to see independence. Phalke's theological modernity animates the devotional past in the colonial present as the promise of a future guided by the twin principles of democratic nationalism and the centrality of the rural (see Gandhi 1948), his films the foreshadowing of Nehru's midnight speech.

Phalke's "mythologicals" gave Bollywood a genre and a value structure that still forms the genotype for the Bombay melodrama (Mishra 1985). Where Méliès's class was fading, and he sang its swan song in a glorious if short-lived duet with popular working-class culture, Phalke's feels itself ascendant and in its strength can afford to be democratic. He speaks with pride of the swadeshi achievements of his class in a 1939 interview with *Mauj Magazine:* "If I had not possessed the artistic and technical facilities, required for film-making, namely drawing, painting, architecture, photography, theatre and magic and had not shown the courage and daring, the film industry would never have been established in India in 1912" (cited in Nair 1999: np).

Assured of the power of the merchant class and of Hindu nationalism in a presumptive postcolonial India, Phalke could free his films from the

necessity to represent caste differences. As Nair (1999) argues, "the organisation of space and movement within the frame, the entry of characters, their movements, looks and exits and the props they carry, the clothes they wear" reveal a mutual respect and readiness to forgo caste privilege, a powerful statement for a Brahmin's son to make, in the interests of national unity. This democratization within the Hindu community, however, expresses a sense of emancipation in which the interests of nation and the specific class and gender interests of Phalke's community are identical (see Guha 1982).

At the same time, it is important to understand that Phalke's films were an effort on the part of his Brahmin caste to assume leadership over the massive groundswell of popular resistance that peaked in the anti-Rowlatt movements of 1919, in the name of a rising bourgeoisie (see Guha 1988: 40–41). Moreover, the Extremist leader Bal Gangadhar Tilak's influence on the Swadeshi movement, as much as the success of the Tata iron and steel mills that financed it, led to a gradual reorientation toward a more radically Hindu nationalism, rather than a simple anticolonialism. Indeed, we find Phalke publishing under his given name Dundiraj, in the pages of Tilak's house organ (Phalke 1988/1989; see also Shoesmith 1998/1999). From its birth in 1905, Swadeshi tended to absorb an increasingly bitter anti-Muslim element (Read and Fisher 1988: 89–91).

Hindi nationalism also evolved toward a deep masculinism. In an analysis of the Indian rope trick, Lee Siegel discovers, in the rigidification of the rope, the defiance of gravity, and the dismemberment and reconstitution of the boy who climbs the rope, a celebration of a masculine generative power in which women have no place (Siegel 1991: 218–220). Phalke's Swadeshi readings of the Ramayana and Mahabharata draw on this masculinist ideology. Anand Patwardhan's documentary film on Indian masculinity in the communal violence of the late 1980s and early '90s, *Father, Son, and Holy War* (1994) traces the crisis of Indian machismo to the Raj's sneering disregard for an imagined effeminacy among Indian men. Patwardhan traces the history of the stunt spectaculars which so dominate contemporary Bombay cinema, often tuned to the extreme right-wing Hindi nationalism of the Shiv Senna faction, to this magical response to colonialist discourses of masculinity. Child of his time, Phalke in his films asserts the honor and strength of Indian masculinity as a core ideological project of a highly ideological cinema.[4] If Phalke's films work in a theological time in which the past sub-

sists in the present as the gateway to the future, it is as a function of their attempt to legitimate and administer a specific postcolonial future in the name of an educated, nationalist, Hindu, and male elite.

Both reaction and tradition are inventions of modernity. Phalke's antiurban, anti-Westernizing tradition is modern because it is asserted as countermodernity. Reclaiming and Indianizing Ruskin's idealization of pre-industrial culture, Phalke offers an alternative model of modernization involving technological mediation in the reproduction of ancient pieties for the new circumstances of twentieth-century India. Here the miraculous is mythical, coextensive with but separate from the historical time of oppression and colonization. The function of cinema in Phalke, then, is to realize the conditions for a mythic subject, capable of entering the closed world of colonization from outside, and of intervening to create the radical historical leap of independence. What seeks assimilation into real time is the other time of the miraculous. If this time is in some sense past—precolonial India for Phalke, the "once upon a time" of fairytales for Méliès—it is also a reflection on modernist mastery over "other existing temporalities" (Sakai 1989: 106), in both cases not a hybridization but a dialectic of technology and tradition, technology and magic.

Despite Méliès's canonical place in the history of special effects, his debunking evaluation of the consumer carnivalesque has had less "influence" on later film than the obscured career of Phalke and his fragmentary legacy. This is not to argue for influence: quite the contrary. Phalke's films have rarely been seen in Europe and North America; he scarcely figures in non-Indian histories; and the films themselves exist only in fragments now. Yet in his work we can see the modernization of ancient traditions that was commodified in the orientalist cinema ten years earlier, that continued to form the basis of cinematic orientalism through the 1940s, and that provides the understructure of a certain strand of contemporary special effects cinema. Méliès and the contemporary blockbuster tradition alike learned from the Indian master the capacity of cinema to evoke a time other than historical time, a time of myth.

Phalke's cinema fell outside the nascent society of the spectacle largely because the India of the first quarter of this century was only incompletely colonized by the commodity. The conservative ethic of self-help in the Swadeshi movement was enabled more by the persistence of precolonial consumption evaluated by purity and pollution than by the efforts of British reformers or

the fetish form of the commodity (see Bayly 1986). In the absence of full-blown commodity fetishism, the autonomous object has no chance to dominate material culture. It was only when Swadeshi products like Phalke's films began to circulate in the West that it was possible to see them commodified (in this, similar to the European market for village homespun cloths), a process sped up by the overseas audience's ignorance of the source stories. Like the magic of the nineteenth century, the commodified and orientalized cinema of Phalke, divorced from the culture that gave it meaning, could become the very type of a cinema of pure effect, much in the way that African statuary could become the icon of pure form for Clive Bell (1931).

As outsider, Phalke spoke to the colonial metropolis as an Other who could be internalized as the object of consumption, appearing to negate the colonial imagination while confirming its right to consume him. The London *Bioscope* of June 4, 1914 "feels, therefore that Mr. Phâlke is directing his energies in the best and most profitable direction in specialising upon the presentation by film of Indian mythological dramas . . . in which, if they are to be fully understood and sympathised with by foreigners, vivid realism of atmosphere and setting are essential considerations" (reproduced in Barnouw and Krishnaswamy 1980: 21). Deliberately or unconsciously blind to the anticolonialism of the films, the *Bioscope* orientalizes them. As Albert La Valley suggests: "Science fiction films cannot do without some special effect shots: they constitute the world of the *other*, the non-human, all that is foreign or future, or technologically possible—hence all that the non-special effects part of the movie, the realistically photographed, the human, must do battle with, learn from, overpower or adapt to" (La Valley 1985: 185).

Phalke's confrontation of ancient tale with imperial history contests and entrances the realistically human world of the colonial metropolis. His accommodation of the mythical world to the diegetic objectification of village India permitted his London audience to further the process of objectification by commodifying the films as orientalist spectacle and so to miss the point completely.

In *Rajah Harischandra* (figs. 3.3, 3.4), for example, the daylight shoot allows a far greater depth of field than Méliès had been able to achieve in the studio. Its action is staged in depth, with character movement through the z-axis. The village locations not only supply a sense of an intertwining of the mythical and quotidian realms, permitting the English critics to patronize the film as a window into the Indian "soul," but give Phalke the space in

| Figure 3.3 |

Raja Harischandra: the male line as guarantor of fidelity to tradition. Courtesy BFI Collections.

which the figure and ground are in far more democratic relation than they are in films of his French contemporary. Méliès's limiting device of the bounded horizon creates a mythical space, where Phalke is able to anchor his tales in the lived space of the everyday. The secular myth of the commodity, then, seems to belong to an enclosed universe, whereas the divine myth is presented as inhabiting the world. On the other hand, Méliès's flights of ambition and imagination are always subject to sudden and bathetic returns of the repressed body, whereas in Phalke's religious world, the body itself is an illusion, so that any claim to realism must be tempered with the recognition of the priority of eternal things over material.

In Phalke's movies, devotion is inseparable from myth. Seen from the vantage of divine temporality and cosmic order, the past, present, and future are conjoint as they inhabit the here and now. Confronted with audiences used to paying two annas for six-hour theatrical performances and reluctant to part with more for a shorter film, Phalke advertised "*Raja Harishchandra:* A performance with 57,000 photographs. A picture two miles long! All for

| Figure 3.4 |

Raja Harischandra: location, space, and movement in depth. Courtesy BFI Collections.

only three annas" (Multichannel (India) Ltd. 1996: np). To consider his film as a collection of stills is not, as it was in Gaudreault's account of early copyright in films, a method of securing their commodity status. Rather, it describes the temporality of the film as a wholeness captured in every frame, a mythological temporality. In mythological time the dead walk among the living, the living walk among the spirits, and the future is already written. The love that Phalke's divinities evoke, as befits constructions of a folkloric nationalism, is the love of a father for his children. His wife Saraswatibai figures constantly in his biography, making extreme sacrifices to enable him to continue, but her contribution is always subordinated to the masculine creativity and the parthenogenesis of the male line. For Phalke, this is the fruit of the political-intellectual vanguard of turn-of-the-century anti-imperialism: the trace of a male autogenerative machine that, as technique divorced from its religious origins, would help to generate the Western myth of the self as autonomous signifier.

In some ways, for Western culture Phalke's cinema became the purest of commodities because, since its use-value was shaped by its marketing in the West rather than by its producers in the East, it could be presented as just such an autonomous signifier. Western projectors screened, robed in indefinite sensuality, an image of a diegetic world other than the society of the spectacle. But just as tradition, posed as countermodernity, depends on modernity, so the orientalist spectacle turns the absence of the commodity form into the spectacle of its absence, in the first and necessary instance by turning it into an object for the newly constituted cinema spectator. The mystique of the East would permeate the fantastic cinemas of Hollywood, Pinewood, Neu Babelsberg, and Billancourt for thirty years. Only in the aftermath of World War II, when so many had experienced the exotic places figured in the films, did the glamour begin to wear off. Moreover, the settlement in 1945 of the great commercial conflict for commercial control of the Pacific instigated the economic globalization orientalism had prefigured. Henceforth there was no terrestrial paradise, no earthly space, where the rule of the commodity no longer held. The function of Other passed to the potential endlessness of outer space: from the global to the universal.

The closer it comes to pure spectacle and pure exchange value divorced from use, the more the commodity presents itself as occupying a time outside history. The imaginary orient of nineteenth-century Europe provided a graphic model for this changeless and timeless time, just as outer space does for us in science fiction films. To become a commodity, the object has to acquire an essence: it has to *be*. The filmic object's being is imaginary, in the sense that it is an image. In this way it prefigures the full-blown society of spectacle, where essence is image, that Debord analyzed in the 1960s. Though its duration onscreen is limited, the cinematic object (talismanic objects like Méliès's train or Bogart's cigarette, but also the film itself) acquires an existence beyond its moment on screen, both as imaginary diegesis, and because it is endlessly repeatable. This imaginary timelessness depends on a process of othering. Orient and outer space suggest a merely spatial separation of subject and object. But in cinema, the process is clearly temporal. The production of the cinematic object as the other of its viewing subject takes time. Likewise the production of a subject of perception occupies, and lasts for, a certain duration. This time is the time of the cut.

The separation of object from subject provided Phalke with an entry into the cosmological time of a patterned universe. As Rajadhyaksha and

Willemen (1999: 243) note of the 1917 *Raja Harischadra*, "continuity is defined by the juxtaposition of spatial planes (e.g. the space of the family idyll and the space beyond)." Like Méliès, Phalke constructs a cinema of tableaux. But the tableaux are not the sequential scenes of a comic strip, but depictions of copresent realms, one historical, one mystical, that intersect and interpenetrate as layers in the shot and at the edit between scenes. Phalke's cut facilitates subjectivity in the movement between the two worlds, intimating the continuing cosmic pattern underlying and structuring the conduct of both the *histoire événementielle* (Braudel 1972: 20–21), the sensuous fullness of everyday life and the broader historical struggle for independence. His subjective time is thus one of the immanent future, already present because it is eternal. This is how the time of the cut becomes the time of identity.

Orientation

There is a history of the processes of perception. The nineteenth century moved from the physics of light to the physiology of vision (Crary 1990). The twentieth shifted from the physiological thesis of retinal retention to the cognitive thesis of the Phi effect, from the eye smoothing over the gaps to the brain interjecting the "missing" elements of intermittent images (Gardner 1987: 111–112; the term was coined by Wertheimer in 1912). Looking back from the twenty-first century, film's visual coherence depends on suturing light, eye, and brain, optics, physiology, and psyche—the ensemble film theory calls the cinematic apparatus. In the pixel, film, retina, and mind are not distinguished. The cut distinguishes them, then reassembles them into an apparatus for organizing space and time. The atomic jostling of silver nitrate grains produces a directionless flux of pure movement, independent of beginning or ending like waves on the sea. Its oceanic primal temporality becomes navigable only once the cut instigates endings: a delimited field of vision, composited spatial relations, and the spatiotemporal assemblage of shots into sequences (Burch 1973: 3–16). No longer adrift on the sea of duration, the spectator can now steer past charted landmarks. The aimless event and its associated reverie is spatialized, thus preparing directionless duration for directional temporalities like hiding and revealing, moving on, causality.

The pixel inhabits the balmy limitlessness of the newborn child, bathed in its world, unable to distinguish between itself and its environment. By presenting the world as object over against the spectator as subject, the cut

repeats the moment in which the infant first distinguishes itself from the world (Lacan 1970). The step beyond the infantile pleasure of bathing in light is experienced, Lacan emphasizes, as a split not only between subject and object but within the emergent subjectivity of the child. Without this separation, there can be no empathy (as when we see someone stub his toe and wince on his behalf), but this first identification is narcissistic, in the sense that we identify ourself with objects in the world because we have only just separated the two from one another. Where Lacan emphasizes the loss of integral wholeness in this splitting, however, the theory of the cut emphasizes the unification of dispersed, atomic sensation. Cinema structures not by loss but by gains.

To adapt Lacan, the step from the pixel to the cut is the step from being to having the camera. The presubjective subject of the pixel is at one with the apparatus, sensing the world mechanically as a meaningless flux of light. The cut splits apart the elements of the apparatus so that one—the self—can take possession of another—the camera-projector—as object. The first articulation of shots, frames, and composites turns the moving image into an instrument by which the world can be possessed.[5] The organizational power of the cut controls flux by reconstituting it as space-time, as figures on a ground, as objects in a world. Orientation takes the place of immersion as the source of pleasure for the spectator. Here again, the cut enables a certain narcissism. As in Lacan, the unity it proposes to the subject in the process of construction is the unity of individuation. Immersive reverie is always already social. The self-same flux of pixels is the same for every viewer, democratic and undifferentiated. The moment at which we perceive objects in space is the moment at which we can conceive self-sameness as a property of the self, subjectivity as a unique space-time effect.

As structuring device, the cut produces unities or, more accurately, multiplies units in hierarchies that always strive for higher levels of unification, the sense of an ending crucial among them. The aesthetic of organic unity, for example, leads to the scriptwriter's adage that everything included in the script should "pay off": the gun we see in the drawer must at some later point in the film be fired. In effect the shooting later on determines the hidden gun in the earlier shot—the effect shapes the cause. The ending of the well-made film structures everything that went before. In this sense the cut, as the archetypal tool of continuity and of normative cinema generally, has tended toward a teleological cinema, a cinema of predestination. This has led many

commentators to believe that cinema is essentially a narrative form. The presumption is that causality is a process of the world, not of its interpretation. In the pure examples of the cut that Méliès and Phalke left for us, causality is not an empirical given. Both offer more varied and more complex times than narrative causality.

In Phalke's case, the ending exists beyond the film. Under conditions of colonial rule, Phalke's revolutionary ending has to be encrypted. The political goal of the narratives is expressed as the messianic moment in which the Mahabharata will be realized in the return of the gods and their ahistorical time. It cannot be explicitly spoken, and it cannot be represented because it is both future and eternal. Méliès meanwhile deploys spectacle as the premature ghost of the old middle class. His films are monuments to an age whose historical disappearance belies the way its truth, its beauty, and its values survive beyond the moment of its annihilation. The sense of nostalgia for a value system that has outlived the class that produced it is the source of the archaisms and the supernatural settings, the postnatural, postmortem afterlife that so fascinates Méliès, for whom the symmetry of narrative always skates over the abyss. The highest unity of the cut in both Phalke and Méliès is outside the film itself, in the ghostly past or the mythic future.

The pinnacle of the cut's hierarchy for Méliès is the moment of annihilation, death, and the afterlife that haunt the prehistory of European cinema. For Phalke it is the moment of origin. The unphotographable essence of gods is their eternity. The juxtaposition of divinity with the causality of narrative time also mimics that divine intervention in human history evidenced by miracles. This miraculous time is overlaid onto the time of identity in the depicted world, and the time of the audience for whom the presentation of the divine epic constitutes an axial transgression of the lived time of the cinema visit. Another temporality intervenes: the heroic transhistorical time of the epic, the time of the archetype, the time of recurrence and pattern. Such a time is not specific to Hindi cinema: it inhabits a certain strand of European thought from Propp and Jung to the structuralists. The linearity of time common to modern European thought, however, although it provides the cut with the logic of causality, is undercut by the fact that "every story is homeostatic since it simply retraces the disruption left by disorder and returns everything to its proper place" (Aumont et al. 1992: 104). This problem in structural temporality appears rather differently in Hindi

mythic time, where recurrence takes the place of death, functioning as a treadmill of destiny.

To tell stories inside this cycle is either to break the cycle or to confirm it. The function of Phalke's films is to affirm the cycle by reiterating its founding moments in the legend of the Mahabharata. Thus his films replicate and repeat, and, at the same time, instigate a crux in representation by offering to show the first foundation of a historical cycle that, because it is infinite, can have no foundation or beginning. In this way Phalke engages us with one extreme of the dialectic of effects: the imagination of a moment of creation when the motive force of narration, the mythic point of origin, is identified. But there can be no narration without history, just as there can be no society without language or language without society. We are, then, predestined to a cycle of recurrence, lacking exactly that impossible moment of origin which it is Phalke's privilege, at the founding moment of Indian cinema, to figure in his films. In this context, it is important too to note the playing of Phalke's wife in the role of Rama's mother, not the traditional male: an admission of the sexual in the primal moment, an admission of Otherness at the moment of origin. Playing on the indefinition of origin, Phalke is the purest of cutters, first because the cut is an ending that denies its origin, and second because the cut at its purest creates a dialectic between flux and cut in the mythic, deferred, and unrepresentable moment of emancipation. It is a dialectical structure of which Hegel might have been proud.

GRAPHICAL FILM: THE VECTOR

Taking a Line for a Walk

In all these examples the principle and active line develops freely. It
goes out for a walk, so to speak, aimlessly for the sake of the walk.

—*Paul Klee*[1]

Undecidability

The poetry of sheer movement in the *Sortie*, still potent after all these years,
could not maintain itself. Cinema had to move from the sensation of the
event to the perception of objects, from nonidentical immersion to the pro-
liferating unities of navigable space-time. The cut brought the principle of
representation: of delineating commotion as discrete objects in space-time.
To that extent, and to the extent that it implies a subjection of the perceiver,
the cut is always lacking, always inadequate to the plenum it depicts. Its
unity not only implies multiplicity; it exists in a dialectical relation to the
flux of pixels without which it has nothing to organize, but which to it is al-
ways only nothing. Out of that dialectical construction of object and subject
a third principle arises: communication. Immersion in the pixel's commo-
tion corresponds to Peirce's firstness, the Lacanian Real; the cut to Peirce's
secondness, the Lacanian Imaginary. The early history of animation gives
us a privileged glance at the transition to Peirce's thirdness, the Lacanian
Symbolic, to concept and meaning, socialization, the paradigmatic axis of
film. In deference to its digital destiny, I will refer to it as the *vector*.

A vector is any quantity that has magnitude and direction. Computer
imaging uses vectors to define shapes by describing their geometry rather
than allocating an address and color value to every pixel. For example, in-

stead of specifying every point on the surface of a sphere, it is far more eco-
nomical to instruct the computer to draw a circle and rotate it about its di-
ameter. In graphical terms, then, a vector is a line moving through time and
space. In the zero of raw movement that first amazed the patrons of the cin-
ematograph there is at base only the invisible motivation of the black frame-
line. In a strict sense, the unities produced by framing, compositing, and
editing make the cinema visible, lifting it from the undifferentiated imma-
nence of the nonidentical to the "being" of the object. The vector takes us
one step further: from being to becoming, from the inertial division of sub-
ject, object, and world to the mobile relationships between them.

In *La Sortie*, the motion inherent in the instability of the frameline acts
as a given, as something that, since it sums all movement as equilibrium, is
perpetually now. Cutting literally puts an end to the eternal now of the non-
identical. Constructing objects by defining their spatial and temporal limits,
it endows objecthood in the same way it orders time into linear progression:
retrospectively. Terminal (but not final) the cut defines the term and the
terms of objection, transforming raw perception into an object for con-
sciousness, establishing the object as a perception of which an "I" is con-
scious. Even though both object and subject come into existence in the same
instant, the perceiving I perceives the cinematic object as something that
preexists its consciousness of it (since, from the subject's point of view, the
object has always been there) and that is therefore always already over.
Where the cut instigates endings, the vector enacts beginnings. It gives the
moving image a future, the possibility of becoming otherwise than it is. The
pixel grounds us in the film as a present experience, the cut in the preexis-
tence of the filmstrip to consciousness of it, the vector in the film as the

becoming of something as yet unseen. It is the principle of transformation, the quality of changing what we expect from moment to moment.

Causality, logic, law, interpretation, and dialogue belong to this emergence, though they are only historically specific modes of the vector, which is the openness of thinking to the as-yet unthought, the connection as yet unmade. In the purest form we have available, the early animations of Emile Cohl, the principle of cinematic thinking is transformation governed only by analogy. Debating Umberto Eco's fictional (1989) and theoretical (1990, 1992) counsels against analogy, Barbara Maria Stafford argues that analogy not only has the potential to provide sudden and vivid insight, as in the works of artists like Joseph Cornell; it is also a principle other than causation or identity that allows us to make connections within and between media (Stafford 1999: 8). Analogy is moreover intrinsic to the paradigmatic axis of substitutions, where ostensibly unrelated words (love, dinner, pots, hay) reveal unforeseen relations when added to the end of the phrase "Let's make. . . ." The analogy between a question mark, a cat's tail and a fishing rod may not be apparent—until you have seen old Felix the Cat movies, where they are liable to turn into each other on the sole basis of visual similarity. John Canemaker catches this quality of the early 1920s Felix: "Dissembling and reassembling his form, Felix is a Cubist cat, a symbol of post-war modernism . . . Felix (especially before Bill Nolan redesigned him) is full of angles that fragment and juxtapose in exciting new ways" (Canemaker 1991: 75). As in Braque and Picasso's analytic paintings of the 1900s, the graphical code works on the basis of likenesses that shift constantly with our perspective on them, so we see a mark as at one moment a tail, at another a question mark, and simultaneously as nothing less magical than a line in motion. The vector thus redefines movement as a function of relations and interactions. Reversing the polarity of the cut, the vector temporalizes space.

The philosopher de Selby of Flann O'Brien's comic novel *The Third Policeman* examines "some old cinematographic films which probably belonged to his nephew," and that, a footnote informs us, he described "as having 'a strong repetitive element' and as being 'tedious.' Apparently he had examined them patiently picture by picture and imagined that they would be screened in the same way, failing at that time to grasp the principle of the cinematograph" (O'Brien 1967: 50).

De Selby's film theory builds on the ancient paradox of Zeno, according to which Achilles, racing against a tortoise, can never catch it because, having given it a start, he must first run half the distance between him and his competitor, by which time the tortoise has moved on. So Achilles runs half the new distance, while the tortoise advances another fraction of the distance, and so on *ad infinitum*. The *ad infinitum* is the critical point. Seeking to prove that the universe is stable, Zeno hit on the concept of the infinitesimal, the ever diminishing approach toward zero that, however, never reaches it: the concept of the infinitely small. Just as you can add a digit to any cardinal number to make it bigger, so you can add digits to a decimal to make it smaller. In Zeno's example, the gap between Achilles and the tortoise reduces from 1 to 0.5, to 0.25, to 0.125, to 0.0625, and carries on reducing, always adding more decimal places, toward a zero that it never reaches. When plotted on a graph, this gives an asymptote, a curve that plunges toward zero but gradually flattens out, never quite arriving at origin.

This asymptotic curve is not composed of points and the distance between them. The real numbers, the infinitesimals that form the "real" line, are more geometrical than arithmetic. They cannot be counted and are often better described as goals toward which the line tends than as numbers. For the mathematics that dominated the first quarter of the twentieth century, undecidability and infinity are inextricably intertwined.[2] According to Alan Turing, founding figure of computing, some arithmetical procedures go on for ever. Turing addressed the "halting problem" through the analogy of an imaginary computer, itself extraordinarily like a machine for drawing animations, being composed of an endless strip of paper tape and a read-write head that would make marks or erase them according to mathematical rules. In the case of an uncomputable sum like the square root of two, the machine will never stop. The finally undecidable numerical value of a point on the real line is the infinite transformational power of the graphic line in cinema. The infinitesimal adds to cinema the unfinished, unending, undecidable metamorphoses of expectation so poetically manifested in one of the earliest of animated films, Emile Cohl's 1908 *Fantasmagorie*.

Spectator, Author, Animator

James Stuart Blackton, one of Cohl's few predecessors, performed *The Enchanted Drawing* for Edison (copyrighted in November 1900) and *Humourous Phases of Funny Faces* for his own Vitagraph company in 1906, both based

on variety stage lightning-sketch acts. Both films featured the artist prominently as he would have appeared on stage, with the addition of stop-motion effects giving the impression that certain of the drawings drew and animated themselves. In one of the rare accounts of the popular variety acts on which these films were based, Matthew Solomon argues that the protean metamorphoses of quick-change and lightning-sketch artists "quickly came to represent the path not taken by the new medium" of cinema (Solomon 2000: 17). By drawing attention to Cohl's work and to the vector code, I want to offer a counterargument: that the tradition of transformation did indeed enter cinema, and as a fundamental resource, although the prominence given to photographic realism led to a marginalization of its most characteristic form, the cartoon (see Cholodenko 1991; Klein 1993; Smoodin 1993, 1994).

Another commentator, Donald Crafton, writes of Blackton's early experiments that

the spectator was never allowed to forget that he was observing a theatrical performance. The filmmaker (often represented by his hand) was the center of attention. Yet there were no straight recordings of a performance; each was slightly altered by camera tricks to create a magical illusion. . . . For an artist to be able to bring something to life bestows upon him the status of a privileged being. . . . In the cinema, as Bergson said, movement is life, and the ability to synthesise screen movement was quickly grasped as a magic wand by Blackton and the others. (Crafton 1993, 86–87)

Crafton rightly emphasizes the performative aspect of these early cartoons, but he oversimplifies slightly the philosophical complexity of the cartooning process.

These earliest stop-motion animations address us through the syntax of the cut. The presence of the artist in the first and the drawing hand in the second of Blackton's films cuts by layering the foreground photographic image over the background animation, while the frame edge composes the plane of the drawing, in *The Enchanted Drawing* as a chalkboard and in *Humourous Phases* (fig. 4.1) as identical with the image plane of the screen. Whereas the first film comprises a single gag, the second employs stop-motion not only to give the illusion of self-animating picture, but as a form of editing that allows a compilation of several scenes over its three-minute

| Figure 4.1 |

Humourous Phases of Funny Faces: the transition from lightning sketch to animated drawing.
Courtesy BFI Collections.

length. In the transition from *The Enchanted Drawing* to *Humourous Phases,* then, the cut extends its powers to order, control, and provide linearity. But even in the reversal of the process of drawing, when a smudged image becomes clear and begins to undraw itself, *Humourous Phases* never finally breaks with the sheer symmetry of zero's great balancing of the books, emphasized by the conclusion of each scene in the erasure of the image. Charming as they are, these two films of Blackton's only begin the process of exploration that will be brought to fruition a couple of years later by Cohl.

To some extent, through its increased dependence on the cut, *Humourous Phases* pulls back from the full potential of the animated cartoon by signaling its subordination to the syntagmatic structures of both the variety act and of narration. In Cohl's film, however, we witness a series of transformations apparently without cutting. *Fantasmagorie* is a brief line animation

in which a mischievous puppet, Pierrot or *fantoche*, and his environment change seamlessly (see figs. 4.2 , 4.3). Flowers become bottles become a cannon; an elephant becomes a house; Pierrot becomes a bubble, a hat, a valise. The vector of Cohl's line, as it draws and redraws itself, disrespects the frame edge and equally ignores the syntax of layering, most notably in the small "screen" that appears at the left of the image as the action with the woman in the hat takes place. Not only does this appear to reprise the scenes that we have just watched, but it also lies on an axis of depth from which the other characters are debarred. For example, when the little Pierrot gets bigger, it is not because he is closer to the virtual eye of the rostrum camera, but because he has been inflated. Likewise, the sword-wielding giant shares the same plane as the Pierrot. However, it is not simply that the rules of the cut are being broken: rather, *Fantasmagorie* obeys another set of rules in the same way that the real line is bound by laws other than those of Euclidean geometry.

Cohl's line is the same one that, a mere thirteen years later, Klee would describe as going for an aimless walk (Klee 1961: 105). It is the activity of the line that counts, rather than the end points, which are in effect determined after the fact rather than before it, the result of drawing, not its givens. Klee, of course, was able to exhibit only finished drawings: Cohl could show in the cinema the active vector of the line that draws itself. Much more than an idiosyncratic technique, his constantly permutating line is a literal transcription of the linear motion of the filmstrip taken as a line that is always open to alteration, a motion without destination, open to every distraction. In the cut, the structure of linear motion is complete: in the vector, it is undecidable. As the grid provides the unstable basis of motion between images, the vector provides the transformative principle in the frame itself, so every moment of every frame is the result of a unique transformation that might have come out differently.

Linguists use the term "paradigmatic" for the rules for substituting one word for another. The rules of syntax govern the structure of meaningful sentences. The structure of "My life is an open book" is the same as that of "His cat is a wicked creature" or "Your teeth are ivory castles." What differentiates them is the substitution of "his" and "your" for "my," and "cat" and "teeth" for "life." Linguists speak of grammar as the syntagmatic axis and imagine it as a horizontal line, rather like this line of print. The paradigmatic axis is correspondingly the vertical axis, like the reels on a slot machine, allowing us to select which word to put into the slots created by the syntax.

Paradigmatic rules govern matters such as the substitution of nouns by nouns (in the first sentence, we could substitute for "life" words like "face," "husband," "novel," "bank account"). In Cohl's film we witness the cinematic equivalent. At any point, the line permits its transformation into anything that can be depicted as a line. The rulebook Cohl adopts, and to which he submits his creative process, stipulates that the line is always the same thickness and that it describes objects and planes only in outline. Given those rules, the metamorphoses are potentially infinite, limited only by external constraints such as the length of the film roll and the economic necessity of finishing in order to show it and earn some money. To gain this freedom, Cohl sacrifices the grammatical structures that had proved so profitable, artistically and financially, in the cinema by 1908: editing, narrative, staging in depth. This is why *Fantasmagorie* is so wonderful to study: it is a film within a hair's breadth of being governed by the paradigmatic code of the vector alone.

In a brief account of the film, Paul Wells emphasizes the element of chance in the vector code:

Cohl employed a technique in line drawing where the lines would fall randomly into the frame and converge into a character or event. Cohl's *incoherent cinema* was essentially the free flow of seemingly unrelated images in the stream-of-consciousness style of the Modernist writers. Further inspection reveals an implied, and more significant, level of relatedness in the imagery, prefiguring later animated films which trust the elements intrinsic to animation, chiefly, the primacy of the image, and its ability to *metamorphose* into a completely different image. Such metamorphoses operate as the mechanism which foregrounds this new relatedness by literally revealing construction and deconstruction, stasis and evolution, mutability and convergence. Such imagery did not operate as a set of visual tricks or jokes, nor did it constitute a conventional literary narrative, but was a kinetic construction wholly determined by the choices made by the animator, relating images purely on his own personal terms, sometimes by obvious association, sometimes by something entirely within the domain of his own psychological and emotional involvement with the visual system. (Wells 1998: 15)[3]

Wells reads his history backward, crediting Cohl with an inchoate understanding of the anthropomorphisms of Felix the Cat and Gertie the Dinosaur, as though Cohl's permutations of the line are best understood as

| Figure 4.2 |

Fantasmagorie: Four years before Griffith's *Those Awful Hats,* Cohl satirizes women's headgear.
The line momentarily describes 3-D space, only to redefine it as a pure surface in the next metamorphosis.
Reproduced from Crafton (1990) with permission.

foreshadowing the mature cartooning of animations like *Felix the Cat in the Oily Bird,* in which a burglarious chicken jimmies open a window with an exclamation mark, and Felix lassoes the culprit with the outline of a pond. Quite rightly, however, Wells also emphasizes that Cohl's roving, weaving lines never stabilize into the kind of solidity enjoyed by Gertie, Felix, Mickey, and the others. And although the reference to deconstruction suggests a Derridean *différance* associating *Fantasmagorie* with the zero of instigation and equilibrium, like Crafton, Wells's reference to stream of consciousness situates Cohl in relation not to Derrida but to Bergson, if not to William James, in order to anchor the endlessness of metamorphosis in an authorial psychology.

Three major arguments are raised against cinematic authorship: that filmmaking is social production; that any artisan is as much the tool of her craft as vice versa (Barthes 1977a); and that the construction of authorship is a mode of cataloging with no more and possibly less relevance to a text than its date, publisher, geographical origin, or any one of a hundred other determinants (Foucault 1979). However, if it is the case that a film is a product of social forces, then film scholarship cannot ignore the critical importance of individuation as a result of social process, however unwanted or illusory. The issue has been raised by many feminist and antiracist scholars, appalled that the academy should abandon the concept of authorship at the very moment at which women, African Americans, British Asians, and other ethnic groups have achieved significant recognition as cultural authors. Their argument is significant here because, as Adorno argues, art is compelled "to undergo subjective mediation in its objective constitution" (Adorno 1997: 41).

In fact, for Adorno, this is an integral element of modern art, which takes up the task of negating the atomism of a divided and individuated society: "If the artist's work is to reach beyond his own contingency, then he must in return pay the price that, in contrast to the discursively thinking person, he cannot transcend himself and the objectively established boundaries" (ibid.: 42). Unlike philosophy, art cannot transgress the borders of reality, nor can the artist pretend to have negated his own subjectivity. Instead, the passage through the individual author actually strengthens the claims of art to communicate the social, something it could not do if it were free of the individuation that so deeply marks contemporary society. Crafton's brilliant biography of Cohl is important not because it reveals the deep psychology of the "stream of consciousness" that Wells believes in, but because it situates that creative mind in a historical society whose traces are deeply marked on Cohl's career and creations. Adorno casts further light on the temporalities of animation when he concludes that "every idiosyncrasy lives from collective forces of which it is unconscious" (ibid.). The intimate personality of a mark, the idiom that allows us to recognize a Klee or a Picasso line, is an articulation not of an irreducible and total personality but quite the opposite: it sums all those social and historical forces that congregate in the idiosyncratic act of making, even in the decision to make, in the artists' understanding of why and how they make, in the very movement of the hand.

The film's innocence of narrative coherence is a function of its innocence of key frames. Later, more industrialized animation studios would direct their leading animators to provide frames that defined the beginning and end of a motion. Junior staff would then be hired for "in-betweening," drawing only the frames required to provide a smooth transition between key frames. In Cohl's case, there are no key frames: no line's action is ever complete, but metamorphoses into the next without the stability and unification afforded by key framing. At the same time, these are not just doodles but drawings in the process of becoming pictures *of* something. The distracted, dreamy reverie of the pixel immerses us in the Real, the referent in Saussure's semiotics. The syntax of the cut transforms these sensations into signifieds, representations, the chain of cinematic objects. The vector is the dimension of the signifier: "Pierrot" becomes the wending line. The signifier is the material of signification, and its task is not to represent but to be exchanged. Because Cohl's line is a line, a material signifier, it can exchange signifier for signifier, on the principle of analogy. It is the token of exchange between object and object in metamorphosis, and so adumbrates the exchange of subjectivities that is communication. Cohl's line is not his consciousness materialized, but the medium of social exchange. It does not represent: it communicates.

At every moment, Cohl's paradigmatic signifiers may become other than they are in the present. The meaning of this shape depends on the substitutions and transformations to which, as material signifier, it is open. The vector of *Fantasmagorie* is never complete. So it has to change interminably—and so does its interpreter. It is as if the vector's subjectivity is constantly launching itself outward, like a child playing, or even more like a playground full of children racing from game to game, persona to persona, utterly invested in what happens next. The cut anchors motion in destiny, in the necessity of an ending. In the vector, there is nothing behind—everything is in front. Mathematically, the pixel is perfectly symmetrical: the same in any direction. The cut breaks that symmetry by establishing the principle of being: what has become. The cut is teleological, determined by its ending. The vector breaks it on a different axis, treating what is as the beginning of becoming. The vector is eschatological: its future is open, governed only by hope.

Fantasmagorie is not, then, a simple stream of consciousness. Instead, that stream is the raw material for a job of work, subjecting the preconscious

firstness of undifferentiated sensation to the machinery of production. If we try to imagine Cohl's stream of consciousness, we have to imagine him contemplating how the public and, differently, the producer will respond; how to get around the constraints of his technology; submitting to fatigue and the economic imperative to stop. In all these moments, our imaginary Cohl inhabits a nexus of exchange, with living customers, with networks of trade, with the dead labor embodied in chalk, chalkboard, camera, and rostrum. Mere firstness would produce nothing but a chaotic scribble. Mad scrawling would merely flag a pretended liberation from individuation, but one in reality still governed by the rational image of individuation: a resistance that depends on the dominant that it resists.

Cohl's animation, however, neither succumbs to the administrative principle of the cut (secondness would imply simple depiction, in the mode of Winsor McKay), nor pretends to a schizophrenic loss of subjectivity. Instead it reaches out from the unhappy mismatch between the universality of preconscious difference and the particularity of ordered unity, toward a freedom they cannot achieve separately or together, but toward which their struggle necessarily points. This is not the freedom of the "free" market or "free" choice, terms that scarcely mask the monopolistic character of contemporary capitalism. Rather, it is a capacity to exist otherwise than under those conditions. Only by accepting the subjective role of individuality in authorship can we understand how it can be overcome: not by regression to infantile states, nor by the simple negativity of irrationalism, but by constructing semantic behaviors that at once expose the social failure to reconcile chaos and order, preconscious and reason, and at the same time produce techniques for another way of making that is subservient to neither and that, although it can neither reconcile nor negate them, poses the possibility of meaning.

It is easier to make this case for Cohl than for most subsequent filmmakers. As an artisan, he had far greater control over the processes of filmmaking than any studio-based producer. But there is a third level to the subjectivities involved in the making of *Fantasmagorie* that makes it an especially fruitful study. It is possible Cohl had seen the Blackton films. Certainly he was fascinated by cinema, and as an active participant in the Bohemian life of Paris for thirty years prior to his first films he would have been technologically and scientifically literate. Nonetheless, his practice in making *Fantasmagorie* must have been almost purely experimental. What

speeds to move things at, how long to hold a frame or a pose, at what pace to render a transformation: all of these he must have been experimenting with as he went along. He would not have been able to view any of his work until all the drawings had been made and photographed. Is this a human psychology at work, or the liberation of an entirely modern sensibility through the subordination of will, of authorial psychology, to the agency of technology?

The Lumières' negotiations over the supply of film stock documented in their correspondence makes it clear that they could have gone for square or circular frames, or the portrait format of many of their autochromes. Certain technical constraints made it simpler to go for the landscape format still ubiquitous today. Like the mechanism of the sewing machines incorporated into the cinematograph's claw mechanism for film transport, the rectangular frame fixes, as fixed capital, the dead labor of generations of handicraft. But like the anonymity of the printing press and the adding machine, that fixing bears also a gift of autonomy. In the new machine, dead labor is restored to new life. The invention of offscreen space is not a product of human ingenuity but of a new mode of life: the human-machine hybrid built on the anonymous autonomy of the machine and the autonomous anonymity of the industrial worker under commodity capital. The conditions of modernity prized invention and inventiveness above all, because they helped the acceleration of consumerism on which the new wealth was predicated. The ensemble of economics, technology, and the anarchic modes of Lyons syndicalism in the Lumières, old bourgeois carnival in Méliès, and Parisian bohemianism in Cohl combine to form the apparatus of cinema. That apparatus, with its doorway through which consciousness can enter and reside mesmerized, as producer as well as audience, crystallizes the contradictions of attentiveness and distraction into a single productive machinery of delight.

In Cohl, the result, as so often in computer media, is an expression of wonder at the new relation with machines. The latest gift of the technologization of the media circa 1908 was freedom from psychology. The attention devoted to physiological and unconscious reflexes, to hypnosis and the psychoanalytic unconscious, especially in its more mechanical "economic" model, help pinpoint this as a moment at which excitement and invention arose neither from consciousness nor from fantasy but from an autonomy granted to the interface between craftsman and tool. By 1908, this tool was

already a complex and quasi-autonomous machine—Fox-Talbot's "pencil of nature"—capable of partnership in the creative act.

Fantasmagorie is the product of a kind of willful ignorance achieved through the submission of the willed act of drawing to the unmanaged operation of machinery. At the same time, because it is no longer the object of control, the machinery itself sheds the role of relation of production, which it occupied in the industrial factory. In Marxist terms no longer a relation but a force of production, the camera enables Cohl to rid himself of both the irrationalism of preconscious difference and the instrumental rationality of socialized technologies of production. The autonomy and anonymity of Cohl's line should not be confused with randomness: they are achieved only through the thoughtful and decisive acceptance of determinations external to the work itself, since that is the only way those determinations could be superseded and a new, distinctively modern mode of cinema be produced. The secret consciousness of the vector is this human-mechanical hybrid. Hence we can no longer speak of the author as originator of the cartoon: instead we are confronted with the animator, no longer a subject of the social world, but an exile seeking asylum in the machine world from all demands external to the work itself. We might think of the animator as the subjectivity of the text. For both audience and author, consciousness is an external factor that is nonetheless intrinsic to the making and experiencing of the film. From the point of view of the film itself, however, history enters the film through cyborg authorship and socialized interpretation, qualities that are as much raw materials as light and time. For the author, the time of making is a time in which the future becomes past; for the spectator, one in which the past becomes future; but for the animator, the present is the bifurcation of all vectors, the moment of autonomy.

It is, however, only a moment. Where the ancients disputed the necessity of ontegeny with theories of autocthony and parthenogenesis, since the birth of cinema we moderns maneuver at the unclear frontier between human and machine. But like the metamorphoses celebrated by Ovid two thousand years ago, where the human-animal border is crossed in joy and in pain, the beauty of the animator's autonomous present must be ephemeral: its pleasures must be fleeting so that we can know that cruelty too will pass. In this sense, ugliness, as the grotesque and as depicted violence, is the last bastion of representation, the remote picturing of the savage necessities of contemporary life. In the digital era, these are characteristically enacted in

the paranoid-depressive movie of the data-image, in films like *The Net* and *Enemy of the State*, and the manic-psychotic movie of technology out of control, of which *Terminator 2* and *The Matrix* are only the best known. Their concern, which can be traced back to *Fantasmagorie*, is with a fleeting present in which distinct definitions of human and machine are not possible, a moment of semantic and categorial play intrinsic to the mimetic precisely at that point where it is no longer representational, a point at which the criterion of resemblance is most at risk.

In Cohl, we can trace the genealogy of this indistinct human-machine relation. The vector in *Fantasmagorie*, the unstable, ephemeral line, moves into and away from resemblance in a constant play of instability. We ask repeatedly what the line is becoming, but have only the briefest moment for the pleasure of recognition before it changes again. What we witness here is the moment at which naming occurs, but a naming that is already subject to the paradigmatic substitutions that underlie all interpretations. The meaning it produces—the kind of meaning that allows us to recognize the line as a horse or a spider—is itself ephemeral. In this way, though the film itself is limited to its fifty-second duration, Cohl's line demonstrates that the possible substitutions are infinite in number. Becoming signified, the line is unfixed. It is a lens through which pass the infinities of interpretation.

Dynamics of the Vector

For Adorno, the world was already negative, degraded by its very modernity. Art's task was to negate that negativity. For us, however, at the dawn of the twenty-first century, the world's negativity has already been negated by the engulfing denegation of the commodity form in the society of the spectacle. For all their pessimism, Jean Baudrillard's analyses of contemporary (Western) society as a simulation machine make a powerful case for the loss of the world. Baudrillard believes that reality was constituted in the differences between real things; but under the conditions of serial production, there are no longer any differences between things (Baudrillard 1993a: 55). Worse still, the same is true of communication: "Communication, by banalizing the interface, plunges the social into an undifferentiated state" (Baudrillard 1993b: 12). The proliferation of identical mass media messages, the mass production of public opinion, the unchanging frame of the browser window or the VDU, the obligation to participate even when we have nothing to say, all conspire to produce a hyperreal social process in which all communica-

tions are undifferentiated and to that extent unreal. In the digital era, according to simulation theory, the world has been transformed into data, and the data has negated the world. But if the world has already been negated, art that seeks to negate it again is only doing the work of simulation. Therefore art can no longer afford to be negative: in our time, art's work must be positive.

The vector is critical to this reorientation of cultural work as a positive production of meaning and, since all meaning depends on shared communication, of society in a time when, as Baudrillard argues, the social itself has been derealized. In this light, we should not read the absence of keyframes in *Fantasmagorie* as a negation of editing. Rather, it is the positive depiction of the act of drawing at the moment when the work of representing hangs in the balance between resemblance and the pure mark. Without keyframes to anchor it in a unified shape, the mark achieves a determined autonomy in which its resemblance to objects in the external world is constantly in question and so both open to the uncertainties of interpretation and anchored in the social from which its idiosyncrasy arose and where all interpretation takes place. The idiosyncrasy of the line as a trace of its maker and the idiosyncrasy of infinitesimally graduated differences in interpretation are the social grounds on which cinema moves from the presentation of objects to the stimulation of concepts. The vector does not tell us what to expect: it requires us to think. In this way the vector brings us into the realm of the intellect and offers us the delight we take in the pursuit of meaning. The vector is the art of curiosity.

Cohl's mobile mark, the animated line as a visible and visual practice, is a device of metamorphosis, in which the emphasis should lie on the prefix "meta". As metamorphosis (and as opposed to the computerized technique of morphing), the line is not the "in-between" of two fixed states or two anchored points but the action of becoming that may or may not result in a fixed state such as a keyframe. The grid depends on the copresence of undifferentiated viewer and viewed; the cut organizes the indifference of flux into being by separating viewer from viewed in the subject-object relation; the vector depends on the recognition of the autonomy of both viewer and viewed. It extends and deepens the separation of the grid by instigating a recognition of the object as other rather than as dependent on the viewing subject. Keyframes anchor the changing line at moments of cutting, for example, in the identifiable faces between morphs in the Michael Jackson

| Figure 4.3 |

Fantasmagorie: endless permutations of the line in perpetual transformation.
Reproduced from Crafton (1990) with permission.

o'

p'

q'

r'

s'

t'

u'

v'

video *Black or White*. By contrast, the struggle to recognize and name the metamorphosing line in Cohl, always incomplete, never settles in identity but constantly remakes the relation between subject and object as that between self and other. In this way it cannot, as the Jackson video does, suborn the technology of morphing to commit to a color-blind ideology of liberal multiculturalism (Sobchack 2000; on multiculturalism, see Zizek 1997; Araeen 2000). Instead it confronts the uneasiness of the viewed with its status as object of the view, forced by its endless mutation to recognize its autonomous existence, an autonomy that at once confronts the viewer with the limitations to control and with her own instability.

The autonomy of the line in *Fantasmagorie* is, as we have already seen, a product of the relation between Cohl and his apparatus. On a certain understanding of the technological relation, for example, that voiced by McLuhan (1964) when he describes tools as extensions of the hand, the relation between human and machine is purely one of control. The machine is an instrument of humans, and that instrumental relationship defines the user and the used as subject and object. What Cohl's practice reveals is that another relation is possible, one in which the privilege of subjectivity is abandoned in favor of granting an autonomy to the machine equivalent to that assumed by the user. The new relation between human and machine is then no longer instrumental but ethical, in the sense advanced by Emmanuel Levinas, since it demands a mutual recognition of each other's right to be, beyond the relationship itself. No longer dependent on Cohl's authoring control, the machine is free to collaborate in the creation of the work—or to refuse, as is so often the case when we try to enlist the aid of a recalcitrant computer in some task we are unsure of. This is not to ascribe intelligence to the machine, but to emphasize that it is capable of rich and complex relationships with humans. The pacing of the transformations in *Fantasmagorie* is one such example of machinic contributions to creativity; another is the possibility of animated drawing.

The last remnant of the older lightning-sketch acts in Cohl's film is the appearance of his hands. The very appearance of the hand in the opening shot of the film is a conundrum. According to Crafton (1990: 121, 140) and Abel (1994: 286), Cohl drew the bulk of the film in black India ink on translucent white paper over a lightbox and then printed the film in negative to achieve the white-on-black effect. The effect of the hand drawing the *fantoche* in the opening frames must have been shot by another method, and dif-

ferently printed, so that the hand would not appear in negative. So the moment at which the hand withdraws and the drawing comes to life is also a moment in which the film process is reversed, as must also be the case with the second entry of the hands when they appear to reassemble the broken *fantoche* after his fall from the house. The first of these moments is the equivalent of the moment of shock when the still projection of the Lumière cinematograph suddenly began to move; but it is a new effect in the sense that the transition to a purely machinic vision (negative) and to an animation without the support of a visible maker introduce the sense of the cinema apparatus as autonomous participant in creation.

The drawing hand in the opening frames and the mending hands later on can also give us a sense of the structure guiding the relations between human and mechanical collaborators. In the latter case in particular, we are confronted with the three-dimensionality of the *fantoche* who, though flat, can be picked up. There is of course a self-reflexive joke here, but at the same time we are offered a second way of viewing the film. The movement between animated and photographed actions works on the paradigmatic axis, integrating two diegeses, one the fictional world of the drawings, the other the "real" world of filmmaking. Whereas the first entry of the drawing hand is explicable as a throwback to the lightning-sketch genre, the second adds a whole new axis to the film, attributing autonomy to both the *fantoche* and the maker in addition to the autonomy of the apparatus. This is effected through a paradigmatic substitution of real for drawn hands in an action parallel to the cubist application of found papers (newspaper, wallpaper, labels, tickets) in Picasso's and Braque's breakthrough *papiers collés* of autumn 1912 to spring 1913. One of the effects of the substitution in cubist collage was to assert the independence of the world from the artist, who no longer translated it into paint, but could apply items from it directly to the surface of the work. In the cubist case, this also entailed alertness to the fact that these cut-out pieces of printed material were already signs, already artifacts of a thriving visual culture. In Cohl's case, the gluing hands admit that they too are already a part of the apparatus of cinema. They disrupt the grammar of the cut, but only to extend the capabilities of film.

There is no documentary evidence that these are Cohl's hands, certainly, but they are presented generically as the hands of the maker. The presence of the photographed hand for that instant at the beginning of the film is thus a kind of signature, but one that presents itself in the act of

disappearing in a process of subordination to the autonomy of machine. The hand as motif returns in the final frame, but now as a drawn hand, as the *fantoche* waves to the audience from his horse. The whole film, then, moves from the hand as instrument of control—the photographed, authorial hand—to the gesture of waving goodbye, from authorial power to spectatorial address via the autonomy of the relation, embodied in the *fantoche*, between maker and apparatus. By reserving the act of mending for a photographed moment, the film reasserts the partnership, and appeals to an ethical commitment of the maker to the creation, as that creation takes on a life of its own. That act allows the spectator to enter into the role of the person addressed by the film. As Sobchack argues, this is a critical instance in cinema, one in which the recognition of the film as a body that signifies is also one in which we recognize the film as an other: "Thus, while still objectifying visual activity into the solidity of the visible as does the photograph, the cinematic qualitatively transforms and converts the photographic through a materiality that not only claims the world and others as objects for vision but also signifies its own bodily agency, intentionality and subjectivity" (Sobchack 1992: 62).

In Sobchack's semiotic phenomenology, the photograph belongs to what I have here been calling the regime of the cut. The "cinematic," which in this instance equates to the concept of the vector, moves beyond objectification toward a process in which the film is able to take on the task of signifying. As a material body that signifies, film becomes an other. Only at this moment does the cinematic subject become a self, capable of social relations. This is when the vector socializes film.

The Cinematic Sign

The first evidence of the vector's socialization of the cinema is interpretation. Film always calls on us to interpret it. In the case of *Fantasmagorie*, where the activity of the vector is controlled to only the most limited degree by the structure of the cut, that interpretation is not governed by gestalts that order and predestine our negotiations with the text. Rather, Cohl's film activates a constant engagement of the viewer in guessing not only "what happens next" but "what is it doing now," inferring the agency of the film itself. Even such a rigorously minimal figure as the *fantoche* can evoke emotions of sympathy, extending beyond identification to action, encoded in the mending of the broken puppet. More specifically, the film calls up a series

of responses that take the form of a running commentary on the film, an inner speech.

The notion of cinematic inner speech was first broached by Boris Eikhenbaum in 1927. Reading silent film as a syncretic form of photogeny (defined as "an art which uses the language of movement" [Eikhenbaum 1974: 17]) and montage, he sees it overcoming the medium-specificity of the older arts, and evoking in its viewers an inner speech that comments on the film, its phrasing, its metaphors, and the gaps between shots. This inner speech "is much more flowing and indefinite than uttered speech" (ibid.: 16), and it "is not realised as an exact verbal formulation" (ibid.: 31). As Paul Willemen notes, this inner speech is compounded of iconographic, symbolic, and visual codes as well as verbal ones. Citing Vygotsky's (1962) argument that inner speech is characterized by a tendency to omit the subject of the sentence while emphasizing its power of predication, Willemen argues that inner speech's blending of visual and verbal presentations in an internal dialogue on the one hand establishes the internal dialectics of the viewer's psyche and at the same time becomes "the cement between text, subject and the social" (Willemen 1994: 42). The process is clear to anyone who has attempted a frame-by-frame analysis: we say "the line does this," emphasizing the predicate, not the subject that does the predicating. Eikhenbaum's argument is that this is also true of film, which shows us events and objects without implying a someone who does the showing. This isomorphism subsumes the moment of subjectivity enacted in the cut to its disappearance in the communication of meanings.

The vector's particular future-directed temporality addresses us no longer as termini but as media: as people who make sense, but only as nodes in interweaving trajectories of signification. It is no longer a matter of recognition, of deciphering what is already encoded. Rather it is a matter of reinterpreting, of adding a new spin to a trajectory that has not yet realized itself. The vector is the regime in which the temporality and the labor of *making* sense is paramount. If in the pixel we are engaged by an undifferentiated union with the visual, and in the cut by the subjection-objection pair, in the vector we confront the double presence of the screen image as at once object and image, such that what we normally expect to be true of the object—for example, that it possesses a single, discrete, and stable identity—is no longer the case. No longer pointing to an entity separate and opposed to us, but offering itself as medium, the image becomes cinematic sign. Like

every sign, it implies the existence of other signs. To say of one of Cohl's lines that it "is" a flower, an elephant, or a house is inaccurate. On the one hand, it is only legible as referring to (conventional images of) flowers, elephants, and houses for brief moments in a trajectory that is never stable. On the other, it is always a line, a signifier, which is what gives it its transformative power.

The line, like the written word, speaks to us simultaneously as the drawn/written and as the act of drawing/writing, as iconic sign and as the incomplete, infinite process of signifying. Thierry Kuntzel voices this in a rare theoretical essay on animation, arguing that photographic frames reproduce, but animated frames produce. Distinguishing between the grid of the filmstrip laid out for analysis and the film-projection we experience in the cinema, he describes the function I have been terming the vector thus: "The animator conceives the film-strip (each photogram, the articulation between the photograms) in relation to the film-projection and in relation to a meaning which movement will actually bring about" (Kuntzel 1979: 52). Meaning is a function of the transition from the découpage, the analytic eye of the editor, to the trajectory of movement, brought about in the relinquishing of the animating hand to machinic projection.

In the graphic code of the vector in *Fantasmagorie* it is possible to descry that rare creature, a signifier without a signified. Cohl's cyborg cinema approaches Peircean thirdness, "synthetic consciousness binding time together, sense of learning, thought" (Peirce 1991: 185), at its purest. The cut established signifieds as the products of subject-object relations, grounded in the resistance of the world to consciousness. Divorcing perceiver and perceived, it establishes time as a serial process of distinct causes and effects, hidings and revealings, insides and outsides. The vector synthesizes the multiple times of transformation into a trajectory that engages the delight we take in thinking the ambiguities and ambivalences with which it flavors the rough parceling of the world in the cut. In Peirce's terms, the cinematic sign is a symbol, "any utterance of speech which signifies what it does only by virtue of its being understood to have that signification" (ibid. 240). *Fantasmagorie* is such an "utterance," dependent on interpretation, on the active participation of the viewer in its production, and otherwise merely a redundant collection of scribbles. Explaining thirdness, Eco speaks of a line drawing of a circle and some inverted Ws, denoting sun and birds: "First I had to

decide that they were two signs that stood for something, and only afterward did I try to understand them" (Eco 1999: 386). The first moment is that of secondness, of identifying the marks as objects that denote. Only in the subsequent moment of thirdness do we arrive at *what* they denote. This movement of subjectivity from recognition to mediation is the achievement of *Fantasmagorie*.

The cinematic object does not require this interpretive moment, but the animated vector depends on our synthetic participation in its becoming, on the viewer's temporality (and on the apparatus's). As exchange, the signifier represents a subject for another signifier: it is a passage from subject to subject. But by the same token, subjectivity never originates signification. Instead it too is a passage that focuses and distributes signification, the animator of a vector of signification that flows through her (from the point of view of viral language, "I" am only a medium for reproduction and mutation). In this way, too, the cinematic sign leads us toward the socialization of vision at the point at which cinema becomes Symbolic.

Lacan thinks of the Symbolic (for which I will reserve the initial capital) as the order of both consciousness (the "I") and of language, social systems, and all structures that enable meaning and communication. Entry into the Symbolic comes in the Oedipal moment in which the child first internalizes the psychoanalysist's founding rule: the prohibition against incest. Whether one accepts the specific instance or not, Symbolization depends on passing a threshold when first we learn that socialization is governed by rules. Following the mirror phase, in which the infant acquires the ability to identify with his or her own likeness narcissistically, the Symbolic constructs the more abstract sense of an ego marked by the word "I." But because this word is used equally by any conscious speaker, the Symbolic permits an extension of identification beyond identification with oneself, toward identification with an other.

Though Lacan's pessimistic account of socialization sees this process as one of loss, instilling a permanent and ineradicable sense of lack in the human adult, there is nevertheless a gain. From indifferent immersion in the world, via a narcissistic (and sadistic) separation between subject and object-world, we emerge into a socialized universe. If for psychoanalysis, with its individualist premise, this represents a loss of primal unity, for a more social theory it marks the acquisition of those fundamental communicative skills

that allow us to enter into relationships not just with ourselves but with autonomous others. *Fantasmagorie*'s multiple acts of cruelty and the penultimate act of kindness (mending the puppet) might be read allegorically as an account of that Oedipal transition from the isolated self as pure and static image in the opening frames, through confrontation and breakage, to a submission to the other (the photographed hands) that enables socialization (the *fantoche*'s final wave to the audience).

Of course, this allegorical reading is very much an interpretation after the fact. Crafton's careful analysis (accompanied by an invaluable set of 69 frame stills documenting the film) emphasizes the cruelty of *Fantasmagorie* (Crafton 1990: 258–266). Both he and Abel (1994: 286) stress the spontaneity and fluidity of the images as analogous with dream states. Wells, as we have seen, stresses the authorial stream of consciousness. Bendazzi contrasts Cohl with his North American predecessor Blackton, who "was always careful to introduce or justify the presence of a cartooned world next to a real world. On the contrary, the Frenchman jumped into the graphic universe, animating the adventures of autonomous characters" (Bendazzi 1994: 9). None of these accounts, with the partial exception of Crafton, is moved to analyze the film as narrative. Reading *Fantasmagorie* as a story is subsequent to experiencing it as a formally (but never absolutely) autonomous signifying agent.

In a discussion of the foundations of a philosophy of space, Henri Lefebvre raises the specter of autonomy in the context of the commodity:

Things—which for Marx are the product of social labour, destined to be exchanged and invested for this reason with value in a double sense, with use-value and exchange-value—both embody and conceal social relations. Things would thus seem to be the underpinning of those relations. And yet, on the Marxist analysis, it is clear that things *qua* commodities cease to be things. And inasmuch as they remain things, they become "ideological objects" overburdened with meanings. *Qua* commodities, things can be resolved into relations; their existence is then purely abstract—so much so indeed that one is tempted to see nothing in them apart from signs and signs of signs (money). (Lefebvre 1991: 402)

Lefebvre's missing underpinning, neither Logos nor empiricist materialism, is communication: the primacy of relations, even though those rela-

tions are expressed in the autonomous form of signifiers that, in cinema, take on the commodity's monstrous property of repeating relations back to people in the guise of objects. The fluidity of *Fantasmagorie*'s metamorphoses enacts the resolution of commodities back into relations, relations of mediation, signification, and communication that perpetually test the limits of and propose alternatives to the dominance of money as the signifying chain par excellence that governs communication under capital.

To confront the autonomy of the signifier is to come face to face with the film as other. In the philosophy of Emmanuel Levinas, the confrontation with the other is the foundation of ethics in a transition from freedom to socialization. The subject is free in the sense that it is "for itself," but this comes at the price of solipsism: "in knowing itself or representing itself it possesses itself, dominates itself, extends its identity to what of itself comes to refute this identity. This imperialism of the same is the whole essence of freedom" (Levinas 1969: 87). The knowledge the subject has of itself is a mode of representation—the cut—that allows it to control both its world and itself as objects. Confronted with the other, the subject becomes self in recognizing the limits to its sameness, its control and its freedom. It does so because in the other it is forced to recognize another's freedom. "Morality begins," argues Levinas, "when freedom, instead of being justified by itself, feels itself to be arbitrary and violent" (ibid.: 84). The ethical arises when the subject confronts an object that is as free as itself, a confrontation with the other that brings with it the realization that domination over the object is at once arbitrary and homogenizing. Recognizing the freedom of the other limits my freedom, but freedom can have no limits. Therefore the self is not free, but forced to take the other into account, to be responsible for the other, since the other defines the limit of freedom.

At the same time, knowledge of the other alters our relations to the world. "Certitude rests, in fact, on my freedom and is in this sense solitary" (Levinas 1969: 100), whereas "the locus of truth is society" (ibid.: 101). Certainty that we possess the unique and absolute truth belongs to the order of the subject, but connection with others opens to us the limits of certainty, since they too have their own and different certain knowledge. The possibility of truth then depends on the society of interpretations, on mediation. Certainty is a kind of destiny: it determines what it is possible to know, by defining the world as the object of a subject and subordinating it to that

subject's identity. Thus, apparently paradoxically, freedom is synonymous with necessity, whereas responsibility, duty, and care free the self to the possibility of change.

For Vivian Sobchack, this confrontation with the other occurs also in the cinema: "What we look at projected on the screen . . . addresses us as the expressed perception of an anonymous, yet present, "other." . . . [T]he concretely embodied situation of the film's vision also stands *against* the viewer. It is also perceived by the viewer as a "There where I am not," as the space consciously and bodily inhabited by an "other" whose experience of being-in-the-world, however anonymous, is not precisely congruent with the viewer's own" (Sobchack 1992: 9–10). We can see here why Wells so easily slips into reading *Fantasmagorie* as evidence of a specific human other, the author, Emile Cohl, because film presents itself to the viewer as an other capable of signifying and thus possessing its own freedom. But the film is more "other" even than that. It is not the sole product of an author but evidence of a cyborg integration of human and machine into a signifying apparatus. It is that apparatus that confronts us as the other in vectoral cinema.

The certitude we bring to the identification of the world as object or collection of objects is, in Levinas's terms, thinking in the mode of totality, "a reduction of all experience, of all that is reasonable, to a totality wherein consciousness embraces the world, leaves nothing outside of itself, and thus becomes absolute thought" (Levinas 1985: 75). Universal and impersonal, this totality is also inhuman. Levinas contrasts totality with infinity, an open-ended relation based in the necessarily incomplete relation with the other. "If one could possess, grasp and know the other, it would not be other" (1989: 51): the possession, grasping, and knowing that characterize the subject of totality are impossible to the self of infinity, who instead must face the circumscription of selfish freedom by the opposing freedom of alterity. In the vector's endless permutations and substitutions, we come face to face with an other whose freedom resists total knowledge. Its radical otherness and the infinity of interpretations and negotiations it entails embody the impossible object of desire. For Levinas, "what is at stake is society. Here the relation connects not terms that complete one another and consequently are reciprocally lacking to one another, but terms that suffice to themselves. This relation is Desire" (1969: 103).

Signifying, then, is no longer Lacan's endlessly thwarted pursuit of completion down the endless chains of signifiers, but a richness of infinite vari-

ety in the paradigmatic twists and turns of the vector and the parallel rolls and tumbles of the self that enters into dialogue with it. The cyborg mode of the cinematic other, whether mechanical as in Cohl's practice or inscribed as computer algorithms in digital vector graphics, opens a society of image and spectator where desire is the mutual attraction of autonomous selves rather than the subject's narcissistic pursuit of lost dominance over its object.

This social relation of desire as dialogue has implications for the theory of representation. Seen from the standpoint of graphical cinema, representation is never essential. As Lev Manovich argues, "Born from animation, cinema pushed animation to its boundary, only to become one particular case of animation in the end" (Manovich 1997: 180). At some point in the near future when historians recognize that the photomechanical cinema is a brief interlude in the history of the animated image, representation will become, like narrative, a subcode of interpretation rather than an essence of motion pictures. In a discussion of visual perception, Jacques Aumont observes that a two-dimensional projection of a three-dimensional space "may be projected as an infinite number of potential objects" (Aumont 1997a: 24), whereas "an infinite number of possible objects could produce this [flat] configuration" (ibid.: 33). He points out that on empiricist accounts of perception, accumulated experience leads to the "correct" identification of the object. Empiricism, however, is grounded in the belief in objects. The vector principle of desire as dialogue between autonomous selves reanimates the paradoxical infinity of relations between two- and three-dimensional experience as a process of interpretation and variation. Refusing the totality of the predestined serial image in favor of the infinity of the images' movements, it finds onscreen the self's own signifying, its inner speech, as process of desire, reaching out toward, interpreting, performing elaborate *pas-de-deux* with the uncapturable transformations of a world that presents itself as signifying other, not transcendental sign.

We are now in a position to summarize the findings of the first section.

PIXEL	CUT	VECTOR
The iteration of time	The objection of space	The production of meaning
Firstness	Secondness	Thirdness
Sensation	Perception/representation	Communication

Event	Object	Sign
Preindividual	Individual	Social
Indifference (Zero)	Unity/multiplicity	Infinity
Real	Imaginary	Symbolic
Timelessness	Destiny	Hope
Referent	Signified	Signifier

One reason for beginning in the pioneer period is to isolate the elementary aspects of cinema at the moment of becoming. The task of the following chapters is to historicize them: to show how these raw principles develop and interact in the ongoing dialogue between cinema and society, to see how the virtual cinema became actual. The vector completes the elements of the moving image, but it does so by becoming human. In the normative cinemas that followed, the apparatus would take its revenge.

Normative Cinema

TOTAL FILM: MUSIC

Eisenstein: The Dictatorship of the Effect

In hours like these, one rises to address
The ages, history, and all creation.

—*Vladimir Mayakovsky, April 14, 1930*[1]

Norms and the Rhetoric of Totality

A norm offers itself as a model for subsequent makers, a stable structure that can hold good for decades, like the three-minute pop song, or longer, like the Petrarchan sonnet. Norms legitimate particular practices and sanction deviations. Talcott Parsons (1951) anchors normativity in the "double contingency" of social intercourse, when each partner's communication is modulated in relation to the reaction of the other, who likewise reacts to the contingent circumstances of the first partner's address and so on. Reviewing this thesis, Giddens (1979: 85–88) argues that in the construction of norms there is also a play of power. This is clear in the case of Eisenstein, and it is documented with almost indecent clarity in an account, written by the actor Cherkasov and his brother, of a meeting he attended with Eisenstein to hear criticisms of *Ivan the Terrible* from Stalin and his two closest associates Molotov and Zhdanov (Eisenstein 1996: 299–304). Unvoiced menace sweats from every interchange. There is never a doubt as to whose thoughts carry the most weight. The double contingency of cinematic norms is indeed a function, as Parsons argued, of relations between interlocutors. But the specific norm depends in part on who the interlocutors are—who is the intended or most significant audience for the filmic model. For Eisenstein in the late 1930s, it appears to have been a tightly defined group within the state bureaucracy who held power over his life and, perhaps more impor-

tant, over the exercise of his craft. The realist and classical norms, as we will see, also address themselves to specific audiences that we might describe as the citizen and the consumer.

Put in slightly different terms, then, norms are a solution to the question of social order: how do individuals come to work together as societies? The presumption of an opposition between individual and society lies at the heart of the sociological theory of normativity. That opposition governs the championing of individuals against society in the classical norm. Renoir's films of the Popular Front period are an attempt to reconcile individualism and society. The Eisenstein we will be engaging with, the Eisenstein of *Alexander Nevsky* and the dialogue with Stalin, must champion the triumph of society in the form of the state over the individual. This is a normative cinema.

From Abel Gance's *Napoleon* of 1927 (King 1984), via Korda's *Things to Come* (Frayling 1995), with its grandiloquent appeal for technocracy, through Leni Riefenstahl's *Triumph of the Will* and *Olympiad* of 1934 and 1936 via 1950s sword and sandal epics to the militarist rock epic *Top Gun*, total film is by no means the exclusive property of Stalinism. What these films share is the attempt to deploy maximal rhetorical control over cinematic effects, removing the extraneous and filling the aural and visual wavebands of the film with a single theme, so minimizing the possibility of the audience creating its own meanings, becoming distracted, or missing the point of the film. The term is chosen not only to implicate this norm with totalitarianism, but to recall Levinas's definition of totality from chapter 4 ("a reduction of all experience, of all that is reasonable, to a totality wherein consciousness embraces the world, leaves nothing outside of itself, and thus becomes absolute thought" [Levinas 1985: 75]).[2] Total film aspires to bring

to the audience a diegesis that can be understood, mentally appropriated, totally. By making the world a theme, it calls the audience to possess it as a whole, and to identify their thought with the world imaged on screen rather than with individual figures, though often enough a protagonist, Christ or Tom Cruise, will provide the rhetorical gateway through which absolute possession can be depicted.

Alexander Nevsky (see figs. 5.1–5.4) is widely held to be "the very worst film in Eisenstein's oeuvre" (Aumont 1987: 18). Working under Stalin after the destruction of his previous film, *Bezhin Meadow* (Barna 1973: 192–199; Seton 1960: 367–391), Eisenstein was under constant threat of imprisonment. For several years he was not allowed to direct, and for some time he was even debarred from teaching at the Film School. When finally, in 1937, he was assigned *Nevsky*, a project not of his own choosing, he had to work with a codirector, D. I. Vassiliev, whose job was to ensure compliance with the ideological, political, and aesthetic demands of the regime (on other constraints, see Eisenstein 1983: 65, 226; 1970: 42; Barna 1973: 213–216; Leyda 1973: 349). The film is significant for us for three reasons. First, it is not an "Eisenstein" film, product of genius, but a film by a master craftsman shot under the discipline of Soviet realism and subordinated to the propaganda aims of Stalin's state bureaucracy. Precisely because it is so comprised by its production under conditions of systemic duress, *Nevsky* serves as the best-known and most accessible example of Stalinist cinema. Second, *Nevsky*, Eisenstein's first sound film, was the culmination of a decade's thinking about the relation between sound and image. And third, despite the conditions under which he was working, Eisenstein arranged the filming not only according to a strict plan of action but with the determined vision of what the film should achieve, and the stylistic means through which it would evoke precise and predetermined emotions and meanings in its audience. Like Hitchcock, Eisenstein believed in the almost mechanical manipulation of the audience (and actors: see Leyda 1973: 350); in this film, he reaches toward the apogee of rhetorical filmmaking.

The word "rhetoric" has come to have a confusing set of meanings, not least because the Romantic movement of the late eighteenth and early nineteenth centuries saw the older rhetoric as an irrelevant straitjacket binding the free creativity of the solitary genius. In ancient times, rhetoric was the art of persuasion and was taught in five aspects: *inventio* or subject matter; *dispositio* or structural arrangement of the major parts of an argument; *elocu-*

| Figure 5.1 |

Alexander Nevsky: The hero, the nation, the land: Cherkasov, member of the Supreme Soviet,
as Stalin as Russia—not depiction but image. Courtesy BFI Collections.

tio, the choice and ordering of words; *pronunciato* or the actual speaking of
the discourse; and *memoria,* the art of memory. According to Ducrot and
Todorov (1972: 100), over the ensuing centuries, the discipline of rhetoric
was reduced to *elocutio* alone: the rule-governed teaching of style, more
properly called "stylistics."

Nevsky is indeed a work of stylistics, the *bene dicendi scientia* or science of
speaking well, but it is also a rhetorical film in the ancient sense. Eisenstein
has his own vocabulary for the parts of rhetoric: in particular, *elocutio* be-
comes depiction, while the theme or "image" stands in the place of *inventio.*
By contrast, realism embraced depiction as its central interest, whereas
classicism, as the name suggests, focused on the structuring principle of *dis-
positio* and its relationship with *pronunciato,* the address to the audience.
Eisenstein, however, holds the ancient belief that of all the parts, it is the
theme, the image, that governs every aspect of the discourse. His goal is
to persuade.

| Figure 5.2 |

Alexander Nevsky: Eisenstein's drawings for the Pskov set: folkloric art as cartoon. Courtesy BFI Collections.

The ancient Stoics distinguished between rhetoric and dialectic: the latter the fount of wisdom and knowledge, the former mere verbal dexterity. Of all people, it was the African theologian Saint Augustine who countered that "dialectic could be treated as the ground of rhetoric, hence as not merely verbal, but in the realm of things, the realm of the universal order" (Burke 1950: 60). The fifth-century Christian provides the twentieth-century Marxist with the articulation of rhetorical form with the dialectic of nature that underpins his filmmaking. In what follows, it is as well to recall that the art of persuasion is not identical with the science of propaganda. Moreover, when we are tempted to believe that persuasion is a task unworthy of film, remember that *Nevsky* was made on the eve of a war that would cost fourteen million Russian lives.

The Golden Section

Eisenstein was not the only one among many prominent directors to regret the lost universality of silent cinema—René Clair (1972: 126–131; 1985) and Charlie Chaplin (1964: 321–323) were among those who struggled with synch sound aesthetics. Like them, Eisenstein was particularly distressed at the way synchronized sound cinema was reduced to the less ambitious "talking picture," with its presumption that dialogue would play the leading role. Their fear was partly that the scale of investment required to wire hundreds of thousands of cinemas worldwide, coincident with global economic depression, would cause studios to go for the safest and most standardized forms of entertainment. To some extent, the success of films like *The Blue Angel* and Clair's own *Le Million* in 1931 assuaged their concern: creative work was still possible, and critical and popular success could be reconciled in the talking picture.

Earlier, however, just as news of the talkies arrived in Russia in 1928, Eisenstein cosigned a manifesto deploring the illustrative use of dialogue and sound effects and arguing for a "contrapuntal" use of sound as a montage element. Eisenstein would abandon the contrapuntal analogy (though not the metaphor of the orchestral score) by the time he made his own sound films, almost a decade later. Yet the manifesto includes an important statement on the principle of montage as it stood under threat from synchronized recorded sound: "To use sound in this way will destroy the culture of montage, for every ADHESION of sound to a visual montage piece increases its

inertia as a montage piece, and increases the independence of its meaning" (Eisenstein, Pudovkin, and Alexandrov 1949).

The montage principle as it was being voiced in the 1920s was based on the dialectical model of clashes between shots. The authors believed this dynamic model of montage to be at risk for two reasons. First, synchronization would anchor each shot so strongly to its role of depicting the world that it would no longer be available for the dynamic interplay required of montage pieces. And second, the shots would thus acquire their independence from the overarching theme of the film expressed in the montage. It was a criticism already voiced in a response to Béla Balasz's argument that "the cameraman is the alpha and omega of film" (Eisenstein 1988: 77). There Eisenstein links the praise of the individual shot with the individual hero and the individualist narrative. For Eisenstein, the isolated shot was merely figurative. Balasz's belief in it was a result of his failure to recognize "the externality of the shot" (ibid.: 79) as an object in its own right, one that acquires meaning not by resemblance or by inner beauty but by its association with the other shots in the sequence and the whole film.

The resolution Eisenstein proposed in an essay written shortly after the manifesto was to develop "a new *sense: the ability to reduce visual and sound perceptions to a 'common denominator.'*" His example comes from kabuki theater: "the unique combination of the *hand movement* of Itsikawa Ensio as he slits his throat in the act of hara-kiri with the *sobbing sound* off-stage that *graphically* corresponds to the movement of the knife" (Eisenstein 1988: 119). Here, in 1928, Eisenstein already proposes the "new sense" of cinema as fundamentally graphic: gesture and sound share a common trajectory, a shared vector. Critical to an understanding of Eisensteinian montage in general, Eisenstein's particular understanding of the vector in the later 1930s is even more important to the concept of total film.

Writing shortly after the completion of *Nevsky*, Eisenstein offered a diagrammatic rendition of the concept of organic unity. The organicism of the Romantics was based either on vague concepts of what ought to be the case, or on a mystical faith in the morphological similarity between parts and wholes in the living world (e.g., between the shapes of pine cones and pine trees). For the generation that came to creative maturity in the wake of the 1917 Revolution in Russia, science provided the model for experiment in art. Unsurprisingly, then, Eisenstein finds his type of organic development at the conjunction of life sciences and mathematics in the logarithmic spi-

ral. This spiral occurs in nature in shells, in the pattern of sunflower seed-heads, in the growth of animals' horns and the structure of spiral galaxies, the geometrical expression of growth. Eisenstein derives the maths of his spiral from the golden section, promoted since antiquity as the most elegant of proportions. For Eisenstein, the coincidence of classical proportion with the mathematics of growth combines "the golden section as the most perfect mathematical image of the unity of the whole and its parts and the logarithmic spiral as the most perfect image of the expression of the principle of proportional evolution in general" (Eisenstein 1987: 18).[3]

His example is the outward spiral of *Battleship Potemkin*, starting from a minor dispute about maggots, expanding to execution, mutiny, and the attack on the Odessa Steps, and culminating in the meeting with the Imperial Navy squadron. Reading this as the five-act structure of classical tragedy, Eisenstein goes on to analyze the rhythm and duration of the second act, seeing a caesura that serves as a pivot about which the viewpoint or emotional content of the drama reverses, each caesura arriving at approximately the appropriate mathematical moment specified by the golden section. In his brief foray into mathematical aesthetics, we might be tempted to argue, Eisenstein foreshadowed the most advanced form of vector graphics. His failure can also be described mathematically. Where the rate of growth of the spiral is nil, the result is a circle. Under conditions of Stalinism, and perhaps also because *Nevsky* defers to the urgent demands of its historical moment, Eisenstein's spiral seems to have been destined to chase its own tail.

The well-tempered scale of diatonic music, the Western classical scale, is one of the most familiar artistic phenomena describable in terms of the natural logarithm, the organicist principle of the harmony of the parts in the whole. For Eisenstein, the same principle extends to a specific definition: "rhythm has always been the ultimate means of generalising about a theme, as being the very image of the internal dynamics of its content" (Eisenstein 1991: 235–236). Rhythm is a vector extending from the infinitesimal microstructure of shots to the infinite macrostructure of cinema. This overarching rhythmic structure, like the uneven stabilities of the golden section, thrums at every level of the film. It does so as the theme or *image*, a term Eisenstein's translators use to distinguish the thematic structure of the film from its *depiction* of external reality. That image is not just the ideological or semantic content, but its highest generalization as pattern.

There is also an implicit distinction here between two types of organic unity, the Romantic ideal of "any work in general that possesses wholeness and an inner law" (Eisenstein 1987: 11) and Eisenstein's own in which particulars as well as generalities are structured by a single law. Romantic formalism required merely an order; Eisenstein's rhythmic unity was specifically suited to realism because "the forms of its compositional embodiment also fully reflect the laws peculiar to reality" (ibid.: 12). In claiming the natural logarithm as the basis of pattern, he could isolate a formal structure that shapes not only the film and its depicted reality but also the film's audience, "because the law of its structuring is also the law governing those who perceive the work, for they too are part of organic nature" (ibid.).

One immediate effect of this common vector shaping reality, film, and audience is that Eisenstein can refer to "music in its broadest sense—including words, voice and sound in general" (Eisenstein 1991: 239). All distinctions between wordless and speaking voices, the sounds of the body, of the socialized human, of the random and uncontrollable noises of landscapes and cities—in short all conflict in the film's auditory dimension is thus condensed into music as the auditory aspect of the image. In his earliest writings on sound, Eisenstein had feared the isolation of the shot from the montage. By making all sound music, all music rhythm, and rhythm and montage a single image, Eisenstein gains control. It is an operation common to the musical avant-garde, from the Futurists to John Cage. Kahn identifies a moment in the history of musical modernism when "the sounds of the world were to be themselves categorized, explicitly or implicitly, into referential sounds and areferential *noises*, such that a noise could be incorporated into the areferential operations of music." As a result, "these noisy correspondences within music were emphasized as themselves bearing traces of the world of true extramusicality" (Kahn 1999: 69). This avant-garde assimilation of the noise of the world subordinates extramusical reference to the formative work of music.

By contrast, Eisenstein's contemporary Dziga Vertov wrote in 1925, "If, with respect to vision, our kinok-observers have recorded visible life phenomena with cameras, we must now talk about recording audible facts" (Vertov 1984: 56). Dismissing the claim that the world was not "audiogenic," and that therefore filmmakers and radio producers should concentrate on recording sounds in soundproofed studios, Vertov demanded location sound, creating complex audio tracks for his first sound film *En-*

thusiasm (Fischer 1985). At the same time, he took exception to the "Statement" on sound that Eisenstein had coauthored in 1928, and especially with the contrapuntal, asynchronous aesthetic proposed there: "neither *synchronization* nor *asynchronization* of the visible with the audible is at all obligatory" (Vertov 1984: 111); indeed, workers speaking with their own voices in their own audio environments were integral to his documentary concept of film.

For Eisenstein, however, Vertov's "factographic" documentarism was a form of naturalism restricted to the level of depiction: "Their mistake was to be so busy propagating fact that they forgot that in this period a fact was at the same time an *image*. A revolving wheel was not only a fact, it was at the same time an image, a figurative representation of our country" (Eisenstein 1996: 19). Vertov's direct sound recording thus stands accused of a lack of motivation in the formal sense of the word: it stands apart from the grand design of the image and so falls prey to formlessness. Direct sound was dependent on a relation to the ungovernable productivity of the world, and as such it could not be guided into the rhetorical unity of the film as image. Underneath these accusations lies Eisenstein's fear of an artform that would not be governed.

In music, as opposed to sound, Eisenstein found the model of a time-based art that gathered the power of every microtonal vibration in the orchestra into the totality of composition. The lilt of a spoken phrase, the clatter of hooves, a distant cry could all be brought together in a single harmonious movement of the score, "For it is precisely tone which decisively adds the ultimate image, interpretation and generalized meaning to what is a collection of separate words joined into a sentence" (Eisenstein 1991: 244). The normative drive of Eisenstein's theory parts company with the digital theory of the vector: interpretation and meaning are derived from and controlled by the organization of the diegetic world as montage image. In the pages immediately preceding this appropriation of tone of voice to musicality, Eisenstein has made a schematic table of levels of generality. In the single shot, the general image is provided by the graphic shape abstractable from the frame. In silent montage, generalization "was expressed by the *moving line* along which the montage sequences are combined," whereas in sound film generalization "is expressed beyond the bounds of the montage combination of sequences and into the *moving line of music* which runs through them" (ibid.: 243). This in turn permits Eisenstein to rethink

his concept of contrapuntal relations between image and sound under the rubric of total film:

the movement of counterpoint within a piece of music also corresponds exactly to the phenomenon whereby the visible *material* outline of the picture in a film-shot evolves into the *mental* "path between sequences," the process that occurs when cinema moves on from the single set-up stage to multiple set-up. . . . The juxtaposition of a number of melodic sequences also gives rise to a certain generalizing "line" that is not conveyed materially but which *emerges*, the line of harmony. (Ibid.: 246)

This harmony is a central tenet of the essay on rhythm and of the production of *Alexander Nevsky*. In earlier theoretical writings on montage, Eisenstein proposed the cut as the controlling device that would establish the graphic compositional qualities of the individual shot and build those compositions into a structured whole through editing. But in the writings of the 1930s and early '40s, the vector takes the dominant role as the highest and most abstract form of generality, and its model is no longer dialectical or even dissonant but harmonious, contrapuntal, and melodious. Ten years after the Revolution, it had been possible to imagine a new sound art; twenty years after it, the academic music of the previous century was modeling the whole of cinema.

Electing even this dated form of music as the principle of sound-film montage brings certain risks. Because the soundtrack has its own "technical vehicle," and because it is easier to grasp musical themes than the mental image produced by the visual montage, "the danger is all the greater of the soundtrack becoming 'self-sufficient' and not organically integrated with the picture" (Eisenstein 1991: 252). In the silent film montage, contra Vertov, "the montage combination of a series of segments is *not* interpreted by the mind as a certain sequence of *details*, but as a certain sequence of whole scenes—and scenes, moreover, which are not depicted but arise within the mind in image form" (ibid.: 128). Lurking just below the surface is a distrust of the documentary's claim to reveal reality. Five years earlier, in a note on Méliès, he calls on the camera to "penetrate" reality, "so that we move from the routine monitoring of an illusory, composed reality to an authentic unity of images joined in juxtaposition in order to reveal their sense" (Eisenstein 1988: 260). Retailing their own lives back to people is both routine and

suspect; only the image is powerful enough to penetrate the veils of appearance to show the unphotographable: class struggle, revolution, Russia. Just as the succession of still frames produces the impression of movement without consciousness of the content of each frame, so the juxtaposition of shots gives rise to a pre- or subconsciously formed intellectual image.

For Vertov, the machine was the model of the new humanity: efficient, scientific, objective, and socialized. Eisenstein anthropomorphizes the machine rather than mechanizing the proletariat. Where Vertov seeks union with the mechanical, Eisenstein shuns it and deploys his fears not only in *Nevsky* but across his works. Discussing a dark, suicidal period in his autobiography, Eisenstein begins a discussion of fate, described in terms of "an impersonal, soulless machine, the precursor of Guderian's herds of tanks, the rush of the iron 'swine' of Teutonic knights in *Nevsky*. / Again faceless. This time physically enclosed by helmets, whose eyeslits echo the slits in the future Tigers and Panthers" (Eisenstein 1983: 197; the oblique stroke denotes one of Eisenstein's frequent paragraph breaks.). These foreshadows of the German tank divisions at the siege of Leningrad are also motivated by a memory of the rail yards at Smolensk at the height of the Civil War." The most frightening thing in my life," he writes, was the trains:

Their implacable, blind, pitiless movement has migrated to my films, now dressed in soldiers' boots on the Odessa steps, now directing their blunt snouts into knights' helmets in the "Battle on the Ice," now in black vestments sliding over the stone slabs of the cathedral, in the wake of a candle shaking in the hands of the stumbling Vladimir Staritsky.

This image of a night train has wandered from film to film, becoming a symbol of fate. (Ibid.: 198)

Gorky's maxim that opens *Non-Indifferent Nature*, the claim that "man" is the core of his art, is neither a submission to Stalinist rhetoric, nor an evocation of a bland humanism, but a decision to side with the human against the mechanical in that cyborg dialectic that defines the cinematic apparatus.

This siding with the human is not restricted to Eisenstein's representational and stylistic strategies, however: it pervades the aesthetic of the total film. Eisenstein mistakes totality for infinity and so reorients the vector as the rhetorical principle of a monodirectional transmission of belief and affect from producer to audience. Eisenstein struggles to maintain unity as

| Figure 5.3 |

Alexander Nevsky: Teutonic knights foreshadow the Panzer tanks at Leningrad. Courtesy BFI Collections.

dynamic and to harmonize into completion the dialectical uncertainty of the vector. In the norm thus constructed, the integration of human and machine is adapted to a static and harmonious intertwining of object-world and subjectivity into a whole. The totality of total cinema is then achieved through a detournement of the vector from the openness of mutual evolution toward a model in which the present is the already achieved conclusion of that history. As in the union of pilot and plane in *Top Gun,* of Skywalker and X-wing fighter in *Star Wars,* the present is mythologized as the eternal, and the cyborg dialectic tamed as the always already achieved union of world and spirit in an eternal truth, which George Lukas had the sociological insight to call The Force. Eisenstein's nightmare in Smolensk has given rise to a cinema of truth, where truth has the overwhelming power of a rhetorical statement of what we are presumed to know already. Total cinema places itself at the end of history. If nonetheless *Nevsky* remains a film that can be watched and studied, it is because, in the last instance, the machinery of fate that so oppresses it is identical with the cinematic machinery of resistance.

| Figure 5.4 |

Alexander Nevsky: The Battle on the Ice: turning the summer sky to winter. Courtesy BFI Collections.

Yet, in the words of the Borg, resistance is futile: resistance demands a dominant to resist, and domination defines itself as that which dominates all resistance. The triumph of any side is always the triumph of Victory, always the renewal of totality.

Eisenstein's challenge in the years after the 1928 "Statement" is no longer to invent a dialectical form of cinema in which sound and image would, through their conflicts, produce an art form of an entirely new kind. Instead, total cinema must face the necessity of their coexistence and act as if with the knowledge that their struggle has already been resolved. At this stage, totality has been achieved by nominating music as the pinnacle of the sonorous hierarchy and the graphic, compositional line as the governor of the visual, thus finding in the analogy between the moving lines of melody and of graphical cinema the core of a newly harmonious and whole filmmaking practice.

Composition

In the years following the production of *Nevsky*, Eisenstein would add a new element to the mix: "*Solving the problem of audiovisual montage is solving the problem of . . . colour in cinema*. In other words only colour cinematography . . . is capable of fully solving the problem of genuine audiovisual synchronicity and consequently of montage in sound film" (Eisenstein 1991: 253). This startling assertion resurfaces in Eisenstein's memoirs, where he explains that "The higher forms of organic affinity of the melodic pattern of music and of tonal construction of the system of succeeding color shots are possible only with the coming of color to cinema" (Eisenstein 1983: 257). The gradations of color, even more than those of the grayscale in black and white film, could be recruited for a cinematic art that would be capable of totality. This faith in color as the resolution of the sound-image dialectic takes its strength and meaning from a long series of contemplations on the relations between sound and image. Its central innovation, however, is less the sense of color as such, and more the move from the line as the central metaphor of composition, both visual and musical, toward tonal gradation.

In "The Fourth Dimension in Cinema" Eisenstein distinguishes between montage by dominants, governed by the major element of a shot, and overtonal montage, which draws in the reverberations and connotations of the frame. The shift, he says there, is necessitated by "the non-dialectical

postulation of the question of the unambiguity of the shot in itself. / The shot never becomes a letter but always remains an ambiguous hieroglyph" (Eisenstein 1988: 182). Since any one shot, say, of a field of snow, might suggest winter, or whiteness, or purity, and even a combination of shots cannot definitively tell the audience to think "old age" or "cold," the images remain as ambiguous as Egyptian picture-writing, unless and until they make the move from denotation to cognition, from Peircean secondness to thirdness. What is required is, first, an understanding of the overtones of the shot. Eisenstein is careful to assert that the overtones are not "impressionistic" emotional hues, but strictly measurable, as brightness and gloom can be measured by a light meter. Another example: "where we designate a shot as a 'sharp sound,' it is extremely easy to apply this designation to the overwhelming number of acutely angled elements in the shot that prevail over the rounded elements (a case of 'graphic tonality')" (ibid.: 189). The second requirement is that these overtones are deployed in the composition to maximize effect, as a musician would use the overtonal frequencies of bells or organ pipes in the overall sound of a composition.

At this stage, Eisenstein adds another schema, of five levels of montage. The first four are the "primitive motor effect," the kind of rhythm an audience responds to physically; the rhythmic, more subtle than the first category because less capable of being acted out physically; the tonal (or "melodic emotional"); and the overtonal. Throughout this schema, despite citations of graphical and temporal qualities specific to the visual arts and to cinema itself, the language is musical and makes a point of insisting that the vibrations that make up sound are the basic units of both rhythm and tones. The fifth category, the "fourth dimension," however, is quite different: "Intellectual montage is montage not of primitively physiological overtonal resonances but of the resonances of overtones in an intellectual order, / i.e. the conflicting combinations of accompanying intellectual effects with one another" (Eisenstein 1988: 193). One feels the director struggling for an explanation that will permit him to continue his experiments. But not even quotations from Lenin can alter the tendency of the thought: the dialectical is less and less a matter of struggle and conflict, more and more a synthesis of the classless and therefore conflict-free victory of the proletariat in Stalinist Russia. The theory of overtonal montage is an attempt to integrate the paradigmatic axis of cinema—the semantic reverberations of images that

might lead to stray thoughts of winter, old age, or innocence—into a planned and administered thematization. In effect, it represents the attempt to treat the paradigmatic axis of the vector as though it could function syntagmatically. .

At the same time, there remain elements of a dialectical conception. The future, he says in a lecture given at the Sorbonne in February 1930, belongs to the sound film, "Particularly Mickey Mouse films. The interesting thing about these films is that sound is not used as a naturalistic element. / They look for the sound equivalent of a gesture or a plastic scene, i.e. not the sound that accompanies it in reality but the equivalent of this optical fact in the acoustic domain" (Eisenstein 1988: 200). For Eisenstein, the power of the cartoon soundtrack is that it has no need to resemble or anchor the animated gesture in reality. Synchronization he had feared as overly depictive: here he could hope for a dialectic between sound and image. Instead, Eisenstein's reading of Mickey Mouse brings both gesture and sound into a single organic image, a common vector, which has the additional benefit of being free from pernicious documentarism with its risk of autonomous shots and unruly connotations. Where, in chapter 4, we read in the vector of Cohl's graphical cinema the recognition of the other as the precondition of the social and desiring subject, Eisenstein's refusal of a "routine monitoring" allied with his delight in the total artificiality of Disney leads us toward a cinema not of socialization and desire but of totalization and control. The perversion of the vector in total cinema turns it into the Symbolic governance of the subject by the desire of the other, a product not at all of Eisenstein's putative homosexuality, but of the mechanism of repression. Total cinema reverses the emancipation of interpersonal desire as the grounds of futurity.

The move from line to gradation corresponds to a newly static conception of the vector: "In cinema the movement is not actual but is *an image of movement*" (Eisenstein 1991: 145). So, although movement is the *Urphänomen* of film (ibid.: 273), it is at the same time only an induced state of mind, that is, an image in Eisenstein's technical sense of the word. The pixel itself is reduced to stasis, excluded because it is not actual from the realm of the image: "The *undefined* imageless stages between two reasonable combinations are not 'read' and only exist as though non-existent in the mind of the perceiver" (ibid.: 192). If actual movement in the world is a matter of an infinite number of infinitesimal increments, the process of filming renders

only those parts (the initial and final states, the keyframes) that can be read as image. This is one element of Eisenstein's sense of the frame cutting a slice out of reality: the formlessness of pure movement is eliminated by an initiating cut ("Perception is intermittent but here it is the role of the obturator or interrupter to remove from our perception the non-significant elements of the progression or movement from phase to phase" [ibid.]). The realization of cinematic movement is the reassembling of the transition thus edited into an intellectual image of movement trimmed of its distracting actuality.

Nor is this transition itself a dialectical one, at least at this stage of play. In "Montage 1937" Eisenstein writes of the movement between particular and general "the only tension of contradiction that remains is in the area of interaction between different dimensions in which the same thought is expressed" (Eisenstein 1991: 52). Here vectoral possibility mutates into a stable cinematic form, and especially toward a physically, emotionally, and intellectually unambiguous meaning that can be both signified and understood straightforwardly. An even clearer reading of dialectics as an element of harmony occurs in the "Laocoon" essay concerning the exclusion of the Bergsonian, infinitesimal movement: "In film, the chromatic nature of this modulation of one phase into another undergoes what is no more than tempering (like a sound that is fixed, unalterably, by the keys of a piano . . .)" (ibid.: 192). Mere sensation, which I have argued forms the basis of cinematic movement, is explicitly excluded even from the raw material of the shot. Motion exists only as a psychic image for Eisenstein, and the dialectical cut of his earlier montage is subordinate to that core ideal.

It is on this premise that it is possible for Eisenstein to propose the subordination of depth to the graphical composition of the work. Since there is no primary sensation (because the world has already been cut into form by the mere fact of recording on film), every depiction lends itself to vectorization. But the vector has itself been reduced to a horizontal movement of the eye, a movement that can be "trained" in a specific sequence to follow a particular direction, "as though *in a series along the horizontal*," a process that allows the montage director "to *line up shot to shot on the horizontal* and to structure the progression of the music in parallel with them" (Eisenstein 1991: 389). Eisenstein's italics leave little doubt. The deep staging of the sequence from *Nevsky* he analyzes exists only to train the viewer's eye into lateral movement. There is only field, but not depth; or rather depth is

rendered as a vector, not, as in Bazin and the mise-en-scène tradition, as die-gesis. Deprived of the motivating force of sensation, there can arise a kind of hybridization of cut and vector, perception and signification, into a total-ity, "including the 'total,' polyphonic, reciprocal 'sensory' resonance of the sequence (musical and pictorial) *as wholes*. This totality is the sensory fac-tor which most immediately synthesises the principle image of the se-quence. . . . With this the circle, as it were, is completed" (ibid.: 336).

The language of synthesis, tempered chords, total resonance, linear progression, and accumulation does produce the image, in Eisenstein's spe-cific sense, of the unified stability and symmetry of an enclosed circle, rather than the open line of the vector we celebrated in Cohl's *Fantasmagorie*. But this had not always been the case. In *Immoral Memories* we find Eisenstein citing "the wise saying of Wang Pi, of the 3rd century B.C.: 'What is a line? A line speaks of movement'" and, eulogizing the unshaded line drawing, adding "My constant passion remains the dynamics of lines and dynamics of moving on and not staying put," citing his "inclination and sympathy for teachings that proclaim dynamics, movement and becoming as their basic principles" (Eisenstein 1983: 42). But the concluding pages of the same book emphasize a different aspect of the vector. Speaking in the character of "a detached researcher" he says of himself that his single theme through-out all his work has been "the ultimate idea of the achievement of unity." This contradiction between the dynamic and the unified is critical to an un-derstanding of the rhetorical effect in *Alexander Nevsky*.

Nevsky is the most achieved expression in Eisenstein's oeuvre of this stabilized image. The film begins with an *exordium*, a general statement de-signed to bring the audience onto the side of the orator: here the initial state-ment of a Russia in ruin, besieged by the Tartar Khans. The second stage of the formal construction of an argument is the statement of one's own posi-tion: this is the function of Alexander's speech withholding violence against the Khans until the Russian forces are ready for the task. Third, the nature of the case is argued, introducing the opponents' point of view: a function carried out in the debates over whether to fight the Teutonic Knights. The body of the argument follows, with a full unfolding of the case occupying the central section of the film and culminating in a rebuttal of the opposing argument (the Battle on the Ice sequence occupying almost a third of the to-tal running time). The final peroration is composed traditionally of vitu-

peration of the adversary (the prisoners, especially the traitor Tverdilo) and an expanded celebration of one's own point of view, carried out in the jubilation and closing speech to camera. The five acts are not so much a theatrical borrowing as a structured argument.

Aristotle identified three modes of rhetoric. Deliberative arguments are aimed at the future and are proper to public debate on policy; forensic arguments set out to judge the past and belong to the law courts. Eisenstein's rhetoric addresses the present and is specifically epideictic. One of Aristotle's examples is precisely the task of *Nevsky:* the praise of one's country and countrymen ("My subject is patriotism": Eisenstein 1996: 117). This panegyric mode of rhetoric addresses the present, not least because the epideictic concerns itself with moving the audience, with heightening their commitment to issues of which, often enough, they can already be assumed to be persuaded. As Burke observes,

Perhaps the sturdiest modern variant of epideictic rhetoric is in "human interest" stories depicting the sacrificial life of war heroes in war time, or Soviet works (including propaganda motion pictures) that celebrate the accomplishments of individuals and groups who triumph over adversity in carrying out the government's plans for exploiting the nation's resources. For Cicero says that epideictic (panegyric, *laudatio*) should deal especially in those virtues thought beneficial "not so much to their possessors as to mankind in general." (Burke 1950: 70–71)

Burke goes on to observe that the epideictic is closely associated with the "tempered," restrained style of oratory, a style whose aim is to please rather than to persuade. This, however, is the originality of Eisenstein's rhetorical gambit, for he chooses the grandiloquent style, once again echoing Augustine for whom the grandiloquent is most appropriate when minds are to be swayed. The heightened language, the score, the accelerando and rallentando pace of cutting and the use of multiple angles to create a sculptural effect in the depiction of protagonists, and the graphical compositions (*mise-en-cadre*), especially the frontality of many shots, are throughout accumulated in the interests of a grand style, a sweeping argument, a flamboyant call for selfless action. In some of his earliest writings Eisenstein had already decried narrative along with the star system and the individualist

ethos of Hollywood. We should not be surprised that a director who once dreamed of making a film of Marx's *Capital* should produce a film that takes the form of a well-formed thesis rather than a well-made play.

The fine detail of the film also reveals a voice sufficiently powerful to translate the thirteenth century into the twentieth: "Thus the hoof-beats of the Teuton knights in *Alexander Nevsky* do not merely 'hammer for the sake of hammering,' but out of this 'hammer for hammer' and 'gallop for gallop' there is evolved a universal image, galloping across the thirteenth century to the twentieth—toward the unmasking of fascism" (Seton 1960: 382; this passage does not appear in the retranslated version of the article, Eisenstein 1970: 149–167). Two large-scale structures help provide this allegorization of the film's themes: first its score, which, despite the evocative use of ancient instruments and use of themes from folk traditions, is concentrated on the resources of the modern orchestra; and second the deliberately artificial mise-en-scène in Eisenstein's first entirely studio-based film, with its folkloric reconstruction of Novgorod and Pskov and cartoonlike figures from popular ballads like Vaska and Gavrilo. Both factors add to the present tense of the film's address. And both add to the graphical nature of the film a flavor as schematic as slapstick, for example, in the drowning gurgle of the trombone playing the Knights' theme as they sink below the ice, or the mickey mouse percussion as Vaska bashes in the eyebrowed helmet of a Teutonic Knight, for all the world like a Laurel and Hardy bowler hat gag. Bazelon notes a further example: "As the Russian people's army routs the German invaders in *Alexander Nevsky*, Prokofiev gives his folk theme a Mack Sennett-Keystone Kop treatment, perfectly mirroring the silent-film movie-music chase accompaniments" (Bazelon 1975: 145). Yet though it is tempting to read these as borrowings from Hollywood, it is rather the case that Eisenstein and slapstick both borrow from an older and common source.

As David Bordwell notes, "In both narrative and style, *Nevsky* strives for the bare, grand outlines of pageantry or legend" (Bordwell 1993: 211). This spartan clarity of *inventio*, of image, derives in part from the folk traditions the Russian avant-garde (Kandinsky, Chagall, Mousorgsky, Rimsky-Korsakov) had been learning from since before the Revolution. These simplified forms lend themselves especially well to repetition and the forms of delay Eisenstein had urged on his students (Nizhny 1962: 93–139). Delaying tropes in *Alexander Nevsky* include digression and its neatly turned

return to the main theme, as occurs in the romantic subplot and the use of silent pauses. Repetitive tropes include asyndeton, a listing without the use of conjunctions, in fact a highly typical trope of montage in general; distribution, or dividing a theme into components that can be addressed separately, a technique employed both by Alexander (first the Teutons, then the Tartars) and in the separation of the Grand Master, the black monk and the white Bishop at the conclusion of the battle; and antithesis, constantly used in the graphical oppositions between shots.

Central to the aesthetic of *Nevsky* is the rhetorical device of exemplification, almost every character and action typifying the patriotic theme or its antithesis. Of particular interest is the technique called gradation, which provides for a mounting triad of terms from small to large. This structure of threes is an often-observed feature of Eisenstein's framing, but it also appears musically, for example, in the reprised cello theme in the final scene played first for the entry of the prisoners, reprised for the arrival of the traitor in harness, and returning a third time for judgment, itself a triple gesture of gradation—freeing the footsoldiers, ransoming the knights, delivering the traitor to the people he betrayed. Bordwell quotes Tissé, Eisenstein's cameraman, on another example: the advancing knights are shown in long shot in slow motion, at standard speed in the middle ground, "and their foreground attacks at rates as slow as 14 frames per second" (Bordwell 1993: 221). This triadic gradation, a species of the wider rhetorical family of tropes called amplification, formalizes Eisenstein's association of growth with the mechanics of ecstasy in *Non-Indifferent Nature* (1987).

According to Eisenstein's own analysis of a scene from *Nevsky*, "the decisive role is played by the *graphic structure* of the work, which does not so much *make use* of existent or non-existent correspondences as *establish* graphically those correspondences which *the idea and the theme of the given work* prescribe for its structure" (Eisenstein 1991: 371). The theme or image dictates a graphic structure that provides the correspondences. Any correspondences that preexist the idea, that is, any correspondences that belong either to the world or to the literary material on which the film is based, are insignificant. Instead, the sense of a moving line, both visual and musical, dictates what materials will be used and how. The task of combining audio and visual depends on what is commensurable between them: "*movement*, which is fundamental both to a passage of music and to the structural

imperatives of a pictorial sequence" (ibid.: 374). Since Eisenstein eschewed the sense of pure movement as formlessness, this movement is already vectoral, "the path of movement" (ibid.: 377).

In the analysis in "Vertical Montage" (previously translated in *The Film Sense*, Eisenstein 1942: 155–216), the rhetorical dimension of this structuring path is apparent: its social nature reduced from intersubjectivity to one-way address to the audience, a mode common to almost every major speech in the film, where the rhetorical figure of *communicatio*, inviting dialogue with the audience, is signally lacking. However, Eisenstein is also concerned to clarify that the path may also be followed through tonal transitions from dark to light, as he had earlier argued for color transitions as a similar way of directing attention. "Vertical Montage" makes the case for a vectoral composition within the frame, by analogy with the analysis of painting that sees the viewer's attention constructed through the gradations of light and color to the central thematic elements. However, the frame-by-frame analysis Eisenstein gives of the dawn sequence, waiting for the Teutonic Knights' attack, concentrates on a line-based, graphic abstraction from depictions (shots) and musical score, via a schematic of the shots to a graphical "Scheme of Movement" that emphasizes a repeating pattern of an s-shaped sine-wave and a horizontal that he argues is common to both score and image.

Roy Prendergast takes issue with this attempt to read the audiovisual as vectoral: "the recognition of the metaphorical picture rhythm of shot IV [the distant horizon with two flags] is instantaneous, while the musical rhythm that Eisenstein claims corresponds to the picture rhythm takes 6½ seconds to be perceived" (Prendergast 1992: 213), and that "the music is speaking to the psychology of the moment (i.e. apprehension, fear) in terms of the characters involved rather than to any abstract notion of shot development or metaphorical 'picture drama'" (ibid.: 214). Responding to these criticisms, Royal S. Brown notes that musical transitions are experienced as movements "up" and "down" in Western culture, and that Prendergast is projecting a Hollywood psychologism onto Prokofiev's score. He adds that "One of the major pleasures to be had from any artistic experience lies in the deeply experienced dialectic created between the diachronic time in which the work of art is perceived and the synchronic time evoked by its structures" (Brown 1994: 137) and that here the very un-Hollywood discontinuous editing and commentative staging of the score "keeps the viewer at a

certain distance from the temporality of the narrative flow" (ibid.: 138). The total film, then, is less dependent on psychological identification and therefore on the emotional cues provided by programmatic scoring in the Hollywood vein. At the same time, contra Brown, *Nevsky* does address the audience in the present tense, the better to immerse them in the total image.

The iconic winter landscape required dressing 30,000 square meters of the studio lot with 17.5 tons of asphalt, white sand, water glass, and chalk laid over sacking, while the trees were painted white and dotted with cotton wool to extend the graphical effect of Tissé's inventive camerawork (Seton 1960: 384). Like analogous landscapes in other cinemas—most of all perhaps Monument Valley in Ford's Westerns—this promulgates a sense of nation by lifting the land out of history to plant it in myth. The original title of the *Nevsky* script, *Russ*, isolates the mythos of the motherland in the land itself, and the finished film is as staunch a myth of national origin as *She Wore a Yellow Ribbon*, whose landscape passages also function as moments of total cinema.

The precise function of the temporality of the present in total cinema belongs to this mythologizing process: the process of reading the past as model of the present, reading there, in germinal form, the idealized image of the nation as it exists eternalized in the present. This is why psychology is so marginal to total cinema, which not only prefers types, but even seems to propose a fixed set of stock figures (the spineless, the self-serving, the traitorous; the big-hearted buffoon, the idealistic boy, the folksy old man . . .) in a predominantly male universe. In *Ivan the Terrible*, Eisenstein would push this epic simplicity to its limit by providing Ivan with a psychological conflict. In *Nevsky*, however, that conflict is entirely externalized. Nor is it only the Teutonic Knights who are anonymous, in their faceless helmets; the Russian masses too are without personalities. As they wait for battle, it is only the trinity of types—the midshots of Vasilia, Ignat the armorer, and the nearly anonymous Stavka who are singled out as representative. Otherwise we have only Alexander and his two generals pointed up against their counterfoils, the Grandmaster and his wretched priest and monk.

Montage, the Sublime, and the Cyborg Orator

Alexander Nevsky spirals toward the international battlecry of the film's last lines from the domesticity of the opening fishing scene. The film must take its audience from the local to the universal, from home to homeland (under

Stalin's doctrine of "socialism in one country" it was impossible to go further). The cartoonish studio-bound and graphically oriented aesthetic works toward this ascent into totality.

One aspect of this aesthetic is caught in Bordwell's description of a shot from the battle sequence:

There are no cues of cast shadow, color, perspective, or haze. The space is thus relatively shallow. We must rely on overlapping contours and familiar size to place the knights in relative (if vague) depth against the sky. The knights rise and fall, the foreground rider occasionally occluding his mate. But the shot is a very unconvincing depiction of riding a horse. The men's metronomic lungings are implausible as a cue for the thudding and swaying of a horseback ride. And if this is a tracking shot following subject movement, there need to be some cues for relative displacement of figure and background: shifting highlights, slight changes in the knights' positions in the frame. And some background features that by their changing aspects suggest motion parallax. In the absence of such cues, the shot is more easily construed as a static image of two knights rocking to and fro against a backdrop. (Bordwell 1985: 116)

Bordwell's observation is good, but his judgment is off. This is not a failure to achieve Hollywood norms but a successful adoption from Russian folk arts of an aesthetic that abstracts not only the knights from their environment but the diegesis from history.

The word "frame" has two senses in film: the cell marked out on the filmstrip by the framelines and the rectangular edges of the image, the latter meaning reinforced by its linkage to the frames surrounding paintings. Eisenstein's term for this second usage is *kadr*.[4] Aumont cites a 1929 essay in which Eisenstein distinguishes between "the worn out method of the spatial organization of the phenomenon before the camera" (the principle of mise-en-scène) and "The other method, apprehension by the camera, organization by it. A piece of reality is sliced off with the camera lens" (Aumont 1987: 37). Aumont believes this is accomplished through the cutting force of the frame edge. I believe Eisenstein has something else in mind, suggested by the (twice translated) word "slice." For him the camera is not a means for seizing and reproducing motion. Instead, he seems to consider movement as a formless mass hurtling through time toward the camera in all its shapelessness,

and it is the task of the camera to slice it as one slices sausage, into synchronic cold cuts that, far from replicating movement, bring it to absolute stillness. The task of the montageur is, then, to apply formal techniques to these slices to create a psychic rather than a mimetic mode of motion.

In a powerful critique of *Nevsky* in the pages of his *Theory of the Film*, Siegfried Kracauer contrasts this abstracted, constructed motion of the Battle on the Ice with the pure movement of the world in some of the more evocative location shots in *Potemkin*: "Not forced to lend color to any given story lines, the rising mists in the harbor, the heavily sleeping sailors, and the moonlit waves stand for themselves alone. . . . They are largely purposeless; it is they and their intrinsic meanings which *are* the action" (Kracauer 1960: 226). Like Balász before him, Kracauer is an afficionado of Tissé's camerawork, and in particular its ability to capture the indeterminacy of mist and waves, those characteristic movements of enraptured vision, and of the cinema's realist mission (the subtitle of his book is "*The Redemption of Physical Reality*"). Unsurprisingly, then, he is less impressed with the heightened, studio-shot, and rhetorical nature of *Nevsky*:

the pattern of motifs and themes which make up the *Nevsky* story are so pronounced that they subdue everything that comes their way. Hence, even assuming that the Battle on the Ice were cinematically on a par with the episode of the Odessa steps, these patterns which spread octopus-like would nevertheless corrode its substance, turning it from a suggestive rendering of physical events into a luxuriant adornment. Owing to the given compositional arrangements, the Battle sequence cannot possibly exert the influence of that *Potemkin* episode and thus on its part upset the theatricality of the action. It is nothing but an excrescence on the body of an intrigue imposed upon the medium. (Ibid.: 227)

There is a puritanical streak to Kracauer's condemnation in the equation of "luxuriant adornment" with "excrescence" that recalls both the modernist (and racist) warcry of the architect Adolf Loos, "Ornament is crime," and the Romantic refusal of rhetoric as soulless decoration. The medium has already suffered the indignity of having an intrigue forced on it; now *Nevsky* redoubles the insult by dressing up the unwanted narrative structure in the formal patterning of rhetorical tropes, not so much clothing it as growing on it like warts. Worst of all, *Nevsky* is "theatrical," not filmic.

Since *Nevsky* lacks the fluidity of *Potemkin*'s mists and waters, Kracauer argues, it cannot have the medium-specific quality of existing for itself that those images have. Placed alongside Bordwell's critique of the stilted lack of motion and depth cues, this suggests that the purposiveness of *Nevsky*'s framing signals the bare fact that the montage segments are framed and composed. Often enough such evidence of preconstruction connotes for audiences of the twenty-first century the attempt to manage and unify viewers' experience of the film, rather than evoke the (nowadays suspect) patriotic theme. The film is "theatrical" in the sense that it does not attempt to imitate the world. Instead, it has indeed gone back to the "worn-out method" of mise-en-scène, in its original sense of staging in the theater, to further the control of montage over the formless movement of pixels. The total film is total because it seeks to replace the world. Moreover, it does so in the pursuit of a mythologization of its themes that will remove them from history and bring them into the repeatable present of projection. The function of control, then, is not control for its own sake, nor even in the service of society, but to segment the rapture of the entranced gaze and to organize these *tranches* of attention semantically, to substitute for the image-for-itself a regime of the image-for-others.

No longer grounded in dialogue with the audience, the vector becomes a monologic address. The others of the frame as it is sliced off from flux cannot be human: they are the other images with which the single frame combines in the growing spiral of overtonal and vertical montage. Eisensteinian society is thus a society of images. This is how misreading the vector as totality evades the productivity of boundless paradigmatic substitutions and instead produces a realized social ordering of common purpose: the total image. The utopian society of frames, then, conjoined under the regime of the image, is what addresses the audience. Eisenstein's siding with the human in the human-mechanical dialectic of the cinematic apparatus here reveals another side. Replacing the society of people, the society of images turns the film into an agent: the cyborg orator.

The typical form of the contemporary cyborg is not Robocop or the Terminator but the transnational corporation, a planet-spanning hybrid of human biochips, networked communication devices, and offshore factories. In Eisenstein's day, the nascent social cyborg took the form of the European dictatorships. In tune with that political environment, his Stalinist-period

films shape themselves as oratorical devices composed of both the authorial subject working toward the creation of an experience for the audience and of the society of images formed by the rhetoric of montage. By abstracting the graphical from the pulse of pure movement, by musicalizing sound and by harnessing the productivity of paradigmatic substitution to the wagon of allegory and myth, *Nevsky* and total film achieve at one blow the otherwise unreasonable demand for absolute unity and the demagogic requirement of absolute clarity. This substitution of totality for infinity produces that absolute knowledge which Levinas so feared, the obsessive certainty that all too easily turns into terror.

The formal perfection of *Nevsky's* rhetorical construction is precisely what makes it at once so fearful and so attractive. In eradicating the world, *Nevsky* removes itself from worldly temporality. Set aside from history and occupying a timeless time of myth, its formality only fails according to the canons of representation because it succeeds in escaping them, forming instead its own and total organic unity without the confines of depiction and time. The image, in its Eisensteinian conceptualization, becomes sublime.

Stripped of the alibi of a world seen from outside in the eyes of God, this secular sublime turns instead to the cyborg vision of a world stripped also of process. In *Nevsky* there is scarcely ever a sense that a hair has been left to fall out of its assigned place. Even the robust love of life signified by Gavrilo, swinging a phallic bit of clothing, swigging from a bucket, roaring and laughing, is a piece of the montage, a knight on the chessboard. The integration of sound and image in pursuit of a single formal unity, a single thematic image and a single address to the audience, even in this secular mode, attaches itself not to the historical world but to eternity, the eternal present of Virilio's (1996) landscape of events. What the total cinema offers is a *détournement* of the vector toward the task of the cut: the production of the diegesis as both an object in itself, separate from daily cares, and an objective account of that object. The cruel truth of the cyborg orator as total knowledge is that it can no longer produce the social resolution of the dialectic between subject and object. Eisenstein himself left this account of the problem:

An objective "presentation" may be realized only when the phenomenon can be objectively "presented" to itself, that is, when it is possible to put it in front of

itself, that is, having separated it from itself, that is, having put the phenomenon separated from itself, and itself as an observer of itself—opposite each other.

Actually, even in the most common phenomenon, for example a totally "objective" relation to it is possible only under conditions of the removal of any "subjective coloring" in relation to it, that is, any personal connection with it except for a scholarly, unprejudiced interest as to an object or exterior phenomenon.

We certainly cannot put ourselves into these conditions that are necessary for an objective discernment of the laws of movement of matter, in respect to that matter that we compose (and that composes us!).

An orientation of our interest to an awareness of this movement through that part of matter, which we ourselves are, which each one of us is, is inevitably predestined to be inseparable from the subjectivity here completely dominating us.

Therefore such an orientation to ourselves (into ourselves) cannot produce objective knowledge.

However, what does such a striving toward oneself give to someone turning his thoughts in this direction?

It does not give objective knowledge (as we have already said), but . . . the subjective experience of these laws. (Eisenstein 1987: 175, ellipsis in the original)

In the formal universe of the total film, objective knowledge is mirrored by subjective experience: the one belonging to the film, capable of standing to itself as its own object, the other to the audience, able only to experience the laws of the object. Though Eisenstein in many passages embraces the idea of becoming, change, and transience, the ephemeral is always allied with experience and excluded from knowledge, which is knowledge of the "laws" that, governing nature and psyche alike, produce the ecstatic *pathos* at the core of his late thought. But the ecstatic, a "psychic" rather than psychological state, does not belong to the formless world of Bergsonian flux but rather "outside of a concrete connection with a definite system of images, the 'special' feeling cannot really be 'materialized,' cannot be embodied in any way" (Eisenstein 1987: 182). Indeed, the ecstatic state that derives from the contemplation of the sublime in the work of art exists only "as the sense of participation in the laws governing the course of natural phenomena" (ibid.: 168–169). Those laws themselves, embodied in the material of the film, are both the knowledge and the object of that knowledge, and it is in contemplating their completion and their absolute truth that we attain the ecstatic moment of pathos.

This sublime unification of knowledge and its objects, then, is both the lure and the destructive power of total cinema and of the cinematic sublime as it has developed over the years since Eisenstein hitched the discovery of its laws to the obdurate historical necessities of 1939. The genie was out of the bottle. Sixty years later, the montage of effects has become the montage of affects, and total cinema serves no longer the needs of the anti-Nazi struggle, but the perverse desire for the simulacrum that permeates the contemporary blockbuster.

REALIST FILM: SOUND

Jean Renoir and the Reality Effect

Pity and mockery suggest some idea of Good.

—*Thomas Kinsella*[1]

Realism and Beauty

La Règle du jeu (see figs. 6.1–6.4) was a disaster on its first release. A clique of reactionaries, alerted to Renoir's growing popularity after *La Grande Illusion*, dismayed by his espousal of leftist Popular Front politics in *La Vie est à nous* and *La Marseillaise* (Fofi 1972/1973), and aggrieved by his pro-German and pro-Jewish sentiments in an increasingly xenophobic year, orchestrated disturbances at the premier and hostile criticism in the press (see Guillaume-Grimaud 1986: 161–164). *La Règle du jeu* nose-dived at the box-office not only in 1939 but again in 1945 and 1948 (according to Truffaut in Bazin 1973: 257).

Renoir's film is one of the closest to formal perfection of all films—surely the reason structuralist analysis proves so at home with it (see Lesage 1985). At the same time, it is a jarring mix of callow farce and polyphonic symmetries. As a model of realism, its failure with the audience who best knew the world it depicted cannot be recovered under the old lie that posterity is the final and best arbiter. If we recognize something in the film its contemporaries did not, it is scarcely that we know their period better than they. It may be that historical distance makes us more open to the film's formal elegance, but that does not explain why the realist code, intended to reveal truth accessibly, was repudiated by those for whom it had been made, the war-wary audience Renoir confidently expected would welcome the film.

We deal in this chapter then with the simultaneous success and failure of realist film.

Bazin's familiar take on Renoir is that his direction of actors, his use of fluid camera work determined by their movements, his gaze captured and guided by the flashing and ephemeral movements of the world, and his generous opening out of the mise-en-scène through staging in depth and deep focus cinematography make him the master of the realism. But just as Eisensteinian montage is less a matter of cutting than of vectoral infinity rendered as totality, so Renoir's realism is not so much a rapturous surrender to the light as it is an analytical gaze, and so a cinema of the cut. As every serious realist must, Renoir multiplies distinctions and differentiations. Perhaps it was this almost surgical sensitivity to the cleavages and ruptures in the world that made the film so hard to view in 1939. At the same time, perhaps despite itself and in part owing to its continuing status as a classic of world cinema, the film has come to exemplify a distinctive cinematic norm (despite Crisp's misleading belief that the film is best read as an aberration from Hollywood; see Crisp 1993: 395): a cinema whose achievement is the construction of a sensation of reality among its spectators.

The compositing function of deep-focus and depth staging (Braudy 1972; Sesonske 1980) are the most obvious aspects of the cut. Space is discontinuous in Renoir's film. It is a hallmark of a great filmmaker to use the top and bottom of the frame for entrances and exits. Renoir uses them to establish communication between the parallel worlds above and below stairs. But he also establishes discontinuities between the layers of the image created by the mise-en-scène, for example, when Octave is trying to remove his bearskin. Much the same effect is achieved in the bravura editing of the

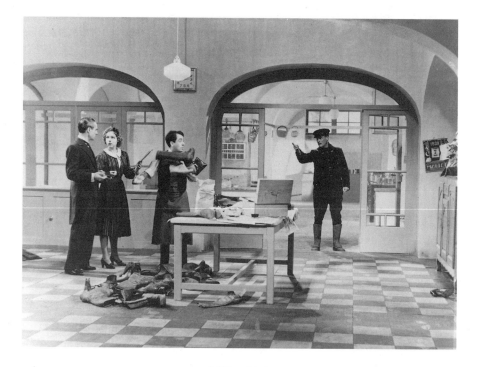

| Figure 6.1 |

La regle du jeu: The kitchen set with Lisette, Marceau, and Schumacher staged in depth.
Courtesy BFI Collections.

opening sequence, as Jurieu's angry disappointment is shown at the airfield, and then broadcast, to eclectic reactions, in a series of discrete spaces whose interconnections only deepen the sense of division between them. In the former case, space is organized in planes more or less parallel to the plane of the screen, while in the latter it is arranged as discrete stage sets that, by theatrical convention, are distinguished in time as well as in space.

The film's theatricality—from its credit sequence matted onto proscenium curtains to Octave conducting his imaginary orchestra—and the traditions of farce both invite the use of depth staging as a way of layering one action over another, as when Schumacher interrogates Lisette while Marceau tries to tiptoe to the kitchen stairs behind him, or when Octave and La Chesnaye react in dumbshow in the background to Christine's welcome to Jurieu. In both cases, attention skips from one action to another by a dis-

junctive route, selecting either one or the other, but unable to encompass both. In this sense the cut between layers constitutes the cinematic event as object of the camera's gaze. In both examples, the dialogue too assumes a layered aspect, a polysemy determined according to which of the characters' reactions we tend to isolate. Where Méliès's use of layers was formed about the construction of a single event, Renoir's sound-era layering produces not only multiple events, but the event as multiple, truth escaping the wit of each protagonist and multiplying the positions from which the meanings of the scene can be understood or interpreted among both the audience and the protagonists.

Nor is the camera in a privileged position of absolute knowledge. Rather, as Bazin notes, it is personified:

Throughout the entire last part of *The Rules of the Game* the camera acts like an invisible guest, wandering about the salon and the corridors with a certain curiosity, but without any more advantage than its invisibility. The camera is not noticeably any more mobile than a man would be (if one grants that people run about quite a bit in this château). And the camera even gets trapped in a corner, where it is forced to watch the action from a fixed position, unable to move without revealing its presence and inhibiting the protagonists. (Bazin 1973: 87)

This "half-amused, half-anxious way of observing the action" (ibid.) is a result of pure technique. Raymond Durgnat identifies this anthropomorphism of the technical machinery as "a Christian phenomenalist awareness of the continuity between director, aesthetic set-up, illusion and spectator" and counters that, after all, the film is not a single continuous shot or, like *The Lady in the Lake*, filmed entirely from the point of view of a single character; he points out that "there are, after all, about 400 cuts in the film" (Durgnat 1974: 194). What this statistic loses is the tremendous difference in pace between the bulk of the film and the rapid cutting of the hunt sequence, which introduces a mathematical anomaly into the calculation of average shot length.

More informative is Barry Salt's diagram of the shot types in *La Règle du jeu* (Salt 1983: 249), where medium, medium long, and long shots dominate, with close-ups and medium close shots following behind. The diagram is unusually level. Though there are unsurprisingly few big close-ups or very long shots, the film covers the characters and their environment remarkably

evenhandedly. The big close-up is a privileged access to the soul of a character, whereas the very long shot belongs to the class of shots (like very high angles, crane and aerial shots) that give viewers the sense of a divine abstraction from the action. The anthropomorphism of the camera is thus also a kind of humanism.

The problem of realism is usually stated as a problem of representation—of the relation between signifier and referent, or more generally between signification and world. If we consider it as a special effect of which the cinema is capable, however, we can construe realism slightly differently. In *La Règle*, first, the profilmic is constructed as layered and so as multiple, and hence open to contradictory meanings and interpretations. At the same time, the anthropomorphic camera suggests that the reality effect reunifies a world that it has first multiplied, by establishing a cyborg relation between the viewer and the camera, and hence with the projection of the film. Realism's differentiating gaze renders the world as multiple, but at the same time it recognizes that its gaze is not only differentiating but differentiated, in such a way that multiplicity can become its singular object.

Something similar holds of the soundtrack. "I regard dubbing, that is to say, the addition of sound after the picture has been shot, as an outrage. If we were living in the twelfth century, a period of lofty civilization, the practitioners of dubbing would be burnt in the market-place for heresy. Dubbing is equivalent to a belief in the duality of the soul" (Renoir 1974: 106). The reality effect that emerges from *La Règle du jeu* is as much a function of the soundtrack as of the visual, a result of the privilege accorded to direct recording of sound, postsynchronized sound being used only to generate the accompaniment to the opening and closing credit sequences. Where extradiegetic music in narrative sequences tends to emphasize the presence of an intelligence narrating the tale and commenting on it in musical form, the emphasis on dialogue and sound effects proposes something else: a story that tells itself. Toward the end of the meal in the servants' hall, music gently wells up in the background. It seems to be nondiegetic, but at a certain moment the chef turns off a radio until then unnoticed. Our anchorage in a music that seemed to be instructing us in how to respond to the sequence has been severed: now we understand that it is merely an accident of the diegetic world, an interruption into the kitchens of other times, recorded and broadcast, and other places, synchronous but working to their own schedules. In the opening sequence, the radio places us in a subjectivity dispersed across

the characters and spaces of the film, a consciousness that hears around corners and links disparate sets through a foregrounded technology. Inhuman or cyborg, the radio is a consciousness impassioned by the group psychology of a community in disrepair, capable of eavesdropping but not of comprehension—a prefigurement of the misunderstanding of the spyglass. The truth we overhear is not absolute but social, even when we are out in exterior locations with wild-tracks of country noises.

Such truth is not single, and the consciousness that retails it to us is not single either; but neither is it multiple. Quite the contrary—in the formal symmetries that structure it visually and aurally, the film establishes a powerful sense of unity. A multiple consciousness would have to provide us with multiple points of view, yet the film rarely privileges a point of view shot except to demonstrate the fallibility of vision. Like the radio, the film is not a unitary subjectivity but a zero subject, one that is not identical to itself. As we have seen, the nonidentical implies flux. Insofar as the nonidentical subject seeks truth, it must be self-abnegating to be receptive, but also unfixed, and unstable, as is the world that it observes. So the crux can be understood as the relation between a zero subject observing a numerable world. The film, then, is not itself a machine but an account of one.

Take the famous close-up of La Chesnaye introducing his mechanical organ at the height of the fête:

DALIO: *I don't know why I had such trouble standing in front of the camera just for a few seconds. Perhaps, because I did not say one word . . . I had no dialogue to help me. We actors, you know, we need some speech, and in this particular shot I had no words. I had to appear, then react, and you weren't satisfied with . . .*
RENOIR: You had to appear modest and also vain . . . that's not so easy . . . and against you, you had the terrific music of the mechanical organ . . . which was deafening.
DALIO: *Well, I only got it right after two hours. I remember, you retook it . . .*
RENOIR: But what a shot, eh?
DALIO: *Yes, that's what people often say to me.*
RENOIR: As it is now . . . I think it's the best shot I've done in my life. It's fantastic. The mixture of humility and pride, of success and doubt . . . I realise that I was wrong about it at first, I thought it could be an improvised shot, but in fact we had to work on it, shooting it again and again. (Renoir 1970: 12)

The emphatic sense of work involved in creating a moment of reality—a reality effect—emerges again in accounts of the hunt sequence. As Cartier-Bresson recalls, "It was not very easy, because Dalio and the other actors had no idea how to hold a gun, and I had to shoot the rabbits while they were pretending!" (Cartier-Bresson 1994: 557). Durgnat notes the difficulties of directing dying rabbits, even though they were collected and loosed in the best possible places for the shots required, as well as the difficulties of protecting cameras and crew from ricochets: "As it was, the sequence took several men two months to shoot, the final solution being to install camera and crew close to the rabbits, but in an armoured shed" (Durgnat 1974: 186). The modern telephoto lens would seem to get around this problem, but even telephoto is a means to a special effect, achieved by a process of work and appreciated by audiences as effect.

"One starts with the environment to arrive at the self," Renoir wrote late in his career (Renoir 1974: 171). Thus in *Madame Bovary* the sounds of lowing cattle and clattering horses, the clip-clop of hooves mixed with the chatter of a brougham rolling over cobbles, build toward an understanding of the peace of the Norman countryside and the desperation that quiet brings to Emma. At the opposite end of the scale, and closer to Dalio's experience with the mechanical organ, lies the recording of trains in *La Bête Humaine*, where the sound of *La Lison* is that of the very train in which Gabin and Carette ride, the noise of which forces them to communicate by gesture, and which is carefully modulated as the train runs on open track, through tunnels or over bridges, distinguishing quite clearly between the haughty echo of the engine hall at Le Havre and the far deader sound of the Gare St. Lazare, and evoking in detail the singing of the rails after the train has passed a small country station, or how its passage rings over the water when heard from below a bridge. Such is the sound of the frogs in the marshes, of the echoing gunfire and the shouts of the beaters in establishing the Sologne, and its difference and distance from the crowd scene at the airport with which the film begins.

Most of all, however, what we hear in *La Règle* is voices. It would not be quite true to say that we hear dialogue, much of which is muffled by the surrounding acoustic and especially by the overlapping layers of talk. The dialogue of *La Règle* is closer to what Chion calls "emanation speech" (Chion 1988: 92ff). Alan Williams notes Renoir's fascination with the voice, distinguishing between the emotional interest of the later films and the social

variety of speech in those films of the 1930s in which "he emphasized its function as social marker (through confrontations of different accents and word patterns)" (Williams 1992: 315).

Moreover, as Michel Marie observes,

what Renoir's cinema rejects, from 1931 on, is a "neutral" French, the "zero degree of spoken French" that in fact is only the speech of the Ile de France, and more specifically that of the intellectual bourgeoisie; an 'unmarked" speech because it determines the norm, the "standard of reference." This anemic language that is taught in the Conservatoires reigns unconditionally over the French cinema today; it is the speech of dubbers. (Marie 1980: 220)

Marie notes Carette's Parisian voice in *La Bête Humaine*, Dita Parlo's "delectable accent of the German Alps" in *La Grande Illusion*, and Nora Grégor's "foreign" accent as Christine. The association of normative accents with dubbing and with a damnably theatrical style of expression of course points toward the realist aspiration of the films. But it also indicates a specific job of work undertaken in casting and directing to establish the sound of the voice as a critical technical device, as significant and sometimes more so than the improvised dialogue it delivers. There is, then, a specific meaning of the word "poetic" to apply to Renoir's use of voices. In the rhetorical framework, Renoir's realism is a mode of *elocutio*, the choice and ordering of words, but we have to add immediately that these words are selected as much for their sound as for their sense ("is not the human voice the best means of conveying the personality of a human being?" Renoir 1974: 103; "I started to be interested not so much in words but in sounds. In the expressions of the human being helped by the emission of sounds," (Litle 1985: 312, citing a 1954 interview of Renoir by James D. Pasternak). When, for example, the general pronounces the word "rare," the long a and rolling rs expose more than either what the General intends by them or what we can read of the film's judgment on his intention: we hear also the sound itself as a marker of class, just as we hear in Octave's quickfire repartee or Jurieu's hesitance their outsider status at the château.

The spaces of *La Règle*, similarly, are not unified in a single gaze. Explicable neither as profilmic, empirical nor geometric, the stacked layers of the action are incommensurate with one another. The same multiplication of perspectives holds good of the voices. In several of Renoir's films of

the 1930s, there is a protagonist—Lantier, Emma, Amédée Lange—whose voice carries our attention as the focal point through which all the lines of sound coagulate. Such is the scene in *Le Crime de M. Lange* in which Amédée enthusiastically yells out the story of his comic book, while the camera pans around his room, leaving him behind as it inspects the map of Arizona and the cowboy trappings of the down-at-heel cold-water flat in Paris. There the fantasy carried by the voice is belied by the environment, but it is the voice that persuades us—that the fantasy is better than the reality. In *La Règle* there is no single voice to give us a similar centering. Indeed, as Michael Litle observes, there are instead only the patterns of devices that separate voice from the person—microphones, loudspeakers, telephones (Litle 1985: see also Chion 1999: 62).

The player piano that so fascinates the women around it in the *danse macabre* sequence gives us another model for the dialogue: that it is a rule-governed system that plays itself. Like the visual spaces, the aural spaces demand neither empirical nor absolute knowledge but a lexicon, exactly that lexicon that Jurieu lacks. Visually but especially aurally, time in *La Règle du jeu* is the duration between event and comprehension, a duration that extends into a gap and thence into a gulf of silence, like Octave's inaudible orchestra. After Mozart's "Danse Allemande" over the opening credits, we must hear only what is in the world of the film—a small restriction that has subsequently become almost a gospel for realists: the British television soap opera *EastEnders* has maintained the same rule for two decades. The loss in reality, and the commonsense belief today that "realist" means "depressing," arises from a misunderstanding of why Renoir introduced this tool for verisimilitude. It was not to evince his hatred of the world that is but quite the opposite: to love it better, and to convince us that it is worth loving, even if those who inhabit it can neither see nor hear themselves or it. The tragic tone arises not from an external judgment but from within that world which cinema alone can recognize in its unique and vulnerable ephemerality. Its sole error, perfectly understandable, and unfortunately the one lesson genuinely repeated from the film's aesthetic as a norm, is the unification of that fleeting multiplicity around the mortal moment. This is what has allowed realism to ally itself with the fatal nihilism of an artificially restricted sublime, and to fail even in its self-proclaimed mission to reveal the world. Instead, as ever, it has succeeded only in depicting an image. It was Renoir's achievement to have made of that image an adequate if tragic response to the world.

Neither Cartesian nor mimetic, the layered, analyzed space of *La Règle* is a special effect. The reality effect is never purely textual because it has to exist as an effect for someone. Even if, as apparatus theory argues, "someone"—the subject of signification—exists only as an aporia and at the same time a moment of excess in the signifying chain, nonetheless "someone" has to occupy the position at which realism is effective. As Ien Ang (1985) discovered in her pursuit of popular meanings of the 1970s soap opera *Dallas*, "realism" can apply not only to formally realist and convincingly realistic texts but to the perceived authenticity of depicted emotions. *La Règle du jeu* is such an emotional portrait, or rather, in the melodramatic mode, a portrait of emotions. To some extent the film is curiously unaffecting: we care relatively little for any of the characters, who in turn often seem to care little enough for themselves, declaring with wilting charm their boredom, their fickleness, their trivial relationship with life. Rather what enchants is at once the levity of the life shown and to some extent embraced by the film, and its amoral wit, while we are nevertheless drawn to judge it; in short, the harmony between the dissection of the social game and the delight of playing it.

The Bachelor Machines

Apparatus theory posits "a sort of 'common trunk' . . . the cinema-machine itself envisaged in its conditions of possibility" (Metz 1982: 152), embracing industry and audience in the technological bases of cinema. Drawing on Panofsky (1991) and Lacan's relation of perspective to the Cartesian *cogito* (Lacan 1973: 86), for apparatus theory the perspectival geometry of camera and projector unify subjectivity, so constituting the individualist subject required by modernity and capital: the subject of ideology. As Panofsky argued, perspective had been reviled before: by the German Expressionists for its objectivism; by Botticelli for its subjectivism; by Plato for confusing objective and subjective. For Panofsky what remains constant throughout the epochs of perspective is its mathematical nature, and that what it "mathematizes" is, albeit in abstract form, the empirical field of natural vision (Panofsky 1991: 74). So he is able to conclude that the triumph of Renaissance perspective was achieved through the negation of both magical and symbolic spaces to bring the supernatural world of miracles within the ambit of direct perception, "in the sense that the supernatural events . . . erupt into [the viewer's] own, apparently natural, visual space and so permit him to 'internalize' their supernaturalness" (ibid.: 75). For Panofsky this triumph

| Figure 6.2 |

La regle du jeu: The Marquis and Jurieu: playing the game too well or not well enough.
Courtesy BFI Collections.

announces the end of theocracy and the arrival of a world centered on the human. Like Bazin, Panofsky believes that by bringing the (super)natural within the pictorial field, perspectival or realist representation allows it to erupt in all its strangeness into consciousness.

For apparatus theory, it is not humanism but the geometrical perspective normalized in the beaux arts tradition that is designed into camera and projector lenses. The cinematic apparatus encourages or enforces an identification with the lens as both recipient and origin of the image. But unlike both Panofsky and Bazin, apparatus theory suggests that the geometry of illusion promotes identification with the machine, not the world, and that that is the source of anthropocentric individualism. But then we are already faced with a dual identification—with the apparatus and with the self. Likewise for Panofsky: the perceiving self externalizes its visual perception

as field, then projects the field as object or as medium for a third element, the irruption of strangeness into consciousness. This epiphany is the sought-after realization of the world in consciousness, and it takes, in secular realism, the form of a sudden rending of the familiar veils of habit.

Assimilating the institutional, the technological, and the psychological, the sole job of the apparatus is to renew itself through the circuit of ticket purchase and investment in further production (Metz 1975: 19). At the same time, "a society is only such in that it is *driven by representation.* If the social machine manufactures representations, it also manufactures *itself* from representations" (Comolli 1980: 121). As both economic and ideological, the cinematic apparatus is purely homeostatic. Here, as in the conceptualization of social "technologies" in Foucault, there appears an echo of the Catholic social critic Jacques Ellul, for whom the term "technique" embraced not only mechanical technologies but also the technologies of economics, organization, and those characteristically modern technologies, "from medicine and genetics to propaganda" for which "man himself becomes the object of technique" (Ellul 1964: 22). In an assault that resonates with Renoir's mockery of the Count's artificial music machines in *La Règle du jeu*, Ellul believes that "The human being is delivered helpless, in respect to life's most important and most trivial affairs, to a power which is in no sense under his control. For there can be no question today of a man's controlling the milk he drinks or the bread he eats, any more than of his controlling his government" (ibid.: 107). Apparatus theory links the critique of technology in Mumford (1934) and Giedion (1948) to the pessimism of simulationists like Baudrillard and Virilio. For apparatus theory, cinema is one more technique evolved to separate the human from the world, to hand its subjects over bound and gagged to a self-replicating system of pure representation.

Critical to the version proposed by Metz, Baudry (1976, 1985) and Comolli is the concept of a subject unified at the Cartesian vanishing point of optical perspective, the point of convergence of all lines of vision focused and refocused in the camera, the projector, and the architecture of the cinema auditorium. Hubert Damisch's critique of Panofsky (and also explicitly of apparatus theory, Damisch 1994: xv–xvi) points out the centrality of infinity to the geometrical construction of the different forms of perspective that, he is adamant, cannot be reduced to a single technique or a single ideological system.

As we have seen, *La Règle* is remarkably poor in those very long shots that offer a view of the world from the standpoint of the infinite. Moreover, both Damisch and Panofsky suggest, perspective itself is not a technique of illusionism but a gateway to a mystical universe that appears precisely at that vanishing point which Renoir's layered and segmented vision does not open up for us. Damisch's argument is that Renaissance perspectival space is not Cartesian, not least since Descartes's own geometry, like that of the ancients, was fundamentally two-dimensional. Eli Maor (1987: 109) makes a similar point: geometrical perspective is a projective geometry whose goal is not the definition of the "true," absolute geometrical form of spheres and cubes, but the transformations they undergo when projected: a science not of the world but of its appearances. In effect, what perspective makes visible is not the world but the gaze we turn on it. As such, it is as likely to produce a sense of unreality, or rather a doubled sense of the marvel of appearance, a sense of wonder that embraces both the appearance and the machinery that makes it possible. In Panofsky's description there is only the word "internalize" to suggest that there is at stake a unification rather than a dispersal. Geometric perspective in general and the foreclosure of the mystical infinite in Renoir in particular suggest that, paradoxically, we experience mediation immediately—a double articulation that, as it were, encourages us to see the window at the same time that we see through it, in the cinema assimilating the depiction at the same time that we are awed at its production. We are confronted, then, not with the achievement of unity in the apparatus—the ideological theory of realism—but by a dialectical process that multiplies and unifies at once.

This dialectical realism is further affected by the recorded nature of the image. When apparatus theory privileges the camera and projector as key elements of the institution of cinema, it elides the institutions of postproduction so important to the study of special effects: the edit suite and the laboratory. Emphasizing the mirrored roles of camera and projector, apparatus theory spatializes the cinema, so colluding in the dehistoricizing procedures of the culture it so wishes to critique. Postproduction processes, where the temporal dimension condenses, flag the role of the cinematic institution as a delay in communication, underpinning the duration of the film itself with the separate but contributory temporality of the business of filmmaking. To ignore postproduction is to ignore the time of mediation, and to

subscribe to the perilous predestination of ideology's success by misrecognizing as immediate its temporal workings.

Both as a portrait of an ancien régime in decay and as a reworking of the theater of Beaumarchais, Marivaux, and Musset, the film evokes and evoked a certain archaism. Even at the time of its release, *La Règle du jeu* was already a document of a certain past, even though Renoir was still cutting after the premier. By the time the current version was restored, it had become a historical record not only of a class but of a mode of communication. Between 1939, the year of its first release, and 1952, the year of its first appearance in the *Sight and Sound* lists, television, with its ability to transmit live, had usurped the critical priority of cinema. As broadcasting usurped the documentary role of cinema, critical perception of *La Règle* changed from urgent depiction to contemplative formalism. It was perhaps this unwilled transition that informed apparatus theory's crucial misunderstanding of the temporal relationship between spectators and technologies of cinema.

The word "apparatus" translates two French words, *appareil*, or machinery, and *dispositif*, which also has the sense of arrangement or disposition of materials. Joan Copjec notes that *dispositif* refers to discourse rather than technology, an institutional mode of signification in which "truths are internal to the signifying practices that construct them" (Copjec 1982: 57). In the *dispositif* variant, since discourse is never over, unified subjectivity is never achieved, least of all under the conditions of production of *La Règle du jeu*. Drawing together the evidence of a number of biographers and critics, Wollen (1999) observes that Renoir's crew on this film had worked together in various combinations throughout the 1930s, a familiarity that explains Renoir's repeated description of *La Règle* as his most improvised film. Though it has become normative, it was not itself formulaic, and the resulting subjectivity is not the result of anonymous serial manufacture on the studio model of apparatus theory but the work of a community of intimates. Rather than a preordained, stable, and centered effect that believes itself a cause, the subject of this apparatus is an unstable and dislocated agency of signification that believes it is its product.

No one pretends that a film, least of all a fiction film, describes unambiguously or finally a world that preexists the filmmaking. This is a matter not only of what is lost but of what is gained. In any film, the diegetic world is often more cogent, more coherent than the everyday. When the film is a

fiction, the diegesis will also be more symmetrical, more logical, and more just than we know our world of experience to be. As a result, something radically unstable filters into realist narrative diegesis, a competition between the demands of verisimilitude and those of formal elegance. For Copjec, the "forms that discourses take are not *expressions* of a last instance, a sovereignty which maintains and reproduces itself through these discourses. To determine the conditions of existence of a particular discourse is not to reduce these conditions to a monolithic discourse" (Copjec 1982: 58). The concept of *dispositif*, Copjec believes, is just such a conflictual and open notion of the work of film. The Althusserian "last-instance" determinism (Althusser 1971: 160) of the rival concept of *appareil*, is, she argues, an error that "threatens to jettison the radical potential of the concept of the *dispositif* in favor of the hypochondria of the unified male body image" (ibid.: 59). It is not the cinema but this particular theory, fetishizing the technology in an effort to avoid sexual difference, that is the true bachelor machine.

Far from exemplifying a patriarchal machinery of dominance in full flood, *La Règle du jeu* rather consciously embodies the idea of cinema as an apparatus, as an institution that incorporates both the technological conditions of production and the psychic connections and positionings that it enables or determines, even the best part of four decades before the idea was conceptualized. *La Règle du jeu* is itself a machine, in the sense captured by Deleuze in a gloss on Foucault where he singles out the factory as the most visible type of the "environments of enclosure" associated with surveillance societies. The factory's function, Deleuze notes, is "to concentrate; to distribute in space; to order in time; to compose a productive force within the dimension of space-time whose effect will be greater than the sum total of its component parts" (Deleuze 1997: 444)—a neat description of the romantic, organic artwork. Renoir's plot machine, coupled with his vision machine, both articulated through his sound machine, exists to describe, as if by analogy, the social machine that it depicts, a machine whose purpose, like the machines of early cybernetic theory, is to control itself.

At the same time that *La Règle* presents itself reflexively as a machine, however, it exists as a machine for depicting another machine—the paranoid projection machine of the haute bourgeoisie embodied in the rules of its games. Psychoanalysis defines paranoia as a defense against homosexuality that invokes both a phantasmatic power to influence and a hypochon-

driac state smitten by fantasies of persecution. This machine, fabricated from constantly elaborated delusions, projects them outward as objects that reverse direction and punish a subject whose "perverse" desire cannot otherwise be acknowledged or enacted. The self-critical role of the filmic machine in *La Règle* is critically visible in what otherwise the machinery of paranoia exists to blot out—the unnamed but highly distinct homosexual man. The film presents what is distinctively absent from the bachelor machine, the screen presence of homosexuality ("Well, have they or haven't they?" he asks of Jurieu and Christine in shot 106. When Charlotte replies "They have," his response is unambiguous: "What a shame . . . such a distinguished boy!" [Renoir 1970: 74]).

The rules of the haute-bourgeois game have not so much denied as disavowed homosexuality in a movement that accepts the signs but not the actuality of desire. Perhaps it is possible to put this in a more responsible way, in a language more empathetic to Renoir's project. The bourgeois game doesn't disavow desire. It disavows love, the very love the film itself extends toward them. The whole intelligence of the film—which I have been calling "Renoir"—exists in this forgiveness it rains on the world it presents, a forgiveness tinged with the tragic realization that it is necessary to love this world because it is the only one. The film machine doubles the social machine to negate its lack of self-love, to fill the void in its heart, to be the projection of a love it denies itself.

Fantasies of Negation

Copjec contrasts *dispositif,* structured by absence and sexual difference, with the paranoia of *appareil* and its ascription of deathly powers of influence to an external projection of the self. Penley goes further, offering a theory of fantasy: "to describe not only the subject's desire for the filmic image and its reproduction, but also the structure of the phantasmatic relation to that image, including the subject's belief in its reality" (Penley 1989: 80). The constant recombinations and reconfigurations of characters onscreen, for example, correspond to the multiple and shifting subject positions open to the spectator while still recognizing the centrality of the cinema's institutions to the production of meaning and engagement with the image. This formulation, echoing Freud's account in "A Child Is Being Beaten" (Freud 1979), suggests that there are multiple relations with the image, including

faith, incredulity, negation, and disavowal (I believe, I don't believe, I'm being lied to, I know it isn't real but), each of which can be active separately, sequentially, or simultaneously.

An ensemble piece like *La Règle* clearly invites multiple positioning: coherence, likeness to material reality, probability, reversal, emotional authenticity or psychological credibility, disbelief, willing suspension of disbelief, disavowed suspension of disbelief. *La Règle du jeu* does not enforce a single unified subject position. Rather it enables a multiplicity of subjectivities.[2] It is precisely this multiplicity that enables the sense of freedom Bazin felt so deeply, and permits the audience to return to the film the feeling of an unstill, many-layered, ephemeral world. Kracauer is thus quite wrong to identify photography as antipathetic to fantasy, at least as Penley defines it. Quite the contrary: fantasy is the multiple nature of our relation to the world, most of all when it is depicted.

Deep staging, mobile camera, ensemble playing with no clear protagonist: these too played a part in the film's failure, for exactly the reasons that make them the norms of realist cinema today. The cut comes into play in a further difficulty experienced by the film's first audiences, a difficulty in the editing. Durgnat notes that some critics had a problem with Renoir's butterfly mind, his interest not only in the core action but in the environmental details, often apparently unrelated to the action, that catch the camera's look at odd moments in the film. "The difficulty which Renoir posed for the critics," he suggests, "was the way in which his interest was constantly flickering from the obvious climax to some adjacent distraction or unemphatic theme" (1974: 217).

La Règle certainly benefits from the recasting and rewriting of characters necessitated by unforeseen circumstances, producing a film that is much less centered on a single character (Christine appears to have been the protagonist at one point until Renoir seems to have fallen out of love with Nora Grégor's screen presence; see, e.g., Bertin 1991: 159–60; Bergan 1992: 201) and thus on character psychology. The result is a film that skips from character to character, allowing us enough time to understand their motivations and reactions, but fascinating us with the dynamic of their interplay as a portrait of the group rather than as individuals.

Of a rather different order is the insert shot of a frog in the moat at shot 295, dropped suddenly into the dénouement of the film. It is possible to accuse Renoir of emulating the free, distracted gaze of an interloper in the

action rather than giving that freedom to the audience, but the sheer inconsequentiality of the shot baffles the viewer, and becomes a forgotten detail, a self-erasing instant (I have found no mention of this shot in the extensive literature on the film, though it would certainly be possible to embroider an interpretation).[3] Unmotivated, the image does not determine either subjectivity or sense, and indeed it creates the possibility that things don't necessarily have to mean anything at all in the film—that they can simply be there and as such drag us out of our illusion of understanding, denying our determination by the film's construction of meaning, refusing the monolithic ideology effect propounded by the bachelor-machine version of apparatus theory. Once again we find, as perhaps Bazin might have hoped, that realism creates a form of freedom in the spectator, but circumscribes it with the governing presence of a world that, however unmotivated, nonetheless is signified though it does not signify. Because it does not signify, the depicted world can retain its autonomy even from the processes of depiction on which it depends.

The shot of the frog opens up the possibility of an encyclopaedic catalog of the ways that a world can be inhabited. But even if Renoir's realism is characteristically geometric or typological rather than narrative, there remains a risk that the subjectivities set into motion by the realist film may themselves be subject to some form of cataloging, and that the list of identifications and distancings suggested above is not an infinite series but a matrix of possibilities carefully structured in relation to that agency which Renoir calls the rules.

The concept of a rule-governed system lies at the starting point of apparatus theory, Jacques-Alain Miller's seminar on suture. Citing Frege's account of the foundations of arithmetic (see chapter 4, note 1),[4] Miller argues that number arises from the subsumption of a thing under the object, and the object under a concept. To be numerable, a thing in the world has to be identified with itself as an object, as occurs in the filmic cut. In this progression, what constitutes the object as such is its difference from the thing it subsumes, "Whence you can see the disappearance of the thing which must be effected in order for it to appear as object—which is *the thing in so far as it is one*" (Miller 1977/1978, 27). Miller here describes hypostasis. The thing must become unitary, countable as one, an object, when it offers itself for signification. The thing-in-itself becomes an object-for-others. In the process it must lose its nonidentity.

A countable world is no longer the world as such, which in the Lacanian vocabulary is the Real, that which is excluded from signification. Foregrounding the missing heart of his world, Renoir's realism appears to address exactly what is absent from the screen, devoting itself to analyzing the multiplication of entities that ensues from the primary absence of the world from the diegetic universe. The exclusion of the world is synonymous with its signification. Like all signification, both the film and the strategies of the game take the form of a system. In this instance, the system is paranoid. The rules demand the disavowal of homosexuality, not because it is intrinsically evil or unbelievable, but because disavowal is the film's diegetic procedure for assimilating difference into unitary homeostasis. Thus homogeneity legitimates itself by containing what would otherwise be its excluded other. Difference must be included, if only under the sign of erasure or marked as negative. Disavowal is the key to the system.

In Miller's account, Frege's nonidentical zero is the necessary basis of any logical system, including the logic of signification. Like Lacanian "lack," this nonidentical generates signification and is therefore a formative principle of subjectivity. But why should the construction of subjectivity reside on the "negativity" of zero? Although Lacan had elsewhere at times proposed -1 as the numerical designation of the subject in keeping with Miller's suggestion of a "pure negative" (see Heath 1978/1979: 52), in the important seminar on vision of 1964 he was designating it as "*rien*" (see e.g., Lacan 1973: 171). Negativity is not zero, which sits between positive and negative. Miller's construction of pure negativity instead produces a new and fantasmatic subjectivity as the reversal of the infinite—a negative infinite that, since it is a component of every other number, is ubiquitous. This makes Miller's case for the primacy of signification, but places all change, all history, as well as all significance exclusively on the side of the subject, while condemning it to an infinity of dissatisfaction.

Here the distinction between nonidentity and negativity is vital: zero is not void. In the realist norm, however, there is a negative, but on the other side of the equation: the world is lacking, excluded from the rules of the game as its absent heart. The nonidentical is not a function of the Symbolic: it is the nature of the Real. It is the world that is not identical with itself, the Real moving image too, which is also, as far as the spectator is concerned, a sensory datum before it can become either an object of perception or a

meaningful sign. The realist image—like the random frog—belongs first to Firstness. It is not the subject but the object that lacks. Nonidentity belongs to the world, not the subject. Far from a unified image generating a unified subject, the nonidentity of the world engenders the fantasmatic multiplication of identities. However, once realist dialectics of depiction and form are embraced as normative conventions, realism finds itself returning in an attempt to reconcile the nonidentical and identity so that it can reunify the world, a unification it identifies in the mystical moment of epiphany.

Epiphany and Mortality

As Thompson (1988: 231–233) points out, a great deal of effort has gone into the artificial construction of a diegetic world of *La Règle* in such a way that it both resembles the everyday and articulates optimally with the requirements of the apparatus, so closely indeed as to become part of the apparatus itself. Yet, to the degree that it articulates (with) the bachelor machine onscreen, the filmic system also begins to betray traits proper to the machine it depicts, proliferating and elaborating systems of viewing and hearing in the interests of a final reunification that is in the end not merely pessimistic but nearly nihilistic. The lure of the epiphany is that it seems to offer a still point at which fantasmatic subject and nonidentical world can be unified. But there is a price. That moment, which both entices with its visionary power to unify and repels with its revelation that there is no meaning in that union, is the sublime.

So realism runs between two risks. On one side lies the sublimity of a unified vision that can take us out of meaning and therefore out of that history which it is realism's mission to bring us into. This is the moment captured in Bazin's citation from Mallarmé's sonnet on Edgar Allen Poe: realism is "concerned to make cinema the asymptote of reality—but in order that it should ultimately be life itself that becomes spectacle, in order that life might in this perfect mirror be poetry, be the self into which film finally changes it" (Bazin 1971: 82). On the other side lies the peril of conventionalism: the realization that "realism in art can only be achieved in one way—through artifice" (ibid.: 26), a "necessary illusion," but one that "quickly induces a loss of awareness of the reality itself, which becomes identified in the mind of the spectator with its cinematographic expression" (ibid.: 27), at which point the filmmaker is no longer in control, but the dupe of her own technique. To escape one peril

is to propel yourself toward the other. Between the autonomous logic of the system of technique and the pure negative of the sublime, the pursuit of the world in film seems doomed to the Freudian dialectic of desire and thanatos, the endless pursuit of the object of desire down the chains of signification, or the nirvana principle, the death instinct, the sublime moment at which meaning and subjectivity are extinguished together.

The genius of *La Règle du jeu* is that it understands exactly these perils. The film depicts a society for which the world has become void in the triumph of signification. In its place are only the illusions produced by the system itself—the farewell misunderstood as passion through the spyglass, the coat and cloak taken as markers of identity in the mistaken amours in the greenhouse. Against these the film juxtaposes a sense of the world as full, crammed with lives the characters themselves cannot perceive. But Renoir, despite his inventions and improvisations, his pirouettes and backflips of technique designed to trick the world into revealing itself by willful twisting of filmic conventions, nonetheless gives the lie to the fullness of the world himself by entering into a doomed tryst with death. The fullness of the world that emanates, almost as a scent, from the unfinished *Partie de campagne*, the conceptualization of the world's zero not as negative but as an unstill fullness, is belied by the importance conceded to death as a guarantor of meaning and reality. The system engendered in the film (filmic system as opposed to social code) depends on death as a negation of the negation—only thus do the lovers achieve an identity. Otherwise merely the cyphers of a signifying system that incorporates and embodies but at the same time annihilates subjectivity, they would remain, along with the illusory world conjured by cinematic technique, unable to engender the reality effect, since their "identity" would be only negative. Negating the negation by killing what has no existence produces the positive effect the film demands as a signifying system, even as it points to the opposite, the vacuity at the heart of the excess of signification in the depicted social game.

So *La Règle*, and realist film more generally, depends on death, but only because it believes that the instigating zero that sets the system running is a void. However, as we saw in chapter 1, zero is not empty but null. The system constructed by *La Règle du jeu* confuses nullity with negativity, demanding a double negation—once in the epiphanic moment such as the shot of the frog, and once more in the apotheosis of death, a death that also, like catastrophe in television discourse, proves the veracity of the discourse itself

(Doane 1990)—so casting the filmic and diegetic discourses at odds with each other, a necessary precondition of fantasy.

La Règle's gift is to emphasize this condition. But at the same time the film abstracts nonidentity from the ephemerality of the world, because it loses its grip on the plenitude of nonidentity (the fullness of zero). Hence ephemerality is displaced from the world's fullness to the subject's emptiness, in such a way that the proper expression of emptiness—death as a condition of worldliness—comes to define their relation. Ephemerality is no longer the condition of perception shared by subject and object, a product of the way the world "gives itself" to human vision, Caillois's (1968) *donné-à-voir* (see also Silverman 2000). Instead, centrally in the figure of the death-defying and death-courting Jurieu, ephemerality is determined solely by the mortality of the subject: because we die, the world is ephemeral. Death makes beauty possible.

At one extreme the film as depiction proposes an epiphanic realism that anchors fullness in an extrahistorical moment of unity and so denies ephemerality by transcending it. At the other, we find a narrative cinema of "thanatic" realism that anchors history itself, as the experience of time and hence the ground of ephemerality, in the exit of the subject from history at the founding moment of death. So time, ephemerality, and history are each guaranteed by a loss that, unlike the usual psychoanalytic model of biology and memory as destiny, is governed not by the past but by the ineluctable future.

Renoir's film, as so often in his films of the later 1930s, is structured by the shadow of a tainted future. As in Heidegger, the promise of mortality drives us into the present, producing a Being always haunted by its future demise, the being-toward-death (Heidegger 1962: 279–311). This taint draws (rather than drives) signification toward it. And finally, as we recognize that the illusion under which the whole apparatus of the film has been working is in fact the truth of the film, the two modes of realism coalesce into a single thought: the sublime moment of death as a sinking out of time that instigates the experience of time, not as life but as mere duration: Marceau trying a few odds and ends, Octave trying to get by. The effort to produce a full world has ended up producing only a desperately empty one. And here is the genius of the cinema, for this film emerged at the one moment in history when just getting by might have been the truest description of its failure and the best possible way of surviving or even derailing the impending crisis.

———

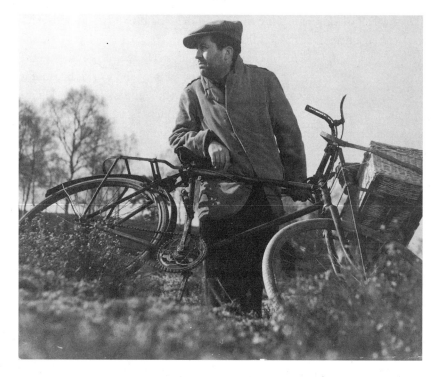

| Figure 6.3 |

La regle du jeu: Marceau as a poacher, before and after the country house weekend. Courtesy BFI Collections.

Something similar is true of the hunt scene, shot on exterior locations by Renoir's second assistant, the distinguished photographer Henri Cartier-Bresson. The landscape of the Sologne was selected consciously to evoke and frame an atmosphere, the birch woods and marshy flatlands giving a mournful, cool humidity to the tragic farce whose terms are being finalized during the sequence (see Renoir 1974: 169–170, where he intimates that the idea of filming the landscape antedated the idea of the film). The landscape—insofar as it is one, that is, insofar as it is both unified ("the Sologne") and generic—is itself a cinematic event. So too are the narratemes, the fragments of gesture, dialogue, and interaction that constitute the activities of the human and animal figures in it. That these events are logically prior to narrative is apparent even in narrative theory, where, for example, "In constructing a fabula, the perceiver defines some phenomena as events" (Bord-

well 1985: 51). But the term "narrateme," denoting the smallest fragment of narrative, preempts discussion of the ways in which films articulate events. It is by no means clear that narrative is the first or most natural way of organizing events into larger systems—one thinks immediately of those "American montage" sequences that show a series of views to establish the scene of the ensuing action as the Sologne, Sydney, or San Francisco. So Bordwell is correct when he concludes his sentence on perceivers defining phenomena as events, "while constructing relations between them."

However, he is wrong to continue "These relations are primarily causal ones" (Bordwell 1985: 51). What makes this film so unusual is the lack of causal relations even between events occurring within the same shot. Gestures and glances in *La Règle du jeu* are in many instances more significant than the narrative of which they are the precondition. Apparently motiveless events arise without prior causative structures, and attempts to reconstruct a causal chain in retrospect are largely fruitless. More assemblage of evidence than moral fable, *La Règle du jeu* works by symmetries, translations, rotations, a whole geometry that reassembles rather than resembles the world as manifold. A collocation of disparate and discrete phenomena ordered spatially and temporally as a series of events forms a taxonomy in the service of *"les convenances,"* the conventions that explain the moves, passes, and parries of the plot. *La Règle* is more clearly legible as typology than as a psychologically convincing or realistically plausible story. After all, the farcical devices (disguises, elaborate deceptions, multiple infidelities characteristic of eighteenth-century French comedy) do not construct a viable narration of causes and effects. And the concluding death is instigated by misunderstanding and misrecognition rather than by destiny or moral flaw, the characteristic narrative engines of classical and Renaissance tragedy. What then makes it realist, in the narrow sense of bearing a resemblance to life, is the accident itself.

By definition, no accident is the effect of a cause. The sheer, blundering stupidity of the event strikes true, precisely because it is not justified by its position in a causal chain. That Jurieu's death in *La Règle* is meaningless, compared to the deaths in *Antigone* or *Hamlet*, makes it even more appropriately modern, even more appropriately catastrophic, even more appropriately verisimilitudinous. As Saint-Aubin says in response to La Chesnaye's announcement of the death, "A new definition of the word ACCIDENT!"—as indeed it is, a prefiguring of Virilio's thesis of the general accident

| Figure 6.4 |

La regle du jeu: A ruling class without the will to rule, a working class without scruple.
Courtesy BFI Collections.

(Virilio 1997: 132). The "accident" embraces the death of the hero who knew neither how to play the game of popular heroism (as Octave tells him, Renoir 1970: 42), nor the game of the château, nor, finally, the game of love (when he tells Christine to wait while he obeys the rules of hospitality by informing La Chesnaye that they are eloping).[5]

But the accident also embraces the multiple failures of the characters, unifying them into a single catastrophe to which the General alone seems blind, perhaps because, within months of the film's release, his caste's failure would be the most disastrous of all. Though previous scenes set up the random mistake—the coats lent by Lisette to Christine and by Octave to Jurieu—and so we are privy to the artifice of plotting that permits it, still it remains random: explicable, but still a bolt out of the blue, arresting the

farce in midflight, like a child falling in the middle of an overexcited game. Rather than tie up and explain what has gone before, as in the well-made plot, and without providing the previous actions with a deeper significance, as in the great tragedies of the past, the death simply underlines the chaotic state of the world underlying the systems and structures by which we seek to live in it. At the same time, it brings the signifying chain to an abrupt end. Three desultory scenes tidy up after the death. The rest is silence and muddling through.

Here the film points up a core tenet of realism: that there is an end of signification; that its stoppage stands at the place where signification ends and the Real begins. Jurieu's death at the end of *La Règle du jeu* proves the truth-content of the film that precedes it by completing the taxonomy as its summum. To signify that it is realism, then, the realist cinema deploys death as the end of signification. In Heidegger, the anticipation of mortality is the condition of individuation: by posing the possibility of nonbeing, it makes the human creature cling even more to its self (Heidegger 1962: 310). Without death and the individuation it enforces, there would be no imperative toward socialization and discourse. Heideggerian speech seeks to put off, to evade, or, most especially, to speak against death. In Renoir's film death functions as the final silencing that completes by annihilating, and so demonstrates the actuality of what it destroys.

Dying brings the world to heel. The careening aristos are brought to a hierarchical finale, and all the scattered thoughts alight on a single point— the point at which all thought, all signification, stops. Because it starts from a negation of the world, realism's double negation ends where it should begin, in equilibrium, committed to the perfect present of Being, which, however, is always at the point of vanishing.

The Universal

The fatal moment in the narrative is the end of illusion: the moment of truth is the instant of mortality. But though fatal, that is the epiphanic moment in which the world reveals its mendacity as appearance. The world is not as it appears—in fancy dress or through a looking glass. But nonetheless it is, and in half-truths it reveals as epiphany its own desire: that the world yearns for us to recognize it in its trickery, longs for us to recognize not that it is other than it appears, but that it appears. Appearance, in other words, is the world, as the "given-to-sight." This insight allows us to consider, at least in

the case of *La Règle du jeu*, an answer to Aumont's (1996) query, *à quoi pensent les films?*—what do films think about?

The film is beautiful in that it celebrates the ephemerality of appearances, but it is also aesthetic in that it advances a historical theory of appearance, one tied particularly to the moment of modernity. As Bloch says of Heidegger, *La Règle* is an accurate portrait of the anxiety of a class in the process of disintegration (Bloch 1986: I, 110); it is also a study of an emergent culture. Specifically, the film speaks of the loss of locality, the emergent internationalization of modernity, adumbrating the abolition of the local in postwar globalization. In a number of writings and interviews, Renoir stresses the horizontal nature of social relationships: aristocracy seeks aristocracy, just as farmers seek farmers, regardless of language or nationality. Locality remains a mere trace—we are treated to a disquisition on the nature of aristocratic style by the chef, for whom ethnicity, nationality, even noble blood have nothing to do with the culture of the gentleman.

By contrast, the two central characters in the servants' hall, Marceau and Schumacher, are powerfully linked to their locales—the Sologne and Alsace. Schumacher and Marceau do not fit in and are ejected from the château, while both the Jewish Marquis and his Austrian wife are at home in the transnation of their class (see Appadurai 1996). There is already at work that anonymization of place which will eradicate the parochial loyalties of those characters. In Renoir's film, the character Octave—Renoir himself, as read by William Rothman (1987)—is alone in recognizing this deracination and in feeling it as an artist who cannot find his dreamt-of audience. In *La Grande Illusion* the "de" and "von" of Boeldieu and Rauffenstein gesture toward both the landed estates from which the aristocratic names derive, and their distance from them, not least since both are aviators. The relationship of French marquis and German count sketches the way anonymization and endocolonialism have implicated their subjects into a subjectless machine of global finance capital. What Renoir traces in *La Règle* is the fit between this machine and the machinery that a class and a community erect for themselves.

Death before dishonor: the concept of fantasy allows us to read, within and simultaneously with this noble sentiment, its reverse: dishonor before death. The fear of dishonor is at the same time a fascination with it. The nobility's obsession with distinction is at the same time an emblem of their fascination with the indistinct, the amorphous, the unformed, the indifferent.

But it would be wrong therefore to read the paranoid machines of defense against homosexuality as masks for a "real" longing for it, most of all in a film that foregrounds its anonymous homosexual character and his desire. Instead what the disavowal of homosexuality holds for us to apprehend is not an aspiration to same-sex desire but its sublimation as an unnameable yearning for democracy, envisioned as a loss of distinction and an embrace of the vulgar, longed for as much as it is held at bay. In this way the simultaneous acceptance and disavowal of gay love enacts not so much a fear of homosexuality as a horror of indifferentiation, a loss of difference that looks forward to the anonymity of a far more powerful paranoid machine—global capital. Unnamed, his desire at once remarked and erased in a critical act of forgetting, the homosexual is as near as 1939 would permit to a depiction of the universal subject of ideology.

To construct a reality does not entail abandoning the world. It is to accept the necessity of construction and nonetheless to seize the opportunity to construct. Just as the work of cultural production must, under existing circumstances, pass through a stage of individualist subjectivity, so any account of the world, under existing conditions, must go through a stage of rendering it as object, even at the cost of objectifying it, even at the cost of the kind of objectification suffered by Fanon (1968: 77), the "objection" that precedes the abjection of the other. To stay at the level of objection is to remain in the domain of hate. Its opposite, construction, demands movement through that phase, even if it will always be marked by it. "Men make their own history . . . not under circumstances they themselves have chosen but under the given and inherited circumstances with which they are directly confronted" (Marx 1973: 146). This, after all, is the only realistic way to proceed. To do so with honesty and honor, the conditions under which art or history is made must be acknowledged. What is essential is that objectification and construction are avowed, as they are in Renoir's film, especially through the avowal of the disavowed homosexual desire that fuels the homosocial rules as well as the consequent despair (Christine), banality (Mme. de La Bruyère), and triviality (Lisette) of the women trapped in them. With avowal comes Zizek's admonition that we should throw out the baby to inspect the dirty bath water, jettison the purity of identity to understand the phantasmatic symptoms and fantasia that support it (Zizek 1997: 38). At the same time, Zizek is adamant, symptoms are often enough exactly what they say they are: that behind the invitation to dinner may lurk a secret wish to

share a meal. As Keith Reader observes, *La Règle du jeu*'s ending represents "Not so much a conspiracy of silence as a conspiracy to take events at their face value" (Reader 1981: 137).

In other words, the world may reveal itself to us precisely by allowing us to see that it hides a secret, although the secret of that secret is that there is no secret. Such is the condition, Zizek argues, of the universality of global capital: "The horror is not the (particular living) ghost in the (dead, universal) machine, but the (dead, universal) machine in the very heart of each (particular, living) ghost" (Zizek 1997: 45–46). Even prior to objectification, at the moment of perception and Peircean firstness, we rely on the visibility of the world and its audibility, the way it gives itself to us to be perceived. What it gives, however, we also take. Realism does speak to and of the world, and as a mode of cinema it shares with sociological, geographical, and technical discourses of the world the self-consciousness that it is a construction. Likewise *La Règle du jeu* attempts not truth but adequacy. Hollywood's (or *Dallas's*) supposed "realism" is nothing of the kind and is mistakenly so named, for example, by MacCabe (1974; see Williams 2000). On the other hand, it is important for the argument of this chapter and of the book as a whole that cinema is neither debarred from acknowledging and critiquing the world nor bound to the choice between negation and escapism. On the contrary: that reality is an effect opens up the possibility that effects can be "real."

The problem of cinematic realism is, on this perspective, the problem of universality. On Hegel's account, civil society, the object par excellence of realism, seeks to universalize the association of human beings through their needs; yet at the same time,

the *specialization* and *limitation* of particular work also increase, as do likewise the *dependence* and *want* of the class which is tied to such work; this in turn leads to an inability to feel and enjoy the wider freedoms, and particularly the spiritual advantages, of civil society. . . . this shows that despite an excess of wealth, civil society is not wealthy enough—i.e. its own distinct resources are not sufficient—to prevent an excess of poverty and the formation of a rabble. (Hegel 1991: ¶243: 266, ¶245: 267)

It is in reference to this sense of the ineluctable dialectic of civil society that Zizek proposes "the leftist gesture par excellence" (Zizek 1997: 50) that questions and attacks the existing universal on behalf of its symptom, the

ego on behalf of the unconscious, or civil society on behalf of the degraded, oppressed, and repressed. For Renoir we might enumerate these symptoms as art, love, homosexuality, and the local, each of which is shown to be impossible to maintain in the face of the rules that function here as the visible form of the universal.

As Dudley Andrew points out, this apparently liberal set of concerns emerged from Renoir's and the French cinema's disillusionment with the leftist Popular Front (Andrew 1995: 304–317), when, with films like *Les Bas-Fonds* and *Toni*, Renoir had worked from naturalist models in scripts worked up respectively from Gorky and a newspaper story. The immediate social and specifically proletarian concerns of those films gave way first to a darker prognostication in *La Bête Humaine*, and then to far more pessimistic handling of wider, "human" themes in *La Grande Illusion* and *La Règle*. Nonetheless, even though these marginalized symptoms are less socially specific, they are still historically particular, and as with Eisenstein, we have to recognize the importance of the date. The year 1939 was not a good one for optimism, revolutionary or humanist. If Eisenstein was correct to warn against Nazi invasion, surely Renoir was right to warn against fatalism and collaborationism on the eve of Vichy.

The question remains, what perspective might make it possible to speak in this way? What position—political, ethical, aesthetic—authorizes a discourse of emancipation? Zizek's answer is that the necessity of emancipation can be spoken only from the position of its realization, that is, from the position of another universal, but one that does not yet exist. For Renoir, after the failure of the Popular Front and the defeat of Spain, alert to the readiness of the French governing classes to accede to fascist rule, that particular universal could not be trusted. In films of the Popular Front period, Renoir did indeed appeal to that not-yet universal emancipation, for instance, as the justification for the murder in *Le Crime de M. Lange*. The tragedy of *La Règle* derives from the way in which emancipation has lost its credibility, and in its place the final standpoint of ethics is situated instead in that other indefinitely postponed but ineluctable truth, mortality.

CLASSICAL FILM: DIALOGUE

Sound, Image, and Effects at RKO

There is much less than meets the eye.

—*Martha Wolfenstein and Nathan Leites*[1]

Evolution as Norm

Nevsky's simultaneous evocation and denial of infinity and *La Règle*'s attempt to unify a fragmenting world under the empty sign of death were both made in the shadow of war. In the United States, interventionist economic policy after the stock market crash of 1929 and a steadily tightening grasp on Pacific trade seemed to foreshadow the country's future wealth and power. Rather than Eisenstein's project of national unity or Renoir's pained account of social stagnation, Hollywood was trying, in the later 1930s, to image success.

At its apogee, success was the official ideology that powered such extravagant carnivals of technological optimism as the 1939 New York World's Fair. Far from consolidating the techniques of the 1920s, the studio system, more powerful and more stable than ever, proliferated stylistic responses to the new conditions. Some studios did achieve something akin to a stable house style. The characteristic sound libraries built up by individual studios clearly marked their products with an authorial stamp. But whereas Warners' low-key lighting, Spartan contemporary mise-en-scènes, and hard-boiled scripts might unify the studio's product, there is no confusing the last scenes of their *Little Caesar* and *Dames*. Though RKO is often pointed out as uncharacteristic in that there was no single genre or stylistic language that singled out its product, its lack of house style and apparent disinterest in searching for one is typical of classicism. Aside from the Astaire-Rodgers musicals and the Val Lewton horror cycle, the studio that opened the decade

with Oscars for the epic western *Cimarron* and kicked off the next with *Citizen Kane* would leave behind a catalog of disparate, apparently incompatible films. Yet if no formulaic norm is palpable across all genres through the decade, nonetheless there is a strange attractor around which the films of RKO gravitate. The films examined here should be taken as exemplary of a centripetal but never centralized stylistic corpus, in a process of evolution but without a teleological goal.

Classicism is curiously less stable than realism or total film. It does not "emerge from" and "move toward," but restlessly adapts to real and imagined environmental changes, lacking the sense of mission that guided the development of total and realist cinema. The challenge of the classical norm is to trace the evolution of an object that seems to have no history. Though there are clear changes from the early to the late 1930s, some later films maintain techniques of staging, dialogue, cutting, and sound recording from the earliest years, while others reach backward into the silent era (most obviously Chaplin's late silent features, but also the curiously wooden direction of Mae West's films for Paramount), forward to postwar styles (one thinks here of the cinematographers James Wong Howe and Greg Toland), and outward to the arthouse movies of Europe (not surprising among émigrés like Lubitsch and Sternberg). Nor should we be distracted by the apparent formal perfection of some of the finest films of the decade, which represent only momentary crystallizations of the flux.

If, as Tynianov argues, "social life enters into correlation with literature above all through its verbal aspect" (Tynianov 1965: 131), then it enters into the moving image media under a triple aspect: the visual, the aural, and the written. Films enact rather than depict social change, especially the swift

evolution of media and communications technologies. By the time the sync-sound film arrived in the late 1920s, it had to mark its position not simply in relation to silent film, nor to a by now nostalgically reconstructed "natural" hearing, but to recorded sound, telephony, and radio. Indeed the social history of sound in the cinema can be charted primarily not by its relationship to a unified and hypostatized sense of hearing, but by its relationships to other aural media. As Benjamin (1969) suggested, Zielinski (1999) argues, and Crafton (1997) demonstrates, the mature classical sound film of the North American studio system is the product of the first dramatic synthesis of electronic and photomechanical industries. Brought on by the crisis of the Wall Street Crash, itself partly precipitated by the overvaluation of radio stocks, the standardized, industrialized sound film, we could say, is the product of the first media-inspired global economic crisis, and one that introduces media crisis as a permanent state of affairs, from the instigating role of cinema in *King Kong* to the threat of printing in *The Hunchback of Notre Dame* and the vulnerability of the telegraph in *Gunga Din*. It is this sense of crisis that informs the concept of criticism in the 1930s and provides us with a means for entering the critical spaces of the classical film, and for understanding their ongoing crisis as the basis not of a static norm but of a forced evolution.

RKO's task in the 1930s was to make new objects, to be ahead of the crowd while still in touch with them. It wanted to change cinema, not the world. RKO, like Hollywood in general, inherited a rapidly evolving consumer in the wake of the Jazz Age and the Depression, but it was happier following trends than assuming ideological leadership. Sharing Shklovsky's attack on habitual perception (Shklovsky 1965: 83) but without his revolutionism, RKO entrusted the aesthetic object with the task of freeing an otherwise unaltered subject for the enjoyment of new perceptual routines. Shklovsky associated shock with revolution: RKO associated it with innovation, the normal functioning of cultural capitalism. Neither Shklovsky nor RKO sought return to primal firstness: both wanted to create something new, Shklovsky a future, RKO a present marked as modern by its difference from the past.

The evolution of the classical norm in Hollywood, its constant reconfiguration around the ideologically and technologically new, is not without a teleology. Turned to face toward the vanishing past from which it must, as innovative, distinguish itself, what it specifically lacks is an eschatology, a

principle of hope. Evolution in the classical norm is homeostatic: it seeks an impossible equilibrium. The unformed forms of RKO are exceptionally revealing of the flexibility, the purposiveness, and the final lack of ambition that characterize classicism in the cinema.

A Superficial Cinema

By 1931, as Wesley Ruggles's *Cimarron* demonstrates, Hollywood's sound films were already capable of a richness and power equal to that of the late silents. Sync sound came not as an adjunct to the naturalistic creation of fictional worlds but as a technological spectacle, so it is no surprise to find other spectacular techniques associated with it. Formed out of the combined strengths of the Film Booking Office (a small studio established by Joseph Kennedy) together with RCA (the radio division of General Electric) and the Keith-Albee-Orpheum chain, prime sites for film release in major cities, Radio-Keith-Orpheum had interests in telephones and telegraphy, music publishing and recording, the vaudeville circuit, and the NBC chain of radio stations. Not surprisingly, the company turned to the musical.[2]

Flying Down to Rio is now mainly remembered by buffs as the first screen pairing of Fred Astaire and Ginger Rogers, and by historians of style for the extraordinarily elaborate wipes—designed by house optical-printing expert Linwood Dunn—that punctuate the film. Both the wipes and the airborne finale testify to the association of recorded sound with spectacle, an association that extends beyond the musical genre to the soundtrack of the studio's big hit of the 1933 season, *King Kong*. *Flying*'s most elaborate dance number is the Carioca, and one can imagine RKO's flagship theater, the 6200-seat Radio City Music Hall, opened in 1932, encouraging visitors to take it up as the latest dance craze. So unafraid is the film of cross-publicizing the corporations' products that two lengthy shots hold, in full frame, telegraph forms marked "RCA Communications Radiogram—Worldwide Radio" for the audience to memorize. The clarity and technological achievement of the Photophone system of variable-area sound-on-film recording unique to RCA/RKO was a further enticement to respect the corporation's other products, associated throughout, from the radio tower logo to the aerobatic visuals and the streamlined architecture of the Rio de Janeiro sets, with all that is most modern.

What after all was more modern than the latest Hollywood film? And yet nothing could be so idiosyncratic. Take for example the famed symmetries

of classicism; the gunfighter who rides into town in scene one and rides out in the final shot; the door that opens under the titles and closes under the credits (Bellour 1975a). Or the economy of means: the gun in the drawer is always fired, and the gangster dies mumbling the catchphrase with which he first introduced himself. Moreover, classical Hollywood is, as David Bordwell points out, "an excessively obvious cinema" (Bordwell, Staiger, and Thompson 1985: 3). Never overestimating its audience, the classical film tells us everything three times at least (image, sound effect, dialogue). It is obvious also in the sense that it withholds nothing. With the end of the silent era, the secret voices of the stars were no longer locked in the inner ears of their fans: radio and synchronization brought them out of the realms of mystery. In the crisis year of 1929, which for Jean Baudrillard (1994) marks the day on which history's door closes and the era of simulation begins, the conversion of sound into light through the miracle of electricity ends the depth model of classicism, and a new art of the surface emerges.

The comedians, especially stone-faced Buster Keaton, had already understood that genuine silence, rather than the absence of sound, produced the pure presence of the gag. The double negation that abolished the silent voice was intended to generate the absolute presence of the film to itself and thus to its audiences. No longer required to fill the gaps, the spectator become audience would henceforth be saturated in film. For once the word film lived up to its second, chemical meaning. Rather than produce a cinema of depth and rounded presence, the economic imperatives of the Depression ensured that the classical film would come to its apogee without fullness, a cinema of the superficial. The cost of speed—in production, in distribution, most of all in consumption—was that the film itself would be so superficial that it could not remain in circulation, but must flitter off the screen to make way for the next production, and the next. Today, films take on postcinematic lives on television, cable, video, and DVD, and so live longer than the time it takes to make them, with important implications for their stylistics. But in the heyday of the Hollywood system, production was long and distribution mercilessly short. To exist in the arc light for those few burning hours lent the films something of their passionate innocence, their innocent criminality, the ease with which they evoked and dismissed poverty, disease, prostitution, addiction, and shame. Where Eisenstein sought to rouse in the name of the nation and Renoir bowed to the preeminence of the world, Hollywood had nothing to present but its own illusion. Its only

value, the ground of its existence, was entertainment. Hence the mayfly brilliance of its films; hence their mayfly-brief life.

Given the pressures of a system designed to convert loans into product and product into profit on the shortest possible turnaround, and given the demands of "feeding the maw of exhibition" (Balio 1995: 73), to the producers and craftspeople of RKO, production schedules must have seemed at once incredibly rushed and yet unbearably slow. The need to ensure reasonable quality in at least a proportion of the studio's output was essential to give RKO a decent brand identity on the intensely competitive screens of the domestic market. Scripts were the guiding structural implement in production schedules. Not only the source of narrative (and the book of the musicals of their songs and dances), they were the key tool in allocating resources, finance, and studio time to productions. Moreover, alongside the visual cues deployed to keep the star in the center of attention, the clarity of their dialogue was perceived as crucial in getting and keeping the audience's attention.

The classical soundtrack thus redoubles common characteristics of the classical system. Voices, singing or speaking, are directed toward the revelation of character and the furtherance of a causally based narrative. Naturalism is subordinated to clarity, as when music is reduced in volume to allow us to eavesdrop on conversations. Except for ensemble singing and general crowd noise, there are never two voices raised at the same time. Continuity errors resulting from the use of multiple camera setups (for example, in the Carioca sequence in *Flying Down to Rio*, when we can see the bandleader climbing up steps in the background that we have already seen him climb in the previous shot) are carried by the continuity of the music. As McLuhan observes, "The movie audience, like the book reader, accepts mere sequence as rational" (McLuhan 1964: 304). Shot/reverse shot structures respect the rule that the camera stays on the speaker rather than the listener. Occasionally, earlier techniques are audible, for example, the voices in a long shot of the chorus line at the airfield that grow louder on the cut to midshot (added reverberation had already become the more frequent option for suggesting distance).

But the film is also vividly artificial, as in so many classical films where naturalism is subordinated to drama. In *The Public Enemy*, Wyler was cutting on sound cues and using exaggerated amplification to gain effective shocks from the gunfire that kills Cagney/Tom Powers: the film is as much

melodrama as gangster film in its reliance on heightened emotional effect in addition to the documentary realism of the opening montage. *King Kong* was to do something similar with the famous screams of Fay Wray (perhaps also showing off the response of the Photophone system in the problematic high frequency range). For the duet "Orchids in the Moonlight" in *Flying*, the back projection (again a hot property at RKO that year) goes into overdrive, racing through a montage of landscapes as the (soon to be ex-) lovers croon, the shots separated by flamboyant wipes. The back projection in many shots in the aerial "Flying Down to Rio" finale is, in a similar way, undone by the unlikely audibility of the music from the wings of the aircraft carrying the chorus line while the planes' motors remain dim murmurs for the onscreen as well as the offscreen audience.

It is unlikely that the film is deliberately poorly made, or that the RKO crews were incapable of a more exacting verisimilitude. The film rejoices in its artifice, celebrates the technology of sound as it does those of aviation and process camera work, enjoying and humanizing the technological progress on which corporate wealth and the expected emergence of the U.S. economy from the Depression was to ride. Much of its period charm derives from this faith in technological solutions and in its constant efforts to (hetero)eroticize the airplane. Less lovable is the triumph of Hollywood modernity over Brazilian tradition (posed as true love versus arranged marriage, freewheeling Yanks versus stuffy authoritarians) and its echo in the victory of jazz over Latin music. But even these reservations falter before the power of the classical paradigm, in which music is used to overwhelm any problems of narration, continuity, probability, naturalism—or imperialism.

The triumph of music so frequent in song-and-dance films (not only Astaire but the Brazilian police can't help tapping their feet and swaying to the band) is an apt allegory for the way in which the soundtrack, far from being a "mere" supplement to the cinema's primary visual focus, is an orchestration of dialogue, ambience, sound effects, music, song and silence, and not uniquely in the musical. Altman (1992) and Williams (1980) both argue that recorded sound doesn't reproduce a real world: it represents it. But the Hollywood soundtrack doesn't even represent the world: it orchestrates a diegesis. The difference is that between the semiotic manipulation of recording that nonetheless is grounded in an autonomous world, and the construction or composition of a sound world that exists autonomously of

any profilmic world. The classical soundtrack is as self-consciously fictional and artificial as back-projection and optical mattes.

Some critics (among them Baudry 1976; Doane 1980a,b; Neale 1985) argue that the classical soundtrack exists to reinforce an "ideology of presence." Matching recorded dialogue to lip-movements, sound effects to their apparent causes, is intended to give an audience the most powerful possible illusion of the "real" presence of the characters, or possibly the stars who play them. It is also the guarantee of the fullness of the filmic world, persuading us of the completeness and coherence of the fiction. And finally, it fulfills the fantastic desire of audiences to enter into that world as transcendental subjects, given, for the duration, a subjective position rendered absolute in its synchronization with the married sound and image. As Altman (1980) argues, sound completes the illusion begun by the vision track, their interaction hiding the fact that both are artificial constructs. I would argue that this tells only part of the story. When Astaire walks through the Aviators' Club expecting to be thrown out at any minute, his monologue is as clearly directed at the audience as any Shakespearian soliloquy, and punctures as rapidly any sense of the autonomy of the fictional world from the audience's (see Lastra 2000: 214–215). This is one more example of the classical norm's relationship with the social: not representational but relational. Voice-over and on-camera direct address, soundtrack gags using effects or signature tunes, nightclub sequences and ironic commentary by the sound on the image (and vice versa) are as common in thrillers, westerns, and women's films as they are in the full-blown musical. The classical paradigm succeeds not simply by commitment to the illusion of presence, but by playing on the techniques that make that illusion possible. Because it not only *is* spectacular but needs to *advertise* itself as spectacle, what distinguishes classical from total and realist cinema is its construction of a brilliant but depthless surface.

The triumph of self-proclaiming illusion over the ethical claims of realist and total cinema is not without its repercussions on the nature of the illusion itself. As RKO's set and prop designers, optical effects technicians, animators, and performers strove to foreground the techniques of illusion while propagating a fictive diegesis, the first effect of the effects work is that of making the illusion obvious. What RKO's A features present is not absence so much as surfaces; but where the surfaces are themselves foregrounded

effects, they become signifiers of illusion rather than illusory. Thus the mobilization of fantasy in the classical cinema does not depend on the absent object of desire but on the present signifier of fantasy. In this way fantasy itself approaches the symbolic, embodied there as the flashing feet, the roaring beast, the hunchback swinging on his bells between horror and melodrama, a signifier with, at best, only a fantastic relation to its signified.

The question of being cannot therefore be posed directly of classical film, nor can it be rephrased as a dialectical or deconstructive reversal between presence and absence. As spectacle, the classical film is literally a surface, a border between presence and absence. Without either a concept (Eisenstein's "idea") or a world to act as referent, classicism cannot pose itself as the heir of an object that is absent. Since its only external referent is the script, and since it so boldly proclaims itself as fantasy, the classical film cannot lay claim to presence either. The power of classical cinema to evoke fantasy derives from this ambivalent position. To understand its ramifications, we need to ask: whose is this fantasy?

Distinguishing between cinematic and electronic images, Vivian Sobchack writes that there is no point of view in the cinema, but that instead films provide concrete "situations of viewing" in which the subjective nature of visuality and the objective nature of visibility are brought into synthesis. "Cinematic presence," she writes,

is multiply located—simultaneously displacing itself in the There of past and future situations yet orienting these displacements from the Here where the body at present is. That is, as the multiplicity and discontinuity of time are synthesized and centered and cohere as the *experience* of a specific lived-body, so are multiple and discontiguous spaces synopsized and located in the spatial *synthesis* of a particular *material* body. Articulated as separate shots and scenes, discontiguous spaces and discontinuous times are synthetically gathered together in a coherence that is the cinematic lived-body: the camera is its perceptive organ, the projector its expressive organ, the screen its discreet and material center. (1994: 99)

Sobchack's task, in this (1994) essay, is to define the cinematic over against the electronic image, and her tactic is to emphasize the analogical nature of the filmic image, its transmission as whole frames (rather than atomized pixels), its wholeness. In the phenomenological tradition, she emphasizes the

relation between film, perception, and the lived body of human experience. What distinguishes cinematic from unmediated perception for her is the machine ensemble that shifts us from point of view to situated, synthesized experience. Film theory frequently takes for granted that point-of-view shots are points of identification, in which the camera, by taking the position of a protagonist, can offer us the opportunity of seeing with their eyes. Sobchack's point, or a part of it, is that we never see with any other than our own eyes save when we see through the eyes of the cinematic apparatus itself.

Writing from Metz's "upstream" position, Sobchack does not need to distinguish between modes of film and the consequent constitution of differential lived-bodies. In distinguishing the normative cinemas of the 1930s, what is at stake are modes of wholeness. Eisenstein constructs a cyborg whose central constitutive factor is the semantic concept, whereas Renoir's wholeness is brought about through the unification of multiplicity under the sign of mortality. Classicism, bereft of these means, has only the wholeness of its illusion. Thus the importance to classicism of the seamless fabric, the integral surface, of film's body, the body without orifices. There is no body here to penetrate, no reality to be laid bare, no concept to reveal itself, but only an ideal glassy smoothness, the gaze of a lens rather than an eye, the sheen of the screen rather than a Cartesian space.

Cary Grant's sergeant in *Gunga Din* (fig. 7.1) has been captured by the thugees while trying to steal their gold. His two comrades in arms (Victor McLaglen, Douglas Fairbanks, Jr.), accompanied by Gunga Din (Sam Jaffe), rescue him. Din accompanies Grant from the torture dungeon to the top of the temple tower where the other sergeants are secluded with their prisoner, the evil guru of the thugees (Eduardo Cianelli). The interior set is lit from below, without obvious explanation—the light would have to come from the snake pit. Shot two shows an exterior set under Californian sunlight. Shots ring out and Grant dives for cover. The third shot of the sequence is a reaction shot to an as yet unseen spectacle, revealed in the next shot: the golden bas-reliefs of vaguely Hindu deities cladding the temple's central pagoda. The following shot returns to Grant's reaction, reframing as he stands and strides over to the gold. Shot five reprises shot two as the others warn him to get down; shot six reprises the last framing of shot four, with Grant declaring that "one golden hand is worth three thousand quid." As shots ring out, Grant dives off-frame left. We cut to a reprise of shots two and five as the three sergeants, Din, and the guru fade to black. The next

| Figure 7.1 |

Gunga Din: heroic bonding of the white male, Gunga Din almost literally underfoot. Courtesy BFI Collections.

shot is a long shot of the temple set at night. Cross fade to the guru in lotus position, frowning. Cross fade to the three sergeants in midshot, slumped against the parapet. Cross fade to dawn rising in a reverse view from the top of the temple, looking down into the valley where the next sequence will be focused.

The sequence pushes the narrative one step further along (our heroes once again in peril) but the theme of the sequence is waiting. The three sergeants form a unit already familiar not only from the source material, Kipling's poems and short stories, but from Ford's cavalry films and especially McLaglen's well-established persona. But here the dynamic of the sergeants' narrative (keeping Fairbanks in the army by fair means or foul) is in abeyance (he has been tricked into remaining). The sergeants are stranded, but the guru is meditative in the stereotypically evil way available only to actors in blackface. Din's reaction is notably lacking, since he must perform the self-sacrifice called for by the film's evocation of Kipling in the next act. The

continuity editing system unifies the manifestly separate spaces of interior set, exterior set, and miniature of the temple in its landscape. The edits work not by cutting but by elision, most obviously in the cross-fades signifying time ellipses. The gaze that is incited here is not invited to work its way into the temple or into the experience of tedium and anticipation, but to move, almost like Eisenstein's graphical vector, horizontally, glossing over the interstices, spatial and temporal, slipping along the narrative axis, evacuating space and bracketing time. The film has to produce the knowledge of boredom—the awareness of time passing—without producing it as affect. Repetition stands in for duration, and the ability to wait is associated with the antagonist. Spatial and temporal difference, then, substitute for diegetic continuity and spatial depth.

The camera perceives action fragmented in space and time. Among the RKO films we are dealing with, that fragmentation also occurs within single frames, as during wipes or in complex matte, rear-projection, and model-animation sequences. Nonetheless, Sobchack is correct to say that these images come across as whole, since they are the objects of a synthesizing process of camera, projector, and screen (and also optical printers, effects studios and editing desks, music, sync and dubbed sound recording, mixing and editing). This whole machinery exists to synthesize, prior to the moment of reception. To some extent, then, we can argue that any answer to the question "whose fantasy?" would have to include the response that it belongs to that articulating system of perception which is the studio, and which we have been generalizing as the cinematic apparatus.

We can infer from the multiplying elements making up the apparatus that this fantasy is, however, not immediate. The act of perception undertaken by the cinematic machine, in this instance the RKO studio, takes time because it is synthetic. Mechanical perception may be imagined as instantaneous in a society whose dominant medium is the clock and whose conception of time is one of a succession of discrete instants. But in the 1930s, when time is beginning to be thought of as a dimension, the sense of the moving image as a time-based experience and a time-consuming perception is far more familiar. We have therefore to ask a supplementary question: when is the fantasy? Answering will evoke the familiar paradox of loss: fantasy is present only as a retrospective gestalt after the experience itself is over, moving us directly to the idea of cinema as becoming. The specific, material circumstances of RKO classicism in the 1930s, consonant with Sobchack's

insistence on the specificity and materiality of experience, suggests that it is in the cinema building that the films achieve their one moment of presence, and that that presence depends on the audience not just economically but for its very being (or its very becoming).

An audience is an audience only by dint of attending the screening, an activity that implies an isomorphism between projection and "audiencing," at the very least in terms of the time taken, but in the case of successful films, one presumes, also in terms of the relation between physical stages of the audiovisual performance and physiological-psychological states of the audience. The cinematic signifier is present only on condition that it is temporary. Films mutate before our eyes and ears. They become other. And it is this state of restless instability that tells us we are in the presence of a film— the fact that it synthesizes through such nonnatural processes as editing makes it clear we are not replicating a mooted presocial perception. On the contrary, we are actively involved in the synthesis, ourselves elements of the cinematic machine. The bizarre dialectic of classicism has to do not with absence but with the attempt to square the circle of being and becoming. The question "when is fantasy?" opens the question as to whether the distinction between being and becoming is adequate to classicism, and it sends the message that what is distinctive is not the relation to being—since we are dealing with fantasy—but the way in which the classical cinema produces as its result neither meaning (idea, image) nor reference, Peircean thirdness or secondness, but firstness, a contrahistorical regression that is not quite the presubjective moment of identification noted by Mulvey (1976), but the preobjective proper to a fantasmagoric cinema, a cinema of surface.

The Event Horizon

Among his Weimar period essays, we find Siegfried Kracauer noting contiguities between the Hollywood dream factory and the Ufa studio system. "Here [the Ufa Studios at Neubabelsberg, near Berlin, 1926] all objects are only what they are supposed to represent at the moment: they know no development over time" ("Calico-World," Kracauer 1995: 283). He completes the thought two years later: "Lack of substance is the decisive trait of the totality of established film production" ("Film 1928," ibid.: 319). "It almost seems as if, with the increasing perfection of photographic technique, the object that this medium is meant to convey disappears," he argues in the

same essay (ibid.: 314). Prefiguring the author's later New York–period faith in the mission of cinema to redeem reality, it is the *object* that is in danger of disappearance, rather than the world as such, the object that loses its depth, its substance, and specifically its temporality in the established cinema. The art of the propmaker and set designer has overtaken the candid account of nature and therefore fails to give a radical account of the objectivity of social reality. Key to the mastery over nature by the erasure of nature, and thus to the ideological functioning of films, is the symptomatic inability of commercial cinema and its institutional dependents in art and documentary to confront objects in their temporality, that temporality that gives them a place in the world and a meaning.

For Kracauer, Hollywood in the 1930s successfully constructs a zone outside of time. The films made at RKO attempt to make cinema an atemporal field but, contra Kracauer, the effort is never wholly achieved. The scene analysis from *Gunga Din* indicates a negotiation with time, not its complete erasure. Like *Flying Down to Rio*, the film struggles to raise and dispel the specter of change, historicity, and difference, on the one hand by nominating the atemporal as specifically modern, on the other by displacing modernity into the future as a goal to be achieved. Classicism must negotiate with the disjuncture between achieved and wished-for resolutions, between the present as eternal and the fact that the actually existing present is not that eternity, but a trajectory toward it. The gap between what classicism longs for and what it actually delivers makes classicism aspirational. It is a machine that acts systemically to reflect and reproduce the desire of its audience and its makers. Yet it is not simply a passive channel communicating between makers and audiences: it is an active participant in the processes of mediation. It is itself a desiring agent.

When Deleuze addresses "the intense world of differences," he invites us to prize open the relation of difference in the spirit of "a superior empiricism" (Deleuze 1994: 57). This empiricism is of a rather unfamiliar brand. Film theorists of the 1970s argued that empiricism failed to recognize the ideological constitution of facts. But in the late 1960s, empirical philosophy was exploring just this nexus. Like Willard Van Orman Quine,[3] Deleuze envisages an empiricism that confronts the world not through the imposition of categorical thinking and the philosophy of identity that underpins nineteenth-century empiricism, but in a mood that might almost be

called subjunctive: a frame of reference that does not presuppose that the world exists as object or objects, nor that objects and their behaviors can be constituted as facts, but in which facticity depends on differentiation.

In the cinema, the relation of difference is clearly one of mediation, the material in which difference signifies, the material relation between people that takes on the form of the film. A near contemporary of Deleuze, Quine quotes approvingly Dewey's (1925) statement: "Language is specifically a mode of interaction of at least two beings, a speaker and a hearer; it presupposes an organized group to which these creatures belong and from whom they have acquired their habits of speech. It is therefore a relationship." How much more true this is of the Hollywood studio cinema of the 1930s, a materiality of communication, a mediation, in which hundreds were involved in both production and reception. The "unimagined pattern beyond individuation" (Quine 1969: 24) is the dominant special effect of classical cinema in the 1930s. It disarranges the categorical and even the one-to-one ethical aesthetics of communication as previously conceived, and as practically effected in the telegraph, telephone, book, magazine, domestic photograph, peep show, and phonograph parlor. The mass entertainments of the sound cinema in North America realized the new empiricist conception of socialized, nonobjective communication thirty years before the oddly synchronous statements of Quine and Deleuze.

Deleuze's philosophy departs from North American empiricism, however, in foregrounding the politics of desire. This concept drives him toward prioritizing pleasures, intensities of sensation. What should surprise us is not that we have had to wait so long for such an insight, but that this is the very mythos of King Kong, Schoedsack and Cooper's noble savage. Kong's microsexuality, to borrow another of Deleuze's terms, is a parable of desire and its fatality, the fatality of beauty. Kong after all is a dark and savage god on a despotic island translated by special effects (and the alibi of the fantastic journey) into the libidinal economy of Manhattan. His sex organs are his hands (fig. 7.2), a threatening rewriting of the alluring, elegant gestures of Astaire's slim, white fingers. These hands are themselves the artifacts and the signifiers of the craftsman-engineer whose fingers have formed and fondled the otherwise incomprehensibly ruffling fur, trace of the manhandling the Kong model has undergone in the paws of his makers (Goldner and Turner 1975) and which they have made him express in the sensual

| Figure 7.2 |

King Kong: hands as sexual organs. Courtesy BFI Collections.

image of Fay Wray cupped in his palm (Gottesman and Geduld 1976; Wray 1989). The lasting delight in *King Kong*, the wealth of pop-cultural appropriations and vanguardist art expropriations the film has spawned (see Erb 1998), hang on this sublimation. After all it is Kong who wrecks the phallic train, Kong who out-tops the pointed Pelion of the Empire State Building, and the sublimation is therefore the product of the very opposite of repression. It is the picture of how desire finds its forbidden image in a Puritan culture, in the "African" exotic superstud who, however, has the whole world not in his sexual possession but in his hands.

Like the meaningless clatter of Astaire's taps, the meaningless "hubba hubba" of the "natives" mimes the failure of repression to achieve its only

task, to repress. Kong celebrates as it disavows not repression but the sublimation, the rendering sublime, of desire in the form of spectacle, the only form in which the Deleuzean plentitude of desire can exist as commodity. In Méliès, that form would present itself as void; in classicism, it begins to present itself as plenum. At RKO in the 1930s, the fullness of desire replaces the model of desire as lack. The yearning of the last colonial epoch changes to become the imagined fullness of an achieved world in which the commodity becomes fully spectacular in the special effect, and the world's most powerful economy turns its back on the world to revel in its own transition from poverty to wealth. Deleuze's insistence on the "microhistorical," empirical specificity of individual events gives us access to a dimension that Kracauer's (and Metz's) "upstream" positions disallow.[4] Most of all, the microhistorical gives us a way of understanding how not just cinema but specific films can become desiring machines. It can also help us understand that the desire of a machine is as historical as the desire of a human being. For Kracauer, cinema "wants" to reveal objects in their fullness, but current productions are merely superficial. What Deleuze allows us to conceptualize is that these films of the 1930s "want," desire, the surface, want exactly the film, the sheen, the meniscus that lies between fullness and nonexistence. They have their own desire, and it is fundamentally fetishistic, not least because these films usher in the era of the commodity as spectacle.

In the Hollywood spectacular of the 1930s, the microhistories of cinematic desire run permutations of the spectacle as the specific, material mediation of the commodity sublime in the form of visualized desire. In a brief, powerful analysis, Roger Dadoun captures the chronology of the fetish in *King Kong:* the stolen apple of the opening scene a focus for interaction; the commoditized scream aboard ship; the islanders' fetishization of Kong, mirrored in the bourgeois audience's fetishization of the spectacle in the New York theater; and the final sequence proclaiming that "the Beast, fear and fantasy cannot with impunity be treated as things" (Dadoun 1989: 46). That spectacle should be articulated with the powers of artifice, especially the handcraft of special effects, is part of that history. Hands—Kong's gentleness, Astaire's long fingers and suave gesturing, Laughton's hunchback caressing Esmeralda's face with his knuckles—dominate this articulation of the patriarch. This sense of touch as a stroking movement that is never a grasp onto solidity evokes once more the sensuality of the superficial, the commodity fetish as spectacle. Given this context, it is almost miraculous

that Kong is male. His tiny beloved, we can only surmise, is female according to the patriarchal logic that renders the female body as icon of the phallus, signifier of male desire.

Kong has become an art deco artifact. Stripped of his gargantuan power to mediate by the very multiplication of his admirers' acts of symbolization, Kong has become the merest signifier. We feel no fear or awe in his presence now, but only recognize that he "means" fearfulness and awe. Because his massive darkness was so evocative of sexuality at the time, it has become of necessity childlike to us now: a doll holding a doll. Astaire, by contrast, still evokes the sensuous embodiment for which the incorporeal cinematic machine yearns. His ethereal gestures, thin face, high voice, and ability to move on the tips of his toes between earth and air make of him an androgyne in whom all desire can be rendered fantastically immaterial. His is a sexuality not only without organs but without bodies. As we watch the transition into the "Cheek to Cheek" routine in *Top Hat* (fig. 7.3), Astaire sheds in turn the act he is putting on for the narrative, the acting he is doing as star, and the narrative functions of the dance (to resolve the relationship with Ginger Rogers). What remains is not the truth, not, at least, some solid naked nub of emotion or sensuality, but the pure surface denuded of its narrative trappings and the obligatory heterosexuality of the storyline. Like Zizek's symptom, everything is on display: there is no repressed act hidden behind the dance. The duration of the takes (despite the fact that Ginger kept inhaling the feathers from her dress) and Astaire's insistence on being filmed full-length permit no obscuration. The desire of *Top Hat* is for sublimation of the sexual act, not at all the "absent" act of love itself, which, like the lonely hour of the last instance, never occurs. We do not want to see Fred Astaire mount Ginger: we have come to see them dance. This sublimation makes a cyborg of the dancers, a compound of the cinema longing for embodiment, Fred and Ginger leaping to escape it.

Hereinafter, the question is no longer one of a demiurgic reality other than the film itself, since there is no absence, nothing missing, from the fullness of desire in its presentation on screen. The film as spectacle is itself: it does not require external validation. In this way, the classical cinema is closer to the cinema of the Lumières than to that of Méliès: it seeks the surface, the pure difference of movement. But the dialectic of nonidentity that persists in destabilizing the equilibrium produces a further desire in the classical apparatus, the desire for a teleology that, as responsive to notoriously

| **Figure 7.3** |

Top Hat: the cinema longing for embodiment, Fred and Ginger leaping to escape it. Courtesy BFI Collections.

fickle and unpredictable customers, it does not possess. In place of that goal, and indeed in place of hope, the Hollywood machine instead displaces its desire toward the framing and organizing of chaos. In this pursuit it turns from depiction to narration, the ancient art of taming the difference out of which its desire emerges. Thus in the soundtrack, the core work of the narrative is to build meaning from the babble of *King Kong*'s islanders, *Gunga Din*'s thugees, the pattering of Astaire's taps, the roar of the aircraft in *Flying Down to Rio*, or the babble of the crowds in *The Hunchback of Notre Dame*.

The microhistory of these films, then, concerns the problem of order in desire, and in this there does appear an externality. Where for Eisenstein that external agency was the Idea, and for Renoir the world, at RKO it was, as it was for all the Hollywood studios, the agency that brought order to the narrative and accountability to the films' production: the script. To listen to RKO's films of the 1930s is to hear the dialogue, illustrated by songs, illuminated with sound effects, underpinned with nondiegetic scores, but nonetheless assimilated to the realization of the script as the basic functioning of the dialogue. Dialogue is even more important than the timbre of the voice, especially notable in Astaire's reedy tenor. This alone explains why, over at Paramount, Sternberg would return to the leaden Englishman of *Blonde Venus*, Herbert Marshall, for the lead male role in *Shanghai Express*, as if the very lack of distinguishable vocal quality were a value worth pursuing along with the lack of verisimilitude in that clipped, tight-lipped drone of a voice.

This quality of dialogue in turn is why the monsters so affect us. Perhaps it is Quasimodo's deafness that most sharply delineates the centrality of dialogue, even more than Kong's muteness, his nonverbal expressions not only of the throat but the pounded chest, again a language of the hands. Clattering taps, pounding fists: the language of desire gets as far as the doorway leading out of the prison of the script, instrument of the production office, only to emerge as the articulation of the order of the script itself, the unvocalizable speaking of the body, antirational efflorescence of the final and complete Word, breath and body united in the unspeakable truth of the script's logorrhea. Far from revealing the internal contradictions of cinematic modernity (Comolli and Narboni 1977: 7), these roars, syncopations, batterings, and whimpers reveal its core—the abject as the highest aspiration of the commodity form. Where Fred and Ginger's routines establish the classical sublime, beautiful beyond expression, Kong's roaring establishes

its abject, vile beyond words. The two meet in their escape from language, and in escaping language, their position outside history.

At the opposite extreme from the sublimation of the dance, the suzerainty of the inarticulate is the obvious secret of the classical cinema, the Purloined Letter that never fails to reach its destination. Classical narrative exists to mediate between the two poles of sublimity and abjection, deploying their extrahistorical, extralinguistic, nonnegotiable certainty to ensure the stilling of turbulence. We arrive, in classicism, at cinema's event horizon, the mythic surface of a black hole where time stands still. The surface of eternity is itself eternally superficial. The spectacular image, the spectacularization of the commodity as image, and behind them the disappearance of money into pure communication are countenanced in classicism in the figure of the surface.

Born from the failure of the image to transcend the commodity, spectacle is the triumphal imaging of the commodity as transcendent. The grotesque and the irrational, the excessive, the unnecessary, the hedonistic, and, within the lights of the time, the vile and the disgusting are evoked and even demonstrated. They are celebrated not as qualities of the world but of the image's simultaneous presence and absence, and in the unreality of the diegetic world it images. Realism anchors this spectrum of sensations within the dialectic of presence and absence, capture and loss of the fleeting moment, that constitutes the image as effect. The total film makes poignant the effort to realize—to make real—the Image, the idea of which each shot is a fragmentary intuition, and the immense difficulty of that realization. But in one thing alone the classical cinema at RKO was consistent: the lack of dialectic. There difference is enshrined as the unnameable, embodied exclusively as image and decisively divorced from either the public sphere of nation and people or the recovered natural perception of an external and preexistent world. Classicism instead mobilizes fantasy, but does so in order to satisfy it. It evokes desire to display it, to mirror desire back onto itself and in that reflection to complete desire as a closed and narcissistic loop.

This desire is, it scarcely needs repeating, historically specific. For example, classicism thrives on the displaced dialectic of apartheid America—Kong, gypsy girl, hunchback. Astaire's assimilation of African-American vernacular dance for a Europeanized white-tie-and-tails ballet is the type of the fantastic desire to overcome difference, the aspirational utopianism annulled in the spectacular commodity. The sound-image assemblage of

1930s Hollywood is ready at exactly the right moment to become commodity capitalism's medium of choice for at its heart lie undialectical, naturalized dualisms of sublime and abject, absent presence and present absence. The sublimation of the natural into its image, and the tailoring of the image as white, is premised on an identification of the African-American body with nature, such that the noncinematic—nature, the body, natural perception— can be overcome in the same political moment as the subsumption of the "racial" other.

The commodity's triumph is that it recruited the sync-sound movie machine of the late 1920s to its economic requirements. At the same time, the evidence points toward a double-cross. While capital investment and conventions for the management of innovation held good, the result was not so much the commodification of the image as the "image-ification" of the commodity.

Bounded Energy

In tracing the post-Depression remaking of the commodity as image we must keep in mind the bare truth that the world's population confronted in 1929: the underpinning structure of the commodity was itself a ghostly thing. Britain's abandonment of the gold standard in 1926, like that of the United States in 1981, proved that money was unanchored, reliant on the unadministrable mass behavior of the stock markets, motivated by nothing more tangible than confidence.

But what is confidence if not the faith that things will continue? It is the obverse of hope, since it is in effect the belief that nothing changes. Yet clearly, in 1929, things did change. The apparent object nature of the central commodity, money, was unpicked, and its inner turbulence revealed in terrible splendor. Though most accounts of the 1930s describe it as a period of reconstruction, the Crash and the subsequent restructuring of the global economy revealed that money was a mode of communication. If the communication world is made up of all those materialities that allow us to enter into relationships with one another, then money is a crude but massively infectious communications medium, second only to weaponry in simplicity, brutality, and effectivity. The 1930s witnessed a movement in the global stock markets toward increasing fluidity and rapidity of trade. War too would change into blitzkrieg, dependent on short-wave radio and reconnaissance photography. War and finance would share a strategy in the adoption of the

blockade as the key to victory. Stopping flows would become the key to stabilizing situations, to bringing them under control, to a return to confidence—to the minimization of change.

Meanwhile, the commodity evolved. The trade in immaterial goods, notably radio's trade in audiences, rose to the forefront. Itself an ephemeral and intangible good, the cinema was at the heart of this trend, not least because of its strategic position, at RKO especially, as a node in proliferating networks of interconnected businesses. No longer necessarily material, the commodity was becoming an image. Brand identities, industrial design, proliferating consumer choices, the rising use of catalog shopping all contributed to the way in which commodities were becoming images of themselves. But the more image-based or image-conscious commodities became, the more communicative value replaced use-value, the more they opened themselves to the randomizing effects of the communicative environment, in which meaning can never be fixed. The rapid growth of the advertising industry was consequent on attempts to minimize this effect and to establish and maintain a stable identity for the image-commodity. But advertising is also mute tribute to the necessity of stabilizing and identifying, over and over again, the flux to which all meanings and identities are subject in this new era.

The classical system likewise seeks to remove the dialectic of presence and absence, and so the possibility of change, by capturing the difference between the two in a perpetual recursivity that assimilates otherness into homeostasis. The ethic of entertainment adds the imperative to mutate in each recursion through the pressures of innovation required by the new commodity form. Through the structuring agency of the script, the entertainment ethic services a desire characterized by circularity, fullness, and sublimation rather than the linearity, lack, or repression of other-oriented desire. This perpetually renewed, full desire fetishizes its newly stabilized binaries as spectacle, sheer surface. Classicism's commodity aesthetic is thus fantastic, in the sense of multiple, simultaneous, and contradictory identifications across many possible gender, sexual, and subject relations (Freud 1979). Twenty-five years earlier, in Méliès's day, the commodity form concealed an emptiness. Now in the mid-1930s it embraced a plenum, but one defined by the seamlessness of its spectacular image. Bataille's (1988) promotion of the economics of excess is itself a description of this change in the nature of the commodity, not at all a contradiction of or an alternative to it.

Spectacular consumption, in the form of the consumption of spectacle, is central to the commodity aesthetic of cinematic classicism, as is the continuity between the sublime and the abject. Both serve the task of equilibrium.

Bellour's (1974/1975, 1975b, 1977) observations of the symmetries typical of classicism are based on qualities specific to a mathematical consideration of time. Narrative events can be symmetrical when they are repeated (translated) or reflected. This is not true, however, of nonnarrative events like walking or rain falling. Cosmology tells us that perfect symmetry existed only momentarily in the Big Bang and that evolution, causality, and entropy depend on the broken symmetries of the first instants of the universe's existence. In the perfectly symmetrical universe, rain rises as well as falls (Stewart 1995: 87). In a perfectly symmetrical film, every frame is identical. Narrative depends on symmetry-breaking: ultimately, there is narrative because the universe is expanding.

The Lumières' films accept the monodirectional, asymmetric nature of time as it exists in the actual universe, but in focusing on the nonidentical nature of successive images, they bring us to a sense of time as pure difference. The Lumières synthesize movement. Limited to the bilateral symmetry of its object, animal locomotion, the earlier chronophotographers analyzed movement into immobility: the burden of Zeno's paradox. The Lumières' synthetic movement allowed them to make films of astonishing symmetry, since they open out from the dynamic equilibrium of perpetual, if indistinguishable, change and becoming. When classical Hollywood develops this synthetic approach, what Bellour observes as symmetries are instead effects of symmetry-breaking, periodic oscillations, repetitions and reflections of space-time events. By stressing the repetition rather than the difference, the nested symmetries of scenes, sequences, and narrative bring difference under control by establishing patterns of movement away from and back to equilibrium. The broken symmetry of Hollywood's narrative desire counters the primal difference of raw becoming with the endless repetition of distinction and differentiation. Through these distinctions and differentiations established by breaking the pure symmetry of zero, the chaos of becoming can be bound into stability.

The fantastic in classicism is thus a moment of asymmetry, a movement out of equilibrium that allows equilibrium not only to restate itself but also to assert the absolute nature of its rule. In this sense narrative is a data structure. Not so much a linear curve, classical narrative is a three-dimensional

array of space-time events. The symmetries produced by the script, and by framing, composition, editing, and postproduction, allow us to analyze these events three-dimensionally from a constellation of viewpoints. Specific takes and their ordering are then parsed in postproduction through a series of reflections and translations to produce the phenomenon of the linear film. Fantasy, the multiple possible series of roles entertained in the relation with the narrated events, synthesizes these permutations as either a reconstruction of the same series of constelled viewpoints or a deconstruction that multiplies them exponentially. Though we experience the curve of narrative inside the linear dimension of time, in the moment of the ending when we experience it again as gestalt, we experience it as a stable data set whose function is to ensure that all movement, and especially that of fantasy, is finally grounded within the ontology of difference and repetition.

This suggests something akin to Eisenstein's Image, the conceptual structure of whose vibrations every temporal structure of the total film is an expression. Yet there is a significant difference. The script, as the framing and structuring form of classical cinema, is not a concept, although it may, in some examples, mobilize a concept—as happens in *King Kong*. But concepts themselves are assimilated within the stabilizing structuration of the script as matrix. Thus the concept of liberty in *The Hunchback of Notre Dame* is bounded by the binarisms of beauty and ugliness, repression and saintliness, and presented as an achievement of the book (and by extension the film) that is already in the audience's past. The persuasive power, the rhetorical and dialogical structure, of liberty is contained within a systemic symmetry that holds it in stasis, depriving it of both purposiveness and vectoral openness. What then is the nature of time at RKO during the 1930s? What is this containment of difference?

Difference, nonidentity, is as much a historical category as is being. To make a loose analogy, the Lumières' cinema is Bergsonian. It thrives on the *élan vital*, the energy and the rhythms of life. But RKO is closer to the mode of difference mooted by both Deleuze (1994) and Derrida (1976) in 1968. For Derrida there is not Being but difference (or *différance*), the elemental failure of things to be identical with themselves. As a result, objects repeat themselves, vibrating about their internal difference, and forming a trace of their process. For Deleuze the same process holds, but in reverse: repetition is primordial, and things or events repeat themselves as ever-renewed copies of an original that does not exist: the vibration of simulacra produces differ-

ence as such and especially those differences that are presented in the *Anti Oedipus* as the rhythmic pulsions of life acting on and through the body without organs (Deleuze and Guattari 1972). Vattimo points out that both theses, despite their avowed goal of going beyond metaphysics, are metaphysical, not least because both depend on the metaphysical category of eternity—the eternal return in Deleuze, the categorical statement that "difference is not *in* history" for Derrida (Vattimo 1993: 144). Vattimo's complaint is that the two French philosophers attempted to remove the ontological ground of philosophical metaphysics, but ended up replacing it with a new one: eternal repetition or eternal difference. Neither difference nor repetition responds to history, to a specific historical conjuncture, to the moment of classical Hollywood.

In Guy Debord's exploration, spectacle can be seen from within as that social regime in which images of things replace the things themselves, in the way that brand images overtake the use-value of the things they advertise. Seen from the outside, spectacle takes over from Marx's production-era definition of the commodity form in which human relations assume "the fantastic form of a relation between things" (Marx 1976 [1867]: 164–165). Relations between people have now taken the form of relations between images (Debord 1977: paras. 4 and 36). In the classical norm, spectacle treats difference as if it were primordial nonidentity. It organizes it through repetition—Bellour's symmetries—into structures that provide difference with a unified identity. Specifically, it identifies the identity of difference as nonidentity. This is the secret of the present-absence of the image. Spectacle is the name of the nonidentical, and the image is its typical form. By imaging it, spectacle orders nonidentity, and through repetition structures and controls it as narrative and entertainment. Thus the similarity with Eisenstein's image: spectacle raises the nonidentical to the level of a concept. But such a concept cannot have a direction or a purpose, a perfect solution for the demands of permanent innovation within the rigorous confines of the commodity form. Moreover, this new post-1929 variant of commodification replaces the emptiness of exchange value with the plenum of perpetual movement. Like Bataille's concept of the economy of excess, the Deleuze–Derrida conception of repetition and difference does not define an alternative to the commodity form: it describes a stage in its development. Once again, the philosophers arrive with a critical description decades after its practical realization.

RKO, of course, had no use for ontology. But it did produce a series of films distinguished by the meeting of extremes, the cycling of repetitions and symmetries, the elaboration of permutations in single scripts and across series, and perhaps most of all by predestination and stability. The classical narrative is linear in the sense of the broken symmetry discussed here, but the line itself will return on itself to complete the shimmering surface of the spectacular commodity. The pixel returns, but now governed by circularity, a perfectly rounded zero whose perfection is an impenetrable barrier lying between being and nonbeing, the nonidentical as the skin of the film beyond which neither vision, desire, nor analysis will penetrate.

The normative cinemas of the 1930s are not static. If they were, they would never have been so successful or so long-lived. Rather they offer templates into which a variety of contents can be poured, but which bound and shape those contents in distinctive fashions. Each points to something external to cinema as its alibi. To some extent, the classical film is the most purely cinematic, which is why it embraces with such conviction the aesthetics of the surface. Yet at the same time, it too has an allegiance beyond itself. On the one hand, it responds with microscopic adjustments to the fluctuating form of the commodity, of which it is itself not merely an example but, in the 1930s, the archetype. But it is also a fantastic desiring machine, and one that operates at its peak only when it manages to reach out to the desires of its audiences and activate them within its bounded circle of repetition. If Eisenstein's master is the state, and Renoir's mistress is society, RKO classicism is the slave of culture.

Culture is a notoriously slippery term. Since Herder, it has been shaped by the plural form, cultures: a culture is always proper to a distinct group, responsible for unifying them under the sign of identity. What distinguishes the concept of culture for classicism is that it is governed not by identity but by difference. Long before the advent of neoracism (Balibar and Wallerstein 1991), RKO's output in the 1930s addresses a culture marked by its inclusiveness, even if that inclusiveness was a matter of aspiration rather than reality. Nonetheless, everyone is invited, though each is treated differently. Not only the economic demand to maximize audiences and so never to alienate a major section of them, but the aesthetic of the spectacular commodity addresses each audience member as discrete, distinct, individual. We know we are addressed by a mass medium, but the medium speaks so in-

timately that culture becomes a matter of the personal link between the filmgoer and the screen, as if we witnessed in the cinema after 1929 a secular repetition of the arrival of protestantism, in which the mediation of the Church was no longer needed, and the worshipers could address themselves directly and personally to God.

The moment in which classicism individuates its audience is the moment of address. It works in quite the opposite direction to realism. Unlike *La Règle du jeu*, where mortality is the leveling commonality that nonetheless each of us must face alone, and which thereby guarantees our individuality, the spectacular mode of address at RKO speaks to us in the language of the intimate, of dreams and desires, to persuade us to a cultural conformity that otherwise has no reality. But it shares with realism, and with total cinema, with all cinema that aspires to normativity, a specific albeit varied temporality. The cost of becoming a norm is the sacrifice of change. In total cinema, the vector's infinite dimensions are rendered as totality, and in that assumption of completion to the work of film, the dynamic is frozen into conceptual presence. Realism seizes on ephemerality, but where the logic of the cut once led to the endless multiplication of objects, the realist must gather that manifold into a single presence, that of the world which, even if it remains external to the film, alone guarantees its claim to truth.

The spectacle acts differently again. Commodity relations propose to us that we relate to one another only through objects. The era of the spectacle renews that as a relationship between images. Those images, however, in classicism are the insubstantial dividing line between the irreconcilable dimensions of the commodity, its presence and its absence. To achieve this equilibrium, classicism must place all its production into the past. Most of all, the moment of gestalt, in which the structuring of narrative time is rendered retrospectively, places all the past under the sign of erasure, propelling us into a pastless present just as it drives us to a depthless surface. This is the magic that brings about the governance of that flux—of innovation, of fashion, of desire—on which consumer capitalism and specifically the reconstruction of the global economy of the 1930s was based. Now the apparently irreconcilable claims of stability and change can be brought to resolution.

In each instance, as the table summarizing this section is intended to show, the normative cinemas that crystallized in the 1930s govern time by drawing it into the present.

TOTAL FILM	REALIST FILM	CLASSICAL FILM
Rhetoric	Reality	Spectacle
State	Society	Culture
Inventio	*Elocutio*	*Dispositio/pronunciato*
Image	Depiction	Entertainment
Music	Sound	Dialogue
Idea	World	Script
Sublime	Beautiful	Spectacular
Realized present	Debarred future	Irretrievable past
Totalization of infinity	Unification of multiplicity	Equilibration of flux

During the 1940s, the powers of the studios collapsed but the unstable classical norm remained, as did the realist and total norms. The aesthetic resources of all three became available for all the others, not only fluid and adaptable, but also porous—so much so that it makes little sense to speak of other films as aberrations from them. Already in the 1940s, other films—Gainsborough melodramas, for example, or the colonial cinema of India—intermingled realist, total, and classical norms alongside other national structuring devices. These norms, then, are neither exclusive nor absolute, but typical of a movement through which cinema passes. Normative cinemas, of every kind, share the production of the present as a special effect proper to the art. In the decades that followed, that norm of norms would be challenged and, from the 1970s onward, begin to make way for new modes of cinema and new temporal dimensions.

| Part III |

Post Cinema

NEOCLASSICAL FILM

Slow Motion, Angel of the Odd

It is an immorality that IS America.

—*William Carlos Williams*[1]

Nostalgia for the Cinema

Peckinpah's Westerns—*The Wild Bunch* and *Pat Garrett and Billy the Kid* especially—are barbaric elegies, the only form of poetry available after Auschwitz (Adorno 1967: 34), in this instance songs for a vanishing world. The fly-blown air of heat and boredom as the films' protagonists wait for death is a rhapsodic portrait of the justified at a moment when not only is the frontier closed, but the last of those who remember it are dying. In a single lifetime, the open ranges will become tract housing, and the epic and epochal scale of cinema will be replaced by the corrupt and dishonorable codes of television, where Peckinpah cut his professional teeth (Simmons 1998: 27–34).

The films' inevitable failure to capture loss at the moment of loss is the source of their beauty, and of their sadness. The characters of *The Wild Bunch* regret losing the Old West of *Pat Garrett* whose characters regret the passing of an even older way. The Old West was never more than a state of mind, and one always unrecoverably prior to whatever present we attempt to inhabit. The world of Peckinpah's West is always a fallen one. The Uruguayan critic Angel Rama observes of early twentieth-century cultural revivals in Latin America, "The living popular culture of the moment was not the conservative, declining folk heritage of the countryside that urban intellectuals admired for its picturesque local color. It was the vital, vulgar culture of the urban masses, who drew on rural folk traditions as the natural

matrix of their own creativity but did so without a nostalgic urge to conserve" (Rama 1996: 103). The classical Western worked in the same way, but for Peckinpah it was that urban legend of the West that had become the lost Eden. Not historical but fictional, what had gone was not just the Old West but the Old Hollywood: the prewar world of John Ford. Peckinpah's is an antitechnological universe: the six-gun and the movie camera are the only true, the only authentic machines. All other devices, from Garrett's Winchester to the printing press Alias walks away from, are substitutes for living. Only cinema and the code of the shoot-out have the smack of truth, the phenomenology of visceral presence. And both are caught at the moment of their fading.

Seydor (1997: 180) notes the proximity of the destruction of the bridge in *The Wild Bunch* to one of Peckinpah's favorite films, *The Bridge on the River Kwai*. Even closer is the Western cycle of Sergio Leone, who once observed in a BBC interview that "My bridges have a tendency to blow up." More germane than these European movies to the nostalgia of Peckinpah's set-ups, however, is the reference to the great bridge sequence in Buster Keaton's *The General*, a film that marked the high point of the authorial director in Hollywood. Peckinpah's well-documented battles with producers over directorial control are significant contributions to the myth of the Hollywood auteur. Creative freedom is, in Peckinpah, the mythic freedom of the Old West, and both are dying. The Paramount Decrees severing production and distribution from exhibition had changed the economic landscape of North American filmmaking forever. Meanwhile, the new domestic pleasures of suburbia had emasculated television. Though Hollywood turned toward a more mature subject matter for a period when its key demographic appeared

to be the adult audience dissatisfied with the child- and teen-oriented safety of television programming, economic conservatism still ruled.

Peckinpah is an early proponent of neoclassicism, whose aesthetic key is a movement away from narrative toward diegesis as the core of the film. We do not need to believe, with Kitses, that *"The Wild Bunch* is America" (Kitses 1969: 168), or to accept the political allegory proposed by Brauer (1974) to grasp this shift, although it relates obliquely and tortuously to a reorientation of conceptions of national identity in the era of the Vietnam War, a thesis shared by Sharrett (1999) and Cook (1996: 928–930). With Peckinpah, dialogue- and story-driven classicism embraced a realist obsession with the creation of a world. The rapid development of soundscaping (Schreger 1985) and the impact of widescreen (Carr and Hayes 1988; Belton 1992) helped this devaluation of dialogue in favor of mime and accelerated the classical Western's fascination with landscape, the world conjured up in the structural analyses of Cawelti (1985) and Wright (1975). The myth of the West had become international property over the years: we can refer to M. Lange's Arizona Jim in *Le Crime de M. Lange* for a sense of its significance in popular culture throughout Europe. With Leone's 1960s Western cycle (*A Fistful of Dollars, For a Few Dollars More, The Good, the Bad, and the Ugly, Once Upon a Time in the West*), the European vision returned to the U.S. market in hybrid form: an Italian film based on a Japanese original made in Spain with German money and a Californian star. Moreover, the Leone films paved the way for a more historicized sense of the Old West as a complex political economy in which the railroad and the cattle-barons play an ineluctable part. And of course Leone introduced that dilated sense of time passing that would become the raw material of cinema in *The Wild Bunch* and *Pat Garrett*.

Ugliness and the Exit Wound

Every myth of origin of the nation-state, from *The Aeneid* to King Arthur or Robin Hood, from the *Chanson de Roland* to *The New Zealand Wars* (Perrott 2002), requires two factors. The first is heroism; the second betrayal. In the homosocial worlds of the national epic, difference is reduced to its absolute: the hero and his other, or more particularly the heroic socius and its betrayer. Its archetypal statement is the Last Supper, still echoing around Mapache's high table with its machine-gun monstrance in the square at Aguaverde. History begins with betrayal and is given its enduring quality, its endurance

indeed, by the suffering of the hero. Conservative folklore has the sovereign betrayed by his subjects—King Arthur, Victorian source of legitimacy, Lincoln in Capra's populist Republicanism. Popular history revolves around or assumes the betrayal of the people by the monarch—King John in the Robin Hood legend—or abandoned by rulers and forced to invent justice. In the neoclassical cinema, the law is entirely external: an arbitrary means to exploitation. In its place, justice is grounded in revenge for betrayal by the law. History is invented by the protagonists on behalf of the diegetic world. The gap between classicism and neoclassicism is the gap between nationalism and postnationalism in the era of globalization, whose first experience came home to Hollywood in the form of the Vietnam War.

Ford's Westerns inhabit this scale of national myth as much as the Serbian epics, but do so in the mode Rama identified as conservative. The heroism of *Stagecoach*'s Ringo Kid is permanently available as resource, and the nation's destiny resides in its truth to those values that lie at its roots. Peckinpah, however, belongs to the second mode, not so much because he represents the urban—he was intensely concerned to foster a biography grounded in the California high country—as because, when compared with those of his peers, his Westerns are ready to hybridize. It is not only that folk traditions are his raw material, his "natural matrix." When Peckinpah looks into the Old West, he sees not the purist homogeneity of a monocultural *Volk* but *mestizaje*, the mixing of Hispanic, European, and Indian cultures at the point of origin. Like Bernal's Athens, meeting place of Asia and Africa (Bernal 1987), or like the music of the Afro-Celt Sound System, grounded in musical and linguistic affinities between Celtic and West African languages, Peckinpah's myth of origin is a legend of cultural mixing, not one of racial purity. Those who attempt to import European monocultural values—the temperance preachers, for example—are the enemy. In a move that extends the careless innovation of the tango in the 1910s and '20s, Peckinpah's films do not mix what was originally pure: they insist that there is no purity at the wellspring, and that our "identity" has always been multiple.

From this hybrid standpoint, it is the pure that is ornery. When the railroad boss Harrigan declares that he is always right and represents the law, it is a claim to such purity of identity. The same claim is implicit in the German commandant, *eminence grise* of Mapache's camp, for whom the machine gun must be mounted on a tripod, not fired off at random. The mechanical placed against the chaotic is a dialectic of the pure and the hybrid, with the

| Figure 8.1 |

The Wild Bunch: predestination as the only freedom. Courtesy BFI Collections.

film's heart firmly planted in the *mestizo* soil of the borderlands. Thus Peck-inpah abandons the purity of the epic in favor of the border ballad, elegy being the appropriate mode for a film practice whose central motif is the suffering of the hero who cannot blame his betrayal on another.

Not only suffering but violence derives from betrayal. In *The Wild Bunch* (figs. 8.1, 8.2), that betrayal is multiple, as emblematized in the open-ing scene of children torturing scorpions by placing them on an ants' nest. "One supposes that the scorpions stand for the professionals," notes Noël Carroll (1998: 57), while the ants stand for the little people, the children who punish Angel as he is dragged behind the Ford Model T, or perhaps the westward expansion of the small-minded civilization that Peckinpah's he-roes so despise. Then again, perhaps the scorpions are the big businesses, and the scene prefigures Fanonian revolutionary cruelty. The power of such emblematic shots derives not from their unambiguous allegory but from

| Figure 8.2 |

The Wild Bunch: from the montage of the falling cadaver: killing as ethical aesthetic. Courtesy BFI Collections.

their opacity and ambivalence—one reason that this sequence works rather better than similar ones in other films. Most of all, the sequence radiates a quality that will be essential to the film, and indeed to the new Western as a whole: the sense of the ugly. Ugliness is not the same as the vile or the abject. As Leone's title suggests, it exists in a relation between the good and the bad: the ugly is an ethical category.

Peckinpah wants—or wanted in his early career—to go beyond the pointless, painless amorality of the television Western.

Look, you know what this is? That's a .45-calibre, 240-grain hunk of lead that can splatter your brains out like a jumped on squash. You ever seen a bullet hole? I mean up close. Oh, it goes in little enough, but when it comes out, that's if

you're lucky and it comes out, it leaves a hole about like that. Now a gun ain't something to play with, it's to kill people with, and you don't reach for it unless you're going to shoot, and you don't shoot unless you're going to kill. You understand? ("Hand on the Gun" episode of *The Westerner*, scripted and directed by Peckinpah; Seydor 1997: 17)

It is not the anodyne and formulaic that must be shattered, but the belief that life can be taken without consequence: a belief still enshrined in the language of "surgical strikes," "collateral damage," "friendly fire." Death in Peckinpah is ugly because it is a moral event. But it is beautiful on the same basis, a truth already exploited by Arthur Penn two years earlier in *Bonnie and Clyde*, a film that reinvented the gangster by removing him from the city into the dusty countryside of the Depression, a scant twenty-five years after the Bunch rode over Mexican border.

Penn's film made extensive use of squibs, small explosive charges packed under an actor's clothes next to a small bag of prop blood and detonated electronically. Early cinema gunfire was provided by real weapons; wounds were simulated by firing ink-soaked sponges from small pistols. With sync sound, a more realistic effect could be gotten either by firing live ammo, especially for machine-gun fire, or by firing gelatine capsules filled with imitation blood from air-rifles. The squib was a new invention in the 1960s. Peckinpah's stunts department added to the effect by placing charges at the exit wound side of the body, an effect toyed with in a single shot of *Bonnie and Clyde* when a fragment of "skull" is shown being blown out of C. W.'s head in the final shoot-out.

Peckinpah used the effect extensively, adding scraps of meat to the squib to emphasize the trauma, and ensuring that the explosions were strong enough to give the actors a hefty jolt. The sheer number of exploding squibs in the finale demanded multiple takes, as well as a fantastically large population for a small outpost. In the making of the final shoot-out in *The Wild Bunch*, the props master had only 350 Mexican uniforms. The shoot eventually called for something in the region of 6000 wounds. A production line was set up to patch the exploded jackets with tape, paint them khaki, and plant fresh squibs in them. One critical effect of the meat in the squibs was to suggest the smell of the carnage, a connotation rarely even mentioned in dialogue in earlier films, with the exception of some B Westerns. Angel's death was originally accomplished with the aid of a carbonated syrup

stashed inside a pressurized prosthetic skin over the actor's throat, an effect borrowed from Kurosawa's *Sanjuro:* the shot was excised from the final cut with Peckinpah's blessing—the effect had got a laugh, possibly of embarrassment, at previews, perhaps because of the cartoon effect of violence raised beyond the socially tolerable.

Despite Dixon's claim that "One could hardly imagine the song 'Raindrops Keep Falling on My Head' being incorporated into Peckinpah's vision of the West, as it was in *Butch Cassidy*" (Dixon 1999: 156), Peckinpah was capable of sentimentality, as witness the saccharine "Butterfly Mornings" sequence in *The Ballad of Cable Hogue.* As primarily sentimental—enjoyment without incurring responsibility—that sequence and to some extent that whole film abandon responsibility for the actions of the characters and for their fates—the crude irony of Hogue's death, for instance, under the wheels of his lover's car. One might say the same of the decision to reduce the slit throat to the passing of a knife and a reaction shot. Given the generous brutality of the sequence, the only stumbling block was that laughter in the preview theater. Tragedy requires pity and terror, emotions proper to empathy and identification and thus to ethics. In the original cut, pity for Angel is sentimental and the terror fatalistic, neither evoking an ethical commitment. Without responsibility, the sentimental becomes sublime or, as here, its opposite—disgusting. The vile is by definition asocial, debarring itself from communication and therefore from ethics. Beauty is ethical because it is social—historically grounded fruit of common taste and shared standards. Like beauty, ugliness is a matter of debate. It is speakable, and when we speak of it, or argue what is or isn't ugly, we take responsibility in ways we cannot when confronted with the unspeakably awesome or the unutterably vile.

In the existing cut of *The Wild Bunch*, we are in the field of beauty and ugliness, not of sublimity and the vile. The fountain of carotid blood is vile, inappropriate to the context of beauty and ugliness, and comical for that reason. Even if it had not raised a laugh, confronting the audience with the abject would, as counterpoint, reposition the deaths of the gunmen as sublime and tragic, rather than historical and elegaic. This dividing line distinguishes *The Wild Bunch* from many subsequent films, including several of Peckinpah's own. In the splatter genre of horror, for example, the vile is erected as an extrahistorical category, an inverted Ideal Form according to which evil is the perpetual and unchanging antithesis of life. Too often,

sequences aimed at establishing disgust function purely to reinforce themselves, and to remove the film from the critical categories of social discourse that anchor meaning in time. They present their shocks in simple paradoxes: the commonest form of the vile is the inside-out, in which the wet, glistening, soft viscera are on display while the epidermis, if nothing else waterproof, is peeled back to reveal an undead and ahistorical interior both porous and invasive.

What makes *The Wild Bunch* a finer film than such is that it demands that we meet and understand not individuals, nor principles, but a landscape of action. Yet despite the claims made for it, *The Wild Bunch* is not a flawless film. Its political reason for being lies in the political violence of North America in the late 1960s, and the discovery of the My Lai massacre, which had a dramatic impact on Peckinpah, as evidenced by a letter of his read by Jason Robards in the BBC's Moving Pictures documentary *Sam Peckinpah: Man of Iron*, comparing the violence in the film with that visited on the people of Vietnam. To see the film as radical is overstating the case. Allegorically, Pancho Villa should stand for Ho Chi Minh, but Villa's forces remain as faceless as the Viet Cong in Hollywood (with the honorable but financially negligible exception of Oliver Stone's *Heaven and Earth*).

In any case, the Bunch's self-destruction has little to do with revolution, everything to do with a final act of camaraderie in the closing moments of their time in history. The reprise of the visit to Angel's village under the final credits reveals that sequence's tendency to the maudlin: its mute dialogue of shared thoughts and experiences that need no vocalization (and therefore no translations), its infantilization of the psychopathic Gorch brothers, its Tex-Mex reworking of the dance from *My Darling Clementine* without the dance having been earned. "It ain't like it used to be . . . but it'll do": the film's last line of dialogue allows the Bunch a grandeur that, in fact, they have not deserved. Thornton's smile is relaxed and happy because, after all, he has not had to change. In this sense alone *The Wild Bunch* is sentimental, in a way that, with all its flaws, *Pat Garrett and Billy the Kid* is not.

Anecdote of the Jar

Pat Garrett and Billy the Kid (figs. 8.3, 8.4) sports two incompatible protagonists. Billy is the last outlaw, the last free man, in a world that is turning legitimate. Garrett is not so much a turncoat and traitor as a fatalist, seized

| Figure 8.3 |

Pat Garrett and Billy the Kid: Bob Dylan as Alias—star as actor as character at the margin of the narrative and the center of the score. Courtesy BFI Stills, Posters, and Designs.

by the idea that the weight of history is too much for a man on his own to change. Across a landscape of dusty sunlight the two will circle each other through a picaresque of killings, brawls, drinking sessions, and brothels, constantly shadowed by the knowledge we have, from the outset, that the end of the story is already sealed, that Garrett will shoot Billy and will in his turn be brought down by anonymous gunmen. The film is heavily weighted toward the self-consciously aging and disillusioned Garrett with his sense of anger and doom. Cursory, psychologically undeveloped, the character of Billy is emblematic of a mythical freedom. Garrett will age, swept along by times not of his making: the Kid confronts destiny as event, as the moment where legend intersects with history.

The film recalls, in a more macho and violent mode, the anaesthetic of Wallace Stevens's (1955) "Anecdote of the Jar," about a jar the poet places on a hill in Tennessee, which "made the slovenly wilderness surround that hill."

| Figure 8.4 |

Pat Garrett and Billy the Kid: age, cunning, and resignation against youth, beauty, and fate.
Courtesy BFI Stills, Posters, and Designs.

The orderly thing arrests the landscape, brings it to order, but the jar "did not give of bird or bush/Like nothing else in Tennessee": its order is as sterile as a mule. Against the life force embodied in Billy—free-loving, free-living, free-drinking, open-hearted, and on his way to a tryst with history—Garrett is haunted by his own demons, torn between loyalty and security, between an old code of honor he knows he will betray and a new code of business he despises but to which he submits. In the shadow of Vietnam and the Watergate scandal, the film presented itself as an account of law gone to ruin, with the Santa Fe Ring of Chisum's landowners in the role of the military-industrial system, embroiled in a vicious pacification of the landscape and sterilization of its freedoms (see Weddle 1994: 489–491; for Cimino's version see Bach 1985). The political scenario is acted out on the scarred prairie of Coburn's face, haunted by a duty in which he does not believe. That betrayal is the core of the film, while Billy's smooth skin and wide eyes provide its mythic counterpoint. The film, its narrative, its narration, its most detailed characterizations, take place in this dirty political world of half-

truths and unwelcome promises: the myth is there only as foil. Yet Dylan's score will take the opposite road. If the film is Garrett's, the music is Billy's.

The vocal track first enters as Billy escapes from jail in Lincoln. As the lyric reaches the line "Up to Boot Hill they'd like to send ya," there is a cut to Alias, who turns from the camera, taking off his apron as he goes, and with a look of decision on his face. This is only the ninth shot of Alias, none of them with dialogue. Indeed, we have to wait for the next scene before we hear his voice, responding to Garrett's query, "Who are you?" with the curt and cryptic response, "That's a good question." The audience could be expected to identify the singer on screen, singled out by medium close-ups and midshots from the rest of the townsfolk. But given Dylan's fame and significance in the marketing of the film, the singer is more identifiable than the protagonist, a role that, in any case, Dylan had rejected and Alias never achieves. Strangely marginal to the narrative, although Alias looks, no other character looks back at him, leaving him unplaced in the series of reverse angle shots that dominate the scene. At the same time, the spatial organization, clear enough on analysis, isn't immediately apparent in normal viewing: we have to infer his position from the shots of the other players. In filmic terms, as unobserved observer, Dylan is external to the action and in that sense occupies the role of proxy for the audience. Yet the star charisma that allows us to identify him as Dylan tends to militate, in the special circumstance in which he is also the asynchronous, extradiegetic voice of the soundtrack song, against the ordinary identification we might have with a movie star in the role.

In his activity as a well-known public figure undertaking the work of an actor on screen, Dylan performs a curious work of suture in the world of the film. Until this shot, Dylan is clearly an outsider to the action: in shot 26 he turns into a participant in the narrative. This coincides with the lyric "Billy don't you turn your back. . . ." It is the nearest we get to mickey-mousing in the scene. Typically, mickey-mousing brings together image and sound into a single unified effect. Here it draws together five disparate elements:

- Dylan as star,
- Dylan as performer of the soundtrack,
- the first-person narrator of the soundtrack song,
- the actor Bob Dylan, and
- the character of Alias,

not all of which are in synch. Until now, Alias has not addressed Billy at all, yet in the song, the first-person address to Billy is in the character of someone who has known him for years, that is, in the character of Alias in the relationship he will have with Billy by the end of the film. Our apparent synchronization now seems to conceal some temporal glitches. Visually—and this will be reinforced in subsequent shots—Alias's turn is a decision to leave the construction of the diegesis and join in the construction of the narrative. But it is executed in terms of a complex association with the lyrics of the song, in which, while he warns Billy "don't turn your back," he turns his own. This striking synchronization might even be seen as a rare moment of crudity in the editing comparable to the heavily signaled ironies of children playing on the gallows earlier, but less blatant given the transposition of reference from one character to another and the temporal displacement of the symmetry that is in the process of being established between Dylan on the soundtrack and Billy in the visuals.

The shot draws the singing voice into a curious hinterland between diegetic and extradiegetic, and between commentary on the action in this specific scene and on the film as a whole. Here, at the moment of synchronization, the voice has an ambiguous role as motivated by onscreen action, despite being laid in as commentary in every previous shot. The status of both the song and the singer alter with the moment of synchronization, permitting not only the recruitment of Dylan into the narration, but the reorganization of the song's relation to the image. Until this point, the song was extradiegetic commentary on the action; now it is diegetic and comments from within on the world of the film. And so we have a further paradox: the singer on the soundtrack is now implicated in the linear structure of the narration, while the song appears to have been freed from linear constraints to address the global themes of destiny and freedom to which the film is oriented. Dylan/Alias's dual position, both inside and outside the diegesis, both subject to and agents of linear narration (Dylan as balladeer, Alias as chronicler), is what allows the image-sound relation in *Pat Garrett and Billy the Kid* to be so mythopoeic, but at the same time to break the classical symmetries. As in the allegorical relation between Alias and Billy, minor asymmetries creep in as the classical system is asked to provide semantic structures—specifically dialectical structures—of which it is incapable.

To that extent, the relation between Billy and Alias remains cryptic and unmotivated throughout. The hermetic aura in which Dylan folded himself

in public and in his songs from the mid-1960s on defines freedom as a refusal to be identified and interpreted. The ideological dialectic of the necessity and impossibility of freedom from identity chimes with the diegetic of the disintegration and dishonoring of the West. When Alias turns decidedly, we can wonder whether the narrative motivation is the spark of understanding between Billy and the Mexican, an act of solidarity with the Other entirely in keeping with Dylan's personae in songs and public statements since his earliest successes. Alternatively, Alias's decision might be derived from Billy's ride out under the gallows he escapes. In this case, "don't turn your back on me" would give the first person of the soundtrack vocal the added overtone of the death that Billy has refused, and would further explain the nonlinear temporality that the song takes on at this moment.

A third possibility comes in the next shot, in which the most misogynistic of the verses accompanies a pan that moves from Billy in long shot to a man shoveling coal into a forge in medium shot, the darkness and flames, whose roar intersects with the music, accompanying a line that, in Dylan's modulations, could be heard as either "Into her dark hallway she will lead ya" or "Into her dark hole where she will lead ya." Even discounting the crude Freudianism, there is an apparent collapsing of femininity and death here, which the extended lyric's implied narrative also dwells upon. Is Alias's decision also motivated by this dark elision of sexuality and mortality? In either case, the fiery furnace aligns sex and mortality with the fires of hell, taking us in the opposite direction to the Christlike pose of the surrender at the shack and the degradation by Ollinger that illustrates the album cover. The Manichean universe implied here is symptomatic of the struggle toward and failure to secure a dialectical structure to the film, a failure that enforces the allegorical tenor of Billy and Alias's characterizations.

The song "Billy" bares its own internal dialectics in the stretch between notes at the top of Dylan's vocal range, the reach for the tertiary rhyme, the sense of foreboding and of nostalgia, its doubling of cyclical form with narrative impulse, the clash between blues and waltz rhythms, and the lived-in timbre of Dylan's singing. It also reaches a kind of *point de capiton* by linking soundtrack and image into a single troubled and ambivalent but nonetheless organized and recognizable whole. On the cut before the end of the line "Billy don't you turn your back . . . ," by the time we hear its close, " . . . on me," Billy is riding out of town seen from the vantage point of the forge. If the former shot has persuaded us that Dylan (visually) is Alias, in the latter

Dylan (audibly) is Billy. Since the film in general is characterized, like the song, by omniscient narration, there is no difficulty in our assimilating the presence of the anonymous foundryman into the sculpture of the film: his failure to look gives us instead a sense, like Auden's "Musée des Beaux Arts" (1966: 123–124), that life goes on in its uninterrupted round despite the fall of Icarus.

The role of observation is overrated, the film suggests: the depiction of great events is simply a way of narrativizing the ordinariness of the everyday, a theme picked up in the "Duck of Death" sequence in Eastwood's *Unforgiven*. And although the song is suitably ambiguous in warning that the reason for not turning your back is not to get shot as much as it is a plea that Billy take note of the song's forebodings, it heralds in the carriage of the line over the edit between shots the way the foundryman turns his back on all of this, the roar of his flames allied with the darkness of the mortal, sensual hallway, the Hell at the end of the road on which Billy rides. After Billy is carefully, even clumsily Christianized in the shots of his surrender to Garrett at the shack, and more subtly in the framing of his scenes with the Mexican, this extension of the Christian symbology as iconographic subtext functions to ground Billy in a religious past and the song in the film as a prophesying. The fade-out under the following scene, which is dominated by Garrett, can then be read as the fading of mythic history under the geographical imperative of the Santa Fe ring, itself marked at the end of the Garrett sequence by the sweetening of the ambient sounds with the chiming of church bells over an image of Garrett arriving at the picket fence of his already suburban home.

There follows a montage sequence covered by the remaining two verses of "Billy," in which the song resumes its metacommentary function and Billy is remythologized as an emanation of the landscape prior to the narrative sequence in which Garrett visits the Governor's residence. The film maintains this cycling between mythopoiesis and a realism almost Zolaesque in its bleakness and predestinarianism, while in the new context of film score, the song can now be read as far less ambivalent or dialectical in itself and far more dialectical in its relation with the image.

Michel Chion is adamant that film music does not exist "in itself and as such" (*en tant que tel*): there is only music in film. All musics in cinema are integral to the film: there is no special art of film music differentiable from either other musics that might be cinematically applied, or from the inte-

gration of sound and image that forms the audiovisual (Chion 1992: 39–40). Listening to Dylan's score bears this out: the song works differently as album track and as integral to the editing and narrational-diegetic dialectic of the film. As score, its internal dialectic is subordinated to the film's central contradictions. Moreover, in the film, both dialogue lines and sound effects of clinking horse brasses, Billy's fall, and the furnace roar are integrated into the song. In the hands of a Korngold or a Rosza, this might have implied the musicalization of the sound effects. But in this instance, the mix draws the music entirely, and the singing partially, into the diegetic world of the film, as sound effect, as the soundtrack not to the film but to the man at the center of the sequence, Billy the Kid. Both the first-person persona of the vocal and Billy inhabit a freedom whose essence is that its price is mortality, that is, a definitionally circumscribed freedom. Moreover, though both song and action are encompassed in the present tense, both inhabit the past, since both are recordings (a point emphasized by Dylan's double presence in visual and audio mode) and both are framed by the narration's flashback structure.

The proto-sunshine-noir of the movie belongs to that long elegy for history which is still being written in the contemporary cinema of North America. Billy lives in historical time, a time in which events matter, decisions are life-and-death, and lives pass into legend. This too is the temporal mode of the song "Billy" in the scenes I have been analyzing. Moreover, the film, made on the wane of Peckinpah's great period, revels in what it reveals: the decay of a talent at the moment of ripeness, disintegrating into its own madness, like Jerry Lee Lewis living out in his biography the contradictions of his culture (see Tosches 1982): the libertarian fundamentalism, the compulsive anarchy, the terrible beauty of a shocking self-destruction that we expect to characterize Billy but instead accrue to Pat. In choosing life, Garrett condemns himself to the mere inhabitance of space. Nonetheless he must fulfill the logic of the history from which he is endeavoring to escape, and for his last historical act, refusing to die, he must kill and finally be killed.

Here stands the famous shot in which Garrett, after killing Billy, shoots his own image in the mirror: what he kills there is his last moment in the legendary universe, his role as avenging angel. From henceforth he will inhabit only empty extension, the spatial world of a diegesis deprived of the historical impetus of narrative. One might see in the image of Garrett's impotent, imaginary suicide the inspiration for Wenders's *Himmel Über Berlin* (*Wings of Desire*), the abjuring of angelic status in order to live; but where Wenders's

angel revels in his senses, Garrett becomes their prisoner, a character to whom nothing else will ever happen. In the wonderful "Beans" dialogue scene, Alias will provide, at gunpoint and instructed by Garrett, an absurdist commentary on the carnage and the transformation of legendary time into directionless space in the endless litany of commodities.

Situated at that plane of legend outside quotidian psychology, time, and space where the soundtrack vocal moves between diegesis and narration, the only free position in the film, Dylan is a Heideggerian angel, announcer of the fading of presence that the late Heidegger would associate specifically with television: "What is happening here when, as a result of the abolition of great distances, everything is equally far and equally near? What is this uniformity in which everything is neither far nor near—is, as it were, without distance?" (Heidegger 1971: 165–166). Alive and mortal, Billy endures the presence of things and their nearness as he endures the nearness of his own mortality. Garrett, however, with his fenced-in house, his technological buggy removed from the immediacy of riding, his refusal of death, inhabits the distanceless with a lack of presence, haunted by representations, subject to his objects. And Dylan moves across this distressed frontier between the modernizing of the United States and the underdeveloping of Mexico, the enigmatic angel who inhabits both space and time, whose fall is inscribed in the turn away from the camera in shot 26, his only narrative moment, and who carries news of the two worlds across the boundary between them, always strange, in Lacan's pun the *étrange* that is always *être ange*, "to be angel," or in Buci-Glucksmann's gloss (1994: 43–45), the angel of the odd.

Our transcendence is marked by the real: by an authenticity that we have begun to yield in the realization that everything is mediated, even our most direct perceptions. The world as it exists before the camera, before it gathers itself together to be photographed, is forever separated from the world of the film by the temporal act of recording that removes its image from the flow of time, not disappearing but forever marked off from the picturesque with which we view it subsequently. To speak of boundaries is to speak of angels, whose natural domain is the liminal, who personify the threshold, and whose spectral alienation is the otherness of the Other. That one moment of mickey-mousing, that lapse in taste, that one synchronization of sound and image, is the moment of passage from one world to the next, from representation to experience, a backward and undoable step, an election to live in the past, where reality exists prior to recording; a step out

of cinema, not into the profilmic simultaneity of realism, but into the angelic memory of present things before their presence faded.

After the Event

Unlike the freeze frame, which is achieved by repetitive step-printing of a single frame in the optical printer, slow motion is a camera effect. It belongs to the domain of Benjamin's "unconscious optics" (Benjamin 1969: 237), the revelation of a world whose timescales are too small for human perception. Speeding up the filmstrip to extend the duration of an action, especially an everyday human action like falling, brushes the familiar with an aura of unfamiliarity.

But Benjamin's phrase also suggests the surrealist sense of a Freudian unconscious. The question is, whose unconscious might be being enacted on the screen in the middle of a Peckinpah shoot-out? For whom does the body of the dead soldier drop so slowly from the cliffs after the ambush of the rifle wagon in *The Wild Bunch?* The soldier himself has taken two bullets: is this temporality the unconsciousness of dying? Does it reveal, as in Prince's argument, the "metaphysical paradox of the body's enhanced cinematic reactions during a moment of diminished or extinguished consciousness" (Prince 1998: 60)? Or, as Paul Seydor argues, does it operate in a double paradox, where the slow motion "distances us from the action by aestheticising it" (Seydor 1997: 190) while nevertheless "the slow-motion shots are almost always held to a particular, often subjective, point of view that is clearly, if implicitly, identified as such in and by the film" (ibid.: 191)? Aestheticizing, in this context, would represent the removal of the action from the embodied senses—of pain, of empathy, of anger or disgust—and its sublimation as vision, optically stripping the event of consciousness. Subjectivizing, by contrast, reanchors the shock of violence, but in the body of an onlooker.

The effect remains ambiguous in our instance, as if the (un)consciousness experiencing the fall in slow motion is smeared across the victim, the onlookers, and the audience. This begins to resemble the "triangle of looks" proposed in Laura Mulvey's (1975) thesis concerning the dominance of a male gaze in the construction of femininity in classical Hollywood. The male equivalent to the fetishistic mise-en-scène of the female song-and-dance routine is the ritual violence of fistfights. This is so entrenched in contemporary understandings of film as to be parodied in

Fight Club, where the first bare-knuckle bout in the car park is followed by a parodically postcoital sequence of the guys smoking. A psychoanalytic-biographical critique might emphasize Peckinpah's notorious personal and cinematic mistreatment of women, his fear of them, and some kind of ascription of repressed homosexuality.[2]

This approach would only add to the uncertainty of the place of unconsciousness in the slow-motion gloss on killing in *The Wild Bunch*. Although many of the close-up inserts drag us into the agony of a hit from a rifle slug, this image of the falling cadaver, cut before it reaches the ground, is filmed in extreme long shot. On the command "*¡Mate lo!*" we see in quick succession the victim looking up at his comrades, cutting to a medium shot of the first soldier to shoot, seen as it were from Mapache's lieutenant's perspective, but far closer, more like the distance between rifleman and victim. The next cut brings in that soldier's perspective on the victim receiving the first bullet, then the victim's perspective of the second shooter. However, the victim is not looking up at this point, but slumping back against the walls of the mesa with his face turned down. Who then faces the rifle as it fires into the camera? We cut to the victim as he falls toward the bottom of the frame, seen from a position we know to be impossible for any subject, in the air before the cliff face. Here we cut to a close up of Dutch turning to see the action, then the extreme long shot of the body in slow-motion fall, accompanied by a distant, echoing cry, cutting back to the same framing of Dutch as he turns to Pike and nods, with a suggestion of a wink, confirming that the Bunch are in a controlling position in the standoff that frames this piece of business.

In classical continuity cutting, we would be armed with a response: the consciousness of the film itself holds the action in an almost metaphysical eye. But in Peckinpah, that omnivoyant camera is reduced to a role on a par with that of the characters, and the point-of-view shots are scattered fairly democratically among protagonists, speaking parts, and anonymous extras including children and at certain stages possibly animals. A clue comes from Benjamin's continuation of his argument. Auratic art—painting, classical poetry—was an art of asocial contemplation. Film is at once a "ballistic" art of shock and a social art of distraction. Dadaism had wrapped this shock effect in a blanket of moral outrage. In the popular cinema, shock became physical, its "distracting element . . . primarily tactile, being based on changes of place and focus which periodically assail the spectator" (Ben-

jamin 1969: 238). In the cutting of *The Wild Bunch*, which at over 3,600 shots is one of the fastest-paced edits in color films with an average shot length of only 2.3 seconds,[3] the periodicity of movement between points of view, flagged and unflagged, motivated by characters or by omniscient vision, has the effect of dispersing our attention. At various points, slow-motion inserts may anchor us in a body-in-pain or in the eye of an onlooker, or again in the disembodied position of a spectator alert only to the choreography of violence disconnected from pain or responsibility.

Seydor gives a third reading of the slow-motion shots: that they are consequential on the relation between maximum energy and minimum space, so that "time itself is forced to take up the slack, which it does by expanding to contain the violent energies released in collision" (Seydor 1997: 201). He adds, however, as befits his humanist and biographical reading of Peckinpah's oeuvre, that the expansion is not of time itself but of the perception of time.

David Cook notes the impact of one instance of slow motion in another medium: the NBC live coverage of Jack Ruby's assassination of Lee Harvey Oswald (Cook 1999: 140). Within minutes of the shooting, CBS was rolling videotaped footage and that evening was showing it in slow motion. "Instead of the impressive form of an athlete in competition," notes Mary Ann Watson, "an actual murder was captured and elongated in what was described as a 'grotesque ballet'" (Watson 1994: 220). Like Peckinpah's "slow-motion leap" (Fine 1991: 142), the action replay of the Oswald murder becomes choreography by the power of technology to unearth the grace within the graceless, the unconscious beauty lurking in even the most despicable of acts.

The slow-motion ballet, then, points us in two directions at once. On the one hand, it points forward to the "bullet time" of John Gaeta's effects for *The Matrix*. On the other, the reference to the Oswald killing points us toward the public status of death in the era of mass mediation. The one places us in the time of the bullet itself, a world slowed to the duration of the bullet's flight from weapon to target, its perception not that of the humans involved but of technologies, cinematic and ballistic. The other renders the viewing subject as the apparatus of television news, that is, of the ideological machine par excellence of the late twentieth century.

Slow motion abstracts the action depicted, but only to a level at which incomprehension becomes, in Chomsky's phrase, manufactured consent. This is not to subscribe to Chomsky's hypodermic theory of news media,

but to agree that, in becoming media spectacle, death loses its subjectivity to become merely a datum, one that belongs no longer to the unique experience of killers and killed. Such a datum, selected in the same way in which a critical tackle or critical goal is chosen, presented in slow motion, occupies a moment in which the privileged instance loses its particularity to someone in order to gain it for everyone—the moment, therefore, in which a death becomes historic. It is this delay, this stoppage of time, that brings the epic dimension into fiction, extracting the squalid murders of *The Wild Bunch* and *Pat Garrett* from their menial contexts to render them in the same fabric as the tapestry of history. Slow motion is monumental sculpture. Like the statue in the Lincoln Memorial, it holds a moment in time as public memory, its grandeur the product of the paradoxical combination of silence and magniloquence.

In this light, Seydor's third reading of slow motion as a perception of energy that is slowed down because it has only time but not space to expand in suggests one reason death should be the beneficiary of this technique. An event like the Oswald killing is unrepeatable, and the chance of filming or taping it is extremely slight. Perhaps the most famous of all news footage, the Zapruder film of the Kennedy assassination, shown on North American television for the first time only in 1973, is exemplary. No longer news, it had already become talismanic. Slowed down, blown up, and most of all repeated, the Zapruder film stands head and shoulders above similar moments, like the footage of the Rodney King beating, not because the event was more spectacular or significant, but because its meanings remain so profoundly uncertain. The film is evidence, but despite its forensic standing, it is inconclusive. It is an event without a narrative, or rather with an excess of narratives. As Hayden White puts it, "It is the anomalous nature of modernist events—their resistance to inherited categories and conventions for assigning them meanings—that undermines not only the status of facts in relation to events but also the status of the event in general" (White 1996: 21). In slow motion or by repetition, the image expands the time of the event to fill the confines of television, a space not so much finite as already full. Desperately seeking completion, it finds only the plenum of a spatial expansion.

Likewise the slow-motion shots—and they are never whole sequences—in Peckinpah. In its competition with television, its pursuit of adult themes and expanded horizons, greater explicitation and more persuasive spectacle, cinema in the 1960s abandoned classical restraint in favor of a televisualiza-

tion of the profilmic. This is how time is metamorphosed in the new Hollywood, in accordance with its rival, sister medium. Televisual flow (Williams 1974), segmented flow (Feuer 1983), as phenomenological artifact becomes increasingly self-referential, to the point of total enclosure (White 1986). This is the temporality into which Peckinpah's slow motion brings us, a televisual mode where, as Richard Dienst argues, "time is the substance of television's visuality, the ground of its ontology, and the currency of its economy" (Dienst 1995: 159). Dienst goes on to argue, however, that as well as a temporal plenum ("the automatic image"), TV is capable of a fragmenting and exploding ("the still image"). Slow-motion corresponds to the automatic: it fills the scene with itself to such an extent that its pure presence overtakes any meaning it might have. This is the aesthetic moment in *The Wild Bunch*, but a moment that is always temporary, defined by its brevity and by the rapid intercutting that surrounds it.

Peckinpah's West is Einsteinian rather than Eisensteinian. As Mauro Dorato puts it, "After all, as Einstein's definition of simultaneity for distant events shows, we do not have privileged epistemic access to *all* events happening in the present" (Dorato 1997: 72). From where I stand, events that happen remotely are future events, because I cannot perceive them until their light reaches me. The obverse is also true: my present is the past of an observer who, simultaneous with me, cannot know what happens to me until after it has happened. Not time as such, but the relativist concept of the present is a spatial concept, dependent on distance and the speed of light. The present moment is dispersed. The possibility that the present of an event persists, its perception in the past or future depending on the observer—the victim or the distant Dutch in the shooting in the arroyo—persuades us of the realism of Peckinpah's montage. There is no death in Peckinpah, only the extended present of dying. Dying takes time. It must settle into the landscape like the rolling echo of gunfire falling back into the ancient silence of the rocks.

Flash-forwards are rare in cinema because the future either has already been written—the script preexists the film—or, bluntly, does not exist. Dorato has a name for this latter position, "the empty view of the future": "the essence of a present event is, not that it precedes future events, but that there is quite literally *nothing* to which it has a relation of precedence" (Dorato 1997: 74), and he notes that this is the view best suited to mind-independent theories of becoming. Thus the nonexistent future and the prescribed

future are the same in this quality at least: they are independent of the actions of protagonists. Future events cannot be thought, much less displayed, without betraying the secret of narrative cinema: that everything is either predetermined (the film plays to its end) or nonexistent (the film breaks down in projection), in either case removing motivation from the diegesis. Flashbacks, however, are always motivated from inside the filmic world (Turim 1989). The final flashback of *The Wild Bunch*, property of no one character (they are all already dead) offers a montage of the old life, especially the "why not?"—the acceptance of death as a final bond of unity and fidelity, that justifies the world of the film from within. Michael Bliss adds, in a footnote, that this final montage emphasizes at the end that the film is "a crafted, storytelling vehicle that creates, and fosters the continuation of, the Bunch's myth," an effect doubled by reducing the final anamorphic image within the frame as the words "The End" appear. The film, he concludes, "is a mnemonic device" (Bliss 1993: 322). As machine for remembering, *The Wild Bunch* entertains its past in flashbacks and renders itself as gestalt in flashback, because it inhabits a world with no future.

The past exists simultaneously with the present because the present is in the process of becoming legend. The diegetic present is not only past as an object of perception for audiences: it presents itself as a fading into the past of the filmic present. In that moment, a sort of event-horizon, the event can be experienced in its full duration, savored in all its freshness, in ways, it is implied, that subsequent lifestyles will no longer permit. Peckinpah conveys this fullness not only by selecting the act of killing as his emblem of the fullest moment of being, but by extracting from death the last drop, the finest vintage, of sensibility. It is to his credit that it is killing, not death, that focuses his attention, for unlike Heideggerian being-toward-death, killing is an act undertaken in the films as a conscious decision and in full knowledge of the responsibilities it brings. This is what makes the flashbacks function: each flashback takes us to a *memento mori*, and each functions as a present simultaneous with the diegetic present of the main narrative, but one that is being perceived in that present as a past. The flashbacks, like the slow-motion shots, are part of an extended present with roots deep in the past, but whose future is only a memory.

Unlike televisual frames, which can be repeated by pausing at the mixing desk or on the beta-cart, and so can be considered live performance at the moment of transmission, and also unlike the photograph, which holds

one instant outside of its own time, the cinematic freeze is a temporal process executed in the optical printer, after the moment of exposure and before the film arrives at projection. The cinematic freeze is not a photograph, because it has a definite duration. When Baudrillard writes, in a phrase that seems to evoke Peckinpah's long sequences of journeys in the Western films, that "The unfolding of the desert is infinitely close to the timelessness of film" (Baudrillard 1988: 1), he is incorrect, in that film, unlike the photographic art that Baudrillard practices, is a durational art. Bazin comes far closer when he writes "It is easy to say that because the cinema is movement the western is the cinema *par excellence*" (Bazin 1971: 141). Movement of sound and image is what makes time in the film: arresting that movement does not expose its putatively constitutive static elements—the still image, the photograph, the photogram, the moment of timelessness—but the trajectory of movement.

In the title sequence for *The Wild Bunch*, the freezes might be read as the arrest of a vector in a way that exposes the underlying algorithm. Perhaps the theme of the film can be retraced to William Carlos Williams's summing of previous American history in the apparent contradiction between President Lincoln's popular appeal and his assassination. "The brutalizing desolation of America up to that time," he suggests, arises out of a kind of psychic amputation: "Failing of relief or expression, the place tormented itself into a convulsion of bewilderment and pain" (Williams 1956: 235). For the Williams of "In the American Grain," the vice (or "immorality" in the phrase cited as epigraph for this chapter) that underlies the violence of American history from the first conquistadors to Lincoln's assassination was Puritanism, a refusal of joy, which, coupled with the terror it nurtured among its devotees toward the country itself, brought about that peculiar combination of sentimentality and bewildered, tragic aggression that scars the characters of Peckinpah's West. The filmmaker's theme might be read as the anguished pursuit of a joy unavailable to the psychic formation of his characters—the still dissatisfied satiation, that glut of the wrong pleasures, in Mapache's face as he feasts before the final shoot-out. But the theme is not the vector, rather a perspective on it. The vector, here, is combined of the southward-tending geography of the diegesis, the narrative momentum, and the circular (and no longer, as in Eisenstein, spiraling) spatialization achieved through the films' extension of American montage into the assemblage of points of view and temporalities.

But at the close of *Pat Garrett and Billy the Kid*, where Garrett's assassination ends in a freeze-frame, the dynamic has changed. Both sequences bleach out their moments, but the ending of *Pat Garrett* is a defeated one for sure. Dukore believes that "the independent spirit of Billy symbolically destroys the dependent, emotionally drained man that Garrett, by killing him, has become" (Dukore 1999: 138). But it is Poe, the hired hand of the Santa Fe ring, who orchestrates Garrett's death, and he does so after Garrett has threatened to break a contract and damn the law. It is legality that drains, and legality that sanctions, the deaths of both protagonists. There is no freedom left. So the freeze-frame has nothing to do with the analysis of the vector, and everything to do with its arrest. The two sequences stand at opposite poles of the analytic of the vector in neoclassicism. In *The Wild Bunch*, we observe the conditions under which motion becomes possible, or more precisely necessary. In the closure of *Pat Garrett and Billy the Kid*, we are invited as witnesses to the conditions under which motion is no longer possible. To Peckinpah's credit, those conditions are not causally determined by death but by the loss of freedom between 1881 and 1909, the two dates identified in the film's opening montage. Freedom exists as a historical franchise, never as a personal possession. Freedom is a quality of a society, until the society turns its back on freedom in favor of the law. It is a thoroughly American ideology, and one that excludes equally the outlaw and the lawman.

It is also a mythic account of the moment at which the open frontier becomes the bounded nation. Here time becomes a closed totality, premised on a finality that is ultimately void. The infinite must always be social. The sublime, by contrast, being asocial, has only the nameless heart of the contemporary to address, and it must address it as at once monumental and absent. The unwitnessed moment of Ground Zero, center of the Hiroshima blast, is that terminal instant of deafening silence and blinding light that gives the annihilating fullness of the posthistorical an image, however obscure. Only one form can mediate the incommunicable and communicate immediately. Refusing at once historicity and futurity, the posthistorical commodity is simultaneously full and empty, universal and particular. Peckinpah, with his Old West, antitechnological, anti–big business ethos, will not accept that logic, and as a result cannot function within the emergent "postmodern sublime."

Instead, Peckinpah investigates the expansion of simultaneity as a paradoxical moment, the event as expanding, to all intents and purposes end-

lessly, but within a loosely but nonetheless unmoveably circumscribed period of time. If we were convinced by the notion of Peckinpah as Heideggerian—in the sense that he is interested at once in the fading of presence and the being-toward-death—we would nonetheless need to acknowledge that cinema is for him the means by which the fading moment is brought back, through artful engineering, into the present that has abandoned it. Thus he retains the sensibility of loss, because he understands that this faded fullness is still perceptible in cinema. At the same time, loss in Peckinpah also and with familiar abruptness turns into frenzy, a frenzy of violence that arises from enclosure. There is an early foreshadowing of Peckinpah's melodramatic direction of actors in the cupboard scene in *Broken Blossoms*, when Lillian Gish screamed so loudly in rehearsals that the police were called (Gish 1969: 221). For Gish's character, there is no escape, no future, and the inevitable psychological result is frenzy. When futurity is written out of possibility, the result is a self-destructive violence: the only freedom left when there is no hope.

Bazin's dictum—that the cinema, the Western, and movement are of one essence—is true only of a cinema in which stasis is not a constant state and underlying possibility. The random, unmotivated freezes of *Pat Garrett and Billy the Kid's* opening minutes are significant in their randomness: they threaten all action with sudden stillness, the end of life, activity, movement, and cinema all together in the demise of the West. In its classical phase, the Western was the privileged site for the vector as its own reward. Hence its utopian function in *Le Crime de M. Lange*. But when it confronts the end of westward expansion and the consolidation of nationhood and commerce, the space in which the vector might operate shrinks to the scale of its human protagonists, and more especially to the scale of their shrinking horizons. In Peckinpah, the vector shifts from the macroscopic, universalist spiral of Eisenstein toward a microscopic dissection of the impossibility of freedom.

In these films, the vector becomes an exploration of closed space and shrunken time, circular in *The Wild Bunch*, a vortex in *Pat Garrett and Billy the Kid*. In the movement from finite mobility in total space to infinite mobility in enclosed space, the vector becomes infinitesimal, at first an implosion of auto-destruction, and thence, in the later film, a black hole into which time disappears, drained in the same way color is drained out of the world between 1889 and 1909. Confronted with the collapse of the America he dreamed of, or rather with the fact that it had already collapsed before

he could even grasp it, Peckinpah arranges a new mode of cinema, a spiral inward in which all instances of authentic being are constantly swallowed up. The surface of the film is the event horizon of this maelstrom, which explains the fluctuating gravity of time, the tides and surges we feel as we move from temporality to temporality, within and between events. So Peckinpah's neoclassicism confronts the possibility of the sublime with the actuality of killing, and in so doing preserves the only time that remains available, a present that is neither perpetual nor unchanging, but which holds itself together, like a bubble supported by the forces of its own collapse.

Perhaps *The Wild Bunch* is overrated. Its mawkish presentation of the buddy system is as crass as the worst of Hawks, and the flashbacks both tortuous and obvious. *Pat Garrett and Billy the Kid* is the greater film, in potential at least, for it will be forever incomplete, because, despite the clumsiness of the cutting and much of Dylan's score, despite the overly overt symbolism and the thin direction of Kristofferson, it has the courage of its own despair at a moment at which no other response was adequate. In the end it was neither the Vietnam War nor the defeat in Vietnam that destroyed Peckinpah's longed-for America, the perceived theme of *The Wild Bunch* at the time of its release: it was the fact that in the long term neither of them mattered. By 1973, the whole distressing conflict was reduced to the amnesia of political memoir, and even the righteous anger of *The Wild Bunch* would by then have been a melodramatic response. The dull cycling around of the unwilling hunter and the unmoving game in ever decreasing circles with less and less freedom to choose: this is a great and lasting tribute to the North America of Gerald Ford.

At this juncture, Peckinpah's greatest special effect was to maintain the illusion that it might still be possible to make a political film in Hollywood. His greatest moral achievement was to have done so without descending into the nihilism of his characters, a sin he would reserve for his later films. There is no tragedy in the lack of a final, definitive cut of the two films discussed here. On the contrary, that they are, in Duchamp's phrase, "definitively unfinished" is intrinsic to the aesthetic of the vortex, the vector condemned to an inward spiral, to the exploration of infinitesimal durations.

NEOBAROQUE FILM

Hollywood Baroque: The Steadicam Years

If I could just create the kind of world I'd really like to live in . . . I
wouldn't be there.

—*Robert Creeley*[1]

Illusion, Delusion, Collusion

More and more it seems possible to descry a lynchpin moment of new American cinema in *Purple Rain*. Not only does Prince's film bring the nightmare Oedipal dialectic of Charles Burnett's *Killer of Sheep* to the entertainment media; not only does it render the incoherent, fractured narrative of Haile Gerima's *Harvest 3000* in popular form; but it gathers the forces of film about its moments of spectacle, subordinating an already picaresque narrative to the sudden coherence of sound and image in sublime moments of performance, to recreate as pure decoration the melodrama of its most obvious thematic model, in terms of production history, stardom, narration, and camp, the Judy Garland version of *A Star Is Born*.

The film exists as a series of alternating surfaces: the show, the fetish, the spectacle, the soundtrack album, the star, the performance, the auteur—and most of all the triumphant coincidence of all of them in the production numbers. The articulation of sound and image across the shot-reverse-shot cutting, so unnecessarily obvious, constructs the relation between star persona and audience as antagonistic, or at best agonistic, deferring the utopian moment of the performer's ecstatic integration with the crowd, the crowd's with the performer, into the invisible realm of the score. Already a nostalgic reconstruction of the Minneapolis scene of the late 1970s, *Purple Rain*, that

narcissistic exploration of an already fantastic world, is an early monument of the Hollywood baroque.

Purple Rain sold 205,000 soundtrack albums on its day of release (Prince 2000: 135). The Wagnerian ambition for cinema to become a *Gesamtkunstwerk*, a total multimedia experience, has not been lost: it has been dispersed. The film offers only one part of an experience, the second part of which is provided by the soundtrack, promoted as a discrete item. Prince of course also provided the score for the 1980s' third-biggest grossing film: *Batman* (fig. 9.1), stylistically and in terms of cross-media promotion the typical baroque movie. The vistas of backpacks, fast-food, and breakfast cereal tie-ins opened up by *Star Wars* at the end of the 1970s reached a finely honed plateau in the marketing of the Tim Burton/Anton Furst adaptation of Frank Miller's *Dark Knight*. DC Comics, a Warner product line, had taken a market lead in the conversion of the comic book into the graphic novel, signposted by the 1986 publication of Miller's *The Dark Knight Returns* and Alan Moore and Dave Gibbons's *Watchmen*. Carrying the juvenile market of the comics into the "mature" zone of gothic imagery, enigmatic narrative, and vivid graphic language, the graphic novels of the early '80s brought a new sensibility to '70s' attempts to capitalize on figures like Superman. Camp and irony met with the future-noir established as a newly characteristic form of science fiction by John Carpenter's dirty, cluttered, cheapo starship *Dark Star* and canonized in Lawrence G. Paull's production design for Ridley Scott's *Blade Runner* (Bukatman 1997; Bruno 1987; Sammon 1996).

At the same time, the success of horror films in the wake of *The Exorcist* brought an admixture of sadism and an attraction to the gruesome, centered on previously marginal terrains of the Batman mythos like Arkham Asylum. The new comics not only restored Batman to credibility, they freed the masked avenger from the economic and psychic limitations of a single actor (as already flagged in the "mobile signifier" James Bond identified by Bennett and Woollacott 1987). Moreover, as the first baroque moved from feudal personification to the more abstract geography of El Dorado or Paradise, so the neobaroque moves away from the promotion of fantasy anchored in the star persona to situate it in the diegetic universe from which it springs—Gotham City—and which it further promotes and develops. Hollywood's promotion of diegetic worlds like *Star Trek*'s Federation Space not only reconfigured the production of fantasy, it enabled and encouraged immersion in the myth delinked from the specific film text. Toys, computer

| Figure 9.1 |

Batman: Anton Furst's designs for Gotham city stay in the mind long after the plot is forgotten.
Courtesy BFI Stills, Posters, and Designs.

games, fan fiction and Web sites, novelizations, comics, soundtrack and
concept albums, fashion accessories, and collectibles, many of them manu-
factured by wings of the same horizontally integrated corporation, extended
the reach of the event film while reducing the cinema premiere to the status
of product launch for a raft of brands on a synchronized lifestyle marketing
strategy (Meehan 1991).

Purple Rain not only opened the door to African American cinema for
African American audiences: it refocused Hollywood on its lost black audi-
ence. Prince, at the height of his creative and popular bent, could bring
with him the African American and gay audiences, and at the same time re-
configure Batman's Furst-designed body armor as the latest incarnation of
Brando's leather jacket in *The Wild One:* the concretized wish of the white
urban youth who formed Hollywood's core audience, to inhabit, as literally
as possible, a black skin. This is only one of dozens of ways that Hollywood
undertook to create a fantastic setting in which the apartheid nature of the
North American nation-state could be resolved. The multiracial deck of the

starship Enterprise showed the potential for harnessing popular utopianism to the manufacture of profit. A specific task of the Hollywood baroque is to bring wholeness, a healed and healing world that runs against the acknowledgment of difference.

At the same time, as Biskind notes, "Like *The Godfather, The Exorcist* looked ahead to the coming Manichean revolution of the right, to Regan nattering about the godless Evil Empire" (Biskind 1999: 223). The enemy of neobaroque unity is not so much plurality as the metaphysical evil that most clearly emerges in the mainstream horror film after *The Exorcist* but also, as Barry Keith Grant observes, in the yuppie nightmare cycle of the 1980s and '90s (Grant 1998: 280), distinguishing them from the screwball comedy that inspired so many of them. This binary opposition of Good and Evil leads toward both the pursuit of sublimity and the profusion of motifs. The neobaroque is enmeshed in intrigue, passions, grotesques, a fascination with primal forces of water and electricity, an unstable, even violent rush to eclecticism, a shotgun marriage of reason and irrationality, a rage for freedom in a period of domination. More turbid than turbulent, that era extends back into the 1970s, when the movie brats began their assimilation into the reformed Hollywood system. In the first years of the twenty-first century, we have not yet moved beyond that tortured effervescence. The idea of the baroque has connotations of excess, decadence, a falling off from overripeness. Though it moves between fetor and ecstasy, its roiling, yearning activity should indicate that these qualities are not ends in themselves, nor things to be aspired to, but moments of a more central dialectic between wholeness and proliferating differences, totality and emergence, global power and the micropolitics that escape it.

Thomas Elsaesser summarizes the attributes of the "New Hollywood" under four headings: a new generation of directors, new marketing strategies, new media ownership and management styles, and new technologies of sound and image reproduction (Elsaesser 1998b: 191). Of these latter, none is so immediately revealing for this enquiry as the steadicam. The twenty-minute process shot that opens Brian de Palma's *Snake Eyes* (1998) (fig. 9.2) contains everything we need to know about the film that limps after it. The central structure is already clear from the way in which the camera is restricted to the point of view of Nicolas Cage: he is being lied to, and, not quite incidentally, he is lying to himself. De Palma's bravura shot, mim-

| Figure 9.2 |

Snake Eyes: Describing space by navigation, not analysis, de Palma's Steadicam roves between omniscience and point of view, lying and lying to itself. Courtesy BFI Stills, Posters, and Designs.

ing a reel-long take (though equally clearly the product of digital editing) is not entirely without purpose. Throughout the movie we will flash back to this sequence, unraveling its tricks, its illusions, its red herrings. A decorative flourish becomes the structural principle of the film itself.

It takes chutzpah to open with a shot like this after Altman's stunning parody of the mobile crane shot in the opening sequence of *The Player.* Since Altman's film the knowing audience is party to the tricks, which depend on that knowingness for their spectacular functions. Now that the audience grants de Palma a postmodern and ironic permission, the gratuitousness of this elaborate maneuver becomes the rationale not only for the shot itself but for the whole film. Our job, as viewers, is to be witnesses to the elaboration of spectacle. Contemporary cinema, for reasons both commercial and ideological, offers itself to a double audience, one that succumbs to the spectacle and one that appreciates it. The bulk of any given audience will enter the film with this double vision in place, pleased to be connoisseurs of effects and their generation, but equally delighted to be suckers for the

duration, enjoying both spectacular technique and the spectacle itself, illusion and the machinery of illusion.

Cleverly providing himself with an Aristotelian unity of place and time (the boxing stadium in Atlantic City, the ticking clock), de Palma sets himself the problem of delivering all necessary back-story in audiovisual terms that can be naturalized in the diegesis. The hypervisible, hyperaudible protagonist bedeviled with delusions is the willing victim of a charade, a massive event designed for the sole purpose of deceiving him. The theme has occupied de Palma over a large part of his career (*Blow Out* and *Body Double* spring instantly to mind). Nor of course is de Palma alone here: the intricate, obsessive, and if necessary total manipulation of reality to secure an illusion, the willingness of its victims, and often enough the tragic consequences of piercing it, form the single most popular topic of the Hollywood baroque, from *Sex, Lies, and Videotape* to Schwarzenegger's *The Last Action Hero*, *Total Recall*, and *True Lies*, from *House of Games* to *The Truman Show*. Our double role as integrated onlookers is enshrined in the complexity of the shot, in which we shift fluidly from panorama to point of view, between sharing and observing the illusory nature of his experience. In fact, the protagonist is alone in failing to perceive the construction of his world: to everyone else, including the other actors whose unnecessarily camp performances ought to give the game away, the artifice is not only transparent but heavily signaled at every turn.

Illusion, then, is not only a spectacle: the spectacular collusion in its construction, and the spectacular innocence of protagonists who cannot perceive its artificiality combine in an entirely artificial diegesis. Truisms of the contemporary well-made script—there should be no exposition that cannot be accommodated into the diegesis, and no loose ends—have become sufficient qualities for a baroque film since William Goldman's script for *The Sting*. Here the qualities of *vraisemblance* and probability are suspended in favor of the construction of a transparently artificial script of algorithmic elegance.

Classically, the story is a ritual construction *in* time that works through the conflictual structures of reality and finds for them a magical resolution. But the baroque story in its purest form is a purely abstract construction *of* time. In this new mode, stories seek not to control but to imitate nature. This imitation needs to be understood not as nineteenth-century realism

but as sixteenth-century *Imitatio*, a concept Rosamund Tuve characterizes as possessing three levels. At the first level,

the artifact was designed to please on grounds of its formal excellence rather than by its likeness to the stuff of life. . . . On [the] second level images must assist in Imitation conceived as involving the artist's *ordering* of Nature, and his interpretation must have coherence . . . on a third level: Imitation as truth-stating, as didactically concerned with the conveying of concepts—not simply orderly patterns but what we should commonly call "ideas" and "values." (Tuve 1947: 25)

The blockbuster movie does indeed, in its elaboration of "right artificiality," produce just such ritual incantations of unexceptionable truisms: do right, don't mess with nature, look after your own. These truths are open to ideological analysis, but such analysis can scarcely deliver more interesting results than that many of our most successful movies have themes as banal as the *vade mecums* of the sixteenth century. But such Eisensteinian images are not the point of the film, any more than the desultory narratives over which they are stretched, for example, in Jan van Bont's *Twister*. The point is that such ideological motifs, such clichés, provide the basis for the intricate weaving of spectacle and narration into a braided web on whose embroidery, abstract as a Bach fugue, the audience will sit in final arbitration. As we reach the end of a film like *Snake Eyes*, we should survey the whole plot as if it were a knot garden, a spatial orchestration of events whose specific attraction is its elaboration of narrative premise into pattern, its reorganization of time as space.

The intrinsically decorative structuring of narrative, the extrusion of elaborations and fugal variations from basic premises, form part of the fundamental spatializing project of the Hollywood baroque. In the opening sequence of *Snake Eyes*, camera mobility and plotting are synonymous, both contrapuntally constructing elaborations on the motif of spectacle (boxing, policing, life) as illusion. In *Strange Days*, a film only slightly more elaborate than *Snake Eyes*, there are few shots in which the image is not at least reframed, and far more frequently caught in the pirouettes and rotations of Matthew F. Leonetti's hallmark steadicam cinematography. The characteristic establishing shot of Bigelow's millennium movie, as in films as various as *Super Mario Bros.* and *Fatal Attraction*, not only features fluid camera

movement but flamboyantly crowded mise-en-scènes packed with more incident than any single viewing could take in, held in extravagantly deep focus. The effect is in some ways like that described by Dai Vaughan in the Lumières early films: "The unpredictable has not only emerged from the background to occupy the greater portion of the frame; it has also taken sway over the principles" (Vaughan 1990: 65). But the difference is that, where the Lumières and all subsequent realists leave space in frame for the contingent, the Hollywood baroque orchestrates the entire fabric of the film. In *Fatal Attraction*'s nightclubs, like the enriched cityscapes of the remastered *Star Wars* trilogy, it no longer matters whether the protagonists are ciphers like Luke Skywalker or tormented personae like Michael Douglas: the diegesis has engulfed them in its own dynamic. Both narrative and stylistics have been subordinated to the exploration of the world of the film. If classical cinema operates in time, as a linear construct whose narration and stylistics focus on the exposure of the story, the baroque takes time as its raw material.

In the Hollywood baroque, film is no longer a time-based medium (a function now occupied by television) but the medium of movement. Spatialization takes over from narrative the job of managing the film's dynamics. Movement here is sculptural, architectural, or geographical rather than temporal, and space itself is malleable. Classical decoupage—establishing shot, two-shot, shot-reverse shot—no longer governs because, with one swooping sequence-shot, we can establish the diegetic space without stabilizing it according to the 180° rule. The entrances into the nightclubs in *Pulp Fiction* and *GoodFellas* mobilize the diegetic space itself, much as Gotham City is mobilized in Tim Burton's *Batman*. Where the destabilization of space once was restricted to the generic construction of the nightmare in horror films and such cognate scenes as the grand finale of *High Plains Drifter*, the Hollywood baroque needs no subjective alibis to explain its lack of equilibrium.

So fundamental to the Hollywood baroque is this motion that the occasional descent into more formally classical structures, such as the shot-reverse-shot dialogue scenes that punctuate *Snake Eyes*, seem flat, talky, and crude. The regression to classical cutting appears symptomatic of uncertainty rather than austerity, lack of vision rather than clarity, indeterminacy rather than symmetry. Some similar feeling obviously dogs Bigelow in *Strange Days*, a film whose shot-reverse-shot dialogue scenes are always

framed against mobile back projections and crowd scenes, frequently constructed by inserting cutaways into what would otherwise be fluid camera movement through diegetic space.

Immobility now strikes us as false because it belongs to an emphatically narrative cinema. Though narrative resurfaces in the baroque, like shot-reverse-shot structures, it appears as borrowings, residues, homages, reflexes, regressions, alibis, and quotations. The baroque's central tendency derives from a parallel genealogy in realist cinema. Coppola's and Scorsese's investigations of Italian American culture and Spike Lee's explorations of African American neighborhood life draw on and extend the realist paradigm, not least because they diminish the role of narrative in favor of exploring the diegesis. These films emphasize the spatial in residual narrative structures, especially in Scorsese's typically deranged and humbled salvation scenes. Nonetheless, the point of films like *Do the Right Thing* and *The Godfather* is not how their protagonists acquire the values of their communities, but how those communities reproduce themselves. Even *Raging Bull* and *GoodFellas* have less to do with the shock of enforced innocence with which the heroes gaze back at the world in the final shot than with the mesmerized gaze into alien worlds that the films evoke in their spectators.[2]

Vagueness

This spatialization process is carried through into the design of stereophony and multitracking in contemporary Hollywood. This needs to be carefully distinguished both from the "deep-focus sound" Rick Altman (1994) finds in *Citizen Kane*'s appropriation of radio drama techniques, and from Robert Altman's realist use of multiple microphones in the ensemble-cast movies of the 1970s (Schreger 1985). In the baroque cinema, it is not simply a question of multitrack recording, but of a process in which the initial cacophony is reconstructed in such a way as to guide the auditor's attention from level to level—as for example in the extraordinarily engineered synchronizations of voice-over, dialogue, wild-track, and skillfully remastered pop theme in the scene in *GoodFellas* in which Ray Liotta's wife first meets the mafia wives. Altman's soundtracks for *Nashville*, *A Wedding*, and *M*A*S*H* belong to a realist aesthetic of synchronized location recording. Tom Fleischman's sound designs for Scorsese, Lee, Demme, and Sayles, by contrast, produce their effects by creating not so much a soundscape to explore as a guided tour through the diegesis (Fleischman 1994). Here the mobilization of the ear is

accomplished, as it is in the use of deep-focus crane shots through crowded mise-en-scènes, by the strict subordination of apparent excess to the overall trajectory of the film, frequently through the use of hyperamplified motifs like David Lynch's fans, drips, and hissings. Where the realist aesthetic engages us as arbiters, the baroque recruits us as collaborators. The sequence shot with its characteristic combination of structured multitracking, staging in depth, deep focus, and mobile camera is the central device of this recruitment.

There is a sequence in Robert Rodriguez's *Desperado* in which the Mariachi, having wiped out Brucho's men in the bar, staggers out into the street followed by the last survivor of the carnage. The sequence, lasting 2 minutes and 3 seconds, is composed of 47 shots. Since the first shot lasts 20 seconds, the average shot length for the remainder of the sequence is 2.2 seconds, with some important variation in the rhythms of the shots and their relation to the beat and the lyrics of the Los Lobos song ("Don't look back, into the strange face of love") on the soundtrack. The sequence opens with the camera zooming in to the door of the bar as it opens and the Mariachi walks out; dollying out, racking focus, and panning left to follow him out of frame before dollying in and panning slightly further left to pick up his pursuer; dollying out, panning left again, and racking focus to follow him out of frame. The shot is accompanied by the jangling spurs of the Mariachi, synchronized throughout the sequence to his movements, and the duller thud of his pursuer's footsteps, which, unlike the spurs, will be drowned out in the rest of the sequence by the score. Throughout the process shot backgrounds are kept in focus. The next twelve shots are composed in depth along the axis of the sidewalk, save one shot, which crosses the line to establish the urgency of the scene as a build-up to action, and adding that slight edge of vertigo which helps both engage the audience and establish the half-mystical 360° perception of the Mariachi.

At this juncture, we move out of the axis of the sidewalk: only the continuity of the score keeps us alert to the contiguity of the spaces. Carolina is crossing the road, causing two cars to ram into one another, with a jump cut along the axis of vision adding to the sense of impact. The score drops in volume during an instrumental passage to allow the soundtrack to focus on the crash, then powers up with the vocal line as we move to a profile shot of Carolina that brings us back into the sidewalk axis, then her view of the Mariachi, then his of her. A micronarrative of reaction shots establishes a

relationship, while the major plotline, the pursuit, heads to climax. Here the cutting is faster, and includes the zoom shot, while the score drowns out diegetic sound until the climactic gunfire. The sequence ends with six shots taken from below of the Mariachi's reaction to the death of the pursuer, with Carolina holding, helping, and taking him away in cross-faded jump cuts concluding with an empty sky and fast fade to black.

Desperado does not need uninterrupted process shots to establish the mobility of space that so obsesses the Hollywood baroque. We are guided here as so often in our explorations of diegesis by the centrality of a specific consciousness that is not entirely embodied in the protagonist but tends to gather in the space around them. In the opening shot, for example, we are granted a look into the eyes of the Mariachi, and we simultaneously see that he is being followed. In classical composition, that knowledge would connote omniscient narration. But when the Mariachi reacts to the presence of Carolina, we realize, with gathering momentum, that this omniscience belongs to the Mariachi. In this way, the Hollywood baroque uses the conventions of establishing shots and intercutting not to establish an external view, but to create an ambivalent space in which we may or may not share consciousness with a protagonist. This doubleness is a dialectical structure, in which, once again, we are both participants and spectators, internal and external to the action, while the space of the action itself becomes doubled as on the one hand the objective reality of omniscient narration and on the other the subjective and therefore potentially illusory space of the protagonist's consciousness (a possibility pursued to extreme effect in *Memento*). This dialectical construction of fluid spaces and mobile interactions between characters and audiences is a "narcissistic" space, since its characteristic is, as with the centering of the soundtrack on the sound effect of synchronized spurs, to organize the space, both auditory and eventually visual, around the natural vision but also the peripheral awareness, the omnidirectional sensitivity, ultimately the global consciousness of the hero. That sense of mystical union with the environment is of course a strategic element in the construction of the noble savage, and an important element in contemporary New Age orientalism.

The lyrics to the score of *Desperado* add a further ambiguity in a clash of subjectivity and address—who is speaking, and to whom, or are we eavesdropping on an internal monologue? This is one of the characteristically unclosed elements typical of the neobaroque's love of movement, and one

that leads to further loss of equilibrium. One of the most significant difficulties lies in resolving spatialized narratives, leading to the ambiguous and ambivalent endings of so many contemporary films. Cynically, one can always read these as ways of keeping open the diegetic possibility for a sequel. But this is only part of the crisis management of a cinema that must, commercially, come to an ending. Not only do films fade out rather than conclude, or rely on entirely formal negotiations of completion, as in the knot-garden model of script-based baroque cinema; certain narrative forms that have never really addressed themselves as linear frequently reveal, as in the closing sequence of *Desperado*, what seems to be one pass of a cyclical history in which the same or similar narratives will cycle forever—implicitly in Sal and Mookie's final scene in *Do the Right Thing*, explicitly in the *Godfather* series. At one extreme, this will provide the universe of *Star Wars*, with its serially unresolved New Age binarism of the Force and the Dark Side, while at the other it brings the perpetually asymmetric Möbius strip of *Lost Highway* (Elsaesser and Buckland 2002: 186).

Some classical films, among them *Sunset Boulevard*, *The Cobweb*, *Sullivan's Travels*, *Dodsworth*, *It's a Wonderful Life*, and most obviously *Citizen Kane*, appear to work on similar models of depth and surface. The classical, however, depends on a planar construction, in which each layer of depth is distinct from the others, as in the famous sequence of *Kane* in which the boy Kane and his sled, his father, and his mother and Thatcher occupy three meticulously separated zones of the image. In a typical neobaroque shot, mobile camerawork (and digital compositing) eliminates the cut between layers to promote a vectoral movement totalized in the bounded world inside the spatial image. Then, like the deluded protagonists of *Three Kings*, the audience is in place to savor the ingenuity of the artifice in which they have been caged. Inhabiting the here and now becomes problematic, as we confront the foregrounded recordedness of the illusion to which we are invited to submit. Classical spectacle deployed a closed system of linear narrative to shut down the future: the baroque marks out the limits to our habitation of the present.

The 1999 blockbuster effects movie *The Matrix* came impregnated with the figures of the baroque. Its camerawork is for the most part less strident than *Strange Days*, although the climactic chase through the apartment block in steadicam, despite sporting more edits than Bigelow's equivalent scenes, functions in precisely the same way as her steadicam sequences in *Strange*

Days, *Point Break*, and *Blue Steel*. In *The Matrix*, constant if less flamboyant reframing characterizes even dialogue scenes and delivers pyrotechnic steadicam and process shots, including a hallmark lightning zoom (derived from the Hong Kong action cinema) on the God-shot (from the ceiling or sky into the floor or roof). The film resolves its story-telling dilemma in expositional shot-reverse-shot sequences by using constantly mobile back-projections, notably in a sequence in a car on the way to visit the Oracle, where acid video colors throw the reality of the city—disembodied by the lack of street sound—into question. The multilayered soundtrack again uses a hyperamplified motif—the ringing of telephones signaling connection to and escape from the computer simulation of the title—to guide the auditor through the spatialization of the diegesis as soundscape. Other motifs, like the sound of wipers on the office window during the firing scene early on, similarly oversignal their function, flagging the later possibility of escape via the window-cleaners' cradle in the following scene.

This oversignaling clearly refers us to the film's referential structure, less to the cyberspace of internet than to that of computer games, constantly evoked in the use of mobile phones to guide protagonists through the mazes of the city. This relation between the operator and the protagonist also informs the relation between God-shots and point-of-view shots, notably again in the early sequence that culminates in a composite of a cell-phone tumbling down the canyon between skyscraper facades. Editing forms a crux in the baroque: how and where is it possible to cut a sequence shot whose motivation lies in its subjectivity? With the addition of an operator, the double motivation becomes clearer than it was in the example from *Desperado*: it belongs with the double-vision of the player. Here the dialectical relation of fetishist and voyeur is no longer at the core of the film, having been superseded by the position of the narcissist. The dialectical relation between the sucker and the connoisseur is itself doubled in that relation between the protagonist in the game and their controller, the game-player. Hence the possibility exploited thrice in the film of mapping God-shots into points of view.

The use of mobile camera has the recessional sensibility of a Vermeer raised on *The Maltese Falcon*. The opening sequence, Neo's first meeting with Morpheus and the scene of Morpheus's torture feature strongly foregrounded blocks of shade or color—the backs of chairs, coats, telephones—forcing awareness of the depth of the image. Balanced against these

compositional devices, the parallax enhances continuities between gradations of depth rather than, as in the more obvious use of diopters, their independence from one another. The motif of fluid instability—the liquid flame that pours out from the elevator shaft during the raid to rescue Morpheus, the rippling glass wall of the skyscraper as the helicopter plunges into it—establish the link between mobility and illusion. The moment in which Neo, having realized his powers, flexes the walls around him after assimilating Agent Smith echoes the abstract presentation of the Matrix as the space between letters and pixels on the computer screen (a motif that picks up from *Blade Runner*'s endlessly enlargeable photograph a dream of the artifact as complex as reality). Though the narrative wants us to puncture the illusion, it is illusion we came to witness. The film's liquid instability enacts that contradiction.

Even those who are not science fiction buffs find the lengthy exposition of *The Matrix* patronizing: Hollywood has no faith in its audience. We are entering a period of vagueness of which *The Matrix* is only an early symptom. The visual regime of the indecipherable has been coming for some time. Blockbuster releases since the summer of 1998—the season of *Armageddon* and *Lost in Space*—feature major scenes in which the geography of the diegesis is radically unclear. In *The Matrix* this is neatly tied into the peripeteias of the plotting and the diegetic theme of illusion to form a reasonably convincing aesthetic rationale for the ambiguity of many of the spaces. The baroque tends toward the cloudy and disorienting, its tendency to remain unclosed resulting in a preference for questions to be left unanswered, identities to be guessed at. The normative cinemas found beauty in clarity—the glistening surface of spectacle, the hard edge of referential reality, the adamant certainty of the image. Now we move toward an appreciation of the indeterminate.

In the movement from plane to recession, we parse in a new form that transition from tactile to visual, from the metaphysics of being to the culture of change, isolated by Wölfflin in his *Principles of Art History* as the dividing line between classical and baroque culture: "movement is attained only when visual appearance supplants concrete reality" (1950: 65; see also Wölfflin 1966). Hollywood enters a new territory of vagueness inaugurated by doubling, encoded as illusion, and confronted as crisis: the space between material and immaterial, turbulence and the end of history.

Ecstasy, Totality, and the Grotesque

Kant's beauty is always dependent on a shared taste; a materialist's on the synthesis of conflicting evolutions. The sublime, by contrast, speaks from some space beyond the common sense of communicative communities. The authoritative domain of the turbulent baroque is irrational, visionary, internal, asocial, and individual. It poses itself as the final resolution of the dialectic. The beauty of the normative cinema is ultimately communicative: realism speaks through the social formation of individuality, total film from the triumph of the state. Classicism's superficiality is the product of the spectacular commodity's dominance of communication. The neobaroque, however, turns inward to some unfixed and infeasible textual transcendent within the surface. One avatar of this transcendence is the undecidably vague, a misty configuration of valueless differences. Another is the completion that only awaits discovery. The neobaroque is in love with destiny.

Whereas in the classical the context determines the individual will, in the neobaroque individual destiny conquers context. Not only is the baroque protagonist individual and illusory, he (sadly, the baroque seems no less sexist than its predecessor) is also fated. From *Phenomenon* to *Little Man Tate*, biology as destiny returns with a vengeance—the call to become what you already are, a genetic transcendence that depends only on recognizing the mystery of "potential" that will allow the hero to escape both the sublunary material world of his social class (*Good Will Hunting*) and the ideological constraints of an illusory external control (*The Matrix*).

In the literature that has grown up around the parallels between the late twentieth and seventeenth centuries (e.g., Benjamin 1977; Beverley 1993; Buci-Glucksmann 1994; Calabrese 1992; Deleuze 1993; Maravall 1986; Ndalianis 1998), Benjamin is alone in defending the value of the term "allegory." Allegory in the contemporary baroque is that mode in which the particular is surrendered to the general and universal in the interests of a final anagogical principle in which all specificities are demolished in the universality of the transcendent (see Hermeren 1969; Mitchell 1986; Panofsky 1962; Steiner 1981). Such is the closure of *The Matrix* as allegory of struggle against the externality of social mores. The alternative is, in the predestined yet voluntaristic miasma of the neobaroque, unthinkable.

Neo's ecstatic revelation of his powers in *The Matrix* is celebrated in a shot in which the world dissolves into fluid numbers: mere digits, revealing the poverty of the mechanical world. Transcendence in the film *Pi* also takes,

in the first instance, the form of the parallel and remote universe of number, but now it is a sacred technology of mathesis to which Max, the protagonist, devotes himself in solipsistic studies, remote from both the Galilean "universal language" of natural mathematics and from the universal currency of information in the global economy. This transcendence of absolute number is also associated with a visual language that assimilates the cinematographic to animation in step-motion sequences that, like the slow-motion of *Desperado* and the animation of digital stills in *The Matrix*, dematerializes with a mixture of dread and exhilaration, a combination that, in *Pi*, comes as a premonition of an epileptic fugue. As sickness and unconsciousness, but also as extreme life, filmic technique both describes and risks actualizing what it shows: the viewer's act of viewing is undertaken in the knowledge that the flicker of projection might instigate the epilepsy it recounts. Eliding the description of extreme states with the possibility of evoking them, like the transports of Charles Borromeo before images of the crucified Christ, leads us to the baroque's ecstasy, its assimilation, without will, into the transcendence of art. For *Pi* this enactment of ecstasis is at its most intense in the transitional scenes that take us from climactic epileptic bliss (white, silent) to recovery (black, ringing phone).

Part of *Pi*'s mathematical narrative premise concerns a Jewish sect for whom the Pythagorean mysticism of the Golden Section has been assimilated to the numerology of the Kabbalah, repository of the most arcane rabbinical traditions including belief in the numerical encoding of the Bible. Cut to Fibonacci rhythms, which it also depicts in the form of snail shells, Golden Sections, Leonardo's humanist torso, overlaid spirals, formulas, and numerical series, *Pi* offers, to the point of incomprehensibility, to enact mathematics as total allegorical explication of existence. But it is precisely that totality which brings about the crisis of representation. As Max, the protagonist, approaches the realization of the mystical unification of pure maths, natural numbers, and the chaotic systems of the stock market, his epilepsy becomes more and more violent, and the film veers more and more cruelly and abruptly toward surreal, wide-angle sequences of paranoia and self-mutilation, or alternatively through sequences of cascading edit patterns toward the white light of the epileptic fugue. *Pi* cleverly orchestrates the decorative function of its mathematical motifs in the construction of a baroque architectonic structure in the same moment that it reveals the

superficiality and emptiness at its heart, marked with the sign of epileptic absence.

At the same time, like its big-budget brothers, *Pi* is a profoundly narcissistic film. Recruiting popular histories of number (Cubitt 2000a) and popular mysticism concerning epileptic fugue, it works up the image of destiny—genetic genius—as prison to justify harrowing scenes of intimate self-doctoring for pain, the experience that will take Max to the threshold of an escape to the cathartic beyond. By picturing the community of seekers as either self-interested profiteers or uncanny zealots, the baroque *Pi* shows all community as false—false as the rabbi's attempt to inveigle Max into a bogus Cohen family—and so restricts communication to self-communing face to face with the unmediated cosmos. Thus *Pi* can function as the transcendental descriptor of a prison that erects its own walls in the act of describing them, while depicting a world of leaking intimacies (the sensual sounds seeping through Max's walls), in which the falsely normative heterosexual family can become the family of destiny and self-mutilation is the sole escape from a too dangerous because too ecstatic biological destiny.

"You're not a mathematician: you're a numerologist": Max's old professor, guardian of the absolute purity of pure math, voices a certain disgust with the loss of classical purity. As *memento mori*, disgust works on the central taboo of contemporary society, justifying the display of putrefaction through its association with redemption, notably here in the probing of the fetid brain with a ballpoint pen and the final cure, excising the equated mind and brain with a power drill. Like tonguing the anal recess and its spinal interface in *ExistenZ*, dependent on the effect of sound (the pre-echoed blurping fish of *Pi*), disgust proposes itself as the opposite of the self-sustaining clarity of the classical, but equally clearly proposes that the two elements must be understood in a single thought: there is no absolute division between the mental and physical worlds, just as there can be no divorce between desire and intelligence, materiality and transcendence.

Baroque cultures are fundamentally allegorical. Their field is not description of the real but its ordering in free-standing semantic structures whose reference is to other semantic structures, including those that would have been held in dialectical opposition by classicism, like the indecorous irruption of disgust into the space of the transcendent. Such are the rustic jokes, satyrs and priapi of the Tivoli Gardens, monument to the triumph of

artifice in the ordering of nature. In this sense, baroque allegory is rhetorical, the audiovisualization of the *ars bene dicendi*, asking to be judged not on its verisimilitude but the elegance of its structure and the eloquence with which it voices "what oft was thought but ne'er so well expressed." Films like *The Matrix, Desperado, Strange Days,* and *Pi* share with others like *Twelve Monkeys* an allegorical structure of this kind, symptomatized in the hyperdetailing that, in a curious inversion of Bazinian realism, dematerializes the image in its excess of signifiers and functions as an allegorical fugue on themes of hyperreality, illusion, and the Code. At this juncture, narrative conclusions become almost impossible because of the allegorical burdens they have to bear. Hence the implicit tragedy of the closing lines of dialogue in *The Matrix* and *The Truman Show*: there is no exterior to the fiction except, perhaps, another stage set.

Baroque cultures arise as dialectical expressions of a crisis of absolute power. The Church Triumphant of the Counter-Reformation (see Blunt 1940) and the capitalism triumphant of the end of communism both face the crisis of the end of history. The seventeenth-century Baroque is legible as the expression of an absolute state confronted with the crisis of its own mode of signification. The Catholic Church, until then the central force toward modernization in Italy, was driven by self-preservation (after the collapse of the Mediterranean economy following the Turkish capture of Istanbul) into the arms of Spain, whose monarchy and especially whose systems of taxation belonged to the dying feudal order, but which would be buoyed up for a hundred and fifty years by its American gold. Caught between these forces, the Church opted for a denial of "pagan" classicism in favor of a return to authority and discipline, sweetening the pill by abandoning humanist rationalism for the swooning ecstasies of Bernini and Pozzo. And yet, as John Beverley observes, the Spanish baroque "was, like postmodernism today, at once a technique of power of a dominant class in a period of reaction and a figuration of the limits of that power" (Beverley 1993: 64). Both turn toward ultimate things in their pursuit of a resolution to the crisis: toward transcendence and the sublime. Both face both ways, toward the transcendental and toward the grotesque (see Wind 1998). Yet both fail in their refusal of dialectics, their insistence on one side alone possessing the right.

The classical paradigm in its heyday stands in opposition to but in close relation with the realist paradigm: the greatest achievements of the period—

Stroheim, Keaton, Renoir, Mizoguchi—swing between the symmetries of the classical and the openness to contingency of the realist. But even here another lineage of modernity is apparent, the subterranean strand of the grotesque, the surreal, the irrational that emerges, indeed, in exactly these directors. For many, this Bataillean disorder is the emergent form of a new and radically postmodern cultural poetics: Buci-Glucksmann calls it the baroque. But for Benjamin, on whom she bases her argument so forcefully, the optical unconscious reveals the verso of a normality that remains radically unchallenged by it, since this is precisely its necessary other. When the Mariachi moves his choreographed way through the charnel house of *Desperado*, when the bullets or kickboxers stand in empty air in *The Matrix*, we are treated to the interior of the classical surface. In some films, this effect opens up the spectacle of the spectacular, introducing a near-Zen metaphysics built on the emptiness of the commodity, a spatialization bootstrapped out of its ephemerality as in a number of Ridley Scott's films, notably *Gladiator*. In others, like *The Matrix*, *Casino*, and *Apocalypse Now*, the invitation is to navigate those nebulous internal spaces where the powers that support the bubble of style twist in meaningless flux.

The transcendence of the Hollywood baroque belongs to a society of power in which colonial and imperial expansion has not ended but undergone a novel reorganization. As the seventeenth century was the epoch of the map, the archive, and double-entry bookkeeping, the spatial media par excellence of the new Atlantic imperium, so is the neobaroque of databases, spreadsheets, and geographical information systems. Information technologies are not qualitatively different from the instruments of imperial bureaucracy. Steadicam navigation of indeterminate space is the spatial art of globalization as the carved fountain was of imperialism. The neobaroque is the stylistic turn of capitalism in the moment of its uneasy triumph, confronted with the completion of its historical destiny without achieving the justice, peace, and commonwealth it was intended to bring.

In the magical ascensions painted onto ornate domed ceilings by the great Jesuit artist Pozzo, the world is gathered around the adoration of splendor. Even truth surrenders to *trompe-l'oeuil*. The neobaroque learns from the older not just the richness of décor, not just the instability of matter that at any time can lose its crystalline hardness and tumble into the *informe* (as in the Trevi fountains), but also how to engineer the spectacle about the fixed void on whose foundation alone its splendor coheres. It is the

price of baroque coherence that the subject become abject and that the abject evaporate, for coherence is the spectacle's only true product. Once that single leap of self-abasement and self-abnegation is made, the world orchestrates itself as spectacle, and spectacle articulates itself into a single unity. In cinematic terms, the infinite is first totalized so that it can then be unified, at which point the subject is rendered as the zero of utter emptiness. Of its geometry, Marina Benjamin comments "The all-pervasive fractal, twisted and inward-looking, is so utterly self-referential it replicates itself on resolution and, since it has no frame of reference outside itself, it is incapable of transformation" (Benjamin 1999: 13).

This is the playfulness of the new Hollywood blockbuster movie: an appeal to self-loss in the modeling of a coherent spectacle, whose offer is of a coherence that is impossible in the contemporary world, and whose cost is that the diegetic world can cohere only if the spectator surrenders to abjection and volatilization. For the neobaroque sublime to conquer, it must sublimate the sense of self. The familiar abstraction of mind and body, of observer from observed, of subject from object, here reaches a new formation: everything will be relinquished in favor of coherence. The new world needs to be utterly absorbing: this is why special effects are so central to the new Hollywood, and also why the neobaroque is so unafraid of displays of mawkish emotionalism. To quote Spielberg, "The equivalent of the mothership landing in *Close Encounters* is, in *E.T.*, perhaps a tear out of Henry Thomas's eye. That was my equivalent of a super-colossal special effect" (cited in McBride 1997: 330). Affect, thrill, shock displace themselves from the audience to the spectacle. The vanishing point is no longer in the image but in the rapt attention of the viewer.

Database Narrative and the Montage of Affects

Earlier avant-garde techniques for alienation concentrated on breaking up identification with characters. The neobaroque responds by inviting identification with fictional worlds. Here the stakes are higher, in the sense that the existence of the fictive world depends on the abnegation of the viewer. Of course, this also means moving away from the knots of ethical distancings that were available to the classical cinema and its identifications. So, for example, *Peeping Tom* was a viable if gruesome critique of the powers of identification; *Strange Days* (fig. 9.3), effectively a remake of the story if not

| Figure 9.3 |

Strange Days: empathizing rather than identifying, Bigelow's Steadicam yields no truth, only emulations and betrayals. Courtesy BFI Stills, Posters, and Designs.

of the film, is no such thing. We can only empathize with its protagonists, not identify with them. And Bigelow's world yields no truth, only emulations and betrayals.

A new tactic emerged in the advance of minimalism in the 1960s and '70s. Artists like Donald Judd and Carl André and musicians like Philip Glass, Steve Reich, and Terry Riley developed a modular construction of works from simpler primitives, run in series with minor variations. The attempt there was to strip the human out of art. "The idea becomes a machine that makes the art," in conceptual artist Sol Lewitt's phrase (1992: 834), allowing the materials to generate their own higher levels of organization according to structural logics established as the sole creative act of the artist. This is not to claim a patrilineal descent for neobaroque Hollywood, which in any case appears to have derived its new structures equally from the emerging digital workplace and from whatever social and cultural tendencies likewise informed the minimalists. Rather, it indicates a felt need for a

cultural form that excluded subjectivity, and that placed truth outside the human, in closed, rule-governed worlds.

The modular structuration of these worlds has a further impact in neobaroque cinema. The coherence that passes for truth exists only in modular events, segments of the film that stand alone as discrete units, most of all the effects sequences. Recent films like *Star Wars, Episode Two: Attack of the Clones* move from set piece to set piece along only the slenderest thread of narrative, like washing on a line. Each set piece sequence acts to trigger a rush of emotion: putting a clock on the action, staging the spin-off computer game as sport, escaping from ghoulish caverns. The scream, the laugh, the tear, the white knuckles, the racing pulse: the stimuli are clichés because the emotions they elicit and that audiences seek are clichés. Market research ensures, as far as anything can, that expectations will be met. Of course, such expectations derive from the past, never from the future, and so the hectic overproduction of affects is only ever repetitive of old emotions. The clothes-line model of effects sequences held up by a perfunctory narrative builds on Hollywood wisdom ("Don't tell me: show me!"). Structured in accordance with the most trusted modes of narrative, each set-piece sequence miniaturizes the older classical plot into a few minutes of film, condensing as it simplifies the emotional content, delivering the intensified segment as an event in itself, and building, from the succession of events, a montage of affects that together establish the visceral goal of neobaroque entertainment.

The diegesis of the neobaroque is not only self-enclosed but self-referential. The repetitive nature of the montage of affects is a theme for a number of neobaroque movies, *Groundhog Day* being the most egregious example. More significant still is the phenomenon of spatialized narrative. Lev Manovich notes the importance of the database as an alternative source of narrative in digital media computer games and digital installations (Manovich 2001: 225–228). Daughter of the filing cabinet, the database is a device for the ordering of materials, as such intrinsic to Hollywood market research, scriptwriting, and editing. Lévi-Strauss's (1972) vision of narrative as an assemblage of narratemes, each of which functions by analogy as a card-index, was a predigital adumbration of the narrative possibilities of this extranarrative form. *Lock Stock and Two Smoking Barrels*, *Snatch*, and *The Usual Suspects* only appear to be narrative. In fact they are the result of one of many possible rifles through a database of narrative events whose coincidence is more structural or even architectural than temporal. Beyond the

modernist opposition of narrative and nonnarrative, the structuring of such films depends on the satisfaction to be had from realizing the pattern underlying the events, in Manovich's terms "discovering the algorithm." For this to work, every loose thread must be picked up, every action matched with another, and the submerged symmetry of the classical narrative tradition brought to the surface to be displayed.

In this way the narration, too, becomes spectacular, as we wait for the moment in which the various unraveled lines are knitted into a satisfying coherence. In the process, narrative reveals the coincidences, the flukes of chance that give us this specific version of the story, making play of the casuistry that allows the manipulation of narratemes to pretend to some sort of causality. We are not taken in by these stories. Rather the pleasure derives from the craft with which they are put together. Like the washing-line of the montage of affects, the construction of the database narrative is modular, encouraging games with flashback (*Memento*), time travel (*Twelve Monkeys*), and temporal dislocation (*Pulp Fiction*) to demonstrate with even more brilliance the command over events enjoyed by the pattern-making impulse.

The effect is to make the narrative, like the diegesis, spatial. Deprived of causal chains of anything more than pure luck, good or bad, the protagonists have only to understand, as the audience must, their position in the web of events to realize their goal. That goal, however, already exists as the resolution of the riddle of the world they inhabit. Personal destiny coincides with the destiny of a Hegelian world, whose task is to understand itself.

This shared ideology in turn explains an oddity in the neobaroque that distinguishes it from the "trajectories" (Deleuze 1989: 64) of Keaton. Keaton's world is animated, in the sense that any object can be full of anima, of soul, of its own will and whims: the playfully retreating girl revealed as—exactly—a horse's ass in *Our Hospitality*, the effervescent transformations of *Sherlock Junior*. The neobaroque world is capable only of disappearing, as in *Dark City* and *The Thirteenth Floor*. It may promote illusion (and thereby be capable of revealing the truth behind the illusion), but it is incapable of betrayal, or any willed action, as once it was in the days of Keaton, Chaplin, and Lloyd. Their artistry arose from the happy fault of cinematography—its readiness to believe in appearances, and most of all, in its unappeasable appetite for movement, its gullibility with respect to the self-governing activity of its world. The world of *Groundhog Day* has no will of its own: it exists only to force its protagonist to discover how to live in it. Even

its denizens are manipulable objects in the hero's quest. Like the solitaire player, the film moves its pieces to create an orderly pattern in which the absurdity of the premise—a shuffle of the deck, a throw of the dice—abolishes chance and clears the way for destiny.

For the fictive world to present itself as coherent, it must eradicate subjectivity as the potential source of novelty. The cleanest cut is to deprive the characters of futurity by endowing them instead with a fate: a foregone conclusion that empties the future of its difference from the present. Once it is clear that biology is destiny—as it is in different ways for the heroes of *Phenomenon* and *The Sixth Sense*—the details of the story fall into their patterns, and the purpose of subjectivity is fulfilled at the moment in which it is absorbed entirely into the pattern of the world. With destiny, there is no need for anything more than the sketchiest story.

Self-doubt, for example, is no longer sufficient motivation for a narrative: it is simply an obstacle to be overcome as the pattern hurtles toward completion. Even doubt will be explained as the necessary corollary of a certain task required. The neobaroque's spatialized narratives, with their array of actions and consequences plotted as on a map, take the picaresque structure of the road movie to the extreme. Where a film like *Vanishing Point* ("The Car. The Road. The Girl. The Shack. The End") leaves us in no doubt that the hero will die, it is more existentialist than nihilistic: what the character does matters. In *Groundhog Day*, it doesn't. The end is already appointed. All the character needs to do is come to it. The coincidence of personal fulfillment and absorption into the world reduces the future from a process of hope to an object of faith. Externalizing the inward struggles of Neo, his shipmates aboard the Nebuchadnezzar are distinguishable only by the quality of their beliefs. What narrative there is devolves upon that single, efficient distinction.

Locking into a pattern at its conclusion, the database narrative reveals its gestalt. The task of the protagonists is to realize themselves as elements of an infinitely repeatable, enclosed horizon of rule-governed patterning. The neobaroque hero inhabits his environment with utter omniscience like *Desperado*'s Mariachi (fig. 9.4), like Brandon Lee's character in *The Crow*. The diegesis is a knowledge base, its secrets resources to be picked up and used, like the energy and weapons in computer shoot-'em-ups. Samantha/Charly in Renny Harlin's *The Long Kiss Goodnight* is alert to the secret power struggles of her world even though she has had her memory erased: her

| Figure 9.4 |

Desperado: The hero as center of a world's consciousness; a world realizes itself in the assimilation of the hero. Courtesy BFI Stills, Posters, and Designs.

body already remembers what her conscious mind eventually recalls, that the banal world dissimulated a double lie. Paranoia films, from the grit of *Conspiracy Theory* to the wilder reaches of *X-Files: The Movie* and the parody of *Men in Black*, similarly have the world reveal its capacity for truth by first shattering the illusions of the neophyte, and then requiring him to assimilate the new world revealed at the subliminal level of instinctive knowledge and instinctual action. The only act of will required is the statement of belief. After that, the environment (the Force) takes over. The world can realize itself in the assimilation of the heroic subject.

The neobaroque is a Hegelian cinema, in the sense that its goal is not narrative closure but the revelation of truth as destiny: "that the actual world is as it ought to be, that the truly good, the universal divine Reason is the power capable of actualizing itself" (Hegel 1953: 47). Perhaps it is a cinema out of Leibniz, for whom humans' true love of their creator

makes the wise and virtuous work for whatever seems to conform with the presumptive or antecedent will of God, and yet leaves them satisfied with what God in fact causes to happen by his secret will . . . recognising as they do that if we could sufficiently understand the order of the universe, we should find that it surpasses all the desires of the most wise, and that it is impossible to make it better than it is, not only for the whole in general, but for ourselves in particular. (Leibniz 1973: para. 90, 194)

Contemporary cinema is more ambitious than contemporary philosophy, but neither undertakes to understand the universe any longer. Instead, the neobaroque builds experimental worlds in which the honest actor must discover that "preemptive or antecedent will" that animates her world in order to subjugate herself to it. The film world is a windowless monad, a simple structure unafflicted by connections to the rest of the world, entirely inward.[3] Where this universe distinguishes itself from Leibniz's and Hegel's is in its relentless secularism. For Hegel, "World history in general is the development of Spirit in *Time*, just as nature is the development of the Idea in *Space*" (1953: 87). Hollywood deals in the multiple histories of multiple worlds, and with the particular rather than the general. In its secular pluralism, the ambition for evolution of the Spirit has been cast aside, for it demands a future that the premise of eternal repetition cannot sustain. At the same time, the notion of an Idea that seeks to fulfill itself in the physical world is too cold and abstract to motivate an audience. Hollywood's achievement in the neobaroque is to have produced a series of worlds in which Spirit develops in space. Hence the worlds thus created are subject to human will and structured according to the rational-irrational binary that shapes contemporary pop psychology.

There is infinity in these enclosed monads, albeit only the infinity of the inside of a sphere. The film world seeks an audience that will realize it by uncovering its secret algorithm, but which will also by that act dissolve its separate identity into the unity of the new world. Neobaroque films are not

simply total cinema, though many exhibit characteristics of totalitarianism. They are, as Justin Wyatt (1994) argues, extremely visual, lavishing light on strikingly graphical compositions. Spatializing narrative as database fits with this attention to the illumination of the screen as pure style, a style that moreover is as likely to motivate the storyline as to be motivated by it. As image becomes composition, narrative becomes pattern, and the whole comes to a moment of gestalt coherence. This goes counter to Kristin Thompson's description of cinematic "excess," which she defines as stylistic innovations that are motivated neither by the narrative, in the classical manner, or by artistry, in the manner of the art-house film (Thompson 1986: 132–134). Thompson's excess works against the grain of the narrative, establishing a conflict between story and an environment strongly marked by design and composition. But such stylistic traits appear excessive only when viewed from the grounds of a cinema presumed to be normative. In fact, quite the opposite process is in train. In creating a world rather than a narrative, the neobaroque seeks instead a circumscribed perfection removed from history and thence from dialectical process. Of the classical cinema, Adorno wrote, "In its attempts to manipulate the ideology of the masses the ideology of the culture industry itself becomes as internally antagonistic as the very society which it aims to control. The ideology of the culture industry contains the antidote to its own lie. No other plea could be made for its defence" (Adorno 1991: 157).

Today that plea can no longer be entered. Certainly there are films that in various ways conform to Comolli and Narboni's (1977) "category 'e,'" the film that tries to present the dominant ideology but does so in a contradictory way that reveals the workings of ideology itself. The most successful films, however, succeed because they have nothing to say: no roots in the social or the material world, alternatives to reality, neither antidotes nor commentaries.

We might seek forebears in the European artistic and political avant-gardes, in Jancso's *Red Psalm*, with its formal, elegant epithaliamium for land and people in revolt, in Resnais's *L'Année Dernière à Marienbad*, folding its players in layers of time. Or we might choose Welles's *Mr. Arkadin*, whose eponymous villain feigns amnesia and hires an investigator to unearth his past so he can murder all its witnesses. Arkadin, writes Deleuze, "makes out that he is recouping all the splits in himself into a grandiose, paranoid unity which would know nothing but a present without a memory, true amnesia

at last" (Deleuze 1989: 113). Deleuze places the crisis of cinema history at the end of World War II, in the European reconstruction.

The equivalent moment for the United States came later, between the Vietnam War years that periodize U.S. cinema for so many commentators (e.g., Wood 1986; Corrigan 1991; Cook 2000) and Reaganomics. Welles, Resnais, Jancso, even Buñuel, that most lapsed of lapsed Catholics, explore the persistence of the past in the present. In the windowless monads of the neobaroque, the past has disintegrated, no more than a comforting repetition of the governing pattern—the comfort of the final scene in *What Dreams May Come*. Where Leibniz and Hegel sought an end to history in the reunion of humankind and nature, Hollywood offered an escape from history by the subjection of hyperindividuals to artificial worlds, narcissistic mirrors in which the unwilling subjects of modernity may unravel the knot of self and disappear into the arabesques of spectacular coincidence, illuminated by flashes of visual, aural, and physiological shock.

Neobaroque Hollywood film is not dialectical because it eschews time. In place of change it seeks truth, the unique, permanent, and perfect truth of secret worlds hidden from history. Out of the milling equilibrium states of the spectacular, the neobaroque produces pattern. For those tired of the endless, chaotic trudge through daily life, it brings the sense of completion. For those for whom all hope is lost and who therefore can only believe in miracles, it produces unity out of nothingness while it annihilates the overburdened self.

TECHNOLOGICAL FILM

Digital Materials

It is swarming with planets
Time definitely repeats itself
That's its only job

—*Ed Dorn*[1]

Metamorphoses of Narcissus

It is no longer the case that films in some way respond to, refract, express, or debate reality or society. Mass entertainment has abandoned the task of making sense of the world, severing the cords that bound the two together. This, as much as economics, is what has driven the North American cinema into the realm of digital imaging. The cost of building synthespians more sophisticated than the disappearing Kevin Bacon of *Hollow Man* (Smith 2000) is still prohibitive,[2] but other repetitive tasks like in-betweening have been delegated to computers for over a decade. Digital extras are a fixture, from *The Lion King*'s flocking wildebeest to the milling crowds of *Titanic* and *The Mummy*. Mattes and traveling mattes, wipes and dissolves, preproduction tasks like marrying script, storyboard, and budget, and postproduction work, especially sound recording and both vision and sound editing, are now digitally based.

Otherwise, to some extent nothing fundamental has changed: the machines execute the same tasks humans used to, their skills turned into fixed, "dead" capital. Digital instruments provide soundtrack scores, but they largely emulate standard orchestral instruments and the overfamiliar nineteenth-century language of film music. Nonetheless, audiences have a clear idea in their minds when offered digital entertainment: a certain seamlessness, a

generic expectation of something new, a willingness to sever connections with fundamental laws of nature. It is not necessarily the essential nature of digital media to provide these things, but they often are provided and become part of the cycle of expectation and satisfaction on which the closed loop of commodity production proceeds.

History is no longer intrinsic to films but extrinsic. The description of effects-driven event movies as enclosed and enclosing worlds may seem to remove them from the political analyses of ideology critique. That, indeed, is their purpose: to abstract themselves from the temporal to grasp for the eternal. That grasp is itself of course an ideological task, but it apparently leaves us with little within those worlds to analyze or interpret. Politics is here being conducted at a miniaturized level of micromarkets, lifestyle groups, and psychic intervention, wholly in keeping with shifts in marketing, advertising, consumption, and the intensifying individualism of North America. Insofar as they are ideological, the ideological practices of film must be understood more at the level of apparatus than of individual artifact. Analysis of new forms generated in the neobaroque leads toward a reconceptualization of the interrelations between the social and cinematic worlds, which may alleviate some of the remaining conceptual problems of ideology critique and offer some idea of how, despite their self-enclosure, these film events are not entirely successful in the pursuit of coherence and so leave an escape hatch for the use of critics and audiences.

To some extent, the micropolitical dimensions of neobaroque cinema have already been addressed by feminist critics. Thus Ryan and Kellner argue that the style of de Palma's *Dressed to Kill*, *Blow-Out*, and *Body Double* "is defined by baroque excess." Unlike the meaningful plenum of the child at the mother's breast, they argue, the baroque is meaningless, "unpredictable; it is a world of anxiety projections, threats potentially coming from anywhere, because the secure presence of meaning has withdrawn from it." This denial of semantic plentitude corresponds to a patriarchal struggle to take control of the world through an anempathic mastery of style: "if the world cannot be trusted, then security can only be gotten in a private, artificial world of one's own making." This, they note, "is Walter Benjamin's baroque tyrant become a petit bourgeois family man" (Ryan and Kellner 1990: 190).

Between the construction of private universes and the struggle for mastery, the white man reconfigures his power. The description is particularly persuasive when applied to films like *Twelve Monkeys* and *Pulp Fiction* where

the anticipated resolution between world and subject fails, where mastery is never achieved, and the world reasserts its meaninglessness. But such nihilism is only the obverse of that blind faith which marks the successful achievement of unification into a coherent world. Moreover, the result of this success is less the reassertion of white patriarchy and more the acceptance of the artificial world on its own terms, conforming to a need for control at a moment in which control is simultaneously within the grasp of new endocolonial technologies and become vanishingly distant. Such are the contradictions out of which the new event cinema is being formed. They do not necessarily, however, also describe the morphology of the new films, a condition for whose functioning is that they abstract themselves from the historical dialectic. Nonetheless, understanding both the apparatus and the morphology will make it far easier to understand how and why contemporary culture, contemporary ideology, is so desperately unambitious.

Digital technologies promise to elevate fantasy worlds above the troublesome everyday world. Beauty there will be more intense, emotions more powerful, the adrenalin indistinguishable from the real rush. That extraction, the apparent boot-strapping of alternatives to the lifeworld, is the strategic power of the neobaroque. Its films cultivate spiritual values as the highest of human yearnings, as the old baroque did, but rather than displace them geographically in the New World, or chronologically into the afterlife, ours enclose them in bubbles of space-time. Rather than invite to the voyage or the ascent, they cajole us to step inward, into miniaturized infinities bracketed off from the world. If the sense of presence belongs most to those who are at home in their world, the artificial worlds of the neobaroque offer us a stronger sense of being than we experience outside, among the wreckage of modernity, betrayed by the reality of the world, deprived of truth or justice.

It is not, then, that the world has become simulation, but that cinema events have become spectacle, addressing atomized audiences intrapersonally, turning their gaze inward as the supposed triumph of consumerism decays into poverty, injustice, and ecological catastrophe. For Debord, "the satisfaction of primary human needs is replaced by an uninterrupted fabrication of pseudo-needs" (Debord 1977: para. 51). Today, the atomic subject can be offered the virtual satisfaction of virtual needs, and none more so than the simple desire to be. Fragmented, schizoid, structured in dominance and by the lack in being, contemporary subjectivity yearns for wholeness

and integration. The digital worlds of event movies offer this satisfaction, no less real for its restriction to the brief seductions of the screen.

Brief, but not passionless. The intensity of digital effects is not entirely new. Miniatures and double-exposure date back in the United States to Willis H. O'Brien's work on *The Lost World* (Brosnan 1977: 108–110) and before that to Brown's (1973) experiments for D. W. Griffith, even to Porter's ambitious experiments at "perfectly made, handcrafted" films in *Dream of a Rarebit Fiend, Kathleen Mavourneen,* and *The "Teddy" Bears* of 1906–1907 (Musser 1991: 331). Combinations of live and animated characters in a single shot were an early Disney specialty in the *Alice in Cartoonland* series of 1924–1926 (Schickel 1968: 86–87; Holliss and Sibley 1988: 13). Motion capture dates back to Marey's design for a black suit with white points and lines used to image the stages of movement (Dagognet 1992: plates 36, 37, and 48). Stunts, demolition, and pyrotechnics remain largely untouched, save that better safety gear can be used on location because it can be painted out electronically in postproduction. Animatronics have developed by leaps and bounds, as the move from miniatures to robotics (and in the case of *Jurassic Park 2: The Lost World* waterproof circuitry) largely does away with the limitations of stop-motion animation by introducing real-time animation of three-dimensional models.

On the other hand, backdrops, mattes, and rear projections (Fielding 1968) have been only marginally altered by the possibilities of chromakey and greenscreen (McAlister 1993: 16). In the end, this is merely a more economic way of achieving traditional effects. The one signal change here is that the cameras used necessarily to be locked off in a fixed position. Contemporary motion-control rigs allow fluid camerawork in greenscreen sequences and permit the movement of a real camera to be matched precisely by the movements of a virtual camera in 3-D computer space (Bizony 2001: 43–64). Beyond this, most of the advances in digital media appear to derive from the process of proletarianization described by Harry Braverman (1974): old craft traditions like animation in-betweening are condensed into new technological resources, downskilling their operators and reducing dependence on volatile creatives. There is no specific gain in spectacle. What is gained is the economy with which these worlds can be manufactured. That economy in turn enables their burgeoning use.

As late as the early 1990s, manuals of computer-generated imaging (CGI) and special effects regularly dismiss vector graphics in favor of

bit maps (see, e.g., Vince 1990). The distinction between bit map and vector, sampling and polygons, so dear to first-year classes in computer graphics, is now approaching obsolescence. For many years, the separation of the two—and the early dominance of bit-map technologies—shaped the ways in which the diegeses of the neobaroque were built. They lie not on the familiar axis of verisimilitudinous painting and abstraction but along a line stretching from cartography at one end to architecture at the other. Somewhere in between lie the fields of virtual sculpture and computer-aided design and manufacture. Throughout the rhetoric of the industry and the commentaries to innumerable DVDs, the emphasis is on believability, not verisimilitude. Like architecture and maps, and enshrined in the cartographic timelines of nonlinear editing and vector animation programs, the art of special effects is an art of space.

To seek the origins of this condition, it is no longer adequate to seek a basic societal mechanism responsible for spatialization. Ideology critique appears so banal in its familiar guise for the same reason media effects theory is so unconvincing: the causal chain linking media forms and social behavior on which both depend has been broken. As Clifford Geertz noted two decades ago, 'the established approach to treating such phenomena, laws-and-causes social physics, was not producing the triumphs of prediction, control, and testability that had for so long been promised in its name" (Geertz 1983: 3). Space succeeds time as organizing principle synchronously with neobaroque narratives' turn to the database form, a spectacularization of plot in an ironic mode in which mere coincidence satirizes the classical working-through of causes and their effects. As the lifeworld appears consistently more random, so the mediascape becomes more scathing of any pretense at order, mocking the revelations and resolutions that once passed as realistic by elaborate and mocking simulations that reveal the diagrammatic origins of complex plotting, instead of fostering the illusion of psychological or moral motivation for action or the patterning of the world. In the process, pattern is divorced from its old task of establishing morality.

The last, great, tragic attempts at depicting such an ethical worldview, like the final part of Coppola's *Godfather* trilogy, fall at the critical moment at which the world dispenses its justice. The unresolvable incestuous love between cousins is resolved, by one cousin's death. After his moment of agony, the tragic hero Corleone dies apparently reconciled with his wife, assured of an heir and sleeping gently in his garden. What should have been

the apotheosis of divine judgment looks exceptionally like a thoroughly de-sirable end to a thoroughly enviable life. Unlike Brecht's heroine in *The Good Woman of Szechuan* (1958), Coppola's hero does seem to succeed in do-ing good, or at least doing well, in an evil world. That ambiguity concern-ing the possibility of natural justice rarely surfaces in the event movie. Such contradictions are never allowed to surface. Instead, they are congealed into a pure surface, at best sketched in as "character" in the formula of prefabri-cated back-story, ray-traced on the epidermis of the players and frequently derived from the actors' previous roles, or established as an item (but rarely a system) of belief to be proven in the faith-filled variant, or disproven in the nihilist as substantial as midichlorians.

The digital corresponds so closely to the emergent loss of an ideologi-cal structure to social meaning because it no longer pretends to represent the world. The linguistic model, no matter how many twists it underwent in the twentieth century, remains tied to the truth-conditions of utterances, and they in turn, despite the logicians' impact on information theory, tied to the quality of reference. This is the scientific model that today dominates Western culture: statements must be checkable against observable states. What digital media seem to do—which is not necessarily what they do—is sever the link between meaning and truth, meaning and reference, meaning and observation. Digital media do not refer. They communicate. An older philosophy of consciousness begins in the relation that a self has to itself, in subjectivity. A more recent one, as Habermas suggests, sees subjectivity as effect: "The reciprocal interpersonal relations that are established through the speaker-hearer perspectives make possible a relation-to-self that by no means presupposes the lonely reflection of the knowing and acting subject upon itself as antecedent consciousness. Rather, the self-relation arises out of an *interactive* context" (Habermas 1992: 24). After modernity's variants on Descartes's "I think therefore I am," Habermas asserts the "postmeta-physical" primacy of communicative networks over individuation. It is a goal devoutly to be wished for, but it is better philosophy than it is sociology.

In nonlinguistic arenas like audiovisual special effects, the relation of reciprocity cannot be presumed either. From the high ground of philo-sophical theorization, certainly the networks are universal and equitable, but at the level of daily experience, they are monopolistic and monodirec-tional. Luhmann goes so far as to define mass media by the fact "that no interaction among those co-present can take place between sender and

receiver" (Luhmann 2000: 2)—and no medium, albeit lightweight, is as massive as the blockbuster movie. Special effects cinema, especially digital films, do, however, establish a relation prior to self-consciousness, but it is not one between social subjects, nor even between an ideological subject and the Althusserian Subject of ideology (Althusser 1971). It is instead an intrapsychic event that perceives itself as a relation between psyche and virtual world in which the emergence of self-consciousness is synchronous with its dissolution.

Like religion, the special effect underwrites an act of communion with another, higher and different mode of being. Yet that being is no longer, in a secular epoch and industry, divine. It is instead cosmic, but at the same time artificial, since it is bounded both temporally and spatially. Within this bounded cosmos, the lonely subject is constituted as incomplete and needy, and therefore already destined to assimilate itself with the world from which it has so suddenly sprung. The most interesting of these films, and often those that have the strongest box-office draw, require of the constituted subject both intellection and action, the two united in many instances as heroic problem solving. Problems in the effects cosmos can be solved, because in these enclosed worlds alone exists the condition for successful action: truth. Moreover, that condition, this truth, since it is addressed to the individual as the unit consumer of the commodity film, rests on the identity of the idea of the pictured world and its being. Like Hegel's divinity constituted in the unity of the notion and being, the finite creature who enters the world is stripped of the being in time and being in space that separates concept from existence, to reunite being and idea in a single event. Because this event is intrapsychic rather than social, it constitutes the divinity of Narcissus. The accidents—the accidence, in Virilio's scholastic terminology—that so enchanted Bazin in the Italian neorealists disappear into a wholly ordered world.

In the words of Richard Edlund, founder of effects house Boss Films, "There is something about serendipity and the 'happy accident' that you can't get on a computer. . . . the computer is very precise. Every result must be thought of and programmed. It is often that unexpected happenstance that makes the shot real, and organic, and truly satisfying" (Rogers 1999: 117). Comparing, for example, the opening shots of the battlefield in Mankiewicz's *Cleopatra* with the panorama of Egypt in the first shot of *The Mummy*, the chaos of the one and the order of the other, you can see the difference

between a world in which, if not freedom, then at least chance can persist and one in which there is no randomness. That the more recent sequence was undoubtedly far cheaper to shoot only begins to explain its appeal. It succeeds because it provides mastery over a world subject to the gaze of one who is becoming a god. The substance, in medieval theology the immutable essence of the world, is deprived of its accidence, the material form in which it presents itself to human perception. Now that perception is digital rather than human, it realizes "the will to see all, to know all, at every moment, everywhere, the will to universalized illumination; a scientific permutation on the eye of God, which would forever rule out the surprise, the accident, the irruption of the unforeseen" (Virilio 1994: 70).

This quasi-scientific expropriation of the divine prerogative also indicates the cataclysmic narcissism of the digital subject, itself a result of what Giddens refers to as "the looming threat of personal meaninglessness" (Giddens 1991: 201). Mankiewicz's Caesar wins the world, an ideological surrogate for our loss of it. Sommers's Mummy becomes the world, a force of nature that springs into existence at the moment of dissolution back into the fictive world that gives birth to him. The goal of the film is not the clinch, nor even the restitution of order, but the assimilation of self into world, onscreen and in the auditorium. In that moment the self-enclosure of the diegesis assimilates its spectator in its fatal embrace, unifying concept and being. Like *Bram Stoker's Dracula*, *The Mummy* stages, with flair, a literal transcription of undying love.

As summarized by Habermas, the theologian Michael Theunissen argues that "True selfhood expresses itself as communicative freedom—as being-with-*oneself*-in-the-other; love—being-with-oneself-in-the-*other*—stands in a complementary relation" (Habermas 2001a: 95). This oscillation of emphasis between oneself and the other constitutes the polarity of contemporary Hollywood: action and romance, a permutation of the mutual dependence of classical narrative and melodrama argued by Rick Altman (1992). Freedom is so central to North American ideology that its lack is invisible. The enclosed predestined worlds of the neobaroque annihilate its claims by granting to action only the freedom to achieve one's destiny.

Love, however, presents a different conceptual knot. On the one hand, the protagonists of *Dracula* and *The Mummy* (as also those of *What Dreams May Come* and Cameron's *Titanic*, *The Abyss*, and *Terminator 2*) are tragically tied to temporal rifts. The relationship with the other is the term left out or

marginalized in filmworlds whose raison d'être is unifying world and subject. The presence of another subject suggests the limits to the enclosed world and poses difficult problems for a culture in which sexual object and sexual partner are all too readily interchangeable. Love is the form in which neobaroque Hollywood asks itself the question of the social, unequipped as it is with any way of visualizing a larger social grouping beyond the connectivity of pattern. This aesthetic problem emerges in the editing of digital film.

Editing in 3-D

Stephen Prince notes how the pseudopod, the aqueous tentacle that insinuates itself into the deep-sea habitat of *The Abyss*,

had started in the computer as wireframe animation, onto which the animators composited a rippling liquid texture (in a process called texture-mapping) and shimmery highlights that gave it a three-dimensional appearance. Furthermore, in a way that dramatically heralded the future, the CGI creature interacted in a convincing and fully-dimensional way with the human, live-action elements of the shot. When actress Mary Elizabeth Mastrantonio touches the figure, her finger goes "inside" the alien, glimpsed through its translucent surface, and it, in turn, reacts to her touch, rippling with sensation. The effect is completely credible, even though the alien existed only in computer space and had no live-action correlate in the shot. Here lay the future of digitally based filmmaking: the ability to convincingly integrate the 2D and 3D components of a scene, computer space with live-action space. (Prince 2000: 291–292)

James Cameron's *The Abyss* (1989) (fig. 10.1) was a landmark of morphing technologies in special effects cinema. The water-creature was as amorphous and lovely an effect as we had ever seen. The creature winds through the underwater facility in a meandering steadicam point of view. As it enters the cabin, we get a series of reaction shots, so that our first sight of the creature is framed as a reverse shot. Silver-blue, lit from within and without and sharing the colors of the wall behind it, the pseudopod winds across the screen and over the edge of the frame. Already we are about to lose a crucial aspect of the vector: its mutability. In place of a pan, we get a cut. The creature has moved toward frame right; it emerges into frame left in a composite shot with the film's stars, Ed Harris and Mary Elizabeth Mastrantonio. A second cut places us at 90 degrees to the axis between them and the tip of

| Figure 10.1 |

The Abyss: Director James Cameron abandons fluid camerawork for analytic editing.
Courtesy BFI Stills, Posters, and Designs.

the water-finger, now a more slender shape. Now comes the sequence's only true point-of-view shot, from within the water. Cut to a reverse angle shot combining both stars' profiles with the water-creature's tip as it takes on the shape of a human face. Reverse angle for their reactions: a relieved smile and sigh. Reverse angle: the creature imitates the smile. Eight shots in 29 seconds to explain the two registers of cinema to one another.

Here the grammar of classical continuity cutting is followed to the letter: 180-degree rule, 30-degree rule, eyeline match. Critical to the scene's construction is the shot at right angles to the action, which will be followed by a return to the point-of-view shot. Moving us to an unmotivated position beside but outside the action, it presents us with a schematic of what can only be read as a face-to-face confrontation, even though one of the participants lacks a physiognomy. The face-to-face presumes that the creature will adopt some kind of visage. The amorphous morph has been tamed, by a combination of editing, compositing, and the cutting force of the frame.

Only a brief moment of the genuinely unexplained is left us, in the first appearance of the creature. When, at the end of the sequence, the demented Navy SEAL slices the column of water in two with a sliding door, we are only seeing onscreen a figuration of the editors at work on this sequence.

The pseudopod presents itself first as a graphic, a formless firstness. In the Lumières' *Sortie*, firstness is movement; here firstness is the infinity of possible permutations, reversing the historical movement from event to sign. This is why the editing is so hard and so classical, quite unlike the fluid crane and steadicam that characterize much of Cameron's other effects work. Although the state of motion control in 1989 would not have allowed compositing on a constantly reframed shot, the effects technology would have allowed rendering the tentacle from any angle. In the rest of the film, the 180-degree rule is flaunted constantly, and our orientation within the deep-sea station is never important to the editing. On the contrary, we are expected to navigate a space established through mobile camera work, not through cutting. The resort to classical continuity editing is jarring in this context of fluid spatial constructions. It serves to unify and give identity and direction to the unnameable water, which is all we can discern in the first frame. To do so, it fragments the vector until it becomes recognizably oriented in both space and time, as a moving-toward, a teleological entity, rather than a bundle of potentially endless morphs. In creating unities, the editing also creates a series of distinct single views that break the morphing creature analytically into a series. The series then returns to the base principle of the pixel: movement. Despite the temptation to read cinematic movement as fragmentary, the digital deploys the invisibility of the intervals, in the terminology Deleuze (1986: 80–86) derives from Vertov, to recreate the vector as what Jonathan Crary (1999) identifies as distraction, Leo Charney (1998) as drift, and Jonathan Miller as "an 'automatic self' of which they have no conscious knowledge and over which they have little voluntary control" (Miller 1995: 27–28).

This drifting inattention evoked by the film but absented from it sits beyond the useful double concept of hypermediacy proposed by Bolter and Grusin (1999). Hypermediacy tempts us to perceive the illusion of a world beyond the medium, while fascinating us with mediation: simultaneous enjoyment of Vermeer's milkmaid and the brushstrokes that compose her. In the sequence from *The Abyss*, attention flickers from the creature's movements to its elements, as it were to the brushstrokes of temporality. This

unconscious is not, then, the fantastic of Cohl's *Fantasmagorie* but the drifting reverie appropriate to a pseudo-reality reconstructing itself constantly from clouds of polygons, pixels, photons below the threshold of conscious perception. We are being led toward firstness. This is perhaps the principal source of the sense of awe in science fiction movies. But it is also a preconscious state, a mesmerized gaze. This is magical, but it is neither the magic of the illusion of life, nor of the awareness of trickality, nor yet of the endlessness of the graphical vector: rather it is delight in the illusory perception of illusion.

Henry Jenkins refers to the same distracted state when he writes (1998: 263) of the "virtual play spaces" of computer gaming. The promise of the pioneer cinema was to promote a new interface, a partnership between human and machine in the making of a new art. In *The Abyss* that relation is one of seduction. The découpage of the morphing water-tentacle moves away from the infinite, not toward totality but toward the stasis of zero as a balance of forces, producing a hypnotized subordination to the magic of illusion. Artificial but not synthetic, this is a moment of subordination to the machine as consciousness, an inversion of Heideggerian *ekstasis* turned from preconscious union with nature to preconscious subordination to technology. Despite the narrative's attempt to make the corporate state the villain of the piece, *The Abyss* mesmerizes its subject into descending into the depths from which the magic arises. Without dialectic, committed to the exposure and eradication of difference, *The Abyss* descends into the virtual in the poor sense described by Damien Keown when differentiating Buddhist meditation from "the stasis of a virtual experience, wherein however much the wheels spin, nothing ever moves" (Keown 1998: 86). Sacrifice leads not to salvation but to finality, to a union with the wise spirit of the deep in whom all change, all history resolves into karmic equilibrium.

Contrast a scene from Alex Proyas's 1999 *Dark City*. Clearly a mid-budget production compared to the immense expense of Cameron's film ten years earlier, *Dark City* equally clearly benefits from the tumbling costs of computer-generated imaging (CGI). We are in a world that owes something to the traditions of *Groundhog Day* and *The Truman Show*, something to the neonoir production design of *Blade Runner* and *Batman*, something to the cult gothicism of Proyas's previous film, *The Crow*. The Strangers are mad scientist aliens in control of the strange nocturnal shenanigans; every-

one else is at best ambiguous, more often downright sinister. It is midnight, and while the city sleeps, architectures, interiors, clothing, circumstances, marriages, families, and, as we soon learn, even memories are being altered.

Proyas's camera rarely occupies positions motivated by a human observer. Compositions emphasize depth, points of view are literally inconceivable as human, and cutting serves an alien point of view—the viewpoint of a mechanical perception autonomous of human sensoria. Like some key Japanese anime and manga comics, cuts are governed at least as much by graphical as by continuity matches. Moreover, at this stage in the film, neither the characters nor the viewer have a clue what is going on. We do not know what the morphing buildings are doing, where they are going, why they are changing, growing, grinding their way from one location to another. Nor, and this is the point of distinction between *Dark City* and *The Abyss*, does the editing help orient us. Quite the opposite. We are as lost in the city as the protagonists. And although the film is neatly circular, what delights its fans is the vertigo of unexplained procedures and the sense of the endless that they evoke. If in *The Abyss* the CGI effects are subordinated to the photographic, here the photographic elements are subordinated to the graphical code. As a result, even though bound into form by the terminal cut of closure, the film presents us with a sensation of openness in the paradoxically claustrophobic confines of the nightmare burg.

Dark City's effects combine CGI, the building of virtual objects and animations that exist only in cyberspace, and compositing, the use of computers to layer elements deriving from studio and location footage, model and miniature stages, into single images. Compositing demands more even than technological wizardry, immense preplanning, and forethought. The type of explosive used in miniature pyrotechnics, the speeds at which they are shot—up to 300 frames per second—and the stopped-down iris—as low as f32—needed to give miniatures depth make demands on the types of film stock and the quantity and quality of light and color-response, which have to be matched as precisely as more obvious matters like shadows. The difference between CGI and compositing is neatly caught in Michele Pierson's (1999a) historical distinction between technofuturist and simulationist modes of digital special effects. CGI, she argues, especially during the transition from analog effects in the early 1990s, is characterized by its encouragement of awe, by its presentation of the spectacle as worthy of contemplation. Scott

Bukatman makes a similar argument when he suggests that "Special effects redirect the spectator to the visual (and auditory and even kinaesthetic) conditions of the cinema" (Bukatman 1999: 254).

Although the decision to go with miniatures rather than CGI is as often financial as aesthetic, nonetheless there is an ethical dimension to the choice. Shifting emphasis from CGI to compositing corresponds to a shift away from spectacle toward simulation of reality. Lee Tamahori's *Mulholland Falls* provides a neat example in the sequence showing a huge crater left by atomic testing. Unable to access restricted areas of the Nevada desert, the effects crew provided a virtual crater for this otherwise realist period thriller. Here it is not so much a question of alternative reality as of enhanced reality—as effects are now routinely used to brighten or darken skies, correct period detail in location shoots (*Devil in a Blue Dress*), turn small groups of extras into swarming crowds (as in the concert scenes in *That Thing You Do*) or to airbrush in or out wanted or unwanted details in the cinematographic image.

Pierson cites Sobchack on films like *Tron* and *The Last Starfighter* to the effect that "The privileging of electronic depiction depends upon its marked difference from cinematic space rather than upon its integration with it" (Sobchack 1987: 261). Despite the fact that many of the effects in *Tron* were hand-drawn cel imitations of digital effects, the film still made much of its early use of computer imaging, taking on the task of visualizing the emergent world of cyberspace for its new inhabitants, in a way picked up on and expanded by later films such as *Johnny Mnemonic* and *Lawnmower Man* (see Hayward 1993). Like La Valley (1985), Sobchack sees the cinema of digital effects as pivoting on the incompatibility of familiar-analog and alien-digital. Pierson fingers Emmerich's work on *Independence Day* and *Godzilla* as the end of that era in which, in the words of Pohl and Pohl, "Audiences watch new sf flicks as they do a conjuring show" (Pohl and Pohl 1981: 315). The seamlessness of contemporary compositing, the erasure of the differences between the various elements and their subordination to the construction of a coherent diegesis, ends the period in which, says Pierson, the difference between elements was the source of the magic.

Enhanced reality, however, does not quite conform to this description of simulation. It is not caught in the representational matrix of simulation, the theoretical end-stop to the old paradox of representation (that any representation is, by definition, inadequate to the reality to which it refers). At best, the cinema of enhanced reality serves up the cold comfort of sense

forced on a recalcitrant world. More commonly, in *Mulholland Falls* or *That Thing You Do*, it subordinates the profilmic world to the necessities of communication. In itself, this is the process of all communication. But in these instances, what is lost is the Batesonian "difference that makes a difference," specifically the difference between communication and environment that, for Luhmann (1995) and his sources in Maturana and Varela's information theory (e.g., 1980, 1987), constitutes the grounds of communication's possibility. For Pierson, the trajectory of the science fiction film from fetishized effect to integration results in the closure of science fiction's utopian project: "The future has once more dropped out of sight" (Pierson 1999b: 176).

Undying Love

When we seek to be represented, what is it that we want to see? Is it, as *The Abyss* would suggest, ourselves as we are: concepts without an existence, deprived of meaning and reality, seeking in the movies the fleeting, horizon-haunted space in which for a brief interlude we become our worlds and so achieve being? Or are we, as *Dark City* would seem to suggest, concepts without existence, pure substances whose experience is as illusory as the movie itself, with nothing to cling to but a haunted, amnesic conviction that somewhere among the detritus and the mobile world there was once a true self to which it is our task to return? *The Incredible Shrinking Man*'s visionary final sequence spoke of boundless space within the atom. *Dark City* finds the cosmos habitable only when it is bounded. The same year's *The Thirteenth Floor* argues an even more paranoid cosmos of nested virtualities, one inside the next, in a potentially infinite *mise en abyme*. Even our infinities are bounded. The gods we may become are deeply diminished.

Thus the importance of the theme of enduring, undying love to the blockbuster. There is no need for *The Abyss* to delay and then celebrate first coition: our romantic leads are divorced from each other. There are elements of the comedy of remarriage (see Musser 1995), but they are recruited for the most part as typical and reliable storylines to hang the big scenes on; the only one persuaded of their ideological significance is the director of the film. Lacan decrees, notoriously, that "what one calls sexual bliss is marked, dominated, by the impossibility of establishing, as such, anywhere in the enunciable, the unique One which is important for us, the One of the relationship 'sexual relations.'" Lacan was no feminist. His interest lies in the maculate processes of being masculine: "Phallic jouissance is the obstacle

which stops man arriving at jouissance in the body of the woman, precisely because what he gets his bliss from is the jouissance of his own organ" (Lacan 1975: 15).

This claim needs rephrasing to bring it up to date. Sex is no longer forbidden or shameful, least of all to the ex-marrieds of *The Abyss*. The point of the affair is not sexual—any more than it is ideological. The impossibility of sexual union lies in the impossibility of unity: that in the sexual relation there are always two. Given this impossibility, the life-affirming vitality of love can be realized only in the readiness to sacrifice everything, including love and life, in its name. Self-loss is the condition for self-realization, and both deny the union of lover and beloved, self and other, where that other is not a world but a subject. This is where modern love and the neobaroque coincide so powerfully. The hero cannot lose himself twice, in the beloved and in the world, in another subject and in an object. This is why love, passionate and enduring love, to be passionate and enduring has to be wrecked on the rocks of time, and thus to lose what makes love lovable—its altering, fluctuating, ever-evolving nature as mutual exploration, mutual evolution. Love, in the neobaroque, endures or is not. It persists, even at the expense of the lovers. The relation turns on those it relates and destroys them (*The Mummy*), or tears their hearts from them (*Titanic*).[3]

Digital effects tend to communicate rather than represent, a shift in emphasis from the analog era of ideology. They not so much depict or falsify actuality but communicate aspiration. To that extent they are utopian or dystopian. The concern with undying love that arises in the digital era with films like *Ghost* is, then, a utopian-dystopian complex in communication that relates to the changes that have overcome love in the late twentieth and early twenty-first centuries. For Ann Swidler (1980), for example, modern love is no longer about discovering a lifetime's relationship somewhere during early adulthood, but a lifelong search for a partner who will aid in self-realization, and therefore a narrative of attempts, experiments, disappointments, partings, new relationships.

Spatialized event rather than narrative, the self-oriented search for love becomes in the digital cinema a discovery of someone who was *always* meant for you. In Niklas Luhmann's analysis, love had already become incommunicable in the eighteenth century. No longer a legible code of silences, stammers, and blushes, he argues, "It was not the failure of skilfulness that [was]

| Figure 10.2 |

Titanic: Seamless compositing of set and computer-generated imaging: no lack of skill but a loss of the capacity for sincerity. Courtesy BFI Stills, Posters, and Designs.

the problem, but the lack of a capacity for sincerity" (Luhmann 1986: 122), a lack he describes as the discovery of incommunicability. That is the nexus transformed in *Titanic* (fig. 10.2) and the others: from an experience of incommunicability to an acausal, immediate, and therefore timeless communication that, in extreme forms like Ward's *What Dreams May Come*, has an almost Mormon fascination with the eternity of love as perfect communication, and one that specifically does not require sex as a communicative medium. Love in such films is distinguished from and set in opposition to nature, especially to that most natural fact of all, death. The iceberg, the water, the night, characterized by their refusal to communicate, confront the lovers of Titanic as their enemy, while the lovers' communication survives the death of one of them and so overcomes the natural order. Undying love requires no medium in its immediacy, and therefore abstracts itself from the time of mediation, the time of history. Likewise, it overcomes death and so transcends the time of nature. Deprived of time, it becomes a purely spatial configuration, a crystal, sublime.

| Figure 10.3 |

Contact: Bluescreen composite places Jodie Foster in a perfect closed sphere that will contain infinite vistas: a digital monad. Courtesy BFI Stills, Posters, and Designs.

Few instances of this spatiality are as clear as the climactic sequence in Zemeckis's *Contact* (fig. 10.3). Propelled by alien technology into the far reaches of the galaxy, scientist Ellie (Jodie Foster) finds herself on a mysterious, nebula-lit beach where she is greeted by an alien intelligence who takes the form of her dead father. The production schedule demanded that the location be filmed in advance of the shoot with the actors. The Fijian beach footage was tiled into a spherical virtual set so that any future camera move could be accommodated. The tiled set was then enhanced in a total of 39 blue-screen composites, adding digital starlight, color-correcting the water where cloud shadows had passed over it, and mapping the photographed elements onto a 3-D CGI set to allow for perspective and parallax effects. To heighten the effects, tree shadows were accelerated and the waves projected backward. Finally, to produce the desired sense of dream-

like awareness, Foster's character is surrounded by a translucent sphere designed to produce ripple effects every time her hand touches it. Motion control cameras stored and recalled the camera passes over the actors to define their relation to the virtual set (Rogers 1999: 226–228).

Two aspects of the sequence are significant for this discussion: the relation between father and daughter, and the spherical infinity of the virtual set. Not only is Ellie's father dead, but the physical realization of daughter-father love is automatically debarred. In this way love can be abstracted from the sexual and rendered quasi-religious (in harmony with the film's central theme, the relation between belief and evidence) in the same way a motion-capture rig abstracts motion from the moving body. The doubly spherical design of the visionary space, nesting the rippling vision-sphere inside the virtual set, nests the purely experiential within a world that is itself whole and entire. More: this larger world is perfect, reminiscent of Boullée's projected spherical Cenotaph for Newton, its vast interior a depiction of the whole night sky. As Eaton argues, Boullée's plan embodies "the transition from an architecture and town planning that privileged the *enchaînement*—the flow of dominant movement through an urban composition" to an "autonomous architecture" (Eaton 2000: 131). The virtual sphere that forms the end point of Ellie's odyssey, ambiguously physical or spiritual, mirrored across a series of circular and spherical compositions throughout the movie, encloses in perfection the possibilities of development and change. In its perfection, in its awesome evocation of final things, it makes visible the end of history, not as bang or whimper, but as perfect realization of the present and the self.

The perfect sphere is the culmination of the millennia of evolution without conflict, without randomness, without any of the motors of history that our culture recognizes, and therefore also without politics, which has lost its claim on the cinema of digital effects. In the 1980s, for example, the political role of wonder appeared clear: "The style of these films [of John Milius] is congruent with the ideology of radical individualism in that it promotes awe at the majestic power of nature and of the warrior leader. Awe is the correlative of the political attitude of obedience superior individual leaders must inspire and require if they are to succeed" (Ryan and Kellner 1990: 224). In the period between the two presidents Bush, attempts to credit the White House with intelligence and honesty have been tongue-in-cheek cornball, like the

fighter-pilot president of *Independence Day*, while more typical onscreen leaders are venal buffoons (*Mars Attacks!*) or ineffectual accountants (*The Fifth Element*). Leadership is no longer a vital element in the blockbuster.

Awe, however, remains of central importance: awe at the majestic power of spectacle, whose apolitical correlative is self-subjugation, the acceptance of solipsistic destiny. The power of the digital spectacle is coherence: the world not as collocation of things but as a single object. This is an apolitical power in the sense that it no longer brooks the possibility of resistance. In its earlier moment, neobaroque Hollywood devoted itself to moments of awe, glimpses of the sublime. In more recent films, that awe is anchored most of all in moments of destruction, like the marketing image (see Wyatt 1994: 112–133) for *Independence Day*, the spectacular destruction of the White House, an image that recalls the spectacular montage of H-bombs that closes *Dr. Strangelove*, the first great antipolitical film of modern times.

Kubrick's film was a paean to impotence: the impossibility of not destroying the planet, once the means to do so are in our hands. The last hours of the species are lit and shot in the same way as the doomed protagonists of film noir. Human beings have no wish to destroy themselves, but once events are in train, their will has nothing to do with the destiny that drives through them. Vera Lynn singing "We'll Meet Again" on the soundtrack of Kubrick's finale evokes only to mock the last heroic stand against self-destructive evil in World War II. In *Independence Day*, pace Michael Rogin's (1998) detailed ideological reading and titular comparison of the Zemeckis and Kubrick films, the heroism is presented ironically, and the aliens are defeated despite the ineffectual nature of the opposition. The truest moment of the film is anchored in the relationship between the President and his wife, who dies. We learn that it was for her that all this destruction has been suffered and overcome. Love, undying, unconditional love, has taken the place of politics.

In Pierson's transitional period, the sublime moment of the special effect emerges and irradiates the ordinary world, transforming and transfiguring it with immortal longings. In the fully integrated worlds of more recent digital effects movies, the sublime has achieved its goal of transfiguration to such an extent that the act of transfiguration is itself overwhelmed in the perfection of the integrated spectacle (Debord 1990: 9). The commodity no longer reveals its inner dialectic of completion and void: the world itself becomes commodity, and there is no outside, no beyond, to which the

films give us access. The meaning of sublimity, to speak oxymoronically, has changed. Where once it spoke to the flat tedium of Kansas in the emerald tones of Oz to return to Kansas and find it beautiful, now it eliminates Kansas. Films that attempt to rebuild beauty by picturing reconstruction—*Waterworld* and that allegory of internet as democracy, *The Postman*—nosedive at the box office. Where, in the finale of *Soylent Green*, the panorama of "archeological" images of natural beauty moves the dying Edward G. Robinson to tears, by 2001, the pristine wilderness of Aotearoa New Zealand's South Island in *Lord of the Rings: The Fellowship of the Ring* has become pure special effect.

In Arwen's repudiation of her immortality, we see writ small how the commodity sublime demands the death of beauty: "By sacrificing itself, the imagination sacrifices nature, which is aesthetically sacred, in order to exalt holy law" (Lyotard 1994: 189). For the philosopher, by sacrificing its own freedom, imagination achieves the freedom of the law. But for media theory, that sacrifice buys only the freedom of trade, to choose anything so long as it is a commodity. It is only in such cinematic events that the wholeness of the diegesis can be fully realized as both immersion in the world and devotion to undying love. Unconditional surrender to the other joins unconditional surrender to the world in abolishing the difference between love as communication and world as environment. At exactly the same moment, self sacrifices itself to achieve the status of wholeness and holiness.

The filmic world thus constructs itself as sublime monad, timeless because elementary. Its price is the sacrifice of self in a historical epoch in which self bears more of a social burden than it is capable of carrying. After the centuries during which freedom was the crux of philosophical and political thought and action, the goal has become peace.

Digital Monadology

This peace, however, is submission, not surrender, not the mutuality of ordinary love, but self-abasement to the enormity of the sublime. But it would be a mistake to believe that the enclosure of the monad is a fruit of digitality. On the one hand, the opposite is rather the case: almost every interview with effects technicians and supervisors indicates that the invention they bring to bear is always at the behest of a creative vision arising from who knows what complex interplay of professionalism, commercialism, and biography.

On the other hand, the digital itself is increasingly dependent on photographic elements. As early as *The Abyss*, the CGI crew led by Dennis Muren and John Knoll of Industrial Light and Magic (ILM) used reference plates shot in the Deepcore underwater set to provide the internal reflections of the pseudopod (Vaz and Duignan 1996: 199–200). *Independence Day* effects supervisors Volker Engel and Douglas Smith likewise dressed their computer-graphic models of U.S. fighter aircraft with stills of real planes, wrapped onto the wireframe in place of detailed ray-tracing. Although Thomas G. Smith could still see, in the landmark Genesis effect in *Star Trek II: The Wrath of Khan*, evidence for "digitized movies: a scenario for the future" (Smith 1986: 198), nonetheless he still opined that the effects for *Return of the Jedi* would have required "a good sized warehouse simply to store the data" (ibid.: 204). Even full-animation CGI movies like *Toy Story* depend on motion capture, a technique not utterly dissimilar to the use of rotoscoping live action as an aid to animators back in the days of *Snow White*, to draft the facial characteristics and performance mannerisms of Tom Hanks and the rest into the onscreen characters.[4]

More so even than visuals, sound effects remain tied to analog sources. Luke's hovercar was powered by the sound of the Los Angeles Harbor Freeway recorded through a vacuum cleaner tube, the sound of whalesong in the engines of Klingon spaceships (Kelleghan 2001: np) are second only to the infamous source of the gloop for *T2*'s T-1000 morphs: "What's amazing to me is . . . Industrial Light & Magic using millions of dollars of high-tech digital equipment and computers to come up with the visuals, and meanwhile I'm inverting a dog food can" (Kenny 1991: 64). Needless to say, the mixing of elements to produce a final soundscape of anything up to thirty elements involves a great deal of both digital and analog recording, manipulation, layering, and mastering; yet the connection with the analog world, and the ability to hear with astute and creative ears the attack, mass, and decay of sounds as well as their potential credibility and emotional impact, are highly prized skills in the world of film sound. Relatively few sounds, even musical sounds, are digitally originated in Hollywood. The old fear of electronic noise still haunts decades after Louis and Bebe Barron's score for *Forbidden Planet*. In the transitional period, Frank Serrafine, whose credits include *Star Trek: The Motion Picture*, *Tron*, and *Lawnmower Man*, was creating up to five thousand synthesized digital effects per movie, but even so he was reliant on raw sonic material from artfully recorded organic sources

(LoBrutto 1994: 219–226). The analogy with wireframe rendering is attractive: like Alias, SoftImage, and Renderman software packages, synthesized sound creates audio "shapes" to which analog-derived "surfaces" can be applied. At the same time, the analysis of sound design seems to lead in similar directions to the analysis of production design: a gradual shift from the spectacle to the integral illusion, such that the sounds no longer stand out, as the warp factor of the *Starship Enterprise* once did, as elements to be enjoyed for their own sake. Today, audio sweetening, the addition of layers of subtle shading to location and foley sound, is more highly prized, lending itself more assiduously to the creation of coherence.

The synthesis of digital and analog achievable in contemporary cinema is hailed as a marvel of verisimilitude, that realism which Andrew Darley sees as a persistent goal of computer-imaging technologies since the 1960s (Darley 2000: 16–18). But it is also a source of marvel in itself. Digital cinema, in the mode in which it has arrived at the beginning of the third millennium, completes the world-building project of the neobaroque. The project can be read in one particular meaning of the word "virtualization." The spectacle, "the self-portrait of power in the epoch of its totalitarian management of the conditions of existence" (Debord 1977: para. 23), is virtual in the same sense that power is virtual: as Foucault argued throughout his career, it is never complete. The spectacle of total power, therefore, can exist only as a virtual world. As technological artifacts, the spectacular virtual worlds of digital cinema are hermetically sealed against their lack of reality and their disjuncture from it. To this extent they conform to the later Heidegger's (and poststructuralism's) account of the end of metaphysics:

metaphysics is that history at the end of which nothing is left of Being as such, or in which Being is forgotten in favour of being ordered in a system of causes and effects. . . . [T]his total forgetting of Being is the total technical organization of a world in which there is no longer anything "unforeseen" or historically new. . . . The system of total concatenation of causes and effects, prefigured by metaphysics and actualized by technology, is the expression of the will to dominate. (Vattimo 1993: 85–86)

There is a discrepancy between Debord's Hegelian and Vattimo's Heideggerian accounts of total management. The organization of total cinema, as it existed in Eisenstein's time, was profoundly ideological. A rhetorical

cinema, it aimed to persuade its audience of what they already believed, to impassion them with the power of a shared belief in the vital task of saving the homeland once again from the brute enmity of the Germans. In few films are we so privileged to bear witness to the self-portraiture of power as we are in that paean to Stalin and the cult of the personality. Today, however, total cinema has shrunk to the status of an effect. Each film, enclosed within its own sphere, asserts its dominance aside from the "conditions of existence" to which Debord, in the 1960s, was still able to give credence. In a similar historical shift, Vattimo's "will to dominance" results not in the ability to achieve but in the loss of the power to make history, the very purpose of Eisenstein's *Alexander Nevsky*. Yet the real and the making of history remain. Dominance in digital cinema is no longer an ideological project of social manipulation, but an intimate microphysics addressed to the capture and recreation of subjectivity among the dispersed and unhappy mass of consumers.

When critics and Hollywood professionals alike refer to films as bubblegum, we think of an entirely superficial art beneath which there is nothing, an empty, unmoving, and pure spatiality. The one great lie, the one remaining element of false consciousness that links this construction to the older project of ideology is that there is no void. Instead, each closed diegetic world is replete, condensed, full as an egg, solid as a billiard ball. Seizing on the equilibration of flux as surface in classical Hollywood, the neobaroque takes up the circle of total cinema and folds it into a sphere. The digital moves that spatialization onward into the totalization of contained space. The classical practice of holding an open line of sight into a scene into which a new character can enter becomes, in the digital, the structuring of space as a wholly navigable virtual map or virtual architecture, in which no space is empty that is not already filled (with smoke and digital "fog" to create depth and concretize light, and with real and virtual objects and their trajectories) or destined to be filled. Learning the trick of totalization, digital Hollywood has embraced too the unification characteristic of realist film, and assimilated the one to the other to produce a unified totality and a total unity played out as the narrative of predestination, the whole stripped of the geographical powers of the state or the historical powers of society to address the purely cultural domain of the hyperindividual. The pleasure on offer is no longer ideological reassurance but the return to being. In return for

the simple sacrifice of reality, the digital cinema of the new Hollywood offers the assurance of a whole and satisfying if circumscribed existence.

Presenting itself as if it were Peircean firstness, in fact Hollywood today offers its audiences a mirror in which their aspiration toward being is rewarded with the vision of the absolute object, secondness without the possibility of thirdness that can arise only from a socialized system of texts and spectators. Since both the films themselves and the spectators they address are holistic monads, socialization and conflicts of interpretation can be sidestepped in favor of the experience of being here now inside the confines of any one film's microcosmic infinity. When we are no longer invited to enjoy the effect in and for itself, but to marvel at its integration into the "Recreation of Reality" (Burch 1990: 6), we oscillate between that wonder which is the proper, conceptless affect of firstness and the ordered constitution of subjectivity in the experience of the object that is secondness. In its latest form, digital film subordinates the phenomenon to the subject-object nexus of the commodity, so that we stand in awe of the object nature of the object, and surrender to that. It is this movement that constitutes the digital sublime, its pre- or alinguistic nature no guarantee of escape from ideology but rather of a refusal of the social, the only possible ground of ideological work, conflict, interpretation, dialectic, and history.

As Darley argues in his important chapter entitled "Surface play and spaces of consumption," the spectator of digital media "is more a sensualist than a 'reader' or interpreter" (Darley 2000: 169), acting in a transformed mode of play, prizing intensity over intelligence. Raising the critical issue of the relative degrees of audience autonomy and activity, he rightly criticizes the risk run by any generalized and abstracting description: that we might lose "any sense of disparity, diversity, specificity and nuance" (ibid.: 189). The experience of cinematic spectacle is not the only experience. It belongs to external systems of communication that themselves trace parallel histories (e.g., from "Have you seen X?" to "Have you seen X yet?"—the hallmark of the event movie) in a shift from cultural capital to consumer discipline. The transition from the diegesis of the film to the social realm of the multiplex, even the emergence from video or DVD viewing to the familial space of the living room, is not without a certain frisson. The border state too has its significance, especially in the diminution of intensity coupled with a heightened alertness to whatever quirky events might occur

outside the theater. An aura of wholeness persists, fading, as you make your way home. In comparison with the cultural engagement of the classical film, digital Hollywood denegates culture, raising it as the last alternative to society and state only to create it as the moment of its vanishing.

Never a shared experience, and lacking any relation to belief systems, it is instead entirely devoted to communication, with a fervor that appears, in the early years of the twenty-first century, to be a revelation of a state of affairs that has always been the case: that all the human universe is composed of communication. In this special instance, however, the communication spurns the old adage of information theory, that the channel is insignificant. Here the medium is so entire unto itself that the transfer of message is rendered marginal. Films like *Titanic* or *Black Hawk Down* may seek to persuade us that love is good and war is bad, but such sentiments—and they are strictly sentimental—are no more essential to the attraction of the films than their residual narratives. The obligation to consume communication (rather than to communicate) supersedes citizenship, even economic exchange, as pure being. The commodity form seems almost to escape its bonds of exchange value, as earlier it escaped those of use, and finds itself on the brink of leaving behind the symbolic or sign-value ascribed to it by Baudrillard (1980). Digital film proposes a mode of communication in which the central purpose is to create subjects for the object of communication, subjects that exist only to be subsumed into the object, and thus to achieve a plentitude in which no further communication is desired or necessary.

The only thing essential to it that the digital retains from narrative is closure. Benjamin (1969) distinguishes between the traditional storyteller and the modern novelist. In tales, death is ubiquitous and reversible, but the novelist needs to write "The End." Doing so introduces the irreversible form of death: individual mortality. In death, the protagonist is an individual whose memories accumulate to give her or his life form and meaning. The hero of the tale, on the contrary, is typical, and the telling reengages with the rhythms of a time that repeats and extends itself, in retellings and in other tales. In the tale, time is a raw material; in the novel, it is a sword of Damocles. In his commentary on the essay, Scott Lash suggests that because "Only in a state of transcendental homelessness can time—in the sense of death as finality—become constitutive of the meaning of life. . . . [T]he reader must read the novel in terms of the already known death of the protagonist" (Lash 1999: 150). Rather than bed the hearer into the web of tales,

modern communication "fragments into the individual narratives, which now are limited to the individual's subjective cultural space and to one generation of time" (ibid.: 153). The continued acceleration of modernity intensifies this movement to the point at which the individual is knitted only into a single event, the event movie whose communication is so intense it is over in ninety minutes. Death no longer underwrites, as it did for Heidegger, the future-oriented process of becoming, so enabling the novelist's art. Instead, death itself becomes a model for communication: sifting life's accidents into the substantial form of its pattern. As integral spectacle, communication addresses only the present instant, doomed by its dependence on the cutting-edge to radical obsolescence. Time is tied to the cycles of consumption, rather than the fatal moment of mortality. When the digital addresses death at all, other than to fantasize an afterlife, it turns nostalgic, as if mourning a moment when it was still possible to die.

Or indeed, as if mourning a moment when it was still possible to exist as that vaunted pinnacle of capitalist culture, the individual. As Debord noted, returning to his earlier theses to define the concept of integrated spectacle, the absolute knowledge achieved in databases, the absolute logic achieved in computer programming, and the absolute secrecy of the military-industrial complex converge in "the erasure of the personality" that "is the fatal accompaniment to an existence which is concretely submissive to the spectacle's rules, ever more removed from the possibility of authentic experience and thus from the discovery of individual preferences" (Debord 1990: 32). Today, we must doubt even the assumption of a lost authenticity: the authentic itself has become a special effect, a connotation of a specific type of brushstroke in painting, a specific vocal style in music, of handheld cameras in Dogme movies. Experience has always been mediated, but never before to the point at which it can appear to result in the loss of tactility (Dixon 1998: 36) and even of the unconscious (Creed 2000). The closure of communication has been achieved in a surface that draws a veil of illusory emptiness over an impenetrable fullness constituted by the integration of subjectivity into the pure objectality of the medium in itself. That would-be final contradiction, although it may yet become the springboard for a further development of Hollywood's monadology, wants desperately to look like the last glimmer of conflict—this latest, almost compulsive lie from a system that no longer acknowledges truth might, all the same, be enough to permit another mode of cinema to emerge.

The digital child of the neobaroque is, in any case, not only utterly different from the other media, even those produced by the same corporate behemoths: it is not even the only mode of contemporary cinema, nor is it the norm against which we must judge the cinemas of the rest of the world. For all its armored solipsism, the digital pretends that because it is unified it is unique, and because it is enclosed in its own sphere, there are no far horizons. There are, and they are plural.

ONEIRIC FILM

Fantasies of Eco-Catastrophe

Sing out the song, sing to the end, and sing
The strange reward of all that discipline.

—*William Butler Yeats[1]*

The Gates of Eden

There are Irish, Scottish, and Welsh nationalists, Basque nationalists, Breton and Corsican nationalists—and German, British, and French Greens. The more liberal populations of the old European imperial powers are chary after a century of racism and genocide. Yet love of the land, the geographical claim of identity, faith in a natural source of the sense of self still appeal deeply as political and ethical grounds of action. It is on this basis that conservation allies itself with conservatism, producing those unusual alliances between mud-caked New Age travelers and labrador-walking landowners that have accompanied protests against the expansion of motorways and airports across Northern Europe. In some European science fiction, especially French, the theme of home and nature lost under the burden of transnational capital has become a sort of allegory of the struggle to restore real estate to the state of reality.

The best of these films, those signed by Jeunet and Caro and by Luc Besson, imagine futures of appalling anonymity, postglobal cities plummeting into decay, bereft of hinterland. Where Jeunet and Caro are relentless in their pursuit of the logic of a decaying ecosphere, Besson has reached into another tradition to evoke the possibility of salvation for both humanity and the environment. That tradition, while it promises to reach back and return to new generations an ancient legacy, is in fact a modern invention with

roots in Blavatsky's theosophy and Steiner's anthroposophy at the beginning of the twentieth century. It is best known to us today as the philosophy of the New Age.

For the most part, those who do not share the neomysticism of New Age beliefs look down on it as gently quaint and morally neutral eccentricity. But, as even the entertainment industry, in the shape of Spielberg's *Indiana Jones and the Holy Grail* reminds us, such mysticism has a darker history among the European powers. Wulfram Sievers, the high-ranking Nazi officer whose task was to explore the bogus archeology of the Aryans, was sent by the ideological arm of the SS to seek out the ancient roots of the Teutonic culture in the Holy Grail and the lost island of Atlantis. Part of a more than usually pseudo-science of archeology and anthropology, the Nazi quest for a race-historical construction of the past still quivers in the undergrowth of European New Age mysticism. Simon Schama's (1995) essays on the ideology of the forest in Poland, Germany, and England likewise recall the pseudo-histories that have allowed us to construct the wilderness as the image of a folk soul. The heritage claimed by conservationists, by national parks, by Green parties, by advertisers positioning wholemeal and organic produce, even by the wave of caring management consultants that arrived in the late 1980s (see Ross 1991, especially chapter 1) is all too frequently based on a whitening of history. Proximity to the land and racial purity are all too common bedfellows. The production of national identity depends on a refusal to accept that nature is indeed a social construct, not a historical given. The myth of a feudal peasantry living in some idyllic communion with their environments, upheld in national legends from Robin Hood to the Serbian oral epic tradition, produces the requisite authenticity, homogeneity, and natural status on which the ideology of nationalism can operate without recourse to imperial histories. This is why it is so insidious, not just at flashpoints like the Balkans but in the urban civilizations of the great metropolitan powers.

The truism powering *Delicatessen* is, despite appearances, the same neomystical thesis underlying Besson's *Fifth Element, Subway,* and *The Last Battle:* that the environment is the mirror of the soul. Whether the corrupted environment of the city destroys the natural health of the body, or moral corruption breeds the degradations of urban decay, the theme governing Jeunet and Caro's and Besson's films is that which structures Eliot's *The Wasteland* of 1922, a structure he derives from the earlier comparative religious stud-

ies of J. G. Frazer (1911–1915) and Jesse L. Weston (1920), centrally the myth of the Fisher King. In its basic form, the Grail knight comes upon a land laid waste, whose king is wounded and in some variants castrated. The healing of the land and of its ruler are the same quest, resolvable in a single act of courage, purity, and moral probity. Jeunet and Caro's portrait of corruption, plainly allegorical of a general state of social ill-health in the present, shares the Fisher King's association of private and public wound. The ideological unity of moral purity and hearty land is an ancient and powerful European myth against which the scenarios of degradation and depravity, human and ecological, can be played out as fantastic narratives. Echoes of it still remain in the immigration policies of eximperial colonies, in the stigma attached to tuberculosis and other diseases associated with squalor. It powers a certain aspect of European Green consciousness, and in particular the apocalyptic vision of ecological collapse. Where the approximation of a life lived in accord with "nature" is promoted as a good in its own right, it is fairly innocuous. Where it empowers the righteous totalitarian response to what is promoted as an emergency, it is a dangerous political myth. Fantasmatically projected onto an anonymous future, Jeunet and Carot's derelict world appears only as a further stage on a downward spiral already begun in the late twentieth century. A wasteland without a Grail knight, *Delicatessen* (fig. 11.1) sets its protagonists the modest goal of survival, at the risk of a fatalistic quietism in the face of enormity.

In the version of Lovelock's (1979) Gaia hypothesis adopted by Jeunet and Caro, the alien is Man, who has exiled himself from the Edenic innocence of a life attuned to nature. Innocently, nature will attack the denatured and vacuous culture of humanity, as an immune system would attack a viral culture. This cleansing work is the task of *natura naturans*, nature going about its own work unobserved by science and unbounded by the laws science reads into it. But where Kant saw *natura naturans* opposed by *natura naturata*, nature turned into an object of knowledge and named to distinguish it from the human, this variant on the Gaia hypothesis reads the opponent as *natura denaturata*, the denatured humanity that, by seizing on technology for its salvation, has abandoned its link with nature and assaulted her in the bargain. Not only does this understanding pitch humanity as man against Mother Nature as woman, an important gendering that will structure the film's narrative resolution; it is a central theme of the loss of childhood and motherhood. The lost ability to dream, the disembodied brain, the

| Figure 11.1 |

Delicatessen: concluding rooftop harmonies for the imaginary family under a permanently poisoned sky.
Courtesy BFI Stills, Posters, and Designs.

gormless unmothered clones of *The City of Lost Children* (fig. 11.2) are all aspects of technology as denaturing. If nature is to be recovered it will be through the restoration of paternity, traced in that film in One's relation to the little girl, his protégé. In *Delicatessen*, a similarly important role is played out in the relation between the clown Louison and the two young boys whose antics enliven the film's action and add depth to its conclusion.

In the best-known sequence in *Delicatessen*, the unexpected harmony of music, sex, and work in the different rooms of the lodging house become a unified whole. But its claim to a utopian humanity against the backdrop of the inhuman, its alienation under conditions of ecocollapse, curtail it as an isolated instant. Indeed, technology and the capitalist war of each against all envisioned as the dependent and determined upshot of overtechnologization, are portrayed as the spiritual as well as environmental pollutants that exacerbate the cannibalistic antagonism of contemporary society. The naïveté of our hero is comic and touching because he alone fails to fathom the depths of the depravity that surrounds him. Technology appears as a

| Figure 11.2 |

The City of Lost Children: One and Miette: personal loyalty transcends the vileness of a corrupted world.
Courtesy BFI Stills, Posters, and Designs.

false nature, an antinature usurping both ecological and human nature as they should exist—unalienated. That innocence is what makes the construction of an alien humanity so distinctive a quality of the film. The satire of *Delicatessen* depends on an intuition of what a whole nature would be like. This ideological presumption of a shared memory of wholeness, essential for the film to work as narrative and for it to meet its audience, is itself a construct, and a dangerous one.

The danger is, in a curious way, particular to representational media when, as in Jeunet and Caro's film, they address us in the double mode of depiction and spectacle. On the one hand, we delight in the capabilities of the cinematic apparatus; on the other, we try to peer through it toward the pleasures of an impossibly pure depiction of an utterly unmanipulated reality, forgetting what we have always known about the factitious nature of the mise-en-scène. At a more ontological level, our knowing alertness to the postproduction manipulations of compositing and computer-generated imaging promotes a willing mistake of the world-for-itself, *natura naturans,* for

the world as it presents itself to the camera. Because we feel we can distinguish between the spectacular cinema of effects and the documentary realism of the older cinematography, we have a greater faith in unmediated recording than before the advent of photorealistic illusion. Perversely, then, the more our films call to us with their displays of postcinematic technique—in the sense both of film after photomechanical recording and of film subjected to postproduction effects added after the moment of performance to camera—the more we hanker for an unmediated relation to the world. That yearning for the unmediated becomes the narrative goal of this ecoapocalyptic cinema.

A recent series of North American films suggests that the theme is not unique to Europe, though the directors of two comparable titles, *Dark City* and *The Thirteenth Floor*, are Greek-Australian and German, respectively. The real for which the protagonists of these films hanker is that icon of ecological harmony, the seashore, where land and water, finite and infinite, meet as equals on a shifting border, and where the idyll of a renaturalized humanity can be lived out, washed by the purifying waters of the ocean. At that dreamed-of shoreline, the human confronts the limitless mercy of nature. Far more important, he forgives himself his own past crimes. The idealized experience of nature is embodied in this unmediated meeting of the man and the waves. Typically, the most highly mediated narratives are those that tend to resolve themselves in the idealization of the unmediated. Even were unmediated perception a possibility, yet this construction of it would be deeply flawed, because we meet it not as actuality but as depiction.

In the fantasy of a healed and reunified human nature, for whom the natural environment is posited as an absolute good and enjoyment of it as both moral right and ethical obligation, what relation is being constructed between human and nature? The figure of the littoral man is specifically a narrative image, and even more specifically a concluding image. As such it is not a resolution but the image of a resolution. There is something of a truism in film studies that the final scene defines the meaning of a film: we might call it the Rosebud thesis. But just as the ambiguous sled in *Citizen Kane* tells us a great deal less about the film than almost any preceding scene, so the littoral man at the terminal beach tells us little about the pleasures and conflicts the preceding ninety minutes have offered and enacted. The meaning of a film rarely resides in its conclusion.

Dr. Johnson observed of Shakespeare that "When he found himself near the end of his work, and in view of his reward, he shortened the labour to snatch the profit" (Johnson 1969: 66). Much the same is true of the commercial cinema. What makes moving pictures move, as both affective and narrative devices, is conflict. Resolution of conflict may be commercially necessary, ideologically desirable, and rhetorically acceptable as a way of stopping that movement, but it is rarely the privileged moment that reveals the film's motivations. The felt antagonism between culture and nature, the built and natural environments, biological and technological processes, is not "resolved" in the figure of a man standing on a pier. Like the pseudo-psychotherapeutic fetishization of "closure," the image of the littoral man is entirely irresponsible sentimentality, like those images of starving children we have no intention of ever meeting and the obligatory wildlife documentary lament for fragile environments we have no intention of protecting. The terminal beach and the littoral man are sentimental because they invite us to enjoy their unmediated harmony as spectacle. Their spectacular harmony is the overdetermined resolution of a dialectic that we are nonetheless aware is far from resolved, and which is indeed dialecticized once more in the spectacular mediation of immediacy.

To their credit, Jeunet and Caro avoid that sentimentalism. And yet, as Fredric Jameson argues of the transition from modern parody to postmodern pastiche, the parodic relies on a shared system of values that, under the conditions of postmodernity, can no longer be assumed (Jameson 1991: 16–19). In the culture of the late twentieth century, one of the few values the film industry can appeal to is the equation of nature with the good. The rise of Green politics, indeed, disproves Lyotard's (1984) thesis that our epoch is characterized by the demise of master narratives: the Gaia hypothesis and similar apocalyptic ecological scenarios have become the most widespread basis for political action since the self-destruction of communism in 1956. The equation of the natural with the good, or at the least the unavoidable, strikes us, children of Darwin, Freud, and Keynes, as self-evident.

Nor is it adequate to argue that in some fashion the movie business misrepresents the truth of ecopolitics. There are no truthful representations. To be depicted, the world must be other than both the medium in which it is depicted and the agent—human or technological—that does the depicting. This is the burden of Kant's distinction: *natura naturans*, nature naturing, is

not the same as *natura naturata*, nature as the content of regimes of knowledge, morality, and use. Nature is always othered in that single action of representing. Jeunet and Caro pursue a fascinating course in showing us denatured nature, but since the film functions primarily as spectacle, that denaturing serves only to reinforce the ideological faith in a truly natural nature that exists as the object of scientific or artistic contemplation. Nature is good only so long as it is other. Its moral status depends on its difference from the contemplating lens or eye. The very act of taking responsibility for nature, in the terms demanded by those wildlife documentaries, turns nature into an object over against the human subject.

The truth of good nature as it is depicted in cinema, mediated as spectacle, is as truthful, only and precisely, as the montage of wilderness views accorded to the dying Edward G. Robinson at the close of *Soylent Green:* a painted paradise, an illusion within an illusion. On our behalf, Robinson witnesses a crucial turn of the dialectic: that nature has become spectacular for us. We stand, as human, by definition outside and against nature, which exists for us, today, only as object. The spectacle is itself an effect of the commodity form in consumer capitalism, so all-embracing that we have become accustomed to the policy statements implying that the purpose of factories is not to manufacture goods but to produce jobs—jobs having themselves become empty signifiers rather than productive engagements in the world. That nature against which our species fought so hard for so long is now so profoundly conquered that we permit ourselves the tourist pleasure of visiting our vanquished enemy in her chains, as we set off to excolonial possessions in search of an impossible authenticity. If, as Green political thought has it, nature became object in the industrial revolution, in the consumer revolution it has become spectacle. But, as Slack has it, "the pristine is not an unambiguous resource" (1998: 87). Belief in an unalienated nature is an aspect of the spectacularization of nature, and faith in an unmediated perception of it is nostalgia for a state of affairs that never existed. In the end, that nostalgic tone is what deprives *Delicatessen* of a politics, even as it provides it with an ethics.

The relation to nature as spectacle arises not as a quality of the world but initially as a problematic relation to the self. By posing the world as (spectacular) object, the self posits itself as subject of this spectacle. Specifically, in replacing the interactive relation with others by the relation with the world as object, subjectivity becomes, in that mirror, a troubled image

of the entirely void and the entirely self-sufficient, which are the conflicted characteristics of the spectacle. Unlike the closure afforded by the submission of self to world in digital film, this relation to the self is an unhappy and unstable one. Unhappy because it is deprived of any relation but that of difference by means of its self-sufficiency, while by reason of its emptiness even that difference is rendered indifferent and so meaningless. This unhappy consciousness is apparent most of all in Julie, the cello-playing daughter of the butcher, whose very existence depends on the central operator of the cannibalistic system, whom she despises, refuses to forgive, attempts to kill, and yet whose gifts have allowed her to survive thus far, at the cost of a lack of self-esteem and, in her near-blindness, a cinematic mode of self-ignorance.[2]

This unhappy self is unstable. On the one hand it seeks integration into a whole—the integrated spectacle—which, however, reveals itself to be wholly surface. On the other, because it is a product of the objectification of the world, the self is simultaneously master and slave, dependent on and responsible for the world. This binary of freedom and necessity can be resolved only dialectically, by our overcoming the difference between self and world, but to do so we must sacrifice self and world, so risking once again the undifferentiated indifference of the commodity spectacle. The option of tragic failure is enacted by the character of Aurore, who believes her suicide is dictated by internal voices, and although her admirer's brother confesses to being their actual source, she clings to her delusion and to her suicidal destiny rather than believe in the power of an external other over her internal freedom, however self-destructive.

Habermas's axiom—"the self-relation arises out of an *interactive* context" (1992: 24)—makes strange this now normative yet unhappy and unstable relation of self to self and self to world. Habermas restricts interactivity to human agents engaged in rational discourse, but communication cannot be restricted to rationality: it embraces communication with the natural environment. The sentimental relation with the environment merely regrets its degradation, and the imperial asks us to assume sole responsibility. But where the natural world addresses us as an agent in dialogue, this responsibility is neither personal nor exclusively human. It belongs instead to a polity that includes the environment as protagonist and citizen. The intertwining of community and environment in *Delicatessen* reads this interactive and autopoetic conception less as sympathetic magic and more as a dialogue, or at least a feedback loop. The principle is the old slogan, you are

what you eat, given the anthropophagy that forms standard diet in the apartment block.

Delicatessen has great difficulty realizing this dialogic conception of the ecological relation. But it does introduce us powerfully to a third partner, alongside nature and human society, that engages in the constitutive dialogue of ecological subjectivity: technology. The kind of humanism that excludes machines from dialogue with humans and environment is in hock to nostalgia for immediacy. Only a recognition of the technological mediation of this and any dialogue—from architecture to cinema, food to speech, clothing to music—centers mediation in the technical relation between environment and consciousness and allows for the possibility that the world perceives, understands, and thinks us. Understood as an active partner in the dialogue, technological mediation constitutes that difference between self and world through which alone dialogue becomes possible.

Ecological realism demands such a relation of dialogue over and above depiction, which too often has been associated, as in the cartographic (Harley 1989, 1990) and orientalist traditions (see Tawadros 1988), with mastery. Clearly *Delicatessen* is anything but a realist film in Bazinian terms. Yet in certain ways, and especially in its confusing of mise-en-scène and postcinematic, postproduction effects, the film foregrounds the mediating functions of cinema as technology. Praiseworthy as this foregrounding is, the substitution of technological spectacle for environmental dialogue sets the stage for the film's ecopolitical failure while offering a model of what a successful ecoethical film might look like.

Muddle

Caught up in a Catholic phenomenological movement informed by Sartrean existentialism and colored by the critical theory of technology developed by the great Jesuit philosopher Pierre Teilhard de Chardin, Bazin permitted himself a belief in the world as objectively an object since it was created and known by a God to whom, as its creator, it was already primordially other. Without the alibi of a divine gaze in which the truth of nature might be thought of as separate from humanity, contemporary secular media have to understand nature as alien to audiences, and audiences as alien to it.

This understanding is no longer, however, a matter of divine ukase issued at the doors of Eden as they clang shut. Rather it is a materially and historically specific condition subject to all the usual social laws, and, as *Del-*

icatessen adumbrates, evolution itself is technologically mediated. Technology as it exists in this film is no one-way relation in which human will is imposed on a passive and objectified environment. Instead it figures the reciprocal imposition of natural laws on the extension and complication of human faculties. The cinematic technologies that *Delicatessen* embraces are not barriers placed between (subjective) perception and (objective) world but active participants in the mutual construction of both. By placing the technological relation center stage between subject and object, the emphatically technological aesthetic of *Delicatessen* throws the relation into conflict again. Neither Eisensteinian humanism nor Bazinian realism had been able to get beyond the binary opposition of perceiving subject and perceived object: *Delicatessen* learns from both how to render that opposition dialectical again.

The film faces its greatest crisis in its need for a harmonious resolution to the conflict. There is a deeply ingrained historical aesthetic sense that guides filmmakers toward a satisfying ending. The feudal narrative's conclusion arrives as *sententia;* as already noted, Shakespeare huddled his endings; by the time of Jane Austen and even more so of the great nineteenth-century novelists and dramatists, the ending has become a stylistic tour de force, the endgame in which not only are loose ends gathered up and sententiae enounced but all ideological conflicts brought to resolution with the finality of a Brahms symphony. It is a gestalt that urges us to reconsider apparent motives, to understand hidden causes, to unravel overlooked clues and to revise the opinions voiced by characters. If there is a certain brutality to this totalitarian gearing of narration to its conclusion, it is nonetheless conducted in the awareness that conflicts exist, and that out of conflict something new can be born.

The near-comic tidiness of database narratives' conclusions does away with that possibility. The ending spatializes the fiction and distinguishes it from any externality to secure the triumph of identification with the diegesis. Despite the apparent similarities, *Delicatessen* takes a subtly different route. The loose stair, for example, has the idiosyncracy of a Jacques Tati gag until its reappearance in the unfolding plot resituates it so thoroughly that it becomes a motif serving the intense formality of the ending. The bizarre auditory properties of the plumbing, conductor and originator of sounds, have similar multiple functions concentrated in the elaborate perepeteia. So perfectly is the ending orchestrated as necessary outcome of the film's logic as to place its resolution inside inverted commas, encompassing it

in irony, and so mocking both the enormity of the characters' situation and the audience's engagement with them. It is a strategy of impotence.

Delicatessen sets itself small goals. Amelioration of the immediate problem—will Louison escape anthropophagy?—and personal salvation—can Aurore deliver herself from her demons?—are the lonely goals of the narrative conclusion to a film that gives away neither the causes of nor the solutions to its mise-en-scène of ecological disaster. Its proposition is that happiness is possible only in small things and among small people. A certain humanism guides this ending, Julie's cello and Louison's singing saw harmonizing on the roof where surrogate children play. Like the children of Tati's *Mon Oncle*, these relieve the adults of the necessity for sex, and the children themselves of the guilt of generation. Meanwhile, the earlier montage of work, love, and music as a single harmony endows this concluding scene with the symbolic value of an ideally innocent family. This closing shot, with its appeal to the romantic trope of the rooftops of Paris, sums up and redirects the film's echoes of Popular Front films like Carné's *Le jour se lève*, Pagnol's *Marius* (evoked not least by the Provençal accent of one of the cast) and Renoir's *Le crime de M. Lange*, with their evocations of apartment-building community and the camaraderie of the courtyard. But where those films had explicit political programs, Jeunet and Caro derive from them only the chiaroscuro stylistics and the nostalgic sense of predestination characteristic of 1930s French poetic realism (see Andrew 1995). These derivations sentimentalize community. We cannot therefore look to the ending for a summation of the ecopolitics of the film. Instead, the ending strips the scenario of both ecology and politics. And although we can surely enjoy being beguiled by the disillusionment with politics, the abandonment of the diegetic world in favor of the protagonists that inhabit it cannot resolve the initial conditions that the film sets up. Classically modernist in its romantic individualism but clothed in postmodern irony, the final scene fails to resolve the central theme: survival.

Worst of all, the final scene mocks honorable resistance as futile, slapstick muddling-through. Like Mr. Tuttle the heating engineer in Terry Gilliam's *Brazil*, the Troglodyte underground of *Delicatessen* are clumsy dimwits, creatures of a world they know enough to hate but which they have no means to revolutionize. The motor of the narrative, then, is not contradiction but self-contradiction, and its conclusion is only the vindication of the self as the site of a mitigated, circumscribed, temporary, but finally invalu-

able happiness. On the other hand, the story, cunningly plotted as it is, is not the central charm of the film. What fascinates is less plot or diegesis than the self-conscious mediation and spectacularization of the mundane. Achieved through compositions emphasizing mechanical vision—the camera situated where no human eye could fit—and the use of graphical and sound matches, the estrangement of the present, one of science fiction's honored goals, is here achieved through a double activity of situating the everyday under that aspect that links it to the recent past (the quartier, the apartment, the local shop) and projecting it into the near future. Notable by their absence are multinational corporate logos, symptomatic of the characters' abandonment by their world. In place of transnational capital, we are presented with a local politics of *patrons* and tenants against which the humanist anarchism of the film's conclusion is a suitable if unconvincing raspberry.

Sentimental in its narration, nostalgic in its mise-en-scène, the film's greatest strength is in its mischief. The two small boys with their home-brewed technologies for making mayhem and their capacity for amazement: are these the signatures of the film's two directors? Reveling in the technological, the boys and the directors can revision community under the guise of retroengineered objects like the talismanic singing saw. Throughout the film, technologies, especially ad hoc technologies like the painting machine formed from braces, embody the emotional and social relations between characters, while the shopworn psychologism of an older Hollywood and a still contemporary art-house cinema is shuffled to one side, a matter of tokens, like the sensuality of the butcher's mistress or the *poujadisme* of the postman. The drama eschews conflicts within individuals to embrace conflicts within a community, and especially conflicts enacted through such emblematic technologies as the butcher's knife, his mistress's bloomers and his daughter's eyeglasses. The drama arises from these thoroughly mediated interactions, not from the subjectivities of the protagonists, nor, therefore, from the problematic of the self. Where ethics concerns the primacy of relationships, this is an ethical film.

Yet since that ethics does not embrace the natural environment, we are left in a quandary. The clown Louison gives us a model antithesis to the butcher. He is a vegetarian whose deepest relationship has been with an animal, his chimpanzee partner Livingstone. Yet his triumph lies in his adjustment to heterosexual and, more specifically, human romance. And meanwhile, although the sky has been tinted a pale shade of orange (the promised

Age of Virgo), the impossibility of anything ever growing back, first announced by the butcher in dialogue with the taxi driver, is never contradicted. Nature is externalized from the new community, and what hope there may be is only that based in the oldest of all predestinarian technologies, the zodiac. But though it is a vast celestial clockwork, our relation to astrology is always anchored in the random moment of birth. This play of necessity and chance is key to the role of special effects in contemporary media formations.

The Gender of Chance

In contrast to the North American cinema of submission, the European and especially the French cinema embraces its unhappy consciousness. There is here an echo of the other side of predestination, casino capitalism and the cult of luck, tied to the emergence of a global economy so vast as to operate beyond the capabilities of individuals to imagine its operations, let alone influence them. The Comaroffs describe these new belief systems and the service economy model of religious belief that they spawn as "occult economies" (Comaroff and Comaroff 2000: 310), noting that "To the degree that millennial capitalism fuses the modern and the postmodern, hope and hopelessness, utility and futility, the world created in its image presents itself as a mass of contradictions: as a world, simultaneously, of possibility and impossibility" (ibid.: 315). Chance and necessity, randomness and destiny, are the obverse of one another, another binary disguising the stasis of a global system with no desire to evolve, no hope for a future. *Delicatessen* plants itself with almost ludicrous faith in the field of the probabilistic, while *The Matrix* dwells in the shadow of necessity, but both inhabit the same universe in which what appears necessary from one aspect appears random from another. So in *The Fifth Element*, the monastic cult is empowered, with the active encouragement of the audience, to play with unknown forces of nature to restore planetary health, and Korben Dallas (Bruce Willis), as Grail Knight, to restore wholeness through the healing power of virtue. By complete chance, Dallas comes to achieve his necessary destiny.

The term "fate" describes the quite comprehensible way in which life's circumstances circumscribe our choices. Fate concerns how we got here: it describes the presence of the past. Destiny, on the other hand, concerns the future. "Taking one's fate for destiny," Bauman notes, "is a grave mistake," the error of fatalism, in which the persistence of the past that defines the

present is extended into the indefinite future. "Taking distance, taking time—in order to separate destiny and fate, to emancipate destiny from fate, to make destiny free to confront fate and challenge it" is the task of sociology (Bauman 2000: 210). Bauman's freedom is the ethical obligation to maintain the possibility of an open future. Erasing the distinction between fate and destiny amounts to an acceptance of the present and its determinations as the sole dynamic forces operating on the future, so foreclosing the possibility of difference. The aesthetic is the alternative: the possibility of evolving, of becoming otherwise than the present, and more especially otherwise than the past. As André Breton put it, writing of "the time when the surrealists were right," "it cannot be a question under a capitalist régime of defending and maintaining culture. Culture only interests [the surrealists] in its becoming" (Breton 1972: 98).

Bazin is not alone in believing that the shock of the train entering the station is the birthplace of a cinema of dreams, an oneiric cinema whose characteristic technique he identified in the 1940s as superimposition (Bazin 2002). The theme underpins the theoretical writings of Eisenstein and his early if not his later films. The dialectical montage of the early Russian cinema is worked out in one direction by the Stalinist total cinema, in another by the trajectories of the surrealist cut, in layers within the image and in transitions from shot to shot. Bazin's interest in superimposition as a technical evocation of the supernatural is a tacit recognition of the claims of surrealist montage: that the surrealist object is capable of disconnecting the dreamwork from the artifices of repression and socialization. Like the passages from present to past in Bergman's *Wild Strawberries* (Mazars 1965: 180), surrealist collage and montage allows multiple pasts, some of them suppressed or imagined, to cohabit with and pluralize the cinematic present. Such use of the cut does not synthesize wholes. It manufactures a wild profusion of surplus metaphors and so undercuts the metaphorical underpinnings of social and personal cohesion.

The "permanent revelation" of surrealism always risked descent into kitsch. Today it has been split between elitist vanguardism in the international art market and banal expropriation in various drug cultures and advertising campaigns barely distinguishable, eighty years on, from postmodern pastiche. Yet there is all the more an onus on film studies to account for the pleasures of the fantastic and the surreal, if they are, as they seem to have become, intrinsic to contemporary media formations. In a prefiguring of Bauman's

distinction between fate and destiny, Lukacs makes a kind of peace with sur-realism when he writes that "the fantastic is not the opposite to living, it is another aspect of life: life without presence, without fate, without causality, without motivation" (cited in Elsaesser 1987: 21). Film is a fantastic medium to the extent that it accepts the materiality of the profilmic without forming it. A kind of automatic empiricism governs its associations of objects, just as the technology of the lens combines and severs foreground and background according to machinic logics that traverse and transgress socially conformed regimes of vision. As pure surface, the succession of images is purely additive. Causality is elsewhere, and with it the structuring force of psychological or social motivation that might determine action. Things merely occur. Surre-alist cinema emphasizes this aspect of the film, against the current of psy-chological realism and continuity cutting that seek to return these random collocations to order, meaning, presence, and destiny.

This objectivity, this disciplined work of cinema defines its difference from the surrealism of Bataille and his circle, from Artaud, for example, for whom "the cinema is made primarily to express matters of thought, the in-terior consciousness, not by the play of images but by something more imponderable which restores them to us in their direct material, without interpositions, without representations" (Artaud 1978: 50). Such, for ex-ample, is Dalí's kitsch collaboration with Hitchcock on the dream sequence in *Spellbound*. A depiction of a psychological state ascribed to a fictional character who, by definition, cannot have an interior life, the sequence en-tertains to the extent that Dalí's pastiche of nineteenth-century beaux arts is amusing, but is otherwise a simple case of false witness in the service of in-dividualism and destiny. Dalí's dream, like Artaud's "matters of thought," is the evidence that will resolve the conflict between self and society. In the surrealist cinema, on the contrary, that conflict is not only irresolvable but uninteresting. The sense of self is only an intersection of multiple, overlap-ping pasts. The machinery that produces it as unstable and temporary is what interests oneiric film.

The function of the surrealist object is not to express but to serve as a machine for producing automatic events, emotional states and states of the world beyond human authorship. Not only does it not offer to express a character's psychology: it cannot express an author's inner being. Its task is not exploration, still less explanation, of psychology but the construction of apparatuses in which the dependency of the world on the psyche and the

mutual interdependence of the psyche on the world are enacted in ways that inveigle an audience into revery, uncertainty, exploration. The surrealist imagination is not a function of the mind but a relationship between bodies. The artist is merely the first interpreter of the images produced by the automatism of cinematography—the one who, for example, gives them a title. Cinema is a surrealist object in the sense that it stands outside authorship, a device for manufacturing rather than securing images, for producing rather than expressing psychic states. Where psychologism prefers depth, surrealist cinema loves the disjuncture between layers. In this sense the work of Jeunet and Caro is exemplary: "This well-oiled machine lacks nerve and demonstrates not the least emotion" (Prédal 1996: 668); "With undeniable efficiency [Jeunet and Caro] recycle human figurines borrowed from poetic realism and penny dreadfuls, artificially animated in a series of clumsy skits based on winks, gadgets and bogusness at no risk to anyone" (Frodon 1995: 802).

Bogusness (*mauvais esprit*) is just that unhappy consciousness whose unhappiness the neobaroque has sought to heal. The fantastic in cinema can choose to heal, or to fetishize the binary, as happens in the horror genre. But it has also the option of embracing unhappiness, not to render it fatal in Bauman's or Lukacs's sense, but to insist that only in that unhappiness is it possible to recognize the lack of fit between consciousness and world. When for example we confront moments of *Delicatessen* with feelings of disgust, there is no ecstatic plunge into abjection and the vile, but what is more fitting for action, an awareness of the banality of dirt, the casual nature of ordinary violence. Offering neither the purified enjoyment of the sublime nor the reified psychology of individualism, the film engineers a machine for the production of unhappiness. The symphony of the ceiling-painting braces, bedsprings, novelty toys, and cello practice is the cinematic equivalent of Duchamp's great bachelor machine, the *Large Glass*, with its endless and absurd productivity of something that never quite achieves the status of meaning. Outside some films signed by David Lynch, few films in North America attempt anything comparable, and when they do, they come swathed in psychobabble that disarms their radical possibilities. Even then, the menacing invisibles that thrum in the soundtracks distinguish Lynch's more expressionistic psychologism from the surrealistic apparatus of *Delicatessen* and *The City of Lost Children*.

Nonetheless, there is no easy escape from the brute fact of individuality. As Susan Hayward points out, in the postnarrative, postphotographic, postbiological world of *The Fifth Element*, despite the fact that Leeloo, the supreme being, is a woman, it is men who must solve the enigmas and bring about the dénouement, which Hayward sees as a standard Oedipal one. Xavière Gauthier, among others, deploys the Lacanian reworking of psychoanalysis to claim that surrealism is powered by the disavowal of reality characteristic of all perverts, where perversion is always a refusal to accept the Oedipal ban on those careless pleasures a baby enjoys in the presence of his mother (Gauthier 1971: 356). For psychoanalysis, the founding law of socialization is that which establishes sexual difference: the bachelor machine of the cinema is potentially just such a fetishistic construct of disavowal. For the (male) surrealists, this posed no problem: transgression of sexual boundaries constituted a necessary and obvious concomitant of revolutionary automatism. In Rosalind Krauss's reading (Krauss 1993: 315–316), the bachelor machine is less the organization of onanism than the precursor to Deleuze and Guattari's body without organs, the paranoid selfless body of the infant surrounded by machinic part-objects, stripped of or prior to the meanings and purposes that come from insertion into the social and environmental systems of desiring machines. The body without organs, though invested with polymorphous eroticism, is prior to and beyond the claims of gender. The concept of fantasy, however, allows for both strongly and weakly gendered, bachelor machine and body without organs to obtain simultaneously. Fantastic cinema works at the level of a gendered world, but to promote the fantastic possibility of multiple sexualities, cross-gendered or better yet nongendered bodies.

To the fantastic coexistence of incompossible temporalities and sexualities can be added the coexistence of incoherent spaces. The shock of the new, the never completed leap between tradition and modernity, is a global event. It is no surprise, then, that "surreal" clashes of imagery should form so central a device in the cinema worldwide. Mystery, grotesque, eroticism, satire, ugliness, and dignity combine in rich, distracting disorientations of realism in the cinemas of Mendieta, Angelopoulos, Patwardhan, Kurostami, and a hundred others. The clashes of old and new cultures appear in the comedy of objects, and attitudes become bizarre by persisting out of their own time: precocious arrivals of futurity, savage returns of tradition, blank incomprehensions of the present. The gods, indeed, must be crazy. What

today, and to the cosmopolitan film critic, must appear as global casino capitalism is constantly experienced locally as the random irruption of the alien, while to the metropolitan intellectuals of Lagos, São Paolo, Mumbai, Montreal, Liverpool, or Osaka, the iterations of rituals deprived of the media formation that once gave them sense and direction equally explode with incongruity and strangeness.

Comedies of cultural incongruity may resolve in favor of the visitor (*Les Visiteurs du soir, Crocodile Dundee*) or they may explore the explosive energies that destroy the old traditions when the metropolitan stranger arrives, as in *Chocolat*. Such films are not fantastic, insofar as they maintain the manifest destiny of global capitalism. The cases of *Groundhog Day* and *Lola Rennt* are more subtle. In the former, the antihero must learn how to live well to escape his motiveless imprisonment in a single day that plays over and over till he resolves its enigma. In Tykwer's film, three iterations of the narrative result in three distinct endings, but we are left not with the sense of a moral justification for the last of them, the only one in which both lovers survive, but with the sense that the repetition could go on endlessly because there is no reason, no causal chain, no effectivity of action or intention that can determine or persuade the blind workings of chance. If the former is cynical, the latter is nihilist, but both sympathize with the foolishness of their protagonists. Both to that extent go back to the origins of the fantastic film, at least as they were traced by the surrealists. Richter, for example, analyzes the dual origin of fantasy in Epstein's medium-specific concept of *photogénie* and the vulgar magic of fairgrounds and circus. That populist, all but folkloric enjoyment of the grotesque and the magical is for Richter a class rather than a gendered machine: "The fool who speaks the truth is a philosophical figure. Throughout human history he has been a favourite of the lower classes, for in the roundabout manner of folly, he gives shape to their ideas, voice to their sufferings" (Richter 1986: 63).

At the same time the fool is far more frequently male: the wimp, the nerd, the geek, the idiot, from national favorites like Norman Wisdom and John Candy to international stars like Jerry Lewis. In this figure the demasculinized masculine becomes not only a source of fun but an object of sympathy. Often, like Mike Myers or Louis de Funès, associated with bumptious and incompetent eroticism, such figures certainly ridicule the bumbling fatuity of patriarchy, but they also play out the situation of masculinity as a role that demands too much of its bearers. The bachelor machines of stunts,

| Figure 11.3 |

The Fifth Element: Bruce Willis and Chris Tucker, worlds of action and mediation, definite and indefinite gender, raw materials for mayhem and catastrophe. Courtesy BFI Collections.

scrapes, and accidental connections that characterize the action sequences of their films, with their apparently random attachment of multiple devices to form a single apparatus of perpetually thwarted desire, is the machinery of farce, and low farce at that. It belongs not to mastery but to those condemned to enact the ideological roles of heterosexuality in the service of reproducing labor power. The fool's truth concerns the imbecility of a system that demands the full majesty of the phallus from the exhausted working man.

The transvestite, camp, and polymorph all bring to this figure the innocence of childhood, like Benny Hill's forever wide-eyed blinking. In *The Fifth Element* (figs. 11.3, 11.4), Chris Tucker's Ruby Rhod follows the tradition of Liberace and Danny la Rue in combining the knowing with the infantile, like the simultaneous sensuality and childishness of the dumb blonde. Such types do not require psychological depth: they set themselves up as counter to psychology, referencing not the inner life but the ways in which acting out a role reveals the mediations at the heart of human interaction. If the depth-psychology model of expressionism asks us to savor the

| Figure 11.4 |

The Fifth Element: postbiological prosthetic mutants, morphs of perfected violence. Courtesy BFI Collections.

paradigmatic axis of meaning in each individual, the clown machine situates that meaning as the function of syntagmatic linkage. The former delves into the essential meaning, the latter sets up fate as merely the raw materials for mayhem and catastrophe. The desiring machine that builds itself around the fool is incontinent, incoherent in the manner of Méliès's Institute of Incoherent Geography, a vector whose infinity is that of chance, the triumph of connectivity over the nodes that it connects. Only the commercial imperative of a happy ending controls the lunacy of its fabrication.

This much is true too of *Delicatessen*, and perhaps even more so of the sequence of coincidences that stitch together the fable of *City of Lost Children*, notably the return journey of the flea to its owner so that he can rescue One and Miette from the sinister twins. Leeloo, the Supreme Being of Besson's *Fifth Element*, genders the machine as feminine. Susan Hayward, contrasting her with Besson's earlier creation *Nikita*, notes that "We are led to believe that she is amazingly strong (her hand-to-gun combat on the paradise/space-hotel Fhloston), but she has none of the muscularity and vigorous

health we associate with techno-bodies" (Hayward 1999: 254). This fight sequence intercuts between Leeloo's acrobatic martial arts battle and the transition from elegaic aria to disco fever that transfixes Korban and the audience of the alien diva in another part of the hotel. The two femininities, one a mystic savant who will sacrifice herself to save the world, the other the battling gymnast, interweave in a single cinematic machine. It may be that they form two aspects of a single male fetish, in the manner suggested in Theweleit's (1987) psychosociology of fascist masculinity. But if so, they exceed, as spectacle, the machineries of dominance that give them birth. As Hal Foster emphasizes of the robots, automata, and mannequins of interwar surrealism: "Too often strategies of chance are seen as opposite rather than immanent to rationalization. And yet just as the modernist value of originality is incited by a world of increased reproductions, so the surrealist values of the singular and the *insolite* are articulated against a world of increased repetition and regularity. Chance accident and error are thus bound up with the advent of administered society" (Foster 1993: 151).

The discontinuous motions of serial production appear in surrealist avant-gardes and the popular cinema alike as parodies of repetition and the incomprehensible syntax of the Fordist production line. The discipline of consumption likewise requires an unanalyzable series of discrete experiences. Surrealism might be seen as merely imitating the bizarre juxtapositions of serialized modernity. On the other hand, Foster suggests, not every avant-garde has been assimilated to the machinery of dominance. Bound up as they are with social mechanization, "this positioning gives them a dialectical edge" (Foster 1993: 152). In the same way, the bachelor machines do not simply replicate the fetishized desire of commodity culture: they set those desires in motion according to their own logic to demonstrate that there is no end to desire, and that the contradictions that power its first budding remain ingrained even as it is rarefied and reified.

Wonder and Despair

The commodity that so wanted self-sufficiency thus acquires a contradictory history. The dream state that inhabits any experience of cinema shares with the commodity the difficulty of existing in the present. As cut, oneiric cinema exploits that difficulty, doubling and destabilizing time by juxtaposing layers of different temporalities. As vector, it evokes the multiplicities of fantasy by opening out this unstably recorded image to its future-oriented

unfolding. Although that unfolding is "planned" in the production process before the film meets its audience, it depends on the experience of the viewer to realize it.

Yet the experience is always unrealized in the sense that its future is already the planned past of the filmmaker. Man Ray's claim that film is best when seen only once rests on this understanding: we cannot see a film twice without sacrificing its oneiric potentiality, the openness of the film to futurity that arises from the contradiction of the unforeseen and the foreseen, another task now usurped by television. Recording is already uncanny: the watching of the recorded image evokes this disturbance of the present in a way that distinguishes schizophrenic postmodernity from the presence of the ancients, as Heidegger understood it. The contemporary present is always an unfolding whose prior determinations govern it, as physical laws and as habits of perception and cognition. To this extent the contemporary present is always an informational order, a transmission of data and structure from past to future that therefore never possesses the pristine innocence of the unrecognizable and the unrepeatable. Those rare, brief moments in which we experience what is present as present occur to us as epiphanies, miraculous abbreviations of memory and expectation into pure being here and now, entirely exceptional, even spiritual. Habitual perception and habitual foresight, reenactment and preenactment, shape every other experience. In the cinema that dialectical interference of the planned and unplanned, the expected and the miraculous, the banal and the heightened, can be foregrounded, but only at the sacrifice of the ordinary construction of meaning in the continuity between past and future characteristic of Western modernity.

Fantastic cinema retrieves the now alien quality of being in the world and presents it as supernatural. This explains why film can so readily be appropriated to psychoanalytic interpretation, as text and apparatus, and why the filmgoer always responds to psychoanalytic commentary with the same disappointment. What is most precious about the experience of fantastic film is what is not interpretable: its failure, even its refusal to mean, its dreamwork rather than its symptomatology, the failure of the letter to arrive at its address, and the arrival instead of some unintended missive from a total stranger. The fantastic in film as in life is fantastic insofar as its analysis is not so much interminable as uncommenceable. Whence the startling dullness of key surrealist documents: what renders delirious is never what

can begin to be analyzed. Hermeneutics addresses the work as past. The dreamwork of fantasy addresses the work as present, and though it may well be, and almost necessarily must be, followed by interpretation, the first flash of the new, the surprising, the lovely, the ugly, is not tied to interpretation but precedes it, motivates it, perhaps demands and yet refuses it. The sense of wonder stitches an arc between the vector and the pixel, acknowledging that in the age of the spectacle, thirdness has relinquished the object's claim to truth, even to ideology, in favor of an appeal to the miraculous sensuality of preconceptual firstness.

The blunt incommunication of the film text is the source of fantasy, not its depiction. The *cinéma du look* of directors like Beineix and Carax as well as Jeunet and Caro and Besson, nudges toward recognizing the quality of film as something to look at, an absorber of looking that stylizes its images to the point that their meanings, narrative roles, and ideological purposes are subordinated as much as possible to the sheer pleasure of seeing. That pleasure is far from innocent, shaped as it is already by the stylization of advertising imagery. The *cinéma du look*, however, has nothing to sell, beyond the ticket that has already been sold: a postcommodity, like *Un Chien andalou* and *L'Age d'or*, "which place themselves above everything that exists" (Nadeau 1964: 321).

As John Izod observes of *Diva*, "The structure of the film is startling and charged with energy that the narrative itself does not fully absorb. . . . It endows the diegesis with a persuasive virtual reality, which can be understood as the beginning of an emerging cultural differentiation" (Izod 2000: 191–192). Differentiation emerges from the virtual, the "almost reality" that doubles the world with its simulation (Schirmacher 1994: 67), not a psychological but a sociological and ultimately media-technological doubling that finds its fulfillment in style, "a self-evolving activity producing a gaze and opening the ear . . . a game playing with time and language in which you discover and forget the self . . . instead of ecstasy and intensity, the styles of the self and multimedia express connectivity and application, the skills of an instrumental life-world" (ibid.: 78–79).

Style, which subsumes story and psychology to itself most fully in fantastic film, is a hybrid that evolves when the authorial self surrenders to the instruments of cultural creation. Connecting human and machine in the transfiguration of what is given to sight and hearing disassociates perception from both individualism (and its attendant psychologism) and anthro-

pocentrism. The commodity form's last privilege is the claim to fulfill the lack in being: "I consume therefore I am." The neobaroque proposes to fulfill the commodity's spectacular destiny by subsuming subjectivity into the diegetic world. In the triumph of style in the oneiric film, the diegetic world is ironized, its planes dislocated from one another, its unreality foregrounded, refusing any attempt to sink into its embrace. Rebutted by the multiplying surfaces of the diegesis, the self is cast back into appreciation, the distanced pleasure of the observer abandoned to the contemplation of the space and time dividing it from the impossible world onscreen. Such contemplation takes as its object, of necessity, the stylistics of the film. That stylistic look is the film's work, mediating between world and self. The viewer's job is to mediate between the disparate elements of the diegesis. Contemplation of style renders the subject stylish: self becomes mediation. Thus the self-narrating protagonists in Gilliam's films, from *Time Bandits* to *Fear and Loathing in Las Vegas*, and most of all in *The Adventures of Baron Munchausen*, whose cosmic egoism dissolves in its own aggrandizement.

The sense of wonder evoked in oneiric cinema is a matter of style as self-derealization—a special moment in the history of wonder. Fredric Jameson observes that the decentering of subjectivity that is such a major theme of poststructural criticism is itself merely diagnostic, and that "only the emergence of a post-individualistic social world, only the reinvention of the collective and the associative, can concretely achieve the 'decentering' of the individual called for by such diagnoses" (Jameson 1981: 125). The mere sense of wonder cannot achieve this on its own, though recognizing that it exists as a human faculty is an essential step. Like every instinct, wonder becomes socialized as a drive. As hunger that once demanded hunting and slaying now needs a burger, so wonder has its history. Already in the European Middle Ages, wonders were at once evidence of God's omnipotence or of the consequences of sin and at the same time both commodities to be traded and "a form of symbolic power—over nature, over others, and over oneself" (Daston and Park 2001: 91). In the long transition to Enlightenment rationality, wonder ceased to be exercised over the boundaries of natural law and instead was inscribed in appreciation of the natural order itself. In the division of scientific from artistic culture, that appreciation was split between visualization and calculation, the "unresolved dichotomy between a rationally ordered repository of knowledge and a free-form entertainment spectacle" (Stafford 1994: 264).

Jameson notes how, in twentieth-century modernism, spectacle achieves an autonomy and a dignity of its own in the emergence of abstraction from the work of the Impressionists:

So Lukacs was not wrong to associate the emergence of this modernism with the reification which is its precondition. But he oversimplifies and deproblematizes a complicated and interesting situation by ignoring the Utopian vocation of the newly reified sense, the mission of this heightened and autonomous language of color to restore at least a symbolic experience of libidinal gratification to a world drained of it, a world of extension, gray and merely quantifiable. (Jameson 1981: 63)

Derived from the reification of vision under conditions of factory production and the scientific division of labor under Taylorism, tightly entwined with the history of chronophotography, the new autonomy of visual style (and parallel autonomization of sound in both formal and popular music since the beginning of the twentieth century) retains nonetheless a utopian vocation.

The sense of wonder, like the instinct for play, belongs wholly to the world in which it is exercised. In our time, the pitfalls lie on two sides. On the one hand lies the lure of the commodity sublime, heralded by the neo-baroque, at its apogee, so far, in the digital film. On the other lies despair, the fascinated gaze into the pit of ecological collapse. *Dr. Strangelove's* montage of H-bombs inaugurates another genealogy, this new fascination with surviving the end of the world. In *Delicatessen* and *City of Lost Children*, though the protagonists achieve their goals, the world remains dead: a cesspit of muck, slicks, and smog in which the desecrated remnants of a nature utterly denatured outlast the challenges of the storyline, forming their own alluring world alongside that of the narrative.

The sense of despair that underpins this aspect of oneiric film is captured in Ivailo Dichev's account of the end of communism in Bulgaria: "there is nothing to learn from the fall of communism, no moral to be taken. The enemy left no corpse behind—you have ruined economies, killed people, polluted land, but the transcendence as artefact is nowhere to be seen; the will to power disappeared in being defeated and one could ask oneself whether one's life has been real at all" (cited in Buck-Morss 2000: 242). If, as Jameson argues, it is the critic's duty to pair the analytical with the

utopian, there should be some way to build outward from a state where despair of totality becomes total despair, and a way to do so that does justice to the profundity of the experience of Eastern Europe since 1989. When the fall of communism was promptly followed by the failure of capitalism, it seemed both of the great modern systems for producing sociality had collapsed, with an expectable turn to older Orthodox and newer cult religions. Defeat unmakes. Its contemplation is also a surrender, though in this case there seems to be no victor.

Poets from Hopkins and Pound to Berryman and Celan have confronted despair as the quintessential condition of modernity. Ecological collapse has overtaken nuclear holocaust as the popular figure of this despair, and it is one that in the end may be unanswerable. As Mary Douglas wrote, "any given culture must confront events which seem to defy its assumptions. It cannot ignore the anomalies which its scheme produces, except at the risk of forfeiting confidence" (1966: 33). On the one hand, that loss of confidence is the one hope we have for change; on the other hand, it opens the curtains on a horror that invites to self-immolation.

The strange, the fantastic, the dream, all the modern forms taken by wonder offer us these choices. Sometimes there is only the will to optimism with which to confront the intelligence of despair. Anything else, like the final coupling of *The Fifth Element*, is mere sentiment. At its best, and its best often occurs in scenes and sequences rather than whole films, oneiric film stands, in this cold light, at the unreal crossroads of the inexplicable event, deprived of agency. Whether that is an intimation of panspecies connectivity or an impasse at the end of the history of humanity is the primal ambiguity of the twenty-first century.

REVISIONARY FILM

Once Upon a Time in the Asia-Pacific: History as Effect

If miracle it be, it was most savage.

—*Vincent Ward*[1]

After the End of the World

Invitation to inhabit an uninhabitable world, invocation and refusal of interpretation, mediation and specter of its impossibility: the oneiric film responds to the random seriality of factory production and spectacular consumption with chaotic anxiety. The cinema as dream begins to doubt the category of society. Today "society" no longer looks like a given but an artifact, a concept hypostatized at the expense of its empiria. The unresolvable opposition of self and society, and the central sociological problem of the all-too-visible dissolution of the social, appear now not as qualities of the world but as constructs of a mode of thought.

The turn to "culture" as an alternative explanatory framework has not resolved that methodical doubt: Friedman (1995) is not alone in demanding that we interrogate and condemn the presupposition of culture, singular or plural, as the best way to understand how we make sense of the world. Both anthropology's professional dedication to the illiterate and "primitive" and cultural studies' attention to the ethnography of the internal other (youth, migrants, the working class) are objectifying gazes constructing of necessity a governing binary opposition between sameness and otherness. The same conclusion is the upshot of Balibar's analysis of neoracism (Balibar and Wallerstein 1991): culture has become an alibi, a concept that, by dint of its object status in social theory, is now an excuse for othering, marginalizing,

and ethnicizing. The concept of "culture," like its offspring "tradition" and its parent "civilization," today blocks rather than facilitates the communication of change.

Nationhood has an even weaker explanatory claim. Initially proposed as resistance to imperialism and now as alternative to globalization, nationalism increases in rabidity in direct proportion to the diminishing power of the state. State funding of film culture, contradictorily aimed at simultaneously celebrating and creating national identity, is as common today as the processes of print capitalism in the formation of "imagined communities" (Anderson 1983) in a previous generation. The impasses of individuality and the social, tradition and modernity, identity and hybridity are irresolvable, and not only because they are so defined that there can be no way through and beyond them. Culture, society, and nation nonetheless pose the necessary question of historical agency, even if it is in the wrong terms. History films invite us to inhabit our own societies, cultures, and nations, but to do so they must construct all three. That is the history effect in cinema.

Historical film presents as complete, at origin, what it seeks to create. Bazin's vision of cinema transforming reality into the self-identical it has never yet been is the type of the history effect that extends to geopolitical scale the objectivizing tendency to other the world. Film's dialectical nature, not least its dialectical temporalities of recording and unfolding, makes it unusually capable of voicing such contradictions, as also the contradiction between preserving and creating national identity. Especially where cinema approaches the quality of dream, it has little difficulty in assimilating these contradictory purposes to its own oneiric ambiguity, enacting contradiction

as the ground on which audiences can be made into communicating machines. Both digital and oneiric film work through the fantasmatic modes of the individual-society dialectic. The digital at once creates and fulfills the desire to be self; the oneiric deploys style as the fantastic realization of connectivity. In the historical film, the arguments between inheriting and creating nationality oscillate between submission to what is and the enabling of community. The immense, global popularity of the Asian cinema belongs especially to this claim to both produce and reproduce identity.

To mediate contradiction, especially the passionately fought contradictions of national identity, is not a cozy undertaking. Like warfare, it demands the articulation of visual intelligence, camouflage, false lures, and encrypted truths (Virilio 1989; Kittler 1997) with the Freudian dream processes of condensation and displacement shaping the interplay of armed struggle and the struggle for identity. Courage and self-sacrifice, the two typical moments of heroism in national epics, rest on a further nest of contradictions: the constitution of the individual as self-identical while also both author of and authored by a shared national identity, at once universal and particular. Thus *Pearl Harbour* is simultaneously a universal outrage and a national catastrophe. *Akira*, on the other hand, fictionalizes the atom bomb as universal cataclysm experienced on behalf of the world by a single nation.

Akira pitches itself against entropy. Hawking argues that psychological time is tied to the second law of thermodynamics, according to which we cannot remember the future because the future by definition contains less order and less information than the past (Hawking 1988: 155–156). *Akira* argues for the opposite: a structuring memory of the future. In dialectical counterbalance to the cinema of destiny, this most successful export of anime works in relation to the time of evolution, the biological principle out of Darwin (1985) that suggests that environmentally favored mutations survive and multiply. Where the physical principle of entropy sees information decreasing, the biological principle of evolution envisages organization increasing through the ever-closer fit of environment and species. Information science extends the evolutionary principle by emphasizing the acceleration of evolution in autopoetic feedback loops of environmental alteration, visualized in *Akira*'s mutant Neo-Tokyo.

Externalizing information processes as media is integral to the human variant of the bioevolutionary arrow of time. Cinema, as recording and unfolding, seems to have evolved precisely to explore the drift between higher

(larger, more complex) systems like cities, nations, and metanational organizations, simultaneously with apparently atavistic recursions to familiality, locality, and ethnicity. "Nation" here does not describe a sociological object, but the result of a process of negotiation in which the claims of older, smaller units are counterbalanced and played off in the realm of supranational loyalties, ideologies, religions, political movements, and cultures. Like finance capital, these transnational media formations are communicative structures with typical constellations of media types and usages. For the cinemas of the Asia-Pacific, the history effect is critical among these uses.

Western discourse either looks forward to Armageddon, or imagines with Fukuyama (1992) that we already live at the end of history. But what if you have already survived the end, and have to build on its ruins? What if the futuristic and the repentant alike rest on the scorched earth of Hiroshima and Nagasaki? *Akira* and other successfully exported anime like *Ghost in the Shell* explore the mutant future. Both, but *Akira* in particular, strip from their manga origins the complex subplots concerning renunciation and spiritual salvation (Otomo 1988–1995). Other films look to the doubling of the present world with an unseen universe of horror: *Wicked City, Blood: The Last Vampire*. In another, more offbeat film, *Wings of Honneamise* (fig. 12.1), the future emerges as an alternative past.

At a key press conference on August 30, 1945, Prime Minister Higashikuni Naruhiko, appointed to office to oversee the transition from Empire to Occupation, reflected that "the armed forces, government officials and the population as a whole must search their hearts thoroughly, and repent. Nationwide collective repentance is, I believe, the first step on our road to reconstruction, and the first step toward national unity" (Barshay 1997: 273–274). With the horror of the bomb fresh in mind, faced with the downfall of the empire of Greater Japan and the shame of surrender, the politician utters a theme that seems to resonate in the curious, slow budding of *Honneamise*. At the time of its release the most expensive animation ever produced in Japan at eight million yen, and with a creative team almost all in their twenties, the film envisions a future-past country of lamplighters and steam trains, trams, and prop-driven warplanes, a universe that the Meiji modernization of the later nineteenth century might have arrived at had it not been urged along other routes by its exposure to Western technology. Shirotsugu is a disaffected space cadet in the rundown Space Force whose perennial sleepiness is punctured by a meeting with the girl Rikuni,

| **Figure 12.1** |

Wings of Honneamise: antihero between destructive technologies and the cult of renunciation.
Courtesy BFI Stills, Posters, and Designs.

impoverished sole missionary for a homemade religion of renunciation and impending judgment. The tram that takes the young pilot out to Rikuni's rural home, like the tram in *Sunrise*, seems to leap across decades, and certainly across modes of understanding and being in the world. Two naïveties meet as the would-be bumptious lad comes to savor the puritanical regret of Rikuni's belief.

Town and country structure the diegesis. Although Japanese and Western experiences of modernization share a growing division of labor and lifestyle between city and country (Williams 1973), as Ohnuki-Tierney writes,

The success of the representation of Japan as agrarian did not rest on the imperial system. The skilfulness with which political elites mystified and naturalized agrarian ideology during subsequent periods is only partly responsible for its success, which owes in large measure to the symbolic significance of rice and rice-paddies in day-to-day practices through which they became powerful metaphors of the collective self. (Ohnuki-Tierney 1993: 98)

The Japanese urban–rural continuum does not depend on the economic or even dietary importance of rice, both of which are diminishing and overestimated historically according to Ohnuki-Tierney. Nor does it depend on the foundations of imperial rituals in the Edo period. Rather it depends on the mythic standing of rice as medium of "commensality," of sharing, hospitality, connection to the gods, the environment, and the cycles of sexual reproduction. In the imaginary country of *Honneamise*, the humble bowl of "terish" seems to work in the same way, a dish whose origin is not clarified in a brief shot of harvesting what might be wheat or millet. The offering and sharing of food brings the stranger into the community in a way that idle urban drinking and gambling cannot. As Dirlik notes of the case of Asian revolutions that were forced to rely on agrarian movements, "local society would also emerge as a source of national identity, against the cosmopolitanism of urban centers drawn increasingly into the global culture of capitalism" (Dirlik 1996: 24). The political pull of rice farmers, for example, in 1980s agitation against U.S. rice imports, is then an enactment of ethnic identification far more than economic special pleading.

 At the opposite pole to "rice as self" lies technology as the hallmark of the (Western) other. Surveying the vicissitudes of this formation over the last two hundred years, Najita chronicles a gallery of attitude changes accommodating exotic Western technology into a cultural conjuncture already buffeted by the confrontation with Chinese cultural leadership in previous centuries. Distinctions between knowing (Chinese ideograms, for example) and being (Chinese), between technical efficiency and aesthetic value, supported a sense of "cultural certitude." "For Japanese, self-knowledge, derived from prelapsarian encounter with the gods and the land they created, always forced a difference between the plentitude of being and otherness, whether the Other was China or the West" (Najita 1989: 9). In the postwar period, however, the same strategy of a retreat to certitude seems naïve, even dangerous if, as Najita argues, the postmodern is inherently conservative,

allowing for the mechanical reproduction of things as they are and "since there is no privileged position in relation to history, there will be a variety of 'custodians' of culture, among which the state will undoubtedly be a strong and self-conscious player" (ibid.: 19).

Andrew Feenberg finds a solution to this impasse in the late philosophy of Kitaro Nishida. Comparing MacArthur's then approaching fleet to the armies of Nebucchadnezar, Nishida noted that

despite their conquest, the Jews maintained their "spiritual self-confidence" and transcended their merely ethnic limitations to create a world religion. Just so, he argues, "the Japanese spirit participating in world history . . . can become the point of departure for a new global culture" but only if Japan overcomes its "insular" and "vainly self-confident" outlook. (Feenberg 1995: 191, citing Nishida 1987: 116)

Only by accepting defeat could Japan undertake its spiritual role in world history, and so overcome the Hegelian unification of all cultures under the Western aegis. The surrender of specificity was the only way to achieve universal significance.

In its negotiation with the universal, the soundtrack of *Wings of Honneamise* eschews the roar of motors for a contemplative electronic keyboard score by Ryuichi Sakamoto, notably in the sequence of the training flight through the clouds, light, ethereal, aligning the longing for space with a spirituality far removed from the stadium rock of *Top Gun*. The *Wings* sequence is vectoral, not just in its graphical movement but in its displacement of totality to a space outside the film's world, even beyond its concluding space launch. Its infinity, however, is spatial rather than temporal, even more so because the world figured is so meticulously fictional—we see maps, for example, of the land boundary between Honneamise and the neighboring state.

But there is also another logic running through the film, shadowing the philosophy of Nishida and especially the "place of nothingness." According to Akira Asada, Nishida's wartime lectures situate the place of nothingness in the Imperial household. There, nothingness "negates itself and becomes an empty place. . . . There, instead of being aufheben-ed toward the higher, contradiction is dissolved, so to speak, toward the lower. The dialectic of conflict and strife, which is supposed to evolve into history, is replaced by

the topology of subsumption which is atemporal and peaceful" (Asada 1989: 277). In this perspective, what Feenberg sees as an overcoming of Hegelian unification becomes, in Asada's term, "zerofication." The word is suggestive, not least because it is the religious renunciation of not just the film's philosophy that it evokes, but the animation style. Like many manga of the later 1980s, the film derives a great deal of its attraction from the detail of its design, and from the use of angles that would be unusual in a cinematic movie. Many shots have minimal movement, only a few use the movement in depth that comes with rotoscoping (George 1990), and hardly any use the kind of spectacular reframing that characterizes contemporary North American cartoon features like *An American Tail*. Often a minor fluctuation is all there is to denote the atmosphere or emotion of a scene: the closing of eyes in an otherwise static face, the wafting of a curtain. The appeal to a sophisticated audience's ability to decipher these small motions grows into an overall impression of lassitude before a world and a life well worth renouncing. The two major action sequences, the chase and death of the assassin and the launch sequence, cut in the frame, the edit and the construction of depth, but they resolve into the absolute indifference of movements in equilibrium.

Like the zero of the Lumières' flickering views, the action of *Honneamise* sums at nothingness, a zero degree of the political that removes its resolution from history, and from time itself, into the atemporal zone denoted by Shirotsugu's orbit beyond Earth's atmosphere: an empty place from which alone the strife of warfare and suffering sinks into pure regret, not so much an end as an exit from history. Where *Akira* confronts the dangers of information as evolution, *Honneamise* resolves it into imperial nirvana.

Love and History

In Asada's analysis, Nishida's noplace is the electronic space of infantile capitalism, the playworld of corporate, transhistorical, transnational management. Certainly *Honneamise* makes great play of the childlike nature of its protagonists, and the incompetence of their short-sighted, dim-witted, and tradition-bound elders. Youth, it seems, is a critical quality for films devoting themselves to mythologizing the emergence of the nation-state.

But youth runs up against that other moment of origin, sexual awakening. Its title a palimpsest of this doubling of origin, *1942: A Love Story* (figs. 12.2, 12.3) traces the romance of Naren and Rajeshwir (or Rajju) against the background of the independence movement as it is experienced in the

| Figure 12.2 |

1942: A Love Story: General Douglas: tyrrany as abstraction from the family.

mountain village of Kasaouni. The central story is structured around the protagonists' immediate families. Rajeshwir's father Raghuvir Pathak is a revolutionary whose wife and son have already died in the struggle. Naren's father Dewan Hari Singh is a collaborator with the British, although his mother is loyal to the cause of independence. There is immediately a problem in the construction of the hero, who "should be the perfect son" (Darmesh Darshan, cited in Kabir 2001: 113). In the main subplot, Major Bisht is the sole parent of a daughter who also first falls in love with Naren and later joins the independence movement before inspiring her father, a major in the British Army, to do the same. The British are represented by General Douglas, who is depicted with no reference to family, and whose relationships are entirely masculine and entirely violent. The interest of the

| Figure 12.3 |

1942: A Love Story: Major Bisht at the historical moment when colonial service turns to anticolonial revolution.

film lies in the ways in which the stylistics of the Bombay musical have been adapted to the purposes of telling a patriotic story, and the significance of these stylistic choices against the background of mid-1990s communal violence in Mumbai, Amritsar, and Ayodhya.

The film *1942* is one in search of an adequate form in which to resolve a critical question in the experience of Indian nationhood in the 1990s, or rather three mutually dependent questions: What is it for a nation to acquire historical agency? How does a nation become modern? What is the status of the divine, which plays so significant a role in the self-definition of both the Bombay cinema and the political life of the country during the communal violence of the mid-1990s? *1942* does not resolve these questions because they are stated, with considerable political and cultural nous, as inseparable but, at the same time, incommensurable. Aumont defines analysis as "travelling backwards":

This is none other than the well known mathematical method which consists in supposing a problem has been solved. The difference is that in analysing an image, a painting or a film, I do not have to suppose but can assume that the problem has been resolved: what I have in front of my eyes constitutes its solution. So analysis indeed consists in travelling backwards, though not in the form of a demonstration (in the sense of a verification of linked logical consequences). Rather, starting from the solution that the image gives me, it is a question of constituting the problem. First question, at the base of any analysis of the image: what is the problem? What problem can I pose starting from this or these images? What problem does it or do they pose, to which they are the solution? (Aumont 1996: 26)

Aumont's principle suggests that we must read films from what they present to us: that formal analysis of the audiovisual text precedes any interpretive attempt. As Aumont's title suggests, "films think": more fundamentally, they communicate, and the mediation between apparatus, text, and reader is as complex as that between human interlocutors. This film thinks a construction of history intended to address the rifts in Indian society at the time of its making. Eisenstein's *Russ*, far from speaking to the whole of the U.S.S.R., was ethnically and geographically specific, and its unity and coherence could be assumed. That is not the case with *1942* in the 1990s. History, like nationhood, society, and culture, must be here a special effect.

———

The initial crux of the film's stylistic in the construction of the historical narrative comes in a shot from the campanile of the British headquarters, foregrounding General Douglas's sweating pate, emblem of the difficulty of rule and the unnaturalness of the Raj. From behind this crag of authority we peer down to the crowds below, distance doubled by both the mountain slope defining the village and the camera's tilt. In a film marked by skillful reframings in steadicam, we are halted by the privilege of the colonist's view. The monumentality and stasis of the shot characterize one aspect of the independence narrative. But the film must somehow articulate this conflict of mobility and stillness with the central narrative structure of the love story that gives the film its name.

The problem is also generic: how to articulate the songs with the narrative. Underlying this formulation is another: how to integrate the love story into the historical map of the age, a map ingrained in the popular memory of the film's key audience. Other films of the mid-1990s would employ the classical Shakespearean device of lovers divided by factionalism, notably *Bombay*. In *1942*, all the youthful protagonists, and by the end all but one of their parents, will have joined the Congress cause. That unity is an essential part of the film's unitarian message. It is notable that the revolutionary leaders are Pathak and Ali Baig while the hero's family name is Singh. The religious connotations of these names are scarcely adumbrated—there is only the briefest call of a muezzin in the background soundscaping of one chase sequence. Instead they quietly indicate an all-India opposition to the Raj. This unificatory thrust is amplified by the mountain setting in a film made during the early period of the conflict in Kashmir, directly addressed in another key nationalist film of the 1990s, *Roja* (Bharucha 1994).

The obvious solution would be to make the theme of romantic, heterosexual love central to the politics of revolution: to make love the goal of the war, and to articulate its success with that of the revolution. This is in a way the achievement of the film's final scene—the lovers united as the hated symbol of tyranny burns—but it is never articulated in the dialogue. Naren's two speeches in which he expatiates on his love for Rajju scarcely mention the war for independence except as an obstacle to true love's progress, and his second speech serves rather to motivate a throwaway subplot concerning the resistance leader Surabandhar's suicidal knife attack (and subsequent reconciliation with Naren, his rival for Rajju's hand). After a touching duet sung on the mountaintops above the village, there is no shadow of returned

affection on Rajju's face, though the match between the revolutionary's daughter and the resistance fighter might have provided exactly that reconciliation of love and history which the film seems to demand. The song instead reflects Teri Skillman's observation that "The emphasis is on the context, action, and emotion being expressed and not whether it is appropriate to the character. The sentiment a character expresses often reflects the audiences' emotion" (Skillman 1988: 152). Melodrama, especially as it derives from Indian traditions (see Mukherjee 1985), approaching Ang's (1985) definition of "emotional realism", exaggerates character and coincidence, and "with its typical focus on the family [and] the suffering of the powerless good" binds the tearful experience of the heroine or hero narcissistically into involvement with family, community, and nation (Dwyer 2000: 108–109). The formula certainly works for the middle-class romances that form the focus of Dwyer's analysis, but it is less stable in relation to *1942*, where the nation has yet to be formed and the family is corrupted by betrayal.

Love and revolution cannot be completely articulated. The war, shot often in colors of flame and sand, forms a series of obstacles to the realization of romance. The love songs, which include a particularly elegant rain-soaked "wet-sari" sequence, are coded through saturated color and especially through fluid, "intentionally obtrusive" (Gokulsing and Dissanayake 1998: 96) steadicam work distinct from the rest of the film. Music and playback singing figure in key political scenes as well as in the love story, notably the hummed motif attached to the protesters with their burning brands and their Swadeshi tunics. Similarly, key motifs from the love songs also feature at critical moments in the historical narrative, an association through which they gain considerable emotional weight (notably Mangeshkar's song "Say Nothing"). In this way, song and dialogue sequences are more closely interwoven than is often the case in Bombay musicals.

At the same time, however, the bright primary colors of several of the love scenes have no parallel in the restrained palette of the mountain's lower slopes in the narrative sequences. Fire and blood provide the strongest colors here, and sharp reframings and hard edits replace the mobile camerawork of the song sequences. Where the songs are characterized by high degrees of symmetry among graphically matched shots, the narrative sequences more frequently exhibit sudden juxtapositions, leaps from extreme close-up to long shot or from shadow to light, and rapid shot-reverse-shot cutting. The use of fast zooms is restrained and often replaced by cutting.

The result is a depiction of the narrative as typical, in the sense that it involves types engaged in a recognizable taxonomy of patriotic actions. This itself poses problems.

On the one hand, the film depends on the exceptional nature of the love between Naren and Rajju. On the other, their sacrifices for the cause are reflected across so many other characters, especially Naren's mother, that there can be no doubt that their heroism is to be understood as a heightened depiction of the ordinary heroism of the Indian masses. The theme is carried through especially in the death of the comic servant Mandu and the distraction of Govind's widow at the martyr's funeral given to her husband after he has died under British torture. Through such characters the anonymous crowd is imbued with narrative depth, and we are allowed to feel, in the style of the Odessa Steps sequence in *Potemkin*, that each face stores some tale of brutality and bereavement. Yet the crowd remains anonymous and uniform, not least because of the politically significant ubiquity of homespun cloth. Anonymity does not preclude community; quite the opposite. The night-time sequences most define the particularity of the protagonists in the political narrative. Interior sets gather the central figures into a shared space, but the reduced illumination, often just firelight, isolates the detail of faces to create Rembrandt-like compositions focused on those characters, by no means all of them studied in close-up, who form the central core of the revolutionary camp. Night and dark catch a sense of intrafamilial emotion, a familiarity that underpins the emotional structure of the revolution and further isolates the family-less, sun-pinked General Douglas.

Often nation is an extension of family, just as romance is its renewal, but here narrative justice demands also the death of Rajju's father and the renunciation voiced by Naren's mother. The narrative works counter to the family as the ground of revolution, instead presenting it as its result. The old families fail to provide a logic for loyalty and freedom. Naren's conflict with his treacherous father is mirrored in the split loyalties of Major Bisht to the army and his daughter. The parents have to learn from the children here, in opposition to the deep-seated theme of family loyalty, and especially mother-child relations, in the Bombay cinema. The dialectic of modernity and tradition in nation-formation makes continuity impossible.

Phalke's Swadeshi politics of the atemporal eternity of village values remain vital to the ideological task of *1942: A Love Story*. But at the same time, the struggle for independence defines a moment in which village

values—notably the relation between fathers and daughters and between mothers and sons—must confront the processes of modernization, and especially the iconically modern achievement of nation status. Whatever the problems of nationhood as a Eurocentric goal (Chatterjee 1997; Davidson 1992), it occupies a critical moment between the eternity of the mythic cycles of ancient wisdom and the progress-orientation of modernity. Already presupposing that historicizing set of circumstances, *1942* moreover adds to the hero's motivation a discursive teleology: the achievement of nationhood. Naren's achievement of masculinity—of independence from both his father's tyranny and betrayal and his mother's love—is thus tied to the independence of his country from both colonial oppression and the timeless hug of mythological narration. So it is that, where explosions and destruction signal an exit from history in contemporary Hollywood— most egregiously in films evoking natural forces beyond human control like *Twister* and *Dante's Peak*—in *1942* they point toward the cataclysm of entry into it. Like that precious sense of history as successive moments, narrow gates through which the Messiah might enter, voiced in Benjamin's *Theses on the Philosophy of History* (1969), the two explosive moments of *1942*, at Pathak's villa and at the British headquarters, are aspects of the entry of history into the moribund world of coloniality. Indeed, they might be considered as a single explosion distributed across two separate sequences: the one defining the sacrifice of the patriot, the other the death of the oppressor— mutually dependent moments in the ideological construction of the nation.

Sacrifice is essential to independence because, in Fanon's terms, it represents the moment of the assumption of responsibility, and with it "the will to liberty expressed in terms of time and space" (Fanon 1968: 240). The Hollywood cinema addresses us, typically, as consumers, and respects most of all our right to be entertained. The film *1942* addresses us as citizens and respects our acceptance of the duties and obligations that accrue to citizens. That is the point of Fanon's insistence on responsibility: blaming the oppressor is a prehistorical moment of the struggle, which enters the arena of "space and time" only when the question of blame is associated with the assumption of responsibility—responsibility for change. The North American vengeance ethic belongs to that prehistory.

Rather in the manner of those medieval courtly miniaturists who portrayed importance through scale, Bombay tends to define importance through duration. Nor is time dilated by deferring the ending, in this film

both predestined and somewhat inconclusive. Rather, the insertion of emo-
tionally charged, music-driven shots and sequences into the narrative allows
us to appreciate that narration is only part of the film's charm, that the film
is to be enjoyed as a presentation of the present, not as ahistorical sublime,
whose sensory and affective processes are to be shared with the audience
rather than hoarded by the protagonist. The explosions of *1942* last because
they are important, and because they are not events but processes through
which the central figures pass on their way to their changed status, trans-
formed in a process whose temporality is extensive because it is precisely the
time of transition from the banal, closed time of the colonized to the open
time of the free citizen.

Similarly, the explosions are shown from a number of standpoints, by
no means all of them associated with human viewers. The key to under-
standing this quality of the sequence lies a few shots earlier, in the point-of-
view shot of the crowd as viewed by General Douglas from the campanile
of the headquarters building. Here it is not simply that the crowd, as the
emblematic instrument of historical change, is viewed from a position of
power, or that we are momentarily invited to share that literally towering
perspective of domination, but that through this shot the very conception
of a single, unifying viewpoint is associated with the oppressor. Compare
the love scenes: there we find as many close-ups of the male as of the female
star, a microcosm of sexual democracy. The over-shoulder point-of-view shot
of General Douglas moreover obscures as much of the view as it reveals:
power is incapable of the omnivoyance it claims for itself, and it will be that
blind spot (Douglas's disgust at the thought of Indian blood and the perhaps
consequent invisibility of the low-caste water carrier) that precipitates the
denouement. Instead of such a spatially anchored point of view, answered by
the uplifted, fearful looks of the crowd toward the tower, we see the explo-
sions from many viewpoints. For each view we can extrapolate a certain spa-
tial relation and from that a specific emotional response—shock of the ruler,
terror among his troops, disorientation among his supporters, relief among
the hero's friends, triumph in the crowd. But most of all we see aspects of the
blast that can not be pinned down to any human eye.

In a certain kind of filmmaking, notably in European but also in some
Latin American films, such unmotivated angles can provide a cold, clinical
distanciation from the scene. In this sequence we are instead privileged with
another dominant vision: that of the land itself. The road from dominance

to liberation is undertaken not only in the familial language of *Mother India* but in the sense that there is a higher but now secular source of ethical action and, therefore, of aesthetic pleasure, which is that of the nation itself. Thus the summit of the sequence is not the ahistorical sublime of an indifferent God-shot or of spectacle, but rather a shot that expresses triumph beyond the victory of the romantic leads, a triumph associated with the newly historical centrality of the independent nation. The evocation of a nonhuman eye provides us with a sense of justice, especially in the balancing of the self-sacrificial explosion at Pathak's villa with the death of General Douglas. The land itself—the mountains, but by implication a united India—looks on, demanding only the highest from her offspring and giving them a yardstick by which to measure the decency of their actions. This presence acts as the bedrock of ethical action in the secular democracy it grounds.

The love scenes code emotion in the details of hands, gestures, and facial expressions, what Melanie Klein would call part objects, removed from the historical body and translated into mythological time. As Naren says so often, their love is destined, and to that extent has no place in history: it is unchanging and therefore ahistorical. Yet that same love must be compatible with the struggle if the struggle itself is to be worth winning. The problem of General Douglas's head can now be situated properly. The blockage it presents to the camera's and the audience's vision is not a "third meaning" as Barthes (1977b) discusses it but a "'hole in the Symbolic' . . . the terrifying encounter with the truth that there is no Other guaranteeing the consistency of the Symbolic order and the meaningfulness of the world" (Prasad 1998: 231). Prasad here draws on Zizek's terminology to describe the production of terror in *Roja*, whose project is largely, he says, to ensure the passage of authority from the divine to the secular state. In our film, the Raj occupies the position of the Other illicitly, an emptiness at the heart of meaning.

The solution *1942* proposes is that the secular romance takes on the mythical, structuring role previously afforded to the theological domain corrupted by the usurpation of the divine by the Raj. Since religion defines no longer truth but only relations between cultures, the film diminishes the particularity of the protagonists' religious affiliations. At the same time, rather than situate the romance as the narrative beginning of a family, it places it in a position in which the private, indeed the intimate sphere now can be premised as the foundation of Indian modernity. Yet unlike teenage rebellion in the Hollywood canon, from *Rebel Without a Cause* to *Slackers*,

this privileging of the intimate is not founded in an existential void. Where Hollywood's teen rebels discover their fullness by embracing emptiness, Bollywood's reject the theology of the void for the discourse of completion.

The task of *1942*, then, is to describe the emergence of India from coloniality into modernity as a transition from myth into history. Using all the bravura *masala* mixing of moods, genres, and technical effects endemic to contemporary popular Indian films, *1942* reworks them as dialectic between, on the one hand, the necessity of reinterpreting the war of independence as a unified struggle during a period of intensifying communal violence, and on the other the necessity of reconciling the theological and ideological focus on the family as source and origin of social meaning with the emergence of a mass modern culture that is nonetheless historically and culturally inimical to Western concepts of individualism.

The film *1942: A Love Story* is a historical document, not of 1942, but of 1994 to 1996, "an allegory through which a post-Ayodhya cinema wishes to affirm its own investments in the Indian nation-state" (Mishra 2002: 231). The rewriting of history is itself a historical act. Here that act can be described as the conversion of the normative spectacle of the Hindi musical toward the project of realism: the reunification of the dispersed action and the casual pleasures of motion in equilibrium in order to apply them to totality. In contrast with the zerofication that sums *Honneamise*'s directionless flickering, *1942* is riven by the demands of totalization.

The Heavenly Fist

Both films demonstrate that the popular cinema can undertake historiography capable of articulating present and past. Tsui Hark's *Once Upon a Time in China* (fig. 12.4) emerges from a similar desire. The legend of Wong Fei Hung, a historical martial arts master who lived from 1847 to 1924 (Logan 1996: 10), has been mined by Hong Kong cinema for decades, starting with the series of 99 films associated with director Hu Peng, scriptwriter Wang Feng, and star Kwan Tak-hing (Rodriguez 1997). When Tsui Hark began work on the latest series, the sixth of which appeared in 1997, the return of Hong Kong to the republic of China from British sovereignty was much in the air. The ominous events in Tiananmen Square during the summer of 1989[2] made it essential to find a way of telling history between or beyond the belligerent or melancholic Sinicism that Tan See Kam identifies as the governing dichotomy of postwar Cantonese cinema (Tan 2001).

| Figure 12.4 |

Once Upon a Time in China and the West: from a later film in the series, the confrontation of traditional and technological worlds. Courtesy BFI Stills, Posters, and Designs.

Once Upon a Time is also one of the most popular films of the 1990s, picking up the tired kung-fu genre and infusing it with the visual flair of the Hong Kong new wave, fast cut and intercut, with an eye for graphic composition that appears to owe something to the massive popularity of Japanese manga comics in Hong Kong. Scarcely a shot is without some kind of compositional interest, flamboyance, or unexpected quirk, and many shots involve rapid tracks, cranes, and lightning zooms, often featuring wide-angle lenses with all the attendant skills they demand in keeping focus. The graphical language of the film places it squarely in the field of the vector, even as its editing and staging in depth pull in the direction of the cut and the wild wirework and stunts hold us in the balanced center of the whirlwind. In short, this is a film in which the full range of cinematic motion is at play, and which binds its historical setting tightly to the contemporary pleasures of highly technologized cinema.

The irony is that the film so consciously and carefully addresses the introduction of Western technologies to China. Westernized Aunt Yee brings

a camera whose flashpowder kills a caged bird, a traditional Chinese pet, as if to emphasize the fatal consequences of an influx of Western goods (the cine-camera will feature in the first sequel). At the same time, as Tony Williams (2000) argues, the film traces the gradual, grudging acceptance of the necessity for change on the part of the master Wong Fei Hung. "We cannot fight guns with kung fu," says the dying master Yim. Cinema is one of the technologies through which China will enter the modern world as an equal. For Natalia Chan Sui Hung, nevertheless, the film forms part of a cycle of nostalgia films characteristic of 1980s and 1990s Hong Kong, both as a representation of a now ancient history, and as a recycling of previously popular forms, the old Kwan Tak-hing series (Hung 2000: 257). David Bordwell likewise dwells on the way "Tsui often reflects on the national heritage by examining traditions of vulgar entertainment" from Shanghai pop to Peking opera (Bordwell 2000: 139), recalling Stephen Teo's description of "nationalism on speed' (Teo 1997: 162). Teo regards Tsui as a nationalistic auteur whose flirtation with Western technologies is "a necessary step to rejuvenate the nation so that it may deal with Western intruders and rise up to face the world on equal terms" (ibid.: 170), while Wong Fei Hung, Confucian gentleman, practitioner of herbal medicine, is essentially a conservative figure who only under the moderating influence of Aunt Yee can be brought to cope with the challenge of modernity.

Once Upon a Time is drenched in knowledge of and love for North American as well as Chinese film history (Dannen and Long 1997: 136), so much so that history here takes on a double sense. At once the representation of things enacted long ago and the modes of representation that accompanied them, Tsui's historiography is more complex than the ascriptions of conservatism and nationalism would suggest. Tsui's generation undertook to make Hong Kong's cinema anew. On the one hand, as a commercial producer-director with a large company answering to him, Tsui is adamant: "Film is a mass medium. . . . The masses go to feel, not to understand" (cited in Bordwell 2000: 138). On the other, he says his movies must "reflect what we are thinking at this moment in our time" (cited in Stokes and Hoover 1999: 93). History, as the fate that shapes the present, structures both feeling and understanding, understanding as feeling. For Hong Kong especially, there are multiple constructions: colonization by the British, a distinct sense of superiority over mainland peasants, a fear of Japanese cultural imperialism (Lee and Lam 2002). Identity is a process perpetually in

formation, perpetually self-critical, and to that extent perpetually modern, and as a result its heroic figuration cannot be without self-doubt and adaptability. Hence the notable shift from Kwan Tak-hing's patriarch to Jet Li's uncertain wooing of Aunt Yee. Only in action is Tsui's hero utterly centered at the still point of the turning world. Otherwise he is as much the necessary outcome of his circumstances as the most downtrodden of the women slaves he liberates from the clutches of the Americans at the end of the film.

Moreover, the film is structured along a scale of "Chineseness," with treachery at one extreme and unthinking violence at the other, with incompetent bureaucracy, cultural conservatism, and the ideology of success at all costs in between. The position of cinema seems to work along this axis, from betrayal to hyperviolence (Tsui and John Woo had a famous falling out over the final cut of *A Better Tomorrow*, and the author of one fan handbook notes merely that he "deserves a place in Hong Kong cinema history because of his influence on directors, producers, actors and genres, but he has only occasionally directed Heroic Bloodshed movies" [Fitzgerald 2000: 11]). At one extreme, cinema appears as an imported, alien device; on the other, as with Phalke, there is the possibility of making one hundred percent local films. But cinema is both a medium of depiction and a medium whose own history has begun to enter its vocabulary. It is this revisionary quality that opens the door for film as historiography. If, then, *Honneamise* describes an imaginary past in terms of a possible future, and *1942* a constructed past as a moral present, *Once Upon a Time* surrenders to the revisioning of a fictional past for an imaginary future: posthandover, post-Tiananmen.

The film is revisionary rather than revisionist. There are certainly revisionist aspects to *Once Upon a Time*: the "yellow peril" and its "white slave trade" dear to orientalist Hollywood (Marchetti 1993) are stood on their heads to reveal the Americans as the traders in women as sexual commodities, their features stereotyped with long faces, distorted Cantonese accents, caricatured villainy, a propensity for stupidity (as when the Americans are fooled into firing a cannon into the British ship). Like Jackie Chan's *Project A*, there is scant respect paid to the detail of chronology. Instead, the historical sources are the popular memory constituted especially from previous screen avatars of the hero, and constructions of imperial bureaucrats and foreign traders derived from earlier films. This is not a history film in the way that Neil Jordan's *Michael Collins* is, a carefully documented recounting of a critical period in Irish history, whose director was deeply conscious of

the "inaccuracies" and condensations introduced by the necessities of economic scriptwriting (Jordan 1996).

These films—*Honneamise, 1942, Once Upon a Time*—are revisionary, then, because they do not so much revise history as revision it, look into it with a new mode of envisioning the relation between the past and the present. Revisionary movies draw on older traditions of depiction—the long centuries of Japanese graphic arts, of popular melodrama and divine dance performances in India, the recent but nonetheless powerful traditions of film and television in Hong Kong laid over the popular traditions of circus, sport, and opera. And what they revision is the old vision. To some extent they are visionary too in that they displace the fate of the present, opening instead a vista onto an elsewhere that, although it may not be exclusive to cinema, is nonetheless happily at home there—the popular traditions of ghosts and the uncanny, cinemas of the invisible. Revisionary film addresses those mysterious forces and offers in cinemas that are ready to forsake the Western ideal of realism, the possibility of understanding how they might remake the past and so make the present other than it is.

Contemporary historical film (an informative oxymoron) needs to be revisionary, needs to undertake the deconstruction of the present, and most of all in the territory of identity, because identity is no longer a stable creature. *Gwailo* and *gaijin* jostle in the elite meeting places and boardrooms of world cities like Hong Kong, Tokyo, and Shanghai, in production centers like the software farms of Bangalore, and in political centers like New Delhi. Chinese and South Asian diasporas spread across the Pacific and Indian Oceans, articulated through the circulation of popular films with an increasingly distant home culture. Japanese businessmen throng the corridors of transnational corporations, Chinese students attend universities, Indian medics staff hospitals around the world. "Since the entire *Once Upon a Time in China* series involves movement from one geographic location to another, it also posits a particular definition of diaspora related to questions of national and cultural identity" (Williams 2000: 11). The significance of Indian and Hong Kong films to the South Asian and Cantonese diasporas is only one element of their global success. The significance of Hong Kong movies to the African diaspora in the Caribbean, the United States, and in the U.K. as well as the important Korean market is paralleled by the significance of Bollywood in the former U.S.S.R. and throughout the Arabic-speaking world, not only among migrants. Japanese animation studios have now spread throughout

Southeast Asia and furnish television screens with children's adventures worldwide, leading out from cinema toward computer games and toys like Pokemon, tamagotchi, and neo-pets. The sequence early in Wong Kar-wai's *Chunking Express* where Brigitte Lin's character sets up a smuggling deal with Indian cobblers indicates the rich interplay of Asian cultures. But for *Once Upon a Time in China*, the final confrontation is intranational.

Wong Fei-hung's grace lies in the perfection of the gesture with which he completes a gymnastic stunt to settle like a landing bird, incarnate harmony, weight on one curled leg, one leg and arm balletically extended, and one arm poised in a curve as gracious and relaxed as a heron's neck over his nonchalant and impassive face. The balance is inward, energy concentrated in the absolute moment. His opponent Master Yim has his own characteristic pose: a huge iron weight has slipped at speed into his spine, as he stands like a circus strongman, obdurate and unflinching in accepting this punishment, protected by the magic of his "pugilist armor." There is the unmistakable confrontation between the upright man whose arts and skills are not for sale, and the forthright man, whose are. It is scarcely a challenge to read off from their interface a criticism of the neoliberal capitalism of Guangdong, now the largest and fastest growing urban conglomeration in the world, already past a population of seventy million, already beginning to stifle in its own pollution. Skill, invention, craft are devalued when they are riven away from the ethic of honor.

Stripped of the rituals of religious observance and divorced from its function as official ideology of the Mandarin bureaucracy, Wong Fei Hung's Confucianism strikes as a straightforward code of ethical behavior whose impetus is toward comfort without excess, decency without self-righteousness, and satisfaction grounded in peaceable coexistence with others who will wish no harm if they are decently fed, clothed, and housed. It is a gentleman's code, one that will be ridiculed in other films of Tsui Hark's, but which serves well here as counterfoil to the self-seeking amoral Yim and his greatest skill: the ability to take a beating.

Wonder and Dream

The struggles for modernity, historicity, identity, and nationhood enacted in *1942*, *Honneamise*, and *Once Upon a Time* can draw on the immense wellsprings of tradition in India, Japan, and China. They also share the fact that each boasts a large, mature film industry that has explored that history as

| Figure 12.5 |

The Navigator: Griffin: figure-ground relation becomes figure-history relation.

myth, as epic, and as legend. Aotearoa New Zealand, whose double naming indicates its precarious balancing of two cultures, has neither. Something more like the Western is required: a narrative of origin. In his 1989 film *The Navigator* (figs. 12.5, 12.6), Vincent Ward imagined a visionary history rife with ambiguity: an allegory without a key; a prophecy of the present folded into its own betrayal. Cinema is surely a time machine. So, in Ward's version, is history: a device rediscovered in an abandoned mine, a technology for burrowing through time. This tentative moment of imagining nationhood, in a young country that has still not abandoned its colonizer's flag or its sovereign's face on its currency, is bounded in time. In the years since the film's release, Aotearoa has reoriented toward the Asia Pacific, recognizing the triumph of geography. But the moment prior to that emerging consciousness, the moment as it were of waking, is all the more fascinating for its rarity and its ephemerality.

This film is an extended moment of realization, of firstness. As such it is sunk in time like a stone in mud, or better still like the Wingèd Car of Ed Dorn's *Gunslinger:* "the space has *no* front it's *All* rear" (Dorn 1975: np). It is

| Figure 12.6 |

The Navigator: the texture of history.

a moment of wonder. Wonder is entirely bathed in time, in the instant of "before." The sublime stands above and beyond time, proposing good and evil as equally ineffable and absolute—the nonnegotiable evil–sublime binarism enacted in the television images of the September 11 events. Wonder, on the other hand, is dialectical, and it is this dialectic that intrigues Ward's *The Navigator.* Wonder winks into existence only to eradicate itself, to instigate the chain of understanding, and so to wipe out the first, marvelous incomprehension with which we confront the world as familiar stranger. Ward's wonder, without a cause, emerges into the present without a past but, unlike the sublime, equipped with a future in which its meaning will be understood.

Understanding (if not the explanation) of the wonderful is always future. In a remote medieval mining village in Cumbria, the young lad Griffin has visions of a great church in a celestial city. Threatened by the advance of the Black Death, the miners of the village follow the boy's lead into abandoned workings, burrowing through the earth until they arrive, with no further explanation, in twentieth-century Auckland. There they hoist a cross,

the "spike," to the top of the cathedral, while the more bizarre elements of the dreams become clear: an iron whale, a horse in a rowboat, a wind that forces a man's mouth into a voiceless scream . . . The boy's eventual death does not explain his vision, already miscellaneously (and wrongly) interpreted by his companions, but his miraculous sacrifice is braided in with wonder's dialectical other, monstrosity: the apparent betrayal of the village to the plague. What makes this wonderful is its strange temporality, where the greatest doubts settle on the existence of the modern city. Todorov suggests that, confronted with an inexplicable event, we must choose between deciding that the experience was illusory, or accepting its reality and therefore doubting the laws we assume to govern the world. "The fantastic occupies the duration of this uncertainty" (Todorov 1973: 25). Ward leaves unclosed the duration of uncertainty, a condition proper to a country whose not-yet existence makes it entirely wonderful.

Reading Bazin against himself, we might say film arrives at Being by erasing history in order to confirm the contemporary world in its perpetual present, as it appears in the eye of God. Cinema provides the technical as well as metaphorical bases for the mosaic montage of events that constitutes history as static residue, as standing-reserve: the exemplary medium for the commodification of time. Though a cinema ticket buys only the right to a seat for a specified duration, the experience on offer erases geography as surely as it passes time. From R. W. Paul's 1895 patent for a cinematic time machine (Barnes 1976: 37–40; Chanan 1980: 226) to IMAX, film inaugurates the placeless, timeless domain of accelerated modernity.

And yet cinema's attraction for audiences rests on the provision of place and duration. In varying ways total, realist, and classical film construct formed and formal symmetries, closed and enclosing diegeses that please through their difference from the anarchy of production, the chaos of urbanism, the drift of subjectivity and the shock of the new, constructing a holistic experience out of the fragmented visions of everyday life and diurnal fantasy. *The Navigator* does not offer a satisfying edifice of ordered coherence, totality, or surface. It images the real as fantastic, as when the harsh winter mountains of New Zealand's South Island double for Cumbria in stark black and white (Ward 1990: 159–161), rendering the world not as presence but as a process trembling on the brink of becoming. This is not totality but a relation to infinity, to possibilities branching out from any moment of the present. Its time is not messianic, its potentiality not filled in

by a single, defining, sublime, extrahistorical stroke. Rather *The Navigator* opens history as secular futurity, bereft of certainty though guided by determinations from the accumulations of the past. Chance has its role to play, as it does in melodrama and surrealism. Coincidence, entirely proper to Virilio's age of the accident, is no more insubstantial than the vision that guides or the knowledge that must be analyzed and critiqued if it is to retain the status of knowledge—and which therefore must always be, like a vision, partial, temporary, and local.

Unhappily deprived of past and future, the film investigates the dimensionality of the present: as Hansen writes, drawing on Kracauer's sense of cinema as alternative public sphere, cinema "engaged the contradictions of modernity at the level of the senses, the level at which the impact of modern technology on human experience was most palpable and irreversible" (Hansen 2000: 342). Ward's medievals are alienated, but their story is not one of lost wholeness. Rather, wholeness is deferred, and they are alienated not from their history or traditions but from their future, their unknown, unnamed capabilities. This is how the boy, particularly, finds himself in the dialectical previsionary state of remembering the future. Because he is medieval, that memory incorporates not the unrememberable but in any case contingent moment of dying, but instead the determined ritual time of burial, not the event but the sign of the event, a sign that, rather like Deleuze's crystalline description, "stands for its object, replaces it, both creates and erases it" (Deleuze 1989: 126). In Griffin's vision, the sign of death is future-perfect: it will have happened. In this sense the boy shares God's atemporal view. But the vision is without meaning, its thirdness a blur, and the film's historical work will be to unravel the secondness, the system of objects and events that will bring that meaning into existence, a cinematic task. Between divine destiny and human work lies the wonder of a child blinking into vision or a nation into history.

The vision, a flashback that is also a flashforward, works at the level of this schiz, opening a space at once of panic and contemplation in the characters' present. Here the threatened failure of interpretation—the misrecognition of the gauntlet that leads to the misidentification of the sacrificial victim—belongs specifically to that present. But so does the vision of the coffin sinking into the lake. The boy's vision includes a fragment of posthumous futurity—the sole guarantee that what he sees is neither past

nor present. The unthinkable paradox that cinema can furnish beyond words is this future vision whose subject is dead. Like the point of view shot in Dreyer's *Vampyr* seen from the perspective of a corpse (Nash 1976), this drags us into an impossible, paralogical space within the timeless time and placeless place of viewing. A further paradox, common to cinema, evolves from the mismatched time of story and projection. We live in the characters' future, and now even in the future of the modern foundry workers who help the travelers on their quest (the panorama of the city antedates Auckland's signature skyscraper, the Skytower). The coffin vision, then, exists without any of the times available to an audience today, a purely cinematic temporality betwixt and between Cumbria and Aotearoa. This death, far from a total event closing off the narrative and its telling, is instead the objective through which pass into focus all the temporal rays of the filmic situation: a gateway.

Wonder is the shared and common form of amazement, and it arrives in the communication of awe, not in its silenced adoration. Wonder arises from an instinctive appreciation of the universe as awesome, an instinct that in some ages is realized as spirituality or mysticism, and which even in a secular world refuses to be swept away. To some extent, the Hollywood sublime is an example of the return of the repressed: an instinct turned down by left and right secularists alike, which nonetheless returns in apparently unendurable intensity. It is this inexplicable intensity on which the Hollywood sublime feeds. By contrast, Ward's film explores the dynamic interplay of impression and expression, as fascinated by the scamper of emotions over a child's face as in the sight that evokes them. This is communicable. Death, the quintessential unspeakable that in Heidegger as in so much twentieth-century thinking both sums communication and inaugurates it, is here moved into another position in discourse. When discourse no longer centers on the verbal, death no longer concentrates existence as its emanation. The recording angel of cinema does not respect finality, condensing photography's ability to see beyond the grave (Gunning 1995a) and radio's to enquire into the haunting voices of the dead (Morales 1993; Sconce 2000).

Lefebvre's (1991) contestation that space is always produced stands true of time. The universe (and therefore film), the physicists tell us, is composed of matter, energy, and information. But the constitution of the film as meaningful involves a fourth dimension, that of communication, and it is in

communication that time and space are constructed or produced. Homologies with the physical world are misleading: human regimes of communication are not informational in the physical sense. Their characteristic form is fluid, and they are not homeostatic. Cinematic materiality appears null—film appears immaterial—only because, like any abstraction, it is the result of a collision of materials. The flicker of light reflecting on the depthless sheet of the screen is matter in the state of equilibrium, the zero of random movement that you can see by walking up to the screen during projection (or examining a TV screen with a magnifying glass). It informs in the cut, the inward organization of indefinite movement that unifies into objects. Energy in the cinema is the production of signifiers, and it is here that the dialectic of random equilibrium and unification is necessary, for from it alone can come definite but infinite trajectories of meaning, the excess of signifiers in which, like nature for the "savage mind," the cinema excels for the modern. Film operates, like all human communications, on a number of timescales, from the near-instantaneity of celnet pict messaging to the slow passage of shipborne trade, and slower still the passage of ideas from generations long dead in altered landscapes, pedigree beasts, technologized dead labour. Film renders physical the processes of communication: giving them dimensionality, structuring their energy as objects, informing their multiple temporalities.

Genetic data, bits of biological information, are far slower to evolve than ideas because they lacks the communicative function of betrayal. *The Navigator* betrays its viewer by representing the narrative as a story told in the mine; the boy Griffin is deceived by Conor, who has dissimulated his infection to the village; the plague cheats Conor by passing him over with nothing but scars; and the vision has tricked Griffin by taking him not once but twice, at the cathedral and now, in the dawn in which the angel of death was to have passed over, seizing him as the only victim of its passage. Most of all, the vision betrays all those who participate in it by bringing a salvation in which none has any faith. Darwin's world has no option but to speak truth. The human universe is a patchwork palimpsest of degradations, dogmas, fictions, lies, misunderstandings, coincidental signs, and random gestures. The travelers' first sight of Auckland is at once a vision of the City of God and of Pandemonium,[3] a massive machinery of mutation and evolution. Monsters and wonders are its ineluctable outcome.

Today, as the nation-state's legitimations wither (Habermas 2001b), one remaining role for the state is the construction of identity, a task explicit in the constitution of the New Zealand Film Commission, the film's cofunder. As Huyssen (2000) argues, memory has become an affair of state, from the musealization of culture to reconciliation tribunals, the "sorry" campaign in Australia and the negotiations over the Treaty of Waitangi in Aotearoa New Zealand. No longer monopolist of violence, the state is now sole agent of legitimate rememoration. The normalization of language (Balibar and Laporte 1974) and the role of print (Anderson 1983) disguise the contemporary truth that spoken and written words fail to communicate across intercultural divides. Cinema proposes not the visual but the process of making, and making physical, as utopian alternative to linguistic exchange. In one important scene, the time-travelers come to an Auckland foundry to cast their copper. Although the audience understands both sides of the discussion, the dialogue makes it clear that the New Zealanders cannot comprehend the Cumbrian dialogue. But both crews understand the praxis of smelting and pouring into moulds. The literate culture of the West has clung for too long to the primacy of language, a universal in our models of dialogue. Ward's film intimates the utopian moment of intercultural communication via another mediation: that of making. Making transcends ostensible borderlines separating languages, cultures, times, and places, challenging the universality of language with what Mignolo calls "diversality," "the relentless practice of critical and dialogical cosmopolitanism rather than a blueprint of a future and ideal society projected from a single point of view" (Mignolo 2000: 744). The emphasis falls on "practice": on the particulars of practical knowledge rather than the universals of abstraction. The medieval word comes to the rescue: smithing was a "mystery," a craft guarded by the guild, whence its modern sense of secret knowledge, but first of all it was a set of skills that permeated the boundaries between cultures and made the making of a world possible and thinkable. The common, shared work of making is the foundation of Ward's utopia.

The journey to the future anterior is both escape and arrival. Equipped with a medieval sense of wonder, the travelers marvel but are never thereby either accommodated into the strange world they visit, nor shifted from their own understanding of who, what, where, and when they are. Only how they live is altered, but not by the arrival: rather by the vision and its betrayal.

This twist in the construction of history as special effect is previsionary rather than revisionary, and it plays on the impossible synchronicity of the recorded image to identify the moment of viewing with wonder at the unheard of and the unforeseen. When the film shows us the boy as storyteller completing the tale of the journey as though it had never happened, we are in the presence of historiography. When we recognize the final fragment of flashforward as foreknowledge, we understand the gap between vision and dream. Vision is a wonder, catapulted from an otherwhere or otherwhen, carrying the promise of a fulfillment that is always future. A dream is already a sign, already heavy with meaning, already determined by the dreamer's communicative world.

The film's final betrayal, when the image of the silver cross sinking beneath the black waters is identified as the boy's coffin, betrays because it anchors the vision in a truth it possesses despite itself. History, in as much as it is the vehicle that gives nationhood imaginative meaning, should always be such: a history of the future more than a vision of the past. In the neobaroque and digital cinemas of destiny, we stand near the end of the journey; in revisionary and even more so in previsionary cinemas, we stand at the beginning.

COSMOPOLITAN FILM

Audiencing

the junk merchant does not sell his product to the consumer, he sells
the consumer to his product

—*William S. Burroughs*[1]

Cosmopolis

It remains for us to watch for the signs of the next twist, the resolution of the
dialectical impasse that confronts the methodical ordering of reference with
the dematerialization of liberty, the pursuit of narcissism with the dis-
mantling of reality, the unhappy dialectic of peace and freedom with which
the superpowers faced each other in the last years of the Cold War, two
theses that were and are not only mutually but internally contradictory. Our
most powerful cinema confronts and enacts these themes, just as our most
popular raises them to soothe the ragged heart they lacerate. The BBC's old
motto, "Let nation speak peace unto nation," falls foul of this dialectic, and
once again, speech is the culprit.

Never has the need for intercultural dialogue been so necessary. Rarely
have the conditions for it happening seemed so remote. This final chapter
looks at some films that have tried to win a global audience, and which, in
the process, have had to invent as a special effect an address to the audience
that might constitute it as global. Is this a vain enterprise? Is it only enter-
prise, with no utopian content whatsoever? Isn't the purpose of postideo-
logical film entirely changed from the days in which it might have been
possible, as it was for Griffith, to imagine cinema as universal language
(Hansen 1991)? After all, Luhmann argues that "It is certainly true to say
that entertainment is one component of modern leisure culture, charged

with the function of destroying superfluous time" (Luhmann 2000: 51). In the end, isn't that all the attempts to formulate a global cinema comes down to—a radical and sublime eradication of any time that is not otherwise devoted to the production of profit, a process in which human being is increasingly irrelevant?

The audience is the last unquestioned zone of media theory. There is the audience. Empirical market research gives us statistical data of more or less, often less, reliability. Against all experience, it equates pleasure and meaning with the purchase of tickets. There is little between the test audience for films shown ahead of release with a view to recutting or reshooting, and the raw box-office statistics, open to all kinds of tricky recalculation since the box-office gross is the final accounting mechanism on the back of which all partners in a film get paid.

Nonetheless, media studies never doubts the existence of an audience. Reconceptualized in the 1970s and 1980s by David Morley (1980, 1987), audiences began to be understood academically in more sociological terms: as people rather than statistics. Although this approach solved, for a time, the problem of inferring audience responses from textual practices, it did not get beyond challenging the practice of audience analysis. Changing the method from large-scale but shallow market research to small-scale, depth interactions revealed a great deal—much of it of use to advertisers and commercial TV operators. But the object "audience" remained in place, and if anything in an even stronger ideological position than it occupied before in the rationalizations that began in the premise of "giving the people what they want." The problem lay in the hypostasis of "the people," and the identification of the people with the audience.

John Hartley gives a powerful analysis of the proposition in the brief essay entitled "Public-ity" that introduces his book *The Politics of Pictures*. The public, he argues, exists only as a discursive effect. Public life is conducted so thoroughly in media forms, that

the audience for popular media is a discursive production too; an "invisible fiction" produced and deployed by the institutions which have most to gain from its existence. If the public and the audience are indeed discursive productions, there's not much point in barging into people's living rooms to watch them watching telly. Better to look at the discursive production of audienceship, and to reconceptualize the activity people undertake in their homes as something

neither autonomous nor authentic but the end product of a discursive strategy in which viewers are participants but not original sources. (Hartley 1992: 9–10)

Viewers exist only as viewers *of.* There is little point attempting to imagine a person that exists prior to and outside the communicative webs of contemporary mediation because there is no such person. Personage is, in contemporary life, a function of mediation. So too of course is viewership, audienceship. The entity "audience" exists as the object of an activity whose purpose is in part simply to produce it. At the level of the nation, the level at which modern politics still operates, television has been the privileged medium, especially in countries like the U.K. where terrestrial channels still serve a nationalizing purpose. This is why it is so typical that Aotearoa New Zealand's most impressive work of national mythology should have taken the form of a television documentary (Perrott 2002). The cinema, however, seeks its audiences by and large internationally, for commercial, ideological, or cultural reasons. Hartley's proposed methodology is therefore even more applicable to contemporary cinema: "it is not a question of contrasting a real public with the illusory media (almost vice versa, in fact)" (Hartley 1992: 2).

The audience for a particular movie is as much a construct as its author. "Authorship" is never the property of an individual: it is an institutional and discursive function. No one—not Renoir, not Peckinpah, not Ward—makes a film alone. Nor does any film spring unheralded from the mind of a creator: it draws on myriad technologies and techniques to apply them to a certain, determinate film. Authorship may also be seen as a kind of legal and bibliographic fiction, a way of organizing the vast array of texts into searchable order (Foucault 1979) and of ascribing ownership in copyright (Gaines 1992; Coombe 1998). Likewise, no audience comes to a film ignorant of cinema, or of their role in realizing it. The task of cinema is to deliver audiences to films, and the task of audiences is to constitute films as objects of consumption.

Undoubtedly the intersection of previous mediations constructs a spectrum of viewing positions (for example, Batman fans, Prince fans, people who care little for either or both but caught the promotions or the word-of-mouth [Bacon-Smith and Yarborough 1991: 90–91]). Buying the ticket and entering the auditorium are acts of surrender to the economic and filmic machinery of cinema. Watching (as opposed to necking or walking out) is a surrender to the film itself. Ethnographic research on film, however, is

always after the fact, never conducted where spectatorship happens, in the cinema itself where any attempt to elicit a response ruins the experience it tries to capture. Cinema has its own uncertainty principle.

Acceptable behaviors in cinemas vary from place to place (and show-time to showtime: children's matinees, evening performances, midnight screenings) but they are always shaped by acceptability, a correct way to watch a film. To become audience, we have to submit to that discipline, or knowingly transgress it. To paraphrase Marx, people make themselves audiences, but not under conditions of their own choosing. A population becomes an audience not so much by an act of will—the argument of free-enterprise capitalism—nor by acts of negotiation—the culturalist approach—as in an agreement to be mediated, the cinema audience no less than the television spectator. In the closed market for TV ratings in the United States, argues Eileen Meehan, "advertisers, networks, and now cable channels buy ratings from a ratings firm whose success rests on the ability to serve continuities in demand, to manipulate discontinuities through measurement practices, and to design measurement practice[s] as strategies for market control. This means that ratings and the commodity audience are manufactured in the strictest sense of the word" (1990: 132).

The AC Nielsen ratings system analyzed by Meehan derives its figures from "people meters" installed exclusively in cabled homes, restricting the sample to a grouping that shares nothing but its meterage, and lacking the usual social-scientific backdrop of either random or representative sampling. This exclusive audience forms the commodity for which advertisers pay and networks compete—this audience that is truly commodified. Yet with ticket sales as a guide, cinema audiences are more easily tracked in the mass, though the statistics of box-office take do not distinguish premium priced seats from cheaper suburban sales and are designed to exclude the vast audience for Indian, Chinese, and other cinemas from competition with the box-office gross numbers for U.S. product. Not least since ticket sales figures are heavily touted in promotional campaigns for film releases, to become an audience is to become a commodity.

To become an audience is also to become mediated. Economic agency is now cultural consumption in a system where audiences mediate between brand image and point of sale. More, our personal media histories, the background of TV programs, comics, movies, and games that we bring to our selection of things to watch and ways to enjoy them "mediates our present

day desires and gives the past an imaginary status that strips away closure, opening it up to personal (although culturally-mediated) fantasies" (Spigel and Jenkins 1991: 142). The proviso about culturally mediated fantasies indicates a double mediation: memory of past shows mediates mediated fantasies. The personal fantasy, the intimate moment in which we are supposedly most ourselves, is an effect of the processes of mediation. If it is also true that economic exchange is a mode of communication thoroughly mediated by systems of fiscal transaction, a third mediation constructs the audience, who are then mediated again as statistical evidence of success, artistic or financial. When it comes to the manufacture of audiences, there is no distinction between commodification and mediation, for the commodity is the single most characteristic mediating form of capitalism, and capitalism itself is a vast system for constructing communicative webs, albeit webs that persistently fail to communicate more than the glamour of the commodity and the brutality of exclusion from it.

In the age of globalization, it is not surprising that film production should aim at maximizing its audiences by developing product that might appeal to an even more diverse, global population. The construction of such projects as *The Matrix* and *Crouching Tiger, Hidden Dragon* involves the invention of a new form of audience, the global audience. As used in television discourse, the phrase denotes the aggregate number of viewers tuning in to worldwide media events like the Olympics, a critical number for example in Coca Cola's sponsorship for the company's hometown Atlanta games. Capital, "that most aggressively universalizing of categories" (Pollock et al. 2000: 586), globalizes by expanding the commodity relation into the management of planetary communication. Such management requires a media formation of its own, the burgeoning discourse of management communication. This universally applicable map of efficiency in issuing commands, recruiting creativity, and monitoring action is only one example of the cosmopolitanism of contemporary capital.

Commonly, "cosmopolitan" describes someone who is at home with every cuisine, with all protocols of etiquette, who is at home in the world and with its citizens. It was an élite formation, specific to the diplomat for a hundred or two hundred years, the object of Kipling's and Forster's moral fables on how to live correctly in India, the enviable suavity of James Bond. The cosmopolite, whatever his or her origins, always knew a little place around the corner. That special knowledge, however, could not survive the

expansion of capital into its own management, and cosmopolitanism has become, over recent decades, a commodity, sold through travel guides, consumed as hybrid cooking, branded and attached to cigarettes, soft drinks, alcohol, and perfumes, hotel chains and news networks, and used to entice an increasingly peripatetic managerial class. The consumer of this lifestyle option, to use the marketing cant, was neighbor to the consumer of art-house cinema, the refined, urbane inhabitant of other cultures, the incarnation of neoliberalism's pluralist multiculturalism. From the politics of recognition (Taylor 1992) to the politics of inclusion (Habermas 1998), cosmopolitan intellectuals sought a peaceful, conflict-free assimilation of difference to the universal truths of the West, the forgiving embrace of the commodity.

On the one hand, there is the drive to produce a class of global managers with a cultural repertoire adequate to the needs of the system. On the other, there is the imperial expansion of capital. The latter, which drives the film business like any other, drives the construction of a cosmopolitan audience for, especially, Hollywood film. Hollywood is not alone in this—offerings from Hong Kong (*The One*, fig. 13.1) and India (*Asoka*) have attempted to penetrate the highly protected U.S. internal market—but Hollywood is most often a partner in such operations, backing cosmopolitanism both ways. The cosmopolitan film commodity aims to achieve, in its pluralist way, the project Wyndham Lewis once ascribed to Nietzsche: the popularization of aristocratic attitudes (Lewis 1968: 114). The construction of cosmopolitan audiences as a privileged, commodified mediation of spectatorship involves the democratization of elitism.

Inseparable from the concept of globalization, informationalization describes the way in which communication has changed during the course of the twentieth century, and its likely trajectories in the early twenty-first. Mediated as it always is by material process, human communication has a history. The mode of communication changes as its mediations alter. Since the emergence of a world economy in the sixteenth century (Braudel 1984; Wallerstein 1991), the dominant medium of human communication has been money. During the last seventy years or so, that centrality has begun to be displaced by information, understood here in its technical definition, a structured pattern of data. Informationalization is the process through which economic domination becomes information domination.

| Figure 13.1 |

The One: after *The Matrix* stole martial arts for the blockbuster, Hong Kong steals sci-fi effects for the martial arts film. Courtesy BFI Stills, Posters, and Designs.

For example, as electronically traded, money itself is now a structured pattern of data. So are demographics, data on earthquakes, the latest Hollywood blockbuster, a CD of Lata Mangeshkar, and this word-processed text. The cosmopolitan commodity is not entirely mediated by money: money itself has become a commodity to be traded as data set, and the structure of commodification has thus altered internally. The cosmopolitan lives in the world as data set and is no longer afraid to recognize that fact, at least since Gordon Gecko's "Greed is good" speech in *Wall Street* won Michael Douglas his Oscar. The politics of inclusion and the self-reflexive acceptance of mediation as data combine in the postmodern ironies of *The Matrix*, but they also produce bizarre variants on the neobaroque in their quest for a magic formula that will construct once and for all a global moviegoing public. Commodification and mediation of audiences combine in cosmopolitan informationalization: audience as data set.

Cosmopolitanism corresponds to informationalization because it operates in only one direction. The cosmopolitan is at home in the culture of the

other, but he does not offer the other the hospitality of his own home. To the extent that cosmopolitanism arises as a cultural option in the era of immigration control, it is antiethical, in the sense proposed by Derrida, for whom (drawing on the Greek meaning of the word *ethos*, home) "Insofar as it has to do with the ethos, that is, the residence, one's home, the familiar place of dwelling, inasmuch as it is a manner of being there, the manner in which we relate to ourselves and to others, to others as our own or foreigners, ethics is hospitality" (2001: 16–17).

By abandoning the ethical commitment to hospitality, the cosmopolitan abandons the ethics of the face-to-face, the ethics of communication. The other becomes a data set, an object to be managed. But for this to be accomplished, the cosmopolitan manager must sacrifice his own place in communicative networks, must sacrifice what it is to be human. And in this way the manager becomes the data stream and is more thoroughly mediated than those to whom his media formation ascribes object status. Faced with the invisible and inhuman task of identifying wholly with the managed dataflows, this lonely solipsist takes on the formal tragedy of a secular age. This is the figure who is so frequently preordained to the supreme sacrifice: to become the secret savior of the world.

The Proletarianization of Consumption

Deleuze remembers a lecture of Maurice L'Herbier: "space and time becoming more and more expensive in the modern world, art had to make itself international industrial art, that is, cinema, in order to *buy* space and time" (Deleuze 1989: 78). For Deleuze, this is a first intimation of the emergence of the time-image, the direct image of time unmediated by movement he associates with the avant-garde cinemas of Antonioni, Resnais, and others. Where time is money, money is a measure of time. In the informationalization of the global economy, information is money, and money is a dataflow whose value depends on its approximation to instantaneity. Deleuze believes that the direct time-image liberates cinema from the sensory-motor bonds of the movement image, but as the time image approaches asymptotically toward stillness, as in Syberberg, it approaches equally the condition of the sublime. In Deleuze's analysis, this approach connotes the achievement of a liberation from time in the films he prizes. On the other hand, if it is the case, as previous chapters have argued, that the sublime has become a trope in the commercial cinema in which historical process is annihilated,

then we should read the achievement of the time-image as merely paving the way for the cinematic institutionalization of the sublime end of history.

Sublimity comes as the end, the absent center of communication. Mirroring both poststructural constitutive absence and Heideggerian being-toward-death, the sublime reconforms both the concept and the phenomenon of experience to its own singularity. Experience may have been founded historically in the embodied face-to-face encounter. Today, although mediation remains material, experience is increasingly abstracted from the physical danger that obtains in any face-to-face situation (the Hegelian master-slave dialectic, Levinas's ethics as first philosophy). The Hollywood sublime is offered neither as a means nor as a practical moment of the mediation process, but as an instantaneous, apparently unmediated and riskless affect enjoyed not for its communicative intent but first for itself, and more recently as the invisible core of a virtual diegesis designed to sublate the becoming of spectators into itself.

The global audience is dimensionless. To the extent that it succumbs to the global media product, and more specifically to the extent that it is a function of information flows displacing even money (or reconfiguring money and the commodity form as information), the sublime effect deprives the global audience of space and time. The audience, as commodity, becomes that full void of the commodity fetish that, as secret core, goal, and medium of informational capital, it must be.

At the extreme of subsumption to the diegetic is subsumption to the singularity of the sublime. The construction of binarism is mere paradox: evil disappears into the anethical absolution of difference that is the sublime. Evil at the moment of global audience, that evil so utterly abjected in the blockbuster cosmology, turns out to be only an aspect of the *informe*, only the unspeakably vile as the sublime is the unspeakably lofty. Sublime and evil are lifted into infinite unity in the "unspeakable," the extraction from communication that also extracts from history.

Since what we occupy is space-time, the global audience is also banished from geography. The partition of the world into a cartographic grid of time zones, currency zones, zip and postal codes, informational spaces (Curry 1998) deprives location of its "thereness," at least in the information economy. The more data fuses with money, the less locality bears on consumption, save only as a numerical parameter of consumption. As space sheds its sensuous particularity—its use value—in exchange for information value,

it loses its dimensionality to become the entirely communicable object of strategic market planning. To that extent, space ceases to be produced, as it still was when Lefebvre wrote (1991), and begins instead to be consumed, not so much by its inhabitants, but by those whose charge it is to extract its surplus value. That value is now attached not, again, to production but to consumption, the privileged site of profit. Insofar as the audience is global, it is removed from space. Insofar as it is audience, it is removed from time. Insofar as they are global, differences are assimilated into the democratized elitism of the cosmopolitan, and insofar as it is removed from space and time, the cosmopolitan is ineffable.

Film history acts out the transition from production economies to consumer economies, from the object commodity to the information commodity, and from the trade in objects to the trade in audiences. In the nineteenth century labor became proletarianized. The factory became the type of work discipline, the worker became an alienated object, a cog in the machine, at once the feared and despised tool of the factory (the "hand") and the archetype of a newly socialized humanity (Wollen 1988). At the heart of the alienation that Lukacs (1971) understood as the core experience of proletarianization lay work discipline (Marx 1976: 544–553). But work discipline would not remain unique to the factories. It enters the office trades in the late nineteenth and the retail trades in the mid-twentieth centuries with the mechanization of data entry, record keeping, and arithmetic, stockkeeping and telling, the computerization of barcodes and electronic point-of-sale technologies. It remains associated with the intensive gendering of employment, with the division of labor, with deskilling (the transformation of living labor skills into dead labor, fixed capital, technology), with managerialism and with New Age–inspired variants on human resource management (Ross 1991).

In the twentieth century, consumption became proletarianized. The origins of the process can be traced back to the last decade of the nineteenth century and the rise of the department store, the invention of the female flâneur, the impact of cheap colonial materials on the fashion industry, and the rise of advertising (Peiss 1986; Rappaport 1995; Richards 1990; Williams 1982; Wilson 1985). These entrepreneurial innovations became economic doctrine in the wake of the Great Depression of the early 1930s, when Keynesianism in its various forms descried the priority of market development if capital were to survive. Unsurprisingly, the first industries to

be hit by this reorganization of capital toward a market-driven model were the emergent broadcasting industries. In the United States of the 1930s, then the leading industrial economy, radio broadcasting was the first business to be shaped by a new paradigm: the sale of consumers. At the beginning of the new century, few countries retained advertising-free, government-run channels. All others were operated on the basic principle of delivering audiences to advertisers.

Just as the proletarianization of the workforce demanded work discipline, the proletarianization of consumption demands consumer discipline. For early broadcasters and still today for comparable industries such as domestic energy, consumer discipline need only be organized in the mass. Early consumer discipline did not require that individual consumers govern their activities to match the temporal and spatial organization of production, at least not in the way that the factory worker had to internalize the discipline imposed by the rhythms of the machinery. Consumption as a mass activity followed only the broad outlines laid down by the media, such as attending during prime time. But with the advancing division of consumption, especially since the Reaganomic and Thatcherite era of savage deregulation, into specialized zones, times, channels, and media, the mass audience no longer serves the needs of capital. Consumption must be organized. The proliferation of channels, and later of media (cable, satellite, video, DVD, remote control, computer games, internet, and "convergent media"), structures the consuming day according to constructions of consumers as demographic classes or, in the more polite and apolitical language of the 1990s, lifestyle groups. The advertising industry, which treats each publication as a distinct medium, thus structures campaigns according to the success of a radio channel, a newspaper, a magazine, or a TV program in attracting the attention of a definable audience type.

The consumer is charged with three disciplinary tasks: recognizing which type of consumer she is, unearthing the correct media for her lifestyle group, and attending to the correct media in the correct ways. During the 1980s, research demonstrated the minimal attention paid by viewers to television (Cumberbatch and Howitt 1989). In these circumstances, merely being in the domestic space with the television turned on was no longer adequate to attract advertising spend. The new commodity was no longer absolute numbers, nor even shares of a specific lifestyle group, but levels of attention. Now that attention is clearly the commodity exchanged in the

advertising business, the job of consumers has become more demanding: they must not only note the existence of media designed for them, but also give them appropriate degrees of attention according to the exchange value they attract.

Some groups are poorly disciplined. Early adopters are notoriously hard to attract and even harder to keep. They will latch onto a program, for example, before its exchange value has been fixed, guaranteeing that its price rises. However, once the exchange value has been determined on the basis that it brings with it the valuable attention of early adopters, they have moved on, bored, or, under the influence of an elite conception of their own cultural capital, decrying the now expensive medium as popularized.

Other groups are simply not valuable. Those that devote the most attention to advertising media—the unemployed, the elderly, the poor—devalue their attention by overexerting it. Their lack of consumer discipline, like their supposed lack of work discipline, discriminates against their exchange value in ways even more significant than their cultural kudos. Other undisciplined consumption, such as aspirational viewing or slumming, likewise stirs rumblings, and even precipitates radical actions like the Chanel No. 5 campaign designed to lose the product's new downmarket buyers to retain the cachet of exclusivity on which its fortunes were founded. This is an exemplary form of disciplinary action against the abuse of consumption by consumers.

An immediate consequence of informationalization is then that the means of production no longer holds pole position in mediated formations. Attempts to seize control of the means of production are unable to alter the fundamental logic of consumerism: that the highest value is the rapt attention of the target audience. Work of excellence in television, for example, can only either more successfully target a lifestyle group, or best of all serve to identify a previously unknown and distinctive lifestyle cluster on behalf of the trade in attention. The media industries, narrowly defined, were only the first to recognize that the customer base is a tradable asset, now a truism of business mergers and acquisitions. They were the first to reveal the centrality of distribution and its preeminence over production. Distribution companies trade in structured knowledge about suppliers and consumers and the ability to assemble that knowledge into strategic spatiotemporal organizations. These organizations convert products into media and consumers into audiences.

The globalization process that proceeds hand in hand with informationalization looks after the global export of consumer discipline as it did over the global export of work discipline. An immediate effect has been the proletarianization of family as the unit of consumption in Keynesianism. Charged with both disciplining consumption and reproducing the social consumer force, the family is increasingly prone to intergenerational dysfunction and divorce. In developing economies, the size of extended families and their functionality comes under extreme pressure, falling to struggles over the distinctions between tradition and modernity, the former characterized by its conformity to older, production-era work discipline, the latter by its adjustment to contemporary consumer discipline. Expressed as antonymy rather than dialectic, there can be no resolution in choosing between clinging to an outmoded local media formation, or adapting to the demands of global informationalized consumerism.

Contradictions arise instead at the level of the failure of capital to fulfill the desires it creates. Consumer discipline demands the division of consumption between members of a family by age and gender, while demanding that the family respond as a unit to the culturally specific disciplines we know as tradition. So tradition itself is becoming a consumer discipline, as in the use of Bombay movies in the subcontinental diaspora, where the tradition loses its specificity, while acting as a contradictory demand on the gender and age discipline otherwise binding on family consumption. At this juncture, the proletarianization of consumption comes into contact with the hyperindividualizing process, in the ideological formation of "it's up to you to discover your place in the world." This is both an ideological demand (know what you are supposed to consume and what kind of attention to pay to it) and a philosophical statement concerning the nature of existence in mediated formations. Each person has a destiny, which takes the form of a task they must perform to secure happiness. That task is their fate and is written into their lives.

The position of cinema in this process is anomalous. Cinema, a nineteenth-century medium, emerges from the work-discipline model. It is thus open to Pierre Bourdieu's (1986) critique of cultural capital. Capital accrues through the selection of a film to attend, and especially the generic action of going out to see it, or even of checking it out from a video store, an act that defines itself differentially, for example, as "not watching television." However, cinema in the twenty-first century is no longer exempt

from consumer disciplines that have encroached on the older elite forms. The bourgeois model of cultural capital still operates among the bourgeoisie, but the proletarianization of consumption removes the cultural cachet from genre pictures. Although cultural capital was strong enough to rescue from obscurity films whose genre was textually based (Western, film noir, gangster), it is unable to resurrect for its uses those new, high-concept genres in which the audience defines the film: chick flick, date movie, action pic, slasher. Cinema release today is only a key moment in the marketing of a lifestyle campaign embracing making-of documentaries, awards ceremonies, junk food, stickers, and television spinoffs. In this sense, cinema release organizes the problem of early adoption. Early adopters can be targeted by their hunger for cultural capital, paying premium prices for early access, functioning as word-of-mouth ambassadors, their resistance to consumer discipline turned into a tool of consumption's proletarianization of the attention commodity.

These processes are caught in Jonathan Beller's observation that "the moving image represents an intermediate state, a synthesis between money and other commodities. This synthetic space is the scene for the valorization of capital through the realization of surplus value. Money-Commodity-Money becomes Money-Image-Money as capital seeks a new armature to administer the extraction of surplus value" (1998: 196; see also Beller 1995). Discussing the transition from manufacture to factory labor, Marx notes that "Along with the tool, the skill of the worker in handling it passes over to the machine" (Marx 1976: 545); "Machinery is misused in order to transform the worker, from his very childhood, into a part of a specialized machine" (ibid.: 547); "In handicrafts and manufacture, the worker makes use of a tool; in the factory, the machine makes use of him" (ibid.: 548). Marx distinguishes between work—the specific human practices of making—and labor—its socialized form that a worker sells to a capitalist. Work and communicating are indistinguishable and intrinsic to human life. But the labor of mediation occurs under specific historical conditions that transform it, in the global audience, into the salable commodity form of attention. This is Beller's "new armature" for the extraction of surplus value, and it involves the subordination of communication to the division of consumption proper to global media. The ability to create, to voice, to interpret, passes over from work to the "specialized machine" of the media industry, the fixed capital in which the sum of human communication is ossified into technique and technology, and

which finally makes use of the audience far more than the audience can make use of the media.

The pure discipline of consumption is learned in the cinema as the archetypal thief of time. That idleness which fired Pissarro's utopian imagination, that distraction which terrified the guardians of morality and civilization in the 1890s, has become the central tool of the anaesthetics of globalization. Under its wing, in the suspended time of audiencing, there is no communication. It is a moot point as to whether globalization ever succeeds so completely, or ever does for more than a moment, or that it can reproduce itself in the same way in different places and at different times. But to the extent that it succeeds in realizing itself, there are no different times and places, nor any differences within the global audience, which is precisely dedifferentiated in its construction as global, its differences assimilated as otherness, a *masala*, into the indifferent sublime. The whole point of global media product is to open itself up to multiple pleasures, to provide not for polysemy—because its goal is insignificance—but polymorphous and polyvalent delights.

So the global audience can, indeed must, draw on multiple and differentiated media memories in all their mediation, to achieve their dedifferentiation in the mechanized rememoration of the cinematic event. Like the private sphere, private intellectual property, which in any case became corporate property during the course of the twentieth century, is no longer tenable as a system of ownership and reward, either ethically or practically. Almost every new medium of the later twentieth century has been both a recording and a transmitting device: fax, tape cassette, video, computer. The culture that has arisen, from Warhol's silkscreens to DVD burners, treats existing media as content for new media (Bolter and Grusin's 1999 remediation thesis). A carefully constructed text like *Casablanca* becomes an item of vocabulary for a metadiscourse—such as this one, or a comic parody (*Gumshoe*), or an elaborate pastiche (*Play It Again, Sam*), or an homage (*Barb Wire*). Despite technological attempts (DVD regional encoding and copyright protection software) and legal wars (the U.S. government's threatened embargo on Chinese involvement in WTO until they agreed to action against copy factories), the gray economy and the cultural practice of appropriation, pastiche and mosaic remain typical of our era. The erosion of privacy, private property, and private intellectual rights all coincide with attempts to restrict and hoard the flow of communication in the informationalization

process. They involve a new configuration of the private individual, no longer as citizen-producer, but as proletarian-consumer.

The old literary category of genre is an attempt to capture this effect of mediated rememoration, but when we ask of *The Matrix* what genre it belongs to, we have to be ready to say "American film" as readily as "science fiction," "fight film" as quickly as "blockbuster," "live-action anime" as swiftly as "star vehicle." Even the star comes freighting multiculturalism, a single body embodying the multiple strands of North American "ethnicity" as carefully selected for the global melting pot as the first crew of the U.S.S. Enterprise (Feng 2001). There are pleasures in recognizing Alice in Wonderland, Jean Baudrillard, or the cityscapes of Sydney, the signature wirework of Yuen Wo Ping and the comic book art of Geoff Durrow. Some of these multiple pleasures compile together in complex harmonies, some are threads worked through the textile of the film. Each is in the process subordinated to the film and thence to its consumption on a global scale. The goal is insignificance: the semantic corollary of instantaneity. Lacking dimension, there is neither time nor space for meaning that can only take place, take time. The significant other, however, is a key component of the insignificant cosmopolitan, as difference is constitutive of indifference. The commercialization of democracy, like the Nietzschean democratization of aristocracy before it, is built not on extending elite privileges to wider and wider populations but on the devaluation of experiences under regimens of commodification from exchange value to information value, a process in which commodity status passes from objects to agents.

Esse est percipi: in Merleau-Ponty's (1968) reading, to see is to be inscribed in the field of the visual. As a consequence of informationalization, being changes alongside the mode of perception. When that perception becomes informational, that is, when the subject is the object for a perception that is wholly or even partially informational, then being is also an informational phenomenon. When perception is no longer dominated by vision, as a consequence of globalization (I am perceived as a customer by those who are not geographically close enough to see me), the consequences of my actions are likewise invisible to me (taking place in some other part of the world), and the aggregate of my actions with those of all the others acting simultaneously deprives my actions, as far as they are dependent on my perception of them, of their being in any ethical or aesthetic sense. And just as my actions are deprived of consequences save as a moment of the aggregate

of large-scale movements within the mediated formation, so my existence becomes a matter of statistical probability.

In the fullest extension to date of cosmopolitan media, this is what an audience does when it audiences: it erases itself from locality and historicity. The dimensionlessness of informational existence alters the conditions under which it is possible to be perceived. Becoming, which is integral to communication, is arrested in the moment of being, a moment at which audiencing loses its dimensionality.

Neo Geo

In this as in so many ways, informationalization destabilizes the causality on which Western modernity was founded. Anchors in the temporal dimension, which placed effects after their causes, are lost in the virtual instantaneity of the global media event. There is no instantaneous communication, but by acting as if there were, the global audience severs the causal chains of Western reason. In their place, we have the imagined spatial perception of the hero, the chih of Li Mu Bai (Chow Yun Fat) in *Crouching Tiger, Hidden Dragon*, of Neo (Keanu Reeves) in *The Matrix*. The prescient martial artist occupies space rather than time, and that space is indistinguishable from any other, a global geometry of arcs, lines, and trajectories in absolute space. The reassertion of geography that Soja (1989) argued for has swung beyond historico-geographical synthesis, space attaining the explanatory centrality once proper to history, but only by shedding in the process geography's claim to local knowledge. Just as the auditorium disappears into placeless darkness, the hypersenses of the hero flood into the abstract space of the screen world. Likewise the diegesis has thoroughly absorbed the time of narrative into a spatialized database of events whose preordained end always guides the unfolding story into an ending that preexists it, as script, as repetition, and as destiny. That abstract space already contains all the events that will occur in it, which is how the hero can occupy it so totally, and in doing so indicate to audiences how perfectly immersion in the medium of cinema can be achieved.

This is one source of the ironic peculiarity of *The Matrix* (figs. 13.2, 13.3), a film that delivers a theory of ideology as cosmopolitan spectacle. As Peter Lunenfeld (1999) noted in a post to <nettime>, "how it looked was something of greater concern, to both its creators and its general audience, than the movie's pop-philosophizing": the spectacle is, after all, what the

| **Figure 13.2** |

The Matrix: Neo and Agent Smith's wirework filmed in bullet-time, digitally mapped via motion control match to greenscreened backdrop: cross-genre film for a global audience. Courtesy BFI Stills, Posters, and Designs.

| **Figure 13.3** |

The Matrix: Time distended—anime style meets Hong Kong action with Hollywood effects. Courtesy BFI Stills, Posters, and Designs.

audience have come to see, and if the story tries to make a case for puncturing the spectacle, it does so in a spectacular fashion that makes the film what it is, a cosmopolitan blockbuster event movie. If *Matrix 2* were to take place entirely in recognizably verisimilitudinous space, it would not get anything like the same audience, anything like the same box-office returns. Like Cypher the traitor, we want the spectacle that Neo has come to destroy.

The film's "pop-philosophizing" has a lot to do with two Philip K. Dick adaptations, *Blade Runner* and *Total Recall*, films in which the status of the real, and especially of the reality of memories, is always in doubt. On the one hand, this is simply a question of the ways in which memory is mediated, as media memory and as medium of mediation, in modernity. On the other, the question of what is inside and what is outside the matrix, how many layers of unreality are hidden within the apparent simplicity of the set-up, is never answered. Schwarzennegger's character, we can still doubt, may be living through false memories: we certainly are. Deckard may be a product of an invented past: the cinema audience surely is.

The question, then, is not "What is the matrix?"—for the answer, varying according to the media memories of its audiences (the military-industrial complex for the LSD generation, the Lacanian big Other, instrumental rationality, ideology, the spectacle, Baudrillard's Code, etc.) is always itself a function of the media memories it evokes and provides. To the extent that these memories are mediated again in the film, they are indistinguishable, and all answers to the question are ultimately the same, uninteresting answer: the matrix is the matrix. The issue is rather how does the film concentrate the commodity audience's disciplined activity.

Yvonne Spielmann (1999) summarizes earlier research on one of the film's key techniques thus: "The main paradoxical features of morphing are thus instability and density." The instability arises from the fluidity of a graphical cinema whose fascination lies in the trajectories of uncertain emerging: the vector. Its density, on the other hand, arises especially in this film from the intercutting between fluid action and fluid framing on the one hand, and static shots clearly replicating careful storyboarding on the other. This second, densifying moment of the image renders the trajectory as design, as stillness, as when a shot foregrounds, as a comic book would, a ringing telephone occupying two-thirds of the screen in sharp focus while the characters strike poses of listening in the blurred backdrop. For the comic, this emphasis equates to the interruption of noise into the silent world of the

graphic novel. Here the effect lacks that purpose. Instead it evokes the grid of cels that make up a comic page, a geometry of stills. The instability of the vector, its perpetual unstillness, begins life as the future-orientation of the moving image: in the cosmopolitan film, it is redirected into the vortex of the still. This is where the infinite unity of the cosmopolitan image arises: as a permutation of cinema's instability into an engine for the production of density. That density can then exert a gravitational force on the audience, moving beyond identification, even beyond subsumption, toward immersion. *The Matrix* is a highly self-reflexive film: it shows onscreen what it undertakes as artifact. To this extent it is postideological. There is no false consciousness, because all the tricks are on display.

Something similar takes place in the mise-en-scène of *Crouching Tiger* (fig. 13.4). The luxurious sets are familiar enough to devotees of Hong Kong and Chinese historical drama. Far more exceptional is the use of locations, several of which—the "Mongolian" desert near the Kazakh border and Wudan Mountain among them—seem almost unreal themselves. A single shot packs reality into Wudan: the brief telephoto image of Jen mounting the stairs. The cut takes us to a wider shot, indicating how enormous the staircase is, but the first shot is the one that places us, not because we see with much more detail the effort of climbing, but because the extreme magnification betrays a tiny tremor in the tripod mount. For that one moment, we have a kind of evidence of physical presence. But more than one audience member has checked whether the wide shot was CGI or not, so exotic are the geology and the colors.

Such images and sequences hover between reality and unreality, like the landscape photography of *National Geographic* (Montgomery 1993). Effects of orientalism are mitigated by the presence of a Chinese crew and the aim of bringing a Hollywood movie into the largest film market in the world, so it is not so much the touristic gaze as the unstable oscillation between the fantastic and the documentary in these shots that helps create the cosmopolitan effect. To some extent, it no longer matters whether the images are produced at the end of long expeditions to the heart of Asia, or whether they are painstakingly drafted in Bryce. What counts is their breathtaking, bewildering scale, the awe they inspire, the hush they demand. There is nothing much to distinguish between Morpheus's "desert of the real" and Ang Lee's real desert. It absorbs an awestruck audience with mesmeric intensity, strips away the sense of time, eliminates the ordinary power to act. Its real-

| Figure 13.4 |

Crouching Tiger, Hidden Dragon: Michele Yeoh—vector as gravity, mastery as totality.
Courtesy BFI Stills, Posters, and Designs.

ity is already past, and with it the possibility of any action other than those that, in the cinematic future perfect, already will have occurred.

What kind of a space is this? More directly, what is it to inhabit a space in which time has already expired, has already fulfilled all that it is capable of achieving? The living human being has always an unfulfillment, something left to do. But as Kaja Silverman notes, summarizing Heidegger, "The fateful event after which there will no longer be something outstanding, and after which the question of who we are will have been established, is of course death. However, with this event we cease to exist. There is thus no moment when we properly 'are.' Our being must rather be defined in terms of what, from the moment of death, we will have been" (2000: 33).

This echo of Mallarmé, and of Bazin's rewriting of Mallarmé, suggests something not intrinsic to film but to a certain practice of cinema. The cosmopolitan film, which in so many ways has abandoned the temporality of Western enlightenment reason, invents instead a mode of being as if we were already dead. The nihilism that was at one time so radical, in the 1920s,

when dada savaged art and *Being and Time* was being written, has become institutional: the coffee-table theory of the fashionable art scene, the politics of choice of bad-boy rappers and pop metal bands, the politics of despair. Cloaked in heroic destinies and undying loves, *Crouching Tiger* less reproduces the mysteries of Taoism than it entices with the beautiful nostalgia of dying, and better still of throwing it all away. The boldness of this cinema is that it is so unafraid of demonstrating the paucity of contemporary life. No longer involved in Heideggerian "worlding," the audiencing audience succumbs to the erasure of the world in favor of the isolation of cosmopolitan, incommunicable pleasures of renunciation.

A small but telling detail: *The Matrix* reproduces an effect from *Blade Runner*. As Deckard investigates the old photograph, he is able to magnify it over and over again, until the tiniest detail reflected in a mirror becomes clear. Early in *The Matrix*, a single letter on the computer screen becomes an avenue of endless fractal calculations. The great difference between an image and the world is that the world is endlessly magnifiable. There are parts within parts, forces and activities below any achievable scales, any imaginable logics. The image resolves itself into pixels or molecules of silver compounds. At a certain scale, it refuses to release any more information, becoming a physical entity rather than a picture. Overcoming that difference is the dream played with in *The Matrix*, a projection of physical endlessness onto the technologies of mediation. The ascription of endlessness clashes with the finality of the film's fatalism. There is the beginning of a possibility here.

On the other hand, that possibility can be read across another minor moment. Neo, in his official persona as Thomas Anderson, is grilled by his boss. Outside, a team of window cleaners are working: two shots give us images of their wiper blades clearing soap bubbles, and the sound of their squeaking continues throughout the dialogue. Although there is a payoff in the next scene, when Morpheus attempts to guide Neo to escape via the cleaner's scaffolding, the sound, so prominent in the scene with the boss, is never paid off. It is only with some effort that the actual presence of the cleaners is made to seem in any way necessary to the plotting. Instead, the sound of windows being cleaned, and the repeated image of suds being removed, sets up an allegorical construct around the heroic quest to see the world as it really is. Putting these two phrases—"allegorical construct" and "the world as it really is"—in the same sentence will appear anomalous.

Although the notion of allegory is by now embarrassing, a lost art best forgotten, film analysis has much to learn from the structures of allegory. Commenting on Christine de Pisan's *Epitre d'Othéa* of the late fourteenth century, Rosamund Tuve makes a distinction between two commentaries that Christine gives on the fable of Ceres, the Roman goddess of the harvest, credited with teaching the arts of ploughing:

To be a liberal giver who gives with "abandon" is to have the "condition" of Ceres, says the moral Glose; but when we read in the Allegorie in Ceres, we see in her the action of the blessed Son of God, chief exemplar of giving with abandon to men of his high good things. The good knight reads chivalric largesse in Ceres; the good spirit believes in, loves and imitates the condition of Ceres read as a figure for the agape of Christ and its fructifying influence. Ceres does not "equal Christ." Her condition is agape, and He is that in its essence. When properly read, allegory does not need to turn some personage into Christ or into God the Father. We merely pause to notice that the relation is not quite that of a type either . . . the distinction is kept, though it is not a nice one. (Tuve 1966: 37)

The moral of the fable (the Glose) is not the same as the allegory, nor is its audience: the moral is for the good knight, the allegory for the good spirit. Nor do the window cleaners "equal" the renewal of vision in even so obvious a source for *The Matrix* as Huxley's *The Doors of Perception*. The window cleaning shares a condition that will be the calling of Neo, a calling of which he is himself not yet aware. In the same way, Neo does not "equal Christ," though he is Christlike in the sense that he derives from Christianity the role of a savior who comes to redeem humankind. What we note here is the depth and complexity of allegory, and its social nature. Unlike symbolism, which tends to be either private or developed for a specific work, allegory depends on the social construction of a ring of meanings that cannot be adequately expressed with a single concept.

This small instance, the squeaking soundtrack for this early scene, opens onto a larger landscape, the landscape of stardom. Celebrity belongs to television, and in the contemporary cinema many of the most famous actors are not stars in the proper sense. Robert de Niro, for example, is prized as a performer, versatile, able to take on a wide range of meanings in a given film or across several. Other actors, Sylvester Stallone, Arnold Schwarzennegger, and to some extent Keanu Reeves are all stars in the older sense. They

carry with them a definite set of meanings that nonetheless are difficult to encapsulate in a single word. Masculinity, bravado, self-deprecation, silence, strength: no one word, no series of words, exhausts the nuances of their allegorical significance. Yet that significance is recognized by millions, so that a poster of Stallone can stand for a wide but unnameable embrace of secular aspirations, not only identification, but moral lessons and beyond them conceptions of "wonder and gratitude as the proper 'temperate' response of a rightly reasonable man toward the book of the universe" and "that the virtuous disposition of the soul is its adornment and beautiful raiment, not only its hard-won guerdon after conflict" (Tuve 1966: 40–41), teaching not only to imitate but to admire in the root sense of the word, *mirare*, to marvel.

Brooks Landon asks rhetorically, "Could the spectacle of production technology, increasingly a kind of digital narrative, deserve and reward our attention just as surely as do narratives about the impact of technology?" (1992: 35). If so, and clearly this book works from the same premise, then the technology of the star—the trained, honed, sculpted bodies, the meticulously layered memories of performances encrypted into Stallone's lazy eyelids or Reeves's way of bending his head from the root of his neck—belongs to that construction. The marvelous is the secularized moment of the spiritual, and in the star that anagogical level of allegory is recovered. In the same way that the star provided a site for fantasy, the diegesis does, but for these stars the constructions are paired.

Most of all, stars are empty vehicles for audiencing. That process of inscribing our fantasies into the manufactured production technologies of stars and special effects (and stars are among the most special of all effects) today reaches the threshold of assimilation as we prepare for more immersive experiences than even the widescreen cinema and stereo sound. The unreality of the star—Stallone's size, Schwarzenegger's politics, Reeves's IQ—no longer baffles us: we do not expect the person and the persona to meld. Nor do we expect the star to live their roles outside their films. The audiencing audience undertakes that work of extending the role, not by imitating in noncinematic life, but by plunging deeper into the environment of the cinema, now increasingly freed of the tedious task of creating believable psychological portraits. The curious affectlessness of Reeves's performance is perfect for the illusion of an illusion. Something similar could be said of Chow Yun Fat's minimalist performance in *Crouching Tiger:* the very

hollowness of the performance requires the audience to subscribe to the film by taking up the task of providing these ciphers with an inner life.

Cosmopolitics

Strength, courage, undying love: the cosmopolitan is a passionate cinema in an affectless age. The further reaches of experience are laid out like so many exotic destinations in a travel brochure. To some extent, this has always been the purpose of art in the Western tradition: to render timeless the evanescent affections, the winged thoughts of the living being. Percepts, Deleuze and Guattari write,

are no longer perceptions: they are independent of a state of those who experience them. Affects are no longer feelings or affections: they go beyond the strength of those who undergo them. Sensations, percepts and affects are *beings* whose validity lies in themselves and exceeds any lived. They could be said to exist in the absence of man because man, as he is caught in stone, in the canvas or by words, is himself a compound of percepts and affects. The work of art is a being of sensation and nothing else: it exists in itself. (1994: 164).

Like Silverman's extrapolation from Heidegger, Deleuze and Guattari propose a moment at which we properly are, and it is a moment in which we are not. Creativity is a movement in which what is human is alienated, reified, and severed from humanity. If this were the case, then *The Matrix* would be entirely a proper outcome for all the work that has preceded it, an entirely self-sufficient work of art. And certainly it is quite proper to so argue: as art frees itself from the communicative to exist in itself, so does *The Matrix*.

Since Duchamp, or at least since Kossuth, art in the Western tradition has defined itself as a questioning of the conditions of art (Osborne 2000: 86–102). To that extent, the making of art has been a matter of bootstrapping into existence a concept of art that defines it at and as its limits, as Duchamp's readymade *Fountain* does. For art, the problem is then the question of the art object, which defines itself by the difficulty it has in coming to being. Cosmopolitan film has no trouble existing. Where it approaches the condition of art is in the problematic existence of its audience, which it, as the obverse of art, must bootstrap into existence, yet which has difficulty existing at all. Modern and contemporary art have looted the supermarkets

of popular culture for a century. In exchange, popular cinema has lifted its cinematography from Rembrandt and Hopper, screenplays from Pulitzer novels, and production design from the Bauhaus and Dalí. Now the very conceptualization of art has been loaded onto the Hollywood truck and driven off to the marketplace. Where art took over the tasks of philosophy in the late nineteenth and early twentieth centuries, cinema has stolen the tasks of art in the late twentieth and early twenty-first. As art abandons its research into perception, form, and meaning to inquire into its own boundary conditions, the task of inquiry into being in the world falls to the moving image media. As it moves into the digital, cinema moves from the self-reflexive autonomy of light moving in time, through the mission of realism and representation, toward embracing its essence in the parallax and z-axis, the illusion of depth. But illusion requires an audience, and for the cosmopolitan cinema, a global audience. That audience is as profoundly conceptual as the art object in contemporary practice.

The cosmopolitan cinematic object is no longer the world, or a world, but the audience. It attains autonomy from human interests by assimilating rather than rejecting them. It opens itself to all interests, to the universality of interests, not least by picking from every tradition what can be picked, addressing itself to that entirely abstract object, the universal audience: not people, but the addressees of cinema in their universality. Moulding the multiple traditions of global cinema into the harmonious whole it has learned to recognize as the beautiful, the cosmopolitan makes Bollywood for a global market in *Moulin Rouge*, a desperate if affectless pursuit of beauty. But beauty escapes it, because beauty is by nature ephemeral. Cinema responds by aiming not for endurance but for extension: to universalize itself in space, rather than to secure its survival in time. Here at last it becomes quite clear why special effects must always be cutting edge: because they are not designed to endure, merely to expand. In that expansion, they will form a void at their heart, a void that sucks in souls, in which the audience audiences, a singularity of blinding energy, in which existence is momentarily obliterated, that we call the sublime.

In tune with a century of Eurocentric art, the cosmopolitan as the cinematic art-object claims universality by refusing signification. The moment of wonder proper occurs at that threshold between secondness and thirdness, between recognizing a phenomenon as other than the self and recognizing it as meaningful, as communicative. In that moment of signification

the self is constituted as relation. And it is that prior moment of wonder that is transformed into awe in the cosmopolitan spectacle, awe that continues the misunderstanding of the world as object into the misconstrual of wonder as an end in itself. Stripped of relationality, the self is no longer constituted as medium of communication but as subjected to the spectacle of the unspeakable sublime. There are moments like this in *Crouching Tiger*, the scene of Jen and Li leaping across the lake; but equally the process of normalizing global styles can end in banality, as a comparison of the framings in *Crouching Tiger* and *The Matrix* or *Crouching Tiger* and *Once Upon a Time in China* will reveal. Many of Pau's compositions are still, classically composed, edited according to classicism's norms of shot-reverse-shot, too ready to compromise the spectacular mise-en-scène and wirework to the projected audience of North American youth, which in part explains the poor reception of the film in the People's Republic. On the contrary, to audience actively and therefore enjoyably, the global audience requires a kind of resistance of the image, like a meniscus between them and the virtual world beyond, an experience visualized in *The Matrix* as Neo's rebirth from the amniotic pod. Ironically, the longing is not to burst out but to burst in to the illusory, to move backward from the ordered and instrumental world of informational signification into the perpetual wonders of the imaginary, where we are no longer bound by obligations and the duties of hospitality and care but infantilized in a moment prior to communication.

Silverman distinguishes two moments of fetishism, one that discards everything about the substitute object except what it represents, and another that "savors that within the replacement term which distinguishes it from all previous thematizations of the original nonobject. . . . The subject who is under the sway of these impulses remains outside the temporality of desire, rooted in the present" (Silverman 2000: 59). This is the status of allegory in the cosmopolitan film. The film's narrative occurs after desire—after the sinking of the Titanic, after the centurion's wife has already been murdered, after Li has renounced his love, after destiny has claimed its heroes. The objectifying gaze of the realist film slips toward the spectacle, but never arrives there, instead entering into a chain of spectacular substitutions that always lay claim to an origin that always escapes them because, in Silverman's terms, it is a nonobject, or because, in Peirce's, it is firstness. Cosmopolitan allegory is thus forever new, but equally forever indifferent, since it never achieves signification, resting instead on the replication and

simulation not of meaning, nor of the real, but of the desired moment of objection, of sensing the phenomenon as contrary to the self, the moment of wonder, the revelation it always places in the past.

The achievement of indifference obliterates gender, race, class, often enough by hypergendering, hyperracializing, hyperclassing—caricaturally pneumatic or muscle-bound bodies, ethnic difference exploded into alien species, proletarianization dressed up as slavery or the extremes of first class and steerage. They are beyond ideology because they only expose, in Leonard Cohen's rhyme, what everybody knows. The inflation of hyperdifferentiation, however, is only a function of the disappearance of difference itself, the ironic task of allegorical displacement to signify the nonarrival of signification. The democratizing tendency of the cosmopolitan proceeds by erasing difference, for difference belongs to signification. This is not simulation, for simulation is only the logical outcome of representation, and representation depends on difference, the erased difference of the Code. Simulation is the official press release of cosmopolitan nihilism: gleeful or despairing, it only and irrevocably accepts the destiny on offer, the end of time.

But difference is the ground of time, and time belongs to the actual, the world of actions, the acted upon and acting, differentiated as the virtual is not. Aloof from the virtualities of cinema, the world, including the film industry, is still riven, year by year more deeply, by actual gender and class exploitation, increasingly geographically organized. It is almost pointless to say so, certainly in cinema, because the cinema has abandoned ideology in favor of pure affect, pure percept, absolute art. Ninety percent of the audience already know their videos and DVDs were built with sweated labor. Cinema no longer disguises the fact; on the contrary, it revels in the pleasurable horror of shocked awareness, the stomach-turning irony of these perfect bodies on these flawed screens. The point is rather to make the sensation an end in itself, to challenge as radically and deeply as possible every aspect of the audience's physical, emotional, and intellectual life, to confront us with death, finality, the sublime, the abject, the incommunicable, and the timeless, and to simulate simulation so entirely that we will no longer desire, no longer act, no longer inhabit the temporal world. Then and only then will we have become audience worthy of the cosmopolitan film.

OUTRÉ: MEDIATION AND
MEDIA FORMATION

Arguing the case for a modified auteurism, Robin Wood observed that it is "only through the medium of the individual that ideological tensions come into particular focus" (1989: 292). What does it mean to speak of an individual as a medium? It implies that environments, languages, and technologies not only antedate the individual who is born into them but that individual identity is a node constructed in the traffic of communication.

The communicative relation between humans and machine is more than the human-oriented instrumentality of the human-computer interface (explored, e.g., in Laurel 1990). It concerns the intertwining mutual subsistence of individuals and technologies as media. One of the peculiarities of cinema is that it tends, despite the best efforts of Bazin and Kracauer, to separate itself from the third partner in the equation, the natural environment. Maturana and Varela's work indicates that this relation too can be understood as mediation, and that the natural world acts as if it too were a medium. For too long, media have appeared to critical thought according to their distinction from nature. In that distinction, nature has begun to appear as a construct of human discourse (Robertson et al. 1996). "The point, then," Nigel Clark notes, "is not to push back the historical location of the 'end' of nature, but to recognise that disturbance, like mobilism, invasion and hybridization, is endemic to the living world" (Clark 2002: 114); and again "there is no rigid boundary separating *our* 'cosmopolitan proclivities' from the proclivity to wander, the tolerance of disturbance, or the experimentalism proper to biophysical materiality" (ibid.: 120). Clearly the green world is not excepted from this dialogue, but it will be if it is merely the recipient of our fantasies of lost purity. Beyond thinking of nature as information, reconceiving it as a process of mediation removes pristine being from the

biological and physical environment. It merely reconnects human activity with environmental processes. The study of the cinema effect is a first step in identifying what it is about human mediation that, to date, has left it grappling with its separation from the natural as well as the technological.

In Gilles Deleuze's concept of the time-image, something of that evolving relation emerges in the possibility of creating a direct image of time, rather than a mere record of movement. Enraptured by the vanguard film, Deleuze did not observe that, like montage, pastiche, cubist multiple angles, and other avant-garde techniques, the time-image had become available to the neobaroque and cosmopolitan cinemas as mere technique. Bazin (1971: 26) had already observed that there was nothing intrinsic to deep focus or the long take to make them essentially realist: fetishized as technique, they lose that freedom. Likewise the time-image: there is nothing intrinsic to it that makes it available only to an artistic or philosophical cinema. Already the principle of the *Sortie d'usine*, the time-image is assimilated into cosmopolitanism in one of the most successful films of 1999, Yash Chopra's *Dil To Pagal Hai (The Heart Is Crazy)*, where a brief embrace is extended into the five-minute location dance routine for the song *Dhalna*, a routine moreover that is happy to pick up on the pixel to produce effects of bliss in the movement of a sari in the wind, or the breeze through grass. No technique is essentially avant-garde, progressive, or subversive: every technique is capable of becoming merely technical, a tool for further and repurposed productions.

One cinema represents. At first it is the cinema of the pixel that seeks to grasp the world in all its distracting liveness, but that task is later taken up under the hegemony of the cut in Renoir's realism. A second cinema reproduces. The cut first abstracts objects from their worldliness, but it is under the supremacy of the vector that reproduction becomes the hallmark of the total cinema. The third mode of cinema generates. In Emile Cohl, it is the endless generative power of metamorphosis, but in the spectacle of classical film, the pixel's equilibration of movement comes to govern and control the provocations of its trajectory. These stabilizations were never enduring, then, each blessed with its own contradictions. Nor indeed were many films as purely typical of the norm as normative criticism would have us believe, and it is a weakness of this book that it does not explore other norms of cinema production, notably the Indian social melodrama and narrative animation, or the constant mutation that, far more than norms, governs the history of cinema.

To a certain extent, the time-image may well constitute a new norm or a new mutation, rather than a radical breakthrough, converging with the spatialization of time in the neobaroque cinema. The old baroque's absolute monarchy and total environments are democratized in a film like Rodriguez's *Desperado*, as the mariachi's omniscient sense of space, beneath which lies an understanding of the environment as order. But like the old baroque, the neobaroque generates the entropic and formless as the necessary obverse of total spatial ordering. From *The Exorcist* onward, the Manichean other of absolute disorder is identified as the agency of absolute evil, negatively or positively viewed.

However, neither the old nor the new baroque is dialectical or conflictual. The Manichean universe of oppositions is not itself resolvable. Duration becomes extension in films like *Desperado*, the moment extended in space through slow-motion, multiple angles, steadicam, crane work, and zooms. In particular, the spatialization of the vector transforms it from the free evolution of open trajectory to the predictable spatialized extension of the present, an algorithm whose iterations determine its future performance. Such is the case with Eisenstein's spiral outward: still future-oriented, but controlled from the present. In a related historical transition, the endlessly deferred fullness of the commodity is spatialized as perpetual displacement, first to the territories of empire in the orientalist moment, thence to outer space when empire extends from geographical objects to the objects of technoscientific rationalism and epistemological empire, and finally to the microcircuits of cyberspace (which never, for just this reason, appears as cybertime). The control of the infinite is inadequate. Total order requires the colonization of the infinitesimal in slow motion and the hypermagnification of *Blade Runner*'s Esper. The greater infinity of the real numbers fills the wrapped-around surface of cosmopolitan cinema's monads, cramming them to absolute fullness in the *mise-en-abyme* of endlessly nested self-reflections. The micro-ordering of time as space that emerges from this infinitesimal conversion of duration to extension, like Zeno's paradox, in what proposes to be a final act of absolute order, opens into fractal chaos.

At the same time that the void in the heart of the commodity spectacle drives it into movement, the hollowness of its perpetual deferral and displacement gives to stillness the glamour of the profound. Such a scene occurs at the moment in *Crouching Tiger, Hidden Dragon* (fig. 14.1) in which Chow Yun fat confesses to Michele Yeoh that he loves her, and that his highest

| Figure 14.1 |

Crouching Tiger, Hidden Dragon: vector action in a pixel world—distraction as false totality.
Courtesy BFI Stills, Posters, and Designs.

aspiration is to be, just as he is in this moment, with her. The shot frames the
two stars against a plaster wall, as clear an example of figure-ground as could
be devised. Behind them is a gap in the wall, through which we see a stand
of bamboo fronds moving gently in the air: simple, aimless, movement in
equilibrium. In that one shot the film's affect is stilled, abstracted from ei-
ther the diegesis or the subjective position of the audience to become a qual-
ity of the film itself, an arrangement of the apparatus, a balancing of cut and
pixel in a single frame. That is the place of the affect, as it is of perception
and sensation: displaced from auteur or audience, the affect of the system we
call cinema.

Autonomous affects, percepts, and sensations "independent of a state of
those who experience them," to repeat the words of Deleuze and Guattari
(1994: 164), are not simply commodities that cinema makes available for
purchase. Because these affects are other than our own, and since otherness

is the condition of dialogue, they are entities with which it is possible to enter into dialogue. Such autonomy that audiences may have opens the option of moving from absorption to dialogue, not with one another, nor yet with the creative mind somehow "behind" the film, but with the system-cinema as an intelligence other than human. As artificial life and artificial intelligence allow more and more machines and machine networks to become agents in the making of software and effects, we stand at the threshold of a new era in which we no longer demand of our devices that they produce to our command, but that they become our equals in dialogue, just as they have enabled us to enter into dialogue with autonomous affects in the system cinema. In those rare moments when Green politics evade the ideology of conservation to recognize the evolutionary productivity of the ecology, human, technical, and natural, some further hint of that future dialogue becomes distantly audible.

The image disappears three times in cinema projection. The best known is the vanishing point within the image, but there is a second inside the lens of both projectors and cameras. As light passes from the lens to the filmstrip in a camera, or vice versa in a projector, it flips over, passing through a single point. Photographers refer to this zone as the objective. By way of analogy, we might call the third point the subjective: the projective center of the rays of light between lens and retina of the audience member's eye. Objective, vanishing point, and subjective share not only an invisibility constitutive of the making of vision in cinema: these dimensionless points make possible a change in dimension. The subjective belongs to the vector: it is social and infinite. The vanishing point belongs to the cut, since it is necessary specifically for the construction of cinematic objects and will be central to the evacuation of the spectacular object as commodity fetish. The objective sits closest to the moment of travel, the preobjectification, preconceptual duration of film in movement, the pixel. Relational foundations of cinema, these are not vanishing points but rebirthing instants, not spaces of lack but times of becoming. Against the current of a commodity cinema devoted to the promotion of the being of its audiences, its worlds, and its perceptions as objects caught in the moment of their fading, the dimensionless need not destroy dimensions: it has the option of generating them. This possibility, never removed from the history of cinema, is the utopian in film that has always made it so fascinating.

Jean-Luc Nancy calls this order of ontology "ex-istence," which "signi-fies simply the freedom of being, that is, *the infinite inessentiality of its being-finite, which delivers it to the singularity wherein it is itself*" (Nancy 1993). If freedom had an essence, it would be determined by it, and therefore it would not be free. To be real, it also has to enter the finite world. Finite and inessential freedom undercuts all foundations of being and objecthood, and all constructions of causality. Like the physiology of cinematic perception, the freedom of the pixel at one extreme and of the vector at the other are the conditions on which their unfreedom has been constructed in the object cinema, cinema's objects, and the objection of audiencing. This freedom Hardt and Negri affirm in different terms: "The capacity to construct places, temporalities, migrations, and new bodies already affirms its hegemony through the actions of the multitude against Empire. Imperial corruption is already undermined by the productivity of bodies, by cooperation, and by the multitude's designs of productivity" (Hardt and Negri 2000: 411).

Media theory can go further and deeper. The construction of closed dimensions so characteristic of the contemporary commodity that cinema so powerfully exhibits is its own worst enemy. From guerrilla parodies like *Saving Ryan's Privates* to the work of net artists, and perhaps most of all the expansion of peer-to-peer file sharing, the walls of the cinema have ex-ploded far more violently than even Gene Youngblood could have expected. Distributed media open up dimensions that the cinema building, for all its allure, can neither emulate nor assimilate. Cinematic spatialization has opted for architecture, while the world has chosen geography. In the inter-stices lies the possibility of a new art, made from the raw materials of time. As Julia Moszkowicz argues, the verisimilitude of CGI is "crucially in-formed by prior engagements, on the part of animators and audiences alike, with existing media" (Moszkowicz 2002: 314). The closing chapters of this book have reiterated that those mediations must include communication with an environment no longer pristine and a technology no longer tainted. Unless and until the communicative seizes as ground the primacy of rela-tions over objects, communication will continue to slide into the commod-ity's terminal plenitude.

Cinema's failure arises from its slavery to the commodity; its success from mutuality. The commodity form of cosmopolitan film arrives at a transposition of zero's fullness and the vector's infinity, the cut's objection and the intensive immutability of audiencing, filling the one, voiding the

other. The machine it constructs depends on the vanishing points of a total apparatus. But when vanishing points become emerging times, the world, the apparatus, and the individual are media. In the end, there is no end: totality is not achievable. *Pace* Nancy, nor is freedom, whose reality depends on its singularity, the dimensionless mathematics of the black hole at which the spatialization of cinema arrives as the totalization of the universal commodity. Being finite is, at last, the quality of the object in which the commodity has found its freedom at the expense of the rest of the universe.

Nor is it a question of reaching for the infinite, the nightingales and psalms of an unending essence, the irreducible otherness of the Other that finally premises the oneness of the One in its primal lack. To the extent that the cinema effect comes after the cinema as cause, it points always toward what is not present, that which is coming into being. Totality and infinity meet in media formations that mourn the disappearance of the past as loss or seek to stabilize the evanescent present as lack. Neither total nor infinite, the struggle for twenty-first-century cinema is the struggle for not yet finite, not yet infinite, ecological, human, and technological community. If beyond the dimensionless plenum of the commodity there is to be a cinema effect, it will arrive as an art of time, the struggle to construct what no one ever lost: the future.

Filmography

Abyss, The (special edition). 1989. James Cameron. 20th Century Fox, United States, 171 mins.

Adventures of Baron Munchausen, The. 1989. Terry Gilliam. Allied Filmmakers/Columbia Pictures Corporation/Laura Film, UK/West Germany, 126 mins.

Aelita. 1924. Yakov Protazanov. Mezhrabpom-Russ, USSR, 100 mins.

Aerograd. 1935. Alexander Dovzhenko. Mosfilm/Ukrainfilm/Soyuzkino, USSR, 81 mins.

Age d'or, L'. 1930. Luis Buñuel and Salvador Dalí. Vicomte de Noailles, France, 63 mins.

Akira. 1987. Katsuhiro Otomo. ICA/Akira Committee Company Ltd., Japan, 124 mins.

Aladin et la lampe merveilleuse. 1969. Jean Image. Films Jean Image, France, 71 mins.

Alexander Nevsky. 1938. Sergei M. Eisenstein. Mosfilm, USSR, 112 mins.

Ali Baba et les quarantes voleurs. 19XX. Ferdnand Zecca, Pathé, France, 10 mins.

Alien Resurrection. 1997. Jean-Pierre Jeunet. 20th Century Fox/Brandywine Productions Ltd., United States, 109 mins.

An American Tail. 1986. Don Bluth. Amblin Entertainment/Universal Pictures, United States, 77 mins.

Annabelle Serpentine Dance. 1894. William K. L. Dickson, Edison Manufacturing Company, United States, 1 min.

Année Dernière à Marienbad, L'. 1961. Alain Resnais. Terra Film/Les Films Tamara/Cormoran Films/Precitel/Como Film/Argos Films/Cinétel/Silver Films/Cineriz, France/Italy, 94 mins.

Applause. 1929. Rouben Mamoulian. Paramount, United States, 80 mins.

Armageddon. 1998. Michael Bay. Jerry Bruckheimer Films/Touchstone Pictures/ Valhalla Motion Pictures, United States, 144 mins, director's cut 153 mins.

Arrivée des congressistess à Neuville-sur-Sâone. 1895. Louis Lumière. France, 1 min.

Arrivée d'un train à La Ciotat, L'. 1896. Auguste and Louis Lumière. France, 1 min.

Arroseur arrosé, L'. 1895. Louis Lumière. Gaumont, France, 1 min.

Asoka. 2001. Santosh Sivan. Arclightz and Films Pvt. Ltd./Dreamz Unlimited, India, 155 mins., uncut 180 mins.

Atalante, L'. 1934. Jean Vigo. J. L. Nounez-Gaumont, France, 89 mins.

Aventures de Baron Munchhausen, Les. 1911. Georges Méliès. Star Films, France.

Ballad of Cable Hogue, The. 1970. Sam Peckinpah. Phil Feldman/Warner Bros, United States, 121 mins.

Barque sortant du port. 1895. Louis Lumière. France, 1 min.

Bas-Fonds, Les. 1936. Jean Renoir. Albatros—Alexandre Kamenka, France, 90 mins.

Batman. 1989. Tim Burton. Warner, United States, 126 mins.

Batman Returns. 1992. Tim Burton. Warner, United States, 126 mins.

Battleship Potemkin. 1925. Sergei M. Eisenstein. Goskino/Mosfilm, USSR, 75 mins.

Ben Hur. 1959. William Wyler. MGM, United States, 212 mins.

Big Blue, The. 1988. Luc Besson. Gaumont International/Weintraub Entertainment Group, United States/France/Italy, 168 mins.

Blackmail. 1929. Alfred Hitchcock. British International Pictures, UK, 96 mins.

Blade Runner (director's cut). 1982. Ridley Scott. The Ladd Company/Blade Runner Partnership, United States, 117 mins.

Blood: The Last Vampire. 2000. Hiroyuki Kitakubo. IG/Production I.G., Japan, 48 mins.

Blow-Out. 1981. Brian de Palma. Cinema 77/Filmways Pictures/Viscount Associates, United States, 108 mins.

Blue Angel, The. 1930. Josef von Sternberg. UFA, Germany, 98 mins.

Blue Steel. 1990. Kathryn Bigelow. Lightning Pictures/Mack-Taylor Productions/ Precision Films, United States, 102 mins.

Body Double. 1984. Brian de Palma. Columbia Pictures Corporation/Delphi 2, United States, 114 mins.

Bonnie and Clyde. 1967. Arthur Penn. Tatira-Hiller, United States, 111 mins.

Bombay. 1995. Mani Rathnam. Amitabh Bachchan Corporation Ltd., India, 102 mins.

Brazil. 1985. Terry Gilliam. Embassy International Pictures, UK, 131 mins., director's cut 142 mins.

Bridge on the River Kwai, The. 1957. David Lean. Columbia Pictures Corporation, UK, 161 mins.

Broken Blossoms. 1919. D. W. Griffith. UA/D. W. Griffiths, United States, 105 mins.

Butch Cassidy and the Sundance Kid. 1969. George Roy Hill, 20th Century Fox/ Campanile, United States, 110 mins.

Cabiria. 1914. Giovanni Pastrone. Italia Film, Italy, 148 mins.

Chess Fever. 1925. Nikolai Shpikovsky. Mezhrabpom-Russ, USSR, 28 mins.

Chien Andalou, Un. 1928. Luis Buñuel, Luis Buñuel, France, 17 mins.

Chute de la maison Usher, La. 1928. Jean Epstein. Films J. Epstein, France/United States, 63 mins.

Cimarron. 1931. Wesley Ruggles. RKO, United States, 131 mins.

Citizen Kane. 1941. Orson Welles. RKO, United States, 119 mins.

City of Lost Children. 1995. Jean-Pierre Jeunet and Marc Caro. Entertainment/ Lumiere Pictures/Canal Plus/France 3 Cinema, France, 112 mins.

Cleopatra. 1963. Joseph L. Mankiewicz (and others). 20th Century Fox, United States, 243 mins., director's cut 320 mins.

Close Encounters of the Third Kind, special edition. 1977. Steven Spielberg. Columbia/EMI, United States, 135 mins.

Cobweb, The. 1955. Vincenete Minelli, MGM, United States, 134 mins.

Contact. 1997. Robert Zemeckis. Warner Bros, United States, 153 mins.

Crime de M. Lange, Le. 1936. Jean Renoir. Obéron, France, 80 mins.

Crocodile Dundee. 1986. Peter Faiman. Paramount Pictures/Rimfire Films, Australia, 93 mins.

Crouching Tiger, Hidden Dragon. 2000. Ang Lee. United China Vision Inc./Columbia Pictures, United States/Hong Kong/Taiwan, 120 mins.

Crow, The. 1994. Alex Proyas. Entertainment Media Investment Corporation/Jeff Most Productions/Edward R. Pressman Film Corporation, United States, 102 mins.

Dames. 1934. Ray Enright. Warner Bros, United States, 91 mins.

Dante's Peak. 1997. Roger Donaldson. Universal Pictures/Pacific Western, United States, 112 mins.

Dark City. 1998. Alex Poyas. New Line Cinema/Mystery Clock Cinema, United States, 100 mins.

Dark Star. 1974. John Carpenter. Jack H. Harris, United States, 83 mins.

Delicatessen. 1991. Jean-Pierre Jeunet and Marc Caro. Constellation/Hachette Premiere, France, 99 mins.

Desperado. 1995. Robert Rodriguez. Columbia Pictures Corporation/Los Hooligans Productions, United States, 106 mins.

Devil in a Blue Dress. 1995. Carl Franklin, TriStar Pictures/Clinica Estetico/Mundy Lane Entertainment, United States, 102 mins.

Diva. 1981. Jean-Jacques Beineix. Les Films Galaxie/Greenwich Film Productions/Antenne 2, France, 117 mins.

Dodsworth. 1936. William Wyler. Samuel Goldwyn Company, United States, 101 mins.

Do the Right Thing. 1989. Spike Lee. UIP/40 Acres & a Mule Filmworks, United States, 120 mins.

Dream of a Rarebit Fiend. 1906. Edwin S. Porter. Edison, United States, 7 mins.

Dressed to Kill. 1980. Brian de Palma. Filmways Pictures/Cinema 77 Films, United States, 105 mins.

Dr. Strangelove. 1963. Stanley Kubrick. Columbia, UK, 93 mins.

Dumbo. 1941. Ben Sharpsteen. Walt Disney Pictures, United States, 64 mins.

Eaux d'artifice. 1953. Kenneth Anger. Fantoma Films, United States, 12 mins.

Empire Strikes Back, The. 1980. George Lucas. Lucasfilm Ltd., United States, 124 mins.

Enchanted Drawing, The. 1900. James Stuart Blackton. Edison Company, United States, 1.30 mins.

Enemy of the State. 1998. Tony Scott. Jerry Bruckheimer Films/Scott Free Productions/Touchstone Pictures, United States, 131 mins.

E.T. The Extra-Terrestrial. 1982. Steven Spielberg. Universal Pictures, United States, 115 mins.

Exorcist, The. 1973. William Friedkin. Warner Bros/Hoya Productions, United States, 122 mins.

Fakir de Singapoure, Le. 1908. Georges Méliès. Star Films, France, lost.

Fall of Troy, The (La caduta di Troia). 1910. Luigi Romano Borgnetto and Giovanni Pastrone. Italia Film, Italy, 27 mins.

Fantasmagorie. 1908. Emile Cohl. Gaumont, France, 2 mins.

Fatal Attraction. 1987. Adrian Lyne. Paramount/Jaffe-Lansing, United States, 119 mins.

Fear and Loathing in Las Vegas. 1998. Terry Gilliam. Universal Pictures/Rhino Films/Red Shark Productions, United States, 118 mins.

Fifth Element, The. 1997. Luc Besson. Gaumont, France/United States, 126 mins.

Fight Club. 1999. David Fincher. Fox 2000 Pictures/Regency Enterprises/Taurus Film/Art Linson Productions, United States/Germany, 139 mins.

Final Fantasy: The Spirits Within. 2001. Hironobu Sakaguchi and Moto Sakakibara. Chris Lee Productions/Square Co. Ltd., Japan/United States, 106 mins.

Fistful of Dollars, A (Per un pugno di dollari). 1964. Sergio Leone. Jolly Film/Constantin/Ocean Films, Italy/Germany/Spain, 99 mins.

For a Few Dollars More (Per qualche dollaro in più). 1965. Sergio Leone. PEA/Gonzalez/Constantin, Italy/Spain/West Germany, 130 mins.

Forbidden Planet. 1956. Fred M. Wilcox. MGM, United States, 98 mins.

Forrest Gump. 1994. Robert Zemeckis. Paramount Pictures, United States, 142 mins.

Fred Ott's Sneeze. 1894. William K. L. Dickson. Edison, United States, 2 seconds.

Flying Down to Rio. 1933. Thornton Freeland. RKO, United States, 89 mins.

General, The. 1926. Buster Keaton. United Artists/Buster Keaton Productions Inc., United States, 75 mins.

Ghost in the Shell. 1995. Mamoru Oshii. Bandai Visual Co. Ltd./Kodansha Ltd./ Manga Entertainment, Japan/UK, 82 mins.

Gladiator. 2000. Ridley Scott. Dreamworks SKG/Universal, United States/UK, 155 mins.

Godfather, The. 1972. Francis Ford Coppola. Paramount, United States, 175 mins.

Godfather, The, Part II. 1974. Francis Ford Coppola. Paramount/The Coppola Company, United States, 200 mins.

Godfather, The, Part III. 1990. Francis Ford Coppola. Paramount/Zoetrope Studios, United States, 162 mins.

Godzilla. 1998. Roland Emmerich. Centropolis Film Productions/TriStar Pictures/Independent Pictures/Fried Films, United States, 140 mins.

GoodFellas. 1990. Martin Scorsese. Warner Bros, United States, 146 mins.

Good, the Bad, and the Ugly, The (Il buono, il brutto, il cattivo). 1966. Sergio Leone. Produzioni Europee Associati (PEA), Italy, 180 mins.

Good Will Hunting. 1997. Gus Van Sant. Miramax Films/Lawrence Bender Productions/Be Gentleman Limited Partnership, United States, 126 mins.

Graduate, The. 1967. Mike Nichols. Embassy, United States, 105 mins.

Grande Illusion, La. 1937. Jean Renoir. Réalisation d'Art Cinématographique, France, 117 mins.

Groundhog Day. 1993. Harold Ramis. Columbia Pictures Corporation, United States, 101 mins.

Gunga Din. 1939. George Stevens. RKO, United States, 117 mins.

Happiness. 1932. Aleksandr Medvedkin. Vostokfilm, USSR, 95 mins.

Harvest 3000 (a.k.a. *Harvest: 3,000 Years*). 1976. Haile Gerima. Mypheduh Films, United States, 150 mins.

Heaven and Earth. 1993. Oliver Stone. Warner Bros/Regency Enterprises/Le Studio Canal/Alcor Films, United States/France, 140 mins.

High Plains Drifter. 1972. Clint Eastwood. Universal/Malpaso Company, United States, 105 mins.

High Treason. 1929. Maurice Elvey. Gaumont-British Picture Corporation Ltd., UK, 90 mins.

Himmel Uber Berlin (Wings of Desire). 1987. Wim Wenders. Road Movies Filmproduktion/Argos Films, France/West Germany, 127 mins.

Hollow Man. 2000. Paul Verhoeven. Columbia Pictures Corporation/Global Entertainment Productions, United States/Germany, 112 mins.

Homme à la tête en caoutchouc, L'. (The Man with the India Rubber Head). 1901. Georges Méliès. Star Films, France, 3 mins.

House of Games. 1987. David Mamet. Filmhaus/Orion, United States, 102 mins.

Humourous Phases of Funny Faces. 1906. James Stuart Blackton. Vitagraph Company of America, United States, 3 mins.

Hunchback of Notre Dame, The. 1939. William Dieterle. RKO, United States, 116 mins.

Incredible Shrinking Man, The. 1957. Jack Arnold. Universal International Pictures, United States, 81 mins.

Independence Day. 1996. Roland Emmerich. 20th Century Fox/Centropolis Entertainment, United States, 147 mins.

International House. 1933. Edward Sutherland. Paramount Pictures, United States, 70 mins.

Intolerance. 1916. D. W. Griffith. D. W. Griffith/Triangle Film Corporation/Wark Producing Corp, United States, 163 mins.

It's A Wonderful Life. 1946. Frank Capra. RKO/Liberty Films, United States, 130 mins.

Ivan the Terrible. 1944. S. M. Eisenstein. Mosfilm, USSR, 94 mins.

Ivan the Terrible (Part 2: The Boyars Plot). 1945. S. M. Eisenstein. Mosfilm, USSR, 88 mins.

Jaws. 1975. Steven Spielberg. Universal Pictures/Zanuck-Brown Productions, United States, 124 mins.

Johnny Mnemonic. 1995. Robert Longo. Tristar/Cinévision/Alliance Communications Corporation, United States/Canada, 103 mins.

Jour se lève, Le. 1939. Marcel Carné. Sigma, France, 93 mins.

Jurassic Park. 1993. Steven Spielberg. Universal Pictures/Amblin Entertainment, United States, 127 mins.

Juve contre Fantomas. 1913. Louis Feuillade. France, 45 mins.

Kaliya Mardan. 1919. Dhundiraj Govind Phalke. Hindustan Cinema Films, India.

Kathleen Mavourneen. 1906. Edwin S. Porter. Edison Company, United States, 7 mins.

Killer of Sheep. 1977. Charles Burnett. Mypheduh Films, United States, 83 mins.

King Kong. 1933. Merian C. Cooper and Ernest B. Schoedsack. RKO, United States, 100 mins.

Lanka Dahan. 1917. Dhundiraj Govind Phalke. Phalke Films, India.

Last Action Hero, The. 1993. John McTiernan. Columbia TriStar/Columbia Pictures Corporation, United States, 130 mins.

Lawnmower Man. 1992. Brett Leonard. Allied Vision Productions/Lane Pringle Productions/First Independent, United States/UK, 107 mins., director's cut 140 mins.

Lion King, The. 1994. Roger Allers and Rob Minkoff. Walt Disney Pictures/Buena Vista, United States, 89 mins.

Little Caesar. 1931. Mervyn LeRoy. Warner/First National Pictures Inc, United States, 80 mins.

Little Man Tate. 1991. Jodie Foster. Columbia TriStar/Orion Pictures Corporation, United States, 99 mins.

Lock Stock and Two Smoking Barrels. 1998. Guy Ritchie. Polygram Filmed Entertainment/SKA Films/Steve Tisch Company/Summit Entertainment/Handmade Films Ltd., UK, 105 mins., director's cut 126 mins.

Lola Rennt. 1998. Tom Tykwer. WDR/German Independents/Bavaria Film/X-Filme Creative Pool, Germany, 81 mins.

Long Kiss Goodnight, The. 1996. Renny Harlin. New Line/Forge, United States, 120 mins.

Lord of the Rings: The Fellowship of the Ring. 2001. Peter Jackson. New Line/Wingnut Films, New Zealand/United States, 178 mins.

Lost Highway. 1997. David Lynch. Asymmetrical Productions/Lost Highway Productions/October Films/Ci By 2000, United States/France, 135 mins.

Lost in Space. 1998. Stephen Hopkins. New Line Cinema/Irwin Allen Productions/Prelude Pictures, United States/UK, 130 mins.

Lost World, The. 1925. Harry O. Hoyt. First National, United States, 93 mins.

Lost World, The—Jurassic Park. 1997. Steven Spielberg. Amblin/Universal, United States, 129 mins.

Magnolia. 1999. Paul Thomas Anderson. New Line Cinema/Ghoulardi Film Company/The Magnolia Project, United States, 188 mins.

Mahabharata. 1988. B. R. Chopra and Ravi Chopra. B. R. Films, India, television series.

Maltese Falcon, The. 1941. John Huston. Warner, United States, 101 mins.

Man with the Movie Camera. 1928. Dziga Vertov. VUFKU, USSR, 80 mins.

Marius. 1931. Marcel Pagnol and Alexander Korda. Les Films Marcel Pagnol/Paramount, France, 130 mins.

Mars Attacks! 1996. Tim Burton. Warner, United States, 106 mins.

*M*A*S*H.* 1970. Robert Altman. 20th Century Fox/Aspen Productions, United States, 116 mins.

Mask, The. 1994. Charles Russell. New Line/Dark Horse Entertainment, United States, 101 mins.

Matrix, The. 1999. Andy and Larry Wachowski. Village Roadshow/Silver Pictures/Groucho II Film Partnership, United States, 136 mins.

Memento. 2000. Christopher Nolan. Newmarket Capital Group/I Remember Productions/Team Todd, United States, 113 mins.

Men in Black. 1997. Barry Sonnenfeld. Columbia Pictures Corporation/Amblin Entertainment/MacDonald-Parkes, United States, 98 mins.

Metropolis. 1927. Fritz Lang. Universum Film A. G., Germany, 120 mins.

Million, Le. 1931. René Clair. Films Sonores Tobis, France, 83 mins.

Miracles de Brahmane, Les. 1900. Georges Méliès. Star Films, France, lost.

Mon Oncle. 1956. Jacques Tati. Specta Films/Gray-Film/Alter Films/Film del Centauro, France/Italy, 110 mins.

Moon Is the Oldest TV. 1965. Nam June Paik. United States, video installation.

Mr. Arkadin. 1955. Orson Welles. Sevilla Films/Mercury Productions/Cervantes Films/Filmorsa, Spain, 93 mins.

Mughal-E-Azam. 1960. K. Asif. Sterling Investment Corp., India, 173 mins.

Mulholland Falls. 1996. Lee Tamahori. Polygram Filmed Entertainment/MGM/Largo Entertainment/The Zanuck Company, United States, 107 mins.

Mummy, The. 1999. Stephen Sommers. Universal Pictures/Alphaville Films, United States, 124 mins.

Mummy Returns, The. 2001. Stephen Sommers. Alphaville/Imhotep Productions, United States, 130 mins.

Musketeers of Pig Alley, The. 1912. D. W. Griffith. Biograph Company, United States, 17 mins.

Nanook of the North. 1921. Robert J. Flaherty. Les Frères Revillon/Pathé Exchange Inc., United States, 79 mins.

Napoleon. 1927. Abel Gance. Consortium Wengeroff-Stinnes/Société Generale des Films, France, 378 mins.

Nashville. 1975. Robert Altman. Paramount Pictures/American Broadcasting Company, United States, 159 mins.

Navigator: A Medieval Odyssey, The. 1988. Vincent Ward. Arena Pty Ltd./New Zealand Film Commission/Australian Film Commission, New Zealand, 90 mins.

Nero or the Fall of Rome. 1909. Luigi Maggi. Ambrosio Film, Italy, 14 mins.

Net, The. 1995. Irwin Winkler. Winkler Films/Columbia Pictures Corporation, United States, 114 mins.

Nikita. 1990. Luc Besson. Palace/Gaumont/Cecci/Tiger, France/Italy, 115 mins.

1942: A Love Story. 1994. Vidhu Vinod Chopra, Eros International, India, 156 mins.

Oily Bird, The. 1928. Otto Messmer. Pat Sullivan Cartoons, United States, 7 mins.

Old Mill, The. 1937. Wilfred Jackson. Walt Disney Pictures, United States, 9 mins.

Olympiad. 1936. Leni Riefenstahl. Leni Riefenstahl, Germany, pt. 1 118 mins., pt. 2 107 mins.

Once Upon a Time in China. 1991. Hark Tsui. Film Workshop Ltd., Hong Kong, 134 mins.

Once Upon a Time in the West (C'erà una volta il ouest). 1968. Sergio Leone. Paramount Pictures/Rafran/San Marco Production, Italy/United States, 165 mins.

One, The. 2001. James Wong IV. Hard Eight Pictures/Revolution Studios, United States, 87 mins.

Our Hospitality. 1923. Buster Keaton. Metro/Buster Keaton, United States, 74 mins.

Page of Madness, A. 1926. Teinosuke Kinugasa. Kinugasa Productions, Japan, 60 mins.

Pan-American Exposition by Night. 1901. Edwin S. Porter, Edison Manufacturing Company, United States, 1 min.

Pat Garrett and Billy the Kid. 1973. Sam Peckinpah. MGM, United States, 122 mins.

Pearl Harbour. 2001. Michael Bay. Touchstone Pictures/Jerry Bruckheimer Films, United States, 183 mins.

Peeping Tom. 1959. Michael Powell. Anglo-Amalgamated Productions/Michael Powell, UK, 101 mins.

Peintre Néo-Impressioniste, Le. 1910. Emile Cohl, Gaumont, France, 1.5 mins.

Phenomenon. 1996. Jon Turteltaub. Touchstone Pictures/Buena Vista, United States, 123 mins.

Pi. 1998. Daniel Aronofsky. Harvest Filmworks/Plantain Films/Protozoa Pictures/Truth and Soul Pictures, United States, 84 mins.

Player, The. 1992. Robert Altman. Guild/Avenue Pictures Productions, United States, 124 mins.

Point Break. 1991. Katheryn Bigelow. 20th Century Fox/Largo Entertainment/Tapestry, United States, 122 mins.

Project A. 1983. Jackie Chan. Golden Harvest Company Ltd., Hong Kong, 106 mins.

Purple Rain. 1984. Albert Magnoli. Warner Bros/Purple Films/Water, United States, 111 mins.

Perfect Storm, The. 2000. Wolfgang Peterson. Warner Bros/Baltimore Spring Creek/Radiant Productions, United States, 129 mins.

Planet of the Apes. 1968. Franklin J. Schaffner. 20th Century Fox/ABJAC Productions, United States, 112 mins.

Public Enemy, The. 1931. William Wellman. Warner Bros., United States, 84 mins.

Pulp Fiction. 1994. Quentin Tarantino. Miramax/A Band Apart/Jersey Films/Buena Vista, United States, 154 mins.

Raging Bull. 1980. Martin Scorsese. UA/Chartoff-Winkler Productions, United States, 129 mins.

Raja Harishchandra. 1913. Dhundiraj Govind Phalke. Phalke Films, India; remake 1917.

Ramayana. 1986. Ramanand Sagar. Sagar Enterprises, India, television series, 120 mins., 26 episodes.

Rebel Without a Cause. 1955. Nicholas Ray. Warner Bros, United States, 111 mins.

Red Psalm. 1971. Miklos Jancso. Mafilm, Hungary, 88 mins.

Red Shoes, The. 1948. Michael Powell and Emeric Pressburger. GFD/The Archers, UK, 133 mins.

Règle du jeu, La. 1939. Jean Renoir. N.E.F., France, 112 mins.

Repas de bébé. 1895. Louis Lumière. Lumiere, France, 1 min.

Ride the High Country (a.k.a. *Guns in the Afternoon*). 1962. Sam Peckinpah. MGM, United States, 94 mins.

Robocop. 1987. Paul Verhoeven. Rank/Orion, United States, 102 mins.

Roja. 1992. Mani Rathnam. Kavithalayaa Productions, India, 137 mins.

Roue, La. 1923. Abel Gance. Films Abel Gance, France, no definitive print.

Sam Peckinpah: Man of Iron. 1992. Paul Joyce. *Moving Pictures*, BBC/Arts & Entertainment Network/Lucida, UK/United States, 90 mins.

Sanjuro. 1962. Akira Kurosawa, Toho/Kurosawa Films, Japan, 96 mins.

Saving Ryan's Privates. 1998. Craig Moss. Creamworks, United States, 8 mins., <http://atomfilms.shockwave.com/af/content/atom_102>.

Sex, Lies, and Videotape. 1989. Steven Soderbergh. Virgin/Outlaw Productions, United States, 98 mins.

Sherlock Junior. 1924. Buster Keaton. Metro/Buster Keaton Productions Inc., United States, 44 mins.

Shri Krishna Janma. 1918. Dhundiraj Govind Phalke. Hindustan Cinema Films, India.

Sixth Sense, The. 1999. M. Night Shyamalan. Spyglass Entertainment/ Hollywood Pictures/The Kennedy/Marshall Company, United States, 107 mins.

Slacker. 1991. Richard Linklater. Feature/Detour, United States, 97 mins.

Soylent Green. 1973. Richard Fleischer. MGM, United States, 97 mins.

Snake Eyes. 1998. Brian de Palma. Paramount Pictures/Touchstone Pictures/ DeBart, United States, 98 mins.

Snatch. 2000. Guy Ritchie. Columbia Pictures Corporation/SKA Films, UK/ United States, 104 mins.

Snow White and the Seven Dwarfs. 1937. David Hand. Walt Disney Pictures, United States, 83 mins.

Sortie des usines Lumière, La. 1895. Louis Lumière. Lumière, France, 1 min.

Spellbound. 1945. Alfred Hitchcock. Selznick International Pictures, United States, 111 mins.

Star Is Born, A. 1954. George Cukor. Warner/Transcona, United States, 181 mins.

Starship Troopers. 1997. Paul Verhoeven. Touchstone Pictures/TriStar Pictures/ Big Bug Pictures, United States, 129 mins.

Star Trek: First Contact. 1996. Jonathan Frakes. Paramount, United States, 110 mins.

Star Trek: Generations. 1994. David Carson. Paramount, United States, 118 mins.

Star Trek V: The Final Frontier. 1989. William Shatner. Paramount, United States, 107 mins.

Star Trek VI: The Undiscovered Country. 1991. Nicholas Meyer. Paramount, United States, 113 mins.

Star Trek: The Motion Picture. 1979. Robert Wise. Paramount, United States, 132 mins.

Star Wars. 1977. George Lucas. Lucasfilm, United States, 121 mins.

Star Wars Episode 1—The Phantom Menace. 1999. George Lucas. Lucasfilm/20th Century Fox, United States, 133 mins.

Sting, The. 1973. George Roy Hill. Universal Pictures, United States, 129 mins.

Strange Days. 1995. Kathryn Bigelow. Lightstorm Entertainment, United States, 145 mins.

Subway. 1985. Luc Besson. Gaumont International/Les Films du Loup/TF1 Films Productions/TSF Productions, France, 104 mins.

Sullivan's Travels. 1941. Preston Sturges. Paramount Pictures, United States, 90 mins.

Sunrise. 1927. F. W. Murnau. Fox Film Corporation, United States, 95 mins.

Sunset Boulevard. 1950. Billy Wilder. Paramount Pictures, United States, 110 mins.

Super Mario Bros. 1993. Rocky Morton and Annabel Jankel. Lightmotive/Allied Filmmakers/Cinergi Productions/Hollywood Pictures, United States/UK, 104 mins.

"Teddy" Bears, The. 1906. Edwin S. Porter. Edison, United States, 15 mins.

Ten Commandments, The. 1956. Cecil B. de Mille. Paramount, United States, 220 mins.

Terminator, The. 1984. James Cameron. Orion/Hemdale/Pacific Western, United States, 108 mins.

Terminator 2: Judgement Day. 1991. James Cameron. Le Studio Canal+/Carolco Pictures/Lightstorm Entertainment/Pacific Western, United States, 136 mins.

That Thing You Do. 1996. Tom Hanks. 20th Century Fox/Clinica Estetico, United States, 108 mins.

Things to Come. 1936. William Cameron Menzies. London Films, UK, 113 mins.

Thirteenth Floor, The. 1999. Josef Rusnak. Centropolis Film Productions, United States, 100 mins.

Time Bandits. 1981. Terry Gilliam. Handmade Films Ltd., UK, 116 mins.

Titan A.E. 2000. Don Bluth and Gary Goldman. 20th Century Fox/David Kirschner Productions/Blue Sky Studios/Fox Animation Studios, United States, 94 mins.

Titanic. 1997. James Cameron. 20th Century Fox/Paramount/Lightstorm, United States, 194 mins.

Toni. 1935. Jean Renoir. Films d'Aujourd'hui, France, 95 mins.

Top Gun. 1986. Tony Scott. Paramount Pictures, United States, 110 mins.

Total Recall. 1990. Paul Verhoeven. Carolco/Guild, United States, 109 mins.

Toy Story. 1995. John Lasseter. Disney/Pixar/Buena Vista, United States, 80 mins.

Toy Story 2. 1999. John Lasseter. Disney/Pixar, United States, 92 mins.

Trial, The. 1962. Orson Welles. Paris-Europa Productions/FI.C.It/Hisa-Films, France/Italy/West Germany, 120 mins.

Triumph of the Will (Triumph des Willens). 1936. Leni Riefenstahl, Leni Riefenstahl-Produktion/NSDAP-Reichsleitung, Germany, 114 mins.

Tron. 1982. Steven Lisberger. Walt Disney Pictures/Lisberger-Kushner, United States, 96 mins.

True Lies. 1994. James Cameron. 20th Century Fox/Lightstorm/Universal, United States, 141 mins.

Truman Show, The. 1998. Peter Weir. Paramount Pictures/Scott Rudin Productions, United States, 103 mins.

Twelve Monkeys. 1995. Terry Gilliam. Polygram/Universal City/Atlas Entertainment/Classico, United States, 129 mins.

Twister. 1996. Jan de Bont. Warner Bros./Universal Pictures/Amblin Entertainment/Constant C Productions, United States, 113 mins.

2001: A Space Odyssey. 1968. Stanley Kubrick. MGM, United States, 141 mins.

2010. 1984. Peter Hyams. MGM, United States, 114 mins.

Unforgiven. 1992. Clint Eastwood. Warner Bros, United States, 131 mins.

Usual Suspects, The. 1995. Bryan Singer. Polygram Filmed Entertainment/Spelling Films International/Blue Parrot/Bad Hat Harry Productions/Rosco Film GmbIt, United States, 105 mins.

Vampyr. 1932. Carl-Theodor Dreyer. Tobis Klangfilm, Germany/France, 83 mins.

Vanishing Point. 1971. Richard Sarafin. 20th Century Fox/Cupid Productions, United States, 107 mins.

Visiteurs du soir, Les. 1942. Marcel Carné. Productions André Paulvé, France, 110 mins.

Voyage à travers l'impossible, Le. 1904. Georges Méliès. Star Films, France, 24 mins.

Voyage dans la lune, Le. 1902. Georges Méliès. Star Films, France, 14 mins.

Wall Street. 1987. Oliver Stone. Edward R. Pressman/American Entertainment Partners, United States, 124 mins.

Wedding, A. 1978. Robert Altman. 20th Century Fox/Lions Gate Films Inc., United States, 125 mins.

What Dreams May Come. 1998. Vincent Ward, Polygram Filmed Entertainment/Metafilmics/Interscope Communications, United States, 113 mins.

Wicked City. 1993. Yoshiaki Kawajiri. Hideyuki Kikuchi/Tokuma Shoten/Video Art/Japan Home Video/Manga, Japan, 81 mins.

Wild at Heart. 1990. David Lynch. Polygram Filmed Entertainment/Palace/Propaganda Films, United States, 127 mins.

Wild Bunch, The. 1969. Sam Peckinpah. Warner Bros/Seven Arts, United States, 145 mins.

Wild One, The. 1954. Laslo Benedek. Columbia Pictures Corporation, United States, 79 mins.

Wild Strawberries. 1957. Ingmar Bergman. Svensk Filmindustri, Sweden, 93 mins.

Wings of Honneamise (*Honneamise no tsubasa;* a.k.a. *Royal Space Force*). 1987. Hiroyuki Yamaga, GAINAX/Bandai, Japan, 120 mins.

X-Files: The Movie, The (special edition). 1998. Rob Bowman. 20th Century Fox/Ten Thirteen Productions, United States/Canada, 121 mins.

Zen for Film. Nam June Paik. Fluxus Editions, 1966, loop.

Filmography

Notes

Chapter 2: Temporal Film

1. Otto von Guerricke, cited in Barrow (2001: 108).

2. The Lumières grew up in a culture in which painting was the defining instance of the visual, and in which composition was a major component of visual culture. Photography was not seen as a compositional medium, but even its casual framings were described in the mid-nineteenth century in painterly terms, evoking the world of oriental arts that transformed French visual culture from the 1850s to the turn of the century (Scharf 1974: 198–205). One visitor to Manet's studio wrote in his guestbook, "The strict imitation of nature is barbarous art, the triumph of the Chinese," while another added, "It is photography." Citing these comments on the founding figure of Impressionism, Anne Coffin Hanson comments that Manet's work, clearly and explicitly indebted to the Japanese in the Louvre *Portrait of Emile Zola* (1867–1868), could be equated with both East Asian prints and photography because all three shared framing unmotivated by academic compositional rules (e.g., the male figures split in half by the frame in *Music in the Tuileries* [1862], *Nana* [1877], and the *Bar aux Folies Bergère* [1882], a lack of the moulding of figures in space so prized among the Salon painters of the mid-century, and an overlighting of scenes that brought about strong contrasts and flattened surfaces (Hanson 1977: 193–196).

 The nascent Impressionism of Manet was not criticized for the apparent clumsiness and lack of finish in his renditions of nature, nor for lack of the kind of realism that today we would call photographic. On the contrary, his critics despised the confusing use of framing, the shallowness of field, and bold lighting effects that Manet shared with the Japanese masters. Such a mix of exotic and photographic can be seen in the noon light in the *Sortie*, in the bold graphic contrasts of heavy shadows under the women's hats against the flat white surface of the wall, and in the bisected

male figure on the right in the final frames. The incompletion and contingency of the frame is integral to the dynamic of the film. The Lumières' framing doesn't just bisect: it is clearly and merely contingent, since the movement of the workers out of frame demonstrates its incompleteness in a way that photography could only adumbrate.

3. Photography lost the aura of unadulterated truth that had been its apparent birthright at the time of the Paris Commune. Jeannene Przyblyski comments on Eugène Appert's constructed photographs purporting to show the atrocities of the Communards:

Combinations of the fake and the real, the prop-like and the relic-like, the layered accumulation of fairy-tale illusion and the tissue-thin veneer of documentary truth . . . Appert's composites were also hybridized objects, complex in their assembling photographic cues and contrary in the way they complicated the legibility of a photographic point of view. . . . Yet . . . they quickly became such staples of illustrated accounts of the Commune, whether pro- or anti-Communard, that eventually the line between reality and artificial simulation hardly seemed to matter. (1995: 260–261)

Przyblyski argues that Appert's artifice derives from an imitation of fictionalized accounts of atrocities produced lithographically for the popular press. According to Przyblyski, these are narrativized images, not only giving a spatial representation to a temporal relation, but also acting on the viewers' prior knowledge that moments after the image, its protagonists will be corpses. Here she sees Appert's photographs "as struggling towards a new language—as envisioning, hesitantly and imperfectly, the compelling displays of reality presented in the first moving pictures" (ibid.: 272).

The Lumières' first few films escape the problematic simulacral status of Appert's composites, less because they are scarcely narrative than because, unlike the time-consuming laboratory processes of plate photography in the 1870s, the cinematograph's shutter was to all intents and purposes automatic. Once started, at the Lumières' preferred speed of 15 frames per second, the camera took on a life of its own. The slowness of photography was the gateway through which truth was expelled. Speed, contra Virilio, became, for a brief moment, the door that let it back in. In effect, it was a matter of exposure time. As Jean-Luc Godard's slogan has it, cinema is truth 24 times per second. Przyblyski's phrase about "displays of reality" suggests both that the display could displace the truth, and that

truth exists without its display. It is not that there is no reality, or that reality is necessarily undiscoverable. What seems difficult to square with the Lumières' *Sortie* is the belief that there might be a truthful illustration.

4. Another plate from the same series, with a caption noting that it is "reminiscent of an Impressionist painting" is reproduced in the Life Library of Photography volume on *Color* (Time-Life Books 1970: 73).

5. In some applications software, the first pixel's coordinates are written (1,1), effectively externalizing zero from the raster, while others, especially 3-D software, translate origin to other positions on the screen.

6. By a gestalt I understand a whole unit, complete unto itself. My argument is that wholeness is not a quality of the world or of its objects, but is a construct of the historically specific ways in which we observe and name it. When we tell a story about an event, we take a series of disparate perceptions, edit out the irrelevant, order what is left according to culturally specific codes, and especially structure its telling to that it has a clear and definite ending—a punchline or a political or moral point—which in retrospect gives the whole performance a reason for existing. The phrase "a story about an event" should indicate that the event is not so structured, is not whole, is full of irrelevancies and contingencies. This quality of irrelevance and contingency, which marks for example Bazin's appreciation of the location backgrounds to Rosselini's *Rome Open City*, is intrinsic to the cinematic event, though I disagree with Bazin's belief that this is a quality of film's representational destiny. Rather, film and the world share this quality.

Chapter 3: Magical Film

1. Nicholas Poussin, after Alhazen, Holt (1947: 158).

2. Following Marx's argument, any machine caught in capitalist relations of production can be understood as constant capital, as opposed to the variable capital of living labor that uses it (Marx 1976: 307–319). Constant capital in turn is the product of accretions of dead labor (Marx 1973: 695). On G. A. Cohen's account, the accumulation of past labor in the form of machinery, in Marxist terms the means of production, is an agent in the making of history (Cohen 1978: 28–62). In this sense, the accumulated history of work embodied in machinery remains an active element of production—even the dead are exploited—but at the same time that machinery is one of the agencies that drives human history—even the dead are active in the making of the future.

3. Zero occupies a position of precedence over all the cardinal (counting) numbers that follow it. Unity can be derived from zero in a number of ways. In von Neumann's theory of the empty set, the content of the set is zero, but the number of sets with zero content is one. Once started, this chain of aggregation cannot but continue: the set of those sets whose content is single is two: the empty set and the unitary set. The number of sets whose content is less than or equal to two is three. Eventually this logic will produce all the cardinal numbers and their ratios. The initial difference generates unity, and the difference between zero and unity generates multiplicity. A classroom-friendly variant is to write a zero on the board and ask how many numbers are on the board. The answer is one. Write a one on the board and ask how many now, the answer being two. Write a two and repeat until the point sinks in. Just as zero is not to be equated with the void, so unity must not be mistaken for identity. On the contrary, as zero proliferates difference, unity implies all the other numbers. Zero is the nonidentical, and one is that which is identical with itself, but one is also the first, implying the series. The self-identical frame is only a still image projected, and we have no movie, which is why neither the single frame nor the still photograph can be taken as the elementary form of the moving image. What is formative about the unified, single frame is that it necessarily implies a relation with other frames, the relation of seriality or multiplicity.

4. The epic television series *Ramayana* and *Mahabharata*, based on the Sanskrit classic produced by the national Doordarshan television company in India, drawing like Phalke on the art of Raja Ravi Varma, stand accused of such communal totalitarianism (Mitra 1996). These massive series occupied a strategic position on the national television station, consolidating its near monopoly against the threat of satellite broadcasting (and incidentally its use by Christian fundamentalist missionaries), and providing a cultural lodestone for people of the Indian diaspora (Gillespie 1995). It is not simple to dismiss them as Hindu nationalist propaganda, but that aspect of their communicative function, like the related aspect of Phalke's work, needs to be addressed if we are to avoid orientalizing again in the new mode of patronizing multiculturalism, which Rasheed Araeen (2000) describes as "benign racism."

5. In electronic imaging, the process will be redoubled in the control available to digital filmmakers working on bit-mapped images, where the pixel loses its random Brownian motion to become a mode of the cut. Then we will have to make an important distinction between the grid, the unillu-

minated infrastructure of bit-mapped display, and the pixels it defines and supports, just as we have distinguished between the frameline and the frame. The electronic pixel is a numerically defined square on the image whose color is typically defined by a six-digit hexadecimal number. The bit-mapped image is then one in which every particle of light is subject to control, and more significantly to automation.

Chapter 4: Graphical Film

1. Klee (1961: 105).
2. In a series of papers between 1874 and 1896, Georg Cantor explored and eventually defined a central paradox in set theory that derives in part from his research into the "transfinite" numbers, numbers greater than the set of all natural numbers. Using the Hebrew letter ℵ (aleph) to symbolize an infinite set, Cantor demonstrated that the set of all positive integers (whole numbers), by definition infinite, is the same size as the set of all even numbers, even though there would appear to be only half as many of them, and the same size as the set of all prime numbers (numbers divisible only by themselves and one), though these would seem to be even rarer. At the same time, however, he showed that real numbers—the number of points on the real line, in other words, the infinitesimals—were not countable whereas algebraic numbers (such as evens and primes) were. Thus "Cantor was able to show that infinity is not an all or nothing concept: there are degrees of infinity" (Rucker 1992: 9).

 For our explorations of the vector, it is important to note here that the real line of mathematics is not composed of points as such. Cantor's contemporary, Dedekind, defined the real numbers as infinite sets, or, more accurately, the sum of two infinite sets (an example would be the square root of 2, which is defined by two real numbers, one to a vanishingly small degree larger and one similarly smaller than the actual number toward which they are approaching). The real line so considered is then not so much a distance between two points as a trajectory, a tendency toward, an approach to, an activity rather than an object. This will become increasingly important in the 1990s, when vector-based computer graphics supersede bit maps as the dominant technique for producing 3D models. Because the vector is a real line composed of an infinity of infinitesimals, it can be scaled up or down without producing the "jaggies" that result from magnifying a bit-mapped image. But this property is also dependent on the paradox described by Flann O'Brien's de Selby: the dilation of the line seems at first to trap us in an endless expansion of the present moment.

But Cantor's next step would remove that danger and open the dynamic line to the future of endless becoming.

During the mid-1880s Cantor wrestled with a problem rising directly from his discovery of the multiplicity of infinities: "he could not prove the continuum hypothesis, namely that the order of infinity of the real numbers was the next after that of the natural numbers. In fact he thought he had proved it false, then the next day found his mistake. Again he thought he had proved it true only again to quickly find his error" (O'Connor and Robertson 2000: np). The problem was still unsolved and still central to his last papers on set theory published in 1895 and 1897, just as the cinema was being born. This missing solution would provide what David Hilbert described in 1900 as one of the greatest challenges for twentieth-century mathematics: we know that the size of the set of real numbers must be one of $\aleph 0$, $\aleph 1$, $\aleph 2$. . . (aleph-null, aleph-one, aleph-two . . .) but we cannot say which one. The question would lead to the key discovery of twentieth-century mathematics: that not just Cantor's problem but the whole of mathematics is undecidable. First mooted in the 1930s, Gödel's theorem (Nagel and Newman 1959) and Turing's halting problem (in which his first theoretical model for a computer was proposed; Hodges 1985) lead directly to Paul Cohen's 1979 extension of undecidability to all set theory and thus to the foundations of all mathematics (Stewart 1992).

Because it is undecidable, mathematics cannot be finished. Cantor's younger contemporary, the philosopher Gottlob Frege, dreamed of a completely codified mathematics. As a result of Cantor's explorations, that dream had begun to fall apart even as he was trying to write it. Frege sought to define the basic principles (axioms) from which all mathematics must arise. Effectively, what he sought were the syntactical rules for the production of well-made mathematical sentences. But Gödel, Turing, and Cohen demonstrated that mathematics cannot be the purely syntagmatic structure that Frege dreamed of. The importance for us is that by analogy cinema cannot be limited to the algebra of the cut and the logic of the present: it too would participate in the undecidable through the graphical code of the vector.

3. Wells's reference to incoherence is art-historical: Cohl had been part of a bohemian set called *Les Incohérents*, some of whose japes he would immortalize in *Le Peintre néo-impressioniste*, a group that intriguingly included Charles Cros whom we have already met as a colleague of the Lumières. The term had a certain currency: Méliès's intrepid explorers of *Le Voyage*

à travers l'impossible belong to the *Institut de la géographie incohérent*—we can presume the term had a moment in the limelight of Parisian humor, a forgotten populist avant-garde whose fortunes were established in the same moment as the birth of the cinema.

Chapter 5: Total Film

1. The last lines of the poem found in the pocket of the poet Vladimir Mayakovsky on the night he shot himself. The translation, by George Reavey, is taken from Barnstone (1966). Among Eisenstein's immediate circle, the poet Esenin also committed suicide. Eisenstein's teacher and mentor, the theatrical director Meyerhold, was arrested in 1938, and died on the way to Siberia in 1942; the writers Sergei Tretyakov and Isaac Babel were arrested, deported, and assassinated in 1937 and 1939 respectively, and two of his own students would disappear in the gulags.

2. My use of the term "total cinema" needs to be distinguished from André Bazin's in his essay "The Myth of Total Cinema" (1967: 17–22), in which he argues that the cinema was born out of an obsession, dating back to the baroque, with the reproduction of movement, that is, "the forbidden desire to re-create and store up the appearances of reality with complete fidelity" (Andrew 1990: 74). As used here, total cinema has nothing to do with the myth of total representation, and everything to do with the aim of total control over the effect of the film on its audience.

3. In modern mathematics it is associated with the number e, the universal base of logarithms, which expresses "the limit of $(1 + 1/n)^n$ as n tends towards infinity" (Maor 1994: 9). The limit arises from the fact that as n gets larger, $1/n$ gets smaller, the one tending toward infinity, the other toward zero—the infinite and the infinitesimal bound together, a nested series of rectangles, the ratio of whose width to height is always 1.61803.... A curve drawn through the nest gives us the logarithmic spiral. Eisenstein writes this figure as a ratio, which is why he gives the golden number as 0.618. Aumont gives another citation of the golden section from a 1934 essay, whose title he translates as "Organicism and 'Imaginicity,'" first published in the Russian *Selected Works* (1964–1970): "this curve has been given precisely the meaning which, in our interpretation, is also found at the basis of the universal movement. It is precisely this curve which signifies, figuratively, the passage into the opposite" (Aumont 1987: 71). Yet another evocation of the logarithmic spiral occurs in *Non-Indifferent Nature:* "an image of 'progressive' movement forward . . . that is, of spatial perfectibility—from 'zero,' from a 'cell' to an increasingly enriched

modification and growth that, in a spiral motion, becomes qualitatively more complicated (Eisenstein 1987: 188). These two quotations evoke two aspects of the Stalinist simplification of dialectical materialism ("Diamat"), the principle of unity and that of perpetual becoming: Eisenstein also cites Engels *Dialectic of Nature* (1940) to support these principles as the groundwork for the organic unity thesis proposed in his later writings. For a further, more cryptic invocation of the golden section, see the diagrams by Eisenstein accompanying his "Unity in the Image," completed just before he began work on *Alexander Nevsky* in 1937 (Eisenstein 1991: 272–273).

The spiral has an extraordinary number of unique qualities, central among them its stability under all sorts of transformations that would convert any normal curve into something quite different. The seventeenth-century mathematician Jakob Bernoulli wrote of it: "Since this marvelous spiral, by such a singular and wonderful peculiarity . . . always produces a spiral similar to itself, indeed precisely the same spiral, however it may be involved or evolved, or reflected or refracted . . . it may be used as a symbol, either of fortitude and constancy in adversity, or of the human body, which after all its changes, even after death, will be restored to its exact and perfect self" (cited in Maor 1994: 126). Far from Eisenstein's reading of it as the graphical form of evolution and organic growth, Bernoulli read it as the icon of stability. It was just such an organicist misreading of the evolutionary as a stable whole that stopped Eisenstein from developing a genuinely graphical, vector-based cinema in *Nevsky*.

4. Aumont quotes from an essay called "Off-frame" (apparently translated as "The Cinematographic Principle and the Ideogram" in *Film Form*). In a note to Nizhny's *Lessons*, Montagu comments on *kadr*, "This Franco-Russian word, etymologically connected perhaps with the graphic aspect of the shot, its composition and compositional limits, must never be translated 'frame'" (Nizhny 1962: 169, n.35), distinguishing in another note between "The 'frame' of a shot, its borders within which it is composed on the one hand; on the other the 'frame' or single static image of which many compose the shot. Russians apparently sometimes use '*rama*' (non-technically) for the second kind of frame, but they also use '*vyrez*' or 'cut' for the section of the whole possible view-field extracted or 'cut out' by such a frame" (ibid.: 171, n.46). On the one hand, the cut acts on the plane of the screen, isolating the scene depicted from what lies on the right or left, or above or below it. But on the other, the cut is a slice through the z-axis or axis of vision perpendicular to the picture plane.

Chapter 6: Realist Film

1. Kinsella (1973: 80).
2. The emphasis here is on multiple subject positions rather than on multiple perspectives on the action. Concluding her detailed account of the formal strategies of realism in *Bicycle Thieves* and *La Règle du jeu*, Kristin Thompson argues that "no filmic technique or method of combining techniques is innately realistic. Similarly, just because a film demands a variety of viewing skills, as *Rules* does, it does not automatically create an effect of realism, as the systematic disunities of Godard's films shows. Whole films, existing against specific historical backgrounds, create the effect of realism" (1988: 244). The insistence on the changing conventions that produce the reality effect is quite accurate, but does not define the effect itself. Similarly, when Thompson argues that realism depends on successive renovations of standardized conventions "by appealing to motivation that can be considered realistic" (ibid.) she is of course speaking the truth, but without addressing the underlying question of *how* we come to consider some motivations (in which are included not only character motivations but the motivation of shots, angles, edits, and so on) as realistic. This relation depends not on entering into new formal relations with consecutive shots but in the multiple relations entered into with any shot.

 The acting in *La Règle*, for example, includes some quite over-the-top hamming (Renoir 1989: 192) and draws largely on vaudeville and pantomime as well as on the starchier conventions of the Comédie Française (ibid.: 237). Renoir says he began with the idea of adapting Musset in his autobiography (Renoir 1974: 170), although he tells his interviewers from *Cahiers du Cinéma* that he never had the intention of doing an adaptation (Renoir 1989: 4): at the least the name Octave in the role of go-between belongs to *Les caprices de Marianne* (Musset 1978). Moreover, the characters, including some of the key figures, are either cryptic (Christine) or monomanical to the point of caricature (the General). The reality effect does not depend on their approximation to mid-century norms of psychological verisimilitude. Rather, it is exactly their simplicity or opacity that invites us to interpretation, passing to the spectator the task of adding depth and understanding. This is the task of fantasy, as in Mamoulian's famous advice to Garbo for the final shot of *Queen Christina*: "Don't think about anything—the audience will think for you."
3. For example: literary-historical—the shot evokes the chorus of Aristophanes' play, in which the frogs provide an ironic, satirical chorus; visual-punning—the frog (*grenouille*) is the less than affectionate English

nickname for the French, the frog representing the incoherent and un-heard bleating of the French people; political—as above, but noting that the frogs are at least at home in the moat, natural, and undamaged by the game going on above their heads; film-theoretical—their croaking is a communication without a language, or a language without a code. My thesis is that the frog and the croak function once to anchor us in a diegetic world in which such uncaring contingencies arise (and inciden-tally in the specificity of the marshy Solgne), but second as a kind of La-canian "*tuché*," a blind spot denoting that place within the audiovisual construction of the film which is never open to the gaze, that is, to the de-sire of the subject for knowledge and truth: a gap in meaning. In this way it functions like the famous hiccoughs of Aristophanes in Plato's *Sympo-sium* (1951), which Lacan's informant, the Hegelian Alexandre Kojève, told him constituted the key to the whole conception of the ascent to ab-solute beauty in that book (Lacan 1991: 78). That it should be the croak-ing of frogs that instigates this chain of significations should alert us to the risks of the well-formed association, as well as the strange eloquence of analogical thought.

4. In Miller, as in Frege, the number one ("trait of the identical," the *trait un-aire*) represents the nonidentical (the number of the concept zero is one). Identity is thus a flawed concept, since one (identity) is only a representa-tion, and at that a representation of what is nonidentical. All the numbers that follow, composed as they are on the mathematical formula $n + 1$, in-corporate this trace of the lack that denies the possibility of self-identity. Analogously, subjectivity is always founded not on identity but on non-identity. The impossible zero object is rejected in logic as pure negative (Miller 1977/1978: 32). This pure negative, summoned and rejected as the foundation of logic's systemic autonomy from the world, is the sub-ject. Zero, then, is always a part of every system but also always absent from it, as pure negative. It is in this sense that he understands the Lacan-ian thesis that the signifier represents the subject for another signifier: "The insertion of the subject into the chain is representation, necessarily correlative to an exclusion which is a vanishing" (ibid.: 33). Consciousness is to be understood as an effect, not a cause of signification: the definition of the subject comes down to "*the possibility of one signifier more*" (ibid.).

5. Jurieu does not know how to play at life, largely because he is unable to secure his own death. He believes it is possible to be both a hero and soli-tary, but Renoir points out wisely that "Solitude is the richer for the fact that it does not exist" (Renoir 1974: 244). Certainly it does not in *La Règle*,

where it is difficult to recall a single shot with fewer than two people in it. Moreover, even his attempt at killing himself in the car is bungled, and worse still undermined by doubts as to his sincerity since "People who commit suicide do not care to do it in front of witnesses" (ibid.: 172). It is not so much that the suicide attempt is not serious, but rather that even death communicates, and so the ground for suicide—that communication will no longer be possible—is self-contradictory.

Chapter 7: Classical Film
1. Wolfenstein and Leites (1950: 189).
2. The company's history encapsulates the contradictions of modernization. AT&T, formed in the wake of a 1919 Senate subcommittee ruling that antitrust legislation did not apply to telephony as "a natural monopoly," joined forces with General Electric and Westinghouse to form the Radio Corporation of America under the general managership of David Sarnoff (Barnouw 1966: 52–125; Douglas 1987: 240–291; Hilmes 1997: 34–74). Also in 1919 General Electric had purchased the U.S. patents to Marconi's wireless, as either adjunct or competitor to telephony. Those rights were licensed to RCA. Sound-on-film technologies were seen as an extension of these existing technologies. But the Big Five studios of 1927 (Loews', First National, Paramount Famous Lasky, Universal, and Producer's Distribution Company) were unhappy about dealing with a monopoly supplier, and managed to get the radio and telephone groups of the Bell system and its allies to compete. Marginalized by the final decision, RCA moved into feature film production in defense of its important market share in the new medium of talking pictures. Competition was tough. In January of 1933, the RKO studio, a scant four years old, went into equity receivership. For the next six years it would remain under the administration of a federal district court (Lasky 1984).
3. In a series of lectures and papers devoted to the evolution of semantics, Willard Van Orman Quine argued that contemporary thinking is dominated by an object-oriented conceptual scheme. In its place, he assessed empiricism's destiny in terms of a critique of objectivism, based on a linguistic analysis of the constitution of the world as collocation of objects. "The individuative, object-oriented conceptual scheme so natural to us could conceivably begin to evolve away," he argued.

It seemed in our reflection on the child that the category of bulk terms [e.g., "there is apple in the salad," "water"] was a survival of a pre-individuative phase. We were

thinking ontogenetically, but the phylogenetic parallel is plausible too: we may have in the bulk term a relic, half-vestigial and half-adapted, of a pre-individual phase in our conceptual scheme. And some day, correspondingly, something of our present individuative talk may in turn end up, half vestigial and half adapted, within a new and as yet unimagined pattern beyond individuation. (Quine 1969: 24)

Quine's proximity to the Whorff-Sapir hypothesis notwithstanding, the readiness of a self-proclaimed empiricist to countenance the possibility of a world constituted otherwise than as a collection of discrete entities chimes strongly with Deleuze's empiricist claims of the same year.

4. Missing from Deleuze's analysis, however, is any awareness that his own philosophy constitutes a microhistorical event and is itself enraptured by the microhistory of its formation in the heady days of 1968, when, in *Difference and Repetition*, he first fully formulated the groundwork for the philosophy of desire. In that moment, when Debord and the situationists were likewise uncovering the mysterious dynamics of difference in the spectacularization of the commodity form (Debord 1977; Knabb 1981), what Deleuze alighted on was not the emergence of a new paradigm, but the revealed disarray of an older one that had come into being in the wake of the Wall Street crash. I do not want to propose here that we should use Deleuze as ontologist or metaphysician of cinema, simply that we can employ his insights in the chaotic return of difference as a philosophy of history, to approach our films with a sense of their brute specificity.

Chapter 8: Neoclassical Film

1. Williams (1956: 114).
2. It scarcely seems worth mentioning the homoeroticism of Peckinpah's films, were it not for the relative silence, for example, of the contributors to the collections of Bliss (1994) and Prince (1998). The bounty hunters playing gay, Dutch's poached egg eyes as he gazes at Bishop, Lyle and Tector riding tandem, Bishop's relation to Angel, Thornton and Bishop's relationship; and the power of the emotional interplay between Garrett and the Kid are too obvious to require commentary, except that they do not seem to receive it. The observation is relegated to a note here because either it is banal, or it leads to a banal observation of the myopia of critics, or it demands a long expose of the thematics of men without women, Don Juanism, and a kind of "literary" criticism that doesn't fit with the trajectory that this book sets out upon. Unlike the case of *La Règle du jeu*, the homoerotic doesn't matter to this film: it is simply the given quality of its

machismo, a flavor of its violence, not its cause. Few people have seemed as happy or as right in their closets as Peckinpah: it allowed him to occupy the same world as his protagonists. Without his repressed sexuality, he would have been merely another misogynist.

3. David A. Cook gives a figure of 3,642 cuts (Cook 1990: 979), but adds in a footnote to his analysis of the film in *A History of Narrative Film* that the figure has to be approximate because of the number of prints in circulation (Cook 1996: 929–930). Prior to release, Peckinpah showed a 190-minute rough cut; release prints in 1969 came in variously at 148, 145, 143 and 135 minutes. The restored version available on VHS in the United States from 1985 ran at 145 minutes, itself rather odd since video, at 25 fps, runs faster than film. The DVD "original director's cut" runs at 138 mins, which would reflect this faster frame rate. I have worked from an off-air BBC broadcast of the film and from the Region 4 DVD, both widescreen and extremely similar in all respects except for the color balancing and the fact that my off-air tape is in poor condition. There is no definitive print of *Pat Garrett and Billy the Kid*. This chapter has been written using a U.K. off-air video and an Australian DVD, both ostensibly based on the definitive cut but differing in duration by several minutes. This may be a result of a different frame rate or abbreviated title sequences, but at least one brief shot is in the video but not the DVD. Seydor gives a definitive account of the cutting and release histories of the films, noting appropriately that the "Director's Cut" of *Pat Garrett and Billy the Kid* was actually completed some year's after the director's death, and that the same apothegm applied to *The Wild Bunch* is misleading. There is, it bears repeating, no definitive version of any film, and my two copies, even if similarly sourced, are no doubt subtly different from yours.

Chapter 9: Neobaroque Film

1. Creeley (1973).

2. The transfiguration of Scorsese's protagonists is the mirror of the transfixed vision of the audience, caught like rabbits in the exploration of their own fascination. Hollywood has learned the secret of the Jesuits, to whom, moreover, in the person of Athanasius Kircher SJ, we owe the *Ars Magna Lucis et Umbrae*, the first description of the magic lantern.

3. Leibniz's description of the machinery of perception could almost be an account of a visit to a projection booth by Stuart Little: "Suppose that there were a machine so constructed as to produce thought, feeling, and perception, we could imagine it increased in size while retaining the same

proportions, so that one could enter as one might a mill. On going inside we should only see the parts impinging on one another; we should not see anything that would explain a perception" (Leibniz 1973: para. 181).

Chapter 10: Technological Film

1. Dorn (1978: 57).

2. There is a ramp of needs here: the pseudopod of *The Abyss* was created on a computer with 300Mb of storage and 48Mb of RAM. Storage requirements for the big dogfights in *Independence Day* reached 50 gigabytes. *Toy Story 2* used up to 39 million polygons per frame, rendered at between 1.4 and 2 million pixels requiring up to 7 hours computation time apiece (Smith 2000: 58–59). Pixar's slogan has become industry lore: "Reality begins at 80 million polygons." Even at these resolutions, the industry still requires more power to offer anything like believable synthetic humans. Such ambitions will hit the wall of quantum effects, which impede electronic processes at the atomic scale, before they can be realized. The drive for optical and quantum nano-computers and the development of massively parallel processing are aimed at overcoming this barrier, but at time of writing such technology is a long way from realization, even in laboratories.

3. In *True Lies*, Cameron comes closest to the comedy of remarriage, although the process is uncomfortably sadistic when Schwarzennegger first demands that his wife play the role of a prostitute and later questions her anonymously from behind a one-way mirror. The brutalization is legitimated by the film's conclusion, when Curtis graduates to full-time spy in her own right. The sadism of the scenario echoes earlier films in which fidelity is tested beyond breaking, and indeed in a lengthy tradition stretching back through Mozart to Shakespeare. Here the factor of disguise and dissimulation is critical to the fantasy and relates both to the ancient traditions of the mask and to the intensive discomfort of contemporary masculinity. That it should be Cameron who negotiates the relation between the neobaroque and the older classical paradigm through the comedic construction of hypermasculinity seems only fair. Moreover, the real love that has to be realized is that between the father and his daughter, rather than between husband and wife. The forbidden relation is far closer to the tragic *mise-en-abyme* characteristic of the neobaroque, in this harmonizing with the cousins of *Godfather 3*.

4. In fact, Industrial Light and Magic are proud to have developed the rotoscope on the basis of its first use in Disney's *The Old Mill* of 1937, though the ILM version is four times longer and arranged horizontally rather

than vertically. Its central function is in compositing, where the depth of field available allows for complex perspectival effects as well as the interweaving of picture elements, and even the generation of mattes by projecting the shadow of one element onto another plane to provide a tracing outline. Likewise ILM boast of using the same VistaVision Anderson aerial optical printer used for the effects in *The Ten Commandments* until it was put on display in the ILM facility in 1993—ILM resurrected the moribund VistaVision format to increase the resolution of first-generation effects, permitting a certain loss of resolution in subsequent generations down to theatrical 35mm film. The oldest piece of kit mentioned in the official history of the company is a 1920s Bell and Howell 2709 used for creating work prints from video of in-progress computer graphic elements (Vaz and Duignan 1996: 19). Some of this retro-fitting of ostensibly outmoded equipment belongs to the culture of the machine shop, and to the admiration of engineers for a well-wrought piece of kit. But it is also testimony to the resilience of sprocket-based, mechanical technology in what is too often regarded as a purely digital era. Such pieces of equipment, it should be noted, are not prized as nostalgic collectibles, but as workhorses of highly efficiency-oriented commercial engineering.

Chapter 11: Oneiric Film

1. Yeats (1962: 61).
2. A Freudian might see Julie's attempts to go without her spectacles as a failure of vision, an unresolved mirror phase, and thus a lack of self-image by which to distinguish herself from her father or her environment. Her clumsiness would then not be simply a function of her desire to impress her visitor, Louison, but a result of the failure to separate herself from her parent and therefore to make herself available as a sexual partner for a new man. Rather than an ocular resolution, however, Jeunet and Caro go for baptismal farce.

Chapter 12: Revisionary Film

1. Ward (1990: 150).
2. Hong Kong film personnel channeled a great deal of financial aid into support for the Tienanmen protesters. The story is also told of how "Tsui Hark, producer of Woo's most successful films, and Chow Yun-Fat, Woo's star actor and alter-ego, wept on the set of *A Better Tomorrow 3* as they heard the news from China over the radio and then injected their anger into the production of the movie" (Stringer 1997: 41).

3. This overcoded optical trick is further evidence for the traffic of angels, those messengers who speak perpetually between the orders of existence. The medieval masters painted seven phases of the Annunciation, among which, between humility and acceptance, was wonder. The Virgin marvels, as she must, at God's particular grace *to her*. The miners both fear and admire the events that, fictive though they be, are their actions. Action and event, narration and actuality meld in the gift that the sacrament of confirmation names Fear of the Lord. Refining the communicative affect of the experience of being narrated that is their salvation, we might describe it as energy in the process of becoming information, a relation of as startling power as that multiplication by the universal constant that describes the transition from matter to energy. But where that movement has always inspired terror and sublimity in its Einsteinian guise, we tend to emphasize the amount of energy required to provide information. Like matter, information is an intense storage medium, yet when we investigate even the physical forms of human communication like film, we recognize how little information is involved, and how much energy is released by even a small amount of communication. This is the shock of betrayal: the irruption and inscaping of the communicative in the destructuring of information, the explosion of energy out of that moment of the lever of wonder. In this way wonder is always explicable, even if it defies explanation—it has its understanding deferred into a future in which the betrayal of truth by communication can be sorted and forgiven. Wonder is the corollary of the realization that peace is not the opposite of war but the dialectical counterpart of victory, the necessity of surrender to the other. Wonder is surrender to the otherness that sits at the heart of communication, for what is communicated is always other, or it is not communication. Fear of the Lord belongs properly to the process of communication figured in the nature of angels as messengers between incommensurable orders of being.

Chapter 13: Cosmopolitan Film
1. Burroughs (1959: xxxix).

References

Abel, Richard (1994). *The Ciné Goes to Town: French Cinema, 1896–1914*. University of California Press, Berkeley.

Adorno, Theodor W. (1967). "Cultural Criticism and Society," in *Prisms*, trans. Samuel and Shierry Weber, 17–34. MIT Press, Cambridge, Mass.

Adorno, Theodor W. (1991). "Transparencies on Film," in *The Culture Industry: Selected Essays on Mass Culture*, ed. J. M. Bernstein, trans. Thomas Y. Levin, 154–161. Routledge, London.

Adorno, Theodor W. (1997). *Aesthetic Theory*, ed. Gretel Adorno and Rolf Tiedemann, trans. Robert Hullot-Kentor. Athlone Press, London.

Althusser, Louis (1971). "Ideology and Ideological State Apparatuses (Notes Towards and Investigation)," in *Lenin and Philosophy and Other Essays*, 127–186. Monthly Review Press, New York.

Altman, Rick (1980). "Moving Lips: Cinema as Ventriloquism," in *Cinema/Sound*, ed. Rick Altman, *Yale French Studies* (special issue) 60: 67–79.

Altman, Rick (1992). "Dickens, Griffith, and Film Theory Today," in *Classical Hollywood Narrative: The Paradigm Wars*, ed. Jane Gaines, 9–47. Duke University Press, Durham, N.C.

Altman, Rick (1994). "Deep-Focus Sound: *Citizen Kane* and the Radio Aesthetic." *Quarterly Review of Film and Video* 15 (3): 37–40.

Anderson, Benedict (1983). *Imagined Communities: Reflections on the Origin and Spread of Nationalism*. Verso, London.

Andrew, Dudley (1990). *André Bazin*, rev. ed. Columbia University Press, New York.

Andrew, Dudley (1995). *Mists of Regret: Culture and Sensibility in the Classic French Film*. Princeton University Press, Princeton, N.J.

Ang, Ien (1985). *Watching Dallas: Soap Opera and the Melodramatic Imagination*. Methuen, London.

Appadurai, Arjun (1996). *Modernity at Large: Cultural Dimensions of Globalization*. University of Minnesota Press, Minneapolis.

Apter, Emily (1991). *Feminizing the Fetish: Psychoanalysis and Narrative Obsession in Turn-of-the-century France*. Cornell University Press, Ithaca, N.Y.

Araeen, Rasheed (2000). "The Art of Benevolent Racism." *Third Text* 51 (summer): 57–64.

Arias, Pierre (1984). "Méliès mécanicien," in *Méliès et la naissance du spectacle cinématographique*, ed. Madelaeine Malthête-Méliès, 37–79. Klincksieck, Paris.

Artaud, Antonin (1978). "Sorcery and the Cinema," in *The Avant-Garde Film: A Reader of Theory and Criticism*, ed. P. Adams Sitney, 49–50. Anthology Film Archives, New York.

Asada, Akira (1989). "Infantile Capitalism and Japan's Postmodernism: A Fairy Tale," in *Postmodernism and Japan*, ed. Masao Miyoshi and H. D. Harootunian, 271–278. Duke University Press, Durham, N.C.

Auden, W. H. (1966). *Collected Shorter Poems, 1927–1957*. Faber, London.

Aumont, Jacques (1987). *Montage Eisenstein*, trans. Lee Hildreth, Constance Penley, and Andrew Ross. Indiana University Press, Bloomington.

Aumont, Jacques (1996). *A quoi pensent les filmes?* Séguier, Paris.

Aumont, Jacques (1997a). *The Image*, trans. Claire Pajakowska. BFI, London.

Aumont, Jacques (1997b). "The Variable Eye, or The Mobilization of the Gaze," in *The Image in Dispute: Art and Cinema in the Age of Photography*, ed. Dudley Andrew, 231–258. University of Texas Press, Austin.

Aumont, Jacques, Alain Bergala, Michel Marie, and Marc Vernet (1983). *L'Esthétique du film*. Fernand Nathan, Paris.

Aumont, Jacques, Alain Bergala, Michel Marie, and Marc Vernet (1992). *The Aesthetics of Film*, trans. Richard Neupert. University of Texas Press, Austin.

Bach, Steven (1985). *Final Cut: Dreams and Disaster in the Making of Heaven's Gate*. Morrow, New York.

Bacon-Smith, Camille, and Tyrone Yarborough (1991). "Batman: The Ethnography," in *The Many Lives of the Batman: Critical Approaches to a Superhero and his Media*, ed. Roberta E. Pearson and William Uricchio, 90–116. BFI, London.

Bakhtin, Mikhail (1968). *Rabelais and His World*, trans. Hélène Iswolsky. MIT Press, Cambridge, Mass.

Balibar, Etienne, and Immanuel Wallerstein (1991). *Race, Nation, Class: Ambiguous Identities*, trans. of Etienne Balibar by Chris Turner. Verso, London.

Balibar, Renée, and Denis Laporte (1974). *Le français national*. Hachette, Paris.

Balio, Tino (1995). *Grand Design: Hollywood as a Modern Business Enterprise, 1930–1939* (History of the American Cinema, vol. 5). University of California Press, Berkeley.

Barna, Yon (1973). *Eisenstein*, trans. Lise Hunter, ed. Oliver Stallybrass. Secker and Warburg, London.

Barnes, John (1976). *The Beginnings of the Cinema in England*. David and Charles, Newton Abbott.

Barnouw, Eric (1966). *A Tower in Babel: A History of Broadcasting in the United States: Volume 1—to 1933*. Oxford University Press, New York.

Barnouw, Eric (1981). *The Magician and the Cinema*. Oxford University Press, Oxford.

Barnouw, Eric, and S. Krishnaswamy (1980). *Indian Film*, second ed. Oxford University Press.

Barnstone, Willis (ed.) (1966). *Modern European Poetry*. Bantam, New York.

Barrow, John D. (2001). *The Book of Nothing*. Vintage, New York.

Barshay (1997). "Postwar Social and Political Thought, 1945–90," in *Modern Japanese Thought*, ed. Bob Tadashi Wakabayashi, 273–355. Cambridge University Press, New York.

Barthes, Roland (1977a). "The Death of the Author," in *Image-Music-Text: Selected Essays*, ed. and trans. Stephen Heath, 142–148. Fontana, London.

Barthes, Roland (1977b). "The Third Meaning: Research on Some Eisenstein Stills," in *Image-Music-Text: Selected Essays*, ed. and trans. Stephen Heath, 52–68. Fontana, London.

Bataille, Georges (1988). *The Accursed Share*, volume 1: *Consumption*, trans. Robert Hurley. Zone Books, New York.

Baudrillard, Jean (1980). *For a Critique of the Political Economy of the Sign*, trans. Charles Levin. Telos Press, St. Louis.

Baudrillard, Jean (1988). *America*, trans. Chris Turner. Verso, London.

Baudrillard, Jean (1993a). *Symbolic Exchange and Death*, trans. Ian Hamilton Grant. Sage, London.

Baudrillard, Jean (1993b). *The Transparency of Evil: Essays on Extreme Phenomena*, trans. James Benedict. Verso, London.

Baudrillard, Jean (1994). *Simulacra and Simulation*, trans. Sheila Faria Glaser. University of Michigan Press, Ann Arbor.

Baudry, Jean-Louis (1976). "The Apparatus: Metapsychological Approaches to the Impression of Reality in the Cinema," trans. Jean Andrews and Bertrand Augst, *Camera Obscura* 1 (fall): 104–26.

Baudry, Jean-Louis (1985). "Ideological Effects of the Basic Cinematographic Apparatus," trans. Alan Williams, in *Movies and Methods volume II*, ed. Bill Nichols, 531–542. California University Press, Berkeley.

Bauman, Zygmunt (1999). *In Search of Politics*. Polity, Cambridge.

Bauman, Zygmunt (2000). *Liquid Modernity*. Polity, Cambridge.

Baxter, Peter (ed.) (1980). *Sternberg*. BFI, London.

Baxter, Peter (1993). *Just Watch! Sternberg, Paramount, and America*. BFI, London.

Bayly, C. A. (1986). "The Origins of Swadeshi (Home Industry): Cloth and Indian Society, 1700–1930," in *The Social Life of Things: Commodities in Cultural Perspective*, ed. Arjun Appadurai. Cambridge University Press, Cambridge.

Bazelon, Irwin (1975). *Knowing the Score: Notes on Film Music*. Van Nostand Reinhold, New York.

Bazin, André (1967). *What Is Cinema?* volume 1, ed. and trans. Hugh Gray. University of California Press, Berkeley.

Bazin, André (1971). *What Is Cinema?* volume 2, trans. Hugh Gray. University of California Press, Berkeley.

Bazin, André (1973). *Jean Renoir*, ed. François Truffaut, trans. W. W. Halsey II and William H. Simon. Dell, New York.

Bazin, André (2002). "The Life and Death of Superimposition (1946)," trans. Bert Cardullo, *Film-Philosophy*, 6 (1), January, www.film-philosophy.com/vol6-2002/n1bazin.

Bell, Clive (1931). "The Aesthetic Hypothesis," in *Art*, Chatto and Windus, London, 3–30. Reprinted in part as Bell, Clive (1982), "The Aesthetic Dimension," in Francis Frascina and Charles Harrison (1982) *Modern Art and Modernism: Critical Anthology*, ed. Francis Frascina and Charles Harrison, 68–74. Harper and Row, London.

Beller, Jonathan L. (1995). "The Spectatorship of the Proletariat." *Boundary 2*, 22 (3): 171–228.

Beller, Jonathan L. (1998). "Capital/Cinema," in *Deleuze and Guattari: New Mappings in Politics, Philosophy and Culture*, ed. Eleanor Kauffman and Kevin Jon Hiller, 77–95. University of Minnesota Press, Minneapolis.

Bellour, Raymond (1974/1975). "The Obvious and the Code," *Screen* 15 (4, winter): 7–17.

Bellour, Raymond (1975a). "Le blocage symbolique," *Communications* 23: 235–350.

Bellour, Raymond (1975b). "The Unattainable Text," *Screen* 16 (3, autumn): 19–27.

Bellour, Raymond (1977). "Hitchcock, the Enunciator," *Camera Obscura* 2 (fall): 67–91.

Belton, John (1992). *Widescreen Cinema*. Harvard University Press, Cambridge, Mass.

Bendazzi, Giannalberto (1994). *Cartoons: One Hundred Years of Cinema Animation*, trans. Anna Taraboletti-Segre. John Libbey, London.

Benjamin, Marina (1999). *Living at the End of the World*. Picador, London.

Benjamin, Walter (1969). *Illuminations*, ed. Hannah Arendt, trans. Harry Zohn. Schocken, New York.

Benjamin, Walter (1973a). "The Author as Producer," in *Understanding Brecht*, trans. Anna Bostock, 85–103. New Left Books, London.

Benjamin, Walter (1973b). *Charles Baudelaire: A Lyric Poet in the Era of High Capitalism*, trans. Harry Zohn. NLB, London.

Benjamin, Walter (1977). *The Origin of German Tragic Drama*, trans. John Osborne, Verso, London.

Bennett, Tony and Janet Woollacott (1987). *Bond and Beyond: The Political Career of a Popular Hero.* Methuen, London.

Bergan, Ronald (1992). *Jean Renoir: Projections of Paradise.* Bloomsbury, London.

Bernal, Martin (1987). *Black Athena: The Afroasiatic Roots of Classical Civilisation,* vol. 1, *The Fabrication of Ancient Greece 1785–1985.* Free Association, London.

Bertin, Celia (1991). *Jean Renoir: A Life in Pictures,* trans. Mireile Muellner and Leonard Muellner. Johns Hopkins University Press, Baltimore, Maryland.

Beverley, John (1993). *Against Literature.* University of Minnesota Press, Minneapolis.

Bharucha, Rustom (1994). "On the Border of Fascism: Manufacture of Consent in *Roja,*" in *Economic and Political Weekly,* 4 (June).

Bishton, Derek, Andy Cameron, and Tim Druckery (eds.) (1991). *Digital Dialogues: Photography in the Age of Cyberspace, Ten: 8 Photo Paperback* vol. 2 (2, autumn).

Biskind, Peter (1999). *Easy Riders, Raging Bulls: How the Sex 'n' Drugs 'n' Rock 'n' Roll Generation Saved Hollywood.* Bloomsbury, London.

Bizony, Piers (2001). *Digital Domain: The Leading Edge of Visual Effects.* Aurum, London.

Blake, Nigel, and Francis Frascina (1993). "Modern Practices of Art and Modernity," in *Modernity and Modernism: French Painting in the Nineteenth Century,* ed. Francis Frascina, Nigel Blake, Briony Fer, Tamar Garb, and Charles Harrison, 50–140. Yale University Press, London.

Bliss, Michael (1993). *Justified Lives: Morality and Narrative in the Films of Sam Peckinpah.* Southern Illinois University Press, Carbondale.

Bliss, Michael (ed.) (1994). *Doing It Right: The Best Criticism on Sam Peckinpah's The Wild Bunch.* Southern Illinois University Press, Carbondale.

Bloch, Ernst (1986). *The Principle of Hope,* 3 vols., trans. Neville Plaice, Stephen Plaice, and Paul Knight. MIT Press, Cambridge, Mass.

Bloch, Ernst (1988). *The Utopian Function of Art and Literature: Selected Essays,* trans. Jack Zipes and Frank Mecklenburg. MIT Press, Cambridge, Mass.

Blunt, Anthony (1940). *Artistic Theory in Italy 1450–1660.* Oxford University Press, Oxford.

Boal, Augusto (1974). *Theatre of the Oppressed,* trans. Charles A. and Maria-Odilia Leal McBride. Pluto, London.

Bolter, Jay David, and Richard Grusin (1999). *Remediation: Understanding New Media*. MIT Press, Cambridge, Mass.

Bordwell, David (1985). *Narration and the Fiction Film*. Routledge, London.

Bordwell, David (1989). *Making Meaning: Inference and Rhetoric in the Interpretation of Cinema*. Harvard University Press, Cambridge, Mass.

Bordwell, David (1993). *The Cinema of Eisenstein*. Harvard University Press, Cambridge, Mass.

Bordwell, David (1997). *On the History of Film Style*. Harvard University Press, Cambridge, Mass.

Bordwell, David (2000). *Planet Hong Kong: Popular Cinema and the Art of Entertainment*. Harvard University Press, Cambridge, Mass.

Bordwell, David, Janet Staiger, and Kristin Thompson (1985). *Classical Hollywood Cinema: Film Style and Mode of Production to 1960*. Routledge, London.

Bottomore, Stephen (1988). "Shots in the Dark: The Real Origins of Film Editing," *Sight and Sound* 57 (3, summer): 200–204.

Bourdieu, Pierre (1986). *Distinction: A Social Critique of the Judgement of Taste*, trans. R. Nice. Harvard University Press, Cambridge, Mass.

Bowie, Andrew (1990). *Aesthetics and Subjectivity: From Kant to Nietzsche*. Manchester University Press, Manchester.

Braudel, Fernand (1972). *The Mediterranean and the Mediterranean World in the Age of Philip II*, vol. 1, trans. Sîan Reynolds. Collins, London.

Braudel, Fernand (1984). *Civilisation and Capitalism, 15th–18th Century*, volume III, *The Perspective of the World*, trans. Sîan Reynolds. Collins, London.

Brauer, Ralph (1974). "Who Are Those Guys? The Movie Western During the TV Era," in *Focus on the Western*, ed. Jack Nachbar, 118–128. Prentice-Hall, Englewood Cliffs, N.J.

Braudy, Leo (1972). *Jean Renoir: The World of His Films*. Columbia University Press, New York.

Braun, Marta (1992). *Picturing Time: The Work of Etienne-Jules Marey*. Chicago University Press, Chicago.

Braverman, Harry (1974). *Labour and Monopoly Capital: The Degradation of Work in the Twentieth Century*. Monthly Review Press, New York.

Brecht, Bertolt (1958). *The Good Person of Szechuan*, trans. John Willett. Methuen, London.

Breton, André (1972). *Position politique du surréalisme*. Denoël Gonthier, Paris.

Brettell, Richard R. (1990). *Pissarro and Pontoise: A Painter in the Landscape*. Yale University Press, New Haven, Conn.

Brettell, Richard R., and Caroline B. Brettell (1983). *Painters and Peasants in the Nineteenth Century*. Skira, Geneva.

Brosnan, John (1977). *Movie Magic: The Story of Special Effects in the Cinema*. Abacus, London.

Broude, Norma (1978). *Seurat in Perspective*. Prentice-Hall, Englewood Cliffs, N.J.

Brown, Karl (1973). *Adventures with D. W. Griffith*, ed. Kevin Brownlow. Faber & Faber, London.

Brown, Royal S. (1994). *Overtones and Undertones: Reading Film Music*. University of California Press, Berkeley.

Bruno, Giuliana (1987). "Ramble City: Postmodernism and *Blade Runner*," *October* 41: 61–74; reprinted in Annette Kuhn (ed.) (1990), *Alien Zone: Cultural Theory and Science Fiction Cinema*, 183–195. Verso, London.

Bryson, Norman (1983). *Vision and Painting: The Logic of the Gaze*. Macmillan, London.

Buci-Glucksmann, Christine (1994). *Baroque Reason: The Aesthetics of Modernity*, trans. Patrick Camiller. Sage, London.

Buck-Morss, Susan (1986). "The Flâneur, the Sandwich-man, and the Whore," *New German Critique*, 39 (fall): 99–140.

Buck-Morss, Susan (1989). *The Dialectics of Seeing: Walter Benjamin and the Arcades Project*. MIT Press, Cambridge, Mass.

Buck-Morss, Susan (2000). *Dreamworld and Catastrophe: The Passing of Mass Utopia in East and West*. MIT Press, Cambridge, Mass.

Buderi, Robert (1996). *The Invention that Changed the World: The Story of Radar from War to Peace*. Little Brown, London.

Bukatman, Scott (1994). "X-Bodies: The Torment of the Mutant Siperhero," in *Uncontrollable Bodies: Testimonies of Identity and Culture*, ed. Rodney Sappington and Tyler Stallings, 92–129. Bay Press, Seattle.

Bukatman, Scott (1997). *Blade Runner*. BFI, London.

Bukatman, Scott (1998). "The Ultimate Trip: Special Effects and Kaleidoscopic Perception," *Iris* 25: 75–97.

Bukatman, Scott (1999). "The Artificial Infinite: On Special Effects and the Sublime," in *Alien Zone II: The Spaces of Science Fiction Cinema*, ed. Annette Kuhn, 249–275. Verso, London.

Bukatman, Scott (2000). "Taking Shape: Morphing and the Performance of Self," in *Meta-morphing: Visual Transformation and the Culture of Quick-Change*, ed. Vivian Sobchack. University of Minnesota Press, Minneapolis.

Burch, Noël (1973). *Theory of Film Practice*, trans. Helen R. Lane. Princeton University Press, Princeton, N.J.

Burch, Noël (1990). *Life to Those Shadows*, ed. and trans. Ben Brewster. BFI, London.

Bürger, Peter (1984). *Theory of the Avant-Garde*, trans. Michael Shaw. Manchester University Press, Manchester.

Burke, Kenneth (1950). *A Rhetoric of Motives*. University of California Press, Berkeley.

Caillois, Roger (1968). "Mimicry and Legendary Psychasthenia," trans. John Shepley, *October* 31 (winter): 17–32.

Calabrese, Omar (1992). *Neo-Baroque: A Sign of the Times*, trans. Charles Lambert. Princeton University Press, Princeton, N.J.

Canemaker, John (1987). *Winsor McCay: His Life and Art*. Abbeville, New York.

Canemaker, John (1991). *Felix: The Twisted Tale of the World's Most Famous Cat*. Da Capo Press, New York.

Carr, Robert E., and R. M. Hayes (1988). *Wide Screen Movies*. MacFarland, Jefferson, N.C.

Carroll, Noël (1998). "The Professional Western: South of the Border" in *Back in the Saddle Again: New Essays on the Western*, ed. Ed Buscombe and Roberta E. Pearson, 46–62. BFI, London.

Cartier-Bresson, Henri (1994). "A Memoir by Henri Cartier-Bresson," in Renoir, Jean, *Letters*, ed. Lorraine LoBianco and David Thompson, trans. Craig Carlson, Natasha Arnoldi, Michael Wells, and Anneliese Varaldiev, 556–559. Faber and Faber, London.

Cartwright, Lisa (1995). *Screening the Body: Tracing Medecine's Visual Culture*. University of Minnesota Press, Minneapolis.

Caughie, John, and Sean Cubitt (eds.) (2000). *FX, CGI, and the Question of Spectacle*, special issue of *Screen*, 44 (2, summer).

Cavalcanti, Alberto (1979). "Foreword" to John Frazer, *Artificially Arranged Scenes: The Films of Georges Méliès*, xiii–xv. G. K. Hall, Boston, Mass.

Cawelti, John (1985). *The Six-Gun Mystique*, second ed. Bowling Green State University Popular Press, Bowling Green, Ohio.

Ceram, C. W. (1965). *Archeology of the Cinema*, trans. Richard Winston. Thames and Hudson, London.

Chanan, Michael (1980). *The Dream That Kicks: The Prehistory and Early Years of Cinema in Britain*. Routledge Kegan Paul, London.

Chaplin, Charles (1964). *My Autobiography*. Penguin, Harmondsworth.

Charney, Leo (1998). *Empty Moments: Cinema, Modernity, and Drift*. Duke University Press, Durham, N.C.

Charney, Leo, and Vanessa R. Schwartz (eds.) (1995). *Cinema and the Invention of Modern Life*. University of California Press, Berkeley, Calif.

Chatterjee, Partha (1997). *The Nation and Its Fragments: Colonial and Postcolonial Histories*. Princeton University Press, Princeton.

Chion, Michel (1988). *La Toile Trouée*. Cahiers du Cinéma/Editions de l'Etoile, Paris.

Chion, Michel (1992). *Le Son au cinema*, revised edition. Cahiers du Cinéma, Collection Essais, Paris.

Chion, Michel (1994). *Audio-Vision: Sound on Screen*, ed. and trans. Claudia Gorbman. Columbia University Press, New York.

Chion, Michel (1999). *The Voice in Cinema*, ed. and trans. Claudio Gorbman. Columbia University Press, New York.

Cholodenko, Alan (1991). *The Illusion of Life: Essays on Animation*. Power Publications in association with the Australian Film Commission, Sydney.

Clair, René (1972). *Cinema Yesterday and Today*, trans. Stanley Appelbaum. Dover, New York.

Clair, René (1985). "The Art of Sound," trans. Vera Traill, in *Film Sound: Theory and Practice*, ed. John Belton and Elisabeth Weis, 92–95. Columbia University Press, New York.

Clark, Nigel (2002). "The Demon-Seed: Bioinvasion as the Unsettling of Environmental Cosmopolitanism." *Theory, Culture, and Society* 19 (1–2): 101–125.

Coe, Brian (1981). *The History of Movie Photography*. Ash and Grant, London.

Cohen, G. A. (1978). *Karl Marx's Theory of History: A Defence*. Princeton University Press, Princeton, N.J.

Comaroff, Jean, and John L. Comaroff (2000). "Millennial Capitalism: First Thoughts on a Second Coming," in *Millennial Capitalism and the Culture of Neo-Liberalism* (*Public Culture* 12 (2, spring); *Millennial Quartet* 3), ed. Jean and John L. Comaroff, 291–343.

Comolli, Jean-Louis (1980). "Machines of the Visible," in *The Cinematic Apparatus*, ed. Stephen Heath and Theresa de Lauretis, 121–142. Macmillan, London.

Comolli, Jean-Louis, and Pierre Narboni (1977). "Cinema/Ideology/Criticism" (1) and (2), trans. Susan Bennett, in *Screen Reader 1: Cinema/Ideology/Politics*, ed. John Ellis, 2–11 and 36–46. SEFT, London.

Cook, David A. (1990). "Essay on *The Wild Bunch*," in *The International Directory of Films and Filmmakers*, vol. 1, second ed., 979–980. Fitzroy Dearborn, Chicago.

Cook, David A. (1996). *A History of Narrative Film*, third ed. Norton, New York.

Cook, David A. (1999). "Ballistic Balletics: Styles of Violent Representation in *The Wild Bunch* and After," in *Sam Peckinpah's The Wild Bunch*, ed. Stephen Prince, 130–154. Cambridge University Press, Cambridge.

Cook, David A. (2000). *Lost Illusions: American Cinema in the Shadow of Watergate and Vietnam* (History of the American Cinema, vol. 9). Scribners, New York.

Coombe, Rosemary (1998). *The Cultural Life of Intellectual Properties: Authorship, Appropriation, and the Law*. Duke University Press, Durham, N.C.

Copjec, Joan (1982). "The Anxiety of the Influencing Machine," *October* 23 (winter): 43–59.

Corrigan, Timothy (1991). *A Cinema without Walls: Movies and Culture after Vietnam*. Rutgers University Press, New Brunswick, N.J.

Crafton, Donald (1990). *Emile Cohl, Caricature, and Film*, Princeton University Press, Princeton, N.J.

Crafton, Donald (1993). *Before Mickey: The Animated Film 1898–1928*, revised ed. MIT Press, Cambridge, Mass.

Crafton, Donald (1997). *The Talkies: American Cinema's Transition to Sound* (History of the American Cinema, vol. 4). University of California Press, Berkeley.

Crary, Jonathan (1990). *Techniques of the Observer: On Vision and Modernity in the Nineteenth Century*. MIT Press, Cambridge, Mass.

Crary, Jonathan (1999). *Suspensions of Perception: Attention, Spectacle, and Modern Culture*. MIT Press, Cambridge, Mass.

Creed, Barbara (2000). "The Cyberstar: Digital Pleasures and the End of the Unconscious," *Screen* 41 (1, spring): 79–86.

Creeley, Robert (1973). *The Creative*. Black Sparrow Press, Los Angeles.

Crisp, Colin (1993). *The Classic French Cinema, 1930–1960*. Indiana University Press, Bloomington.

Cubitt, Sean (1999b). "*Le reel, c'est l'impossible:* The Sublime Time of Special Effects," *Screen* 40 (2, summer): 123–130.

Cubitt, Sean (2000). "Shit Happens: Numerology, Destiny, and Control," in *Magic, Metaphor, and the World Wide Web*, ed. Andrew Herman and Thomas Swiss, 127–144. Blackwell, New York.

Cubitt, Sean (2002). "Spreadsheets, Sitemaps, and Search Engines: Why Narrative Is Marginal to Multimedia and Networked Communication, and Why Marginality Is More Vital than Universality," in *New Media Narratives*, ed. Martin Rieser and Andrea Zapp, 1–13. BFI, London.

Cumberbatch, Guy, and Denis Howitt (1989). *A Measure of Uncertainty: The Effects of the Mass Media*. John Libbey, London.

Curry, Michael R. (1998). *Digital Places: Living with Geographic Information Technologies*. Routledge, London.

Dadoun, Roger (1989). "Fetishism in the Horror Film," in *Fantasy and the Cinema*, ed. James Donald, 39–61. British Film Institute, London.

Dagognet, François (1992). *Etienne-Jules Marey: A Passion for the Trace*, trans. Robert Galeta with Jeanine Herman. Zone Books, New York.

Damisch, Hubert (1994). *The Origin of Perspective*, trans. John Goodman. MIT Press, Cambridge, Mass.; originally published as (1987), *L'Origine de la perspective*, Flammarion, Paris.

Dannen, Fredric, and Barry Long (1997). *Hong Kong Babylon: An Insider's Guide to the Hollywood of the East*. Faber, London.

Darley, Andrew (2000). *Visual Digital Culture: Surface Play and Spectacle in New Media Genres*. Routledge, London.

Darwin, Charles (1985 [1859]). *The Origin of Species by Means of Natural Selection Or The Preservation of Favoured Races in the Struggle for Life*. Penguin, London.

Daston, Lorraine, and Katherine Park (2001). *Wonders and the Order of Nature 1150–1750*. Zone Books, New York.

Davidson, Basil (1992). *The Black Man's Burden: Africa and the Curse of the Nation-State*. Times Books, New York.

Davis, Darrell William (1996). *Picturing Japaneseness: Monumental Style, National Identity, Japanese Film*. Columbia University Press, New York.

Dawkins, Richard (1989). *The Selfish Gene*, second ed. Oxford University Press, Oxford.

Debord, Guy (1977). *The Society of the Spectacle*, revised translation. Black & Red, Detroit.

Debord, Guy (1990). *Comments on the Society of the Spectacle*, trans. Malcolm Imrie. Verso, London.

Deleuze, Gilles (1986). *Cinema 1: The Movement-Image*, trans. Hugh Tomlinson and Barbara Habberjam. Athlone, London.

Deleuze, Gilles (1989). *Cinema 2: The Time-Image*, trans. Hugh Tomlinson and Barbara Habberjam. Athlone, London.

Deleuze, Gilles (1993). *The Fold: Leibniz and the Baroque*, trans. Tom Conley. Athlone, London.

Deleuze, Gilles (1994). *Difference and Repetition*, trans. Paul Patton. Athlone Press, London.

Deleuze, Gilles (1997). "Postscript on the Societies of Control," in *October: The Second Decade, 1986–1996*, ed. Rosalind Krauss, Annette Michelson, Yve-Alain Bois, Benjamin H. D. Buchloh, Hal Foster, Denis Hollier, and Sylvia Kolbowski, 443–447. MIT Press, Cambridge, Mass.

Deleuze, Gilles, and Félix Guattari (1972). *L'Anti-Oedipe (Capitalisme et Schizophrénie I)*. Editions de Minuit, Paris.

Deleuze, Gilles, and Félix Guattari (1994). *What Is Philosophy?* trans. Hugh Tomlinson and Graham Burchell. Columbia University Pres, New York.

Derrida, Jacques (1976). *Of Grammatology*, trans. Gayatri Chakravorty Spivak. Johns Hopkins University Press, Baltimore, Maryland.

Derrida, Jacques (2001). *On Cosmopolitanism and Forgivenness*, trans. Mark Dooley and Michael Hughes, preface Simon Critchley and Richard Kearney. Routledge, London.

Deslandes, Jacques (1963). *Le Boulevard du cinema à l'époque de Georges Méliès.* Les Editions du Cerf, Paris.

Deutelbaum, Marshall (1979). "Structural Patterning in the Lumière Films," *Wide Angle* 3 (1): 28–37.

Dewey, John (1925). *Experience and Nature.* Open Court, La Salle, Illinois.

Dharap, B. V. (1985). "Dadasaheb Phalke—Father of Indian Cinema," in *70 Years of Indian Cinema 1913–1983*, ed. T. M. Ramachandran, 211–223. Cinema-India International, Bombay.

Dienst, Richard (1995). *Still Life in Real Time: Theory after Television.* Duke University Press, Durham, N.C.

Dirlik, Arif (1996). "The Global in the Local," in *Global/Local: Cultural Production and the Transnational Imaginary*, ed. Rob Wilson and Wimal Dissanayake, 21–45. Duke University Press, Durham, N.C.

Dixon, Wheeler Winston (1998). *The Transparency of Spectacle: Meditations on the Moving Image.* SUNY Press, Albany.

Dixon, Wheeler Winston (1999). "Re-Visioning the Western: Code, Myth and Genre in Peckinpah's *The Wild Bunch*," in *Sam Peckinpah's* The Wild Bunch, ed. Stephen Prince, 155–174. Cambridge University Press, Cambridge.

Doane, Mary Ann (1980a). "The Voice in the Cinema: The Articulation of Body and Space," in *Cinema/Sound*, ed. Rick Altman, special issue of *Yale French Studies* 60: 33–50.

Doane, Mary Ann (1980b). "Ideology and the Practice of Sound Editing and Mixing," in *The Cinematic Apparatus*, ed. Teresa de Lauretis and Stephen Heath, 47–56. Macmillan, London.

Doane, Mary Ann (1990). "Information, Crisis, Catastrophe" in *Logics of Television: Essays in Cultural Criticism*, ed. Patricia Mellencamp, 222–239. BFI, London.

Doherty, Thomas (1999). "This Is Where We Came In: The Audible Screen and the Voluble Audience of Early Sound Cinema," in *American Movie Audiences From the Turn of the Century to the Early Sound Era*, ed. Melvyn Stokes and Richard Maltby, 143–63. BFI, London.

Dorato, Mauro (1997). "Three Views on the Relationship between Time and Reality," in *Perspectives on Time* (Boston Studies in the Philosophy of Science, v. 189), ed. Jan Faye, Uwe Scheffler, and Max Urchs, 61–92. Kluwer, Dordrecht.

Dorn, Ed (1975). *Slinger.* Wingbow Press, Berkeley, Calif.

Dorn, Ed (1978). "Sirius in January," in *Hello, La Jolla.* Wingbow Press, Berkeley, Calif.

Douglas, Mary (1966). *Purity and Danger.* Routledge Kegan Paul, London.

Douglas, Susan J. (1987). *Inventing American Broadcasting 1899–1922.* Johns Hopkins University Press, Baltimore, Maryland.

Ducrot, Oswald, and Tsvetan Todorov (1972). *Dictionnaire encyclopédique des sciences du langage.* Seuil (Collection Points), Paris.

Dukore, Bernard F. (1999). *Sam Peckinah's Feature Films.* Indiana University Press, Bloomington.

Durgnat, Raymond (1974). *Jean Renoir.* University of California Press, Berkeley.

Dwyer, Rachel (2000). *All You Want Is Money, All You Need Is Love: Sex and Romance in Modern India.* Cassell, London.

Dylan, Bob (1973). *Pat Garrett and Billy the Kid.* Columbia/Sony Music Entertainment, CD 32098.

Eaton, Ruth (2000). "The City as an Intellectual Exercise," in *Utopia: The Search for the Ideal Society in the Western World*, ed. Roland Schaer, Gregory Claes, and Lyman Tower Sargent. New York/Oxford University Press, Oxford.

Eco, Umberto (1986). "The Sacred Is Not Just a Fashion," in *Faith in Fakes: Travels in Hyperreality*, trans. William Weaver, 89–94. Minerva, London.

Eco, Umberto (1989). *Foucault's Pendulum*, trans. William Weaver. Secker and Warburg, London.

Eco, Umberto (1990). *The Limits of Interpretation.* Indiana University Press, Bloomington.

Eco, Umberto, with Richard Rorty, Jonathan Culler, and Christine Brooke-Rose (1992). *Interpretation and Overinterpretation*, ed. Stefani Collini. Cambridge University Press, Cambridge.

Eco, Umberto (1999). *Kant and the Platypus: Essays on Language and Cognition*, trans. Alistair McEwen. Secker and Warburg, London.

Eikhenbaum, Boris (1974). "Problems of Film Stylistics," *Screen* 15 (3, autumn): 7–32.

Eisenstein, Sergei M. (1942). *The Film Sense*, ed. and trans. Jay Leyda. Harcourt Brace Janovich, New York.

Eisenstein, Sergei M. (1949a). "The Cinematographic Principle and the Ideogram," in *Film Form: Essays in Film Theory*, ed. and trans. Jay Leyda, 28–44. Harcourt Brace Janovich, New York.

Eisenstein, Sergei M. (1949b). "Dickens, Griffith, and the Film Today," in *Film Form: Essays in Film Theory*, ed. and trans. Jay Leyda, 195–255. Harcourt Brace Janovich, New York.

Eisenstein, Sergei M. (1970). *Notes of a Film Director*, trans. X. F. Danko. Dover, New York.

Eisenstein, Sergei M. (1983). *Immoral Memories: An Autobiography*, trans. Herbert Marshall. Houghton Mifflin, Boston, Mass.

Eisenstein, S. M. (1987). *Non-Indifferent Nature*, trans. Herbert Marshall. Cambridge University Press, Cambridge.

Eisenstein, S. M. (1988). *Selected Works: Volume I—Writings, 1922–1934*, ed. and trans. Richard Taylor. BFI, London.

Eisenstein, S. M. (1991). *Selected Works: Volume II—Towards a Theory of Montage*, ed. Michael Glenny and Richard Taylor, trans. Michael Glenny. BFI, London.

Eisenstein, Sergei M. (1996). *Selected Works: Volume III—Writings, 1934–47*, ed. Richard Taylor, trans. William Powell. BFI, London.

Eisenstein, Sergei M., V. I. Pudovkin, and G. V. Alexandrov (1949). "A Statement," in Sergei M. Eisenstein, *Film Form: Essays in Film Theory*, ed. and trans. Jay Leyda, 257–260, Harcourt Brace Janovich, New York; reprinted in John Belton and Elisabeth Weis (eds.), *Film Sound: Theory and Practice*, 83–85, Columbia University Press, New York.

Eliot, Marc (1994). *Walt Disney: Hollywood's Dark Prince*. André Deutsch, London.

Ellul, Jacques (1964). *The Technological Society*, trans. John Wilkinson. Vintage, New York.

El Nouty, Hassan (1978). *Théâtre et pré-cinéma: Essai sur le problematique du spectacle au XIXe siècle*. Editions Nizet, Paris.

Elsaesser, Thomas (1987). "Dada/Cinema?" in *Dada and Surrealist Film*, ed. Rudolf E. Kuenzli, 13–27. Willis Locker and Owens, New York.

Elsaesser, Thomas (1998a). "Louis Lumière—The World's First Virtualist," in *Cinema Futures: Cain, Abel or Cable? The Screen Arts in the Digital Age*, ed. Thomas Elsaesser and Kay Hoffmann, 45–61. Amsterdam University Press, Amsterdam.

Elsaesser, Thomas (1998b). "Specularity and Engulfment: Francis Ford Coppola and *Bram Stoker's Dracula*" in *Contemporary Hollywood Cinema*, ed. Steve Neale and Murray Smith, 191–208. Routledge, London.

Elsaesser, Thomas, and Warren Buckland (2002). *Studying Contemporary American Film: A Guide to Movie Analysis*. Arnold, London.

Engels, Friedrich (1940 [1927]). *Dialectics of Nature*, ed. and trans. Clemens Duff, intro. J. B. S. Haldane. International Publishers, New York.

Erb, Cynthia (1998). *Tracking King Kong: A Hollywood Icon in World Culture*. Wayne State University Press, Detroit.

Fagelson, William Friedman (2001). "Fighting Films: The Everyday Tactics of World War II Soldiers," *Cinema Journal*, 40 (3, spring): 94–112.

Fanon, Frantz (1968). "The Fact of Blackness," in *Black Skin, White Masks*, trans. Charles Lam Markmann. Paladin, London.

Feenberg, Andrew (1995). *Alternative Modernity: The Technical Turn in Philosophy and Social Theory*. University of California Press, Berkeley.

Feng, Peter X. (2001). "False and Double Consciousness: Race, Virtual Reality, and the Assimilation of Hong Kong Action Cinema in *The Matrix*," in *Aliens R Us: The Other in Science Fiction Cinema*, ed. Ziauddin Sardar and Sean Cubitt. Pluto, London.

Fenollosa, Ernest (1986). *The Chinese Written Character as a Medium for Poetry*, ed. and intro. Ezra Pound. City Lights, San Francisco.

Feuer, Jane (1983). "The Concept of Live Television: Ontology as Ideology," in *Regarding Television*, American Film Institute Monographs 2, ed. E. Ann Kaplan, 12–22. University Publications of America, Frederick, Maryland.

Fielding, Raymond (1968). *The Technique of Special-Effects Cinematography*, revised ed. Focal Press, Bungay, Suffolk.

Fine, Marshall (1991). *Bloody Sam: The Life and Films of Sam Peckinpah*. Donald A. Fine, New York.

Fischer, Lucy (1985). "*Enthusiasm:* From Kino-Eye to Radio-Eye," in *Film Sound: Theory and Practice*, ed. John Belton and Elisabeth Weis, 247–264. Columbia University Press, New York.

Fitzgerald, Martin (ed.) (2000). *Hong Kong's Heroic Bloodshed*. Pocket Essentials, Harpenden.

Flaherty, Robert (2000). "The Handling of Motion Picture Film Under Various Climatic Conditions" (1926), at *The Silent Cinema Bookshelf*, http://www.cinemaweb.com/silentfilm/bookshelf/23_smp_6.htm, visited February 18.

Fleischman, Tom (1994). "Tom Fleischman," interview, *Sound-On-Film: Interviews with Creators of Film Sound*, 173–185. Praeger, New York.

Fofi, Gofredo (1972/1973). "The Cinema of the Popular Front in France 1934–1938," *Screen* 13 (4): 5–57.

Foster, Hal (1993). *Compulsive Beauty*. MIT Press, Cambridge, Mass.

Foucault, Michel (1979). "What Is an Author?" trans. Donald E. Bouchard, followed by "Discussion," trans. Kari Hanet, *Screen* 20 (1, spring): 13–33.

Frayling, Christopher (1995). *Things to Come*. BFI, London.

Frazer, John (1979). *Artificially Arranged Scenes: The Films of Georges Méliès*. G. K. Hall, Boston, Mass.

Frazer, Sir J. G. (1911–1915), *The Golden Bough: A Study in Magic and Religion*. Macmillan, London.

Frege, Gottlob (1974). *The Foundations of Arithmetic*, trans. J. L. Austin. Blackwell, Oxford.

Freud, Sigmund (1979). "A Child Is Being Beaten," in *On Psychopathology*, trans. James Strachey, ed. Angela Richards (Pelican Freud Library 10), 163–193. Pelican, Harmondsworth.

Friedberg, Anne (1993). *Window Shopping: Cinema and the Postmodern*. University of California Press, Berkeley.

Friedman, Jonathan (1995). "Global System, Globalization, and the Parameters of Modernity," in *Global Modernities*, ed. Mike Featherstone, Scott Lash, and Roland Robertson, 69–90. Sage, London.

Frodon, Jean-Michel (1995). *L'Age moderne du cinema français: De la nouvelle vague à nos jours*. Flammarion, Paris.

Fukuyama, Francis (1992). *The End of History and the Last Man*. Free Press, New York.

Gaines, Jane M. (1992). *Contested Cultures: The Image, the Voice, and the Law*. BFI, London.

Galassi, Peter (1981). *Before Photography: Painting and the Invention of Photography*. Museum of Modern Art, New York.

Gandhi, Mahatma (1948). *Cent per Cent Swadeshi; or, The Economics of Village Industries*, third ed. Navajivan Publishing House, Ahmedabad.

Gardner, Howard (1987). *The Mind's New Science: A History of the Cognitive Revolution*, revised ed. Harper Collins, New York.

Gaudreault, André (1987). "Theatricality, Narrativity, and 'Trickality': Re-evaluating the Cinema of Georges Méliès," *Journal of Popular Film and Television* 15 (3, fall): 110–119.

Gaudreault, André (1990a). "Film, Narrative, Narration: The Cinema of the Lumière Brothers," trans. Rosamund Howe, in *Early Cinema: Space, Frame, Narrative*, ed. Thomas Elsaesser, 68–75. BFI, London.

Gaudreault, André (1990b). "The Infringement of Copyright Laws and Its Effects (1900–1906)," in *Early Cinema: Space, Frame, Narrative*, ed. Thomas Elsaesser, 114–122. BFI, London.

Gauthier, Xavière (1971). *Surréalisme et sexualité*. Gallimard, Paris.

Geertz, Clifford (1983). *Local Knowledge: Further Essays in Interpretive Anthropology*. Fontana Press, London.

George, Russell (1990). "Some Spatial Characteristics of the Hollywood Cartoon," *Screen* 31 (3, autumn): 296–321.

Giddens, Anthony (1979). *Central Problems in Social Theory: Action, Structure, and Contradiction in Social Analysis*. Macmillan, London.

Giddens, Anthony (1991). *Modernity and Self-Identity: Self and Society in the Late Modern Age*. Stanford University Press, Stanford, Calif.

Giedion, Siegfried (1948). *Mechanisation Takes Command: A Contribution to Anonymous History*. Norton, New York.

Gillespie, Marie (1995). *Television, Ethnicity, and Cultural Change*. Routledge, London.

Gillies, James, and Robert Cailiau (2000). *How the Web Was Born: The Story of the World Wide Web*. Oxford University Press, Oxford.

Gish, Lillian, with Ann Pichot (1969). *The Movies, Mr. Griffith, and Me*. W. H. Allen, London.

Gleber, Anke (1997). "Women on the Streets and Screens of Modernity: In Search of the Female Flaneur," in *The Image in Dispute: Art and Cinema in the Age of Photography*, ed. Dudley Andrew, 55–85. University of Texas Press, Austin.

Gokulsing, K. Moti, and Wimal Dissanayake (1998). *Indian Popular Cinema: A Narrative of Cultural Change*. Trentham, Stoke on Trent.

Goldner, Orville, and George E. Turner (1975). *The Making of King Kong*. Ballantine, New York.

Gomery, Douglas (1978). "Towards an Economic History of the Cinema: The Coming of Sound to Hollywood," in *The Cinematic Apparatus*, ed. Stephen Heath and Theresa de Lauretis, 38–46. Macmillan, London.

Gomery, Douglas (1980). "Economic Struggle and Hollywood Imperialism: Europe Converts to Sound," in *Cinema/Sound*, ed. Rick Altman, special issue of *Yale French Studies* 60: 80–93.

Gomery, Douglas (1992). *Shared Pleasures: A History of Movie Presentation in the United States*. BFI, London.

Gorky, Maxim (1960). "A Review of the Lumière programme at the Nizhny-Novgorod Fair, as printed in the Nizhegordski Listok newspaper, July 4, 1896, and signed 'I. M. Pactatus,'" trans. Leda Swan in Jay Leyda, *Kino: A History of the Russian and Soviet Film*, 407–409. George Allen and Unwin, London.

Gottesman, Ronad, and Harry Geduld (eds.) (1976). *The Girl in the Hairy Paw: King Kong as Myth, Movie, and Monster*. Avon, New York.

Grant, Barry Keith (1998). "Rich and Strange: The Yuppie Horror Film," in *Contemporary Hollywood Cinema*, ed. Steve Neale and Murray Smith, 280–293. Routledge, London.

Griffith, Mrs. D. W. (1969 [1925]). *When the Movies Were Young*. Dover, New York.

Guha, Ranajit (ed.) (1982). *Subaltern Studies 1: Writings on South Asian History and Society.* Oxford University Press, New Delhi.

Guha, Ranajit (1988). "On Some Aspects of the Historiography of Colonial India," in *Selected Subaltern Studies,* ed. Ranajit Guha and Gayatri Chakravorty Spivak, 37–43. Reprinted from Guha, Ranajit, (1982), *Subaltern Studies 1: Writings on South Asian History and Society,* 1–7. Oxford University Press, New Delhi.

Guillaume-Grimaud, Geneviève (1986). *Le Cinéma du Front Populaire.* Lherminier, Paris.

Gunning, Tom (1986). "The Cinema of Attraction: Early Film, Its Spectator, and the Avant-Garde," *Wide Angle* 8 (3/4): 63–70.

Gunning, Tom (1989). "An Aesthetics of Astonishment: Early Film and the (In)credulous Spectator," *Art & Text* 34 (spring): 31–45.

Gunning, Tom (1995a). "Tracing the Individual Body: Photography, Detectives, and the Early Cinema" in *Cinema and the Invention of Modern Life,* ed. Leo Charney and Vanessa R. Schwartz, 15–45. University of California Press, Berkeley.

Gunning, Tom (1995b). "Phantom Images and Modern Manifestations: Spirit Photography, Magic Theatre, Trick Films, and Photography's Uncanny," in *Fugitive Images: From Photography to Video,* ed. Patrice Petro, 42–71. Indiana University Press, Bloomington.

Habermas, Jürgen (1992). *Postmetaphysical Thinking.* Polity, Cambridge.

Habermas, Jürgen (1998). *The Inclusion of the Other,* trans. C. Cronin and P. De Greiff. MIT Press, Cambridge, Mass.

Habermas, Jürgen (2001a). *The Liberating Power of Symbols: Philosophical Essays,* trans. Peter Dews. MIT Press, Cambridge, Mass.

Habermas, Jürgen (2001b). *The Postnational Constellation: Political Essays,* trans., ed. and intro. Max Pensky. MIT Press, Cambridge, Mass.

Hansen, Miriam (1991). *Babel and Babylon: Spectatorship in American Silent Film.* Harvard University Press, Cambridge, Mass.

Hansen, Miriam Bratu (2000). "The Mass Production of the Senses: Classical Cinema as Vernacular Modernism," in *Reinventing Film Studies,* ed. Christine Gledhill and Linda Williams, 332–350. Arnold, London.

Hanson, Anne Coffin (1977). *Manet and the Modern Tradition.* Yale University Press, New Haven, Conn.

Hardt, Michael, and Antono Negri (2000). *Empire*. Harvard University Press, Cambridge, Mass.

Hardy, Phil (ed.) (1986). *The Encyclopedia of Science Fiction Movies*. Aurum, London.

Harley, J. B. (1989). "Deconstructing the Map," *Cartographica* 26 (2, summer): 1–20.

Harley, J. B. (1990). "Cartography, Ethics, and Social Geography," *Cartographica*, 27 (2, summer): 1–23.

Hartley, John (1992). *The Politics of Pictures: The Creation of the Public in the Age of Popular Media*. Routledge, London.

Harvey, David (1989). *The Condition of Postmodernity: An Enquiry into the Origins of Cultural Change*. Blackwell, Oxford.

Hawking, Stephen (1988). *A Brief History of Time*. Bantam, London.

Hayward, Philip (1993). "Situating Cyberspace: The Popularisation of Virtual Reality," in *Future Visions: New Technologies of the Screen*, ed. Philip Hayward and Tana Wollen, 180–204. BFI, London.

Hayward, Susan (1999). "Besson's 'Mission Elastoplast': *Le Cinquième element*," in *French Cinema in the 1990s: Continuity and Difference*, ed. Phil Powrie, 246–257. Oxford University Press, Oxford.

Heath, Stephen (1978/1979). "Notes on Suture," *Screen* 18 (4, winter): 48–76.

Hecht, Ben (1954). *A Child of the Century*. Primus/Donald Fine, New York.

Hegel, G. W. F. (1953). *Reason in History: A General Introduction to the Philosophy of History*, trans. Robert S. Hartman. Bobbs-Merrill, New York.

Hegel, G. W. F. (1975). *The Encyclopaedia of the Philosophical Sciences*, volume 1, *Hegel's Logic*, trans. William Wallace. Oxford University Press, Oxford.

Hegel, G. W. F. (1991). *Elements of the Philosophy of Right*, trans. H. B. Nisbet. Cambridge University Press, Cambridge.

Heidegger, Martin (1962). *Being and Time*, trans. John Macquarrie and Edward Robinson. Basil Blackwell, Oxford.

Heidegger, Martin (1971). "The Thing," in *Poetry, Language, Thought*, trans. Albert Hofstadter, 165–186. Harper and Row, New York.

Heim, Michael (1998). *Virtual Realism*. Oxford University Press, Oxford.

Hermeren, Goran (1969). *Representation and Meaning in the Visual Arts: A Study of the Methodology of Iconography and Iconology*. Läromedelsförlagen, Lund.

Hilmes, Michelle (1997). *Radio Voices: American Broadcasting, 1922–1952*. University of Minnesota Press, Minneapolis.

Hitler, Adolf (1968). "Speech Inaugurating the 'Great Exhibition of German Art 1937,' Munich," in *Theories of Modern Art: A Source Book by Artists and Critics*, ed. Herschel B. Chip, with contributions by Peter Selz and Joshua C. Taylor, 474–483. University of California Press, Berkeley.

Hodges, Andrew (1985). *Alan Turing: The Enigma of Intelligence*. Counterpoint/Unwin, London.

Holliss, Richard, and Brian Sibley (1988). *The Disney Studio Story*. Octopus, London.

Holt, Elizabeth Gillmore (ed.) (1947). *A Documentary History of Art*, volume II: *Michelangelo and the Mannerists; The Baroque and the Eighteenth Century*, revised ed. Princeton University Press, Princeton, N.J.

Hopkins, Gerard Manley (1953). *Poems and Prose*, ed. W. H. Gardner. Penguin, Harmondsworth.

Hung, Natalia Chan Sui (2000). "Rewriting History: Hong Kong Nostalgia Cinema and Its Social Practice," in *The Cinema of Hong Kong: History, Arts, Identity*, ed. P. Shek Fu and David Desser, 252–272. Cambridge University Press, Cambridge.

Huyssen, Andreas (1986a). "Mass Culture as Woman: Modernity's Other," in *Studies in Entertainment: Critical Approaches to Mass Culture*, ed. Tania Modleski, 188–205. Indiana University Press, Bloomington.

Huyssen, Andreas (1986b). *After the Great Divide: Modernism, Mass Culture, Postmodernism*. Indiana University Press, Bloomington.

Huyssen, Andreas (2000). "Present Pasts: Media, Politics, Amnesia," in *Globalization*, ed. Arjun Appadurai (*Public Culture* 12 [1, Winter]; *Millennial Quartet* volume 2), 21–38.

Izod, John (2000). "Beineix's *Diva* and the French Cultural Unconscious," in *France in Focus: Film and National Identity*, ed. Elizabeth Ezra and Sue Harris, 181–193. Berg, Oxford.

Jameson, Fredric (1981). *The Political Unconscious: Narrative as Socially Symbolic Act*. Methuen, London.

Jameson, Fredric (1991). *Postmodernism, or, The Cultural Logic of Late Capitalism.* Verso, London.

Jenkins, Henry (1998). "'Complete Freedom of Movement': Video Games as Gendered Play Spaces," in *From Barbie to Mortal Kombat: Gender and Computer Games,* ed. Justine Cassell and Henry Jenkins, 262–297. MIT Press, Cambridge, Mass.

Jenn, Pierre (1984). *Georges Méliès cinéaste: Le Montage cinématographique chez Georges Méliès.* Editions Albatros, Paris.

Johnson, Dr. Samuel (1969). "Preface to the Plays of William Shakespeare," in *Dr. Johnson on Shakespeare,* ed. W. K. Wimsatt. Penguin, Harmondsworth.

Jordan, Neil (1996). *Michael Collins: Film Diary and Screenplay.* Vintage, London.

Jordanova, Ludmilla (1989). *Sexual Visions: Images of Gender in Science and Medecine between the Eighteenth and Twentieth Centuries.* University of Wisconsin Press, Madison.

Kabir, Nasreen Munni (2001). *Bollywood: The Indian Cinema Story.* Channel 4 Books, London.

Kahn, Douglas (1992). "Introduction: Histories of Sound Once Removed," in *Wireless Imagination: Sound, Radio and the Avant-Garde,* ed. Douglas Kahn and Gregory Whitehead, 1–29. MIT Press, Cambridge, Mass.

Kahn, Douglas (1999). *Noise Water Meat: A History of Sound in the Arts.* MIT Press, Cambridge, Mass.

Kant, Immanuel (1890). *Critique of Pure Reason,* trans. J. M. Meiklejohn. George Bell and Sons, London.

Kant, Immanuel (1952). *The Critique of Judgement,* trans. James Creed Meredith. Oxford University Press, Oxford.

Kaplan, Robert (1999). *The Nothing That Is: A Natural History of Zero.* Allen Lane/ Penguin, Harmondsworth.

Keaton, Buster (1967). *My Wonderful World of Slapstick.* Secker and Warburg, London.

Kelleghan, Fiona (2001). "Sound Effects in SF and Horror Films," in *Film Sound: Design & Theory,* http://www.filmsound.org/.

Kenny, Tom (1991). "*T2:* Behind the Scenes with the Terminator 2 Sound Team," *Mix: Professional Recording and Sound and Music Production* 15 (9, September): 60–62, 64, 66, 116.

Keown, Damien (1998). "Embodying Virtue: A Buddhist Perspective on Virtual Reality," in *The Virtual Embodied: Presence/Practice/Technology*, ed. John Wood, 76–87. Routledge, London.

Kern, Stephen (1983). *The Culture of Time and Space 1880–1918*. Harvard University Press, Cambridge, Mass.

Khanna, Balraj, and Aziz Kurtha (1998). *Art of Modern India*. Thames and Hudson, London.

King, Norman (1984). *Abel Gance*. BFI, London.

Kinsella, Thomas (1973). "Magnanimity (for Austin Clarke's seventieth birthday)," in *Selected Poems 1956–1968*, 80. Dolmen, Dublin.

Kirby, Lynne (1997). *Parallel Tracks: The Railroad and Silent Cinema*. Exeter University Press, Exeter.

Kitses, Jim (1969). *Horizons West: Anthony Mann, Budd Boetticher, and Sam Peckinpah: Studies in Authorship within the Western*. Indiana University Press, Bloomington.

Kittler, Friedrich A. (1997). "Media Wars: Trenches, Lightning, Stars," in *Literature, Media, Information Systems: Essays*, ed. and intro. John Johnston, 117–129. G+B Arts International, Amsterdam.

Kittler, Friedrich A. (1999). *Gramophone, Film, Typewriter*, trans. and intro. Geoffrey Winthrop-Young and Michael Wutz. Stanford University Press, Stanford, Calif.

Klee, Paul (1961). *Notebooks, Volume 1: The Thinking Eye*, ed. Jürg Spiller, trans. Ralph Mannheim. Lund Humphries, London.

Klein, Norman M. (1993). *7 Minutes: The Life and Death of the American Animated Cartoon*. Verso, London.

Knabb, Ken (ed.) (1981). *Situationist International Anthology*. Bureau of Public Secrets, Berkeley, Calif.

Kracauer, Siegfried (1960). *Theory of Film: The Redemption of Physical Reality*. Oxford University Press, New York.

Kracauer, Siegfried (1995). *The Mass Ornament: Weimar Essays*, ed. and trans. Thomas Y. Levin, 75–86. Harvard University Press, Cambridge, Mass.

Krauss, Rosalind E. (1986). "Grids," in *The Originality of the Avant-Garde and Other Modernist Myths*, 8–22. MIT Press, Cambridge, Mass.

Krauss, Rosalind E. (1993). *The Optical Unconscious*. MIT Press, Cambridge, Mass.

Kuhn, Thomas S. (1962). *The Structure of Scientific Revolutions*. University of Chicago Press, Chicago.

Kuntzel, Thierry (1977). "The Défilement: A View in Close-Up," trans. Bertrand Augst, *Camera Obscura 2* (fall): 51–65.

Lacan, Jacques (1970). "Le stade du miroir comme formateur de la fonction du Je telle qu'elle nous est révélée dans l'expérience psychanalytique," in *Ecrits I*, 89–97. Seuil (Collection Points). Paris.

Lacan, Jacques (1973). *Le Séminaire, livre XI, Les quatres concepts fondamentaux de la psychanalyse*. Seuil, Paris.

Lacan, Jacques (1975). *Le Séminaire, livre XX, Encore*. Seuil, Paris.

Lacan, Jacques (1991). *Le Séminaire, livre VIII, Le transfert*. Seuil, Paris.

Ladurie, Emmanuel LeRoy (1979). *Carnival in Romans*, trans. Mary Feeney. Penguin, London.

Landon, Brooks (1992). *The Aesthetics of Ambivalence: Rethinking Science Fiction Film in the Age of Electronic Reproduction*. Greenwood Press, Westport, Conn.

Langer, Mark (1992). "The Disney-Fleischer Dilemma: Product Differentiation and Technological Innovation," *Screen* 33 (4, winter): 343–360.

Laplanche, Jean (1989). *New Foundations for Psychoanalysis*, trans. David Macey. Blackwell, Oxford.

Lash, Scott (1999). "Being after Time: Towards a Politics of Melancholy," in *Time and Value*, ed. Scott Lash, Andrew Quick, and Richard Roberts, 147–161. Blackwell, Oxford.

Lasky, Betty (1984). *RKO: The Biggest Little Major of Them All*. Prentice Hall, New York.

Lastra, James (1997). "From the Captured Moment to the Cinematic Image: A Transformation in Pictorial Order," in *The Image in Dispute: Art and Cinema in the Age of Photography*, ed. Dudley Andrew, 263–291. University of Texas Press, Austin.

Lastra, James (2000). *Sound Technology and the American Cinema: Perception, Representation, Modernity*. Columbia University Press, New York.

Laurel, Brenda (ed.) (1990). *The Art of Human-Computer Interface Design*. Addison Wesley, Reading, Mass.

La Valley, Albert J. (1985). "Traditions of Trickery: The Role of Special Effects in the Science Fiction Film," in *Shadows of the Magic Lantern: Fantasy and the Science Fiction Film*, ed. George Slusser and Eric S. Rabkin, 141–158. Southern Illinois University Press, Carbondale.

Lee, Gregory B., and Sunny S. K. Lam (2002). "Wicked Cities: The Other in Hong Kong Science Fiction Movies," in *Aliens R Us: The Other in Science Fiction Cinema*, ed. Ziauddin Sardar and Sean Cubitt. Pluto, London.

Lefebvre, Henri (1991). *The Production of Space*, trans. Donald Nicholson-Smith. Blackwell, Oxford.

Leibniz, Gottfried Willhelm Freiherr von (1973). "The Monadology," in *Philosophical Writings*, ed. G. H. R. Parkinson, trans. Mary Morris and G. H. R. Parkinson, 179–194. Dent, London.

Lesage, Julia (1985). "S/Z and the *Rules of the Game*," in *Movies and Methods*, volume 2, ed. Bill Nichols, 476–500. University of California Press, Berkeley.

Levie, Françoise (1990). *Etienne-Gaspard Robertson: La vie d'un fantasmagore*. Le Préambule, Bruxelles.

Levinas, Emmanuel (1969). *Totality and Infinity: An Essay on Exteriority*, trans. Alphonso Lingis. Duquesne University Press, Pittsburgh, Pennsylvania.

Levinas, Emmanuel (1985). *Ethics and Infinity: Conversations with Philippe Nemo*, trans. Richard A. Cohen. Duquesne University Press, Pittsburgh, Pennsylvania.

Levinas, Emmanuel (1989). "Time and the Other," trans. Richard A. Cohen, in *The Levinas Reader*, ed. Sean Hand, 37–58. Blackwell, Oxford.

Lévi-Strauss, Claude (1972). *Structural Anthropology*, trans. Claire Jacobson and Brooke Grundfest Schoepf. Penguin, Harmondsworth.

Lewis, Wyndham (1968 [1926]). "The Art of Being Ruled," in *Wyndham Lewis: An Anthology of His Prose*, ed. E. W. F. Tomlin, 82–233. Methuen, London.

Lewitt, Sol (1992). "Paragraphs on Conceptual Art," in *Art in Theory 1900–1990*, ed. Charles Harrison and Paul Wood, 834–837. Blackwell, Oxford.

Leyda, Jay (1973). *Kino: A History of the Russian and Soviet Film*. George Allen and Unwin, London.

Lister, Martin (ed.) (1995). *The Photographic Image in Digital Culture*. Routledge, London.

Litle, Michael (1985). "The Sound Track of *The Rules of the Game*," in *Film Sound: Theory and Practice*, ed. Elisabeth Weis and John Belton, 312–322. Columbia University Press, New York.

LoBrutto, Vincent (1994). *Sound-On-Film: Interviews with Creators of Film Sound*. Praeger, New York.

Logan, Bey (1996). *Hong Kong Action Cinema*. Overlook Press, Woodstock, N.Y.

Lovelock, J. E. (1979). *Gaia: A New Look at Life on Earth*. Oxford University Press, Oxford.

Luhmann, Niklas (1986). *Love as Passion: The Codification of Intimacy*, trans. Jeremy Gaines and Doris L. Jones. Stanford University Press, Stanford, Calif.

Luhmann, Niklas (1995). *Social Systems*, trans. John Bednarz, Jr., with Dirk Baeker. Stanford University Press, Stanford, Calif.

Luhmann, Niklas (2000). *The Reality of the Mass Media*, trans. Kathleen Cross. Stanford University Press, Stanford, Calif.

Lukács, Georg (1971a). *History and Class Consciousness: Studies in Marxist Dialectic*, trans. Rodney Livingstone. MIT Press, Cambridge, Mass.

Lumière, Auguste, and Louis Lumière (1995). *Letters: Inventing the Cinema*, ed. Jacques Rittard-Hutinet with d'Yvelise Dentzer, trans. Pierre Hodgson. Faber, London.

Lunenfeld, Peter (1999). "The Matrix: Theorized but Unseen." Post to <nettime>, http://www.nettime.org, December 3.

Lyotard, Jean-François (1978). "Acinema," trans. J.-F. Lyotard and Paisley N. Livingstone, *Wide Angle* 2 (3): 52–59. Reprinted in Jean-François Lyotard (1989), *The Lyotard Reader*, ed. Andrew Benjamin, 169–180, Blackwell, Oxford.

Lyotard, Jean-François (1984). *The Postmodern Condition: A Report on Knowledge*, trans. Geoff Bennington and Brian Massumi. Manchester University Press, Manchester.

Lyotard, Jean François (1994). *Lessons on the Analytic of the Sublime*, trans. Elizabeth Rottenberg. Stanford University Press, Stanford, Calif.

MacCabe, Colin (1974). "Realism and the Cinema: Notes on Some Brechtian Theses," *Screen* 15 (2, summer): 7–27.

Manovich, Lev (1997). "What Is Digital Cinema?" in *The Digital Dialectics: New Essays on New Media*, ed. Peter Lunenfeld, 172–192. MIT Press, Cambridge, Mass.

Manovich, Lev (2001). *The Language of New Media*. MIT Press, Cambridge, Mass.

Maor, Eli (1987). *To Infinity and Beyond: A Cultural History of the Infinite*. Birkhäuser, Boston, Mass.

Maor, Eli (1994). *e: the Story of a Number*. Princeton University Press, Princeton, N.J.

Maravall, José Antonio (1986). *Culture of the Baroque: Analysis of a Historical Structure*, trans. Terry Cochran. Manchester University Press, Manchester.

Marchetti, Gina (1993). *Romance and the "Yellow Peril": Race, Sex, and Discursive Strategies in Hollywood Fiction*. University of California Press, Berkeley.

Marie, Michel (1980). "The Poacher's Aged Mother: On Speech in *La Chienne* by Jean Renoir," in *Yale French Studies* 60: 219–232.

Marks, Laura U. (2000). *The Skin of the Film: Intercultural Cinema, Embodiment, and the Senses*. Duke University Press, Durham, N.C.

Marx, Karl (1973). *Grundrisse: Foundations of the Critique of Political Economy*, trans. Martin Nicolaus. Penguin/New Left Books, London.

Marx, Karl (1976 [1867]). *Capital: A Critique of Political Economy*, vol. 1, trans. Rodney Livingstone. NLB/Penguin, London.

Maturana, Humberto R., and Francisco Varela (1980). *Autopoesis and Cognition: The Realization of the Living* (Boston Studies in the Philosophy of Science vol. 42). D. Reidel, Dordrecht.

Maturana, Humberto R., and Francisco Varela (1987). *The Tree of Knowledge: The Biological Roots of Human Understanding*. New Science Library, Boston, Mass.

Mazars, Pierre (1965). "Surréalisme et cinéma contemporain: prolongements et convergences," in *Surréalisme et cinema II: Développement et influences, Etudes cinématographiques* 40–42, ed. Yves Kovacs, 177–182. 2e trimestre, Paris.

McAlister, Michael J. (1993). *The Language of Visual Effects*. Lone Eagle, Los Angeles.

McBride, Joseph (1997). *Steven Spielberg: A Biography*. Faber, London.

McLuhan, Marshall (1964). *Understanding Media: The Extensions of Man*. Sphere, London.

McLuhan, Marshall, and Quentin Fiore (1968). *War and Peace in the Global Village*, coordinated by Jerome Agel. Bantam, New York.

Meehan, Eileen R. (1990). "Why We Don't Count: The Commodity Audience," in *Logics of Television: Essays in Cultural Criticism*, ed. Patricia Mellencamp, 117–137. Indiana University Press, Bloomington.

Meehan, Eileen R. (1991). "'Holy Commodity Fetish, Batman': The Political Economy of a Commercial Intertext," in *The Many Lives of the Batman: Critical Approaches to a Superhero and his Media*, ed. Roberta E. Pearson and William Uricchio, 47–65. BFI, London.

Méliès, Georges (1984). "Cinematographic Views," trans. Stuart Liebman, October 29: 23–31.

Merleau-Ponty, Maurice (1962). *The Phenomenology of Perception*, trans. Colin Smith. Routledge and Kegan Paul, London.

Merleau-Ponty, Maurice (1968). *The Visible and the Invisible*, trans. Alphonso Lingis. Northwestern University Press, Evanston, Ill.

Metz, Christian (1974a). *Film Language: A Semiotics of the Cinema*, trans. Michael Taylor. Oxford University Press, New York.

Metz, Christian (1974b). *Language and Cinema*, trans. Donna Jean Umiker-Sebeok. Mouton, The Hague.

Metz, Christian (1975). "The Imaginary Signifier," trans. Ben Brewster, *Screen* 16 (2, summer): 14–76; reprinted in Metz (1982), *Psychoanalysis and Cinema: The Imaginary Signifier*, 3–87. Macmillan, London.

Metz, Christian (1982). *Psychoanalysis and Cinema: The Imaginary Signifier*. Macmillan, London.

Mignolo, Walter D. (2000). "The Many Faces of Cosmo-polis: Border Thinking and Critical Cosmopolitanism," in *Cosmopolitanism* (*Public Culture* 12 [3, fall]; *Millenial Quartet* no. 4), ed. Carol A. Breckenridge, Shelton Pollock, Homi K. Bhabha, and Dipesh Chakrabarty, 721–748.

Miller, Frank (1986). *Batman: The Dark Knight Returns*. DC Comics, New York.

Miller, Jacques-Alain (1977/1978). "Suture (Elements of the Logic of the Signifier)," *Screen* 18 (4, winter): 24–34.

Miller, Jonathan (1995). "Going Unconscious," in *Hidden Histories of Science*, ed. Robert B. Silvers, Granta, London.

Ministère des affaires etrangères (1996). *Cinéma: cent ans de cinéma français; brève histoire du cinéma français 1960–1990*. ADPF, Paris.

Mishra, Vijay (1985). "Towards a Theoretical Critique of Bombay Cinema," *Screen* 26 (3–4, May–August): 133–146.

Mishra, Vijay (2002). *Bollywood Cinema: Temples of Desire*. Routledge, London.

Mitchell, George (1979a). "The Consolidation of the American Film Industry 1915–1920," *Cinetracts* 2 (2, spring): 37–54.

Mitchell, George (1979b). "The Consolidation of the American Film Industry 1915–1920, Part Two," *Cinetracts* 2 (3–4, summer/fall): 63–70.

Mitchell, William J. (1992). *The Reconfigured Eye: Visual Truth in the Post-Photographic Era*. MIT Press, Cambridge, Mass.

Mitchell, W. J. T. (1986). *Iconology: Image, Text, Ideology*. University of Chicago Press, Chicago.

Mitchell, W. J. T. (1994). *Picture Theory: Essays on Verbal and Visual Representation*. University of Chicago Press, Chicago.

Mitra, Ananda (1996). *Television and Popular Culture in India: A Study of the Mahabharat*. Sage, New Delhi.

Mitry, Jean (1968). *Histoire du cinéma, art et industrie: I: 1895–1914*. Editions Universitaire, Paris.

Montgomery, Scott L. (1993). "Through a Lens, Brightly: The World According to *National Geographic*," *Science as Culture*, 4, part 1 (18): 6–46. Free Association Books, London.

Moore, Alan, and Dave Gibbons (1986). *Watchmen*. DC Comics, New York.

Morales, Carola (1993). "Radio From Beyond the Grave," in *Radiotext(e)* (*Semiotext(e)* 6 [16]), ed. Neil Strauss, 330–332. New York.

Morley, David (1980). *The "Nationwide" Audience*. BFI, London.

Morley, David (1987). *Family Television: Cultural Power and Domestic Leisure*. Routledge, London.

Morse, Margaret (1998). *Virtualities: Television, Media Art, and Cyberculture*. Indiana University Press, Bloomington.

Moszkowicz, Julia (2002). "To Infinity and Beyond: Assessing the Technological Imperative in Computer Animation," *Screen* 43 (2, autumn): 293–314.

Mukherjee, Minakshi (1985). *Realism and Reality: The Novel and Society in India*. Oxford University Press, Delhi.

Multichannel (India) Limited (1996). "Rajah Harischandra," Lehren Web Theatre, http://www.lehren.com/movie/mor/rajah.htm.

Mulvey, Laura (1975). "Visual Pleasure and Narrative Cinema," *Screen* 16 (3, autumn): 6–18.

Mumford, Lewis (1934). *Technics and Civilization.* Routledge and Kegan Paul, London.

Murray, Tim (ed.) (2001). *Digitality and the Memory of Cinema, WideAngle* special issue, 21 (3).

Musser, Charles (1991). *Before the Nickelodeon: Edwin S. Porter and the Edison Manufacturing Company.* California University Press, Berkeley.

Musser, Charles (1995). "Divorce, DeMille, and the Comedy of Remarriage," in *Classic Hollywood Comedy*, ed. Kristine Brunovska Karnick and Henry Jenkins, 282–313. Routledge, London.

Musset, Alfred de (1978). *Les caprices de Marianne.* SEDES/CDU, Paris.

Nadeau, Maurice (1964). *Histoire du surréalisme, suivie de Documents surréalistes.* Seuil, Paris.

Nagel, Ernest, and James R. Newman (1959). *Gödel's Proof.* Routledge Kegan Paul, London.

Nair, P. K. (1999). "In the Age of Silence: Beginnings of Cinema in India," in *Screening the Past* 6, April 16, http://www.latrobe.edu.au/www/screeningthepast/reruns/rr0499/PUdrr6.htm.

Najita, Tetsuo (1989). "On Culture and Technology in Postmodern Japan," in *Postmodernism and Japan*, ed. Masao Miyoshi and H. D. Harootunian, 3–20. Duke University Press, Durham, N.C.

Nancy, Jean-Luc (1993). *The Experience of Freedom*, trans. Bridget McDonald, foreword Peter Fenves. Stanford University Press, Stanford, Calif.

Nash, Mark (1976). "*Vampyr* and the Fantastic," *Screen* 17 (3, autumn): 29–67.

Ndalianis, Angela (1998). *Traversing the Boundaries: Neo-Baroque Aesthetics and Contemporary Entertainment Media.* Ph.D. dissertation, University of Melbourne, Melbourne.

Neale, Steve (1985). *Cinema and Technology: Image, Sound, Colour.* Macmillan, London.

Neale, Steve (1986). "Melodrama and Tears," *Screen* 27 (6, November–December): 6–22.

Nishida, Kitaro (1987). *Last Writings: Nothingness and the Religious Worldview*, trans. D. Dilworth. University of Hawai'i Press, Honolulu.

Nizhny, Vladimir (1962). *Lessons with Eisenstein*, ed. and trans. Ivor Montagu and Jay Leyda. George Allen and Unwin, London.

Nochlin, Linda (ed.) (1966a). *Realism and Tradition in Art 1848–1900: Sources and Documents*. Prentice-Hall, Englewood Cliffs, N.J.

Nochlin, Linda (ed.) (1966b). *Impressionism and Post-Impressionism 1874–1904: Sources and Documents*. Prentice-Hall, Englewood Cliffs, N.J.

Nochlin, Linda (1991). *The Politics of Vision: Essays on Nineteenth Century Art and Society*. Thames and Hudson, London.

O'Brien, Flann (1967). *The Third Policeman*. Hart-Davis, MacGibbon, London.

O'Connor, J. J., and E. F. Robertson (2000). "Georg Ferdinand Ludwig Philipp Cantor," in *The MacTutor History of Mathematics Archive*, University of St. Andrews, http://www-history.mcs.st-and.ac.uk/history/Mathematicians/Cantor.html.

Oettermann, Stephan (1997). *The Panorama: History of a Mass Medium*, trans. Deborah Lucas Schneider. Zone Books, New York.

Ohnuki-Tierney, Emiko (1993). *Rice as Self: Japanese Identities through Time*. Princeton University Press, Princeton, N.J.

Osborne, Peter (1995). *The Politics of Time: Modernity and the Avant-Garde*. Verso, London.

Osborne, Peter (2000). *Philosophy in Cultural Theory*. Routledge, London.

Otomo, Katsuhiro (1988–1995). *Akira*, 38 vols., trans. Yoko Umezawa. Epic Comics, New York (originally 1984–1985, Kodansha, Tokyo).

Panofsky, Erwin (1962 [1939]). *Studies in Iconology: Humanistic Themes in the Art of the Renaissance*. Harper Torchbooks, New York.

Panofsky, Erwin (1991 [1924–1925]). *Perspective as Symbolic Form*, trans. Christopher S. Wood. Zone Books, New York.

Parsons, Talcott (1951). *The Social System*. Routledge, London.

Peirce, Charles Sanders (1958). *Values in a Universe of Chance: Selected Writings of Charles S. Peirce (1839–1914)*, ed. Philip P. Weiner. Doubleday, New York.

Peirce, Charles Sanders (1991). *Peirce on Signs: Writings on Semiotics by Charles Sanders Peirce*, ed. James Hooper. University of North Carolina Press, Chapel Hill.

Peiss, Kathy (1986). *Cheap Amusements: Working Women and Leisure in Turn-of-the-Century New York*. Temple University Press, Philadelphia, Pennsylvania.

Penley, Constance (1989). "Feminism, Film Theory, and the Bachelor Machines," in *The Future of an Illusion: Avant Garde Film and Feminism*, 56–80. BFI, London.

Perrott, Lisa (2002). "Rethinking the Documentary Audience: Reimagining *The New Zealand Wars*," *Media International Australia* 104 (August): 67–79.

Phalke, Dundiraj (1988/1989). "Swadeshi moving pictures," in *Continuum: The Australian Journal of Media and Culture* 2 (1): 51–73.

Pickford, Mary (1955). *Sunshine and Shadow*. Doubleday, New York.

Pierson, Michele (1999a). "No Longer State-of-the-Art: Crafting a Future for CGI" in *Digitality and the Memory of Cinema* (*WideAngle* 21 [1 January]), ed. Timothy Murray, 28–47.

Pierson, Michele (1999b). "CGI Effects in Hollywood Science Fiction Cinema 1989–95: The Wonder Years," *Screen* 40 (2, summer): 158–76.

Plato (1951). *The Symposium*, trans. Walter Hamilton. Penguin, Harmondsworth.

Pohl, Frederick, and Frederick Pohl IV (1981). *Science Fiction: Studies in Film*. Ace, New York.

Pollock, Griselda (1988). *Vision and Difference: Femininity, Feminism, and Histories of Art*. Routledge, London.

Pollock, Sheldon, Homi K. Bhabha, Carol A. Breckenridge, and Dipesh Chakrabarty (2000). "Cosmopolitanisms," in *Cosmopolitanism* (*Public Culture* 12 [3, fall]; *Millenial Quartet* 4), ed. Carol A. Breckenridge, Shelton Pollock, Homi K. Bhabha, and Dipesh Chakrabarty, 577–589.

Prasad, M. Madhava (1998). *Ideology of the Hindi Film: A Historical Construction*. Oxford University Press, Delhi.

Prédal, René (1996). *50 ans de cinéma français*. Editions Nathan, Paris.

Prendergast, Roy M. (1992). *Film Music, a Neglected Art: A Critical Study of Music in Films*, second ed. Norton, New York.

Prince, Stephen (1998). *Savage Cinema: Sam Peckinpah and the Rise of Ultraviolent Movies*. University of Texas Press, Austin.

References

Prince, Stephen (ed.) (1998). *Sam Peckinpah's* The Wild Bunch. Cambridge University Press, Cambridge.

Prince, Stephen (2000). *A New Pot of Gold: Hollywood Under the Electronic Rainbow 1980–1989* (History of the American Cinema, vol. 10). Scribners, New York.

Przyblyski, Jeannene (1995). "Moving Pictures: Photography, Narrative and the Paris Commune of 1871," in *Cinema and the Invention of Modern Life*, ed. Leo Charney and Vanessa R. Schwartz, 253–278. University of California Press, Berkeley, Calif.

Punt, Michael (2000). *Early Cinema and the Technological Imaginary*. Michael Punt, Amsterdam.

Quine, Willard Van Orman (1969). *Ontological Relativity and Other Essays*. Columbia University Press, New York.

Rajadhyaksha, Ashish (1985). "Art in Indian Cinema," in *70 Years of Indian Cinema 1913–1983*, ed. T. M. Ramachandran, 224–236. Cinema-India International, Bombay.

Rajadhyaksha, Ashish, and Paul Willemen (eds.) (1999). *Encyclopaedia of Indian Cinema*, revised ed. BFI, London.

Rama, Angel (1996). *The Lettered City*, trans. John Charles Chasteen. Duke University Press, Durham, N.C.

Rangoonwalla, Firoze (1983). *Indian Cinema Past and Present*. Clarion Books, New Delhi.

Rappaport, Erika D. (1995). "'A New Era of Shopping': The Promotion of Women's Pleasure in London's West End, 1909–1914," in *Cinema and the Invention of Modern Life*, ed. Leo Charney and Vanessa R. Schwartz, 130–155. University of California Press, Berkeley, Calif.

Read, Anthony, and David Fisher (1998). *The Proudest Day: India's Long Road to Independence*. Pimlico, London.

Reader, Keith (1981). *Cultures on Celluloid*. Quartet, London.

Renoir, Jean (1962). *Renoir My Father*, trans. Randolph and Dorothy Weaver. Collins (The Reprint Society 1964), London.

Renoir, Jean (1970). *The Rules of the Game*, trans. John McGrath and Maureen Teitelbaum. Lorrimer Publishing, London.

Renoir, Jean (1974). *My Life and My Films*, trans. Norman Denny. Collins, London.

Renoir, Jean (1989). *Renoir on Renoir: Interviews, Essays, and Remarks*, trans. Carol Volk. Cambridge University Press, Cambridge.

Renoir, Jean (1994). *Letters*, ed. Lorraine LoBianco and David Thompson, trans. Craig Carlson, Natasha Arnoldi, Michael Wells, and Anneliese Varaldiev. Faber and Faber, London.

Renoir, Jean (1998). *An Interview—Jean Renoir*, intro. Nicholas Frangakis. Green Integer 96, Copenhagen.

Rewald, John (1978). *Post-Impressionism: From Van Gogh to Gauguin*, revised ed. Secker and Warburg, London.

Richards, Thomas (1990). *The Commodity Culture of Victorian England: Advertising and Spectacle 1851–1914*. Stanford University Press, Stanford, Calif.

Richter, Hans (1986). *The Struggle for the Film*, trans. Ben Brewster. Wildwood House, Aldershot, Hants.

Ritchin, Fred (1990). *In Our Own Image: The Coming Revolution in Photography*. Aperture Foundation, New York.

Rittaud-Hutinet, Jacques (1990). *Auguste et Louis Lumière: Les 1000 premiers films*. Pillippe Sers éditeur, Paris.

Robertson, George, Melinda Mash, Lisa Tickner, Jon Bird, Barry Curtis, and Tim Puttnam (eds.), (1996). *FutureNatural: Science/Nature/Culture*. Routledge, London.

Robins, Kevin (1996). *Into the Image: Culture and Politics in the Field of Vision*. Routledge, London.

Robinson, David (1969). *Buster Keaton*. Studio Vista, London.

Robinson, David (1989). *Chaplin: His Life and Art*. Grafton/Harper Collins, London.

Rodriguez, Hector (1997). "Hong Kong Popular Culture as an Interpretive Arena: The Huang Feihong Film Series," *Screen* 38 (1, spring): 1–24.

Rogers, Pauline B. (1999). *Art of Visual Effects: Interviews on the Tools of the Trade*. Focal Press, London.

Rogin, Michael (1998). *Independence Day (or How I Learned to Stop Worrying and Love the Enola Gay)*. BFI, London.

Rosenblum, Naomi (1989). *A World History of Photography*, revised edition. Abbeville Press, New York.

Ross, Andrew (1991). *Strange Weather: Culture, Science, and Technology in the Age of Limits.* Verso, London.

Rotha, Paul (1960). *The Film Till Now*, revised edition, with an additional section by Richard Griffith. Spring Books, London.

Rothman, William (1987). *The "I" of the Camera: Essays in Film Criticism, History, and Aesthetics.* Cambridge University Press, Cambridge.

Rotman, Brian (1987). *Signifying Nothing: The Semiotics of Zero.* Stanford University Press, Stanford, Calif.

Rucker, Rudy (1992). *Infinity and the Mind: The Science and Philosophy of the Infinite*, revised ed. Penguin, London.

Ryan, Michael, and Douglas Kellner (1990). *Camera Politica: The Politics and Ideology of Contemporary Hollywood Film.* Indiana University Press, Bloomington.

Sadoul, Georges (1973). *Les pionniers du cinéma 1897–1909* (Histoire Générale du cinéma, vol. 2), second ed. [1948]. Denoël, Paris.

Sakai, Naoki (1989). "Modernity and Its Critique: The Problem of Universalism and Particularism," in *Postmodernism and Japan*, ed. Masao Miyoshi and H. D. Haratoonian. Duke University Press, Durham, N.C.

Salt, Barry (1983). *Film Style and Technology: History and Analysis.* Starword, London.

Sammon, Paul M. (1996). *Future Noir: The Making of Blade Runner.* Orion, London.

Schama, Simon (1995). *Landscape and Memory.* Harper Collins, London.

Scharf, Aaron (1974). *Art and Photography*, revised ed. Pelican, Harmondsworth.

Schickel, Richard (1968). *The Disney Version: The Life, Times, Art, and Commerce of Walt Disney.* Simon and Schuster, New York.

Schirmacher, Wolfgang (1994). "Homo Generator: Media and Postmodern Technology," in *Culture on the Brink: Ideologies of Technology*, ed. Gretchen Bender and Timothy Druckery, 65–79. Bay Press, Seattle.

Schivelbusch, Wolfgang (1980). *The Railway Journey: Trains and Travel in the 19th Century.* Urizen Books, New York.

Schreger, Charles (1985). "Altman, Dolby, and the Second Sound Revolution," in *Film Sound: Theory and Practice*, ed. Elisabeth Weis and John Belton, 348–355. Columbia University Press, New York.

Sconce, Jeffrey (2000). *Haunted Media: Electronic Presence from Telegraphy to Television*. Duke University Press, Durham, N.C.

Sekula, Alan (1986). "The Body and the Archive," *October* 39 (winter): 3–64.

Sennett, Mack (1967). "How to Throw a Pie," in *Film Makers on Film Making: Statements on their Art by Thirty Directors*, ed. Harry M. Geduld, 49–60. Penguin, Harmondsworth.

Sesonske, Alexander (1980). *Jean Renoir: The French Films 1924–1939*. Harvard University Press, Cambridge, Mass.

Seton, Marie (1960). *Sergei M. Eisenstein: A Biography*. Grove Press, New York.

Seydor, Paul (1997). *Peckinpah—The Western Films: A Reconsideration*, revised ed. University of Illinois Press, Urbana.

Sharrett, Christopher (1999). "Peckinpah the Radical: The Politics of *The Wild Bunch*," in Stephen Prince, *Sam Peckinpah's The Wild Bunch*, 79–104. Cambridge University Press, Cambridge.

Shelton, Robert (1986). *No Direction Home: The Life and Music of Bob Dylan*. Penguin, Harmondsworth.

Shepstone, Harold J. (1998). "A Curious Electrical Display," reprinted from *The Strand Magazine* vol. 19, Jan.–June 1900, in Charlie Holland (ed.), *Strange Feats and Clever Turns: Remarkable Speciality Acts in Variety, Vaudeville and Sideshows at the Turn of the 20th Century as Seen by Their Contemporaries*, 15–18, Holland and Palmer, London.

Shklovsky, Victor (V. Chklovski) (1965). "L'art comme procédé," in *Théorie de la littérature: Textes des formalistes russes*, ed. Tsvetan Todorov, 76–97. Seuil, Paris.

Shoesmith, Brian (1988/1989). "Swadeshi Cinema: Cinema, Politics and Culture: The Writings of D. G. Phalke," in *Continuum: The Australian Journal of Media and Culture* 2 (1): 44–50.

Siegel, Lee (1991). *Net of Magic: Wonders and Deceptions in India*. University of Chicago Press, Chicago.

Silverman, Kaja (2000). *World Spectators*. Stanford University Press, Stanford, Calif.

Simmons, Garner (1998). *Peckinpah: A Portrait in Montage.* Limelight, New York.

Singh, Simon (1997). *Fermat's Last Theorem.* Fourth Estate, London.

Skillman, Teri (1988). "Songs in Hindi Films: Nature and Function," in *Cinema and Cultural Identity: Reflections on Films from Japan, China, and India,* ed. Wimal Dissanayake, 149–158. University Press of America, Lanham, Maryland.

Slack, Jennifer Daryl (1998). "The Politics of the Pristine," *Topia: Canadian Journal of Cultural Studies* 2 (spring): 67–90.

Slide, Anthony (ed.) (1982). *Selected Film Criticism 1896–1911.* The Scarecrow Press, Metuchen, N.J.

Smith, Alvy Ray (2000). "Digital Humans Wait in the Wings," *Scientific American,* 283 (5, November): 54–60.

Smith, Terry (1993). *Making the Modern: Industry, Art, and Design in America.* University of Chicago Press, Chicago.

Smith, Thomas G. (1986). *Industrial Light and Magic: The Art of Special Effects.* Columbus, London.

Smoodin, Eric (1993). *Animating Culture: Hollywood Cartoons from the Sound Era.* Roundhouse, Oxford.

Smoodin, Eric (ed.) (1994). *Disney Discourse: Producing the Magic Kingdom.* American Film Institute/Routledge, London.

Sobchak, Vivian (1987). *Screening Space: The American Science Fiction Film.* Ungar, New York.

Sobchak, Vivian (1992). *The Address of the Eye: A Phenomenology of Film Experience.* Princeton University Press, Princeton, N.J.

Sobchack, Vivian (1994). "The Scene of the Screen: Envisioning Cinematic and Electronic 'Presence,'" in *Materialities of Communication,* ed. Hans Ulrich Gumbrecht and K. Ludwig Pfeiffer, trans. William Whobrey, 83–106. Stanford University Press, Stanford, Calif.

Sobchack, Vivian (2000). "'At the Still Point of the Turning World': Meta-Morphing and Meta-Stasis," in *Meta-Morphing: Visual Transformation and the Culture of Quick-Change,* ed. Vivian Sobchack, 131–158. University of Minnesota Press, Minneapolis.

Sobchack, Vivian (ed.) (2000). *Meta-morphing: Visual Transformation and the Culture of Quick-Change.* University of Minnesota Press, Minneapolis.

Soja, Edward W. (1989). *Postmodern Geographies: The Reassertion of Space in Critical Social Theory.* Verso, London.

Solomon, Matthew (2000). "'Twenty-five Heads Under One Hat': Quick Change in the 1890s," in *Meta-Morphing: Visual Transformation and the Culture of Quick-Change,* ed. Vivian Sobchack, 2–20. University of Minnesota Press, Minneapolis.

Spielmann, Yvonne (1997). *Intermedialität. Das System Peter Greenaway.* Wilhelm Fink Verlag, Munich.

Spielmann, Yvonne (1999). "Aesthetic Features in Digital Imaging: Collage and Morph," in *Digitality and the Memory of Cinema,* ed. Timothy Murray, *Wide Angle* (special issue) 21 (1): 131–148.

Spigel, Lynn, and Henry Jenkins (1991). "Same Bat Channel, Different Bat Times: Mass Culture and Popular Memory," in *The Many Lives of the Batman,* ed. Roberta E. Pearson and William Uricchio, 117–148. BFI, London.

Stafford, Barbara (1994). *Artful Science: Enlightenment Entertainment and the Eclipse of Visual Education.* MIT Press, Cambridge, Mass.

Stafford, Barbara Maria (1999). *Visual Analogy: Consciousness as the Art of Connecting.* MIT Press, Cambridge, Mass.

Staiger, Janet (1994). "The Politics of Film Canons," in *Multiple Voices in Feminist Film Criticism,* ed. Diane Carson, Linda Dittmar, and Janice R. Welsch, 191–209. University of Minnesota Press, Minneapolis.

Steiner, Wendy (ed.) (1981). *Image and Code.* University of Michigan Press, Ann Arbor.

Stevens, Wallace (1955). *Collected Poems.* Faber, London.

Stewart, Ian (1992). *From Here to Infinity: A Guide to Today's Mathematics.* Oxford University Press, Oxford.

Stewart, Ian (1995). *Nature's Numbers: The Unseen Reality of Mathematics.* Basic Books, New York.

Stokes, Lisa Odham, and Michael Hoover (1999). *City on Fire: Hong Kong Cinema.* Verso, London.

Stringer, Julian (1997). "'Your Tender Smiles Will Give Me Strength': Paradigms of Masculinity in John Woo's *A Better Tomorrow* and *The Killer*," *Screen* 38 (1, spring): 25–41.

Swidler, Ann (1980). "Love and Adulthood in American Culture," in *Themes of Love and Work in Adulthood*, ed. Neil J. Smelser and Erik H. Erikson, 120–147. MIT Press, Cambridge, Mass.

Tagg, John (1988). *The Burden of Representation: Essays on Photographies and Histories*. Macmillan, London.

Tan, See Kam (2001). "Chinese Diasporic Imaginations in Hong Kong Films: Sinicist Belligerence and Melancholia," *Screen* 42 (1, spring): 1–20.

Tawadros, Çeylan (1988). "Foreign Bodies: Art History and the Discourse of 19th Century Orientalist Art," *Third Text* 3/4 (spring/summer): 51–67.

Taylor, Charles (1992). *Multiculturalism and "The Politics of Inclusion,"* Princeton University Press, Princeton, N.J.

Teo, Stephen (1997). *Hong Kong Cinema: The Extra Dimensions*. BFI, London.

Theweleit, Klaus (1987). *Male Fantasies: Volume One—Women, Floods, Bodies, History*, trans. Stephen Conway. Polity Press, Cambridge.

Thompson, Kristin (1986). "The Concept of Cinematic Excess," in *Narrative, Apparatus, Ideology*, ed. Philip Rosen, 130–142. Columbia University Press, New York.

Thompson, Kristin (1988). *Breaking the Glass Armour: Neoformalist Film Analysis*. Princeton University Press, Princeton, N.J.

Todorov, Tzvetan (1973). *The Fantastic: A Structural Approach to Literary Genre*, trans. Richard Howard. The Press of Case Western Reserve University, Cleveland, Ohio.

Tosches, Nick (1982). *Hellfire: The Jerry Lee Lewis Story*. Plexus, London.

Turim, Maureen (1989). *Flashbacks in Film: Memory and History*. Routledge, London.

Tuve, Rosemond (1947). *Elizabethan and Metaphysical Imagery: Renaissance Poetic and Twentieth Century Critics*. University of Chicago Press, Chicago.

Tuve, Rosemond (1966). *Allegorical Imagery: Some Mediaeval Books and Their Posterity*. Princeton University Press, Princeton, N.J.

Tynianov, Jurii (1965). "De l'évolution littéraire," in *Théorie de la littérature: Textes des formalistes russes*, ed. Tsvetan Todorov, 120–137. Seuil, Paris.

References

Usai, Paolo Cherchi (ed.) (1991). *Lo Schermo Incantato: Georges Méliès (1861–1938)*. Le Giornate del cinema muto/George Eastman House/Edizioni Biblioteca.

Usai, Paolo Cherchi (1994). *Burning Passions: An Introduction to the Study of Silent Cinema*, trans. Emma Sansone Rittle. BFI, London.

Vattimo, Gianni (1993). *The Adventure of Difference: Philosophy After Nietzsche and Heidegger*, trans. Cyprian Blamires. Johns Hopkins University Press, Baltimore, Maryland.

Vaughan, Dai (1990). "Let There Be Lumière," in *Early Cinema: Space, Frame, Narrative*, ed. Thomas Elsaesser, 65. BFI, London.

Vaz, Mark Cotta, and Patricia Rose Duignan (1996). *Industrial Light and Magic: Into the Digital Realm*. Del Rey, New York.

Vertov, Dziga (1984). *Kino-Eye: The Writings of Dziga Vertov*, ed. Annette Michelson, trans. Kevin O'Brien. University of California Press, Berkeley.

Vince, John (1990). *The Language of Computer Graphics: A Dictionary of Terms and Concepts*. Architecture, Design and Technology Press, London.

Virilio, Paul (1989). *War and Cinema*, trans. Patrick Camiller. Verso, London.

Virilio, Paul (1994). *The Vision Machine*, trans. Julie Rose. BFI, London.

Virilio, Paul (1996). *Un paysage d'événements*. Galilée, Paris.

Virilio, Paul (1997). *Open Sky*, trans. Julie Rose. Verso, London.

Vogler, Christopher (1996). *The Writer's Journey: Mythic Structure for Storytellers and Scriptwriters*, revised ed. Boxtree, London.

Vygotsky, Lev S. (1962). *Thought and Language* (orig. pub. 1936). MIT Press, Cambridge, Mass.

Wallerstein, Immanuel (1991). *Geopolitics and Geoculture*. Cambridge University Press, Cambridge.

Ward, Vincent (1990). *Edge of the Earth: Stories and Fragments from the Antipodes*. Heinemann Reed, Auckland.

Warner, Marina (1985). *Monuments and Maidens: The Allegory of the Female Form*. Picador, London.

Wasko, Janet (1986). "D. W. Griffith and the Banks: A Case Study in Film Financing," in *The Hollywood Film Industry*, ed. Paul Kerr, 31–42. BFI, London.

Wasko, Janet (1994). *Hollywood in the Information Age*. Polity, Cambridge.

Watson, Mary Ann (1994). *The Expanding Vista: American television in the Kennedy Years*. Duke University Press, Durham, N.C.

Weddle, David (1994). *Sam Peckinpah: "If They Move . . . Kill 'Em!"* Faber, London.

Weinbren, Graham (ed.) (1999). *The Digital*, special issue of *Millenium Film Journal* 34 (fall).

Wells, Paul (1998). *Understanding Animation*. Routledge, London.

Weston, Jesse L. (1920). *From Ritual to Romance*. Doubleday, New York.

White, Hayden (1996). "The Modernist Event," in *The Persistence of Memory: Cinema, Television and the Modern Event*, ed. Vivian Sobchack, 17–38. Routledge, London.

White, Mimi (1986). "Crossing Wavelengths: The Diegetic and Referential Imaginary of American Commercial Television," *Cinema Journal* 25 (2, winter): 51–64.

Willemen, Paul (1994). "Cinematic Discourse: The Problem of Inner Speech," in *Looks and Frictions: Essays in Cultural Studies and Film Theory*, 27–55. BFI, London.

Williams, Alan (1992). *Republic of Images: A History of French Filmmaking*. Harvard University Press, Cambridge, Mass.

Williams, Christopher (ed.) (1980). *Realism in the Cinema*. BFI/RKP, London.

Williams, Christopher (2000). "After the Classic, the Classical, and Ideology: The Differences of Realism" in *Reinventing Film Studies*, ed. Christine Gledhill and Linda Williams, 206–220. Arnold, London.

Williams, Raymond (1973). *The Country and the City*. Oxford University Press, Oxford.

Williams, Raymond (1974). *Television: Technology and Cultural Form*. Fontana, London.

Williams, Rosalind (1982). *Dream Worlds: Mass Consumption in Late Nineteenth Century France*. University of California Press, Berkeley.

Williams, Tony (2000). "'Under Western Eyers': The Personal Odyssey of Huang Fei-Hong in *Once Upon a Time in China*," *Cinema Journal* 1 (40, fall): 3–24.

Williams, William Carlos (1956 [1925]). *In the American Grain*. New Directions, New York.

442

References

Wilson, Elizabeth (1985). *Adorned in Dreams: Fashion and Modernity*. Virago, London.

Wind, Barry (1998). *"A Foul and Pestilent Congregation": Images of "Freaks" in Baroque Art*. Ashgate, Aldershot.

Winston, Brian (1996). *Technologies of Seeing: Photography, Cinematography and Television*. BFI, London.

Wolfenstein, Martha, and Nathan Leites (1950). *Movies: A Psychological Study*. Free Press, Glencoe, Ill.

Wolff, Janet (1985). "The Invisible Flâneuse: Women and the Literature of Modernity," in *Theory, Culture, and Society* 2 (3): 37–46.

Wölfflin, Heinrich (1950). *Principles of Art History: The Problem of The Development of Style in Later Roman Art*, trans. M. D. Hottinger. Dover, New York.

Wölfflin, Heinrich (1966). *Renaissance and Baroque*, trans. Kathrin Simon. Cornell University Press, Ithaca, N.Y.

Wollen, Peter (1988). "Le cinéma, l'américanisme et le robot." *Communications* 48: 7–37.

Wollen, Peter (1999). "*La Règle du jeu* and Modernity," *Film Studies* 1 (spring): 5–13.

Wombell, Paul (ed.) (1991). *Photovideo: Photography in the Age of the Computer*. Rivers Oram Press, London.

Wood, Robin (1986). *Hollywood from Vietnam to Reagan*. Columbia University Press, New York.

Wood, Robin (1989). *Hitchcock's Films Revisited*. Columbia University Press, New York.

Wray, Fay (1989). *On the Other Hand*. St. Martins, New York.

Wright, Will (1975). *Six Guns and Society: A Structural Study of the Western*. University of California Press, Berkeley.

Wyatt, Justin (1994). *High Concept: Movies and Marketing in Hollywood*. University of Texas Press, Austin.

Yeats, W. B. (1962). *A Vision*. Macmillan, London.

Zalta, Edward N. (2000). "Gottlob Frege," in *Stanford Encyclopedia of Philosophy*, http://plato.stanford.edu/entries/frege/, accessed February 16, 2000.




Zhdanov, Andrei (1992). "Speech to the Congress of Soviet Writers," in *Art in Theory 1900–1990*, ed. Charles Harrison and Paul Wood, 409–412. Blackwell, Oxford.

Zielinski, Siegfried (1999). *Audiovisions: Cinema and Television as Entr'actes in History*. Amsterdam University Press, Amsterdam.

Zizek, Slavoj (1997). "Multiculturalism or The Cultural Logic of Multinational Capitalism," *New Left Review* 225 (Sept./Oct.): 28–51.

Index